TURKISH ART

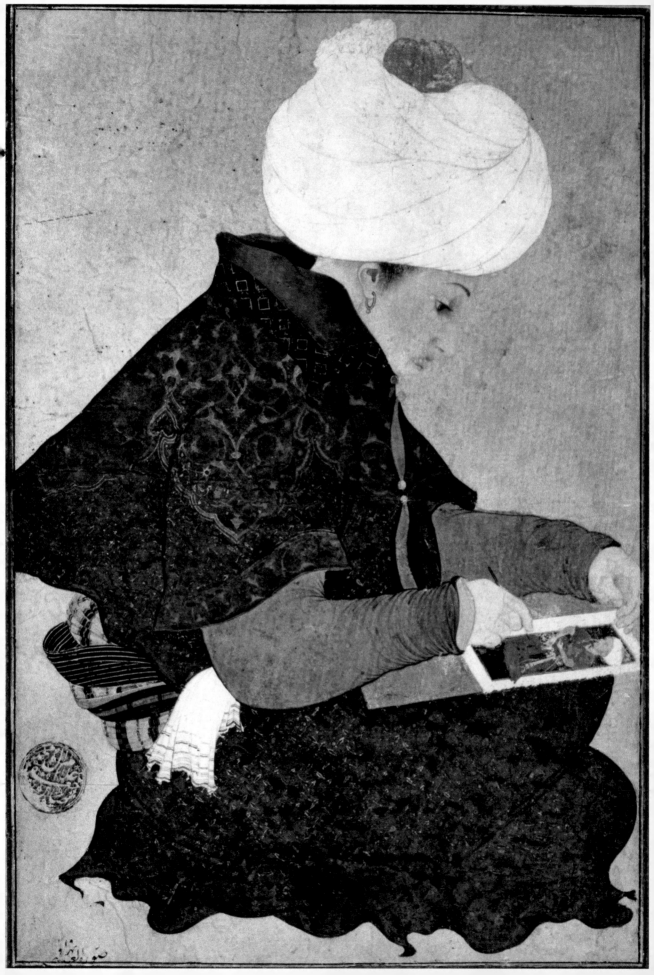

Edited by Esin Atıl

TURKISH ART

Copublished by
Smithsonian Institution Press, Washington, D.C.,
and Harry N. Abrams, Inc., New York

Frontispiece: Portrait of a Painter.

Designer: Darilyn Lowe

Library of Congress Cataloging in Publication Data
Main entry under title:

Turkish art. /Edited...

 Bibliography: p. 375
 Includes index.
 1. Art, Turkish. I. Atıl, Esin.
N7161.T84 709'.561 79-22171
ISBN 0-87474-218-8 (S.I.P.) 386 p.
ISBN 0-8109-1659-2 (H.N.A.)

Library of Congress Catalog Number: 79-22171

Printed and bound in Japan

10/82

Contents

List of Illustrations

MAPS

Foreword

The study of Turkish art and architecture is essential for understanding the cultural history of the Near East, since the Turks dominated the political, social, and artistic developments of that region for almost a millennium. The artists blended local traditions with indigenous forms and styles, creating a synthesis that not only characterized their world but also had a strong and long-lasting impact on the arts of neighboring lands.

There has been a need for a comprehensive book on Turkish arts that could be useful to both the serious student of Near Eastern civilizations and the interested non-specialist. Since a definitive and scholarly work on such a vastly rich and complex topic cannot be competently undertaken by one author, this volume was prepared by a team of educators and curators who specialize in particular aspects of Turkish art and civilization. Their contributions include a thorough and analytical study of a singular theme, incorporating current research, documentation, and bibliography.

The primary purpose of this volume is to serve students; it was designed as a handbook to be used either in surveys of the history of Islamic art or as supplementary reading in courses in Near Eastern and Turkish studies. The book was also conceived to benefit the reader who has little or no background in the field by defining the characteristic features, techniques, and styles of the art and architecture executed between the twelfth and twentieth centuries under the patronage of the Seljuks and the Ottomans.

The volume is devoted to the major Turkish art forms: architecture, manuscripts, ceramics, carpets, and textiles. The traditions of stone and stucco carving, woodwork, metalwork, glass, and other minor arts are beyond the scope of the survey. It is hoped that in a subsequent publication these much-neglected and little-studied branches of Turkish art will be discussed.

Many persons and institutions assisted in our research and enabled us to study the treasures in their collections. We wish to express our special gratitude to the following individuals: Belkıs Acar, Fikret Altay, D. Michael Archer, Ayda Arel, Oktay Aslanapa, Nurhan Atasoy, Nurhayat Berker, Marthe Bernus-Taylor, Filiz Çağman, Kemal Çığ, Afif Duruçay, Charles Grant Ellis, Irene Emery, Ihsan Erzi, the late Richard Ettinghausen, E. Godman, Godfrey Goodwin, Can Kerametli, Aptullah Kuran, Erol Pakin, Ralph Pinder-Wilson, Joseph Rankin, J. Michael Rogers, Leman Şenalp, Marie Lukens Swietochowski, Zeren Tanındı, Norah Titley, and Enise Yener. For the study of textiles we would like to acknowledge the assistance given by the following institutions: Near Eastern Art Research Center, New York; and National Endowment for the Arts, Museum Professional Traveling Grant.

<div align="right">E. A.</div>

Note on Transliteration

All Turkish names, places, and titles are spelled according to official modern Turkish orthography. The Arabic and Persian words follow accepted transliteration systems. For example, the translation of Firdausi's *Shahname* into Turkish is *Tercüme-i Şahname*.

The following is a guide to the pronunciation of Turkish words:

c	pronounced "j" as in "John"
ç	pronounced "ch" as in "chair"
ğ	soft guttural, lengthens vowel preceding it
ı	pronounced somewhat like "e" as in "open"
j	pronounced like the French "j" in "Jacques"
ö	pronounced like the French "eu" as in "peu"
ş	pronounced "sh" as in "shall"
ü	pronounced like the French "u" as in "lune"

Introduction

Few enterprises are more welcome in the underdeveloped field of Islamic studies than manuals treating important segments of the field without trying to cover all of it. Several ways exist. One can pick a period, an area, or a technique. Or, as the editor and authors of this volume did, one can choose an entity that is territorially coherent, yet not uniquely tied to one area; that is culturally and ethnically different from other parts of the Islamic world, yet also the culmination of many older traditions deeply rooted in Islamic civilization; that is unique, yet encompasses themes and motifs ranging from China to Great Britain. It would require generations of scholarly activities to unravel the thousands of strands making up the rich art of Turkey and the Turks. This book is at least a first step in helping to outline the main problems and in defining what is already known. This introduction is somewhat more speculative. I will try to outline what has seemed to me, as a partial outsider to the art and culture of the Turks, to be some of the more fascinating paradoxes of their creativity and especially some of the ways in which a knowledge of this art can be of interest to all art historians.

Perhaps more than any other of the numerous traditions of Islamic art, the Turkish one is connected to an unusual number of different pasts and is contemporary with some of the more revolutionary premodern developments in the arts. Although much romantic nonsense has been written on the subject, the original homeland of the Turks in fact was in Central Asia, where they had created an original culture embodying Chinese as well as Iranian and local elements. At the time (and perhaps under the impact) of the Mongol invasions (thirteenth to fourteenth centuries), a fully identifiable Turkic culture came into its own in several parts of the Muslim world, not only in Anatolia; it was of course the time of the single strongest influx of Chinese themes into western Asia. Particularly in the thirteenth century the Turkish world, and especially Anatolia, became a refuge for all sorts of people fleeing the Mongols, above all for Iranians. Thus Iranian ideas, artists, and technicians permeated the fledgling Turkish world. But Turks had already been prominent, especially as military commanders and founders of dynasties; they were heavily involved in the victory over the Crusaders, and as many of them moved on to conquer new frontiers they also brought a recently revitalized art of Ayyubid Syria. In all these connections they were in a sense the heirs of the whole Islamic legacy of the Middle East, and they carried with them a profound memory of the great universal caliphate of the past. A wedding at the Seljuk court of Konya was organized almost as a pastiche of the legendary wedding of the caliph al-Mamun's daughter to a Barmakid grandee. It was for a minor Turkish ruler that al-Jazari manufactured toylike machines, some of which were replicas of the lost first palace of Baghdad.

Anatolia conquered by the Turks was itself a culturally complex land. And as the Ottomans expanded into the Balkans and beyond, Turkish culture was enriched by the high Byzantine tradition as well as by the traditions of the Armenians, Greeks, Serbs, and Bulgarians, not to speak of the less fully controlled Georgians and northern nomads. In the Ottoman world itself, descendants of most of these ethnic entities came to play an important role as faithful servants of the Ottoman state, and it is well-nigh impossible to determine whether any of them maintained a memory, conscious or not, of their origins. But the successful maintenance of the millet (religious community) system until the eighteenth century certainly prevented the disappearance of practices, ideas, and ideals from earlier centuries. And then there was the land itself. As any traveler or archaeologist knows, the regions that eventually were to become the Ottoman Empire are still among the richest existing repositories of monuments of all times, most particularly Hellenistic and Roman. The latter were certainly even more striking and better preserved in the twelfth century than they are today, but they were not the only ones. There were small churches and a few large ones; there were monastic establishments, palaces, baths—in short, all the paraphernalia of centuries of highly developed and diversified imperial or peasant living.

And, finally, the formation of the Seljuk kingdom and the Ottoman Empire did not take place in a vacuum. Even if the Western Christian world was for centuries hardly sympathetic to the new Turkish power, it was heavily involved with it. Ottoman trade routes led to Mediterranean ports, whence Italian merchants from Pisa, Genoa, or Venice took export goods to Western markets. Later, traders came from other countries as well, and especially after the Ottomans had established themselves along the Mediterranean coast, from Algeria to Slovenia, European colonies of merchants, diplomats, adventurers, eventually real or self-styled experts of all sorts became common in almost every major city under Ottoman rule. The centuries between the thirteenth and the eighteenth were not, however, centuries of linear, even growth in Europe, but a period that began with the psychological and physical defeats of the Crusades and Mongol invasions and ended with worldwide supremacy. And, as far as the arts are concerned, it was in large part the Italy of the merchants dealing with the East that initiated the formal and intellectual revolution of the Renaissance. It is unreasonable to assume that its ideologies and its forms were not known to the world of the Turks, thanks to many new contemporary techniques of cheaper reproduction. As time passed, especially from the sixteenth century onward, another type of relationship between the Ottomans and Christian Europe developed. Within a balance of power that was to be slowly shattered in the latter part of the eighteenth century, what became the Sublime Porte was an equal or superior power, which developed a special symbiotic relationship with the Austro-Hungarian Empire and the expanding Russian one. Yet another type of contact was then established: a contact of trade, diplomacy, exchanges of precious gifts, of prisoners of war, of ways of life. The Russian vocabulary for objects and techniques contains many Turkish words, and an Ottoman-flavored cuisine is found in Hungary.

The historical idiosyncrasies of the formation and growth of a Turkish cultural entity thus quite naturally led to an unbelievable number of possible influences and impacts: China, Central Asia, Iran, Syria, the classical Islamic world, Hellenistic and Roman Mediterranean, Italy, high Byzantium, local Christian groups, the Holy Roman Empire, post-Petrine Russia. It would be easy and at times interesting to trace the impact of any one of these traditions on the Ottoman world, and some work has

been done in this direction. It should also be easy to trace the impact of the Ottomans on others, from specific instances of Turkish forms and subjects in the art of Venice, for instance, to the *Turquerie* of eighteenth-century Western aristocracy. This has been done less frequently. But, though justified and appropriate, neither of these approaches is likely to answer the far more fundamental questions of the originality and character of Turkish art itself. Is it simply a synthetic combination of forms and ideas from many sources? Or is there some fundamental unity to it?

To answer these questions without intellectual (and at times national) prejudices is hardly possible. To the contemporary user or maker of a Seljuk *medrese* or an Ottoman *külliye* and to the illustrator of a *şahname,* influences or impacts were hardly pertinent questions; they were using, viewing, or making useful and beautiful things for their own time. But the historian, of course, is different, as the study of forms becomes to him a nexus of relationships between past traditions and contemporary creativity. Within this nexus how can one suggest the originality of the art created by the Turks or sponsored by them?

First of all, a clear separation must be made between the thirteenth and fourteenth centuries in Anatolian and Ottoman art. The former is, on the whole, a rich and fascinating variant of an ecumenical Islamic art. Most of the forms can easily be traced to Iran, Syria, Armenia, Byzantium, and occasionally an odd westernized source as in Sivas; there are nomadic elements in ornament, probably memories of Central Asia here and there. Truly new and original forms tend to be very idiosyncratic and difficult to explain. Functions of monuments, especially in architecture, are perhaps more original, not so much because any one of them is new, but because their statistical ratios to each other (mausoleums to mosques, small sancturaries to large ones) have changed and a few differences in plan or construction foreshadow things to come. What is missing in thirteenth- and fourteenth-century Anatolian art is the sense of a strong unified style, a self-conscious awareness of a proper way to build, to decorate, or to represent.

Such a style is clearly present in Ottoman art. What are its components? I should like to discuss two that seem to me to be particularly unique. One is that it is an imperial style, and the other is that it exhibits a unique tension between Islamic tradition and artistic revolution.

The imperial character of Ottoman art is most apparent in architecture. As one travels from Algeria to Bosnia, almost every city's landscape is dominated by the characteristic profile of Ottoman mosques: the single large dome framed by tall, slender minarets and preceded by a colonnaded courtyard. Even in nineteenth-century Cairo the independent Muhammed Ali transformed (and in a way ruined) the old citadel with a sort of parody of a classical Ottoman mosque. It does not much matter that so much controversy surrounds the origins of the form and that the mighty Aya Sofya (Hagia Sophia) of Justinian was undoubtedly a major model for Ottoman architects. In reality, it became a symbol of the presence of a unique rule. Its striking simplicity and the abstract quality of its elements so easily usable for many different purposes became models for many European architects of the nineteenth century. The ubiquity of Ottoman types is one aspect of the art's imperial character. Another one is their formal quality; a little more than a century was needed to refine the dome-centered building of several older traditions into a formula of unique sturdiness and magnificent sophistication. And then there is another aspect of imperial Ottoman art that is not as clearly visible in this book, perhaps because it does not lend itself as easily to art historical definitions. It is its *Pracht-*

kunst, its art of beautiful clothes and objects visible in the parades and receptions depicted by the painters. It was a brilliant courtly art that collected Chinese ceramics, Iranian carpets, and Iranian miniatures as well as Western paintings, even though its taste in the latter was perhaps not as discriminating. It transformed the imperial palace into a private museum. It is difficult to know how much of this collecting and occasional exhibiting of objects and paintings from all over the world was a function of conscious love of art works. In a way it does not matter, as the gathering of expensive or allegedly precious items is the imperial function. Appreciated or not, conscious or not, the collecting instinct created a taste, an Ottoman taste, and its impact can be found wherever the empire existed.

The tension between Islamic tradition and revolutionary ideas is a far less tangible feature of Ottoman art. It is true, of course, that the spectacular engineering feats represented by some sixteenth-century mosques are accompanied and at times obscured by an ornament that is very traditional. Portals and windows may have acquired the complex profiles of Mediterranean Renaissance or later of Baroque modes, but almost everywhere there still remain the stalactites of older Near Eastern Islamic architecture. In painting, a new realism and precision in detailed observation are certainly there, but the size of the images, the conception of pictorial space, and the use of color are still very much in an older Iranian tradition. And, while the art of Ottoman ceramics reached new peaks of perfection and developed several new techniques and many new designs, the idea of a brilliant art of ceramics and the ways in which tiles or other objects were used still belong to earlier times.

Thus the art of the Ottomans expresses a curious paradox. At times Ottoman art attained the brilliant inventiveness that makes it a worthy contemporary of Renaissance and Baroque Europe. But it was also the conscious and willing repository of a millennial Islamic culture. Therein lies its fascination to the general art historian. Like Ottoman culture, it was a bridge between different worlds that never quite knew how much of a bridge it really was.

Right: Circumcision Festival of Beyazıd and Cihangir (detail). Arifi, *Süleymanname.*

The Turks in History

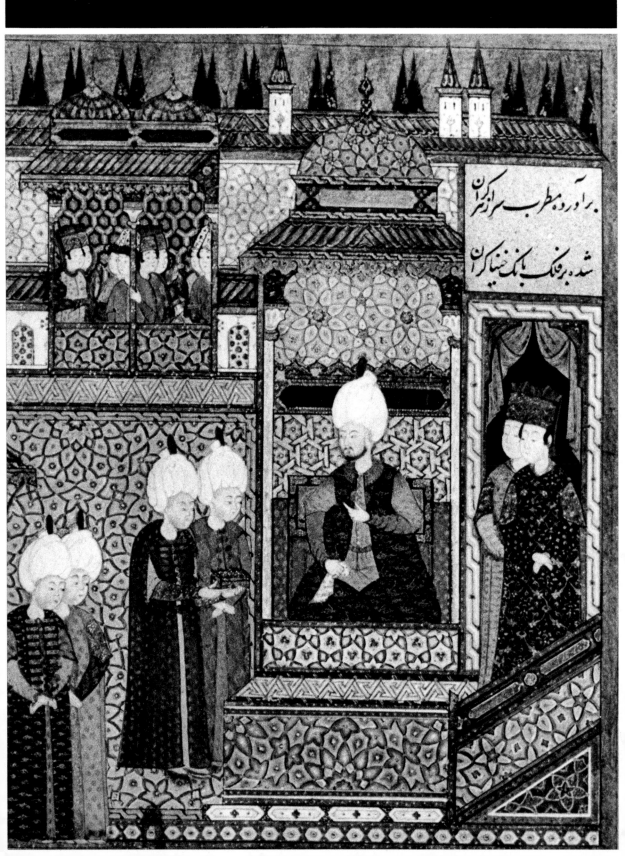

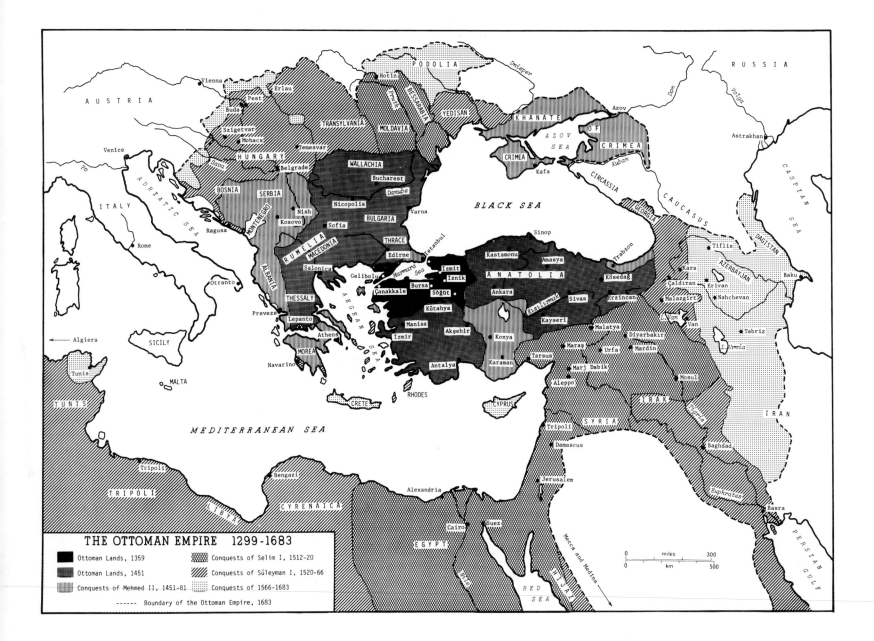

THE OTTOMAN EMPIRE 1299-1683

Ottoman Lands, 1359
Ottoman Lands, 1451
Conquests of Mehmed II, 1451-81
Conquests of Selim I, 1512-20
Conquests of Süleyman I, 1520-66
Conquests of 1566-1683
------ Boundary of the Ottoman Empire, 1683

WHEN FIRST KNOWN to history, the Turks were a nomadic people living in what is now Russian Siberia. They moved west, adopted Islam as their religion, again moved west, and built one of the world's great empires. At its apogee in the sixteenth century, the Ottoman Turkish Empire stretched from the borders of Morocco to the borders of Iran, and from southern Poland to southern Yemen. It then entered two centuries of slow decline, followed by a century of efforts to reverse the decline by a process of westernization. Finally it collapsed at the close of World War I. From its ruins sprang the Turkish Republic, which soon will celebrate its sixtieth anniversary. This frame will serve for the historical sketch that follows: rise, height, decline, reform, and republic.

The Rise of Turkish Power

It is not certain when the Turks first used that name to describe themselves. The earliest known writing in a Turkish tongue dates from the eighth century A.D.; it was found in the Orhon inscriptions near Lake Baykal. Yet Byzantine records of two centuries earlier refer to Turks, and Chinese chronicles mention them in 1300 B.C. Nor is it clear whether the word Turk first designated one tribe or a group of tribes. The latter was true at least by the late seventh and early eighth centuries, when the expanding forces of Islam came into contact with tribal groups they called Turks. Presumably at about the same period Turks also began to call themselves collectively by that name.

The designation is primarily linguistic: Turks are speakers of Turkish. Turkish, the language spoken by western Turks in Turkey today, is one of a large family of closely related Turkic languages; its tens of millions of speakers also inhabit parts of Iran, areas of the Russian Caucasus, and most of Russian and Chinese Turkestan. The Turkic tongues in turn are a part of the Altaic group, whose relationships are not so clear, but which includes Mongolian and perhaps Korean. Place names in Turkish are sprinkled in a vast belt from central Mongolia and western China across inner Asia through Iran, the Caucasus and Black Sea regions, and Turkey, into the Balkans as far as Yugoslavia. This indicates the route of migration and expansion of Turks in past centuries.

Early in the Christian era Turkish tribes living on the fringes of Mongolia seem to have been bumped westward by stronger tribal confederations. They migrated to new homes near the Syr Darya (Jaxartes) in Central Asia. Some established urban centers. For a time in the sixth century there was an organized state in the area, which sent ambassadors to Constantinople, the Byzantine capital, and received tribute and ambassadors from the Byzantines. This little kingdom controlled the silk route from China

to the West—not a road, of course, but a series of merchants and caravan stops. But the kingdom soon broke into smaller tribal units or incipient city-states.

When in the seventh century the Arabs, under the banner of their new religion, burst from their peninsula to overrun Syria, Irak, and Iran, they encountered the edges of the Turkish world in Central Asia. Through military contact, trade, and the proselytism of itinerant holy men and dervishes the Turks came to know Islam and gradually to adopt it. Some had been Buddhists, some Zoroastrians, some Christians, some Manichaeans, but most had been pagans. By the tenth century most Turks who lived in the Syr Darya region had become Muslims. They were still predominantly horsemen, and the life they led is reflected in the great Turkish epic *Dede Korkut*. The tales, told by Grandfather Korkut, originated among the Oğuz confederation of Turkish tribes probably in the tenth century. They praise the traditional virtues of tribal life: horsemanship, heroism, loyalty. They show devotion to Islam (in both orthodox and heterodox forms) and also reveal a monogamous society in which women played a prominent role.

Then there began a reverse penetration. Groups of Turks began to enter the classical world of Islam. At first some were employed as slave fighters and guards for the caliphs of Baghdad or their subordinates. Then in the eleventh century other Turks struck out on their own, taking control of eastern districts in the caliphal lands. These were Seljuk Turks, so called after a warrior leader from one of the Oğuz tribes. In 1055 Tuğrul, a grandson of Seljuk, led his followers to the capture of Baghdad, the seat of the caliph himself. The caliph was neither killed nor deposed but remained as religious head of the community, while Tuğrul and his successors, also in the name of Islam, exercised political and military control with the title of sultan. For a half-century they ruled in the central lands of the Abbasid caliphate. The Seljuk Turks now appeared as strong defenders of orthodox Islam against the varied heterodoxies of the Shiites. Their intent was to continue expanding their control to the west, to rescue Syria and Egypt from the rule of the Fatimid schismatics. Unplanned but portentous events diverted them from exclusive concentration on this objective.

These events were the successful raids of Turkish bands into Byzantine Anatolia. The raiders were nomadic Turkish tribesmen from Central Asia, usually called Türkmens (Turcomans), whom the Seljuks had earlier shunted to fighting along the borders of Christian Byzantium in order to be rid of them. The Türkmens fought both for booty and for Islam, but an Islam of a more popular and dervish-inspired sort than the variety approved in Baghdad. It happened that the Byzantine Empire was at one of its weaker stages in the later eleventh century. The Türkmen raiders infiltrated Anatolia, as the Arabs of the seventh and eighth centuries had never been able to do. They raided as far as Kayseri. When the Byzantine emperor gathered a large army for a counterblow, Tuğrul's successor, Alp Aslan, felt obliged to respond with his regular forces. The ensuing Turkish victory of Malazgirt (Manzikert) near Lake Van in eastern Anatolia in 1071 broke the Byzantine hold in the east, leaving Anatolia open to further penetration. Recently the nine-hundredth anniversary of Malazgirt was celebrated in Turkey. It symbolizes not only the military victory of the Turks but also the beginning of what would be a four-hundred-year process of Turkification of Anatolia.

It was not soldiers of the organized Seljuk state who infiltrated Anatolia but Türkmen raiders. Calling themselves gazis (warriors for the faith) they rode in from the east in increasing numbers, some even going all the way to the Aegean coast. To stabilize the situation the Seljuk rulers sent one of their family, Süleyman, as organizer and ruler

of the unruly elements. He fixed his forces and his capital far to the west, at İznik (Nicaea), and for a few years in the 1080s it looked as if a new frontier of some stability had been secured in western Anatolia between Byzantines and Turks. But Süleyman's ambitions for more eastern lands led to his death in battle against other Seljuks in 1086, and for a decade thereafter Anatolia was the scene of many-sided conflicts among local Turkish leaders seeking power, and between them and Byzantine rulers in the west.

In this situation the Byzantine emperor Alexis I appealed to the Christian West for aid. The resultant First Crusade retook İznik for the Byzantines in 1097. The Christian successes pushed the Turkish frontier eastward, back to Dorylaeum near modern Eskişehir, where it remained for more than a century. Seljuk control in Anatolia was then limited to a region on the central plateau, flanked in the west by Byzantine territory and in the east by Lesser Armenia and the crusader state of Edessa.

Konya became the capital of the Anatolian Seljuk state, now quite independent of any control from Baghdad or elsewhere. Turks called their state the Sultanate of Rum, since it occupied territories that once belonged to Rome—although to the Turks "Rum" no longer meant Latin civilization but Greek, for the Eastern Roman Empire had long since lost what Latin veneer it once had possessed. So the Seljuk sultanate was a successor state ruling part of the medieval Greek empire, and within it the process of Turkification of a previously Hellenized Anatolian population continued. That population must already have been of very mixed ancestry, deriving from ancient Hittite, Phrygian, Cappadocian, and other civilizations as well as Roman and Greek. The Turkish language, the Arabic script that Turks had adopted, and Islam became dominant along with Seljuk rule. Among the instruments of Turkification and Islamization was the Mevlevi order of dervishes, established at Konya in the early thirteenth century by the mystic poet Celaleddin Rumi. The whirling dervishes seem to have been effective missionaries. At the same time the Greek church lost many properties, and bishops were often kept from their sees by the Turks. Thus, material difficulties and self-interest as well as conviction led to conversions of Christians to Islam.

For more than a century, from about 1100 to 1240, the Seljuk Sultanate of Rum flourished. It took lands from the rival Türkmen state of the Danişmends to the east. In the early thirteenth century it gained seaports on both the northern and the southern Anatolian coasts, at Sinop and Antalya, and conducted a thriving commerce with Italian city-states. The remains of Seljuk roads, bridges, mosques, hans (khans), and other monuments in Konya and elsewhere in Anatolia bear testimony to its vigorous life. Then from the outside came an anti-Seljuk blow far more shattering than the Crusades, and from the opposite direction.

Mongol hordes, still pagan, swept out of Asia into the Near East, spreading terror as they came. Even before destroying Baghdad in 1258, they invaded eastern Anatolia and defeated the Seljuk army of Rum in 1243 at the battle of Kösedağ. Thereafter the Seljuk state was tributary to the Mongols, who, following a local rebellion, kept troops and a governor in Anatolia. The Sultanate of Rum became a dependency of the Ilkhanid dynasty of Islamicized Mongols who ruled from Iran. The weakened Seljuk state was further beset by new waves of Türkmen tribesmen, some driven from Central Asia or eastern Anatolia by the Mongols and some following in the Mongol wake. Here in Anatolia in the late 1200s Marco Polo encountered the Türkmens—"a rude people," he called them, who bred fine horses, sought good pastures, and revered the Prophet Muhammed. He remarked on the cities, with their many Greek and Armenian inhabi-

tants, on the fine carpet and silk manufactures, and on the dependence of Konya and Kayseri on the Mongol Great Khan.

Though the Seljuk dynasty of Rum lingered until 1307, the newly arrived Türkmens provided the moving force in a rearrangement of power in Anatolia and in a renewed expansion of Turks into western Anatolia, where the Byzantines had ruled since the First Crusade. Again, as had occurred two centuries before, there was a period of Byzantine weakness that the gazi warriors exploited. Byzantine rulers had been evicted from their great city in 1204 by the Latins of the Fourth Crusade, who then set up their own Latin kingdom of Constantinople. Then in 1261 the Byzantines, from their base in western Anatolia, regained Constantinople—but at the expense of weakening their Anatolian defenses and of becoming involved with other enemies to the west, like the Bulgars and the Serbs. The Turks profited from this. Pushing on the Byzantine frontiers, competing with each other, Turkish emirs (local princes) with their followers carved out little emirates in former Byzantine territories. They did this also in former Seljuk territories, as the Ilkhanid control faltered in the fourteenth century.

One of the emirs was Osman (1299?–1324?), whose emirate was based on Söğüt, a small town near present-day Eskişehir. His was originally one of the lesser principalities, yet it grew, surprisingly, to eclipse all its competitors. The explanation now usually accepted is this: Osman's northwestern situation, closest to the remaining Anatolian Greek territories that formed the Byzantine defense for Constantinople, not only attracted vigorous gazis to his ranks but also forced a slow, step-by-step conquest from the Christians that had to be solid and well organized. Osman became the first of a ruling dynasty that continued unbroken until 1922. From his name were derived the names both of the dynasty and of the state—"Osmanlı" in Turkish, "Ottoman" in western European languages (from the Arabic form of his name, Othman or Uthman).

Ottoman expansion was slow for the first half-century. It was only Osman's son and successor Orhan (1324?–62?) who gained the first important cities: Bursa in 1326, İznik and İzmit (Nicomedia) soon thereafter. Striking his own coinage a year after taking Bursa, Orhan in effect declared by this act of sovereignty that he was free of Mongol control. Bursa became his capital, which he provided with good streets, a covered market, a hospice, a bath, and a caravansaray. Here the first Ottoman sultans —as they now began to style themselves—are buried in stately mausoleums in the city that Turks today affectionately call "green" for its verdant environs, green mosque tiling, and pious Muslim atmosphere. From his capital of Bursa, Orhan annexed the lands to the west that verged on the Dardanelles. The leap across the narrow strait to Europe was first made by his forces in 1345, when they were called in as allies by a Byzantine emperor in a conflict with a rival claimant to his throne. The Ottomans took a liking to Europe, and evidently resolved to stay.

In the next half-century Ottoman expansion went more rapidly. By 1354 the conquerors had established themselves for good in fortress towns on the Gelibolu (Gallipoli) peninsula. In 1361 they took Edirne, which shortly became the new headquarters for the conquering sultans. Now under Murad I (1362?–89) Turkish armies advanced through Thrace and Bulgaria and up the river valleys into Serb territory. Conquering towns such as Sofia and Nish, making vassals of Bulgars and Serbs, Turkish horsemen reached the Danube. Simultaneously the Ottomans pressed eastward in Anatolia, incorporating lands of other gazi leaders. Victory over a Serb-led coalition at the battle of Kosovo in 1389 consolidated the Balkan gains, though at the cost of Murad's life. His son Beyazıd I (1389–1402), "Thunderbolt" to his followers, continued the expansion

both east and west. He probed into Hungary and began to besiege Constantinople itself. Europe's answer was a crusade organized by the king of Hungary, the pope, and Western knights—a real threat to the fledgling Ottoman Empire but met boldly by Beyazıd. In 1396 at the crucial battle of Nicopolis (Niğbolu) on the Danube in Bulgarian territory, the Western knights were routed. It was the last real crusade.

But Beyazıd's expansion to the east in Anatolia brought an even greater threat. It was always somewhat embarrassing for the Ottomans to fight other Muslims; religious law condoned warfare only against the unbeliever. But the Ottoman sultans did fight brother Muslims when they could not take over Turkish emirates by marriage or any sort of peaceful annexation. Beyazıd had particular success against the rival Turkish emirs of the Karaman family. He then ran up against a greater rival—himself a Turk and a Muslim—who had also become the champion of dispossessed Anatolian emirs. This was Timur the Lame (Tamerlane), heir to a large part of the Mongol realm. From his capital in Central Asia, Timur had conquered Iran and now appeared in eastern Anatolia. Mutual insults and threats between Timur and Beyazıd were followed by the inevitable clash, and in the battle of Ankara in 1402 Timur won a major victory. He captured Beyazıd, who died the next year. The Ottoman state, headless, fell into chaos as Timur restored ousted emirs to their former lands, while Beyazıd's sons fought among themselves for the Ottoman succession. Had a major crusade now been launched from the Balkans, there is no telling what the course of Ottoman history might have been, or whether the dynasty and state might then have come to an end, after a century of remarkable expansion that had created an empire stretching from the Danube to the Euphrates.

The first half of the fifteenth century, however, brought Ottoman recovery. For a decade the empire remained fragmented, until Beyazıd's youngest son triumphed and, as Mehmed I (1413–21), began to put the pieces back together. Both he and his son Murad II (1421–51) were constantly engaged in warfare, partly against Venetians and Hungarians, but just as much against those local rulers and tribal elements who hated the curbs that a centralized state with a strong ruler would put on them. The centralizing forces won not only because of the individual ability of the two Ottoman rulers, but because the rulers enjoyed significant popular backing. Townsmen and merchants tended to favor the order and unity that a centralized state created. Peasants favored a check on the exactions of local lords. The cavalrymen, who lived on lands granted by the sultan in return for services, furnished him strength, as also did the elite infantry, the Janissaries. This corps of shock troops, the first standing army of modern Europe, had been created by Murad I from slaves who had been prisoners of war. Now numbering 6,000 or more, they had no equal in fighting. In this period of recovery the Ottomans also began to use muskets and cannon, borrowing the best they saw in use by their Western opponents. The first use of cannon by Turks was perhaps in an unsuccessful siege of Constantinople in 1422.

The Ottoman Empire at its Height

When Mehmed II (1451–81) succeeded his father, his consuming desire was to win Constantinople, the prize that had for so long eluded his forebears. The conquest of this Christian stronghold would not only be a gazi deed, but would also knit together

the Anatolian and Rumelian halves of the resurgent Ottoman Empire. In 1452 Mehmed built the great fortress of Rumeli Hisarı—still standing today—to control ship traffic in the Bosporus. Then he gathered his army, perhaps 50,000 regulars and as many irregulars, outside the land walls of the city. The siege began on April 6, 1453. The world's largest cannon, one with a barrel twenty-six feet long, hurled huge stone balls at the triple walls surrounding the city. The 7,000 defenders nightly repaired the damage. To distract defenders from the land walls, a fleet of small Turkish ships was hauled up the hill behind Galata in one night and gently dropped into the harbor of the Golden Horn, behind the chain that closed off its mouth. But it was the land assault of May 29, undertaken by Mehmed against the counsel of his grand vezir, that finally broke through the city's walls. Turkish troops poured in for a day of pillage. At its end, Mehmed the Conqueror entered Constantinople to restore order and to pray in the Church of Aya Sofya, now at his order turned into a mosque.

The Ottoman capture of Constantinople in 1453 has sometimes been shrugged off as historically unimportant—the conquest of an already surrounded and largely depopulated city. But for the Turks the capture of Constantinople has a triple significance. It gave them a splendid harbor and a leading commercial center, commanding the routes from the Black Sea to the Mediterranean and from Rumelia to Anatolia. It further gave them a new capital with an aura of imperial majesty, the second Rome, seemingly destined to be the capital of another great empire; now Mehmed added "Roman Caesar" (Rum Kayseri) to his titles. Finally the capture confirmed the Turks' position as a European power. They were no longer a frontier gazi state, no longer an Asian state with a foothold in Europe, but a state with a claim to deal equally with other great European states.

Mehmed II was a builder as well as a conqueror. He began at once to repopulate the city, bringing in craftsmen, merchants, and husbandmen of all religions from various parts of his realm. He had bazaars, hans, mosques, and other buildings constructed. İstanbul—as the Turks popularly called it, presumably from hearing Greeks say they were going *eis ten polin,* "to the city"—was again becoming *the* city. Mehmed also continued to enlarge the empire of which it was the capital. He retook Karaman lands in Anatolia, conquered Trabzon (Trebizond) from its last Greek rulers, reconquered and absorbed some Serb lands, took some Aegean islands from Venice, overran and annexed the Morea, Bosnia, and Albania, made the Crimea a vassal, and did the same with Wallachia. Turkish power was fast extending over all the shores of the Black Sea and Aegean Sea and into the Adriatic. This Aegean and Mediterranean expansion, largely at the expense of Venice, continued under Mehmed's successor Beyazıd II (1481–1512). Turkish naval units under Kemal Reis raided as far west as the Balearic Islands. One of the results of such raids was the acquisition of the most up-to-date geographical and cartographical knowledge, through capture from a Spanish seaman of a map or chart of some of Columbus's discoveries in the New World. The surviving half of the world map with many marginal notations drawn in 1513 by Kemal's nephew, the admiral Piri Reis, shows in detail sections of the Caribbean and South American coastlines.

If the impression given thus far is one of almost uninterrupted warfare by the Ottomans, this is not far from wrong. By the early sixteenth century this warfare had consolidated the Ottoman position as heirs of the Byzantine Empire in Anatolia and Rumelia and as heirs of much of the Venetian maritime empire on the coasts and islands around the Balkan peninsula. The conquests had usually been achieved in two stages:

first, a conquered principality or other area would be made tributary, supplying troops and money; then, sometimes after a renewed campaign, it would be put under direct Ottoman administrative control. Some areas therefore were conquered more than once. But there was also cooperation with the Ottoman conquerors. In the early days in Anatolia, numbers of Greeks, including some leaders, had voluntarily joined the Ottomans. In the Balkans the peasantry seems often to have welcomed the Ottoman advance as a release from extortionate rule by local lords, and there too some of the leaders had joined the Ottoman cause. In some cases the Turkish sultans appointed leading Christian fighters in the Balkans to posts in local military-civil government, giving them, as cavalrymen, grants of fief lands.

But, as repeated rebellion showed, there were also some who wanted no strong central government and who resented Ottoman control. Among these were many of the still-nomadic Türkmen tribesmen in Anatolia, who opposed not only central authority and its taxes but also its Orthodox Sunnite Islam. Türkmens tended to favor some form of Shiite heresy, usually mixed with pagan survivals, and they were encouraged by dervish leaders. Often called *kızılbaş* (redhead) from the red caps they wore, these heterodox Anatolians were a perpetual danger to the Ottoman state. They were a danger particularly in Beyazıd II's reign, because the newly resurgent Iran under Shah Ismail was also Shiite and could rouse the Anatolian discontented as a fifth column in the never-ending struggle of Ottoman state against Persian state. The great *kızılbaş* rebellion at the end of Beyazıd's reign had to be suppressed by his son Selim I (1512–20), called "the Grim" (Yavuz), who slaughtered perhaps 40,000 rebels. Selim then marched into Iran, winning a major battle at Çaldıran in 1514 and securing further territory in eastern and southeastern Anatolia as far as Diyarbakır. This success in turn brought Selim into conflict with the northern Syrian forces of the Mamluk sultanate and opened the way for the first of seven major expansionist drives that ensued during the sixteenth century.

In 1516 Selim's forces marched south into Syria against the Mamluks. This warrior caste of Turk and Circassian slaves had ruled in Egypt since 1250, though they were unloved by the native population of Egypt as well as by the Arabs of Syria. In the early 1500s the Mamluks were threatened by the Portuguese, who, having circumnavigated Africa, preyed on Muslim commerce in the Arabian Sea and nibbled at the southern Red Sea approaches to Egypt itself. Selim may have conceived of himself as a deliverer of Arabs from both the Mamluks and the Portuguese. In any case, he was welcomed by the people of Aleppo in 1516, defeated the Mamluk sultan and his army nearby at Marj Dabik, and proceeded south to take all of Syria. Continuing the long march into Egypt, Selim routed another Mamluk army near Cairo in 1517. Firearms, which the skilled Mamluk horsemen refused to use because they disdainfully considered them unchivalrous, were the key to the Ottoman victories.

The result of the victories was to add to the Ottoman Empire a vast expanse of territory—Syria, Egypt, and also the Hijaz, which had been under Egyptian protection. More than just territory, these areas constituted a major part of the Arab heartland, including the ancient capital cities of Medina and Damascus and the modern capital of Cairo. Aleppo and Cairo were also great commercial centers, and the revenues of the Ottoman Empire now began to swell from the eastern trade that came through Egypt and Syria. Perhaps the most significant result of the conquest was that Selim and his successors became without question the world's leading Muslim rulers, guardians of the three holy cities of Mecca, Medina, and Jerusalem. Sunnite orthodoxy and the

şeriat (the holy law of Islam), expounded by the ulema (learned men) of the Arab world, became even more important at the Ottoman court.

This first expansionist drive, to the south and southeast, was followed soon by a second, to the north and northwest, under Süleyman I (1520–66). He first had to take the key city of Belgrade, which for years had resisted the Turks with Hungarian aid; he then had to secure his rear in the Mediterranean by winning the island of Rhodes from the Knights of Saint John, effective harassers of Muslim shipping. Then, urged on by Francis I of France, Süleyman advanced up the Danube in two major campaigns against the forces of the Hapsburgs, whose monarch Charles V was also the Holy Roman Emperor. A great victory on the field of Mohacs in 1526 established Ottoman suzerainty over Hungary. Renewed Hapsburg opposition provoked a repeat campaign in 1529. This time the Ottoman armies went all the way to Vienna, though they lifted the siege at the onset of the autumnal equinox without taking the city. This was the high point of Turkish advance into Europe. They never were able to enter the gates of Vienna but for a century and a half kept Hungary and Transylvania under their control.

The third expansionist drive of the sixteenth century was an outgrowth of the land wars against the Hapsburgs. When Charles V's fleet threatened Turkish-held coasts in the Balkans, Süleyman's response opened a half-century of intermittent naval war in the Mediterranean. Barbaros Hayreddin Paşa, the famous Turkish corsair who already had conquered Algiers, was appointed grand admiral. He led the Turkish fleet in a series of encounters with the Christians, at the end of which Tunis and Tripoli as well as Algiers and other North African ports were firmly in Ottoman rather than Hapsburg-Spanish hands. The Ottoman military success in the Mediterranean was, however, never total. In 1565, near the end of Süleyman's reign, an attempt to take Malta ended in ignominious failure. Yet Ottoman influence extended beyond the confines of the war zone to the German and Dutch Protestants who were rallied against the Hapsburgs, to the Muslims and crypto-Muslims (Moriscos), and to the Jews and crypto-Jews (Marranos) who fled from persecution in Spain to the haven of Ottoman lands.

The fourth major expansionist drive was again to the east, in the alternating sequence characteristic of Ottoman warfare. Süleyman's armies turned against Safavid Iran in 1534–35. The campaign resulted in the conquest of Tabriz and Baghdad. Tabriz was lost in renewed warfare in the 1550s, but Irak and Baghdad remained in Süleyman's possession. Now the Ottomans were on the shores of both the Persian Gulf and the Red Sea. In Basra, as they had done earlier in Suez, they built a fleet to confront the Portuguese in the Indian Ocean. But here again the Ottomans were halted. They could not compete with the Atlantic powers in the art of navigating the high seas, nor could they oust the Portuguese from Hormuz, control point for entrance to and exit from the Persian Gulf. Vienna, Malta, Hormuz—these marked the points at which the Ottomans remained forever blocked by the Christian European world.

The next two expansionist drives of the sixteenth century came during the reign of Süleyman's son, Selim II (1566–74). Boldly envisioning a scheme for opposing the growing Muscovite power in the north, Grand Vezir Sokollu Mehmed Paşa mounted an expedition with the Tatars of the Crimea to cut a canal from the Don River to the Volga, so that Ottoman ships could join land forces in attacking Russian-held Astrakhan and sail the Caspian Sea. But the expedition of 1568–69 failed. No canal was dug, and Astrakhan resisted siege. Then Ottoman attention turned to a smaller but more accessible prize, Cyprus, which was a Venetian colony. An amphibious as-

sault in 1570–71 won the island by bloody fighting. During the war the Ottoman fleet lost to a combined Christian fleet a major engagement at Lepanto, off the coast of Greece, but Cyprus itself remained in Turkish hands.

The last great drive—against Iran in the reign of Murad III (1574–95)—gained much territory for the Ottomans. Georgia and other Iranian provinces bordering the Caspian Sea passed into Turkish control. Ottoman ships finally were launched on the Caspian itself. Yet this victory, confirmed in 1590, was undone in the early years of the next century. Ottoman expansionism seems at last to have come to a halt. Even though additional bits of territory—Crete and southern Poland—were added to the empire in the seventeenth century, the élan by then was gone. The sixteenth century saw the apogee of Ottoman territorial conquest.

Straddling three continents, the Ottoman Empire of the sixteenth century had a population that has been estimated at anywhere from twenty to fifty million—perhaps thirty million is a realistic guess—at a time when France had about sixteen million. It was composed of an extraordinary mixture of peoples. In Europe there were Hungarians, Serbs, Croats, Romanians, Bulgarians, Albanians, Greeks, and Turks. In Asia were Turks, Greeks, Lazes, Armenians, Kurds, Circassians, and Arabs. In Africa there were Arabs and Berbers. There were also other smaller groups. The multitude of languages and dialects was almost matched by the variety of religious sects. Muslims were probably a majority if one adds together Turks, Arabs, Kurds, Berbers, and those Bosnians, Albanians, Bulgarians, and others who had converted to Islam. Of the Christians, the vast majority were Greek Orthodox; the next largest Christian church was the Armenian. The Jewish population, never as numerous as the others, was composed of important communities in Baghdad and other cities and during the sixteenth century was swelled by tens of thousands of Sephardic Jews who fled Christendom for the toleration of Muslim rule. Salonica became a major Jewish city; İstanbul had an important Sephardic community. Some of these peoples, and some of these sects, lived in fairly compact agglomerations, but others lived intermixed in cities—a Greek or Armenian quarter side by side with a Muslim quarter—or in adjacent villages, or in scattered locations.

The mixture of peoples was more confusing than might otherwise have been the case because of two processes that had accompanied Ottoman expansion. One was conversion of other peoples to Islam when the Turks took territorial control. Most of the Hellenized population of Anatolia had become Islamic during the centuries of invasion and disruption, but important pockets of Christians remained. Most of the Greek Orthodox peoples of Rumelia, more swiftly conquered by the organized Ottoman state, retained their traditional faith. Yet numbers of Greek Orthodox did apostatize in Rumelia; an outstanding example is the Serb peasantry surrounding the Islamicized towns of Bosnia, a distinct group of Muslims embedded in the generally Christian Balkans. The second process was *sürgün* (forced migration). Ottoman sultans not infrequently ordered the transplanting of groups of people for reasons of nomadic sedentarization, defense, security, or economic development, as Mehmed II had done in repopulating İstanbul. In the sixteenth century, for example, some 20,000 or more Turkish peasants of Anatolia were moved to Cyprus as a partial remedy for overpopulation in Anatolia and to develop Cyprus. These processes made the settlement patterns in the Ottoman Empire heterogeneous in the extreme.

The governing of so heterogeneous an empire, in an age when a man's religion was his identifying mark, was made simpler by the fact that each major religious community

was also a community in civil law. All Muslims, as members of the *umma* (the community of the Prophet), were subject to the religious law of Islam, and their disputes were judged in the Muslim courts. The non-Muslims were members of millets (religious communities), which had their own civil law for matters of personal status—marriage, divorce, property inheritance—and their own courts. The millets, from the time of Mehmed II on, were headed by clergymen whom the sultans confirmed as civil heads of their communities: the Greek Orthodox and Armenian millets under their respective patriarchs in İstanbul, the Jewish millet under the grand rabbi of the same city. The millet organizations were responsible not only for civil status and the judicial process but also for church property, worship, education, charity, and even for the collection of some taxes to be remitted to the central government.

At the head of the central government of this vast empire was the sultan of the Ottoman dynasty. The ten sultans in the line from Osman to Süleyman, individuals differing greatly in character, were men of considerable, and in some cases conspicuous, ability. Each sultan had been given experience in military and civil affairs during his teenage years as a prince guided by a tutor and advisers. Contests for the succession among brothers were not uncommon. Once on the throne, the victor usually had any surviving brother killed; the cruelty of this fratricide was accepted by religious leaders and the public as justifiable, since it helped to avoid anarchy arising from disputes as to who was rightful ruler. The sultan was in theory absolute, accountable to no one but God, and restricted only by God's law, the *şeriat*. In fact, he was often held in check by rebellion, or the threat of it, and sometimes by the religious men who interpreted the law for him, though they were subject to his dismissal. Yet Ottoman sultans had never abandoned the *örf* (right of pre-Islamic Turkish rulers to legislate) and therefore often issued *kanuns* (regulations having the force of law).

Except when the sultan was away from the capital, most often on a campaign, he ruled from the New Palace, so called to distinguish it from the first palace built by Mehmed II on the present site of İstanbul University. Known today usually as Topkapı Sarayı, the New Palace was a series of garden-courts and buildings erected at various times—all rather modest for the ruler of so great an empire but magnificently situated on the point overlooking the confluence of the Marmara, the Golden Horn, and the Bosporus. Topkapı Sarayı included kitchens, storerooms, ateliers, reception rooms, private quarters, and of course the harem—most of whose female inhabitants were servants of various kinds rather than favored imperial concubines. In the palace chamber called the Kubbealtı (Under-Dome) the sultan's council, or divan, met several days a week. Its members included the top ranks of the various branches of officialdom. The chancellor and two chief treasurers were "men of the pen," from the hierarchies of bureaucrats who did the office work of government. The two chief judges, for Europe and Asia, "men of religion," represented the hierarchy of jurists who presided over *şeriat* courts in various judicial districts throughout the realm. The grand vezir, who was the sultan's alter ego and presided over the divan, was a member of the empire's most peculiar institution, the system of slave officials of the sultan.

Since the time of Mehmed II the slave administrators had become the most powerful segment of the Ottoman government. Seljuk rulers and early Ottoman sultans had had officials who were personal slaves known as *gulams* or *kuls*. They usually were young men taken as prisoners of war or bought in slave markets. Since no born Muslim should, under Islamic law, be enslaved, the slaves were of non-Muslim origin. In the time of

Murad II the *devşirme*, a system of collecting Christian peasant boys from areas within the empire, became regularized. Every few years an imperial commission selected boys between eight and twenty years of age, who were sent to İstanbul for screening and training. All were obliged to become Muslims; evidently most did so willingly. Strong ones of less intelligence became Janissaries. Those of highest ability were trained in Topkapı itself, in the Palace School. After a thorough education and apprenticeship they were assigned to palace posts, provincial governorships, or military commands. By merit the slaves could advance to the highest post in the empire, that of grand vezir. For more than 200 years after Mehmed II the *devşirme* group thus controlled the pinnacle of central government. Sultans found two advantages in this system: they could counterbalance the influence of the old leading families, the natural aristocracy, through reliance on their own men, and they could demand complete personal obedience from the slaves. For though the slaves might gain power and wealth, their careers and their very lives were at the ruler's disposition. Their children, furthermore, as freeborn Muslims, could not follow in their fathers' careers.

In the sultan's divan the governor-general of Rumelia, the European half of the empire, was also privileged to take a seat. He represented "men of the sword" other than the Janissaries, since he was commander of the provincial governors and ultimately of the cavalrymen who held local fiefs. Whenever conquered land had been incorporated into the empire, it had been carefully surveyed. Great *defters* (registers) recorded population and economic production—the oldest now surviving in the İstanbul archives dates from 1431. Units of villages and farmlands were assigned as *timars* (fiefs) to cavalrymen according to the expected productivity and tax revenue. The local *sipahi* (horsemen) then lived on the revenues of his fief, kept order, carried out the sultan's regulations, and gave military service on campaigns. This system was particularly strong in the Balkans; later conquests in the Arab areas were put under administrators who were tax-farmers rather than cavalrymen.

All of the foregoing groups—men of the pen, men of religion, men of the sword—constituted, with their families, the upper level of Ottoman society, the so-called *askeriye* (military) class. They served faith and state, in the Ottoman formula. They paid no taxes. The bulk of the *reaya* (population) were peasants, nomadic herdsmen, artisans, merchants. They were the food growers, goods producers, and taxpayers. Transfer from one class to the other was possible, but infrequent. In Ottoman theory, each person had his designated place in society; the good order of society required that he remain there. Enforcing this was sometimes difficult. In the sixteenth century great numbers of villagers migrated to the cities, almost doubling the urban population and often causing economic and political problems. At various times then and later, the government would bar their entry or deport them back to the countryside.

Among townsmen, the craft guilds played a primary role, providing religious fellowship as well as economic status and protection. Tailors, tanners, tallow chandlers, taxidermists—each trade was organized as an *esnaf* (guild). It conferred economic status, regulated employment, purchased and apportioned raw materials, oversaw standards of production and fairness of prices. İstanbul had about 150 major guilds. Collectively they could be a powerful political as well as economic influence. There were guilds of small merchants as well. The great merchants who participated in the flourishing international trade—with the East via Egypt or Syria, with the Black Sea regions, and with the Italian city-states and western Europe—were often individually powerful and

well connected with officials of high rank; such merchants were big investors, lenders, and accumulators of capital.

The empire was not only Ottoman but thoroughly Islamic, the greatest among the Islamic states of its day (which included Morocco, Safavid Iran, and Mughal India). Ottoman sultans were leaders of the Muslim community; they were defenders of the faith, of the holy cities, and of the Sunni branch of Islam in particular. This orthodox Islam was taught and interpreted by the ulema, who were teachers, preachers, judges, and jurisconsults. In the sixteenth century the most prominent scholar among the ulema was Ebussüud, who worked out the codified accommodation of religious law and the sultan's *kanuns*. For thirty years he was the *şeyhülislam* (chief interpreter of the law). Law, theology, and other subjects were taught in the *medreses* (schools attached to major mosques); of these, the highest ranking were established in İstanbul by Mehmed II and Süleyman I adjacent to the mosques they had also built and which bear their names.

Medreses, their libraries, adjacent kitchens, their teachers and students were usually supported by funds from property established as a *vakıf* (religious foundation). Such property, legally dedicated in perpetuity for charitable purposes, was in theory God's and no longer subject either to ordinary taxation or to sale. In the Ottoman Empire, as in all Islamic lands, the institution of *vakıf* played a major role in supporting works which, in modern times, are customarily financed by the public fisc. Mosques, *medreses,* libraries, hospitals, hospices, kitchens for the needy, public water fountains, even roads and bridges were built and maintained by foundations established by sultans, high officials, and other wealthy individuals. Some of the empire's major architectural monuments owe their existence to *vakıfs.* In the sixteenth century the master builder Sinan, a product of the *devşirme* who started life as a military engineer, created many of them. For thirty-five years as chief architect to Süleyman and his successor, Sinan dominated the age in his field as Ebussüud did in his. Sinan is reported to have built 304 structures, from Hungary to the Hijaz; the Mosque of Süleyman in İstanbul and the Mosque of Selim in Edirne rank among his greatest and finest.

There was a popular Islam as well as the orthodox Islam of the law and the learned ulema. Sufism, the more personal and mystical path to the knowledge of God, had greater appeal for many. The two varieties of Islam often intermixed; even Ebussüud harbored some Sufi tendencies. But the common popular expressions of this path to divine knowledge, the *tarikats* (dervish orders), espoused beliefs and modes of worship quite different from the austere theology and prayer ritual of strict orthodoxy. The Mevlevis (Whirling Dervishes) attracted many upper-class Ottomans to their search for direct ecstatic experience of God. Other orders, particularly the Bektaşis, attracted many ordinary Turks in addition to more cultivated individuals. Eclectic in their beliefs, incorporating elements of shamanism and Christianity, the Bektaşis tolerated wide variation in doctrines and practices. The Mevlevi and Bektaşi orders, and others, had convents called tekkes, which were not only the residences of full-time dervishes, but the centers to which on occasion the thousands of lay brothers came.

Just as there were two Islams, so also there were in more general terms two cultures. The true Ottoman wrote a Turkish intermixed with many words of Arabic and Persian origin, all embedded in a complex style that was incomprehensible to the ordinary Turk. Subtle elegance of expression, rather than simple clarity, was the usual objective. Poetry flourished—for the Ottomans, usually a poetry of a Persianate sort. Süleyman himself was known as an accomplished poet. Fuzuli of Baghdad was perhaps the most distinguished of the age. To an Ottoman, a "Turk" was an uneducated, rather boorish

and peasantlike fellow who spoke common Turkish and was illiterate. The Turk enjoyed mystical folk poetry of the dervishes, the love poetry of wandering minstrels, the professional storyteller, the shadow play.

All classes began to enjoy coffee, which invaded the empire from the south by way of the Arab provinces in the mid-sixteenth century. At first condemned as a vice by many of the ulema (though not by Ebussüud), it conquered all, even the ulema. The coffeehouses of villages and town quarters became gathering places for the men, sometimes for rabble. This was sometimes the case also with the public bathhouses, which were a necessary part of life in every city and town, centers for social gathering of women (during women's hours) as well as of men. One bathhouse built by the rather Rabelaisian poet Gazali of Bursa became so notorious as a center for dissolute characters that Süleyman ordered it destroyed. Tobacco joined coffee as a companion vice, or pleasure, around 1600; in this age, it was smoked in long pipes or water pipes, the cigarette being a more recent invention. There were also the joys of nature—streams, shady groves, flowers. The tulip was much cultivated—it was from Turkey that the Dutch first imported it in 1559.

The Decline of the Ottoman State

Though the age of Süleyman was undoubtedly one of prosperity and military victory with a reasonably well-ordered society and a high level of culture, there was evidence of both social discontent and the beginning of economic and military problems. These became quite obvious in the last decade of the sixteenth century and increased during the seventeenth, so that Ottoman writers began to comment on the decline and to call for a return to the good order of the preceding golden age. Economic, military, social, administrative, and psychological problems, more clearly seen now by hindsight, interacted to produce the decline.

Economic difficulties stemmed in part from a massive inflation in the later sixteenth century caused by the influx of cheap silver from the newly discovered mines of Peru. Prices of staples rose, hurting all who lived on fixed revenues and taxes, like cavalrymen, bureaucrats, judges, and beneficiaries of pious foundations. The Ottoman government, accustomed to stable currency and prices, had no idea what to do; when some sultans debased their own coinage it only forced prices up faster. Revenues failed to meet needs, even when taxes were sharply increased. Shortly thereafter Ottoman profits from Eastern trade fell off, as the East India Company and other European merchants found it cheaper to import goods from India and the Persian Gulf by the all-sea route around Africa. Meanwhile Ottoman manufactures suffered from competition with European goods that came into the empire under low tariffs fixed by the capitulations—treaties of privilege and commerce granted by the sultans to European states—while Ottoman exports were themselves subject to tax to raise revenues.

These economic problems helped to create an almost permanent financial crisis for the government just at a time when it needed greater cash income to pay new troops. Cavalrymen from the fiefs were less effective in an age of gunpowder, so a corps of infantrymen with muskets was built up, composed mostly of Anatolian peasants. Some fiefs were taken from cavalrymen and made into tax-farms to get cash. Other fiefs, however, were given to palace favorites or otherwise got into private hands. As the

timar system broke down, fewer cavalrymen turned out for campaigns, partly because they could no longer afford the expense. Local order, entrusted to cavalrymen, was less well kept; this in its turn adversely affected agricultural production and revenues. Such was also the case when the new tax collectors in the former fiefs tried to squeeze too much out of their peasants.

Social discontent was exacerbated by such military-economic difficulties. The new infantry units of musketmen were often turned loose at the end of campaigns, no longer on the payroll. They then became brigand bands, principally in Anatolia. Their ranks were on occasion swelled by former *timar*-holders who had lost their fiefs. In addition, there seems to have been a marked population increase during the sixteenth century, contributing to the number of landless peasants. Migration to the cities was one result. Another result was the further swelling of brigand bands who staged, in effect, a number of revolts—the so-called *celali* revolts of the 1590s and early 1600s—that the government suppressed only with the greatest difficulty. Curiously, at the time of rural overpopulation there seem also to have been increasing numbers of deserted villages and farms, perhaps owing to flight from plague, from extortionate taxation, and from marauding brigands.

One way of maintaining order in the provinces was to station Janissary units there. This was done, but the total result was not always beneficial. For the Janissary corps had begun to decline even as it was increased in size. First, Janissaries on active duty had been allowed to marry. Then their sons were allowed to enroll in the corps. Then other Turks, not products of the *devşirme*, became members. Having family ties, not just a simple loyalty to the sultan, Janissaries looked for more money, especially in the age of inflation. They could get pay increases by threats of revolt. Many also began to lead a double life, moonlighting at jobs in the city. When Janissary units were stationed in provincial cities to keep order, they continued in their new evil ways and often became part of an unruly local ruling clique, along with notables among the ulema and the *esnafs*.

The breakdown of discipline in the Janissary corps reflected a breakdown in the whole slave-official system. Though the *devşirme* was continued through the seventeenth century and into the eighteenth, it produced fewer recruits. More and more sons of slave officials managed to insinuate themselves into official careers. Promotion by merit became less common, replaced by favoritism and corruption. This was true among the bureaucrats as well. The corruption involved buying and selling of official posts and favors, understandable in a time when government salaries failed to keep pace with inflated living costs, but still subversive of orderly government. Judges, too, became corrupt; one of the commonest complaints of would-be Ottoman reformers was that justice was a mockery when it was bought and sold. There were still able officials, even within a corrupted system, but they were probably fewer. The most outstanding were members of the Köprülü family who occupied the office of grand vezir many times between 1656 and 1710.

It is tempting to blame the decline of the Ottoman administrative system on the sultans themselves. "The fish begins to stink at the head," said a much-quoted Turkish proverb. It it tempting even to single out one ruler, Selim II, known to his subjects as "Selim the Sot" for his overindulgence in Cyprus wine. But Selim II was not without ability. It was after his reign that the real problems of the sultanate developed, owing more to a change in the system of succession to the throne than to anything else. It formerly had been the practice that a sultan's sons be sent out into the provinces to gain

military and administrative experience. It also had formerly been the custom that a newly enthroned sultan kill his surviving brothers, thereby eliminating possible contenders and fomenters of civil anarchy. In the early seventeenth century both practices were changed. Princes were no longer exposed to firsthand experiences in the field, but were kept in special apartments in the palace known as the *kafes* (cage or lattice). Nor were brothers any longer routinely slain (though it still sometimes happened) by a newly acceded sultan, partly because Mehmed III (1595–1603) had had nineteen younger brothers killed at his accession; this wholesale slaughter turned opinion against the practice of fratricide. Ahmed I (1603–17) on his accession allowed his brother, Mustafa, to live on in the *kafes*. This became the custom. Thereafter, the oldest surviving male—uncle, brother, son—would succeed on a sultan's death. Mustafa I was twice placed on the throne (1617–18, 1622–23) and twice removed because he was mentally deficient. His retardation was originally not due to internment in the *kafes,* but the internment undoubtedly did not help him. Nor was it a help to any potential heir to the throne. The lack of practical experience, in addition to the debilitating life of confinement, produced some sultans who were incompetent, some who were simply disinterested in government, and some who were mentally unbalanced.

On the whole, the seventeenth-century sultans were not a very able lot. Ahmed I was known for his piety but also for the lack of success of his armed forces. "Mad Mustafa," as he was called, was incompetent. İbrahim (1640–48) was also incompetent and unbalanced. Mehmed IV, whose long reign (1648–87) began at a tender age, became known as the "Huntsman Sultan" because the chase rather than administration became his principal occupation. Two sultans were exceptions, in that they exhibited energy and ability. Osman II (1618–22), who had been only a few months in the *kafes* before accession, harbored thoughts of reform but was soon assassinated by the suspicious Janissaries, whom he had wanted to replace with new levies of more effective and more loyal forces. Murad IV (1623–40) was equally energetic and extraordinarily cruel in punishing malfeasance or disloyalty with instant execution. But these two were atypical in a period when power generally was exercised by court officials and palace cliques. Among the most influential politicians, for such in fact they were, were a number of women of the imperial harem. Kösem Mahpeyker, mother of Murad IV and of İbrahim, and Hadice Turhan, mother of Mehmed IV, were effectively the real rulers of the Ottoman Empire for considerable periods.

The weakness in the sultanate and the economic and social difficulties of the period following Süleyman might have been less injurious to the Ottoman Empire in the long run had there not been also an intellectual or psychological metamorphosis. Considerable numbers of ulema, backed by many of the uneducated and by poor *medrese* students, inveighed increasingly against innovation. A pride in Islamic achievement, combined with a strict interpretation of the Koran, worked especially against borrowing new concepts or techniques from the Christian West. There were always learned men among the Ottoman ulema, and always some who sought European knowledge in this field or that, but Ottoman Islam seems to have become generally more ingrowing and less absorptive than it had been in the early days. This prejudice—that innovation was blasphemous—spread at an unfortunate time, when western Europeans were making strides in geographic discovery, rational thought, scientific investigation, technology, and manufacture. The gap between East and West was widening; it made Ottoman decline more dangerous in the face of relative Western superiority.

It was in warfare that the gap first became excruciatingly obvious. In the late

sixteenth and early seventeenth centuries, Ottoman armies were less easily and less often victorious than before. Ahmed I, for example, was faced with simultaneous wars on two fronts, something that the sultans had always sought to avoid. He fought a long intermittent war against Shah Abbas I of Iran and in some of the same years fought the Austrian Hapsburgs. His Iranian war was a losing proposition in the long run; his Austrian war more nearly a draw, at the end of which, in the Treaty of Zsitvatorok (1606), he had to acknowledge for the first time that the Hapsburg ruler was his equal— emperor, not just king. Ahmed's naval strength was in decline, while the Barbary corsairs ceased to obey him and independently operated out of Tripoli, Tunis, and Algiers. At the same time fleets of small Cossack ships came down the Russian rivers and raided in the Black Sea; in 1614 they burned Sinop, though they were later defeated at the mouth of the Don. In 1621 Osman II embarked on an ill-conceived Polish campaign partly because of Cossack raids from the Polish frontier. The war was unpopular; the unenthusiastic Ottoman forces performed indifferently at best. Wars such as these were costly to support and were not compensated by booty or new taxable territory. Even the victorious campaigns in the seventeenth century, which gained Podolia from Poland and the island of Crete from its Venetian masters, exhibited neither the old élan of the sixteenth-century armies nor a military and naval establishment rejuvenated by new Western techniques.

In 1683 it seemed for a moment that this situation might be reversed. A vast Ottoman army marched to besiege Vienna for the second time. But the siege was broken by a Hapsburg victory, aided by Polish forces. It was not simply that the Turks voluntarily retired, as they had done in 1529; they were driven into retreat. The continuing warfare brought Venice and Russia also into the anti-Turkish coalition. When peace was finally made at Karlowitz in 1699, the Ottomans had to abandon all of Hungary and Transylvania and were back at Belgrade on the Danube. The Russians under Peter the Great had gained Azov, their first appearance on the shores of the Black Sea. Even Venice, a declining power, had been able to seize the Morea. This was the first great Ottoman retreat from Christian lands they had earlier conquered and ruled. It gave a somewhat bitter flavor to the epithet "ever victorious" that was incorporated into the *tuğra* (official signature) of each Ottoman sultan.

Though it was weakened from within and without, the Ottoman Empire still was far from total collapse. In the first half of the reign of Ahmed III (1703–30) some territories were regained. Azov was retroceded by the Russians in 1711 at the end of a short war that the Turks had entered as a result of urging by Charles XII of Sweden, who had been allowed refuge in Ottoman lands after a defeat by Peter the Great. The Morea, whose Greek Orthodox inhabitants chafed under a Roman Catholic government and sought the rule of Muslim Turks again, was reconquered from Venice. The one significant loss of these years was Belgrade, yielded up in 1718 to the Austrian Hapsburgs by the Treaty of Passarowitz and regained by the Turks only in 1739.

In the time of Ahmed III the atmosphere in the Ottoman Empire seemed to change, at least superficially. The first man of the pen to become grand vezir took office in 1703. The grand vezir's residence, the Sublime Porte (Bab-ı Ali), in the eighteenth century began to rival the palace as the center of government. The change in atmosphere was especially marked in the years of peace following 1718, when the sultan gained a reputation for avoiding war and cultivating luxurious tastes. In these pursuits he was vigorously aided by his grand vezir, Nevşehirli İbrahim Paşa, who had married a daugh-

ter of the sultan, one of Ahmed's thirty-one children. Festivities celebrating his sons' circumcisions and his daughters' marriages were frequent in his reign. Nedim, the poet laureate of his day, expressed the new tone with his familiar line, "Let us laugh, let us play, let us enjoy the world to the full." The pleasure seeking of Ahmed's court was often directed into artistic channels. Music, poetry, and literature were cultivated. Five libraries were established in İstanbul, and Nedim was put in charge of the sultan's own. Growing tulips became a craze, which has given to the last twelve years of Ahmed's reign the name of Lale Devri, the Tulip Period. Some of the new inspiration of the time came from the West, either directly or by way of the Greek community of the Fener quarter of İstanbul. The Ottoman ambassador Yirmisekiz Mehmed Çelebi was sent to Paris to investigate French institutions that might be useful for the empire. The most important innovation was the establishment of the first Turkish printing press in 1724 by İbrahim Müteferrika, originally a Hungarian; the ulema agreed to sanction it if secular works alone were printed. A fire brigade of pumpers was organized in İstanbul by a French convert to Islam. There was some interest in Western military techniques, not seriously pursued until later, although in the 1730s a French renegade, Count Bonneval, turned Ahmed Paşa, helped reorganize the bombardiers.

There was, however, no major transformation in the Tulip Period. The superficial westernisms, though they affected court tastes and some of the architecture of the period, did not penetrate deeply. In fact, popular antagonism was aroused against Frankish manners at a time when there were economic hardship and new rural migration from villages to İstanbul. When Ahmed III's military weakness was revealed in a losing campaign on the Iranian frontier in 1730, a revolt in İstanbul led by Patrona Halil, a junk dealer and Janissary associate, expressed the popular indignation. Grand Vezir İbrahim was sacrificed to the mob, and Ahmed III abdicated. So ended the Tulip Period and its somewhat liberal atmosphere.

Throughout the next half-century there were intermittent attempts to profit from Western knowledge and techniques. But the "long peace" lasting from 1739 to 1768 resulted in more complacency and in less military rebuilding and reform than was needed. Peripheral provinces continued to slip from effective central control—the North African provinces were long gone into almost independent corsair hands, while Egypt, Irak, Lebanon, and many tribal areas oozed from the sultan's grasp into the control of local strongmen. In Anatolian and Rumelian provinces *ayans* (local notables), professing allegiance to the Ottoman Dynasty, were still on occasion able to defy or disregard the sultan's authority.

War with Russia from 1768 to 1774, and particularly the treaty that concluded it, ended Ottoman complacency. Though both sides fought poorly, the Russians won the final campaign. The Treaty of Küçük Kaynarca in 1774 sealed the Ottoman defeat with consequences felt ever after. The Crimea was detached from Ottoman control and made independent. Russia gained a strategic coastal strip to the north of the Black Sea, her first permanent foothold there. For the first time Russian ships were allowed to trade freely in that sea, through the Bosporus and Dardanelles, and in all Ottoman ports. A permanent Russian embassy in İstanbul and Russian consulates throughout the Ottoman Empire were permitted. In a few years Catherine II annexed the Crimea and seized more Black Sea coast; after renewed war the Porte was also obliged to recognize this in 1792. The Russian advances served to spur Ottoman efforts at reform, first of all reform of the military establishment.

The Era of Ottoman Reform

Between the late eighteenth century and the early twentieth century, the Ottoman government initiated many changes, all in the direction of westernization. The process of changing established ways was inherently difficult. Progress was also hindered and interrupted by two parallel sets of events: a series of foreign attacks, many of which resulted in loss of Ottoman territory, and a series of risings among minority peoples of the empire who sought self-government or independence. Napoleon's invasion of the province of Eygpt in 1798 made it clear that even the central parts of the Ottoman realm were not immune from foreign attack. Thereafter, the Turks fought four wars against Russia (1806–12, 1828–29, 1853–56, 1877–78), only one of which—the Crimean War of the 1850s—resulted in victory; in each of the others, Russia gained Ottoman territory. France seized Algeria in 1830 and Tunis in 1881; Britain occupied Cyprus in 1878 and Egypt in 1882; Austria took Bosnia in 1908; and Italy seized Tripoli (Libya) in 1911. Finally, in 1912–13 a coalition of Balkan states took from the empire all its remaining European territory except the region immediately surrounding İstanbul. Over the same period Greece, Serbia, Romania, Montenegro, Bulgaria, and Albania had gained independence, while among Armenians and Arabs of the empire there were also nationalist stirrings. Under such conditions reform was difficult and the progress made was fitful rather than steady. Yet war and rebellion were also added spurs to reform. By the early twentieth century the cumulative effects of the reform efforts were enormous.

Abdülhamid I (1774–89) had attempted some measures of military reorganization, but it was his successor Selim III (1789–1807) who plunged wholeheartedly into the effort. Despite fifteen years in the *kafes,* Selim had acquired some knowledge of governmental affairs and also of Europe. On ascending the throne, he asked his top advisers for memoranda on needed reforms and then began to improve Ottoman weapons, military organization, and technical military schools. In the process, the door to Western influence was opened wider than it had ever been. Several hundred Europeans were in Ottoman employ, many of them French. Some Western styles, even some secular concepts, began to penetrate the top levels of Ottoman society. The first porcelain works were established in İstanbul. The printing press, which had been closed in 1742, was again set to work producing books about military and other useful matters. Selim's major project was to recruit and train fresh troops for a modern army more efficient than the corrupt Janissaries. The new recruits were equipped with imported guns, uniformed in tight red breeches and blue berets, and drilled by instructors with Western experience. But a combination of reactionary forces, Janissaries and ulema among them, threatened Selim. He lost his nerve and yielded, disbanding his new corps of 20,000 in 1807. The reactionaries deposed Selim anyway. Had he resisted, he might have been able to go on to further westernization. Instead, traditional prejudice and vested interest triumphed against the perceived threats of innovation and godless French influence.

Mahmud II (1808–39), a determined reformer, had to be cautious at the start because of the strength of the reactionaries. He was also plagued by Greek and Serb revolts and by the rebellion of the ambitious Muhammed Ali, governor of Egypt. Finally, in 1826 Mahmud completed plans to rid himself of the Janissary danger by retraining the old corps, unit by unit, in modern tactics. Though the Janissary command had approved the plan, the corps again revolted. Then Mahmud, unlike Selim, gathered all available

loyal forces, even arming theological students in the *medreses,* and crushed the rebels. Eight executioners thereafter worked for weeks carrying out orders of courts-martial. The Janissary corps was abolished after this "auspicious event," as Turks call it, and a new westernized army was slowly built up. The Prussian army captain Helmuth von Moltke was secured as military adviser; the Italian composer Giuseppe Donizetti was hired to train military musicians; the American master shipbuilder Henry Eckford was brought from New York to produce the world's finest frigates in İstanbul dockyards. Western methods, Western books, sometimes Western instructors appeared in the new military academy and military medical school. The French language became the usual vehicle for transfer of new ideas and techniques, as more and more Ottoman officers, diplomats, and bureaucrats learned it. Those fluent in French began to constitute a new westernized elite in the Ottoman government.

The central government itself was reshaped by Mahmud. He abolished old sine-cures and established the first Western-style ministries: war, foreign affairs, interior, treasury. He deprived the ulema of some official functions. He founded the first official gazette, the *Moniteur Ottomane,* soon followed by its Turkish counterpart, the *Takvim-i Vekayi,* which represents the start of Turkish journalism. Mahmud's most dramatic move was to oblige his officials to give up flowing robes and turbans for black trousers, the stambouline (*istanbulin*) frock coat, and the fez. As its use spread, that conical red felt cap became the symbol first of the new bureaucracy, then of Ottoman subjects generally. What Mahmud did was often superficial. The fez did not guarantee Western thought processes in the head that wore it. Mahmud nevertheless launched his country firmly in the course of westernizing reform and reestablished the power of the central administration not only as the governing but as the reforming agency.

His successor, Abdülmecid I (1839–61), pursued a similar policy under the urging of Reşid Paşa, a westernizing French speaker who was first a diplomat, then foreign minister, then grand vezir. The imperial edict of 1839 that Reşid inspired, the Hatt-ı Şerif of Gülhane, set the tone of Ottoman affairs for the next forty years, a period known as the Tanzimat—the Ordering. It promised reforms in conscription, taxation, and justice; further, it promised that reforms would apply equally to all in the empire, regardless of religion. This was a big step toward secularism, toward thinking of each individual as an Ottoman subject rather than as a member of a millet.

From 1840 to 1871 Reşid Paşa and two of his disciples, Ali Paşa and Fuad Paşa, pushed ahead with reforms whenever circumstances allowed. A scheme of secular education, patterned on French models, was elaborated; the most famous of the schools established was the Galatasaray lycée, where instruction was in French. Commercial and penal law codes were recast, also on French models, though the reformers dared not touch the Islamic law of personal status. A revised system of provincial administration, the vilayet (province) system, copied many aspects of France's organization by *départements.* These and other secular, westernizing changes were superimposed on the traditional society; in some cases two sorts of institutions existed side by side—the old *medreses* and the new Western schools, traditional religious law and courts and modern secular law and courts. For some Ottoman subjects the changes were confusing, for others they were abhorrent, and for others they were insufficient.

Among the critics of the Tanzimat reformers were journalists writing for the news-papers that began to burgeon in the 1860s and 1870s. Some journalists, along with some government officials, were members of a group calling themselves the Yeni Osman-lılar (New Ottomans). They criticized Abdülaziz (1861–76) as irresponsible and authori-

tarian and demanded a parliament to curb autocracy. Discovered in conspiracy, the most prominent New Ottomans had to flee to Paris. Namık Kemal, the writer whose fiery play *Vatan* (Fatherland) still awakens patriotic sentiments a century after its first performance in 1873, is the most renowned of the group.

A Balkan crisis in 1875–76 gave reformers, including some of the New Ottomans, a chance to get their parliament. Abdülaziz was deposed, and the leaders of the coup enthroned Abdülhamid II (1876–1909) only after he promised support for a constitution. A commission headed by Midhat Paşa, one of the leaders of the coup, and including Namık Kemal, then hammered out a constitution. It was promulgated on December 23, 1876. Thereafter elections were held for the chamber of deputies, and two sessions of the new parliament took place in 1877 and early 1878. But when the deputies became too critical of Abdülhamid, he dismissed the chamber and called no new elections for thirty years.

For those thirty years Abdülhamid ruled as an autocrat. He became increasingly fearful and oppressive, censoring the press, forbidding meetings, relying on spies to ferret out opposition. Ottoman intellectuals led two lives, one open, one secret; proscribed works and anti-Hamidian poems circulated from hand to hand. Abdülhamid was, however, not unpopular with the masses. He emphasized religiosity, called himself caliph of all Muslims, and pushed building the Hijaz railway from Damascus to the holy city of Medina. He was progressive in a technical sense, for he encouraged expansion of the telegraph and railway lines that had first come to Turkey during the Crimean War—the Baghdad Railway is the major example. He also continued to build the army with the advice of a German military mission.

But inevitably the political and intellectual repression bred opposition. This time the opposition was led by the Young Turks, as they often called themselves, who wanted the constitution restored. A secret society, the Committee of Union and Progress (CUP), grew up among younger officers, officials, and writers. Some were exiled and had to flee, smuggling propaganda back into the empire from Europe. Cells of opposition also sprang up among army officers, especially in the Salonica region, and they were in touch with the CUP members in Paris. In the summer of 1908 some army units began revolting, and the CUP leaders in Salonica demanded by telegraph that Abdülhamid restore the constitution. Frightened, he yielded on July 24, calling new elections.

The news that the constitution would be restored brought Ottoman citizens pouring out into the streets amid unbelievable scenes of rejoicing and fraternization. Many were not sure what "constitution" meant, but all seemed sure that a new day of liberty had arrived. In a way, it had. The press was now free; newspapers, political comment, cartoons flourished. Exiles returned from abroad. Elections were held, and the first session of parliament opened in December 1908. The new regime survived an attempted counterrevolution by disgruntled common soldiers and political reactionaries in April 1909; loyal CUP troops from Salonica suppressed the rising. Since Abdülhamid seemed to have been involved in the counterrevolution, the chamber decided that he must be deposed. For the first time in history an elected body dismissed a sultan of the line of Osman. Abdülhamid's successor, Mehmed V (1909–18), furthermore, was permitted only to be a figurehead. The Ottoman house still reigned, but it no longer ruled.

In the next half-dozen years the political life of the Ottoman Empire was anything but smooth. The parliament was usually dominated by the CUP, which finally became an open political party. Opponents, especially the Liberals, felt that the Unionists, as CUP members were called, were in their turn becoming too authoritarian. By 1913 this

certainly was true. Enver Paşa, a Unionist hero of 1908 and now minister of war, and Talat Paşa, minister of the interior, were the dominant government figures. The Unionist domination came at a time of external crisis, when Italy had made war for Tripoli and when the Balkan states also had attacked. Some 200,000 Turkish refugees from the Balkans flooded into İstanbul. Ethnically, the shrinking empire was perforce becoming less heterogeneous and more Turkish. Ideologically, this also began to be true. The egalitarian Ottomanism of the Tanzimat period was giving way to a greater emphasis on Turkishness. The most prominent advocate of Turkishness was Ziya Gökalp, a sociologist and popular writer. For Turks, he insisted, culture must be Turkish. The traditional Persianate-Arabic-Islamic culture and the nineteenth-century Europeanized culture were artificial, "like flowers raised in hothouses." Ziya would abandon neither Islam nor the best aspects of European civilization but maintained that they would have to contribute to and merge into a basic Turkishness.

Then, largely through Enver's negotiation of a secret anti-Russian alliance with Germany, the Ottoman Empire became engulfed in the Great War of 1914. During the four-year ordeal Turkish armies fought on several fronts, usually on the defensive. On only one front were they clearly victorious. This was the defense of Gelibolu and the Dardanelles in 1915 against an Anglo-French attack trying to break through to İstanbul. In 1916 an Arab revolt, supported by the British, began in the Hijaz. By the time of the armistice on October 30, 1918, all the Syrian and Iraki conquests of Selim I and Süleyman had been torn from Ottoman rule. The war also ended the Unionist regime, whose leaders fled abroad. British, French, Italian, and Greek occupation forces controlled strategic areas, including İstanbul and the straits. The new sultan, Mehmed VI (1918–22), was not popular and hardly of leadership caliber. There was an atmosphere of despair. Meanwhile, Allied statesmen dictated to the Ottoman government the Treaty of Sèvres, signed on August 10, 1920. It confirmed the total dismemberment of the Ottoman domain, leaving only central Anatolia under unrestricted Turkish sovereignty and imposing foreign control in various areas, including a Greek zone around İzmir.

The Founding of the Turkish Republic

Well before the treaty was signed, however, a national resistance movement had arisen. It was led by Mustafa Kemal, better known by the surname Atatürk (Father Turk), which he adopted in 1934. Mustafa Kemal was a general, the most successful Ottoman field commander, who had made his reputation at Gelibolu in 1915. Seeking to revitalize his country after its defeat, he went from İstanbul as military inspector to Anatolia, landing at Samsun on May 19, 1919. In the next four years, he created an army, a government, and a state. He also forged a greater degree of political cohesion, a most difficult task when many Turks still thought of themselves as natives of a locality, or as Muslims, or even as subjects of the sultan-caliph, but not primarily as Turks.

During the National Struggle, as Turks call it, a National Pact, setting forth nonnegotiable minimum demands for an independent Turkish territory, was worked out in two representative gatherings. Then the newly elected Ottoman parliament, meeting in İstanbul early in 1920, with many nationalist deputies as members, adopted the pact as Ottoman policy. Shortly, in the face of this new sign of resistance, the British military forces arrested many of the deputies. Other deputies escaped from İstanbul and

joined Mustafa Kemal in Ankara, where together they constituted the new government of the Grand National Assembly on April 23, 1920. From this point on the assembly, with Mustafa Kemal as its president, was the true government of Turkey. Mehmed VI with his ministers remained in occupied İstanbul, almost powerless. In 1921 the Ankara government adopted a constitution proclaiming that sovereignty resided in the nation. It also officially called the state "Turkey" for the first time. Thus, even before a republic was proclaimed, its essence existed, though no one used the term "republic." To Mustafa Kemal, that is what sovereignty of the people, who were the Turkish nation, meant.

Between 1920 and 1922 the government and army of the Grand National Assembly achieved a series of successes, both diplomatic and military, that led to liberation of most of the territory specified in the National Pact. The split between Soviet Russia and the Western powers was used to Turkish advantage, for Russia was willing to give some military aid if the purpose were anti-English or anti-French. Lack of harmony among the Western powers themselves was exploited, leading to withdrawal of Italian and French occupation forces. The Greeks, by contrast, launched a major offensive from İzmir in 1920 that was checked only in 1921 by Mustafa Kemal's colleague İsmet İnönü at the battle of İnönü and again by Mustafa Kemal himself when the Greeks were some fifty miles from Ankara. Then the tide turned, and in 1922 a Turkish offensive pushed the Greeks out of Anatolia. At that point the British remained as the sole effective opponents of the Turks, but they were now willing to negotiate. A new armistice in October 1922 led to a new peace conference, which met at Lausanne, Switzerland, the next month.

Britain invited the sultan's government also to send a representative, whereupon Mustafa Kemal persuaded the Grand National Assembly that the sultanate itself should be abolished. After stormy debate, this was done on November 1, 1922. Mehmed VI went into exile aboard a British vessel, and the Ottoman sultanate of more than 600 years was ended. The assembly did elect a member of the family as caliph, but he was to be a religious figurehead with no political power. Two years later he also was ousted and the caliphate abolished.

The Kemalist military victory of 1922 paved the way not only for the end of the sultanate but also for three events of 1923 that, taken together, symbolize the firm establishment of the new Turkey. The first was the signing of the Treaty of Lausanne, by İsmet İnönü as Turkish plenipotentiary, on July 24, 1923, after seven months of hard bargaining, interruption, and near breakdown of the peace conference. By the treaty, which was freely negotiated rather than imposed as the Treaty of Sèvres had been, the new Turkey gained essentially its present-day borders and the end of foreign capitulations. The second event was the official moving of the capital, for the first time since 1453, from İstanbul to Ankara on October 13. İstanbul was the cosmopolitan center of the dead empire; Ankara, on the Anatolian plateau, was the far more Turkish center of the newborn state. Finally, on October 29, the assembly formally proclaimed Turkey to be a republic. It began its life by electing its founder, Mustafa Kemal, to be president and İsmet İnönü to be prime minister.

Modern Turkey: Change and Continuity

The Turkish Republic has now been a member of the family of nations for over a half-century since its formal establishment in 1923. During that period it has changed greatly.

It has developed a completely secular government and many secular cultural institutions. It has worked out a democratic multiparty political system. It has pursued a policy of peaceful foreign relations. It has embarked on the path of industrialization. Its population has tripled since the 1920s. The literacy rate has increased five times in the same period. Women play an entirely new role in the political, economic, and cultural life of the country. The sense of Turkishness—of belonging to the Turkish nation and culture, as opposed to purely local or religious loyalties—has become much stronger and more widespread. These developing trends encounter obstacles and problems, but they continue. They mark, in many ways, radical change from the days of the Ottoman Empire.

Yet there is also continuity. Modern Turks are heirs of the pre-Islamic past of the early Turks in Central Asia. They are also heirs of the pre-Islamic past of various early Anatolian civilizations. They inherit much from both their Islamic past and their Ottoman past. They also inherit from the Western past, as well as forming a part of the Western present. All these heritages, Eastern and Western, Asian and European, are intermingled in the civilization of modern Turkey. The symbol of the union is the bridge, opened in 1973, that spans the Bosporus, springing on one shore from beside a mosque, on the other shore from beside a French-style palace, linking two continents with many pasts and one future.

Right: Edirne, Selimiye Complex: general view of the mosque.

Architecture

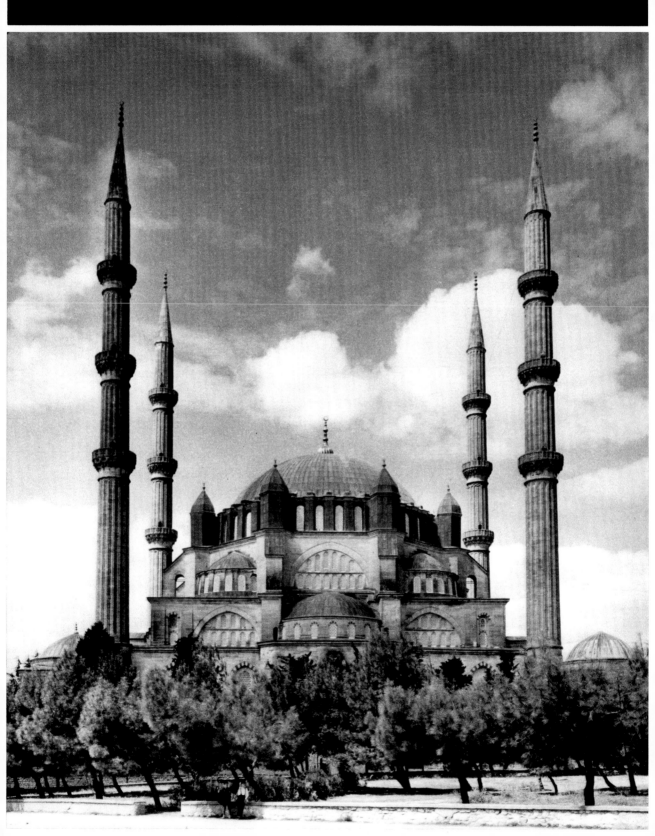

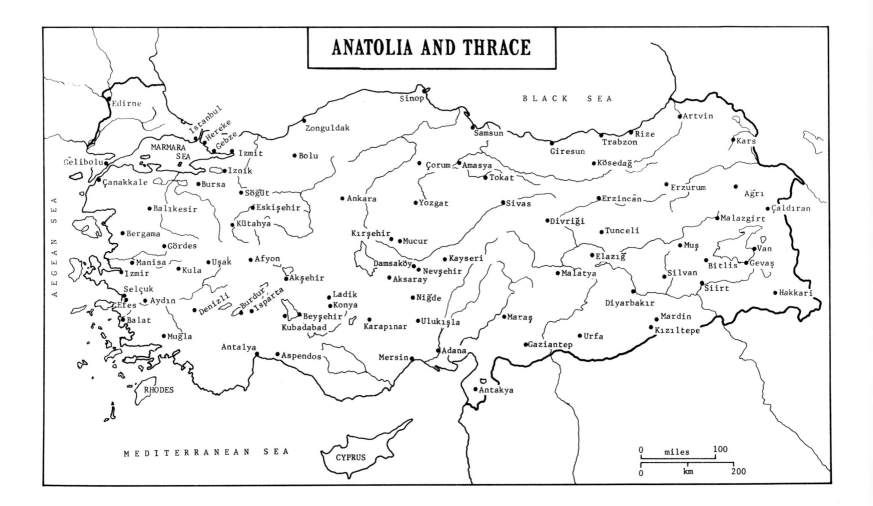

ANATOLIA AND THRACE

BLACK SEA

AEGEAN SEA

MARMARA SEA

MEDITERRANEAN SEA

CYPRUS

RHODES

Edirne
İstanbul
Hereke
Gebze
İzmit
Gelibolu
Çanakkale
Bursa
Söğüt
Balıkesir
Eskişehir
Kütahya
Bergama
Gördes
Manisa
İzmir
Kula
Uşak
Afyon
Selçuk
Efes
Aydın
Denizli
Burdur
Isparta
Balat
Muğla
Antalya
Aspendos
Beyşehir
Kubadabad
Ladik
Konya
Karapınar
Mersin
Adana
Antakya
Zonguldak
Bolu
İznik
Ankara
Yozgat
Kırşehir
Mucur
Akşehir
Aksaray
Niğde
Ulukışla
Damsaköy
Nevşehir
Kayseri
Maraş
Gaziantep
Urfa
Sinop
Samsun
Çorum
Amasya
Tokat
Sivas
Giresun
Trabzon
Rize
Kösedağ
Erzincan
Erzurum
Divriği
Tunceli
Elazığ
Malatya
Silvan
Diyarbakır
Mardin
Kızıltepe
Artvin
Kars
Ağrı
Çaldıran
Malazgirt
Muş
Van
Bitlis
Gevaş
Siirt
Hakkari

0 miles 100
0 km 200

THE DEVELOPMENT OF Turkish Islamic architecture in Anatolia parallels the political and economic fortunes of the land under various Turkish states. In fact, architectural monuments, magnificent or humble, often stand as the best witnesses to the events of the past, to the evolution of Anatolia as an Islamic society. Although a number of Islamic structures were built in the wake of the Arab campaigns into Anatolia following 655, there is today virtually no sign of these early buildings.[1] The lack of any significant settlement by Islamic peoples in Anatolia during the first 400 years of Islam undoubtedly was responsible for the paucity of remains from this period. The appearance and spread of Islamic architectural monuments were essentially Turkish contributions and followed the battle of Malazgirt in 1071, which opened the doors of Anatolia to Islamic people, and more significantly to the Turks. Following this date, Anatolia was gradually transformed into an Islamic land, resplendent with mosques, schools, caravansarays, hostels, and mausoleums. Whether viewed against the golden, treeless, and quiet plateau of central Anatolia or against the blue glitter of the Aegean Sea, slender minarets—like towers of victory—claimed the land for a new social order.

The great historic importance of architectural remains in Anatolia lies in the fact that they are a chronologically unbroken document. Not only is this document a record of the aesthetic expression of a people, but it is also a statement about the political and economic forces at work in different periods. This chapter on Turkish art will discuss the evolution of architecture in terms of such a historical perspective. The significant developments in architectural activities in Anatolia between approximately 1150 and 1900 will be indicated and the discussion will be limited to selected key monuments.

For general purposes, the history of Turkish architecture is best divided into three periods: the first from 1150 to 1300; the second from 1300 to 1450; and the third from 1450 to 1900. The beginning or termination of any of the three periods does not coincide with any single significant historical event. Rather, each period corresponds to distinctive stages in the political and social development of Anatolia, creating a series of unique conditions that influenced its architectural development.

The first 150 years are generally known as the Seljuk period. The settlement of Turkish populations in Anatolia together with the formation of Türkmen states rapidly followed the battle of Malazgirt. However, it was not until 1150 that the Seljuks of Rum emerged as the most powerful state, recognized and respected by other Türkmen dynasties, and a calm was established in Anatolia. Then followed fervent architectural activity on a grand scale, especially in parts of Anatolia directly controlled by the Seljuks, who considered themselves the heirs to the culture and state organization established under their cousins in Iran during the eleventh and twelfth centuries. As the Seljuks expanded their state in Anatolia, they created an atmosphere in which artistic communication among the Türkmen states and between Anatolia and Iran was possible.

The period of Mongol suzerainty, following the battle of Kösedağ in 1243, did not immediately affect the social and political order the Seljuks had secured. Therefore, a sudden change in architectural styles or activities did not occur. Yet, by 1300 a new era had already started in Anatolia. Soon after this date the Seljuks left the political scene forever. The urban society they had formed was by then seriously eroded. The central power formerly concentrated in the hands of the Seljuk sultans was divided among numerous Türkmen emirs or princes. The period of Türkmen emirates or principalities, which lasted between approximately 1300 and 1450, was marked by a shift in population, with substantial numbers coming from the east and the development of a warlike but seemingly very religious society in Anatolia. The gazis, the ideologically motivated soldiers of the Türkmen principalities, carried their battle standards to the Christian lands of western Anatolia and later to Europe. Instead of the traditional "high Islam" of the Seljuks, the gazis represented a mystical or heterodox expression of the religion. These changes in the religious, political, and social makeup of the principalities are mirrored in the architecture, as the character of buildings evolved with the new order. The Ottomans carried the gazi spirit into the fifteenth century and became the leading and most powerful state while lesser emirates submitted to them. By 1400 the Ottoman realm extended from Iran to Hungary. Their architecture is, therefore, the most remarkable and important representation of this second period.

In 1453 the last Christian fortress in the midst of the Ottoman state, the city of Constantinople, fell to the Turks. One of the dreams of Islam was thus realized, a dream that had started in 655 when the Umayyad caliph Muawiya first besieged the mighty capital of Christianity. It would be valid to state that a new era of Turkish architecture began in 1453. The Ottomans had become a world power, the rulers of an empire. The Ottoman sultan, whose forebears' names were followed by the humble appellation "gazi" in the inscriptions of mosques in the fourteenth century, now was honored with titles worthy of emperors. An emperor he was, ruling over Muslims as well as Christians living in his domain. In the center of this vast empire was the new capital, İstanbul. Its architectural monuments came to provide the models for the buildings to be erected in all corners of the empire. The architecture of this period reflected the new order in the Ottoman lands. It fulfilled the needs of and adopted the symbols of a great and centralized power.

Since the development of Turkish architecture so strongly expresses major political and social changes, the same criteria for describing buildings cannot be applied to all three periods.

The discussion of the first period of Turkish architecture will follow a typological as opposed to a chronological order, beginning with mosque architecture between 1150 and 1300. Mosques of this period are remarkable because of regional diversity in plans and ornamentation, which undoubtedly reflects the varied patronage that created them. The patrons ranged from the gazi Danişmends to urbanite and highly Persianized Seljuks. The congregations ranged from the ulema to new converts in Anatolia. On the other hand, the patronage for *medreses* (schools) and caravansarays came from one group within Anatolian society, the urban elite class. The ulema, a learned and conservative group of people, dominated the *medrese*. The most magnificent structures of the thirteenth century, the caravansarays, were designed to promote trade. The mausoleums, which flourished after the Mongol invasion, reflect a different social phenomenon, appealing to a form of popular religion. The patronage and purposes of these four types of buildings vary greatly, and they will be treated separately.

The discussion of the second period, between 1300 and 1450, will be largely limited to mosque architecture, because this type of building is virtually the only monumental undertaking of the time. The mosque is multipurpose, containing in its most spectacular examples numerous rooms in addition to the prayer hall, designed in response to the needs of a different society.

The third and last architectural period, from 1450 to 1900, is the age of empire and is best represented by the *külliye*, or the royal mosque and its dependencies. The mosque, symbolic of the sultan, the *padişah* of Islam, is in the center of a *külliye*, a complex of charitable and educational structures that include *medreses*, *tabhanes* (hospices), *şifahanes* or *bimarhanes* (hospitals or asylums), imarets (soup kitchens for the needy), *muvakkithane* (timekeepers' quarters), caravansarays, *türbes* (mausoleums), and a cemetery. This type of immense *külliye* is a mirror of the highly centralized Ottoman Empire: the buildings exist as satellites of the mosque, on which the creative energies of the royal architects were lavished. Each royal mosque, without being revolutionary, has an innovative element in relation to its spatial, ornamental, or massive compositions. Subsidiary buildings of the complex remain conservative, quiet, and with low profiles.

Seljuk Architecture of Anatolia: 1150–1300

Although the Seljuks of Rum were not the sole rulers and builders of this period, the term "Seljuk" still seems appropriate and convenient since it was the monuments commissioned by the Seljuks of Iran that provided models, or at least inspiration, for most of the buildings. Although Türkmen tribes had entered Anatolia earlier, it was a Seljuk prince who officially joined the newly conquered "Roman" lands to a greater Islamic world dominated by the Seljuks of Iran. In the eyes of the Turkish population of Anatolia, the Seljuks of Iran were the most significant Islamic power. Early architecture in Turkey displays great continuity with the traditions established in Iran and Syria. The types of buildings erected, both religious and secular, follow the earlier models in ground plans and elevations; and the ornamental vocabulary is largely adapted from existing Islamic architecture. This resulted from the political and social milieu of the land, as the use of any architectural form or style is a public statement about those who commission it. At this early juncture in Anatolian development, the contrast between the newly evolving Islamic society and the still numerically dominant Christian one was intentionally emphasized. Needless to say, before the settlement of the Turks, Anatolia had an ancient architectural tradition, highly developed yet regionally diversified. These regional or local architectural styles represented competing religious ideologies, peoples, and political organizations and could not be directly assimilated or imitated.

Even so the Turkish-Islamic architecture that evolved in Anatolia is in certain ways distinct from Syrian and Iranian traditions and clearly reflects the forms that were to mature under the Ottomans.[2] Among the features that distinguish Anatolian-Islamic architecture, even at its inception, are the application and organization of decoration, the handling of the space inside and around a building, and a selective emphasis on certain structural elements. Furthermore some differences result from the adaptation to a new climate and terrain and available building material. An example of the latter may be seen in southeastern Turkey, which is hot in late spring, summer, and early fall. As a result, the soothing coolness of buildings, the sound of water in courtyards transform

the mosques from simple places of prayer into havens from the hot and dusty city, making them symbolic harbingers of paradise. Diyarbakır, Siirt, Silvan, Urfa, and Mardin—the major cities of this region—each possess a monumental mosque built around a great courtyard.

Since much of the subsequent architecture relied upon these early models, it is useful to take up in detail the distinctive qualities of Anatolian-Islamic or "Seljuk" architecture between 1150 and 1300. While regional differences so apparent in pre-Islamic architecture are perpetuated under the Islamic rulers, certain elements are common throughout the land. The existing homogeneity in architecture is largely due to similarities in the nature of the patronage of diverse Türkmen states and the strong cultural influence of the Seljuks of Iran.

MOSQUES

The oldest surviving mosque in Anatolia is in Diyarbakır. It is the Ulu Cami or Great Mosque.[3] The inscription over the entrance gives the date 1091–92 as the year when it was repaired at the order of Sultan Malik Şah, the ruler of the Seljuks of Iran.

The period during which the mosque was built and repaired belongs to the time of the Seljuks of Iran. Although the structure subsequently underwent various restorations, a detailed study is nevertheless quite informative because it illustrates several characteristics of early Anatolian building.

Perhaps it is not surprising that the Great Mosque at Diyarbakır, although it contains the name of the ruler of Iran, architecturally is more closely related to the traditions of Syria. Diyarbakır, of course, belongs geographically to Syria and northern Mesopotamia.

The mosque and its courtyard are both shallow rectangles. The closed part of the building contains three aisles parallel to the *kible* wall (also spelled *qibla* and *kibla*, it is oriented toward Mecca, to which Muslims turn in prayer). The aisles are transversed by a wider and higher aisle from the entrance from the courtyard to the mihrab. The Umayyad mosque in Damascus, built in the early eighth century, unquestionably served as a model for the mosques of southeastern Anatolia, particularly this example. The Iranian mode of construction in brick with stucco and tile decorations does not appear here. The stone construction and carved stone ornamental elements, some of them consisting of reused material from the late classical period, are characteristic of Syria as well as Anatolia. Another feature of this mosque—one which is essentially Anatolian—is that on the north side of its courtyard is a *medrese,* erected by the Artukids in 1198. The practice of placing two separate buildings on the same grounds, as related components of one complex, continues in the Seljuk and Ottoman periods.

The second oldest mosque is the Ulu Cami of Siirt, also located in southeastern Anatolia, not very far from Diyarbakır. It possesses an inscription giving the name of a sultan of the Seljuks of Irak who ruled Siirt during the twelfth century, although the mosque was not completed until the following century. The ground plan also derives from the mosque of the Umayyads but it has at least two features particular to the architecture of Anatolia: the aisle perpendicular to the *kible* wall is divided into three bays, each of which is covered with a dome, and the building is constructed in stone with a brick minaret.

The mosques constructed in the southeastern region of Anatolia during the rule of the Artukids (1098–1232) retain the basic plan of the Diyarbakır and Siirt structures: aisles are parallel to the *kible* wall and are vaulted; the mihrab, the only architectural

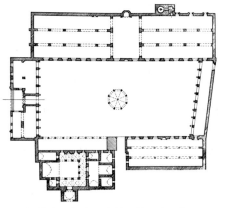

1. Diyarbakır, Ulu Cami: plan; 1091–92 and later.

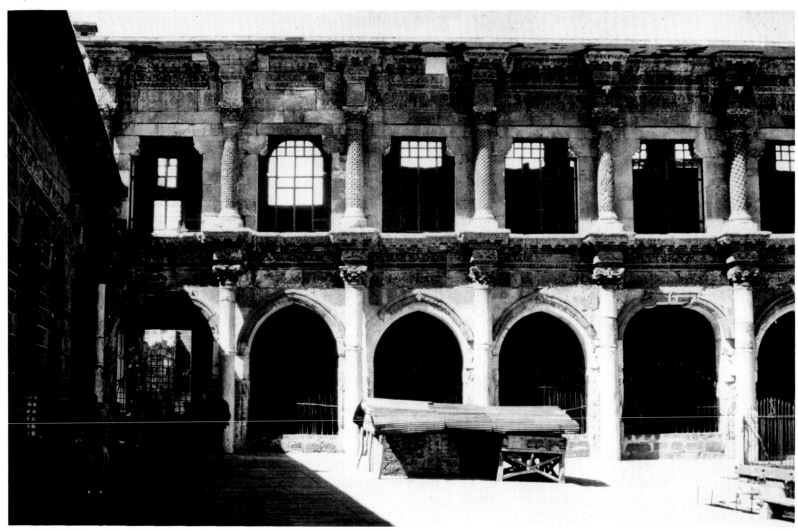

2. Diyarbakır, Ulu Cami: courtyard, looking east; 1091–92.

unit emphasized inside the mosque, is heavily decorated, with the dome in front stressing its significance; the bays leading to the mihrab area are wider and higher than the lateral sections. In Artukid architecture there is a tendency to reduce the amount of ornamentation on the walls. For example, the walls of the courtyard in the Diyarbakır mosque are covered with extensive decoration, as if to simulate the mosaic sheath seen in the Umayyad mosque in Damascus. In comparison, very modest decoration is seen in the Ulu Cami at Kızıltepe (Dunaysır), dated 1152–57. Here, lobed arches are the only element of ornamentation used to enrich the exterior wall surfaces. The Artukid mosques on the whole represent a regionalism in Anatolian architecture, but one that shares several common characteristics with the rest of contemporary Anatolia.

Another area ruled by Türkmen dynasties that created important architecture is eastern Anatolia. Erzurum became the center of the Saltukids (ca. 1071–1243), Divriği the capital of the Mengücüks (ca. 1071–ca. 1250), and Sivas the center of the Danişmends (ca. 1071–ca. 1177). The great mosques of these cities date from the late twelfth and early thirteenth centuries. This region differs from the southeast, geographically as well as architecturally, having closer historical and architectural affiliations with Armenia, Azerbayjan, and Georgia. The material for construction is a dark gray basalt, and the

decoration is carved. The intensity of ornamentation varies from a minimal amount on the mihrab, as in the case of the Ulu Cami in Sivas (1197), to the highly exuberant portals of the Mosque and Hospital at Divriği (1228–29).

The mosques of eastern Anatolia have a deep rectangular ground plan with three or more aisles set perpendicular to the *kıble* wall. Central aisles are wider, and the bay in front of the mihrab is often covered with a dome. From the exterior the mihrab area is accentuated by an outer shell, which is in the form of a pyramid. The two Danişmend mosques in Kayseri and the Ulu Cami in Erzurum, built by the Saltukids in 1179, have a second dome on the axis of the mihrab, placed in the center of the aisle. A shallow pool or fountain for ritual ablutions is placed directly under this second dome.

The slightly pointed arches carried by multiple piers lead to the darkened depths of the mosque and toward the mihrab. The interiors tend to be dark because of the heavy stone supports, the rather oppressive stone vaulting, and the limited window openings. Sparingly used but strongly marked entrances also contrast with the multiple doors found in the southeastern region.

In northern Anatolia increasing attention is paid to the superstructure of a mosque. In the small but well-proportioned Saltukid Kale Cami (Citadel Mosque) from the twelfth century in Erzurum three different systems of vaulting, including a dome, were used over its six bays.[4] But the richest conception in terms of variegated vaulting is to be found in the Mosque-Hospital in Divriği. The mosque has a domical vault in front of the mihrab; the remaining twenty-four bays within the five aisles, all perpendicular to the *kıble* wall, are covered with rather flat vaultings that create fantastic effects through the arrangement of stone blocks, some simulating stars, others concentric circles like a midday sun. In the hospital section the central dome is raised to resemble a lantern through which sunlight sweeps into the hall.

The portals of two mosques in Divriği demonstrate growing emphasis on doorways in Anatolian architecture. On the small Kale Cami dated 1180–81, whose inscription gives the name of the architect, Hasan bin Firuz from Maragha,[5] the portal is a large rectangular panel composed of four gradually receding bands that frame the modest opening of the doorway. The rectangle of the door is relieved by a high, two-centered pointed arch. The arch and its spandrels are faced with brick and glazed turquoise tiles; the rest of the portal is executed in stone. The decorative motifs are largely geometric, mainly interlacing hexagons, and muted vegetal forms in thinner bands. Kufic inscription bands also make their appearance on this early mosque. The portal is important because it is one of the earliest instances of portal composition in Anatolian-Turkish architecture and contains the major themes of decoration. The interior of the building is undecorated, and the well-cut stone architecture is left to adorn itself.

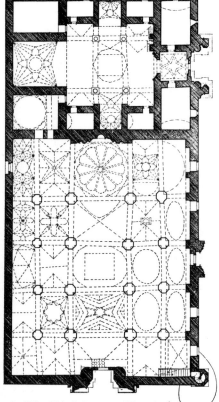

3. Divriği, Mosque-Hospital: plan; 1228–29.

plate 3 (pp. 64–65)

The second mosque in Divriği, together with the adjoining hospital, was built in 1228–29 by the Mengücük Ahmed Şah and his wife Malike Turan. The mosque has a south-north axis while the smaller hospital is on an east-west direction. The mosque has two main portals: the first is on the north facade on an axis with the mihrab while the other is on the west, on the same side as the entrance of the hospital. Each portal exhibits a slightly different order of composition and use of basic decorative vocabulary. Although the overall effect of the mosque is not very harmonious, the structure is interesting and important in denoting the wide range of sources available to the artisans.

The north portal of the rectangular blocklike mosque rises approximately 2.5 meters above the level of the roof. The doorway is surrounded by a deep niche with a

4. *Right*: Divriği, Mosque-Hospital: north portal; 1228–29.

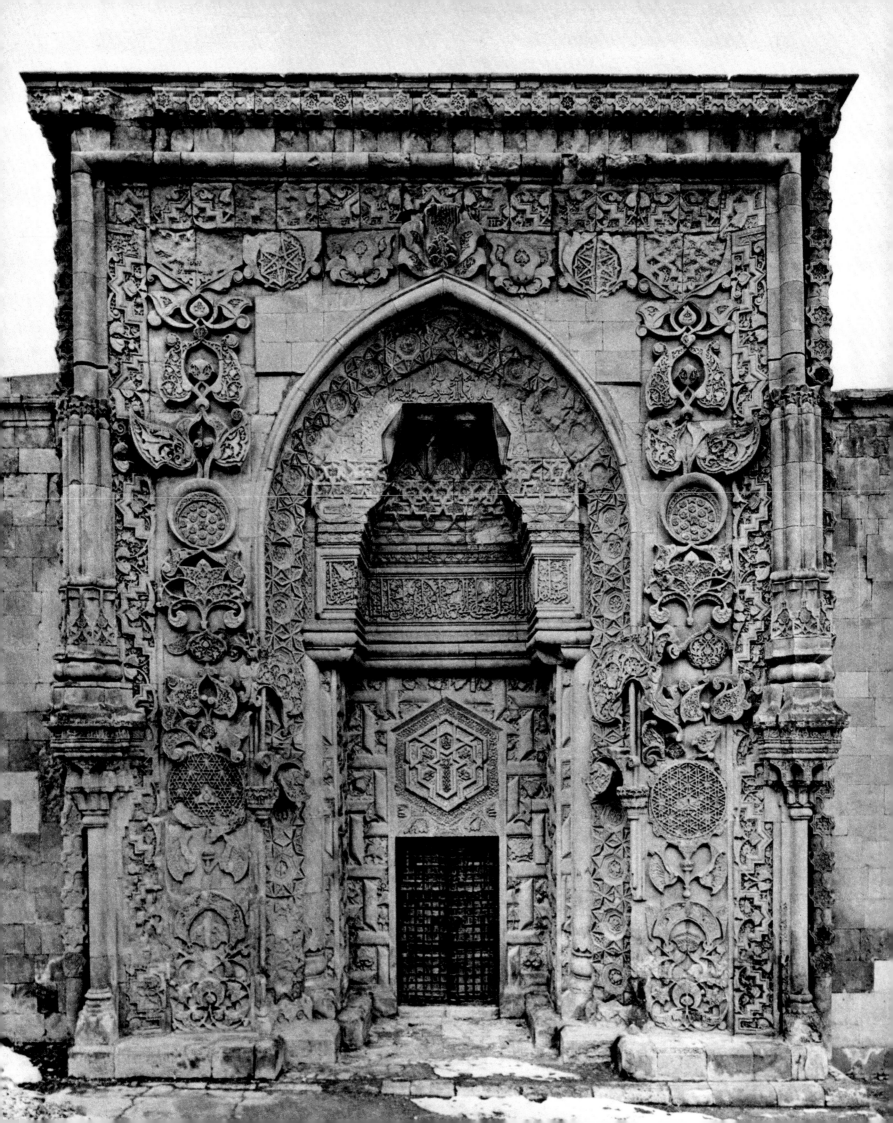

"broken" rounded arch, which itself is encircled by another pointed niche similar in shape to the portal compositions seen in Armenian churches. The entire unit is framed by a rectangular band embellished with circular plates, large leaves, and rosettes that stand out from the background. The unusually high reliefs seem to have been inspired by ornamentations from another type of medium, perhaps that of carved stucco.[6]

Nothing resembling this extravagantly carved portal is found elsewhere in Anatolia. However, it represents the general scheme of Anatolian portal composition: the portal is a large block projecting above and from the facade of the building, while the doorway is a small opening contained within a narrow and high niche. The niche-head is heavily decorated, most often with *mukarnas* (stalactite vaulting). Between the doorway and beginning of the niche-head is the place for the dedicatory inscription, which usually has a formula praising the donor, giving his or her name and titles, the date of the building, and sometimes the name of the architect.

The motifs most frequently used on the portals of the Divriği complex, and the structures of the Seljuk period, are geometric interlacings, hexagons, stars, circles, and a wide range of vegetal forms, including artichokelike plants. The rest of the facade is most often left plain. The portal composition not only dominates the building but also becomes the main theme.

Mosques of central Anatolia tend to be rather conservative, as seen in examples in Konya, the capital of the Seljuks, and in the neighboring cities of Niğde, Aksaray, Akşehir, Malatya, and Kayseri. The general layout and the treatment of materials and space are reminiscent of the mosques in northeastern Anatolia built by the Türkmen states, such as the Danişmends. The mosques of central Anatolian towns that date from the first half of the thirteenth century generally bear the names of members of the Seljuk royal family in their inscriptions.

ill. 6

The mosque in Konya, attributed to Sultan Alaeddin, is situated on the citadel of the city. It was most probably planned as a small structure attached to the royal residence rather than as a Ulu Cami. The ground plan shows that its present shape is not the result of one project, but that it had undergone alterations and additions throughout the twelfth, thirteenth, and fourteenth centuries. One of the oldest components is the magnificent *minber* (pulpit), made in 1155 by Hacı Mengüberti of Ahlat.

The most impressive and outstanding feature of the mosque is the large dome placed in front of the mihrab. In front of the dome is a deep rectangular bay, reminiscent of an *eyvan* in an Iranian mosque (an *eyvan*, also spelled *iwan*, is a three-sided vaulted chamber open at the front). The two units are flanked on two sides by deep bays that run perpendicular to the *kıble* wall. In other words, the domical unit is surrounded by rectangular bays that frame it within the vast and irregular layout of the mosque. The asymmetrical "wings" of the mosque, extending to the east and west of the mihrab-dome area, consist of aisles parallel to the *kıble* wall. The flat roof is supported by reused columns and piers of different periods and origins. Two polygonal mausoleums abut the northern wall on the axis of the domed area. However, their axial orientation is accidental, expecially since one axis is formed by a pre-Seljuk building. Various parts of the mosque and the funerary buildings are more or less united by a courtyard, which spans the total width of the structure. The facade of the courtyard is studded with various inscription plaques taken from the mosque itself or from other Seljuk buildings in Konya, as well as sections of moldings and carved stone blocks belonging to pre-Islamic periods. Located on the citadel near royal pavilions and tombs, the structure is unimpressive. The extent to which Sultan Alaeddin contributed to the building of the mosque

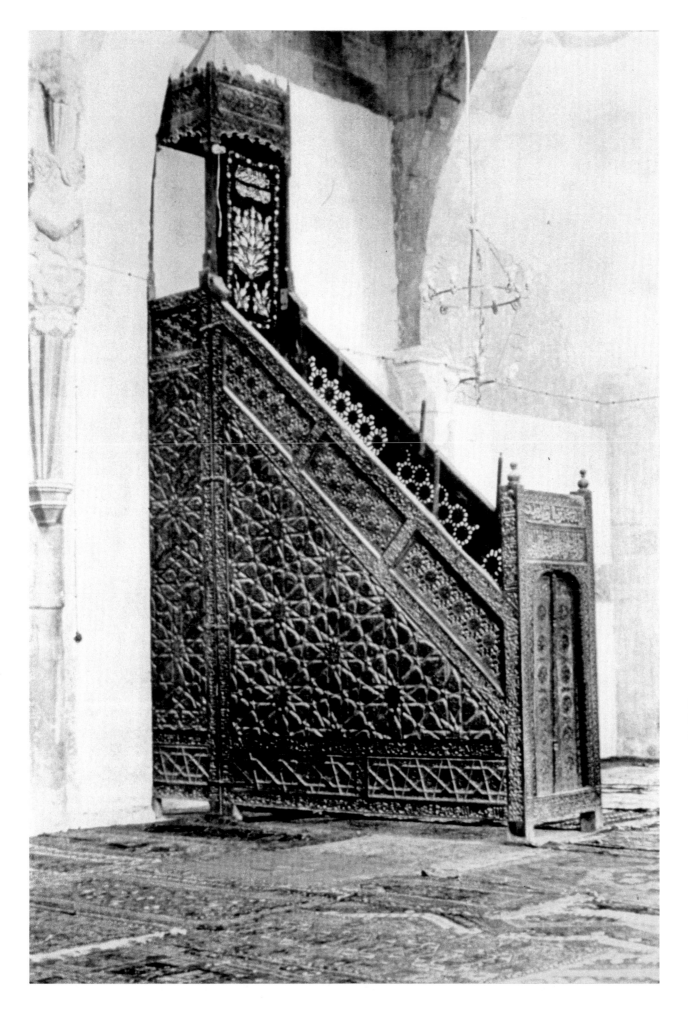

5. Divriği, Ulu Cami: interior view showing the ebony *minber* dated 1240.

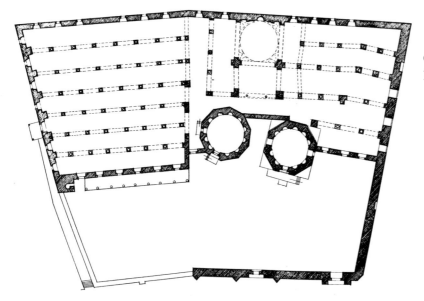

6. Konya, Alaeddin Cami:
plan; 1219 and later.

7. Konya, Citadel: stone angel;
twelfth century. (Konya, Konya Müzesi)

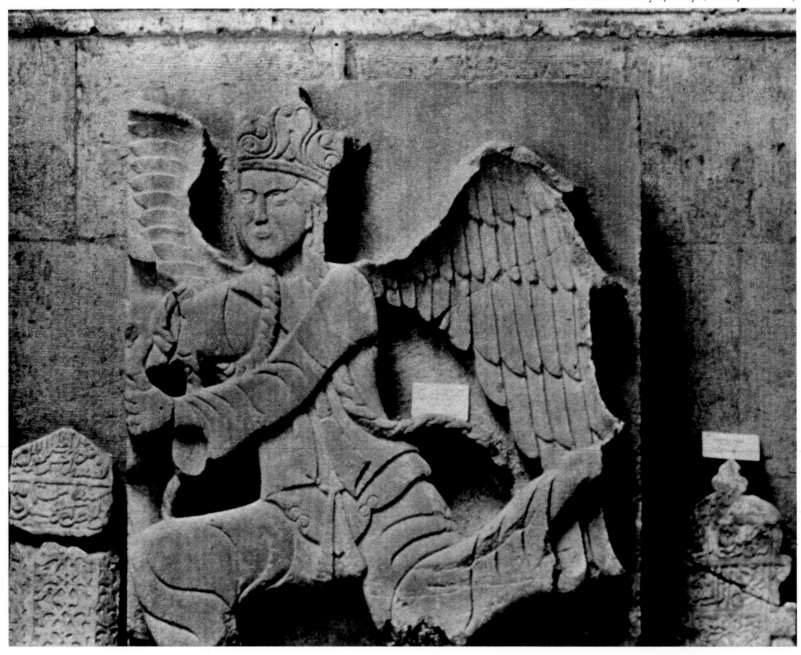

is now difficult to ascertain, although his name appears in several of the inscriptions.

The Mosque of Alaeddin was transformed in the thirteenth and fourteenth centuries into a large-scale congregational mosque. This transformation denotes a change in the use of the citadel and the buildings there, and in the relationship of the citadel-fortress to Konya, or the city proper.

The royal mosques of Akşehir, built by Sultan Keykavus in 1212, and of Niğde, built for Sultan Alaeddin Keykubad in 1223, are both situated in citadel forts. The mosques are laid out with aisles perpendicular to the *kıble* wall and with a dome on the bay in front of the mihrab. The mosque of Niğde, the more lavish and better built of the two, has two additional domes on the *kıble* wall. Its stone domes rest on squinches divided into *mukarnas* units. It also has a stone mihrab decorated entirely in geometric motifs; it does not employ vegetal decoration, which was the trend in the ornamental vocabulary of Anatolian architecture during the twelfth and thirteenth centuries. Although purely geometric designs gradually predominate, the vegetal ornaments enjoy an undisputed revival toward the end of the thirteenth century and are in "full bloom" in the fourteenth, probably under a renewal of Iranian influence resulting from the Mongol invasion.

A general remark should be made concerning one aspect of twelfth- and thirteenth-century Anatolian architecture. The mosque was not the dominating element in Anatolian cities and remained unimaginative, rather somber in construction, overshadowed by such undertakings as *medreses* and caravansarays. One might take the Divriği mosque to be an exception, but there the building is planned and executed with the hospital in a unified complex.

The Ulu Cami in Malatya is another exception. The original mosque in old Malatya, about five kilometers north of present Malatya, was built by Alaeddin Keykubad in 1224. However it underwent at least four different periods of restoration and rebuilding, which greatly altered its appearance and developed it into one of the most interesting buildings of the thirteenth century. The documented repairs occurred in 1247, during the sultanate of Keykavus II; and in 1273–74, when the city was under the occupation of the Mamluks of Egypt. The same architect, Üstad Husrev, worked on both recorded restorations.[7]

The mosque as it stands today differs from its Anatolian counterparts but comes closer to Iranian examples, such as the mosque in Zavare (built in 1153). The ground plan consists of a central courtyard, a dome-*eyvan* combination between the mihrab and the court. The building material is stone for the outer walls, but the *eyvan* and the dome are of brick covered with tiles. The portals, including the one added in 1247, are stone and in the Anatolian tradition.

The Iranian influence appears in the brick dome that rests on an eight-sided zone of transition, the four corner units fitted with tripartite squinches. A sixteen-sided belt, placed between this zone and the curvature of the dome, is decorated with calligraphy that runs in a complete circle. The bricks of the dome form a six-pointed star like those in Iran. The tile-mosaic in the *eyvan* and on the walls surrounding the courtyard is rich in its color range, with a lavish use of turquoise, manganese purple, and white. The court is much smaller, overpowered by the *eyvan* with its wide opening and colorful tiles. The shrunken size of the court and deep aisles opening into it are reminiscent of the Artukid mosques. The single minaret and two stone portals—one placed on the southeast side adjacent to the *kıble* wall and the other in the center of the west facade containing the name of Keykavus II—give the structure its local or Anatolian appearance.

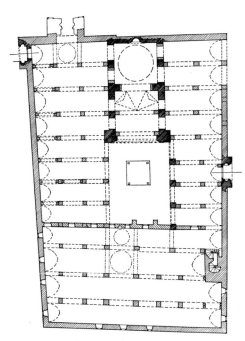

8. Malatya, Ulu Cami: plan; 1224 and later.

ill. 9

plate 2 (pp. 62–63); ill. 133

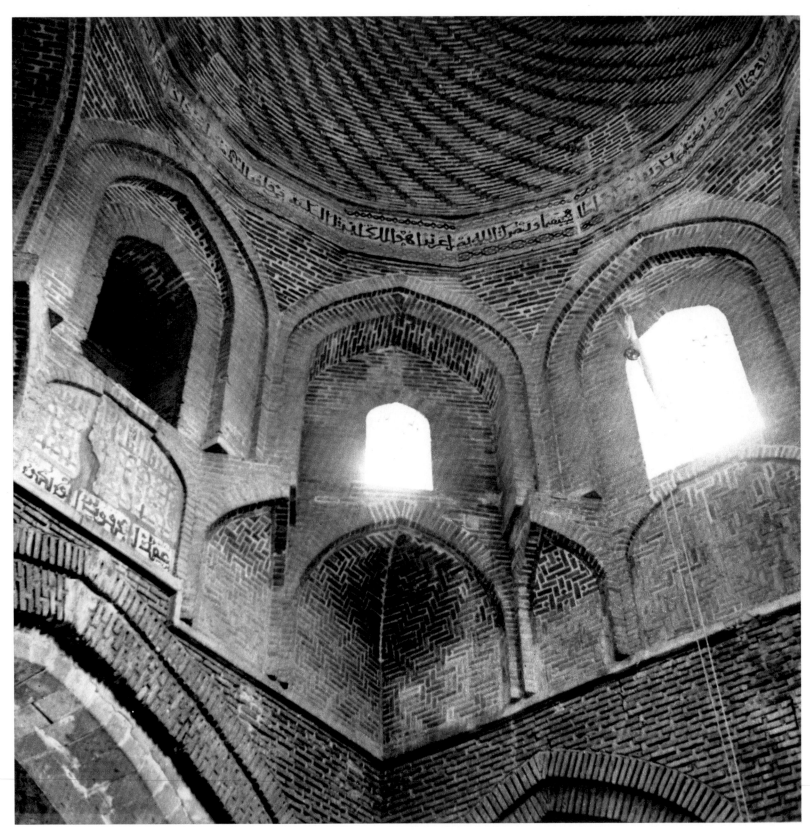

9. Malatya, Ulu Cami: interior view showing the zone of transition under the dome; 1224.

The exterior of the mosque belies the Iranian influence, which dominates the interior of the building. Even though certain features of the mosque can be traced to Iranian architecture, Anatolian characteristics still can be seen in the handling of open and closed spaces and also in the delineation of the interior and the exterior by means of the high carved portals.

In Turkish architecture a small neighborhood mosque, usually lacking a *minber* and thus not offering a Friday sermon, is called a *mescid* (from the Arabic *masjid*), the earliest surviving example of which is the Taş Mescid in Konya dated 1215. Despite their small size and inconspicuous profile in a city, these *mescids* bear a very important relationship to the development of fourteenth-century mosques. A Seljuk *mescid*, such as the Taş Mescid, has a square room covered with a single dome, and the facade opens into the street by means of a three-arched vestibule or portico, the so-called *son cemaat yeri* (area for latecomers), which was to become a permanent feature in later mosques. The domed single room of the *mescid* and the intermediary space between the mosque and the street or the porch already foretell the classical Ottoman mosque.

Our discussion of the mosque in the Seljuk period has concentrated on the regional differences in building types. It is remarkable that comparable variations did not develop in the *medreses* and caravansarays. Several hypotheses can be offered for the lack of a uniform plan and consistent scheme of decoration employed in mosque architecture and for the persistence of regional differences from pre-Islamic times.

One explanation is that when the Türkmen states claimed sovereignty in various parts of Anatolia, they did not attempt to found new towns but simply settled in existing cities, where they remained a minority for a long time. In fact, they did not even change the names of towns, many of which remain to our day. However, in order to claim sovereignty and authority over a predominantly Christian city, the Türkmen immediately raised a mosque to symbolize their power. They most probably employed indigenous artisans whose training and experience were in local traditions, which in turn affected the local mosque structure. The mosque has a political implication, publicizing the presence of the new faith and of the Islamic community. Its monumentality was to be comprehensible to Muslims and Christians alike. At the same time the mosque was to be distinguished as a sacred building, characterizing a singular faith. Therefore the great contrast between mosques and churches was deliberate. Due to the urgency in the construction of mosques as political symbols, most of them were built before the formulation of a more or less unified "Seljuk" style in Anatolia and thus remained bound to local traditions more strongly than any other type of Islamic structures.

Given this regionalism, how is the mosque, as the congregational hall for Muslims, identifiable as such and distinguishable from its Christian counterpart? The outstanding characteristics of a mosque, shared by all structures built in this period, are the shallow mihrab niche on the *kible* wall, a dome in front of the mihrab, frequently a court with a fountain, a minaret, and the absence of a central space for processional and liturgical rituals that are part of church activities.

MEDRESES

The study of the *medrese* presents a totally different case since there are only two basic types, distinguished by open or covered courtyards.[8] The type with the open courtyard is far more common and persists longer, extending into the seventeenth century. Moreover it was developed by the Seljuks of Iran and spread to all Islamic lands by the twelfth century.

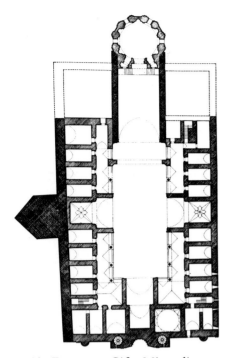

10. Erzurum, Çifte Minareli Medrese: plan of the upper level; ca. 1271.

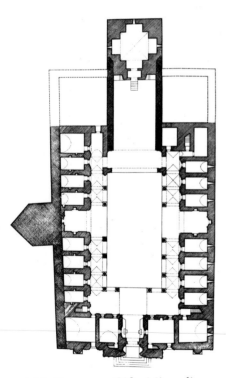

11. Erzurum, Çifte Minareli Medrese: plan of the lower level; ca. 1271.

The main reason for the crystalized and universal plan of the *medrese* is that it was built to answer the needs of a small group of scholars: the ulema class, whose basic makeup and orientation did not change dramatically in the course of time or from one land to another. The Anatolian *medrese* was the seat of learning for "high Islam," which included jurisprudence, as well as history, astronomy, and medicine.

Following the development and legal acceptance of heterodox religious orders in Anatolia around 1250, various institutions for teaching, learning, or merely for living and holding meetings were established and continued to be used until recently. Buildings devised as tekkes, *dergahs,* and *zaviyes* would fit the general rubric of dervish convents. However, these structures, which follow the *medrese* plans, were never constructed on a monumental scale.

In Turkey the term *"medrese"* is applied to buildings that served as hospitals, observatories, libraries, and schools. There are more than one hundred such *medreses* dating from 1150 to 1300. Most of these buildings had spectacular beginnings, as their careful construction shows, but after education became centralized in İstanbul and several other western Anatolian cities during the Ottoman period, they fell out of use and deteriorated into ruins.

As noted above, *medreses* can be grouped into two types according to their plans. The first is the open courtyard *medrese* in which the cells or dormitory rooms and *eyvans* or classrooms are arranged around an open central space. This type of arrangement is known from Iran to North Africa as a basic plan for structures serving various functions and was not restricted to schools. The second type of *medrese,* which seems to be uniquely Anatolian, resembles the first in that the *eyvan* and rooms are placed around a central space, which, however, is smaller and covered with a dome. The second type exhibits a more unified space-flow in the structure, with its central room intimately connected to the surrounding space and to the *eyvans.*

The open courtyard *medrese* was found all over Anatolia from the late twelfth century onward and was also adopted by the Ottomans. On the other hand, the covered *medrese* is found only in central Anatolia. The earliest is a Danişmend building at Tokat, dating from 1157–58, and one of the last examples is in Çay (Afyon), dated 1278. It is probable that these buildings served rather specific functions and, though related to teaching, were not necessarily restricted to theology. The hospital next to the mosque at Divriği belongs to this type as well as the Medrese of Caca Bey at Kırşehir, which also served as an observatory. The covered *medrese* was no longer built in the Ottoman period, quite possibly because its original functions had disappeared or had come to be served by other types of buildings.

The more common open courtyard *medrese* makes its first appearance under the Artukids in southeast Anatolia in Diyarbakır and Mardin. There are five *medreses* in these two cities alone, all dating from the late twelfth century. They are stone structures recalling Syrian architecture in ornamental details; the square courtyard is surrounded by an arcade and there is an *eyvan* on the axis of the entrance.

The open courtyard *medreses* in eastern and central Anatolia are rectangular in ground plan with a monumental entrance portal. The courtyard is smaller than those seen in Iran, Syria, and southeastern Anatolia, and the single *eyvan* opposite the entrance dominates the open space. Stone is the construction material for the walls, but in central Anatolia, brick vaulting and tile decoration inside the *medreses* are frequently seen.

The earliest Seljuk *medrese* is the Çifte Minareli Medrese in Kayseri. One part of the building was planned as a medical school and the other as a hospital, connected by a

narrow hallway. Each structure contains four *eyvans* and smaller rooms around an arcaded courtyard. The school, built in 1205 by the Seljuk sultan Giyaseddin Keyhusrev I, is larger than the adjacent hospital, while the latter, the oldest in Anatolia, was built by his sister Cevher Nesibe about the same date. One of the rooms of the hospital has been converted into a mausoleum.

The mosque-*medrese* complex in Kayseri, known as Hacı Kılıç Medrese but dedicated by Abu'l-Kasim of Tus in 1249, is organized so that both buildings share a common courtyard and one facade. A similar layout will be exploited by the Ottomans in the sixteenth century, as found in the Mosque of Mihrimah Sultan in İstanbul.

Another mosque-*medrese* combination in Kayseri was donated by Mahperi Hatun, the wife of Alaeddin Keykubad and the mother of Keyhusrev II. Called the Mosque-Medrese of Huand Hatun and dated 1238, the two buildings are set at right angles to each other and are joined at the northwest corner of the mosque. Between the two structures is a mausoleum. Consisting of an octagonal building surrounded by a small court on all sides save one, this mausoleum was built within the rectangular space of the mosque but is entered from one of the *medrese* rooms. Each building preserves its own identity, while physically connected to the others. The *medrese* is oriented east-west, in contrast to the south-north orientation of the mosque, and is dominated by one large *eyvan* placed opposite the entrance.

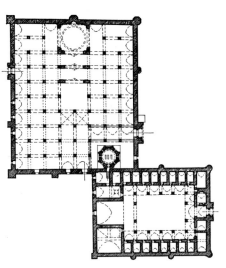

12. Kayseri, Mosque-Medrese of Huand Hatun: plan; 1238.

Two-storied *medreses* are quite common in Anatolia. The Çifte Minareli Medrese in Erzurum, named after the two brick minarets above the portal, is the largest and most famous of all. The deep rectangular courtyard is surrounded by four *eyvans* with one constituting the entrance passageway. The *eyvans* rise to the height of two floors, and the walls between them are sliced into two horizontal strips with thick columns supporting the pointed arches of the double-storied arcading. The thickness of the solid columns plays against the dark voids of the arcading.

ills. 10, 11, 14

A common but not universal feature of the *medrese* is the funerary room. This room, almost always distinguished by an outer conical or pyramidal dome, serves as a funerary chamber for the donor. The *medrese* was considered not as sacred as a mosque, but important and prestigious enough for the donor to be interred in it. As a rule a mosque, with the exception in western Anatolia of a few connected with heterodox religious orders, does not contain a tomb inside the building.

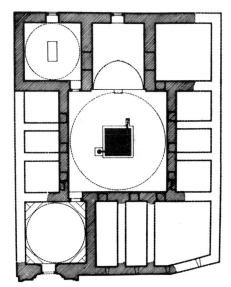

13. Konya, Medrese of Celaleddin Karatay: plan; 1251–52.

A *mescid* is found less frequently in a *medrese* than one might expect. The presence of a mihrab in the main *eyvan* of several *medreses* indicates that this area may have served as the prayer hall. However, most *medreses* are in close proximity to a major mosque in the center of the town and thus needed no *mescid* for the students' daily prayers.

Covered or domed *medreses* in Anatolia are far fewer in number than the open *medreses* (the ratio is 18:100). The covered *medrese* essentially duplicates the units found in an open courtyard type; the central and unifying area is still the court with its fountain in the middle, the largest space within the structure.

The Medrese of Celaleddin Karatay in Konya was built by a Seljuk scholar and vezir in 1251–52. Its rich and splendid decoration and graceful proportions mark the highest architectural accomplishment of the Seljuk capital. The dome defines the space in the court into which one large *eyvan* and several side rooms open. The *eyvan*, framed with a pointed arch, is so large that were it not for the differentiation of the ground levels, it would have formed a continuous area with the court. The *eyvan* appears like a stage or throne room placed several steps higher than the level of the courtyard.

plate 4 (p. 66)

The oculus of the dome, with a pool directly below it, is the focal point of the en-

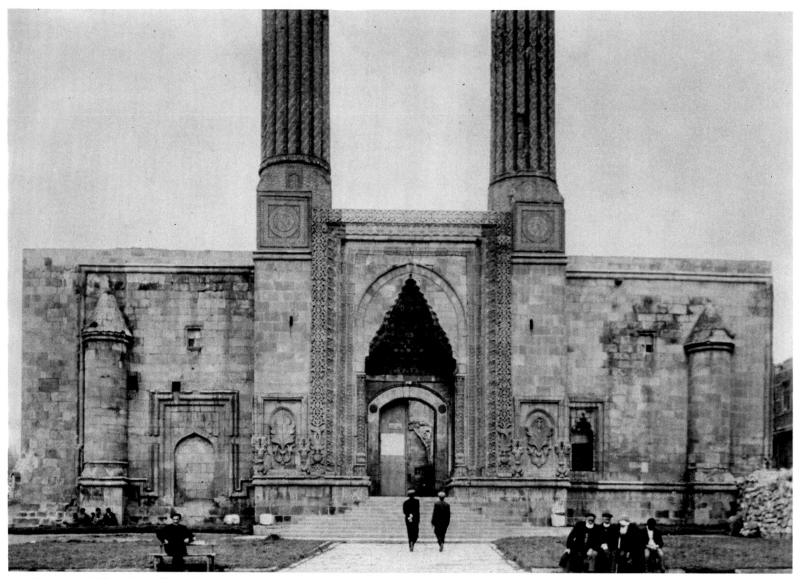

14. Erzurum, Çifte Minareli Medrese: north facade; ca. 1271.

ills. 137, 138

tire court. The dome and the fanlike triangular planes of the zone of transition are covered with mosaic tile. The tile decoration simulates the sky with its stars and sunrays swirling in concentric lines around the oculus, giving the impression that the universe is revolving around an unchanging, still, and fathomless center. The vault and arch of the *eyvan,* also covered with tiles, counterbalance this burst of energy. The interior of the Karatay Medrese reveals a dramatic expression created by color and architectural lines. Despite the elevated floor level of the *eyvan,* space flows continuously from the center to the *eyvan.* This concept will be reused in the so-called inverted-ⲧ mosques of the early Ottoman period. Although a differentiation of spatial areas is attempted by the raised floor, the *eyvan* was not meant for prayer since it lacks a mihrab and is not oriented toward Mecca.[9]

MAUSOLEUMS

Mausoleums constitute another major group of monuments; nearly 340 funerary buildings were erected between 1150 and 1350. The earliest examples appear in northern

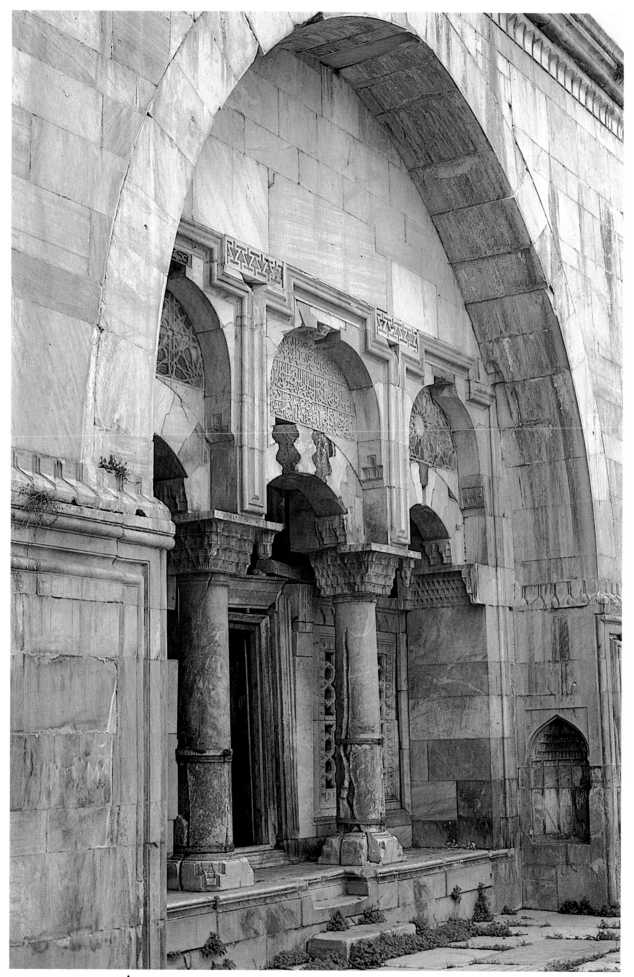

1. Balat, Mosque of İlyas Bey: entrance on the north facade; 1404.

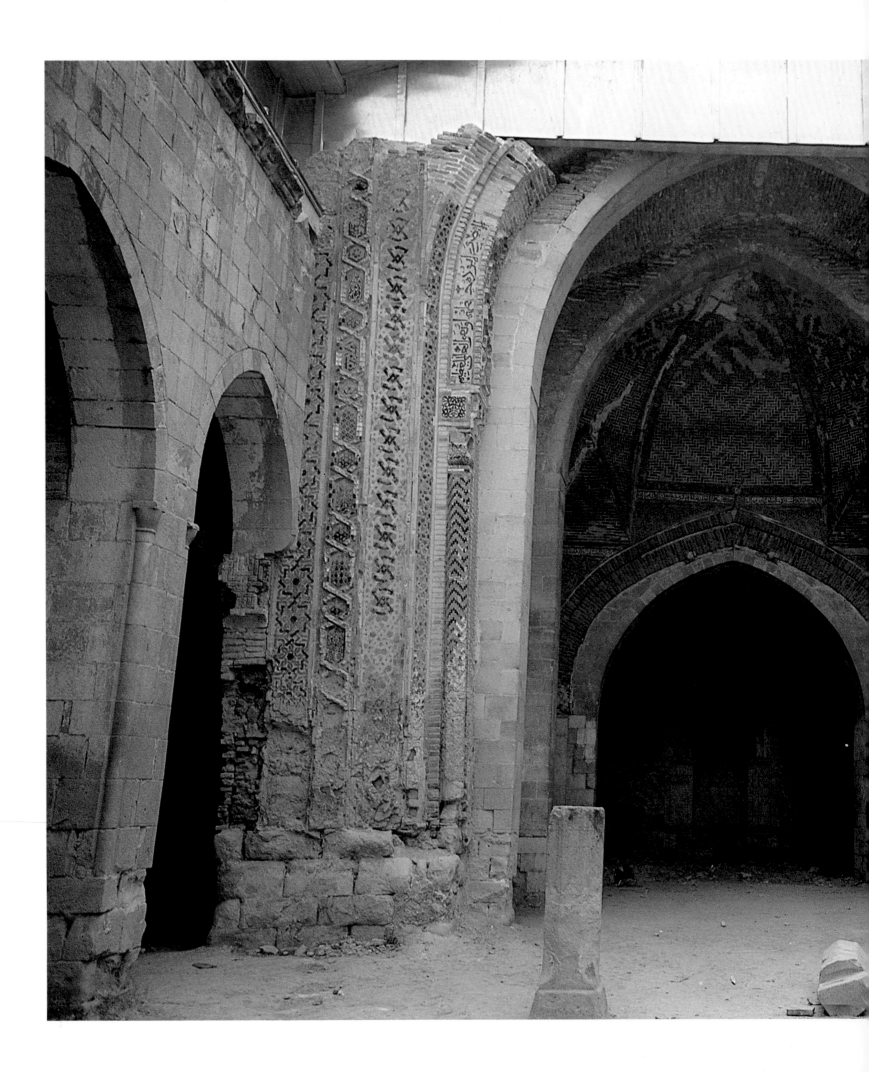

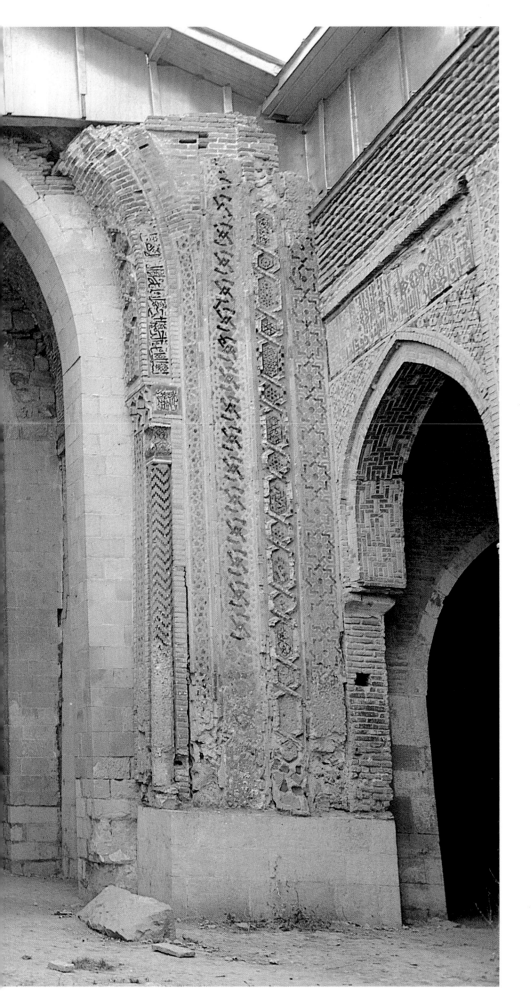

2. Malatya, Ulu Cami: courtyard, looking south toward the great *eyvan;* 1224 and later.

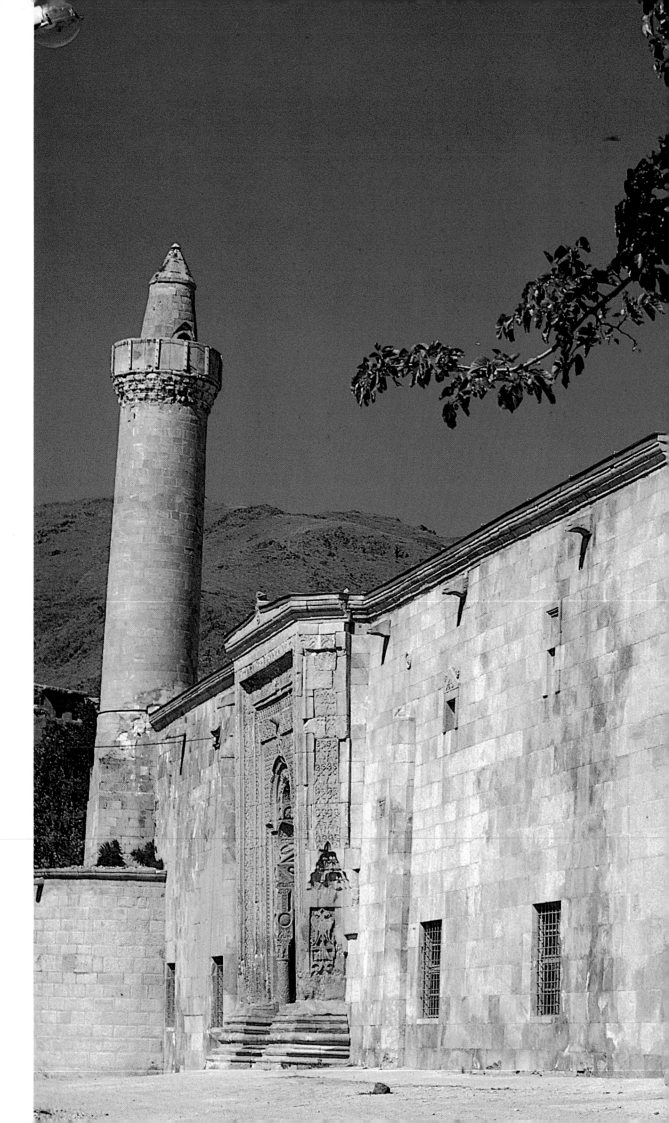

3. Divriği, Mosque-Hospital:
west facade; 1228–29.

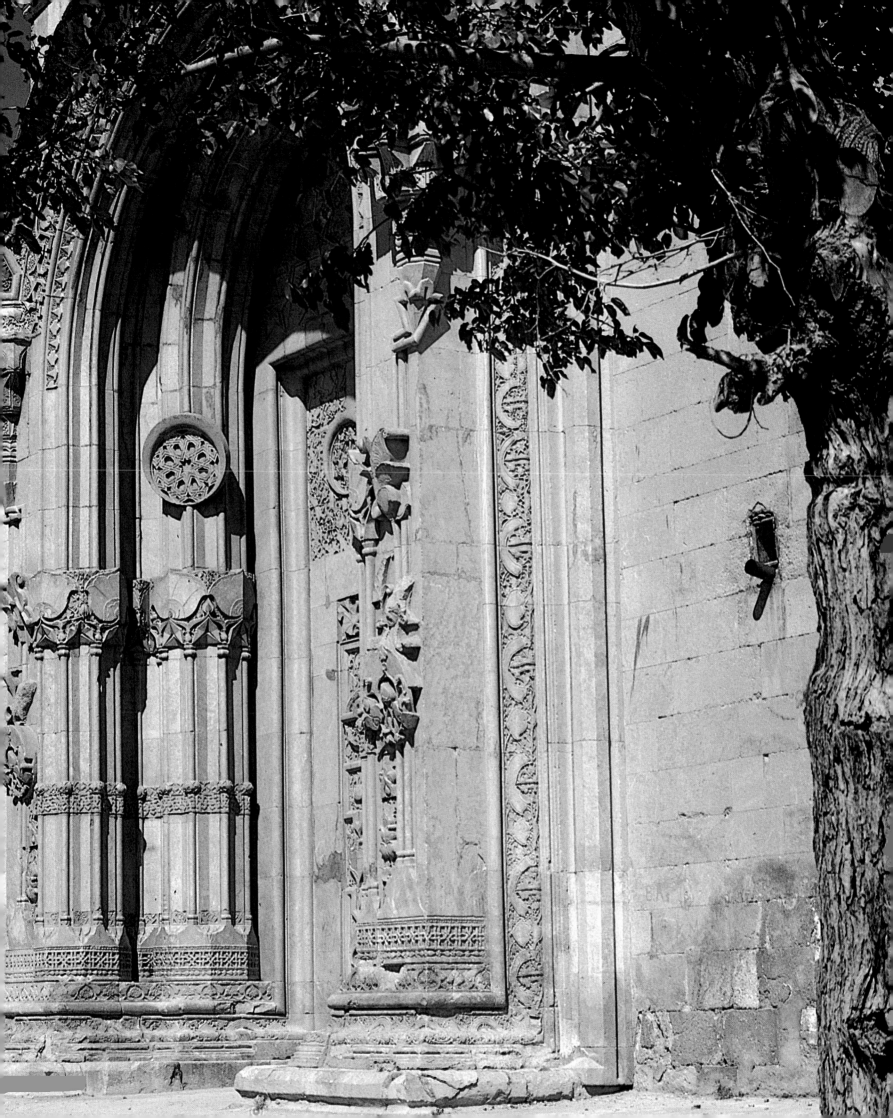

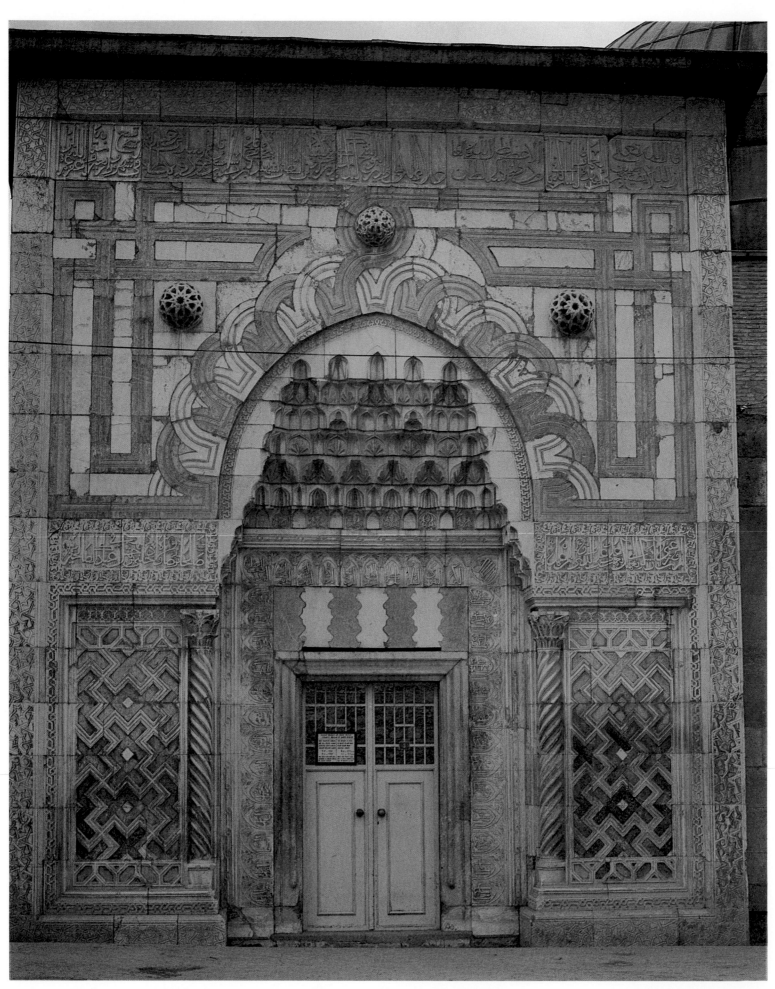

4. Konya, Medrese of Celaleddin Karatay: entrance; 1251–52.

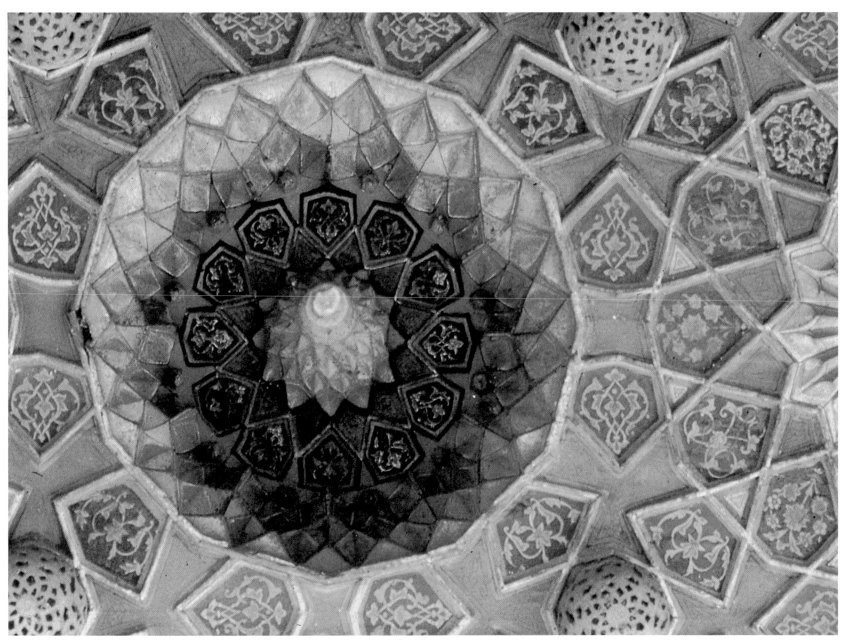

5. Bursa, Mausoleum of Murad II: underside of the wood eaves; 1452.

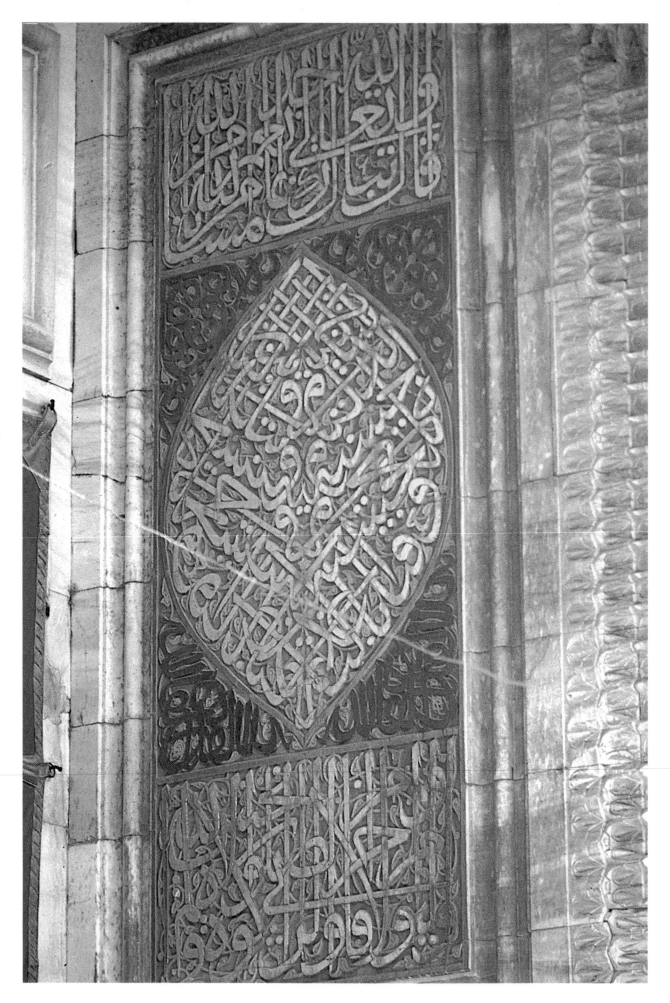

6. *Left*: Edirne, Üç Şerefeli Cami: dedicatory inscription over the entrance to the mosque; 1430–47.

7. *Right*: İstanbul, Şehzade Cami: interior view showing the marble *minber;* 1544–48. Architect: Sinan.

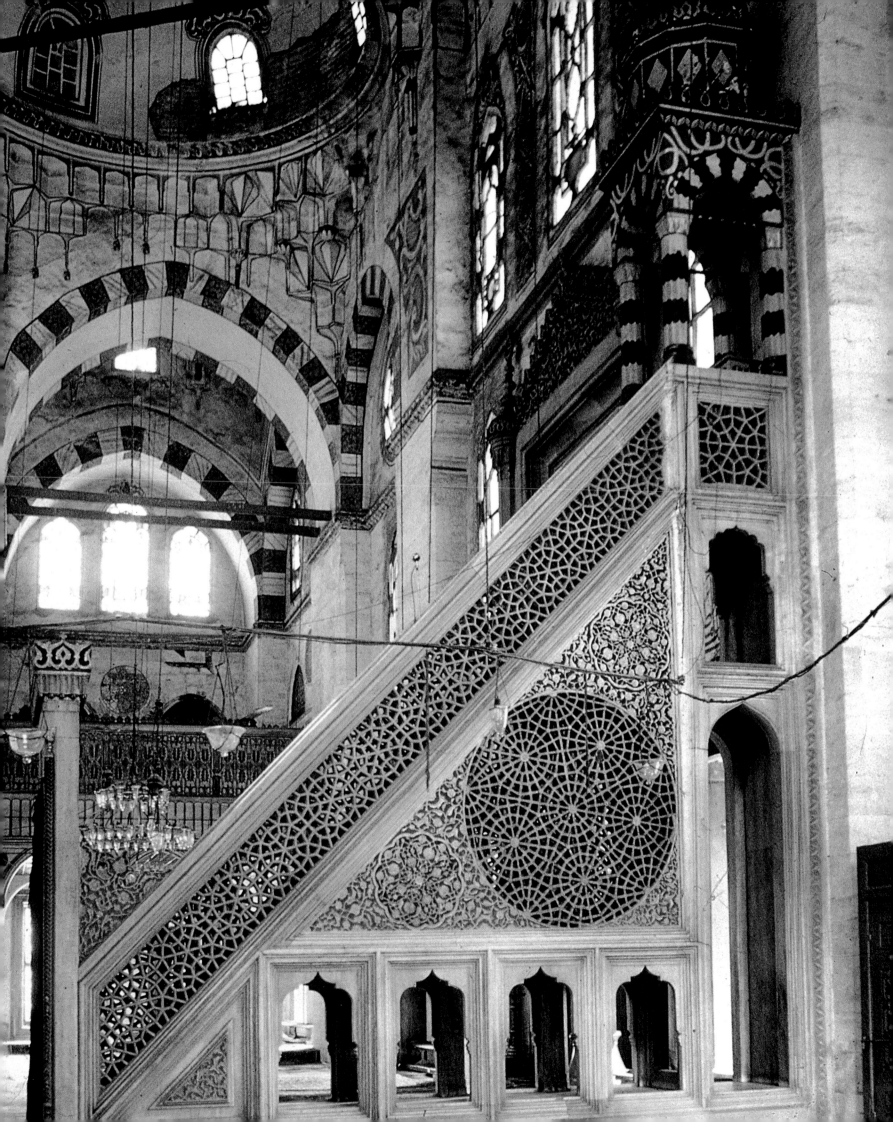

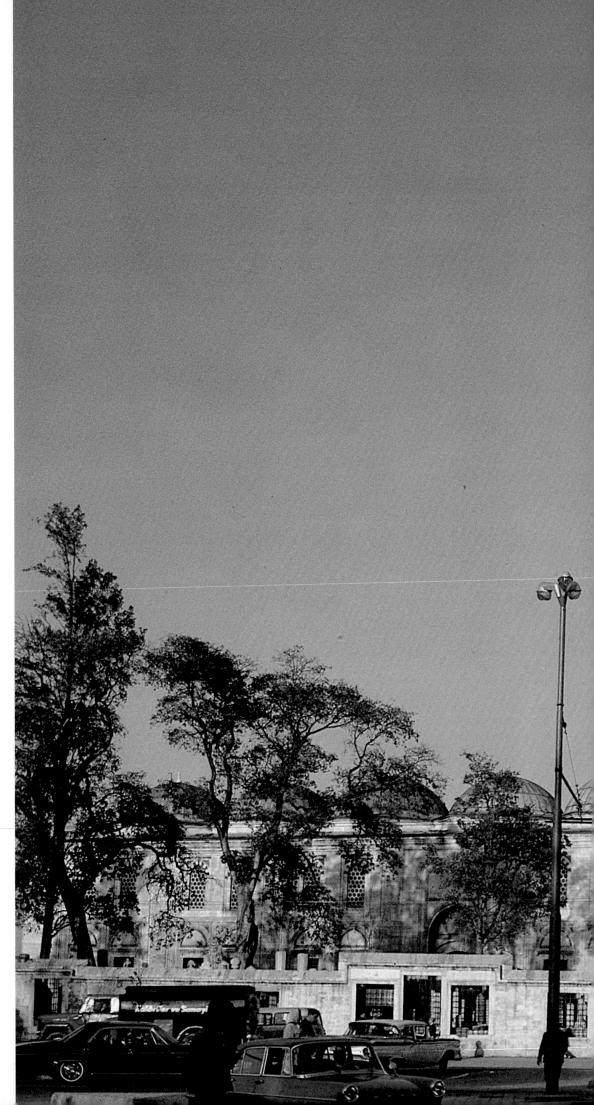

8. İstanbul, Şehzade Cami: general view;
1544–48. Architect: Sinan.

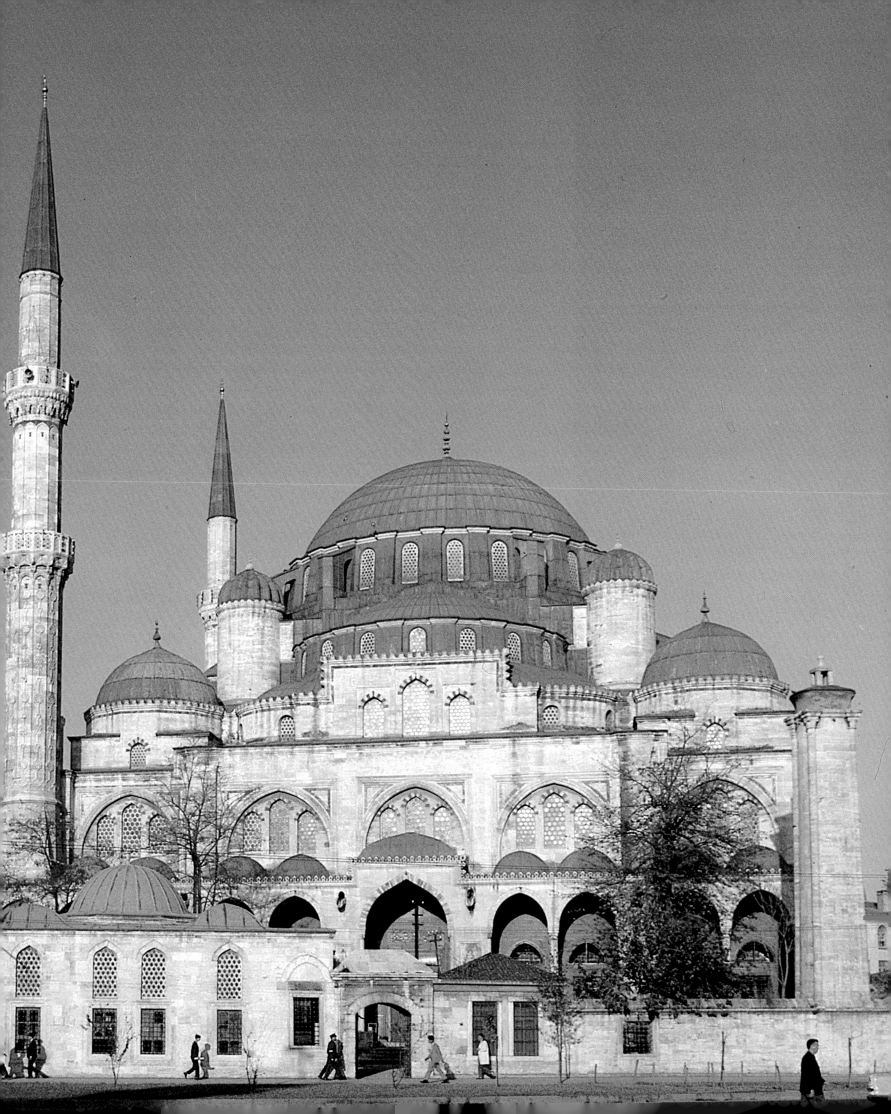

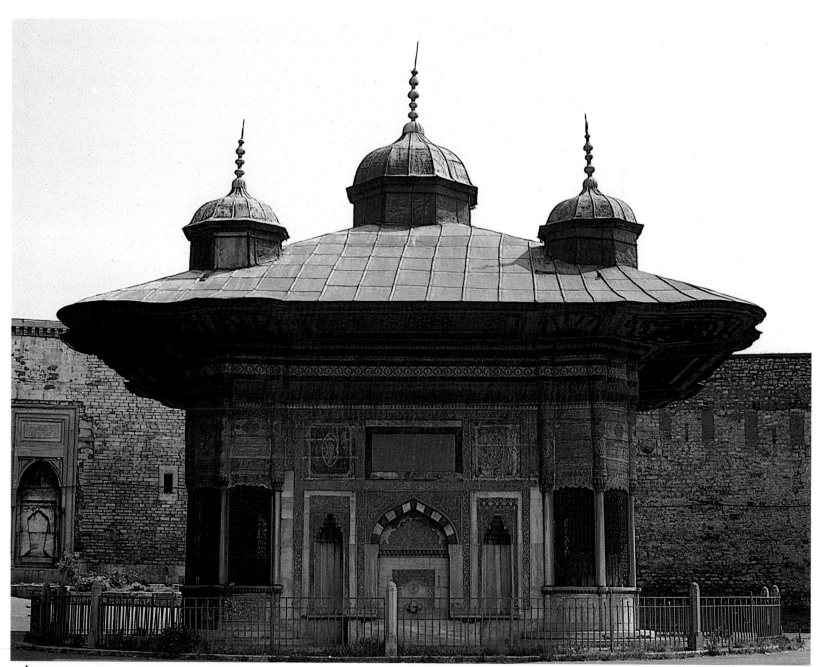

9. İstanbul, Fountain of Ahmed III; 1728.

and eastern Anatolia and later spread to the central and western regions. Most mausoleums were built between the years 1250 and 1350, that is, between the Mongol invasion and the rise of imperial Ottoman architecture; those in eastern Anatolia, especially in the Van-Erzurum region, are more numerous than in any other area. The reasons for this concentration in time and place require further explorations of Anatolian social history. However, it may be pointed out that the population of eastern Anatolia has been traditionally sympathetic to Shiism[10] and that the Mongol conquests not only caused changes in the ethnic makeup of Anatolia but also prepared an atmosphere that favored the spread of heterodox orders. These orders appear to have gained considerable power and importance in learned and military circles during the late thirteenth and fourteenth centuries.

The leaders of Sufi orders were often forced to flee the Mongols to the relatively peaceful land of the Seljuks of Rum. As their spiritual heirs founded new cities, these men were immortalized in mausoleums, which were to become centers of veneration. Although they never reached the same position as the *imamzades* in Iran, mausoleums in Anatolia occupied a special niche in the religious system, at least on a folk level.

As an architectural form, the Anatolian-Islamic mausoleum can best be described as a monumental tombstone. Its shaftlike structure usually rises from a well-defined and squared-off base, which often contains the crypt. The building consists of a single-vaulted room with three windows and an entrance from the north. Its exterior is compact and usually adorned with a high, pointed roof, which can be pyramidal or conical. The sculptural quality of the monument is increased by its verticality, sculptured roof, rich carvings, and multifaceted appearance. Since the body almost always rises on a base, the entrance is high and is approached by very narrow steps not intended for frequent use. The body is buried in the crypt, in accordance with Islamic law, although a symbolic sarcophagus is found in the room above. With its small size, diminutive door, rather inaccessible staircase, and cluttered interior containing one or more sarcophagi, the mausoleum does not allow room for the living. Commemorative rites were traditionally held outside the building, in the same manner in which a visit would be paid to a grave.

ill. 15

CARAVANSARAYS

Without doubt, the most magnificent examples of architecture from the Seljuk period are the caravansarays or hans. They are among the best examples of secular building in Anatolia as indicated by the quality of their construction, monumentality of their portals, forbidding rise of their walls, and fine workmanship of their architectural decoration. Considering that more than one hundred such caravansarays were built between 1200 and 1270 along the south-north and east-west routes radiating generally from Konya, one may wonder what compelled the Seljuks to invest in these monumental structures. When the political and economic conditions of the period are reviewed, however, it is not surprising to find architectural enterprises of this kind. The Crusaders, while waging war with the Islamic people, still traded with them, and the formation of "Latin States" in the Near East, especially in İstanbul, put Anatolia midway between Europe and the Holy Land. Italian cities were greatly encouraged by the Seljuk rulers to trade with the sultanate of Konya,[11] and the rise of the Mongols in the east could have opened new markets and hence traffic on the routes leading in that direction. This rise in the commercial importance of Anatolia stimulated wealthy pa-

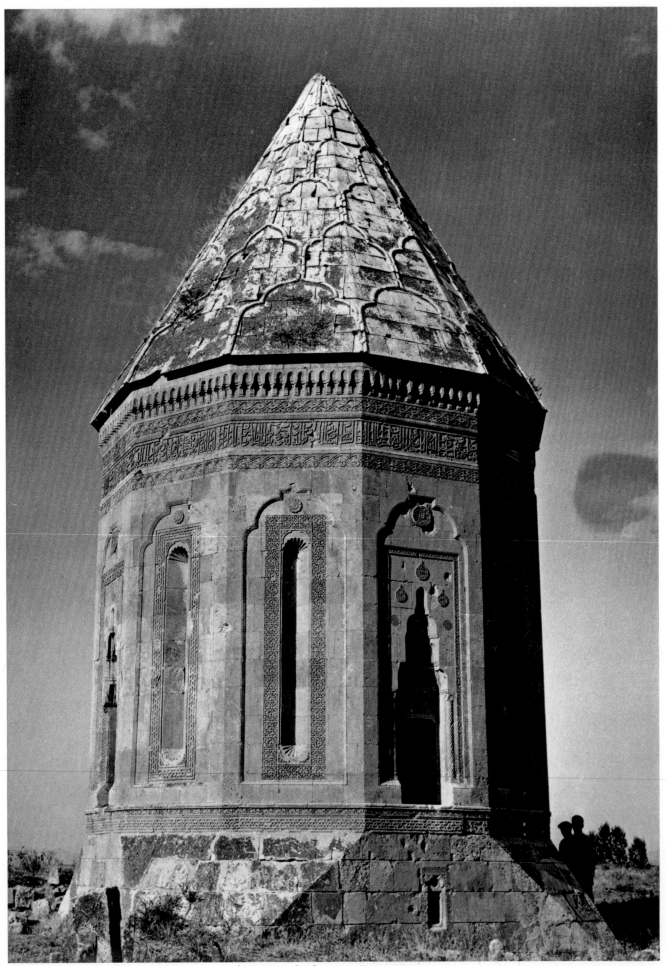

15. Gevaş, Tomb of Erzen Hatun: general view; early fourteenth century.

trons to build caravansarays in order to attract tradesmen, merchants, and ambassadorial envoys. It seems that nothing was spared to encourage travelers, including a three-day free stay.[12]

Caravansarays are spaced at intervals of one day's travel on the major routes. An outstanding and highly ornate portal in the middle of the facade often beckons the travelers. The walls are bare except for half-rounded towers placed at regular intervals, which serve as buttresses.

Since there are no outstanding palatial residences surviving from this period, the importance of caravansarays as examples of secular buildings increases. According to contemporary sources, the sultan and other dignitaries stopped and spent time at larger caravansarays during campaigns or during visits from one city to another.[13] The cities of Konya, Kayseri, and Sivas all served as royal centers during the Seljuk rule, especially in the latter half of the thirteenth century. While traveling, the sultan and his retinue would pitch their tents and reside in the caravansarays. Special troops were appointed to safeguard the buildings.[14]

Although their functions are similar, not all caravansarays utilize the same plan. There are three basic designs according to which the existing one hundred buildings can be classified. The particular design or plan used in each case seems to have been chosen not for geographical or climatic reasons, but for reasons of the construction costs involved.

The smallest structures, and those humblest in their decoration and stonework, are without courtyards; they consist of only longitudinal halls with three aisles that are covered by barrel vaults bisected with transverse arches. Usually the middle aisle is wider than the outer two. Solid walls and the lack of windows give the interiors the appearance of a storage area rather than the atmosphere of a hostel. The goods were probably stored in the enclosed area while tents were set up for the travelers who remained outside with their animals.

The second type of caravansaray is dominated by a large open central courtyard surrounded by a deep arcading. This type of building obviously has stylistic connections with those in Syria.[15] Like the open courtyard *medrese*, it was also taken up by the Ottomans.

The third group of caravansarays, which combines the plans of the first and second types, includes the most magnificent buildings in Seljuk history, the "sultan hans," sponsored by the rulers themselves. The sultan han near Kayseri on the road to Sivas is perhaps the best example of this type.[16] It was built between 1232 and 1236 under the patronage of Sultan Alaeddin Keykubad. The structure as well as its decoration is in yellowish local limestone. Each stone slab is carefully finished and polished while the core of the walls is of rubble stone, including fragments taken from pre-Islamic buildings. Such reusing of old material is not limited to caravansaray constructions, but is common in this period. However, since the structures were strictly secular, late classical stone pieces, some with figural representations, are often exposed on outer walls, thus adding to the structure's ornamentation.

ills. 16, 17

The sultan han near Kayseri consists of two parts: the courtyard and the covered hall. The only entrance is from the north through a monumental gate. Inside the court is surrounded on all sides, except the south end, with small rooms arranged in apartments. One of the apartments of four rooms served as the bath. The south side of the courtyard contains another monumental portal, leading into the closed hall. The hall is narrower but deeper than the courtyard. It has three deep aisles stretching in a south-north direc-

tion. The central aisle is narrower but higher than the side aisles. The middle bay of the central aisle is raised into a lantern-shaped tower, capped with a pyramidal roof. Windows of the tower provide the main source of light into the enormous hall. A significant part of caravansarays of this type is the so-called kiosk-mosque placed in the center of the courtyard. The small *mescid* is raised on four arches supported by corner piers, so as not to hamper the traffic in the courtyard.

In the Kayseri Sultan Han the exterior portal and the one leading to the closed hall are examples of the most harmonious compositions in Anatolian Seljuk architectural decoration. The enormous exterior walls appear like fortifications, an effect accentuated by the polygonal half-towers. Although solid inside and not used for defense, the towers lend a forbidding appearance and do not prepare the visitor for the delicate ornamentation of the entrance portal. Two half-domes, their surfaces composed of vertical fluted segments, flank the rectangular block-portal, which is dominated by a deep niche containing a small entrance. The niche-head is filled with rows of *mukarnas*. Smaller niches are also placed on the lower side walls within the niche indentation, flanking the doorway. The inscription, above the door, gives the name and titles of the donor, Sultan Alaeddin Keykubad, as well as the date, 1232–36. Enclosed by the rectangular portal, the niche has a pointed arch framed with shallow bands, the surfaces of which are covered by interlacing geometric patterns. The carving is in low relief and does not interfere with the architectural lines of the portal. The decoration of the two portals and of the mosque of the Kayseri Sultan Han serves as a classic example of thirteenth-century ornamentation.

The names of architects, such as the one originally inscribed on the Kayseri Sultan Han, are also seen on other contemporary buildings and continue to appear in the Ottoman period. The possibility of tracing the artistic style of an architect whose name is inscribed on more than one building is problematic since the dominating factors appear to be the taste and demands of the patrons. The status of the architect as the creator of monumental works was high when compared with that of other artists. Nevertheless, the architects do not seem to have sought to create individual styles or schools but worked within the traditions and conventions current in each region. They were restricted by the type of building they were erecting and above all by the taste of the patron, which was not always so conservative, as demonstrated in the Divriği hospital-mosque complex. In the Divriği complex the architect left his name carved onto the stone and yet the names of stone carvers are not identified. It is not possible to say whether the architect was also responsible for the selection of the portal compositions and the motifs used in the decoration. However, the marks prove that masons were organized and that they often identified the stone blocks they carved.

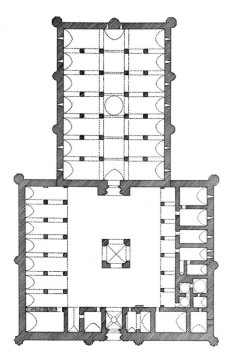

16. Kayseri-Sivas road, Sultan Han: plan; 1232–36.

The Period of Türkmen Emirates: 1300–1450

The establishment of the Mongol suzerainty in Seljuk Anatolia after 1243 seemingly did not bring about a sudden upheaval in local society and institutions. The Seljuk dynasty, though shaken, withstood the Mongols another sixty years. Yet, a gradual and at first rather inconspicuous transformation in society and institutions took place, culminating in the shifting of centers both of power and of the arts to western Ana-

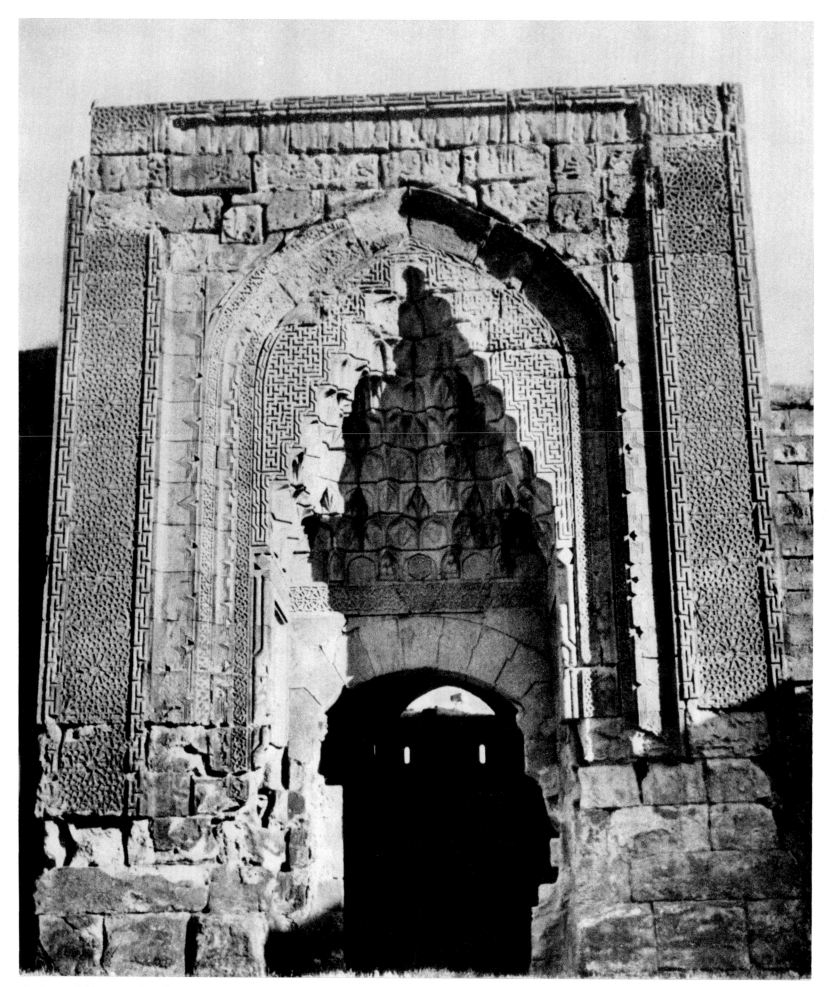

17. Kayseri-Sivas road, Sultan Han: portal; 1232–36.

tolia in the following centuries. This shift had a direct impact on architectural activities, as a series of transformations and innovations was introduced in response to the needs of the new society. The transformations gave a new direction to architectural developments, which led eventually to the classical Ottoman buildings.

The peculiarity of this development is that it no longer derived its models and inspiration from the east, that is, from Iran, but drew largely on western Anatolian or eastern Mediterranean traditions. This change was by no means a radical transformation but rather a result of the political situation and the related change in the taste of patrons and in construction materials.

One force in the evolution of architectural style and the conceptual changes underlying its manifestations concerns the social milieu in Anatolia between the Mongol victory over the Seljuks in 1243 and the end of the Seljuk rule in 1307. Following the Mongol invasion the power of the central state, still nominally headed by the Seljuks, was seriously eroded, and Anatolia became torn by competing tribal politics. But factors other than political changes also affected social and religious institutions in Anatolia, thereby altering the environment in which architecture evolved.

Starting around 1220, large groups of people moved to Anatolia as a result of the Mongol invasion. Scholars and religious leaders, individually or in groups, migrated westward in front of the Mongol armies and took refuge in the relative calm of Anatolia. The influx of religious leaders brought a new dimension to the then-changing Anatolian political boundaries. During the years of social transformation under the rule of the Mongols and the final collapse of the Seljuks, a new social ideology developed. The prevailing intellectual framework seems to have been grounded in religion as molded by the newly arriving mystics. The religious orders that took firm root at this time among the population of Anatolia were strongly influenced by Shiism and espoused a syncretic ideology. The expansion of heterodox orders and the proliferation of charismatic religious leaders found a favorable climate, especially along the provinces of the western *uç* (frontier). The frontier provinces, until then semiindependent and largely tribal in local organization, became transformed into states, which gained land by occupying territories along the Aegean. Economically, however, they depended on settled urban populations.

The most significant political and social consequence of the Mongol suzerainty and the eventual deterioration of the Seljuk rule was the transformation of western Anatolia into a Turkified and settled environment where independent emirates emerged, among which were those of the Ottomans. This development is significant for the history of Anatolian architecture.

The social and political makeup of the Türkmen emirates in western Anatolia differed considerably from the Seljuk period. Unlike the strong and centralized Seljuk state, the Türkmen states were small and weak, ruling over predominantly Christian lands. The Seljuks were considered the continuation of the Seljuks of Iran and the chief defenders of Islam against the Crusaders. They remained conservative in their culture and state organization. Aloof from the population, they were Persianized to the extent that they had to rely on interpreters when conversing with Turkish subjects, and the names of their sultans were inspired by Persian mythology and history. The political, economic, and social roots of the Seljuks were in the cities. The ulema class was well entrenched and protected by the power of the established order.

The heads of the Türkmen states, on the other hand, had Turkish-Islamic names; their modest titles were emir, bey, or gazi, and, less frequently, sultan. Although power

struggles among the emirs occurred, their main base of military operation was in the non-Muslim territories, which distinguished them from the Seljuks. The Türkmens were gazis, or religious warriors, waging war from the frontiers of Islam. The gazi spirit was zealous and religious. The Seljuk sultans had various titles, but none called himself a gazi.

The gazis received instruction from the *şeyhs* and dervishes, the supporters of popular Islam, who in the view of the urban, scholarly, and conservative ulema were tainted with asceticism and heterodoxy. However, the gazis did not resemble the disorganized bands of the nomadic frontier plunderers. Motivated by their fight for Islam, they were highly disciplined and served the individual principality where they lived. The gazis were distinguished from the rest of the population in their costumes and ceremonies; for example, the Ottoman gazi wore a high white cap.[17]

One urban element that participated actively in the social order of the principalities was the *ahi*.[18] The *ahis* were traders or artisans belonging to a particular guild. They lived in ascetic retreat, worked by day, and in the evening retired to their hospices, which were under the spiritual guidance of the *şeyhs*. Like the gazis, the *ahis* led a "virtuous life" and had a mystical orientation in their religious observances. Because of their original connections with the *futuwwa*, they maintained military discipline.[19]

The ulema did not die out during the period of the emirates. They formed the core of the administrative system and thereby preserved a relatively strong position. Their centers were still in the *medrese*. Far from trying to stamp out the heterodox organizations, they came to an accommodation with the *ahis* and the gazis. Political power, including that of the rulers, was distributed among these institutions and thus decentralized.

Among the western emirates the Ottomans were geographically in the most advantageous position. While others found the sea a barrier to expansion, the Ottomans were able to cross the Dardanelles and to carry their offensive to the heart of Europe. By 1400 they had reached Hungary, but in so doing they were forced to bypass the walls of Constantinople.

From 1300 to 1450 the new social and political order of the Türkmen emirates, especially that of the Ottomans, had an immediate impact on architectural activities. In addition to the Ulu Cami in the center of the city, smaller mosques and buildings were designed to accommodate various groups of gazis, *ahis,* and dervishes. A new type of mosque, the so-called inverted-т building, seems to have served different groups. The *ahis* were a commercial brotherhood akin to a guild, while the gazi brotherhoods were largely military in nature. These mosques provided room not only for prayers but also for activities stemming from the nature of the brotherhoods, such as meetings, lectures, meditation, and the reading of the Koran.[20]

The *ahis* lived in *zaviyes*, which can be defined as convents and hospices for the wandering dervishes and travelers. Ibn Battuta, the fourteenth-century traveler, stayed at such hospices run by the *ahis,* whose organization and hospitality he highly praised.[21] The ulema retained control of the *medreses*, but the number of such buildings greatly diminished from the previous period. The various *tarikats* (religious orders) congregated and resided in tekkes, *dergahs*, and possibly in *zaviyes*. Such buildings not only were situated in cities, but they became widespread in the countryside where the popular form of Islam found ready adherents. The teaching of the wandering ascetics and mystics who lodged in these was very different from that of the orthodox theologians of urban centers. These humble buildings are not architecturally significant and are built mainly

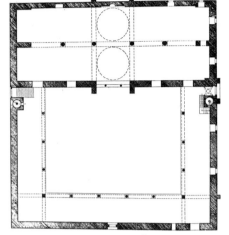

18. Selçuk, Mosque of İsa Bey: plan; 1374. Architect: Ali bin al-Dimişki.

of rubble stone or even mud brick. Although important in the social history of the land, they are almost ostentatiously lacking in architectural monumentality.

Another significant product of the religious and social orders of the fourteenth and fifteenth centuries is the proliferation of mausoleums. The *şeyhs*, dervishes, and "holy men" in general were honored after their death in funerary chambers, sometimes standing alone or incorporated into a tekke or a *dergah*.

The western emirates ruled lands that had never been occupied for long periods of time by Islamic peoples. These lands were rich in monuments of the Greek and Roman periods, as well as those of Byzantine origin. These provinces had always been closely related to the Byzantine capital and, hence, more strongly influenced by its civilization. The architecture of the Türkmen emirates reflects these newly acquired perspectives; those structures, which were required to conform to Islamic law or traditional belief, remained unchanged in their essential forms. They were, nevertheless, influenced by local techniques. Thus, the Islamic architecture of western Anatolia became more directly and closely related to that of the Mediterranean world. This infusion of new architectural styles and concepts caused Islamic architecture of western Anatolia to evolve in a divergent direction in the fourteenth and fifteenth centuries.

By 1500 the architecture of Anatolia reflected that of the new capital of the state, and the Ottoman style permeated all provinces. The buildings of the imperial capital became the models for structures of all types and sizes in the rest of the empire. The important change is that Iran, and in a larger sense Asia, no longer provided architectural models, but İstanbul did. This, however, is the culmination of a series of developments in Anatolian history.

In central Anatolia the Karamans (ca. 1256–1483) succeeded the Seljuks in governing Konya and its surroundings. In addition to building new structures they repaired many Seljuk buildings that were crumbling from neglect or war. Nevertheless, the Karamans followed the suit of smaller and not so well established emirates in western Anatolia; for example, they used Turkish as the official court language. Their architecture, though along the traditional lines of the Seljuks, timidly imported some innovations from the west, such as facade compositions, narrowed simple portals, and windows on lateral walls.

Various provinces farther to the east could not afford innovative or large-scale architecture during their independent periods prior to the Ottoman conquest. Only the states of the Karakoyunlu (Black Sheep) Türkmens (1380–1468) and Akkoyunlu (White Sheep) Türkmens (1378–1508) left monuments that are architecturally noteworthy. The Blue Mosque in Tabriz, built during the rule of the Karakoyunlu Türkmens in 1465, displays architectural peculiarities borrowed from the Ottomans as well as the local conventions of Azerbayjan.[22]

The most outstanding type of building during the period of the emirates is the mosque. In place of the rather inconspicuous mosque of the earlier era, which was surpassed in glory by the *medrese* and the caravansaray, the mosque now dominates other kinds of structures in number as well as being the center of the town and its activities. Unlike the horizontal and sprawling Seljuk examples, the general appearance of the mosque becomes vertical, with one or more spherical domes raised on high drums emerging as the dominant element. Large and multilayered windows on the facades allow abundant light into the building. Few architectural obstructions are placed in the way of a large and flowing space, which is dominated and defined by a dome or a high vault set directly on walls mediated by the zone of transition.

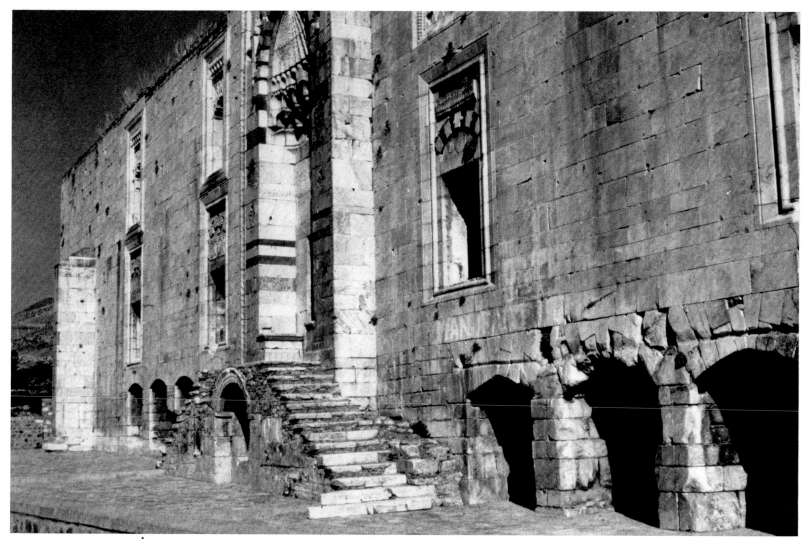

19. Selçuk, Mosque of İsa Bey: west facade; 1374. Architect: Ali bin al-Dimişki.

The zone of transition gains another element in this period: the so-called Turkish triangles, which are prismatic, fanlike triangular forms arranged between the cube and the curvature of the dome. Turkish triangles and pendentives are preferred to the broken-up and flattened forms like tripartite squinches found in the zone of transition in Seljuk buildings. The mihrab becomes one of the elements within the unified space of the mosque, and its area is no longer isolated or emphasized as a separate unit.

Architecture of Western Anatolia

The Aydınlı Türkmens (ca. 1300–1426), who settled and formed a state around Ephesus and ancient Tralles, became the major naval force in the Aegean, carrying their forays to the Greek islands and to Greece. One important mosque built by the Aydınlıs is the İsa Bey Cami in Selçuk, near Ephesus. It was built in 1374 by an architect known as Ali bin al-Dimişki, or Ali, the son of the Syrian. The Mosque of İsa Bey consists of a closed, rectangular section and an open courtyard. Inside the mosque, two aisles run parallel to the *kıble* wall and intersect the nave leading to the mihrab. The nave possesses two domes while the rest of the mosque was originally covered with a flat wooden roof. This longitudinal development is a borrowing from the Syrian tradition, as is the

ill. 18

ill. 19

plate 1 (p. 61)

large arcaded courtyard that has two lateral entrances with minarets placed next to them. Its plan develops laterally, not axially, a feature that will be found in classical Ottoman architecture. The most important feature of the mosque, however, is its magnificent facade, the first of its kind in Anatolia.

Because the mosque is built against the slope of the citadel, the west facade rests on arches. The high, narrow, and slightly projecting portal on this facade is reached by two stairs. The carving on the portal is limited to a row of double-tiered *mukarnas* stretching between the spring points of a blind arch. The lateral walls of the facade are pierced by two rows of large rectangular windows, encased by frames with different ornamentation. The frames are of stone, the construction material of the mosque.

The closed section of the mosque also has windows on all sides, including the one facing the courtyard. Windows, especially in multiple tiers, are not a feature seen in earlier Anatolian architecture, which was based on Iranian models. The Mosque of İsa Bey thus displays a Mediterranean architectural feature that is also shared by the contemporary Mamluk architecture in Egypt.

The mosque also illustrates a stage in the development of an articulated street facade. The high walls have ornamentation restricted to specific areas of the facade around the openings and above the cornice, but never overpowering the architectural lines. The highly emphasized portals of the thirteenth century have now become an integral part of the overall planning of the facade.

The Mosque of İlyas Bey at Balat (ancient Miletus), built in 1404, is a small, and now abandoned, building standing amidst Greco-Roman and Byzantine ruins. Despite its diminutive size, the mosque exhibits several features characteristic of fourteenth- and early fifteenth-century architecture. It is a cubelike structure covered with a round dome raised above a high drum. The entrance is composed as a square block, jutting forward from the facade but not above the roof line. A deep and slightly pointed arch spanning most of the block contains the most significant feature, a triple-arched entrance reminiscent of the triple gates of churches. In the Mosque of İlyas Bey the doorway is in the center, and the sides are covered by panels enriched with openwork and inlaid with colorful stones. The exterior of the mosque is reveted with marble. The side walls, like those of the Mosque of İsa Bey near Ephesus, contain double-tiered rectangular windows, framed with carved ornamentation.

The interior of the Mosque of İlyas Bey, like many other contemporary mosques, is dominated by the dome, which centralizes and unifies the space. A similar handling of space was seen in the small *mescids* of the Seljuk period. Nevertheless, unlike the dark Seljuk buildings, the mosque at Balat is illuminated with the natural light that pours in from the windows. A second focal point in the building is the mihrab, a magnificent rectangular marble panel dominating the south wall. The minaret of the Balat mosque is placed on the northwest corner of the building, which eventually becomes the traditional corner for the minaret. The minaret is of brick, some glazed, while the dome of the mosque is covered with ceramic tiles.

Another significant point about the Mosque of İlyas Bey emerges when we compare it with the Yeşil Cami (Green Mosque) built in 1391 in İznik, the early capital of the Ottomans. It is also a single-domed structure, paneled with marble, but the brick minaret is enriched with glazed tiles. In front we find the *son cemaat yeri,* the portico already noticed in the simple *mescids* of the Seljuks. The portico in this mosque, and in other Ottoman mosques to follow, is an addition to the north wall that runs along the full width; it is shallow and open at the sides.

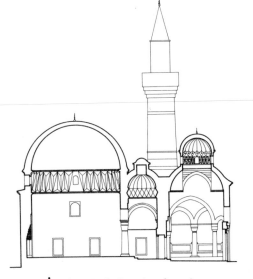

20. İznik, Yeşil Cami: elevation; 1378–91. Architect: Hacı bin Musa.

The important feature of the portico of the Yeşil Cami at İznik is its similarity to the arched facade of the Mosque of İlyas Bey. The middle arch is the widest and fitted with a rectangular frame that serves as the entrance. The frame has double rows of *mukarnas,* an element that is increasingly used in decoration. The dedicatory inscription, placed within the portico above the door leading into the mosque, appears in the traditional place found in the Ottoman mosques. The Yeşil Cami at İznik shows a further reduction of ornamentation, while its architectural and plastic components have become more distinct.

In the fourteenth century a change in the architecture of western Anatolia took place. The portal, although still the dominating feature, begins to be composed of architectural forms rather than carved or applied ornamentation. The main facade as well as the sides are ornamented and articulated with windows, introducing thereby a new element that changes the static nature of the earlier examples. The building is now designed as a cube with all four facades related to each other. This approach links the western Anatolian, and later the Ottoman buildings, with Mediterranean tradition. The

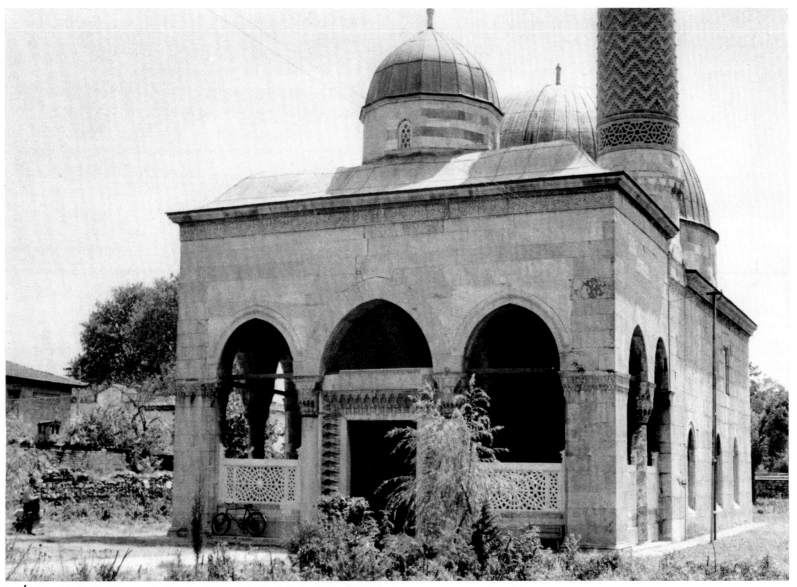

21. İznik, Yeşil Cami: north facade; 1378–91. Architect: Hacı bin Musa.

round dome, so conspicuous from all angles, raised on a high octagonal drum adds to the plasticity of the structure.

The small and single-domed mosque of western Türkmen emirates can be regarded as a continuation of the Seljuk *mescids*. Ottomans developed this type of mosque into one of monumental dimensions. On the other hand, the Ulu Cami is in the tradition of the previous period. However, the Ulu Cami in Bursa, built by the Ottoman Beyazıd I in 1396–1400, departs from its Seljuk predecessors in that each of the twenty bays is covered with a dome. The enormous building, covering an area of sixty-three by fifty meters, is considerably higher than any earlier mosque in Anatolia. The facade composition is not limited to the north side, but extends to the other walls. Since the mosque stands on a slope, the north side is on a high platform and the north portal is reached by a steep flight of stairs, adding to the monumentality of the facade. The portal itself is a quieter version of the Seljuk compositions; the ornamentation is low-keyed and carefully subordinated to the architectural lines. Double rows of windows, enclosed by a single arch, appear on all sides, enlivening the walls while giving a unified overall effect. The building is conceived in its totality as an architectural composition, with the portal and the main facade no longer seen as separate entities. The interior, with thick piers supporting the multiple domes, is lofty with natural light pouring in from the windows on the side walls, in the drums of the domes, and from the oculus of the central dome over the fountain.

The most interesting type of early Ottoman mosque, occasionally found in other parts of western Anatolia, is the so-called inverted-т building. This "mosque" consists of a long rectangular space in the *kible* direction with smaller rooms flanking the northern half of the building. The central rectangular space is divided into two sections; the southern half contains the mihrab and is raised above the ground level; and the northern section is connected to the smaller side rooms by a door or an arch. This section, which may also contain a water fountain, is paved and more like an enclosed courtyard or passageway than a prayer area. The side rooms vary in size, decoration, and possibly in function. Some mosques, such as the Yeşil Cami at Bursa, built by Mehmed I between 1412 and 1419, have side rooms with fireplaces and cupboards, indicating that they were in use all day long, probably as study- or classrooms.

The inverted-т plan was not necessarily devised for a mosque. The Zaviye of Nilüfer Hatun at İznik, built in 1388 by Murad I in memory of his mother, has an inverted-т plan and contains all the features of a mosque. Yet it is not oriented toward Mecca and hence did not serve as a mosque. Its only mihrab is from a later period and is carved rather clumsily onto the southern wall. The Medrese of Caca Bey in Kırşehir, dated 1272, is the first building of this inverted-т type and was originally used as an observatory although now it is converted into a mosque. The side wings are now utilized as classrooms for religious instruction. It is quite probable that these rooms once served the needs of religious orders, which were strong and widespread in western Anatolia and especially in the Ottoman lands.[23] In later periods the inverted-т mosque and the *zaviye* become obsolete, possibly because individual buildings were designed for various activities that had formerly taken place within the same structure.[24]

ills. 24–27

The most spectacular example of this type of mosque is the Yeşil Cami at Bursa, built between 1412 and 1419 for Mehmed I by the architect Hacı İvaz. The north and main facade of the mosque is incomplete; bonding stones were prepared for a five-domed portico that was never built. As it stands now, the facade is divided into two stories with the central portal rising to the height of both floors. The upper-storey

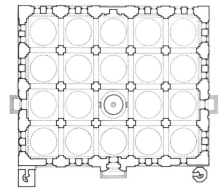

22. Bursa, Ulu Cami: plan; 1396–1400.

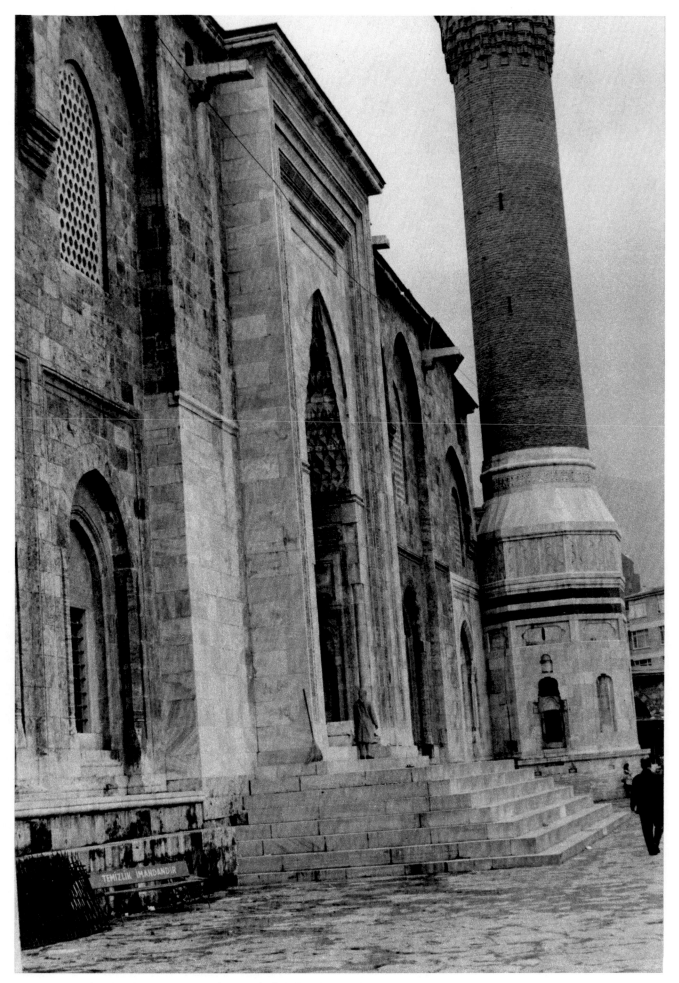

23. Bursa, Ulu Cami: entrance on the north facade; 1396–1400.

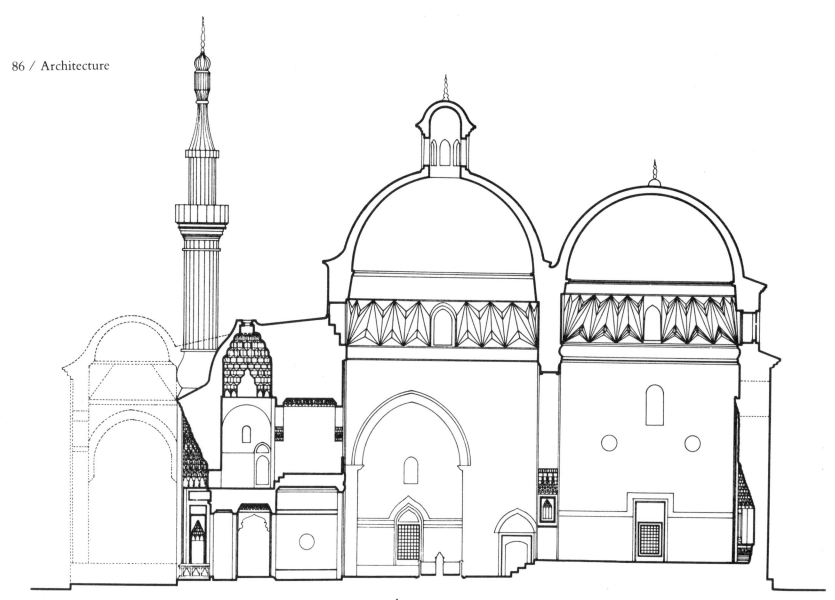

24. Bursa, Yeşil Cami: elevation; 1412–19. Architect: Hacı İvaz.

25. *Right:* Bursa, Yeşil Cami: plan of the lower level; 1412–19. Architect: Hacı İvaz.

26. *Far right:* Bursa, Yeşil Cami: plan of the upper level; 1412–19. Architect: Hacı İvaz.

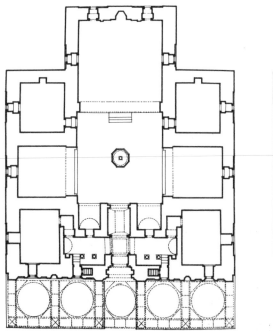

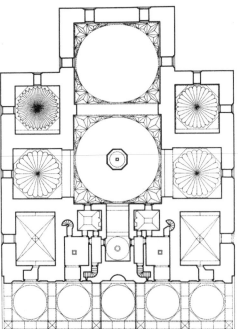

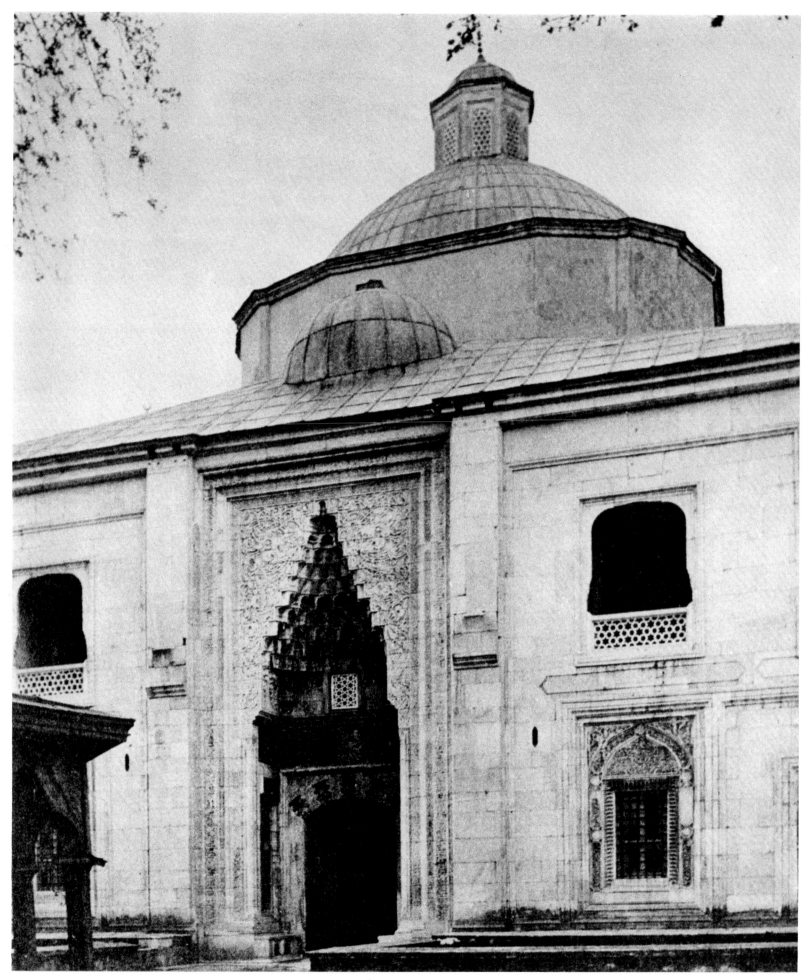

27. Bursa, Yeşil Cami: north facade; 1412–19. Architect: Hacı İvaz.

windows are designed more like loggias and contain low marble balustrades. The lower tier of windows is set within blind arches, enclosed by rectangular frames. The spandrels of arches are filled in with floral motifs carved in low relief.

The portal composition is in the Seljuk tradition but decidedly bears the mark of the new style. It is not a projecting block like the earlier ones but a sunken panel in the facade. The doorway is set inward, in semidarkness under a triangular niche-head filled with rows of *mukarnas*. The spandrels are filled with vegetal interlacings in low relief. The arch of the entrance is round and the voussoirs are in two-toned stone. The portal of the Yeşil Cami in Bursa is the first example of the classical or imperial Ottoman style and will be repeated with only minor changes until the nineteenth century.

The interior of the Yeşil Cami follows the conventional inverted-т plan described above. The central rectangular space is divided into two equal sections. The southern part with the mihrab is a square room covered by a dome that is set over a zone of Turkish triangles. The mihrab room is separated from the northern section by an arch and, because it is raised on a platform, is reached by several steps. The walls are covered with deep green and turquoise tiles.

The second or northern section has a dome with a lanternlike elevation in its center, below which is the fountain. Four rooms of approximately the same size as well as the royal loggia on the second floor open into this courtlike area. Therefore, this section with its water fountain acquires the physical qualities of a court into which three *eyvans* converge.

ill. 141 The loggia on the second floor faces the mihrab and is like a throne room. Its walls, including the vaulting, are covered with turquoise tiles, highlighted with touches of gold. Reserved for the ruler, this room is placed above the entrance overlooking the "courtyard" in accordance with ancient Mediterranean practice.

The exterior of the building also has the appearance of an imperial mosque because of its monumentality and the great care given to its construction, ornamentation, and material. The double domes of the rectangular central space and the smaller domes of the adjoining rooms provide a semicircular design to the roof line. Such an outline of semicircles—more correctly of spheres—becomes a major feature of Ottoman classical architecture. The Yeşil Cami is the immediate forerunner of the great İstanbul mosques. The mosque belongs to a group of buildings of which a mausoleum, the Yeşil (Green) Türbe; a *medrese;* an imaret; and a *hamam* (bath) still survive.

Most *medreses* built during this period follow the open courtyard plan. There is a tendency, however, to diminish the size of the central *eyvan* by reducing the span of the arch. The ornamentation is also kept to a bare minimum; usually wall surfaces are unadorned, revealing the construction material.[25] In some cases columns and capitals are taken from pre-Islamic buildings, but Ottoman capitals with rows of miniature *mukarnas* begin to be seen more frequently. Along with these small changes in architectural ornamentation, the proportions and dimensions of various elements are also altered.

The Mosque of Murad I (Murad Hüdavendigar) in Bursa, is an impressive and innovative structure, using the rooms on the second floor as a *medrese.* Built between 1365 and 1385, it follows the inverted-т plan. On the south side, the mihrab projects from the wall, lending the mosque a churchlike appearance. The main facade is organized in terms of dark and light, or masses and voids, by the use of arches. Both the lower and upper stories have a five-domed portico, but since the domes are not visible from the outside, the facade maintains a flat rectangular composition. The pointed arches on the second floor are blind and enclose a double arch sharing a central column, while

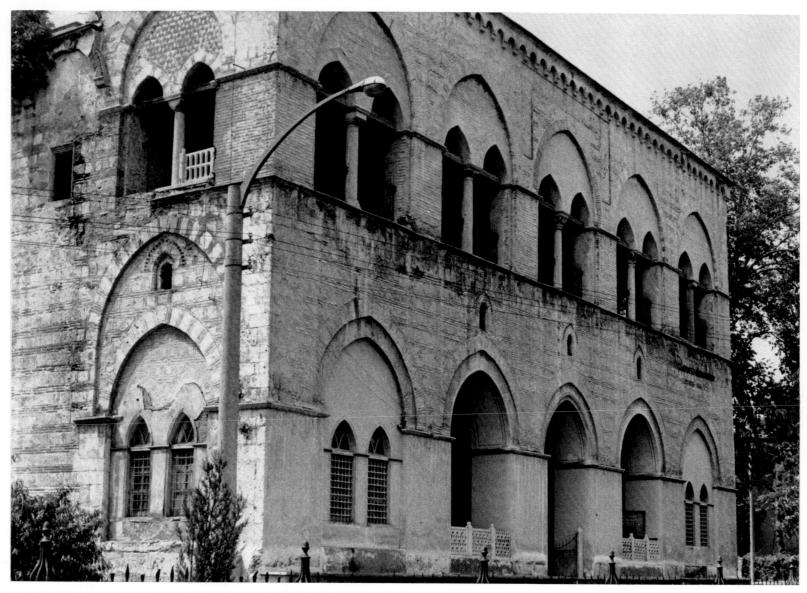

28. Bursa, Mosque-Medrese of Murad I: north facade; 1365–85.

those on the first floor open to the street. The arcaded porticos and gallery link the building with the Mediterranean tradition and give it a palatial appearance.

The core of the structure is made up of a deep rectangular space, divided into two sections by an arch and differentiated by floor levels and vaulting. A deep entrance leads to a vaulted area, similar to an *eyvan,* that opens into the first of the two sections. This section is two stories high and covered with a dome, which has an oculus over the central fountain. On the east-west axis two deep barrel-vaulted *eyvan*-like rooms are placed. Two smaller rooms, on each side of these *eyvans,* are also barrel-vaulted and accessible by means of narrow doors. A symmetrical balance is achieved by distributing the four rooms around the entrance passageway and the closed "courtyard." The second section of the deep rectangular space is a vaulted, slightly narrower and deeper room containing the mihrab. The floor level of this section is higher and reached by five steps. It also rises to the height of two stories. The mihrab is a deep niche that projects beyond the *kıble* wall and is almost a room in itself.

The interior is bright, but lacks the rich decoration of the Yeşil Cami. The zone

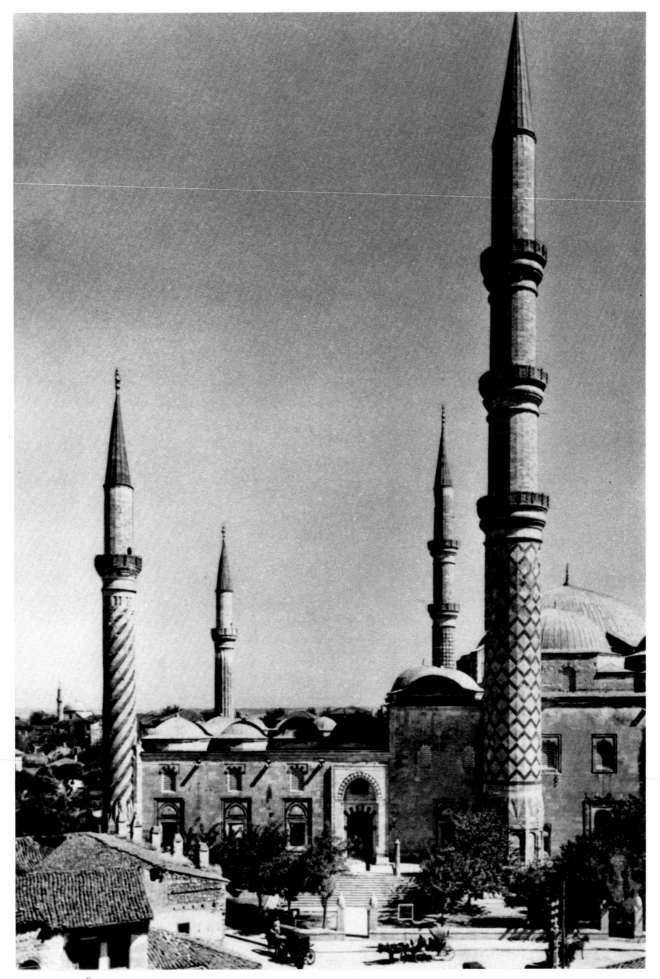

29. Edirne, Üç Şerefeli Cami: general view; 1430–47.

of transition under the dome consists of sober pendentives instead of the usual exuberant prismatic Turkish triangles. The second floor is reached by a double staircase on either side of the entrance. Between the two staircases is a large vaulted room that spans the portico of the second floor. The remaining rooms, or cells, are all barrel-vaulted and are arranged along side walls. These cells open to a corridor that surrounds the perimeter of the domed "courtyard." The *medrese* cells do not extend to the mihrab area, but a narrow corridor circumambulates the vault. A single-domed room is placed directly over the projecting mihrab. The purpose of the room is not very clear, but, because of its honorific place over the mihrab and its isolation, it could have served as a meditation area.

The mosque-*medrese* of Murad I is an example of the type of experimentation that took place during the transitional period in Anatolia. It is not too successful, as the plan is unsuitable for the multiple functions of the building; the units within the structure are not well integrated or balanced. Nevertheless, in later Ottoman architecture we frequently find the mosque and *medrese* adjacent to each other and around the same courtyard.

ARCHITECTURE OF EDIRNE

The city of Edirne (old Adrianople) was chosen as the third capital of the Ottomans (İznik and Bursa being the first two). By this time the Ottoman principality was no longer bound to Anatolia, as the campaigns carried out in the Balkans had been successful in the incorporation of additional provinces. The Ottomans were no longer a small Anatolian power, and it was appropriate that their center also should be moved to the west. The architectural developments following this change show an expansion in the proportions of buildings. The evolution is marked and decisive, in terms of a single unified space, as opposed to divided smaller units. The best example that achieves a unified space within the peripheral outer walls is the mosque built by Murad II in 1430–47 at Edirne, called the Üç Şerefeli (Three-Balconied, referring to the balconies of the minarets).

The Üç Şerefeli Cami, one of the largest early Ottoman structures built prior to the conquest of Constantinople, is stylistically closer to the sixteenth- and seventeenth-century imperial mosques of İstanbul than to the Bursa edifices. The Üç Şerefeli has an open, narrow rectangular courtyard with an even narrower, enclosed part. Because the mosque is built on a platform, high staircases proceed up to the three portals; two lead into the court, and the third opens directly into the mosque. Four minarets, placed at the corners of the courtyard, emphasize the verticality of the structure in opposition to the horizontal spread of the mass and serve as compositional devices framing the open courtyard. The courtyard is paved with marble and has a low fountain in the center. The rhythm provided by the pointed arches of the arcading that encircles the court is echoed by the domes of the *revaks* (arcades) on three sides and of the *son cemaat yeri* in front of the mosque. Integrated with the *revaks* of the court, the portico utilizes the same architectural units and can no longer be viewed as an architecturally separate element. This scheme is repeated in classical Ottoman architecture.

The interior of the mosque comes as a surprise to the visitor. The shallow space is loosely divided into three aisles leading toward the *kıble* wall. The partitions between the aisles are no longer rows of columns but two massive hexagonal piers. These two piers, with pilasters jutting to the south and north, carry the large dome, which dominates the interior space. The dome is of an enormous span (twenty-four meters

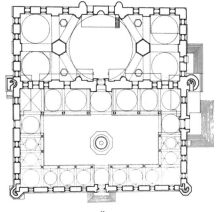

30. Edirne, Üç Şerefeli Cami: plan; 1430–47.

plate 6 (p. 68); ills. 29–31

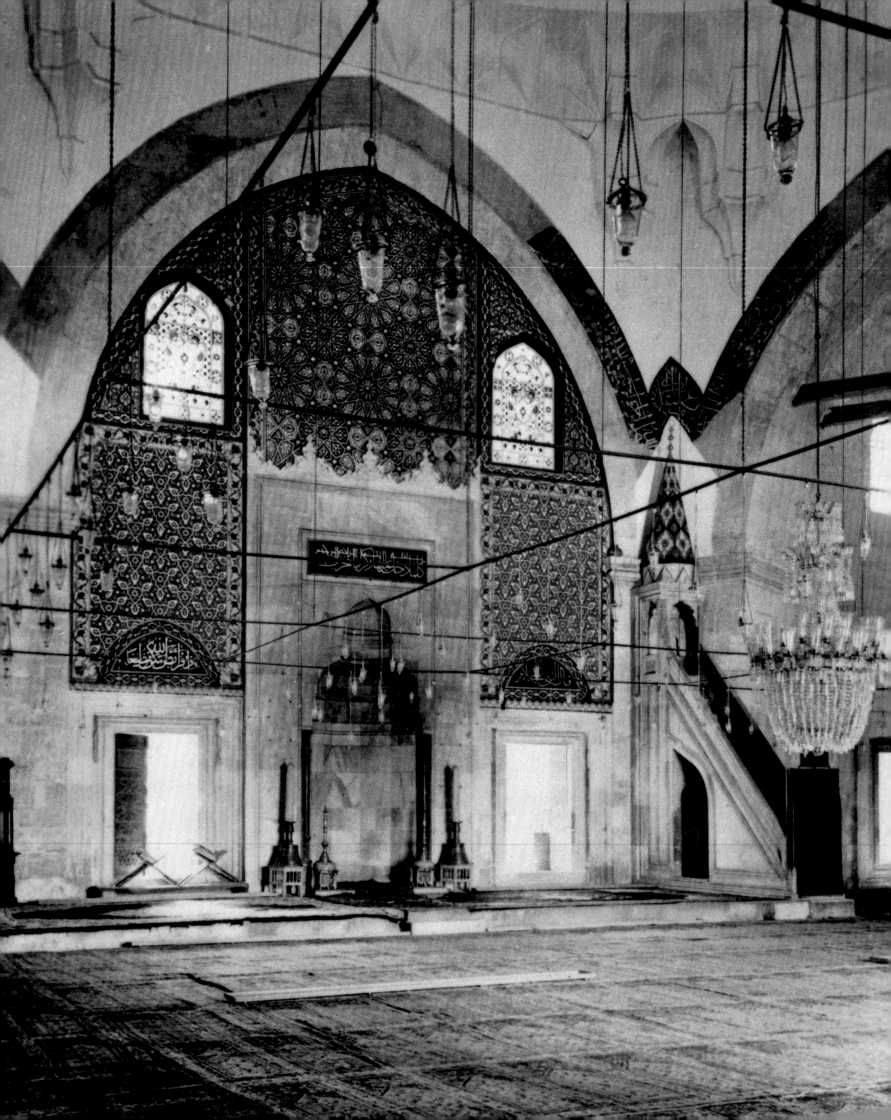

in diameter) and is the highest point in the composition of the mosque, except for the minarets. Internally, the dome covers the central space and incorporates the mihrab, which is no longer the focal object. Thus, a spatial unity is accomplished at the expense of the mihrab. Since the dome spans a rectangular space, its zone of transition is of particular interest. The four corners of the rectangle as they merge into a square are filled in with a combination of squinch and pendentive. The half-domes of the squinches have become full-fledged miniature domes. Each of the lateral aisles is divided into two small bays and covered with low domes. The hexagonal piers obstruct the view of the mihrab from the side aisles, and the diversity in vaulting prevents the large dome from being fully appreciated. However, there is an obvious attempt to achieve a large and uninterrupted unified space under a dominant dome. This creation of a single and large space under a dome is the outstanding achievement of Ottoman architecture. The trend from divided multiunit interior space to a spatially unified one is clearly seen in the Üç Şerefeli Cami.

On the exterior of the mosque, the dome provides the mode for the superstructure. A crescendo of domes—starting from the smaller ones of the northern *revak,* passing to the higher domes of the portico, and finally reaching the single large dome of the mosque—will be repeated in most of the imperial mosques. The division between the mosque and its courtyard is clearly expressed on the exterior. As the domes rise and fall, they reflect the relative positions of various segments within the mosque.

The Üç Şerefeli Cami is a part of a large complex of related buildings all built by Murad II: a *medrese,* an imaret, and a *dar ül-hadis* (a school for teaching the Traditions).

Imperial Ottoman Architecture: 1450–1900

The conquest of Constantinople and the move of the capital to this city terminated the era of the emirates and commenced the imperial Ottoman age.[26] The new seat of power was called İstanbul, in the center of the vast empire that stretched from Iran to Hungary. Selim I added the title *halife* (caliph) in 1517 to his string of honorifics, after his conquest of Egypt, where he appropriated the symbols of the caliphate from the Mamluks. The Ottoman ruler had become the protector of Islam, its *padişah,* the sultan. He was the center, the foundation of the empire, and as such he was the foremost patron of the arts. He resided in his palace amidst complex ceremonies and formalized audiences with his administration and his subjects. Extensive palace grounds were laid out to secure his privacy in the heart of İstanbul, built on the remains of old Byzantium.

The Islamic ideology on which Ottoman private and public life was based also changed after 1453. The balance between the popular Islam represented by the *tarikat* and the formalized Islam advocated by the ulema soon tipped to favor the latter. One of the repercussions of this shift in power was the forced settlement of heterodox nomads and the movement of the Shiites to eastern Anatolia and Iran.

The power of the Ottoman sultan was replicated in architecture. The sultan, as the most munificent patron, no longer sponsored single or scattered buildings but mammoth *külliyes,* composed of a central mosque and its charitable, educational, and pious buildings in the best location in İstanbul and in the provincial capitals. The gathering of so many buildings fulfilling various functions within one enclosure was a symbolic expression of the power of the sultan who ruled a vast array of ethnically distinct subjects and presided over a highly specialized administrative bureaucracy.

31. *Left*: Edirne, Üç Şerefeli Cami: interior view showing the mihrab area; 1430–47.

The governors of provinces, districts, and cities were also patrons of architecture. Their undertakings, although on a more modest scale, often duplicated the layouts of royal *külliyes*. Moreover, the architectural style developed in the Ottoman capital made its way to the most remote corners of the empire. An Ottoman building, irrespective of its patronage, is recognizable as an Ottoman building. Whether in Buda or in Cairo, an Ottoman structure has closer architectural connections with its İstanbul counterparts than with local buildings. The conquest of Constantinople, then, is the turning point in the architectural history of the Ottomans.

THE EARLY YEARS

Soon after the completion of the Üç Şerefeli Cami on the European lands of the Ottoman state, the city of İstanbul finally fell to the Turks. The conversion of the old Byzantine capital into an Islamic city marks the beginning of the imperial phase in Ottoman architecture.

After the conquest of İstanbul the cathedral of the former Christian state, the Aya Sofya (Hagia Sophia) built by Justinian between 532 and 535, was at once converted into an imperial Friday mosque to serve the religion of its new masters, and it

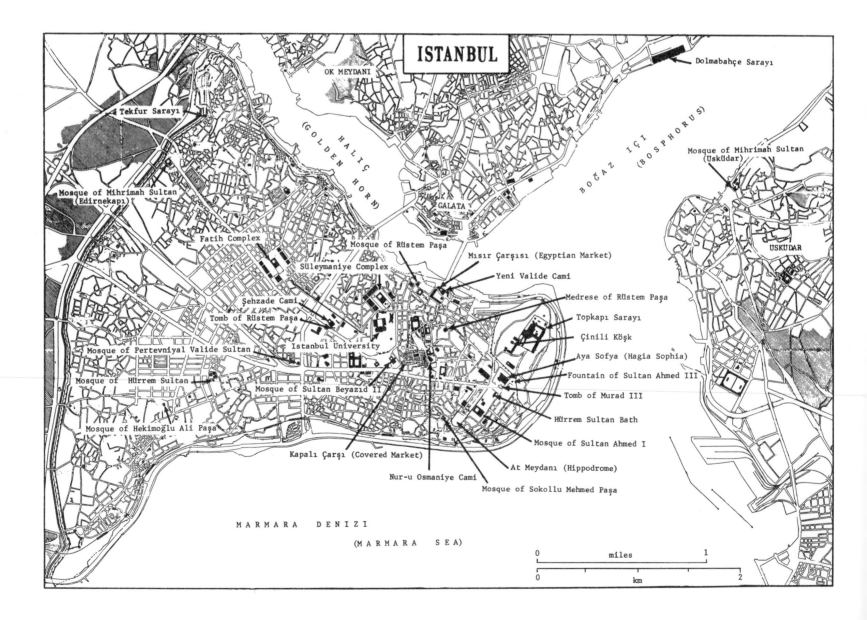

became an important model for mosque architecture, partly due to its symbolic association with the triumph of Islam. It came to be seen as an almost miraculous architectural achievement in terms of monumentality, space, and form, and kindled the technical and artistic imagination of generations of Ottoman architects.[27] The Aya Sofya was the pinnacle of the architectural tradition that the Ottomans had inherited in north-western Anatolia.

In order to use the Aya Sofya as a mosque, drastic changes were not necessary. Figural mosaics were whitewashed, icons and other signs of the Christian church and Byzantium were removed, and finally a small mihrab niche was built at an angle toward Mecca within the enormous apse. Later, minarets were added. The architectural shell—that magnificent technical and artistic achievement—was left intact.

The earliest Ottoman palace, which is no longer in existence, was built at a distance from the Aya Sofya, but soon the former Greco-Roman and Byzantine acropolis of the city was chosen as the new site. This site, on a peninsula overlooking the Golden Horn, the Bosporus, and the Marmara Sea, contains the Aya Sofya as well as several other Byzantine buildings, such as the Church of Aya Irene, which was converted into the Royal Mint. The Ottoman masters fully appreciated the significance of the city and attempted to recreate and surpass its glorious past.

The palace started by Mehmed II continued to be the seat of the Ottoman sultanate until the mid-nineteenth century. However, not many of the palace buildings built during his reign have survived. Among those surviving are the buildings known as the Hazine (Treasury), located almost at the tip of the peninsula, and the Çinili Köşk (Tiled Kiosk) at the other end of the complex. Judging from these two buildings set at opposite ends of the palace grounds, the future growth of the Topkapı Sarayı (Palace) must have been envisioned in the middle of the fifteenth century.

The grounds of the Topkapı Sarayı are arranged as a system of adjoining courtyards. Passages from one court to the next are well marked by gates, and the courts are separated by means of walls or arcades. As one proceeds from the outside to the innermost court, the sequence of ceremonial gates marks the transition from the public areas to the Harem or private area. In the public areas, the buildings are arranged formally behind arcades encircling the courtyards. In the more private and informal locations of the palace, or in the residential sections, we find a cluster of buildings, individual köşks, or pleasure pavilions, surrounded by gardens and set on sites with magnificent views. The Topkapı Sarayı differs from contemporary Western palatial structures, which are set in the midst of cities and are part of the cityscape; but it adheres to the Islamic-Oriental traditions in which clusters of apartments and individual buildings are scattered over vast expanses of adjoining courtyards, removed from the center of the urban life. The ruler does not reside in the populated areas with his subjects but is removed by several stages to the privacy of his palace-city.

The Hazine, which served as the repository of ceremonial and religious objects for the Ottoman state, was set on a high platform commanding a magnificent view. It was designed by Mehmed II as an apartment of four rooms on the same axis over a basement; a pair of adjoining rooms are domed with windows that open on three tiers while the next two are lower and flat-roofed. The room at the western end is more like a hayat (loggia), its two sides opening to the landscape through double arches. These domed or vaulted chambers, united externally by means of an arcaded porch, set the model for future structures in the Topkapı Sarayı.

The Çinili Köşk, closer to the gate leading to the city, has a more formal and

ills. 32, 33

ills. 34, 35

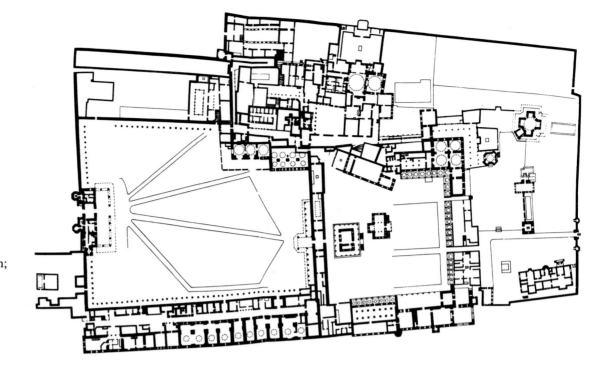

32. İstanbul, Topkapı Sarayı: plan;
1468 to nineteenth century.

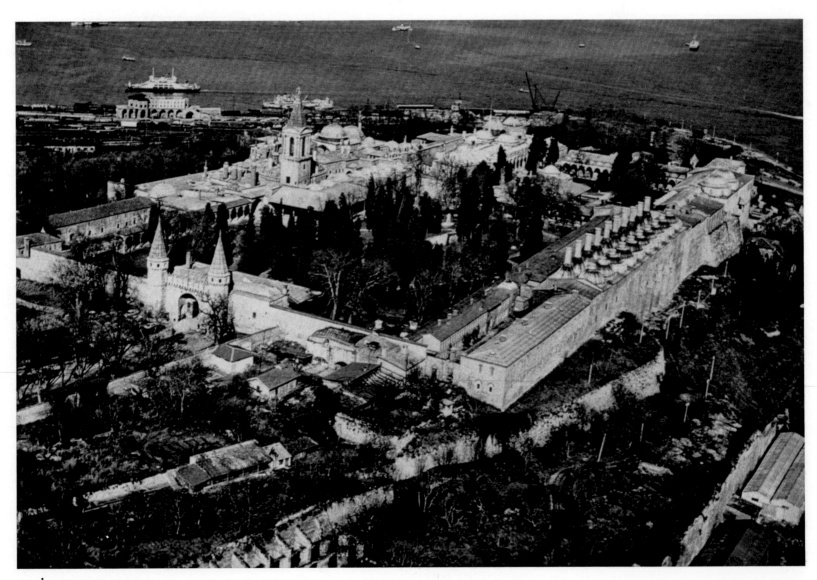

33. İstanbul, Topkapı Sarayı: aerial view; 1468 to nineteenth century.

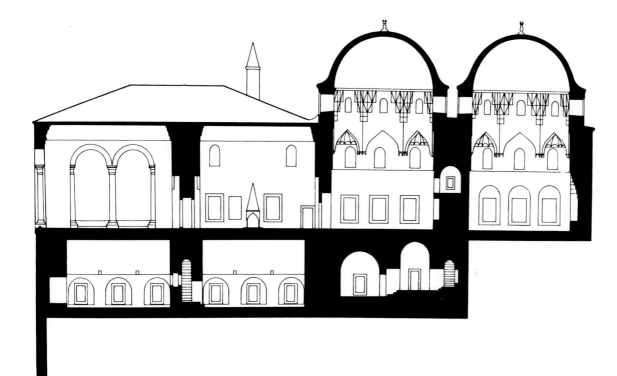

34. İstanbul, Topkapı Sarayı,
Hazine: elevation; 1468.

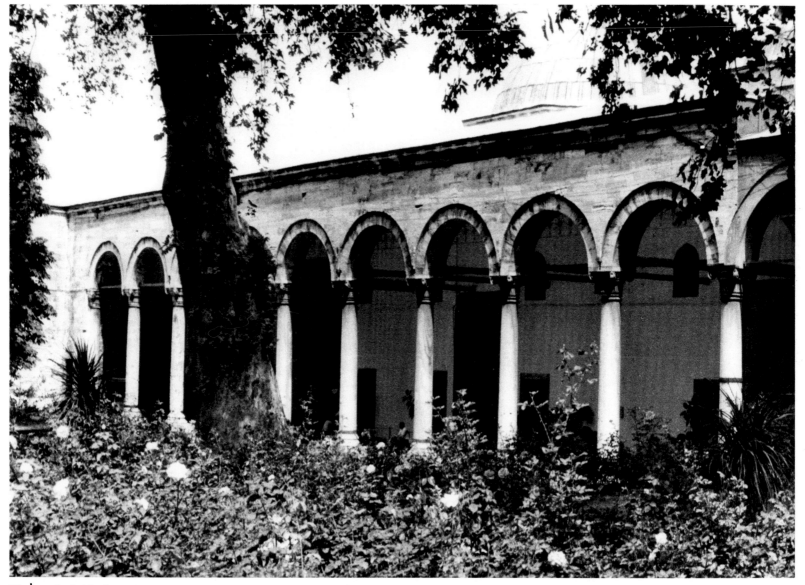

35. İstanbul, Topkapı Sarayı, Hazine: portico; 1468.

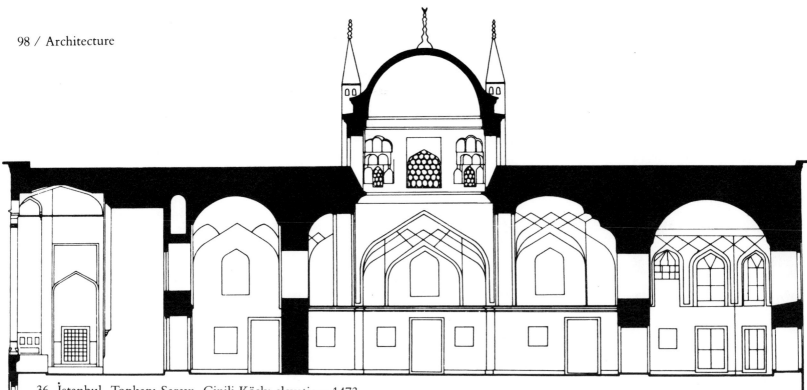

36. İstanbul, Topkapı Sarayı, Çinili Köşk: elevation; 1473.

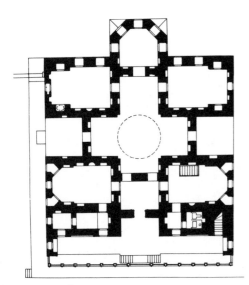

37. İstanbul, Topkapı Sarayı,
Çinili Köşk: plan; 1473.

grandiose appearance. Its plan is closer to Iranian palaces, and it is likely that the *köşk* follows a type of palatial structure adapted from Iranian models familiar to the Seljuk or Türkmen princes. The *köşk* is a single-storied square building on a high base. A double staircase leads to the porch, which has fourteen multifaceted stone columns bearing narrow pointed arches. The entrance proper is a deep arch faced with tiles. Tiles appear on the facade as well as on the sides of the building. The plan shows four *eyvans* opening onto a central court, forming a cross; the center of the cross is domed while the arms are vaulted. Opposite the entrance is a room projecting beyond the building and overlooking the gardens. Situated at the end of the cross, it is reminiscent of the throne room in the Near Eastern palaces and contains a *hayat*.

The Çinili Köşk is well illuminated from multiple windows on all sides. The rooms contain cupboards and fireplaces and are designed for comfort. Unlike the four large rooms of the Hazine, the space in the *köşk* is more intimate.

Mehmed II, the conquerer of Constantinople, or Fatih as he is known in Turkish history, sponsored a large number of buildings in various parts of the Ottoman Empire. Among his works are some 300 mosques; 50 *medreses*; 59 *hamams*; and various palaces, forts, bridges, hans, and caravansarays.[28] His most important undertaking was an enormous mosque complex in İstanbul, donated between 1463 and 1470.

An organized complex of buildings—such as schools, hostels, and tombs arranged around a mosque—existed in Islamic Anatolia, especially in Bursa and Edirne before the establishment of the capital in İstanbul. However, the complex dedicated by Fatih Sultan Mehmed in İstanbul is the first of grandiose dimensions, organized within a rectangular enclosure of roughly 330 by 200 meters. The enclosure is set on one of the many hills of the city and covers an area rich with relics from the Byzantine period. The mosque, which dominated the complex, was destroyed during an earthquake in 1765 and was later rebuilt, deviating from the original plan. *Medreses,* hospital, caravansaray, and baths are found at the two short ends of the enclosure with the mosque in the center separated from the dependencies by an enormous square court of approximately one

ill. 39

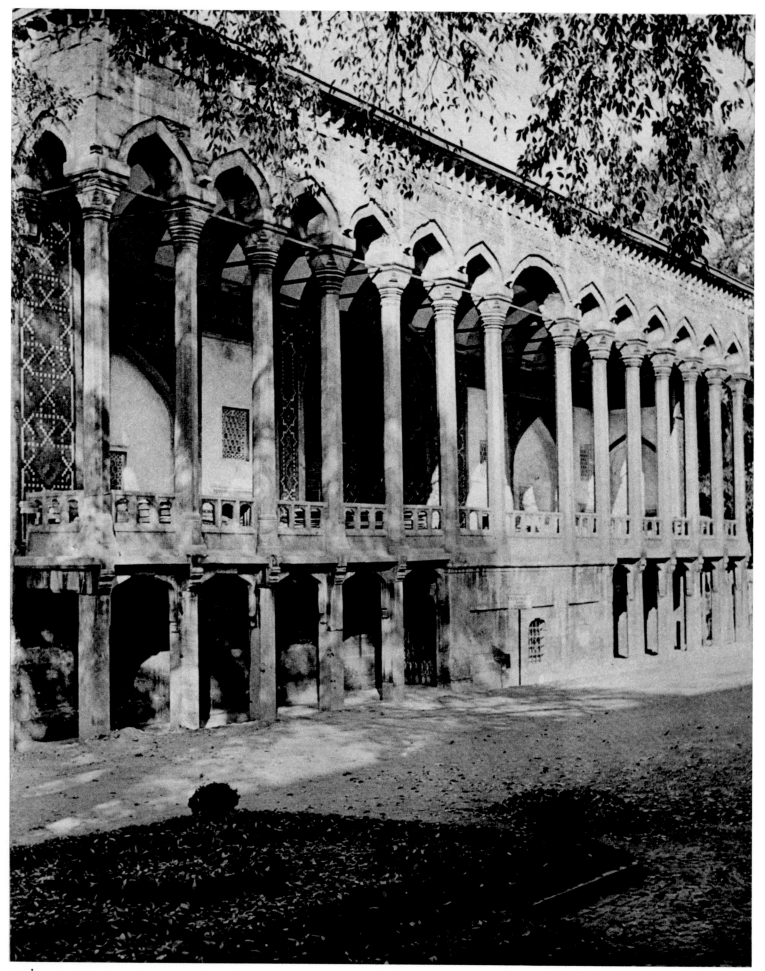

38. İstanbul, Topkapı Sarayı, Çinili Köşk: facade; 1473.

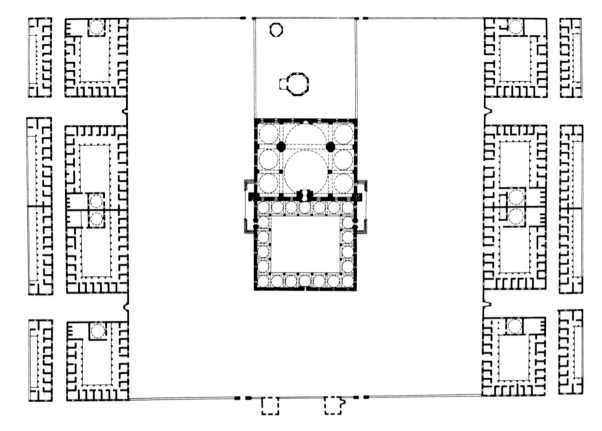

39. İstanbul, Fatih Complex: plan; 1463–70. Architect: Sinan-ı Atik.

hundred meters to a side. This court is not paved but planted. The present mosque rises on a platform in the center.

Complete symmetry rules the arrangement of the buildings; one end of the immense court is a mirror image of the other. The dependencies of the mosque, whether an imaret or a *medrese,* all share the same characteristic plan with cells arranged around an arcaded courtyard and a large domed room that has replaced the main *eyvan.* This all-purpose building retains a low profile with horizontal lines. The focal point of this tranquil and rather static arrangement is the dome of the mosque, and the doorway leading from the courtyard to the mosque is the absolute center of the complex. This layout was to be elaborated upon by the greatest architect of Turkish history, Sinan, who built a mosque not far from the Fatih Külliye for the most illustrious sultan of the Ottoman Empire, Süleyman the Magnificent.[29]

With the Fatih Külliye, the first mosque and its dependencies established in the imperial city of İstanbul, Ottoman architects seemed to have found a solution for the needs of the prayer hall, the *medrese,* and similarly utilized structures. After the late fifteenth century, Ottoman architecture was preoccupied not with new expressions and innovations in spatial concepts or radical changes between mass and proportion, but with the perfection of the existing architectural forms. Radical changes did not come to the fabric of Ottoman society until the nineteenth century. The imperial age of Ottoman architecture should not be credited for experimentation but for achieving great structural and ornamental clarity.

ills. 40, 41 Since the original mosque of Mehmed II was destroyed, the earliest surviving imperial mosque in İstanbul belongs to Beyazıd II. The Mosque of Beyazıd II is the center of an extensive complex, built on a hill neighboring the Old Palace, the first residence of the Ottoman sultans. The Mosque of Beyazıd II, dated 1500–1505, is remarkable in the fact that it repeats the plan and the vaulting system of the Aya Sofya, although

the spatial effect is totally different. The philosophical and ritualistic differences between the two religions affect the utilization of the architectural forms. Like the ground plan of the Aya Sofya, the Mosque of Beyazıd II is partitioned into three aisles with the central one twice as wide as those at the sides. As in the former church, the central aisle is covered by a large dome, flanked by two half-domes, but the side aisles have four domes instead of the vaults seen in the Aya Sofya. In the church the axis is toward the focal point, the apse, and is emphasized through the "lacework" curtain walls of pillars and columns that separate the nave from the side aisles. This horizontal axis is challenged and to some degree impaired by the forceful uplift of the enormous dome. The basilical scheme and the centralized power of the dome are not reconciled and remain disunified.

On the other hand, in the Mosque of Beyazıd II, the architect Yakub Şah bin Sultan Şah attempted a spatial unification of the interior by minimizing the partitions. The superstructure creates a natural movement toward the mihrab, but the shallow, almost two-dimensional niche of the marble mihrab bounces this movement back toward the center, to the dome. The central dome, resting on four large piers, flows into the smaller ones and then onto the walls. No obstructions are present, and the eye does not linger on any architectural unit other than the dome.

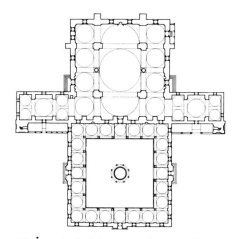

40. İstanbul, Mosque of Beyazıd II: plan; 1500–1505. Architect: Yakub Şah bin Sultan Şah.

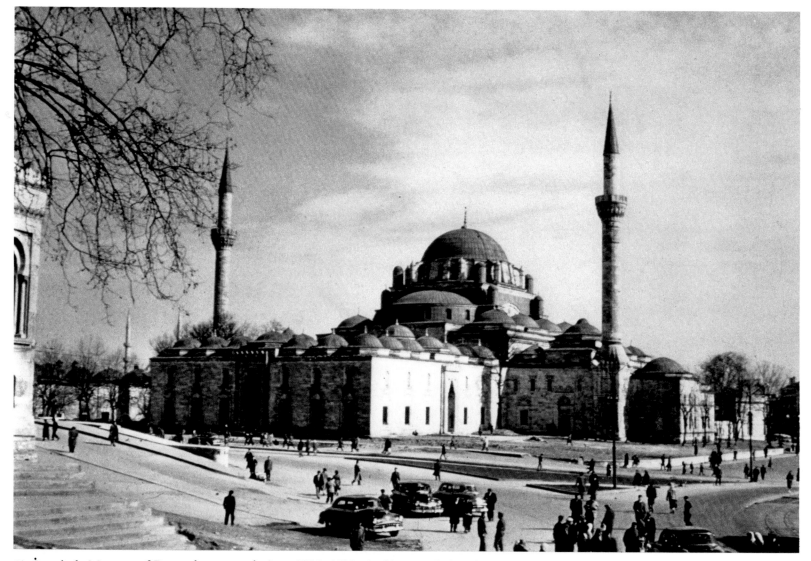

41. İstanbul, Mosque of Beyazıd II: general view; 1500–1505. Architect: Yakub Şah bin Sultan Şah.

The clarity of forms, the openness and comprehensibility of spatial relationships and architectural units seen inside, are also visible on the exterior. For instance, the heavy piers on which the dome rests are articulated from the outside by means of four turrets, and the buttresses of the dome are not disguised. The structure is constructed in carefully cut stone, not combined with brick as in the case of the Aya Sofya. The interior walls are covered with plaster and painted, thereby softening the somberness of the stone.

The Seljuk system of *vakıf*, or maintenance of religious buildings, continued in the Ottoman period. Proceeds from baths or rents from a group of shops and hans provided the income for religious, nonprofit buildings. Two hans were built by Beyazıd II in İstanbul to support the maintenance of his mosque.

THE CLASSICAL PERIOD

The greatest architect in the history of Turkish art was Sinan. He was born most probably of Greek parents around 1489–90 in Kayseri, a central Anatolian provincial capital.[30] In 1512 he was conscripted as a *devşirme* and despite his advanced age joined the Janissary corps, probably admitted because of his extraordinary talents and training as a builder. He joined many campaigns and built or repaired bridges for the army before he was appointed royal architect. Three hundred and four monuments scattered throughout the Ottoman Empire have been attributed to him, according to lists and laudatory writings drawn up after his death in 1588. Most of his career was under the protection and patronage of the greatest Ottoman sultan, Süleyman I. For the sultan's wife, daughter, sons, and vezirs he designed structures in İstanbul that are masterpieces of architecture. For Selim II, the heir of Süleyman, Sinan built his greatest monument, the Selimiye Mosque in Edirne.[31]

Sinan was by no means a revolutionary architect who changed the course of Ottoman architecture. Instead, his work marks the highest point in the evolution of the Ottoman mosques, which are built in accordance with their environment, often making the utmost of the landscape in order to create a civic center. The site and the building seem to grow and blend together, neither overpowering the other. The size and the silhouette of the structures are adapted to their location, and the buildings with many windows are open to their surroundings.

During this period, the highest point of the Ottoman Empire, the clients of Sinan were powerful and demanding. In all the complexes he designed in İstanbul for the various members of the Ottoman dynasty, the mosque continued to be the spiritual and physical center dominating the dependent structures. Sinan's works are a study in dome construction, the organization of the space below the dome, and the relationship between the volume of the dome and its enveloping structural parts. His primary concern was to create the most perfect and unified space under the dome through the unification of individual elements into an indivisible whole with each unit retaining its clarity. From the interior and exterior every part and its relationship to the whole are easily visible and clearly understood. In this sense, the monuments of Sinan highlight the classical period of Ottoman architecture. The plans or elevations of his works are uniquely thought out; each building, whether a mosque or a *medrese*, is intentionally different.

One of Sinan's earliest undertakings in İstanbul was for the remarkable wife of Süleyman, Haseki Hürrem Sultan, known in the West as Roxelana. The fact that Hür-

rem Sultan could and did sponsor buildings while her husband was still alive is highly unusual.[32] It is also remarkable that in the capital of the Ottomans the first large complex by an up-and-coming architect was commissioned by a woman. Nevertheless, the complex built by Sinan in 1539 for Hürrem Sultan is not an outstanding group of buildings. The site is quite remote from the center of the city, and the complex does not follow a unified plan. For example, a street separates the hospital and the *medrese* from the mosque, primary school, fountain, and imaret. The mosque is a simple single-domed unit preceded by a five-domed portico; the *medrese* cells are organized in a U-shape around an open courtyard. The hospital, built behind the *medrese*, has a rectangular courtyard, surrounded by rooms.

In 1553 Sinan built for Hürrem Sultan a *hamam* that is the largest and most re-markable building of its kind. The bath, known as the Haseki Hamam, is a double structure serving men and women separately with respective entrances on opposite sides. The entrance to the men's section is more elaborate and contains an arcaded porch; otherwise, the two units are almost identical, and their plans follow the *hamam* layout used in Anatolia since Roman times.

ills. 42, 43

Upon entering the *hamam*, the visitor finds himself in the lofty cold-room, which is well lit with windows on side walls and a "lantern" window in the center of the dome. A small, narrow hall with three domes serves as the intermediary passage between the cold- and hot-rooms; latrines are located to the side of this unit. The hot-room is the most spectacular area with its small and low dome, studded with dozens of glass bowls sitting on a ring of eight columns. The area around the ring has four indentations transforming the ground plan into a cross. Between the arms of the cross there are small domed recesses for private use, while under the dome is a large public pool.

The long and narrow building, covered with alternating courses of brick and stone and two sizable domes over the cold-rooms, creates a dramatic silhouette. The Haseki Hamam, the mosque and its dependencies of Ahmed I (completed in 1616), the remains of the Hippodrome, the Aya Sofya, and the Topkapı Sarayı—these constitute the civic center in the heart of İstanbul. A considerable amount of the revenues from the *hamam* went to the maintenance of the mosque-complex of Hürrem Sultan. Sinan was also commissioned by her to build caravansarays, bridges, and other buildings in small towns between İstanbul and Edirne.

The first monumental work of Sinan is the Şehzade Cami (Mosque of the Crown Prince) in İstanbul. The complex, ordered by Süleyman I to commemorate the death of his son Şehzade Mehmed was built between the years 1544 and 1548. The work, according to its creator, dates from his "apprentice" years and is a prelude to his larger works for the sultan.[33] The central building is the mosque, the tomb of the prince is on the south (the traditional place for a mausoleum adjoining a mosque), the imaret and *tabhane* are on the east, and the *medrese* is on the west, across the street. The subsidiary buildings retain their low profile and dependent status next to the dominating dome of the mosque. The two minarets, signs of royal patronage, add to the upward surge of the domical mass of the mosque.[34] Both the closed area for prayer and the courtyard are square in plan; the open area of the latter is reduced by the excessive depth of the surrounding arcade. The plan of the mosque reveals a cloverleaf arrangement: the central dome is flanked by four half-domes, which in turn are bordered by two smaller half-domes placed over the exedrae. The thrust of the dome is shared by the half-domes, supported by the four polygonal freestanding piers and the square pilasters abutting the side walls. The square corners of the mosque are topped with domes. The

plates 7, 8 (pp. 69–71)

ill. 44

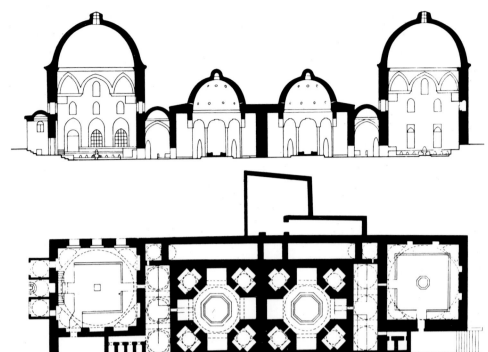

42. İstanbul, Hürrem Sultan Bath: plan and elevation; 1553–54. Architect: Sinan.

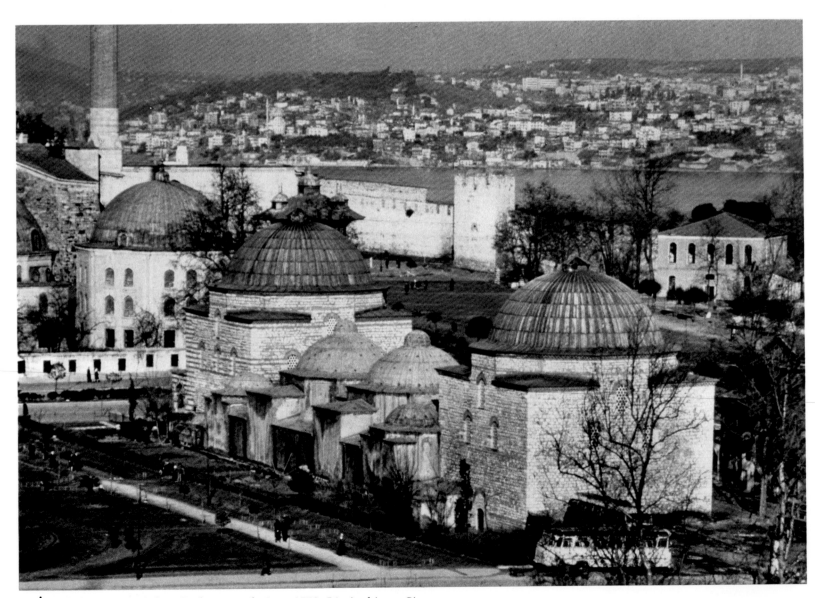

43. İstanbul, Hürrem Sultan Bath: general view; 1553–54. Architect: Sinan.

transition consists of pendentives for the major dome and *mukarnas* for the half-domes and minor domes.

The Şehzade Cami is a strongly centralized building emphasizing the circle within the square. Internal unity is achieved by removing the columns, which in the Mosque of Beyazıd II support the arches that separate the side aisles from the central space. In Sinan's building one cannot speak of "side aisles" or separate spatial areas within the mosque, as the rounded surfaces flow to all sides from the pinnacles of the central dome without any obstructions. The radiating arrangement of the domes is emphasized by the three portals on the cardinal points of the mosque and the mihrab niche in the middle of the fourth or *kıble* wall. The interior is flooded with light streaming in from double-tiered windows that are arranged in groups of threes as well as from those in the drum of the domes. The walls of the courtyard repeat the two-tiered window composition but are grouped in pairs.

The east and west walls of the mosque have an arcaded loggia, which fills the space between the stepped buttresses. The buttresses culminate in high turrets placed over the interior polygonal piers and counterbalance the thrust and the weight of the dome. The loggias consist of two lateral bays covered with domes. These domed loggias contribute to the rhythm and massing of the mosque and accelerate the upward motion of the rounded forms toward the central dome. They also soften the sudden rise of the walls to the cornice below the domed superstructure. Such lateral loggias, appearing in the major mosques of İstanbul, have ablution fountains, which draw the crowds away from the courtyard. The fountain or the pool inside the court becomes symbolic of earlier *şadırvans* (ablution fountains) and a compositional device. The horizontal groupings of the domes and windows create a force interrupting the spherical mass of the mosque, particularly noticeable when compared with the later works of Sinan, such as the Süleymaniye Mosque. The Şehzade Mosque is an outstanding work by Sinan in the years before he reached the summit of his experience and ability.

In the same year Sinan was given the job of building another mosque-complex, this time for Mihrimah Sultan, the beloved daughter of Süleyman, who was later buried beside her father in the same mausoleum. The site for the mosque-complex of the princess, like the one given to her mother, is far from the center of the city, on the Asian shores of the Bosporus at Üsküdar. Since the plot is narrow and abuts a steep hill, the architect raised the mosque on a platform above sea level. The plan consists of a central dome flanked by three half-domes. Although the side facing the Bosporus lacks a dome, it displays a strong verticality leading toward the apex of the central dome. The omission of the usual courtyard, dictated by the restriction of space, is compensated for by a double portico and a rather impressive fountain. The inner porch has the customary multiple arcading, but the outer one is covered with a steeply sloping roof. The Mosque of Mihrimah Sultan is imposing from the exterior and despite the limitations of the site achieves monumentality. The architect successfully overcame the problem of creating a conventional building in an unconventional location.

Sinan was commissioned to build for the same princess a second mosque, which is equally successful in solving the problems caused by the location. This mosque—part of a complex containing a *medrese*, tomb, *hamam*, and shops—is immediately inside the city walls at Edirnekapı, in a locale rather remote from the city center. The structure lacks a date but is probably later than the Üsküdar edifice completed in 1548. The Mosque of Mihrimah Sultan in Üsküdar was probably built by Süleyman for his daughter, as it has the royal two minarets. Since the Edirnekapı mosque has only one

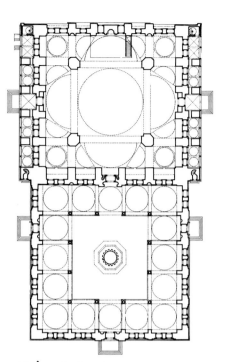

44. İstanbul, Şehzade Cami: plan; 1544–48. Architect: Sinan.

ill. 45

ills. 46, 47

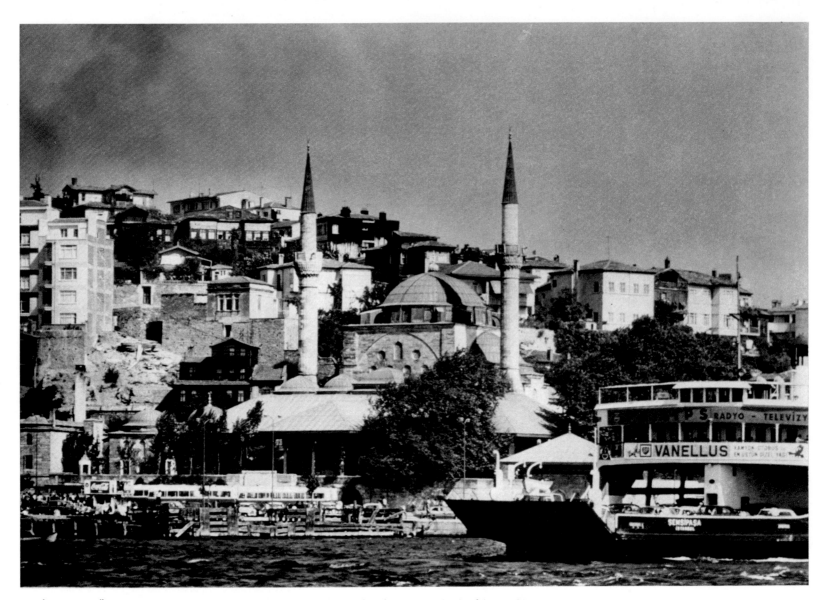

45. İstanbul (Üsküdar), Mosque of Mihrimah Sultan: south facade; 1544–48. Architect: Sinan.

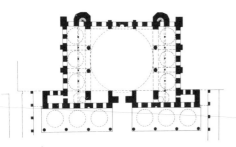

46. İstanbul (Edirnekapı), Mosque of Mihrimah Sultan: plan; ca. 1550. Architect: Sinan.

ill. 48

47. *Right*: İstanbul (Edirnekapı), Mosque of Mihrimah Sultan: general view; ca. 1550. Architect: Sinan.

minaret rather than two, it is safe to say that Mihrimah herself ordered the construction. The Edirnekapı mosque is also on a high artificial platform and not overwhelmed by the Byzantine walls or the low ground level. The platform on which the mosque stands is approached on three sides by stairways. The approaches are made particularly attractive by landings for viewing the city, small *köşks* for resting, vaulted passages, and double gates. Seen from the platform, the limited size of the courtyard is disguised by trees and shrubbery. The *medrese* with seventeen rooms is placed behind the arcading around the courtyard-garden combination. Thus, not wishing to sacrifice the *medrese*, Sinan organized the courtyard to serve dual purposes, an arrangement quite rare in Ottoman architecture.

The interior of the mosque is perhaps more lofty and bright than any mosque in İstanbul. By transferring the weight of the dome to the thick arches, the architect was able to reduce the walls to a screen on which he could open rectangular and round windows. As the famous seventeenth-century writer Evliya Çelebi noted, the mosque recalls a festive place, more like a *kasır* or palace.[35] The plasticity of the cube, the bulk of the round dome, and the accentuated arches framing the depressed curtain walls

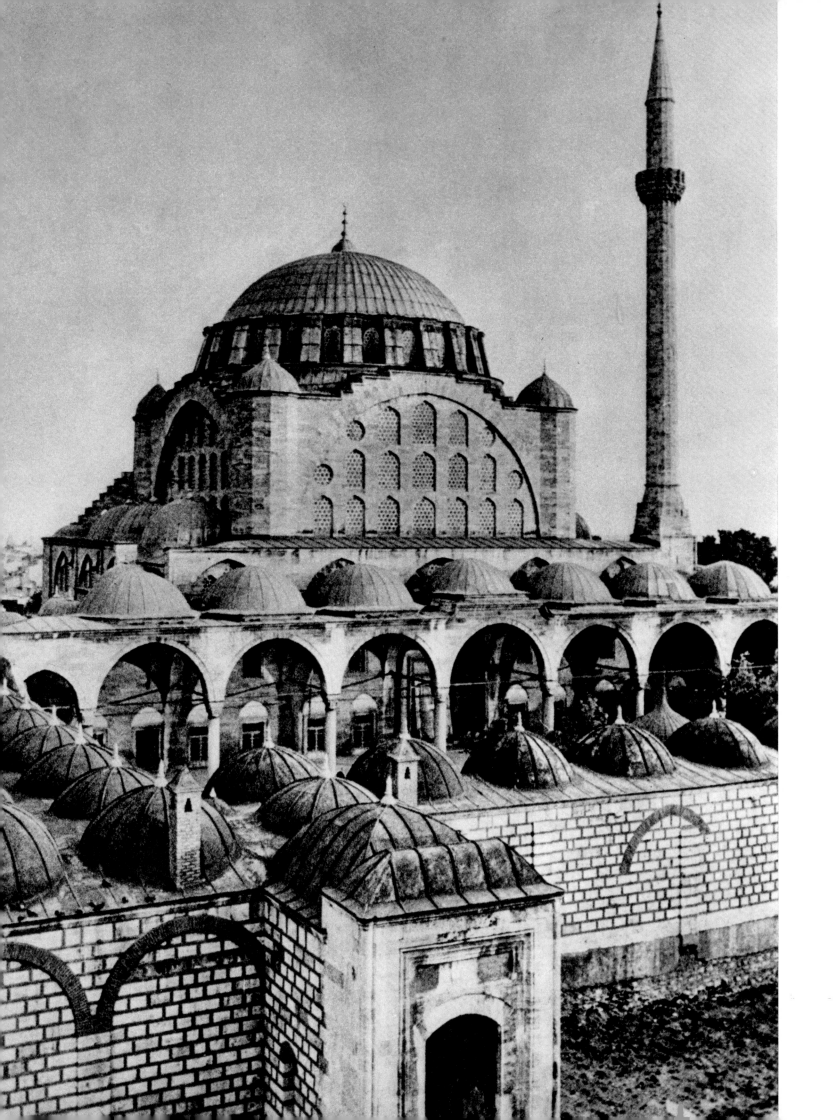

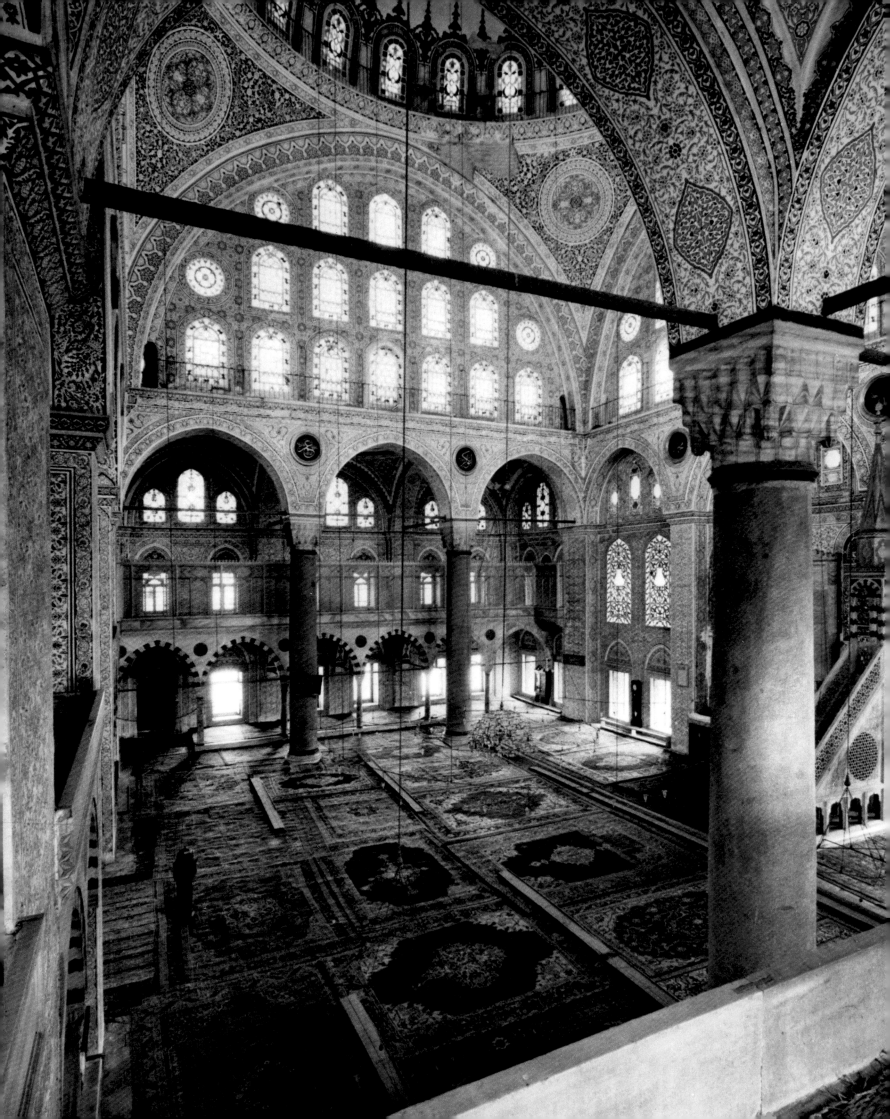

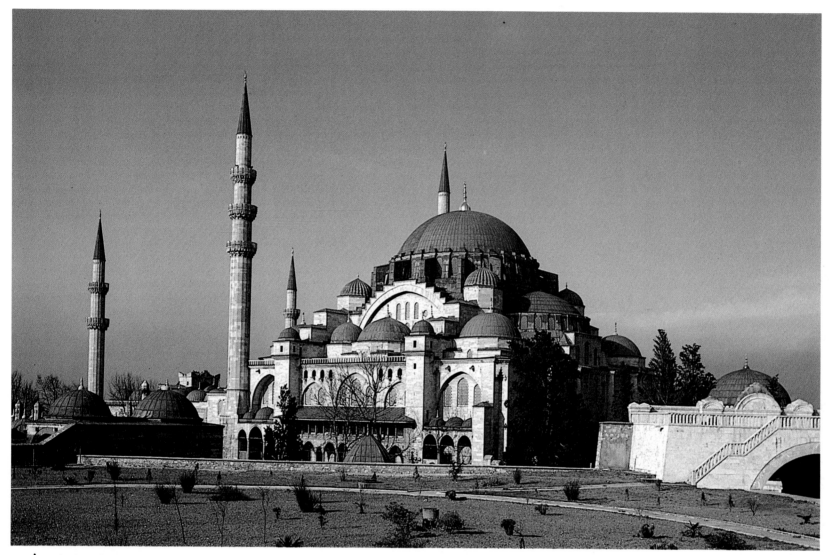

10. İstanbul, Süleymaniye Cami: general view; 1550–57. Architect: Sinan.

48. *Left:* İstanbul (Edirnekapı), Mosque of Mihrimah Sultan: interior view; ca. 1550. Architect: Sinan.

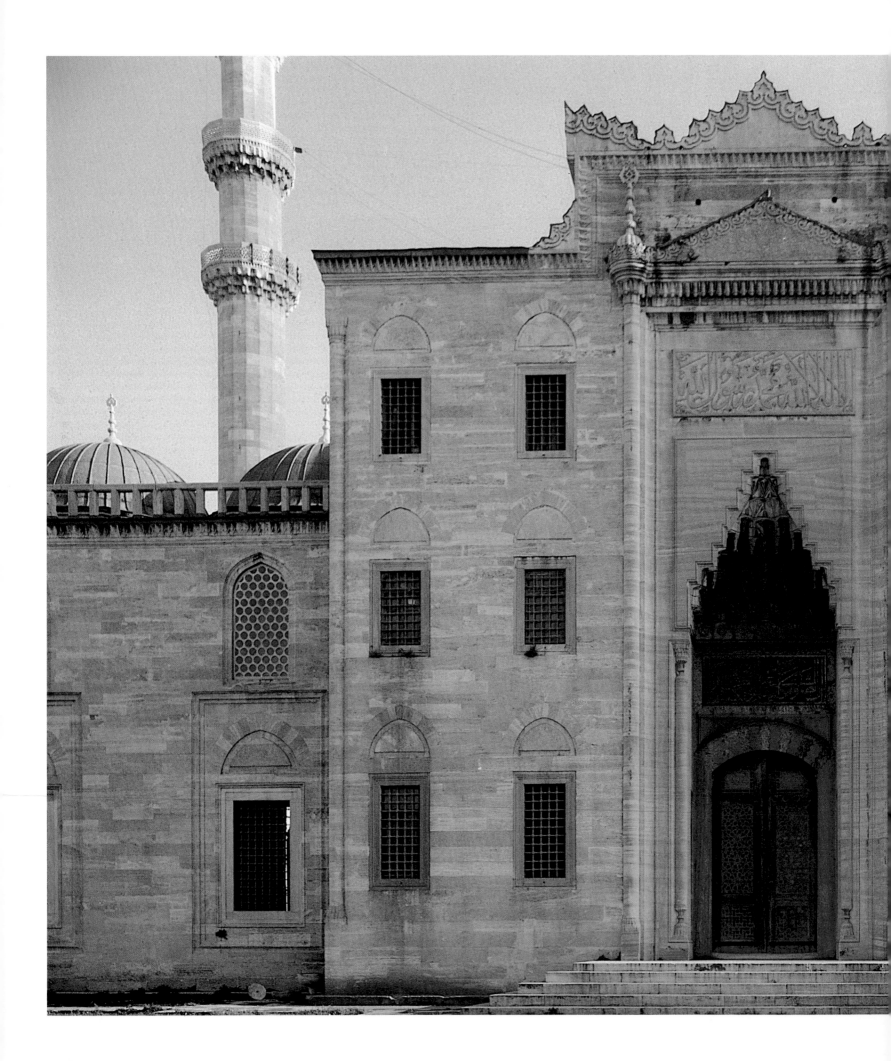

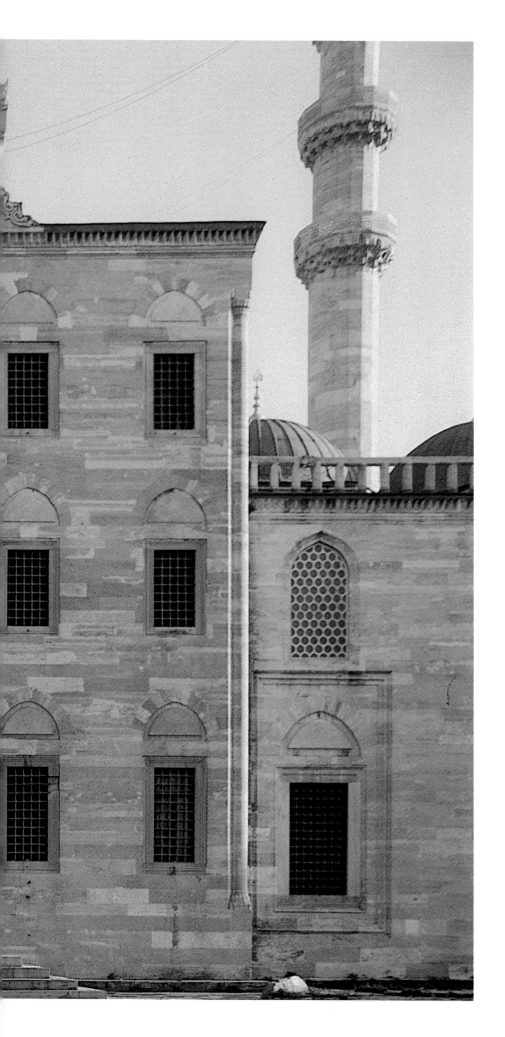

11. İstanbul, Süleymaniye Cami: entrance facade;
1550–57. Architect: Sinan.

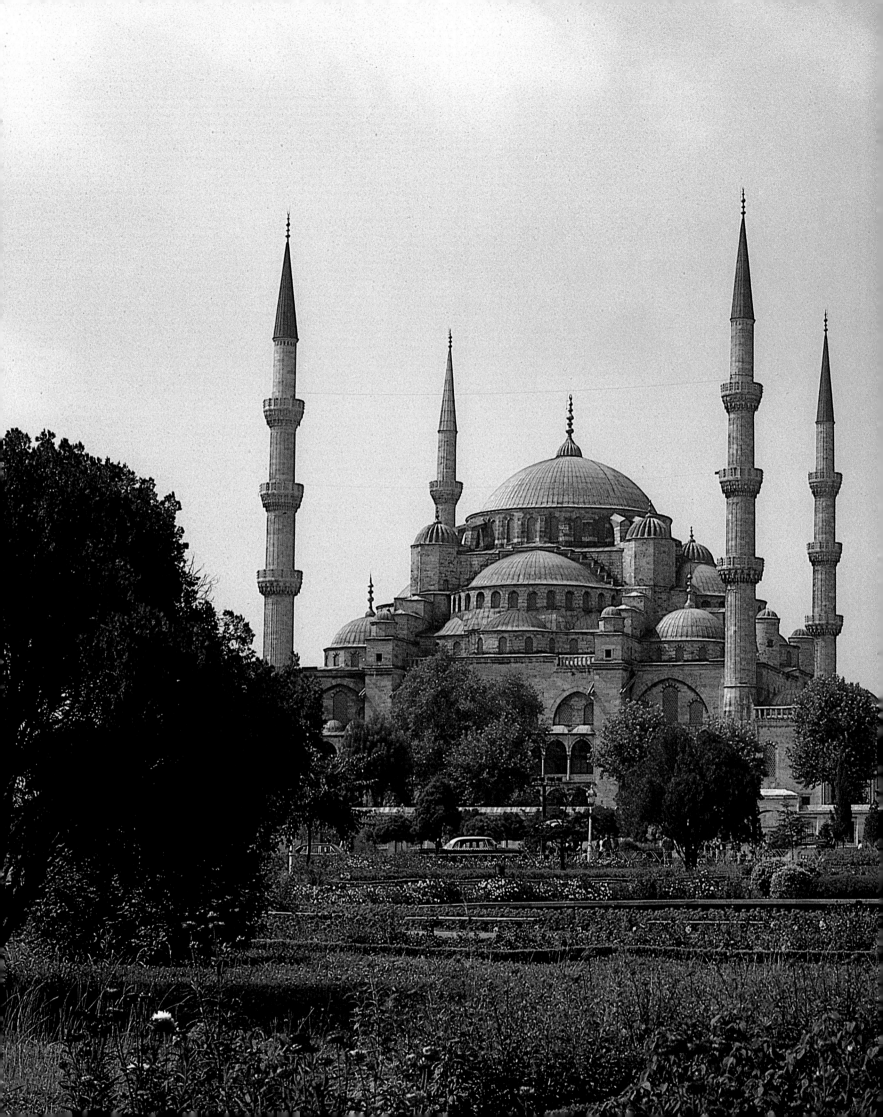

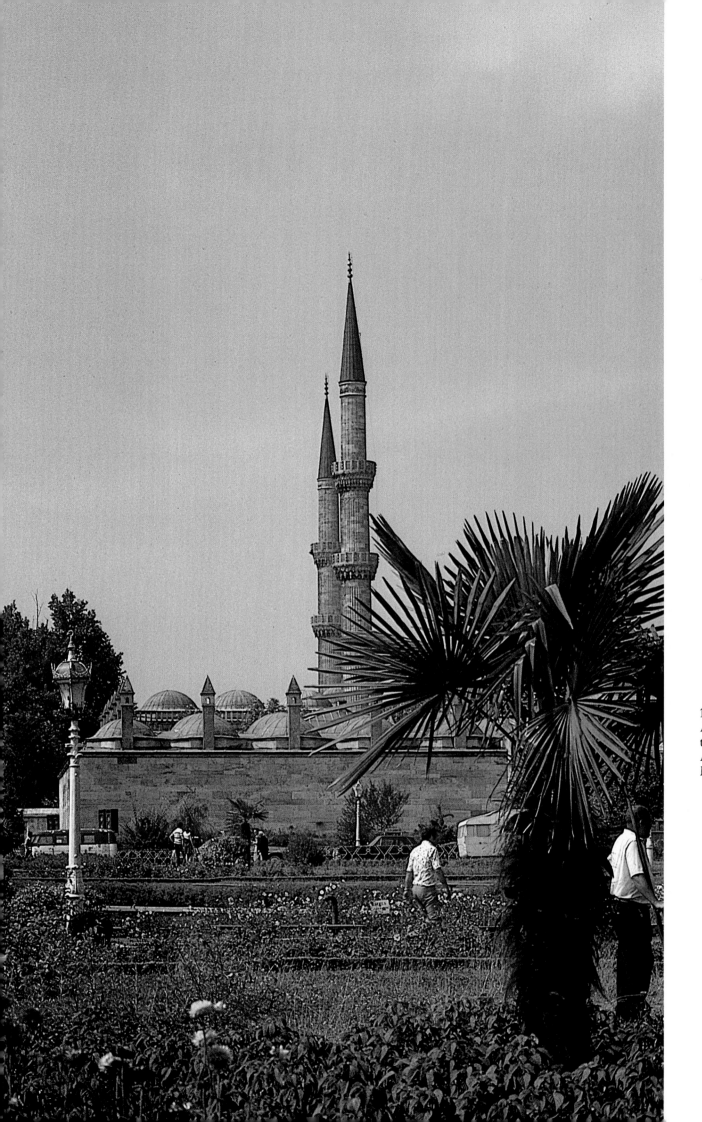

12. İstanbul, Mosque of
Ahmed I: view from
the west; 1609–17.
Architect: Sedefkar
Mehmed Ağa.

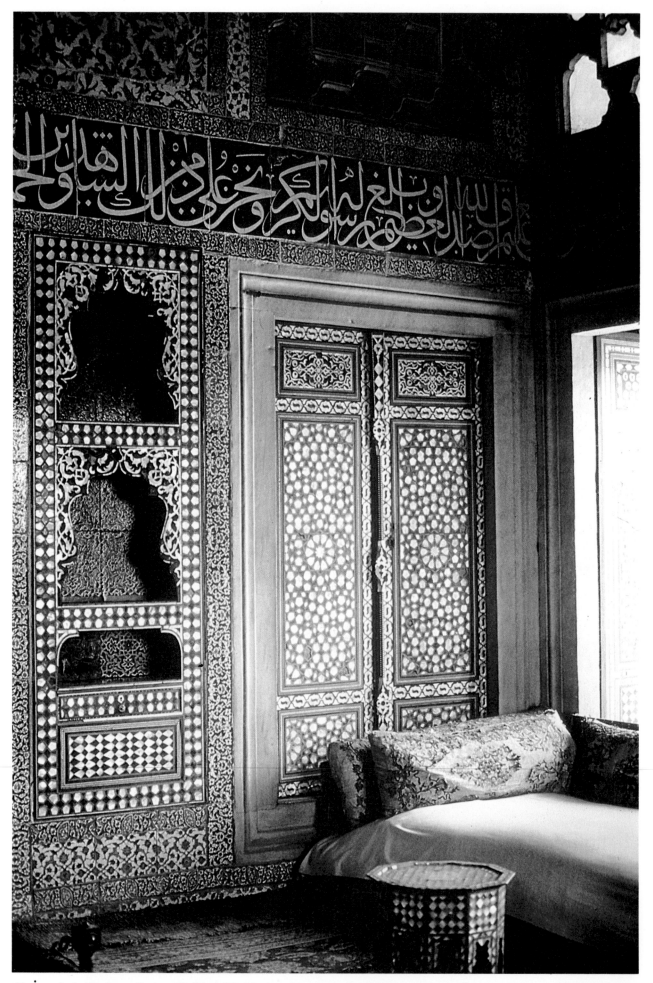

13. İstanbul, Topkapı Sariyı, Bağdad Köşkü: interior view showing an *eyvan*; 1638.

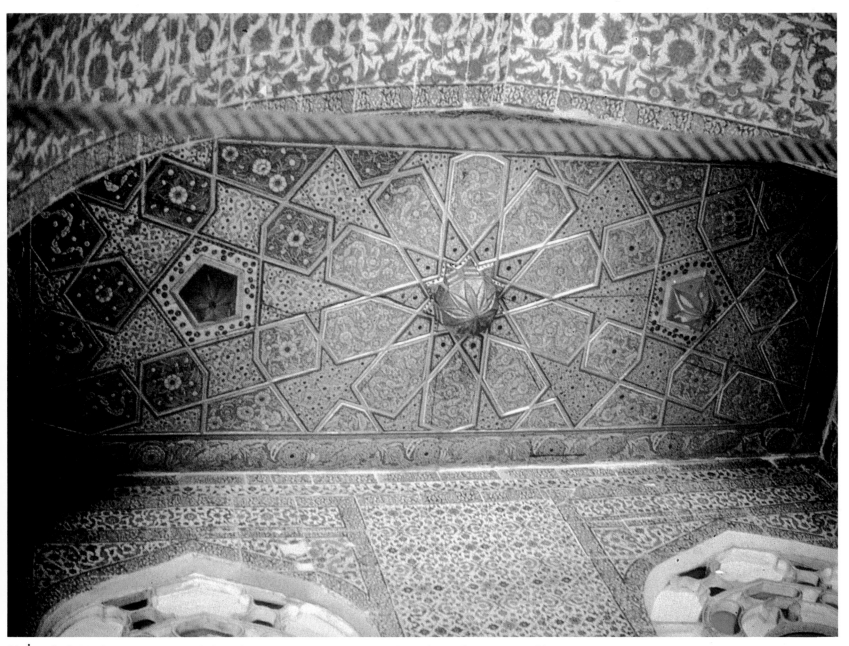

14. İstanbul, Topkapı Sarayı, Bağdad Köşkü: interior view showing the ceiling of an *eyvan*; 1638.

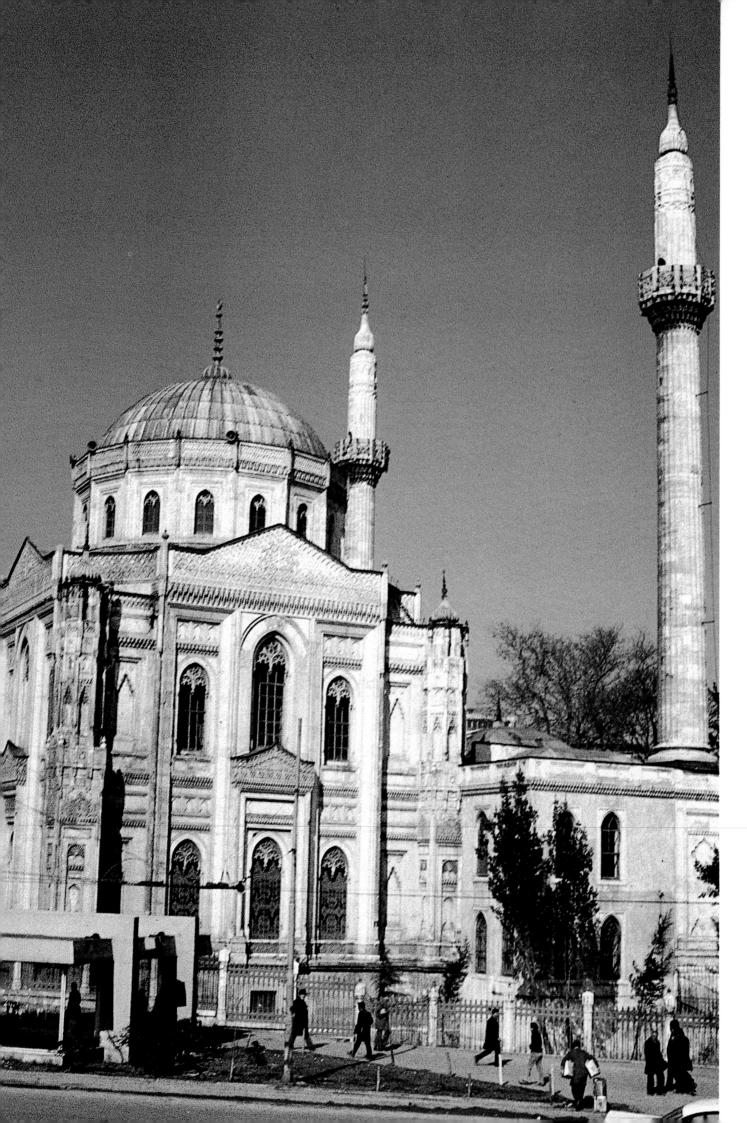

15. İstanbul, Mosque of Pertevniyal Valide Sultan: general view; 1871. Architects: Agop Balian and Montani.

give the exterior of the building a sense of monumentality despite its modest dimensions. It has been called one of the few revolutionary buildings of Ottoman architecture.[36]

The primary school and tomb, arranged around the eastern landing, are less obtrusive and do not interfere with the imposing height and silhouette of the single-domed mosque. The other buildings attached to the mosque—the *hamam* and shops—are below the platform on street level. The mosque and dependencies of Mihrimah Sultan at Edirnekapı are remarkable testimonials to the utilization of space and create grandeur on a small and cramped site without sacrificing any of the essential parts of a royal edifice. Mihrimah Sultan was a woman who did not compromise easily, as the historians of the Ottoman Empire tell us, and her monuments stand as evidence to her spirit.[37]

Sinan built a number of buildings in İstanbul for Rüstem Paşa, grand vezir and son-in-law of the sultan. The Mosque of Rüstem Paşa is similar in many ways to the one built for his wife, Mihrimah Sultan. The mosque is rectangular, but the dome rises over an octagon formed by four freestanding and four engaged piers. The narrow sides have three small bays covered with vaulting; they rise to two stories and contain the galleries overlooking the interior. The Mosque of Rüstem Paşa is situated on an awkward site, amidst crowded market streets. It lacks a courtyard, like the mosques of his wife, but a double portico makes up for the lack of open space. The mosque is raised on a high platform and thus is not lost in the city. Shops are built into the base of the mosque. The important aspect of Rüstem Paşa's monument is the use of brilliant tiles covering most of the interior walls, perhaps among the finest that the İznik kilns produced. Sinan also built for Rüstem Paşa a *medrese* in İstanbul dated 1550; hans in İstanbul, Edirne, and in distant Erzurum; and a caravansaray in Ulukışla, on the route to the Cilician Gates.

It was for Sultan Süleyman the Magnificent that Sinan designed and between 1550 and 1557 built the monumental royal mosque with its dependencies in İstanbul, on one of the imposing hills that commands a view of the Golden Horn. The Süleymaniye complex of buildings, once again dominated by the mosque, is placed on a series of terraces. When seen from the opposite shores of the Golden Horn, about 400 domes of various sizes seem to cascade from the pinnacle of the mosque almost down to the edge of the water. Yet the eighteen buildings, housing hundreds of rooms, are organized tightly around the mosque while being contained at the perimeter by the city itself. Acknowledging the life and needs of the city, the dependencies include coffeehouses and shops tucked along the raised edges of terraces. As expected, the magnificent group of buildings contains an imaret, a *tabhane*, a hospital, a school of medicine, a *hamam*, schools for young children, four *medreses*, a cemetery, and a house for the caretaker of the mausoleums of Süleyman and his wife, Hürrem Sultan. Regardless of the functions they were meant to serve, the subsidiary buildings are quite similar in the organization of space, both closed and open. A rectangular or square courtyard surrounded by arcading on four sides is the center of the buildings. The rooms or cells, almost always domed, are behind the arcading. In the four *medreses* one large room replaces the main *eyvan* of the Seljuk period and is situated on the east side. This room, known as the *dershane* (classroom), extends into the arcading in all four examples.

The mosque, conforming to what by then had become conventional in Ottoman royal mosques, is set in a large rectangular enclosure, which also contains on its south side the mausoleums of the sultan and his wife. The enclosure wall is pierced with several entrances and windows. The mausoleum of the sultan is large and opulent, built of carefully finished stone faced with fine İznik tiles. Both mausoleums are octagonal,

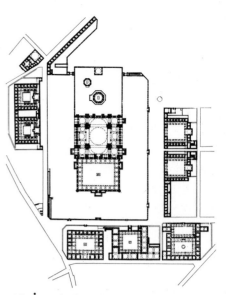

49. İstanbul, Süleymaniye Complex: plan; 1550–57. Architect: Sinan.

ills. 158–161

plates 10, 11 (pp. 109–11); ills. 49, 50

ill. 51

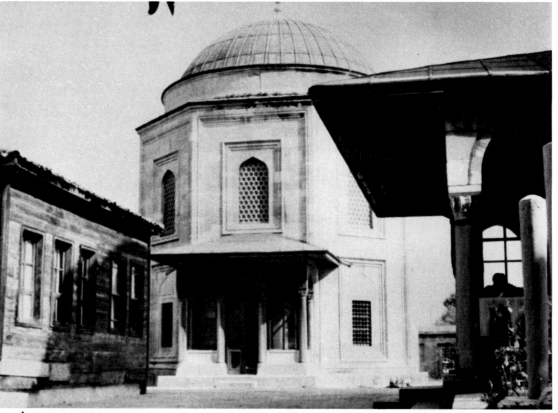

51. İstanbul, Süleymaniye Complex: Mausoleum of Hürrem Sultan;
1550–57. Architect: Sinan.

50. İstanbul, Süleymaniye Complex: dedicatory inscription over the entrance to the mosque, attributed to Ahmed Karahisari; before 1557. Architect: Sinan.

a shape popular since pre-Ottoman times. Instead of the pyramidal dome of the Seljuk period, the Ottoman outer dome is round. Another Ottoman feature is the porch in front of the entrance. In the Süleymaniye the sultan's mausoleum is enlarged from the outside by an arcade encircling the octagonal building. Multiple windows, a characteristic feature of Ottoman tombs, open on all sides of the octagon in several tiers. The high base, traditional in twelfth- and thirteenth-century tombs, has disappeared in the Ottoman period and is not found in the Süleymaniye.

Sinan was responsible for many tombs in İstanbul and in other cities of the empire. His structures are traditionally Ottoman: they are squat compared with the earlier mausoleums and hug the ground with only the roundness of the dome relieving the heavy proportions.

The courtyard of the Süleymaniye, which counterbalances the mausoleums and is to the north of the mosque, is surprisingly shallow. The narrow arcading is covered with closely set small domes. The domes also vary in height; those at the corners and over the portico are larger. The plan of the mosque reverts back to the Aya Sofya: a central dome is flanked by two half-domes, which in turn are enlarged by exedrae. The narrow side "aisles" are treated as secondary spaces along the strong south-north direction of the central composition. The diameter of the dome is nearly twenty-seven meters; the height of the crown from the floor is fifty-three meters, almost twice the diameter. The dome defines the internal space with a stupendous force. The concave vaulting of the superstructure, created by two half-domes and a full round dome, rolls toward the mihrab like a supernatural wave. The uneven pacing of domes in the courtyard is carried to the interior of the mosque: the low side aisles are covered with five domes

ill. 52

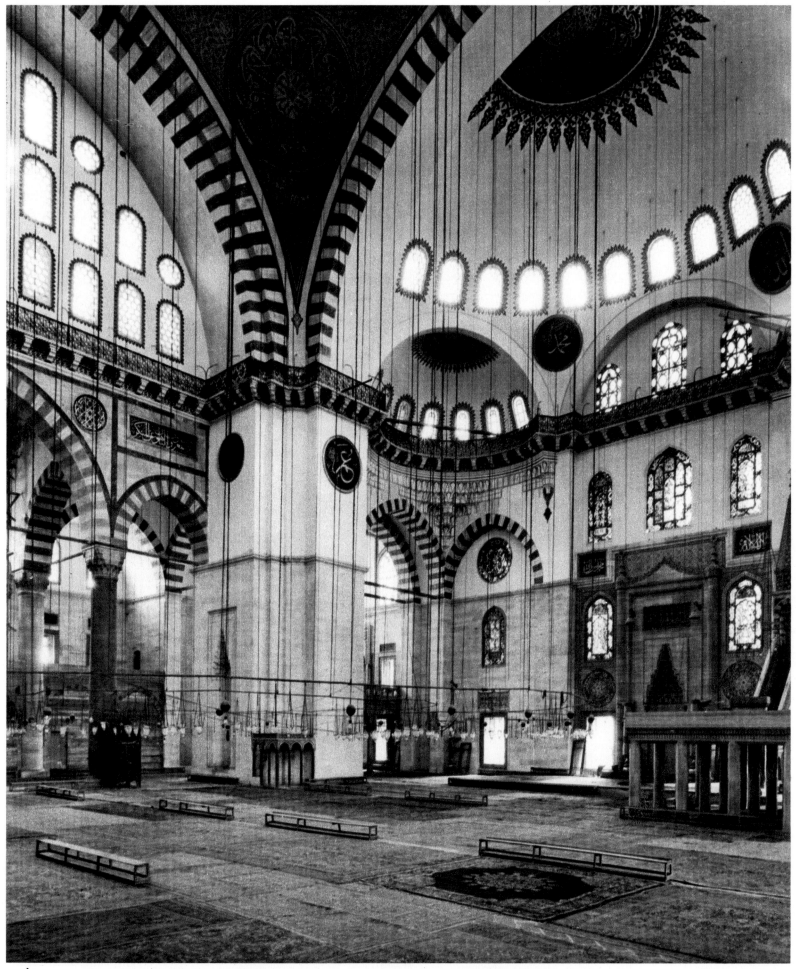

52. İstanbul, Süleymaniye Complex: mosque interior, view showing the mihrab area; 1550–57. Architect: Sinan.

alternating in size. The zone of transition consists of the powerful curvature of the pendentives, and the dome sits on four enormous piers.

The undisguised plasticity of forms, the heavy pull of piers against the soaring height of the domes, the physical against the mystical create a tension in the Mosque of Sultan Süleyman that is not felt in the Aya Sofya. In the latter, man is overpowered by the mystical and the immateriality of the structure; in the Süleymaniye, he is constantly made aware of the material and its interplay with the spiritual.

The original stained-glass windows now remain only on the *kıble* wall.[38] The mihrab is a simple marble panel framed by magnificent tiles. The windows on the walls and tympana and along the base of the domes are sources of natural light. At night thousands of lamps, hung from the domes by chains, transform the immense hall into a mysterious world, its boundaries felt but not exactly seen. Within the conventional boundaries of a mosque the master architect Sinan introduced a new dimension that would not be reproduced again. This new dimension is tension created by physical forms that seem to move in accordance with a force beyond the man-made material world. This tension permeates the mosque and is felt in the court, inside the great hall, and on the exterior.

The mass of the mosque as encountered from outside is equally forceful, at times intriguing, but never obscure. Small flying buttresses encircle the base of the central dome and relieve its thrust together with the polygonal turrets placed over the interior piers. The turrets are integrated into the silhouette of the mosque and stepped buttresses rise from the ground toward the dome to meet them. The massing of cubes and spheres is highly plastic.

If Sinan interpreted the Süleymaniye in almost a baroque manner, he reverted to a classical, perfectly proportioned, and tranquil monument with the Selimiye Mosque in Edirne. The Mosque of Selim II, the son and heir of Süleyman, was built between 1569 and 1575 when Sinan was in his eighties, a period in his career during which he called himself a "master." It is probably Sinan's greatest personal accomplishment and represents the highest point of Ottoman architecture. The mosque and its dependencies are constructed on a platform at the outskirts of Edirne. The mosque, framed by four slender minarets, can be seen from any point in the city, and its impression on the traveler approaching Edirne is stupendous. The magnificence of the Selimiye Mosque was never to be achieved again.

Both the Selimiye Mosque and its court have rectangular plans. The *revaks* of the courtyard are deep, leaving a relatively narrow opening with an octagonal pool in the center. Alternating colors used in the voussoirs of the wide arches and the semicircular tile panels over the windows play against the marble pavement of the court and the warm yellow limestone of the massive mosque, which rises behind the *son cemaat yeri*.

Upon entering the mosque through one of five portals, one is aware only of the immense and unobstructed space created by the soaring dome whose diameter is more than thirty-one meters. The dome is supported by eight clearly exposed piers, which are pulled back toward the walls, and the four exedrae filling in the corners blend into the octagonal space, which is unbroken from the ground to the apex of the dome. The mihrab is placed in a room of its own projecting about six meters from the octagonal space. This withdrawal of the mihrab from the central space does not interrupt the unity created by the dome and the four exedrae. In the mihrab recession, which is quite rare in Ottoman architecture, Sinan has created a room enlivened with light coming in from the windows and adorned with colorful tiles, stained-glass windows, and painted

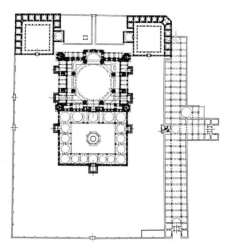

53. Edirne, Selimiye Complex: plan; 1569–75. Architect: Sinan.

ill. 55

plates 46, 47 (pp. 272–73)

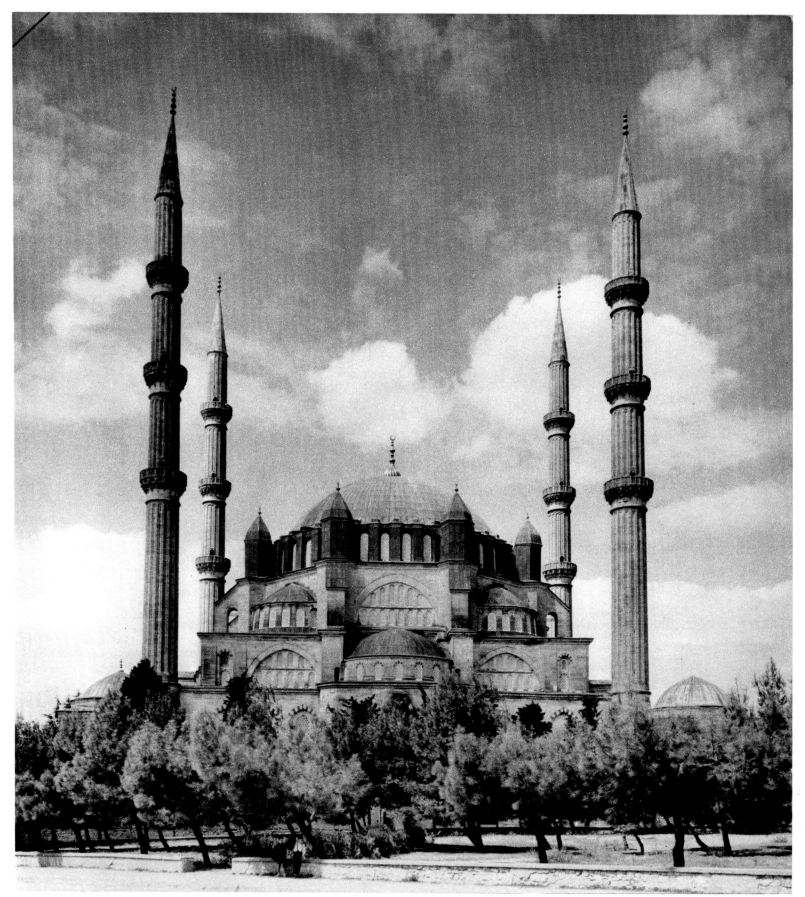

54. Edirne, Selimiye Complex: general view of the mosque; 1569–75. Architect: Sinan.

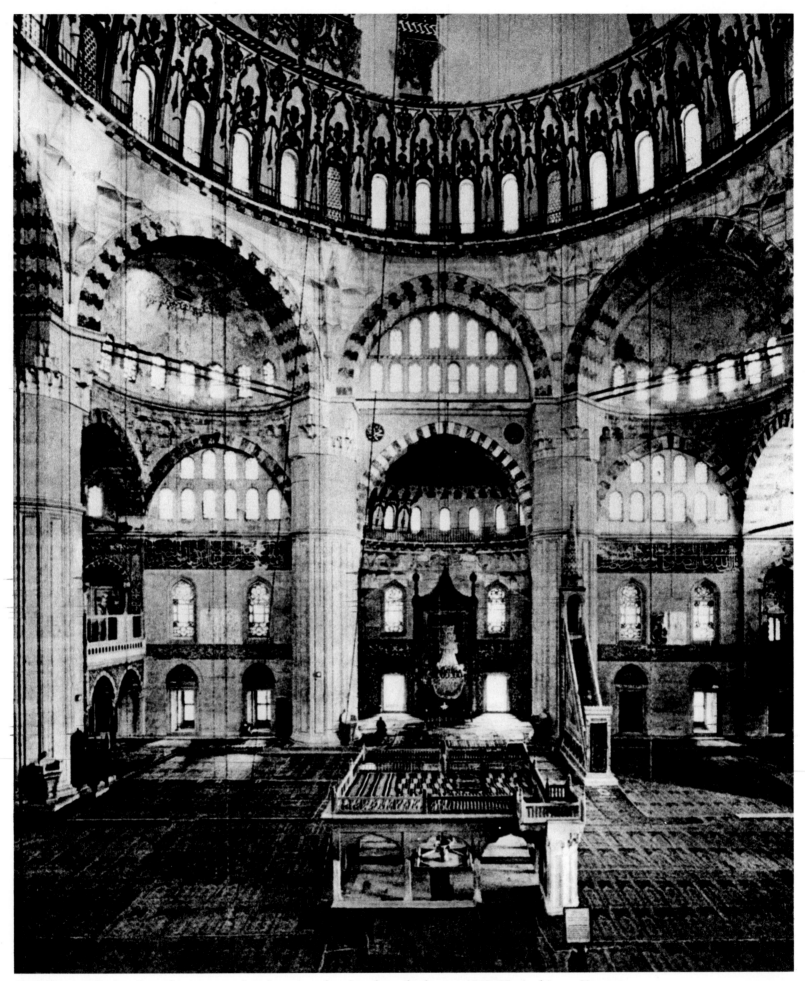

55. Edirne, Selimiye Complex: mosque interior, view showing the mihrab area; 1569–75. Architect: Sinan.

plaster. The room, separated from the vast hall of the mosque, is an intimate site for the marble mihrab niche.

The element of light in the Selimiye Mosque is almost tangible. Numerous windows on the walls, tympana, and along the base of the dome render a dimension of immateriality to the unified space. From whichever angle the light enters, it falls on the center of the mosque. The serenity and the totality of the interior are absolute. The galleries on the ground level and above are set back behind the piers and do not interfere with the centralized space. Part of the gallery to the north of the *kıble* wall is transformed into a room for the Ottoman ruler, its walls reveted with the best examples of İznik tiles.

The *minber*, one of the finest in Turkey, is carved of marble. The triangular marble block appears weightless as a result of an overall filigree of interlacing geometric designs. The tall conical head of the *minber* is covered with tiles. Directly below the apex of the dome is the raised *müezzin mahfili* (tribune for chanters), having been moved from its traditional site at the left of the *minber*. Here, at the center, the marble furniture serves a spatial purpose, marking the point from which an invisible shaft rises toward the dome. A shallow pool, corresponding to the one in the courtyard, is half-hidden underneath the tribune.

The exterior of the mosque is so superbly rendered that not even the tall minarets interrupt its massive form. There are no half-domes or cascades of galleries to distract attention from the curving stone block. The four minarets, closely set against the block, delineate the space enveloping the mosque. Eight rather thin turrets, capped with elongated domes, encircle the drum. Since the drum and the turrets are constructed in stone darker than that used for the mosque, they seem to add weight to the dome. Flying buttresses extend from the turrets to the level of the galleries, where they merge into the walls. The windows grouped under the rounded arches give a lacelike quality to the walls. Even the minaret bases are narrowed and softened to blend in with the side walls.

The platform on which the mosque rises houses shops that provided part of the revenue for the maintenance of the building. A covered market to the east of the platform, finished after the death of Sinan, seems to disturb the balance of the layout. Within the outer enclosure of the mosque platform, at the southern corners, are two structures that serve as a *medrese* and *dar ul-kurra* (Koran school). The buildings contain an arcaded square courtyard with cells placed only on the outer two sides, which share the edge of the platform. In deference to the monumentality and integrity of the mosque, the schools are reduced in size; the rest of the enclosure is left empty.

The Mosque of Selim II was the best work of the greatest architect in Turkish history. It is the last perfect monumental structure of the classical era.

POSTCLASSICAL ARCHITECTURE

A slow decline in building activities of the Ottoman Empire is visible following the era of Süleyman I and the master architect Sinan. Dwindling state treasuries, incapacitated rulers, lack of good building sites, and finally a loss of interest in architecture contributed to the decline. Decorative arts, especially the craft of the ceramicist—which had helped to embellish countless square meters of wall surfaces—also faced a shortage of funds as well as a lack of master artisans. The precision and clarity attained by the earlier architects, masons, ceramicists, painters, and other artisans were gradually lost.

In the post-Sinan age, mosques continued to be built in greater numbers than other types of structures, since dedicating a mosque has always been considered an act

56. İstanbul, Mosque of Ahmed I: interior view showing the *kursi* (lectern) of wood inlaid with mother-of-pearl; 1609–17. Architect: Sedefkar Mehmed Ağa.

plate 12 (pp. 112–13)

of devotion. Those who could not afford the costly mosques often built fountains, which are also charitable offerings, providing water to various quarters of the city. These vary from elaborate square structures with fountains on all sides to attractively carved marble plaques containing a water spout and large drinking basin.[39] Hundreds of fountains of all sizes are found all over the city of İstanbul.

The royal fountain donated by Ahmed III in 1728 is at the entrance to Topkapı Sarayı. It is an elegant square structure with rounded corners projecting slightly from the facades. The grillwork at the corners masks the *sebil* (public fountains), while on the facades there are additional marble fountains. The scalloped eave projects on all sides of the fountain, its five miniature domes marking the corners and the center of the roof, protecting the users from rain or sun. The overall decoration on the walls in carved marble or ironwork makes use of color and gilding. Naturalistic floral themes and elegant calligraphy—the motifs selected for the ornamentation of this eighteenth-century structure—encircle the fountain. Calligraphy, usually verses praising the donor and offering blessings to his soul, and floral motifs are the preferred themes for fountains of all sizes in the Ottoman Empire.

Mosques with extensive dependencies become rare after the sixteenth century. However, by the nineteenth century the city had a skyline embellished with domes and almost every alley boasted its own domical structure whether mosque, imaret, or *hamam.*

The first major mosque and its subsidiary buildings to be undertaken after Sinan is the complex of Ahmed I built across from the Aya Sofya between the Hippodrome and the Marmara Sea. The mosque, better known as the Blue Mosque, has a graceful silhouette and is almost lyrically framed against the blue of the sky and the sea. But upon close scrutiny, one becomes aware of its shortcomings: it lacks the innovative details that Sinan introduced into all his major mosques. The Mosque of Sultan Ahmed, in spite of its graceful and harmonious exterior, does not have the tensions created by mass, space, and movement found in the Süleymaniye, or the quietude and classical proportions of the Selimiye. The chief architect of the Mosque of Ahmed I was Sedefkar Mehmed Ağa.[40] The site of the mosque had to be cleared of extensive Byzantine ruins and of Ottoman residences. The purchase of land and the amassing of material for the new mosque and its dependencies—the largest complex in the empire—must have placed a tremendous burden on the imperial treasury. The empire had just experienced one of its earliest severe military defeats, and the time for building a gigantic complex did not seem right, even to the *şeyhülislam,* the religious head of state. Only the determination of Sultan Ahmed, who was otherwise less successful in matters of state, carried the architectural adventure through to completion around the year 1617.

Both the Mosque of Sultan Ahmed and its courtyard are square in plan. The mosque interior is a quatrefoil: a central dome is flanked by four half-domes and the corners are covered with small round domes. It is smaller than that of the Süleymaniye, but larger than that of the Şehzade Mosque, the first important structure of Sinan. The height of the dome is 43 meters and the diameter is 23.5 meters. The impression given by the dome is that it is not as lofty as those in Sinan's works, partially because the four "elephant feet," or the giant circular piers that carry the main weight of the dome, undermine its effect. The spacious and airy quality found in the mosque is largely due to the multitiered windows and tiles on the lower walls and the stencil work covering the plaster of the superstructure. The dominant color is blue, which gives the mosque a cheerful and light atmosphere, somewhat diminishing the heaviness of the "elephant

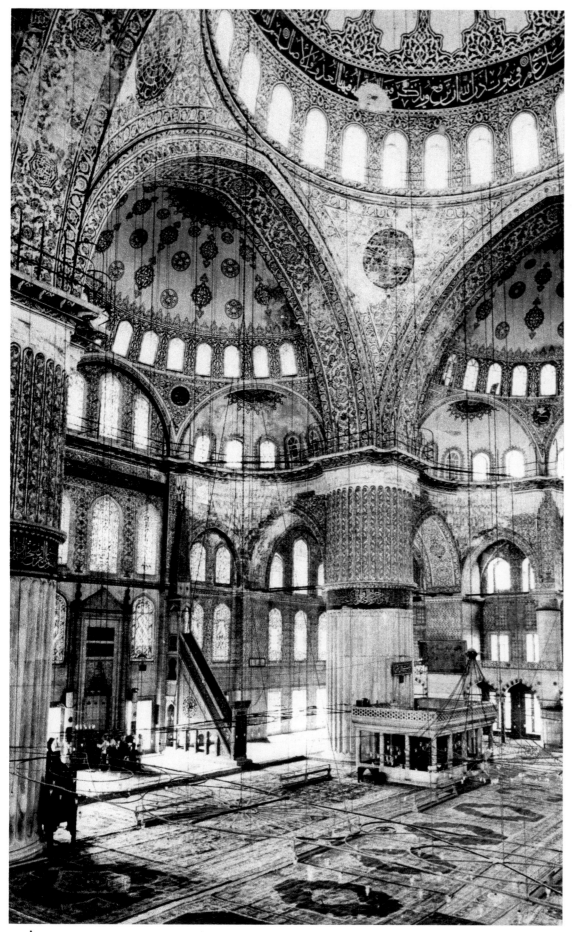

57. İstanbul, Mosque of Ahmed I: interior view; 1609–17.
Architect: Sedefkar Mehmed Ağa.

58. İstanbul, Mosque of Ahmed I:
plan; 1609–17. Architect: Sedefkar
Mehmed Ağa.

feet." Some of the tile panels, upon close inspection, reveal that the work is not precise; colors tend to run and the glaze is dull compared with the faultless examples found in the mosques built by Sinan. The rhythm of arches is slightly tedious, devoid of tension created by moving curvilinear and spherical masses in the Süleymaniye. The ingenuity and popularity of the mosque interior lie in its colorful and bright impression on the visitor who does not cast a critical eye.

The unusual view of the exterior is created by six minarets; this is the only mosque in Turkey with so many minarets. Four are placed at the corners of the mosque proper and two slightly shorter ones mark the corners of the courtyard on the north side overlooking the Hippodrome. If the four minarets were to be removed from the mosque the impression would be of monotonous piling up of curved forms. The slender minarets grant the mosque a harmonious and impressive profile from the distance. The daring spacing of the minarets makes the mosque complex seem longer than it is, although the view of the mosque from the north and south is rather plain and static. The dependencies of Sultan Ahmed's mosque are not laid out in a symmetrical or even a balanced way. This is probably due to the urban crowding around the mosque-complex at the time of construction. The various buildings are stretched out between the mosque and the street separating it from the precinct of the Aya Sofya. The dependencies of Sultan Ahmed's mosque, however, conform to urban architecture in that they create a continuous facade opening to the street rather than to an inner courtyard, as was the case in earlier structures. The street that runs along the south side of the Hippodrome is even today crowded with two-storied shops and coffeehouses.

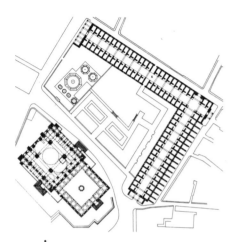

59. İstanbul, Yeni Cami Complex: plan; 1598–1663. Architects: Davud Ağa and Mustafa Ağa.

An impressive number of royal mosques in İstanbul after the sixteenth century were donated by the *valide* sultan (queen mother), which indicates the newly acquired power of women in the court. The mosques of the *valide* sultans are distributed on the outskirts of the city and not located near the palace in the central part of İstanbul, which seems to have been reserved for structures undertaken by the male members of the royal family or the administrative elite of the Ottoman Empire.

The Yeni Cami (New Mosque), or as it is more appropriately called, the New Mosque of the Queen Mothers, was the last mosque to be built in İstanbul in the classical style. It is on the shore of the Golden Horn, an inconvenient location for such a large structure. The mosque had a long history of construction, which involved the direct planning and supervision of three architects by three successive *valide* sultans. The construction, started in 1598 under the auspices of Safiye Sultan, mother of Mehmed III, was interrupted during the reign of Ahmed I; it continued under the patronage of Kösem Mahpeyker, the mother of Murad IV and İbrahim and the grandmother of Mehmed IV. In 1651, having replaced the old *valide,* Hadice Turhan Sultan resumed work on the abandoned mosque, building a pavilion next to it.[41]

The mosque and its dependent buildings were completed in 1663. Among its dependencies are mausoleums, fountains, a *hamam,* and the Mısır Çarşısı, the famous Egyptian Market. The latter was completed before the mosque and is an L-shaped market with six gates, eighty-six shops, and chambers over the major gateways.

The first architect entrusted with the construction of the mosque was Davud Aga, successor to the architect Sinan in competence and fame. In order to raise the mosque on the narrow and unsuitable site on the seashore, he had to build a series of islets and bridges on sunken piers of stone reinforced with iron. The mosque itself is not in any way innovative: it is a square building attached to a square court and has a central dome flanked by half-domes on its south-north axis while four smaller domes appear

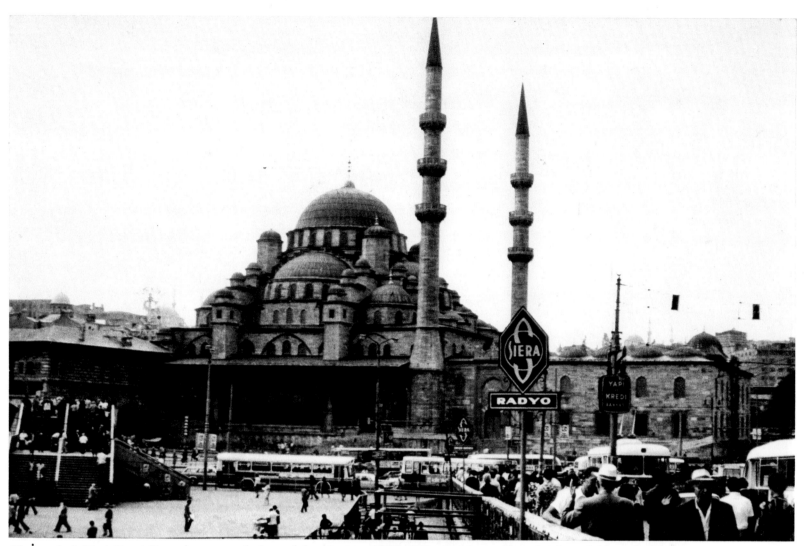

60. İstanbul, Yeni Cami Complex: general view of the mosque; 1598–1663. Architects: Davud Ağa and Mustafa Ağa.

on the corners. The central dome comes to a sharp point, having suffered from changes in design throughout the years. To achieve a harmonious and vast complex on artificially filled land was not, however, a small task, and only the strong will and perseverance of the two *valide* sultans made the enterprise possible. The significance of the ambitious undertaking is more apparent when one considers the dwindling power and wealth of the Ottoman Empire at that time and particularly the fact that Mehmed IV, although the ruler, did not build a mosque to commemorate his own name.

The most engrossing and innovative part of the vast complex is the pavilion built over a deep and high arch abutting the mosque. It has a separate entrance, leading to the mosque by a long ramp. The pavilion, with a view of the harbor, consists of two rooms, an L-shaped hall, and a corridor that connects the structure with the *hünkar mahfili* (royal loggia) in the mosque. The loggia is spacious and has a gilded lattice; it is more enclosed than the open galleries and loggias of the earlier mosques and was clearly meant to serve the *valide* sultan. The pavilion is one of the most exquisite examples of Ottoman secular architecture. The walls and ceilings of the rooms are covered with tiles and paintings of the period.

61. İstanbul, Topkapı Sarayı, Bağdad Köşkü: cupboard door inlaid with mother-of-pearl and shell (detail); after 1638.

THE LAST PHASE

ills. 62, 63 The Nur-u Osmaniye (Light of the Ottomans) is the first imperial mosque clearly demonstrating the influence of Western artistic concepts in Ottoman society.[42] The mosque was started under Mahmud I in 1748 and was completed in 1755 under the auspices of Osman III. The eighteenth century was the beginning of an era when Ottoman envoys were sent to European courts and came back with descriptions of Western societies and their arts. It was also the beginning of the period in architecture when non-Muslims were commissioned to build important royal edifices, including mosques, and architects and artisans were invited from Europe. The impact of the West does not go beyond ornamentation; the form and major elements of a mosque remained unchanged. European influences add novel ornaments, such as naturalistic flowers, or bend straight lines into undulating ones.

Such is the case with the Mosque of Nur-u Osmaniye. Although the name of the architect has gone unrecorded, there is a strong probability that he was a Christian, or at least familiar with Western architecture. The mosque and its courtyard are raised on a base, reached by bent staircases that are not regularly placed. The mosque is immediately adjacent to the entrance to the Covered Market of İstanbul and, therefore,

in one of the busiest sections of the city. By raising the mosque on high foundations, the architect was able to achieve a monumentality in spite of the encroaching buildings surrounding the mosque. The courtyard is a daring horseshoe shape, the first and only one of its kind. It is clearly a concession to Western architectural forms. The portico has five domes, while the arcades have ten domes. The court does not contain the traditional pool or fountain. The rounded *revaks* seem to undulate around the open space. The mosque itself responds less favorably to new ideas: a single but large dome, approximately twenty-four meters in diameter and forty-three meters high, is carried by slightly pointed arches. The springing points of the arches are disguised by strongly projecting moldings and side galleries. The mihrab is set within an apselike recess that projects beyond the cube of the mosque. Since the walls are released from the weight of the dome by the arches, they are opened with multiple layers of windows that, unfortunately, are too closely set together. The window arches are round or trefoil, framed with strong rounded moldings. Such moldings and arches are certainly taken from Western sources. The columns of the double-storied side galleries are relatively short and closely spaced, their round arches short-spanned, effecting an undulating movement.

The mosque is more interesting from the exterior. It dominates the surrounding multiple domes of the bazaar and hans. The architectural elements of the building are not disguised behind decorative details. The slightly pointed arches that support the dome spring from heavy corner piers of which multifaced corners are exposed to the outside. The stabilizing turrets also rest on the corner piers. The profile of the flying buttresses over the turrets is curvilinear. The arch is emphasized through a set of moldings that gradually rise to a sharp cavelike projection.

The two fluted minarets of the mosque are located at the junction where the courtyard adjoins the mosque. One novelty in the minarets is that the capping is in stone whereas the traditional cap is in lead, the material used to cover the domes.

The Mosque of Nur-u Osmaniye is a good example of an eighteenth-century mosque in which innovations were introduced. Thus it appears that daring elements were permissible as long as the patron agreed to them.[43] The effects of the mosque are felt in several subsequent structures, but the later ones were more timid in using Western features.

In the nineteenth century there were renewed attempts to integrate alien elements into the fabric of the mosque. One example is the Mosque of Pertevniyal Valide Sultan in İstanbul, the last to be donated by a *valide* sultan. The donor was the wife of Mahmud II and the mother of Abdülaziz. The mosque, in the Aksaray quarter of İstanbul, was completed in 1871. Attached to it are a tomb, fountain, and a splendid courtyard, approached by wide marble stairs leading to the monumental and ornate gates. The mosque is small, single-domed, and has two minarets. Its originality lies in its daring surface decoration. The motifs carved on its marble facades included those recalling Seljuk floral and geometric interlacings as well as the Indian flower arrangements found on the Taj Mahal and fanciful Western neo-Gothic windows. It is the only religious building in İstanbul that attempted the fashionable eclectic style of the time employed in the residential structures. One of the architects of the mosque was an Italian named Montani. Single-domed mosques continued to be built in İstanbul in the nineteenth century, especially on the shores of the Bosporus, where the royal residence had been transferred. These mosques are small in scale and did not contribute to any architectural development.

The impact of European architectural styles on Ottoman Turkish religious archi-

plate 15 (p. 116)

tecture was restricted to decorative elements. Foreign influences did not affect the spatial and structural forms of mosque or *medrese* architecture, which had remained conservative. On the other hand, Ottoman palaces and residences underwent basic transformations in the nineteenth century. Changing life-styles of the middle and upper classes (which were more closely integrated with Western ways), interaction of Ottoman Turkey with European countries, visits of princes to European capitals, introduction of Western-style education and institutions, and finally the Crimean War, during which Turkey formed alliances with Western forces—all were contributing factors to the "westernization" of residential buildings.

The first "European" palace to be built in İstanbul is located in the innermost court of the Topkapı Sarayı and was sponsored by Abdülmecid. Named after the donor, the palace is small, more like a *köşk* in the tradition of older structures of the Topkapı Sarayı. However, its white marble facade decorated with engaged columns, garlands, and curving moldings lend it a "transplanted" look among Islamic-Turkish buildings.

Sultan Abdülmecid, obviously not satisfied with the "old-fashioned" Topkapı Sarayı and its limited grounds that did not permit for a large-scale palace, planned and had built an enormous residence in the outskirts of the city. The grandiose and ambitious palace was completed in 1853 and named the Dolmabahçe or the "Filled-Gardens," land having been gained from the waters of the Bosporus on its European shore. The palace was conceived as a single structure of two stories. Wings housing numerous apartments give the building an undulating facade on the land side. In the center of the complex stands the imposing, spacious, and domed audience hall, designed more in the tradition of Western throne rooms than the shallow and small reception rooms of the Oriental palaces.

A u-shaped garden surrounds the Dolmabahçe Sarayı complex on three sides; the fourth side banks on the Bosporus. Highly ornate bronze doors and marble-paneled high walls separate the palace gardens from the busy street outside. This layout of the gardens is in direct contrast with the grounds of the Topkapı Sarayı. The nineteenth-century building is a single structure of palatial dimensions in the Western tradition, defined by formal gardens; whereas in the Topkapı Sarayı, small and mostly single-storied structures are joined together to define the central negative, or empty, spaces.

The ornamentation of the Dolmabahçe Sarayı, both inside and outside, borrows freely and indiscriminately from the decorative motifs of European architecture in vogue since the Baroque period or the seventeenth century. Inside the palace, curving staircases, multiple engaged columns, walls painted with illusionary landscapes, color, light, and, above all, gilding give this palace an ornateness that is hard to match. With the Dolmabahçe Sarayı, Turkish architecture had closed a phase in its history and entered the international "style" of architecture.

62. İstanbul, Nur-u Osmaniye Cami: plan; 1748–55.

Conclusion

The monuments of Turkish Anatolia are architectural records of religious, political, and social processes that have taken place between 1071 and the present. Following the large-scale arrival of the Turks into Anatolia after the battle of Malazgirt, the land became the scene of massive Muslim settlement. As the architectural remains indicate, the process of transforming the land from one of Christian character to that of Islamic started in the urban centers of southeastern Anatolia and gradually spread toward the

west. The cities, strongholds of Islamic-Turkish urban power, symbolically laid claim to the land through the erection of two types of buildings: the mosque as the center of worship and ideological basis in the society, and the *medrese* as the instrument for the advancement of knowledge, particularly of religion. The royal residences are far less obtrusive. This process of claiming the land for the followers of one religion continued until 1453, when the task was completed with the fall of Constantinople, and the whole of Anatolia was converted into an Islamic land.

Just as the mosque-*medrese* structures were built under the protection of various Turkish heads of state in order to advocate the power of the government as well as the values upheld by the urban classes, the claiming of the countryside and the spiritual needs of nonurban population appear to have been fulfilled by another form of monumental architecture, the *türbe*. The mausoleum is more than simply a commemorative structure for individuals. It marked the land where it was erected physically by its monumental form and socially as a sacred site prepared for the visits of local Muslims. A large number of early funerary structures are, in fact, in the countryside. Such rep-

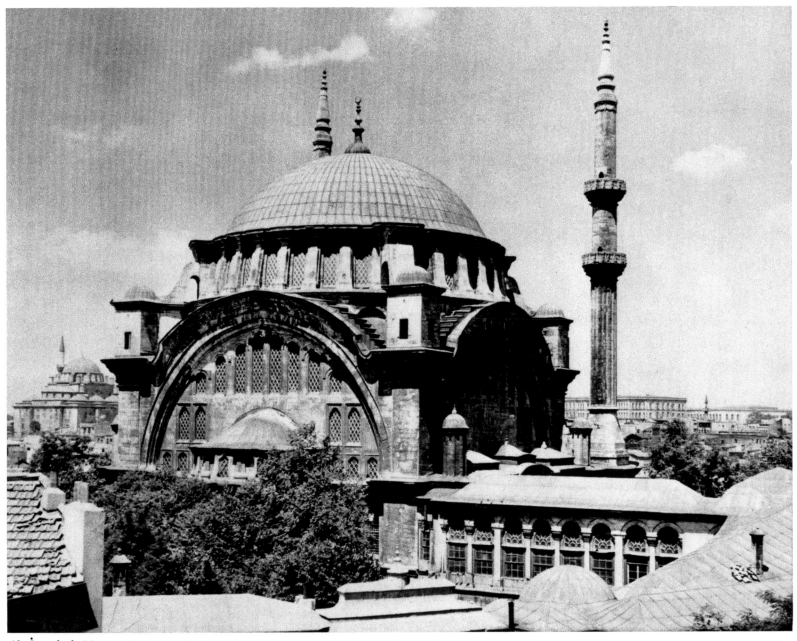

63. İstanbul, Nur-u Osmaniye Cami: general view; 1748–55.

resentatives of "holy" or important personages, religious or otherwise, in time became sites for veneration and visitations among the rural population, prompting traveling and exchanges on various levels. If the mosque and the *medrese* answered the needs of the urban and orthodox followers of Islam, then the mausoleums became the centers of "folk" or heterodox orders. In the fourteenth and fifteenth centuries, with the proliferation of heterodox orders in Anatolia and the collapse of powerful urban centers, the dwelling places and burial sites of religious leaders stimulated the development of a rural folk architecture. Convents, hostels, and mosques serving various orders were built in close proximity to an important religious site. These complexes in turn became the nuclei of future settlements. Many towns, especially in western and northeastern Anatolia, can claim similar beginnings. Since almost none of these building complexes can claim royal sponsorship, they are not architecturally outstanding but nevertheless form a significant part of Turkish-Anatolian architectural history.

As Turkish rule in Anatolia took firm root and the Seljuks emerged as one state that could control its rivals, caravansarays on routes connecting the cities, inns in towns, marketplaces, and "villa" country residences began to appear in Anatolia, especially in the first seven decades of the thirteenth century. Trade relations with the Islamic states in the Near East, Mediterranean countries, and the Crusaders were encouraged by the Seljuks. Magnificent caravansarays, totaling more than a hundred built within a century, are the architectural results of the great economic enterprises of this period.

Unfortunately the urban calm of the thirteenth century and the building activities associated with it were disturbed with the Mongol invasion of Anatolia following 1243. Rapid changes in the political scene and the disruption of urban classes affected architectural activities. The ulema of orthodox Islam, who were placed in urban *medreses,* found themselves without protection. The needs of popular Islam, as represented by heterodox orders, were now served by new types of buildings, including the so-called inverted-т mosque. The architecture of Turkish Anatolia evolved to answer the needs of the society.

The buildings of Anatolia prior to the conquest of İstanbul bear the marks of a political structure that favored regionalism rather than a central government. Although the Seljuks were the most powerful state during the twelfth and thirteenth centuries, various Turkish dynasties maintained a high degree of local autonomy. Local traditions in architecture, construction materials, and ornamentation survived independent of a unified style. Regionalism is apparent even within the Seljuk state itself. Even though Konya was the city most favored by the Seljuks, the rulers traveled to Sivas and Kayseri and resided in those cities. The sultans and their families sponsored building activities in all these centers.

After the fall of Constantinople to the Turks in 1453 and its designation as the center of the Ottoman Empire, there is a shift from regional architectural traditions and styles to centralization and unification. İstanbul became the center for imperial structures symbolizing the undisputed and unrivaled power of the Ottoman sultan. The city became the site of a number of royal foundations of monumental size, the *külliyes,* which shared similar layouts. Imperial power came to be symbolized and recognized in the central and massive structure of the mosque, while around it secondary buildings—such as schools, hospitals, almshouses, hostels, libraries, and similar types of civic buildings—were grouped unobtrusively and in low profile. As the sultan ruled over all groups and classes of people, the mosque dominated its dependent buildings. The monuments of the imperial city, İstanbul, served as models for architectural under-

takings in provincial centers. The imperial mosque and its dependencies formed the stylistic models, and soon regional differences in the architecture of Anatolia became minimal.

The patrons of Turkish architecture came from the royal family, led by the sultan himself. The heads of the Seljuk, Ottoman, and local dynasties in Anatolia made up the group that sponsored and dedicated the largest number of structures. Aside from the sultan and his sons, it included the female members of the royal family who had access to wealth. This wealth is seen more in the form of personal belongings, such as jewels, rather than real estate, since the land belonged to the sultan alone, and only he had the right to dispose of it to individuals and to revoke it back to royal holdings. Building activities were also sponsored by the administrative and military classes. These patrons were usually granted land from the royal holdings for their building endowments in addition to their salaries from the royal treasury. The ulema, or the scholars of the patrician class, almost never endowed buildings. However, they were granted the right to private dwellings and professionally operated the structures put up by the royal, military, and administrative classes. The merchants, traders, farmers, and similar groups in Seljuk and Ottoman societies never became that prominent and wealthy. The mercantile class, at least in the Ottoman period, was made up mainly of non-Muslims.

A complex of religious, charitable, and educational institutions was usually planned together with a secondary but vital group of commercial buildings, such as caravansarays, inns, bathhouses, markets, and soup kitchens, which provided the necessary funds for the upkeep of the first group. Founders of such multipurpose complexes usually created them as *vakıfs,* the *vakfiye* (deed of endowment) being drawn up before a *kadı* (judge), entered in his register, and confirmed by the sultan.[44] Such property was no longer within the royal holdings, and the continuance of the public service was guaranteed. In the *vakfiye* recorded in the *kadı's* register, the founder of the *vakıf* determined its purposes, conditions, and forms of management, and appointed its *mütevelli* (chief trustee), who in most cases was the founder. In the Ottoman Empire, however, the state controlled and confirmed all *vakıfs,* since they had the character of freehold property.[45] From the income derived from the commercial buildings, the conditions of the endowments were fulfilled, the employees were paid, and the buildings were maintained.

Turkish architecture in Anatolia evolved its types, its styles, and its forms in concordance with the changes and transformations in the political, social, and religious makeup of the land. The patronage of architecture found its sponsors among the elite class of the society, which dominated wealth and power. However, through carefully drawn *vakfiyes* the architectural endowments became part of the public trust serving all classes of the society.

Notes

1. P. K. Hitti, *History of the Arabs* (London, 1960), p. 199.

2. The precise function of each building or of each room, except for the mihrab room, is still not clearly understood. Undoubtedly, the appearance of the so-called inverted-T mosque coincides with and corresponds to the upsurge of various powerful *tarikats* or orders in Anatolia. The unorthodox plan of the "mosque" could have been made possible only with the existence of an unorthodox religious atmosphere in the emirates during the fourteenth and early fifteenth centuries.

3. Albert Gabriel, *Voyages archéologiques dans la Turquie orientale* (Paris, 1940), pp. 184–94. The term Ulu

Cami is used only for the major mosque in a city and refers to the structure in which the congregation hears the Friday sermon (*khutba* in Arabic) and at which the ruler attends the prayers.

4. Rahmi Hüseyin Ünal, *Les Monuments islamiques anciens de la ville d'Erzurum et de sa région* (Paris, 1968), pp. 18–22.

5. Signatures of architects and marks of stonemasons are quite commonly found on Anatolian architecture of the twelfth to fourteenth centuries. It seems that architects, masons, and artisans connected with architectural activities were more highly esteemed than other craftsmen during this period. We lack information and even names for contemporary outstanding painters, calligraphers, rug or tile makers, although some of their works have survived.

6. This portal has been compared to the Mausoleum of Alaviyan in Hamadan, Iran, dating from the twelfth century. See Oktay Aslanapa, *Turkish Art and Architecture* (London, 1971), p. 107.

7. Ibid., pp. 111–12.

8. Two studies have appeared on the Anatolian *medreses*, both written in Turkish: Aptullah Kuran, *Anadolu Medreseleri*, vol. 1 (Ankara, 1969); and M. Sözen, *Anadolu Medreseleri*, 2 vols. (İstanbul, 1972).

9. In early Ottoman architecture a similar relationship is found in the inverted-T mosques, where a room with a mihrab adjoins a closed courtyard covered by a dome with an oculus in the center. See Aptullah Kuran, "The Eyvan Mosque," in *The Mosque in Early Ottoman Architecture* (Chicago, 1968), pp. 71–136.

10. The various orders introduced into Anatolia among the Türkmens by *şeyhs, babas, pirs*, etc., in the thirteenth and fourteenth centuries were strongly inclined toward Shiism. This problem is discussed briefly by C. Cahen, *Pre-Ottoman Turkey* (London, 1968), pp. 248–50 and 258–60; and in length by F. Köprülü, *Türk Edebiyatında İlk Mutasavvıflar*, 2d printing (Ankara, 1966). For example, Bektaşis, an order to which the Janissaries swore alliance, believed that the founder of the order, Hacı Bectaş, had received from Ali the power to work miracles, and Hacı Bektaş's fictional ancestry was traced back to Muhammed and Ali. See J. K. Birge, *The Bektashi Order of Dervishes* (London, 1965), pp. 35–36 and *in passim*.

11. M. Akdağ, *Türkiye'nin Iktisadi ve İçtimai Tarihi*, vol. 1 (İstanbul, 1974), pp. 28–39.

12. The *vakıf* (deed or trust of the foundation) of the caravansaray built by the Seljuk vezir Karatay is published in facsimile in O. Turan, "Celaleddin Karatay Vakıfları ve Vakfiyeleri," *Belleten* 12 (1948): 170. According to the deed, each traveler, whether Muslim or Christian, freeman or slave, received a daily ration of bread and meat without charge. There was also a special budget for such expenses as oil for the lamps or wood for the fire.

13. Contemporary writers narrate episodes of various sultans using the caravansarays as halting places for themselves or as military posts for their armies. In the *Danishmendname* (I. Melikoff, *La Geste de Melik Danishmend* [Paris, 1960], pp. 36, 62), a certain *ribat* or caravansaray is described as the headquarters of Danişmend gazi. *The History of Ibn Bibi* (edited by A. Duda, *Die Seltschukengeschichte* [Copenhagen, 1959], pp. 256, 279, 307) mentions that the sultan hans were used by İzzeddin Keykavus and Rukneddin Kılıç Arslan as a fortress where they gathered their troops consisting of some 10,000 men. Baybars I of Egypt spent some time with his army at the caravansaray of Karatay while besieging Kayseri. And finally Sultan Alaeddin Keykubad, while going to Konya from Kayseri, made a stop at the caravansaray of Pervane near Aksaray, where the townspeople came to meet him.

14. Tavernier traveled in Anatolia around 1650 and left a nearly complete record of the routes he followed. He also described a caravansaray and the conditions of lodging: "They are not as commodious for the rich as the European ones [but] they are more convenient for the poor and do not refuse to give admittance." He adds, "In the country you pay nothing for your chambers. In the city you pay something" (J. B. Tavernier, *Les Six Voyages de J. B. Tavernier, en Turquie, en Perse, et aux Indes*, 2 vols. [Amsterdam, 1678], chap. 10, p. 45).

15. For Syrian caravansarays see J. Sauvaget, "Caravanserails syriens du Moyen-âge," *Ars Islamica* 6 (1939): 48–56.

16. The caravansaray is discussed at length by K. Erdmann, *Das Anatolische Karavansaray des 13. Jahrhunderts* (Berlin, 1961), pp. 90–97, illus. 142–60.

17. The tall white cap worn by the gazis was later adapted by the Janissary corps.

18. For *ahi* see the article by F. Taeschner, "Akhi" in *Encyclopedia Islamica*. Ibn Battuta talks of the *ahis* whose hospitality he enjoyed. He says that the members of the brotherhood were called *fityan* (youth) and their leaders *ahi* (Ibn Battuta, *Travels in Asia and Africa, 1325–54*, trans. and ed. H. E. A. Gibb [London, 1963], p. 126).

19. *Futuwwa*, meaning the chivalrous qualities of a *fata* (young man), is a term given to certain organizations, artisan and chivalrous. In Sufism *futuwwa* is an ethical (rather than mystical) ideal that places the spiritual welfare of others before that of oneself (J. S. Trimingham, *The Sufi Orders in Islam* [London, Oxford, New York, 1973]).

20. In several provincial mosques in Anatolia small side rooms in a so-called inverted-T mosque are now being used as studies or classrooms. For a discussion of the implications of the mosque-*zaviye* see Semavi Eyice, "La Mosque zaviyah de Seyyid Mehmed Dede a Yenişehir" in *Beiträge zur Kunstgeschichte Asiens, In Memoriam Ernst Diez*, ed. Oktay Aslanapa (İstanbul, 1963), pp. 49–69.

21. Ibn Battuta, *Travels*, pp. 126.

22. Saliha Hatun, the daughter of Cahan Şah, was the patron of the Blue Mosque in Tabriz. The mosque is briefly discussed by A. U. Pope, *Persian Architecture* (London, 1965), p. 203, figs. 272–76.

23. The inverted-T mosques were built until the end of the fifteenth century. There are at least two mosques of this type in İstanbul: Atik Ali Paşa Cami, 1479 (Godfrey Goodwin, *A History of Ottoman Architecture* [London, 1971], fig. 109) and Mahmud Paşa Cami, 1464 (ibid., figs. 103–4).

24. It can be assumed that the imaret, *tabhane, zaviye*, and *medrese* buildings situated within a complex fulfilled the various purposes that the humbler and simpler inverted-T mosque answered during the early years of the Ottoman state.

25. The rich wall texture achieved by alternating three rows of bricks with a row of well-cut stones was in use in northwestern Anatolia in Byzantine architecture as early as the ninth century. In Ottoman architecture, this wall construction became the standard system for small buildings, including *mescids*.

26. The change of the Ottoman state from a small principality to a world power is well stressed in the short but concise work by Paul Wittek, *The Rise of the Ottoman Empire* (London, 1967).

27. The great architect of the sixteenth century, Sinan, compares his masterworks with the church of Aya Sofya technically and artistically (Aslanapa, *Turkish Art*, pp. 223–24).

28. The words han and caravansaray are frequently interchangeable in Turkish. However, han usually denotes a commercial building or an inn situated in a town and may contain workshops as well as stores. A caravansaray is a large inn with a courtyard built expressly as a lodging.

29. The building of *külliyes* was not limited to the capital. Many structures were built in Amasya and Manisa, which were important provincial centers and served as the seats of the crown princes who were sent there as governors.

30. In Turkey Sinan is known simply as Mimar (Architect) Sinan.

31. The *-iye* suffix denotes possessor or owner; hence Selimiye translates as "of Selim."

32. The Ottoman sultans did not take legal wives after the fourteenth century. The reason is traced to the humiliation of the wife of Beyazıd by Timur in 1402 following the defeat of the Ottomans. The legal marriage of Süleyman to Hürrem Sultan was an exception, as was her capacity as a patron of architecture. Hürrem was a *haseki* (favorite) of the sultan before her marriage to him; hence she is also called Haseki Sultan in Ottoman history. The complex and the *hamam* she sponsored in İstanbul are known as "Haseki." As far as is known, no woman, except Hürrem Sultan, in the harem of a ruler sponsored a building during the lifetime of that sultan. The power in the harem quarters was concentrated in the hands of the mother of the ruling sultan. The *valide* sultan (queen mother) was traditionally a patron of the arts.

33. Aslanapa, *Turkish Art*, p. 218.

34. A mosque sponsored by a sultan can contain two or more minarets. Mosques built by a *valide* sultan generally have two minarets.

35. Evliya Çelebi, the celebrated Turkish traveler of the seventeenth century, refers to the Mosque of Mihrimah as "the *kasır* [palace] of all royal mosques."

36. Goodwin, *Ottoman Architecture*, p. 255.

37. Ogier Ghiselin de Busbecq, the sixteenth-century ambassador to the court of Süleyman, portrays Mihrimah Sultan as a strong-willed woman (*The Turkish Letters of Ogier Ghiselin de Busbecq*, trans. E. S. Forster [Oxford, 1968], p. 29 and *in passim*). A contemporary Ottoman historian, Müneccimbaşı (1631–1702), confirms this impression in his account of the events of the period (*Müneccimbaşı Ahmet Dede Tarihi*, vol. 2 [İstanbul, n.d.], p. 565.

38. Stained-glass windows were made quite differently in the Near East than in the West. Pieces of glass

were fitted to a panel of stucco on which the design was traced and cut out.

39. Various forms and sizes of fountains have become part of the city architecture in Turkey. Names of different types are: *çeşme,* fountain, often large square structures; *şadırvan,* tank of water with a jet in the middle, which is most commonly found in large mosques; *sebil,* public fountain, often placed on the corner of a *çeşme* or building; and *selsebil,* ornamental fountain.

40. Sedefkar Mehmed Ağa, also a court musician, received his nickname Sedefkar from the fact that he was an excellent worker with *sedef* (mother-of-pearl). The magnificent inlaid doors of the Blue Mosque could be the work of the architect himself.

41. The two patrons of the mosque, Kösem Mahpeyker, and her daughter-in-law, Hadice Turhan, intrigued together but more often against each other for almost a half-century. They were instrumental in the making and unmaking of the Ottoman sultans as well as vezirs. This period ruled by these two women has often been called the "Sultanate of Women" by Ottoman historians.

42. The baroque forms and tendencies found in the Mosque of Nur-u Osmaniye and in other buildings of the period are studied by Doğan Kuban, *Türk Barok Mimarisi Hakkında Bir Deneme* (İstanbul, 1954).

43. "The Sultan Mahmud I when he commissioned it [the mosque] was said to have wanted a building in the Western manner but was dissuaded from such a folly by the Ulema" (Goodwin, *Ottoman Architecture,* p. 383).

44. Halil İnalcık, *The Ottoman Empire: The Classical Age, 1300–1600* (London, 1973), p. 142.

45. Ibid.

Right: Talikizade with Hasan and the Calligrapher (detail). Talikizade, *Şahname-i Mehmed III.*

The Art of the Book

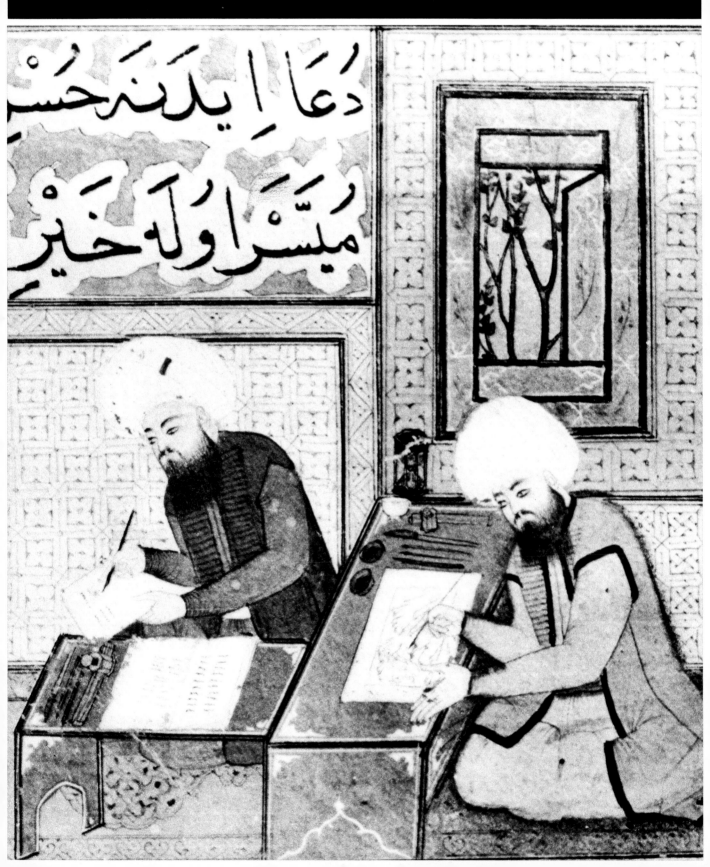

64. Entertainment of Shah Nevruz. Badi al-Din al-Tabrizi, *Dilsizname*, 1455–56.
(Oxford, Bodleian Library, Ms. Ouseley 133, fol. 80b)

THE STUDY OF Ottoman illustrated manuscripts, the most representative of the imperial arts, illuminates the creative genius as well as the social and political milieu of the Ottoman world and the patronage of its supreme ruler, the sultan. A singular work reveals not only the taste, ambitions, and achievements of its patron, but also the multifaceted social and administrative structure of its age. The morphology of the Ottoman world can be analyzed through a historical survey of its imperial manuscripts, which reflect states of development that parallel the birth, growth, height, stagnation, and ultimate decline of the empire.

The development of the art of the book, particularly of manuscript illustration, traces the life-style of a society that evolved from a classical Islamic world into one that was uniquely Ottoman and, with the eventual ingesting of Western ideologies and concepts, culminated with the foundation of the Republic. The tradition of illustrated manuscripts—the most elite and imperial branch of the arts as well as the most conservative—belongs to the Islamic-Ottoman tradition and consequently could not survive the collapse of the Ottoman Empire and the loss of royal patronage.

This analysis of the art of the book will include a preliminary discussion of the imperial academy in which the manuscripts were produced and a survey of pre-Ottoman works. The development of Ottoman manuscripts unfolds through six stages, each of which will be handled separately: the formative years under Mehmed II, Beyazıd II, and Selim I (1451–1520); the transitional period under Süleyman I and Selim II (1520–74); the classical age under Murad III and Mehmed III (1574–1603); the late classical period followed by the decline covering the entire seventeenth century; the second classicism under Ahmed III and his followers during the first half of the eighteenth century; and the final phase that extends to the Republic.

The Nakkaşhane

The patronage of the Ottoman sultans is best reflected in the illustrated manuscripts specifically commissioned for the imperial libraries. The artists of the book—including calligraphers, illuminators, painters, and bookbinders—belonged to the *nakkaşhane* (imperial studio), which was established shortly after the conquest of İstanbul by Mehmed II. The members of the *nakkaşhane* were responsible not only for the execution of books but also for the creation of designs to be utilized by artisans who worked

in other techniques and materials, such as ceramics, tiles, woodwork, carved stone, jade, metalwork, textiles, and carpets. The "period" style was first formulated in the *nakkaşhane* and subsequently employed in the other arts.

The institution of the *nakkaşhane*—or, more correctly, the *ehl-i hiref* (the community of craftsmen and artists)—was established to undertake all forms of decorative arts and crafts required by the state. It included academies for the *nakkaş* (decorator-painter), gilder, and bookbinder with their training schools and internal hierarchy. The duties of the *nakkaş* ranged from ruling marginal lines on folios (*cedvelkeş*), tracing designs, drawing, painting, and illumination to the execution of portraits of individuals (*sebihnüvis*) or of groups (*meclisnüvis*), architectural rendition (*tarrah*), and wall decoration. The *nakkaş* was also responsible for affixing the *tuğra* (imperial signature) on the *fermans* (edicts) of the sultans.

Promising young men were admitted into the training schools, graduated as assistants of established artists of the *nakkaşhane*, and eventually became masters themselves. The rank-and-file members consisted of those who grew up in the training schools as well as foreign or native-born artists who were admitted into the academy as masters. Registration of new members, determination of commensurate salaries, and advance in status were rigidly controlled by the state. As the *nakkaşhane* belonged to a subsidiary branch of the army, its members were requested to join the sultan on his campaigns, the result of which will be seen in the documentary paintings in the historical manuscripts. The superb administrative system of the *nakkaşhane* enabled it to execute a great number of manuscripts simultaneously and to maintain remarkably high standards.

The organization of the *nakkaşhane* is documented by a series of payroll registers listing the artists in order of rank and giving the salary each earned. Other archival documents provide additional material, such as the background of the artists, the date they entered the studio, the names and duties of those who worked on a particular manuscript, and records of gifts presented by the artists to the sultans on special occasions or given by the rulers to the artists in recognition of outstanding achievements. Some of these documents, which span the years between 1526 and 1797, have been published.[1] Other valuable *tezkeres* (biographies of calligraphers, illuminators, and painters) still wait to be properly studied.[2] Although there are problems in trying to match the names of the artists listed in the documents with the existing paintings, we have a fairly clear understanding of the administration and scope of the *nakkaşhane*.

There is little evidence of manuscript production in Anatolia during the rule of the Seljuks, the Türkmen emirates, and the early Ottoman periods of Bursa and Edirne. It is only after the conquest of İstanbul and the establishment of the *nakkaşhane* that an extensive and systematic production of illustrated manuscripts was undertaken. The *nakkaşhane* reached its classical age by the second half of the sixteenth century and continued to produce monumental works for a hundred years. The ensuing period of stagnation was followed by a remarkable but brief revival that took place during the first quarter of the eighteenth century. From this date onward the production of manuscripts steadily declined, coming to a halt by the end of the nineteenth century.[3]

The members of the *nakkaşhane* executed hundreds of volumes, reproducing classical Persian, Arabic, and Turkish texts devoted to theology, science, literature, and history as well as the works of contemporary authors. The most outstanding contribution of the studio is the creation of a characteristically Turkish genre: illustrated histories of the empire documenting events with historic personages and actual locations.

آنم از میانی اصحاب شهریار کرد کنغادست صلح در آغوش کلیدکه

الکه بحکم شاه جهان باز سرد و زرا نبواخت وکشت بدین قصه ختم

ای کانتی قصیده که کفتی بنام شاه هم از طریق خاطر ا و باد شتهر

تا جذ نالی از دل اتنگ رقیب او آنراکه دولتیت بروں آید ازجر

16. Entertainment of a Prince.
Katibi, *Külliyat,* ca. 1460–80.
(İstanbul, Topkapı Sarayı
Müzesi, R. 989, fol. 93a)

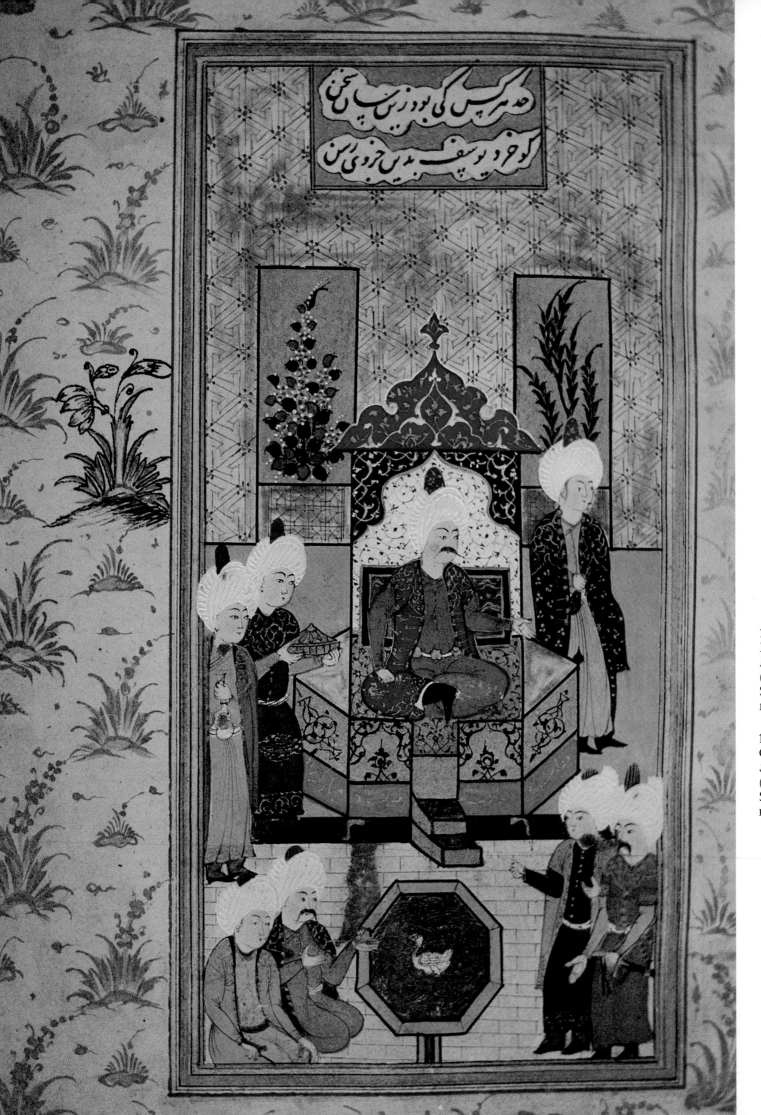

17. *Left*: A Prince Enthroned. Attar, *Mantik al-Tayr,* 1515. (İstanbul, Topkapi Sarayi Müzesi, E.H. 1512, fol. 84a)

18. *Right*: Rustam Cooking. Firdausi, *Shahname,* ca. 1535. (İstanbul, Topkapi Sarayi Müzesi, H. 1499, fol. 303a)

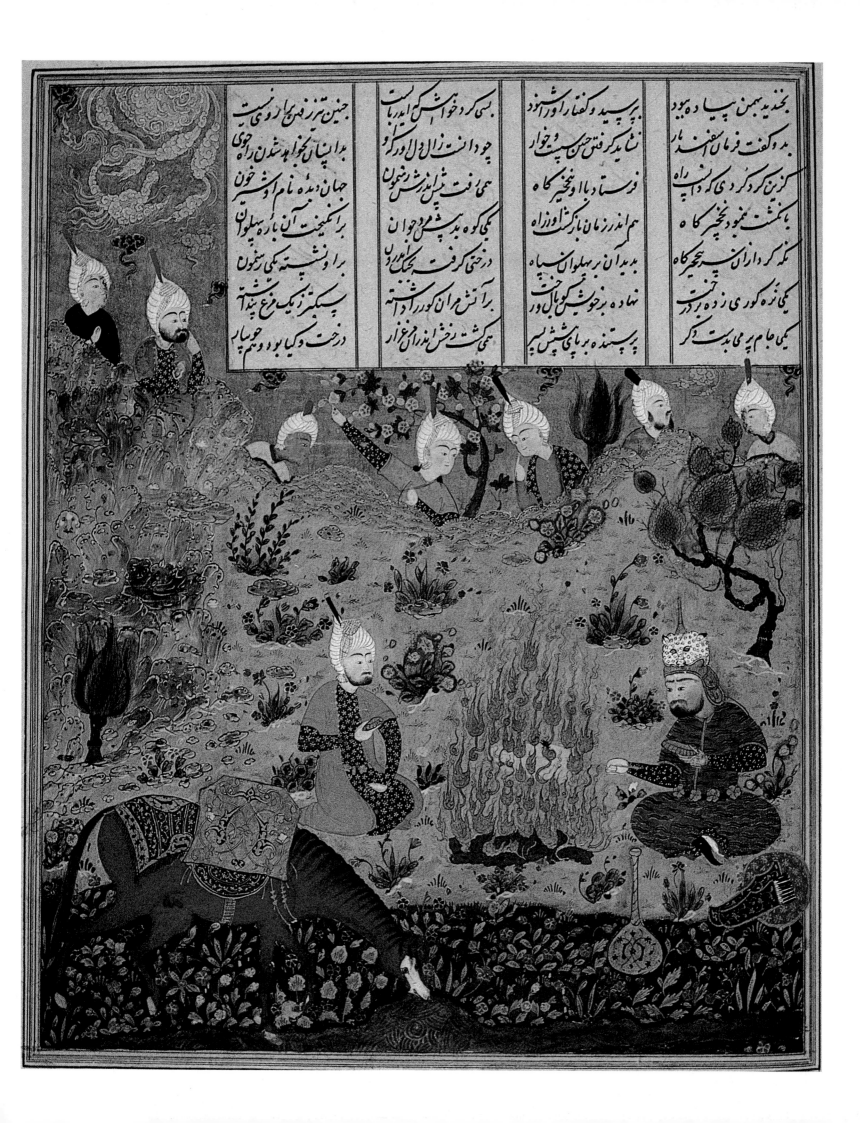

145 of 392

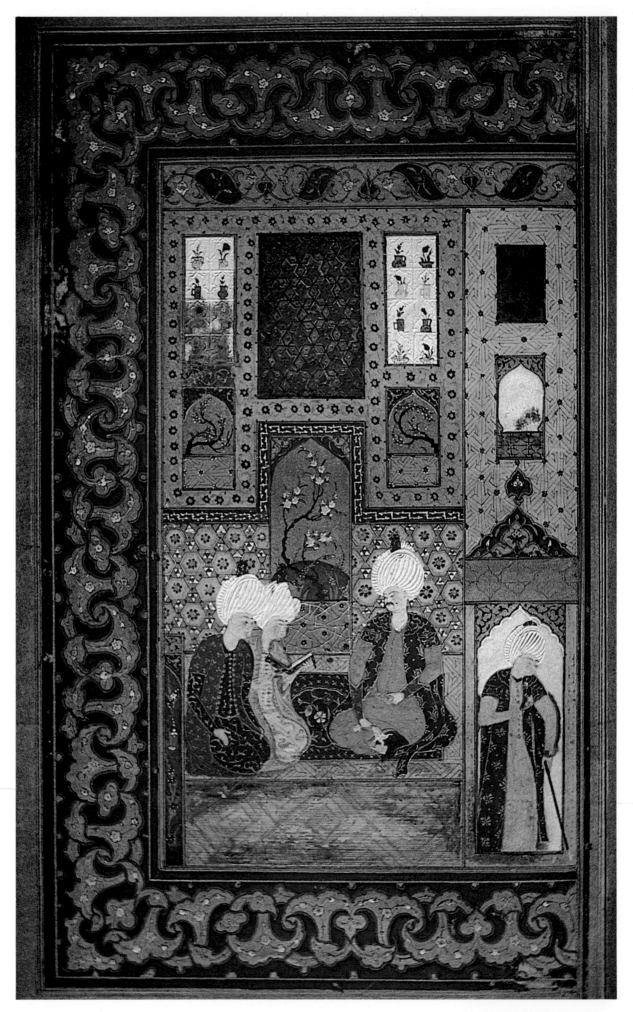

19. *Left and right:* Selim I in his Library and Hunting with his Court. Selim I, *Divan-ı Selimi,* ca. 1530–40. (İstanbul, Universite Kütüphanesi, F. 1330, fols. 27b–28a)

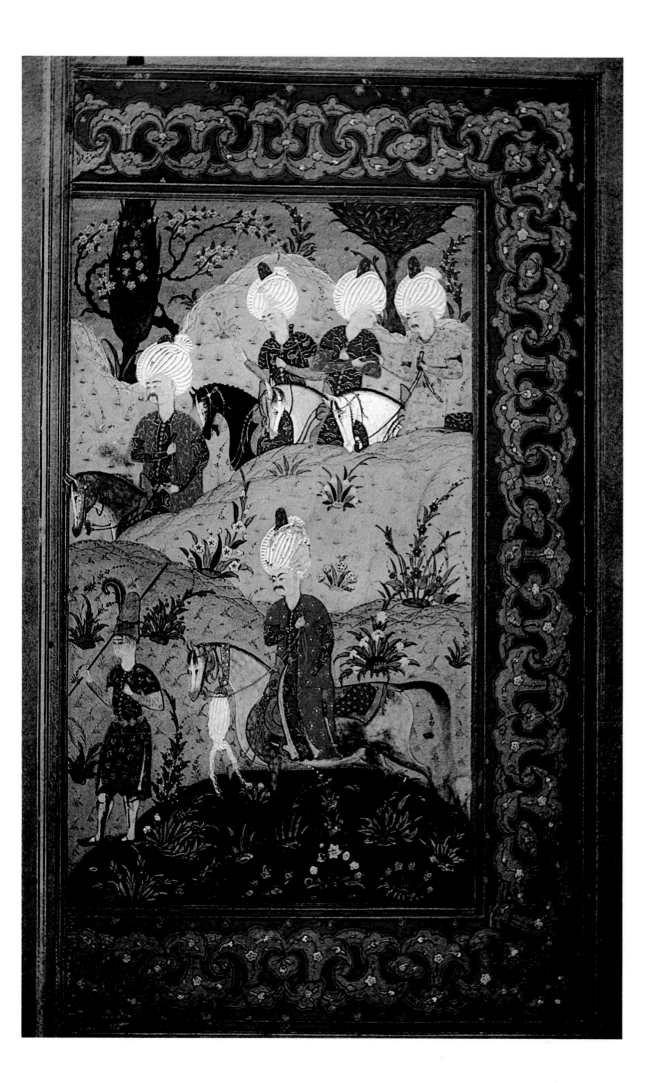

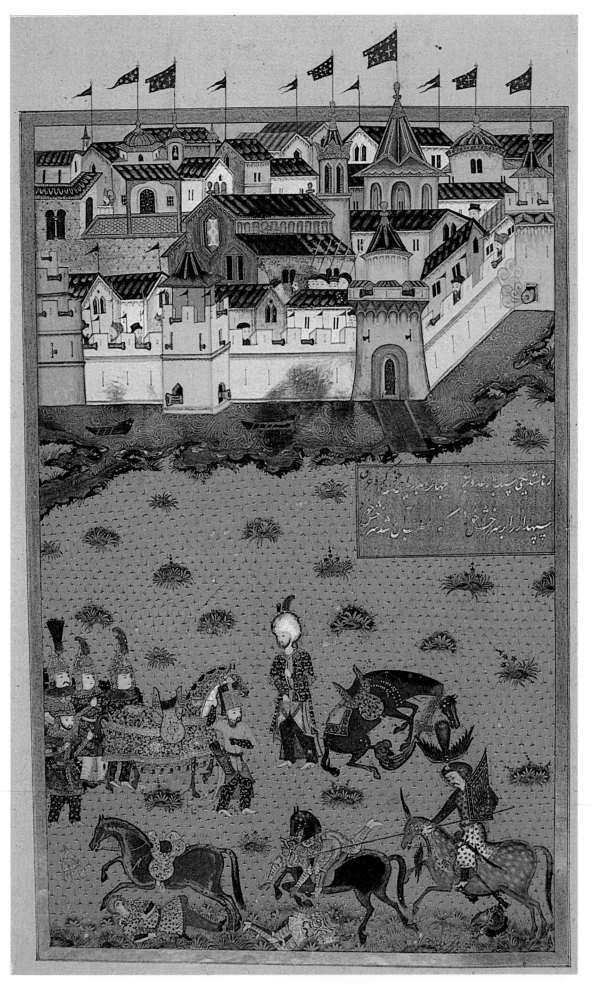

20. Siege of Temeşvar by Ahmed Paşa. Arifi, *Süleymanname*, 1558.
(İstanbul, Topkapı Sarayı Müzesi, H. 1517, fol. 533a)

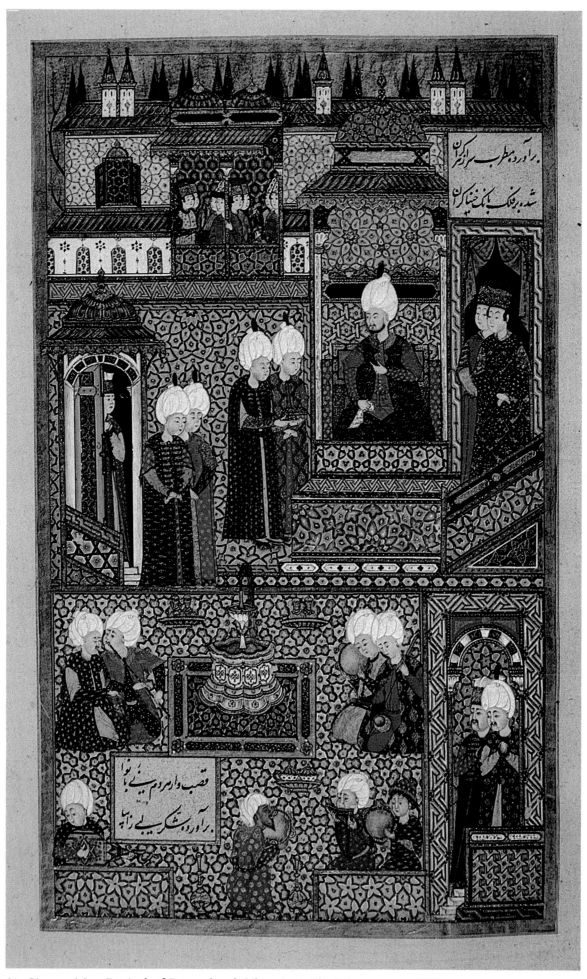

21. Circumcision Festival of Beyazıd and Cihangir. Arifi, *Süleymanname*, 1558.
(İstanbul, Topkapı Sarayı Müzesi, H. 1517, fol. 412a)

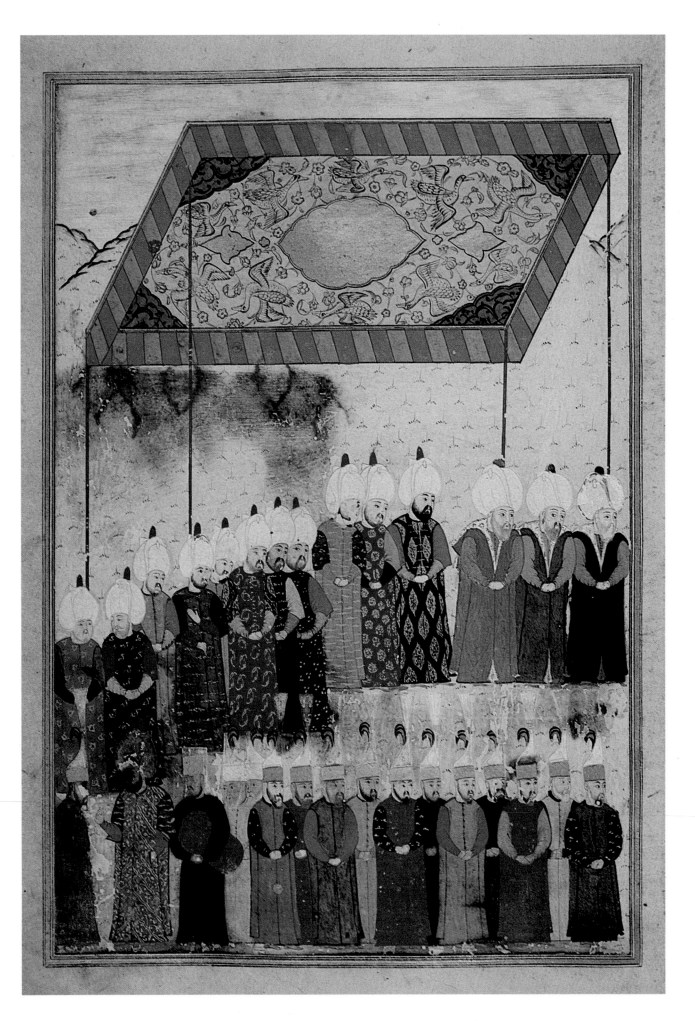

22. *Left and right:*
Accession of Selim II.
Ahmed Feridun Paşa,
*Nüzhet al-Ahbar der
Sefer-i Sigetvar,*
1568–69. (İstanbul,
Topkapı Sarayı Müzesi,
H. 1339, fols. 110b–111a)

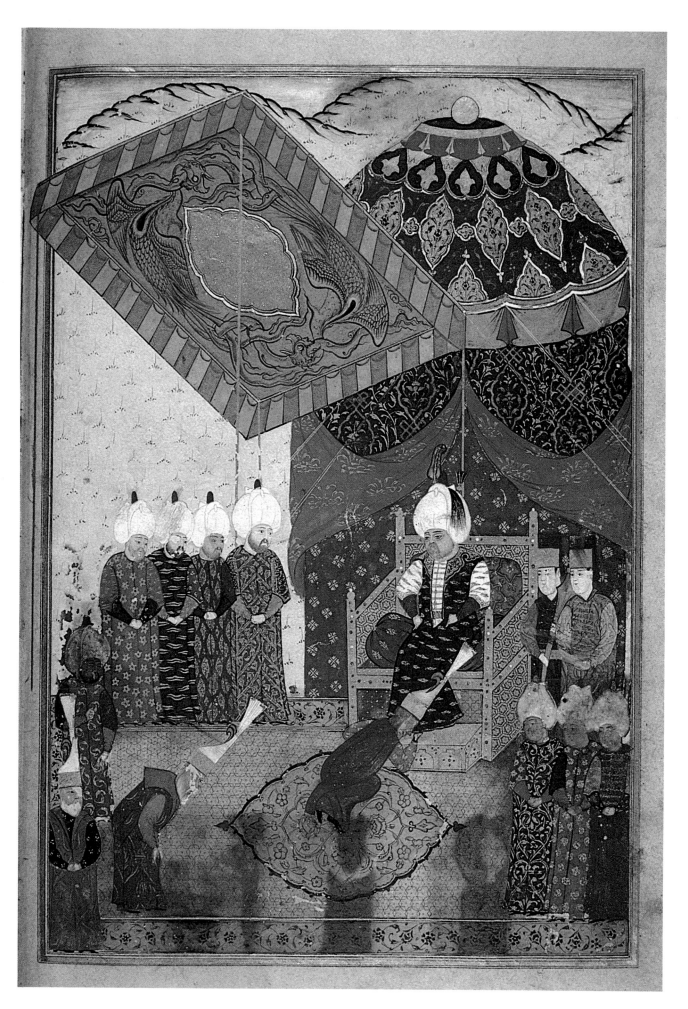

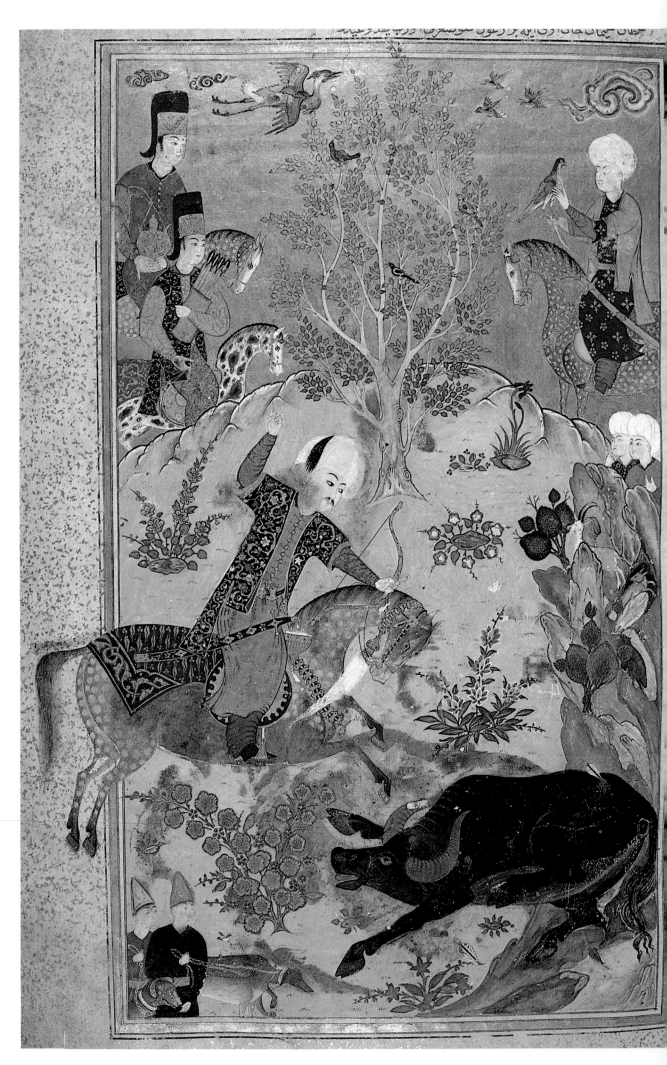

23. *Left and right:* Süleyman I
Hunting a Water Buffalo. Lokman,
Hünername, volume two, 1587–88.
(İstanbul, Topkapı Sarayı Müzesi,
H. 1524, fols. 52b–53a)

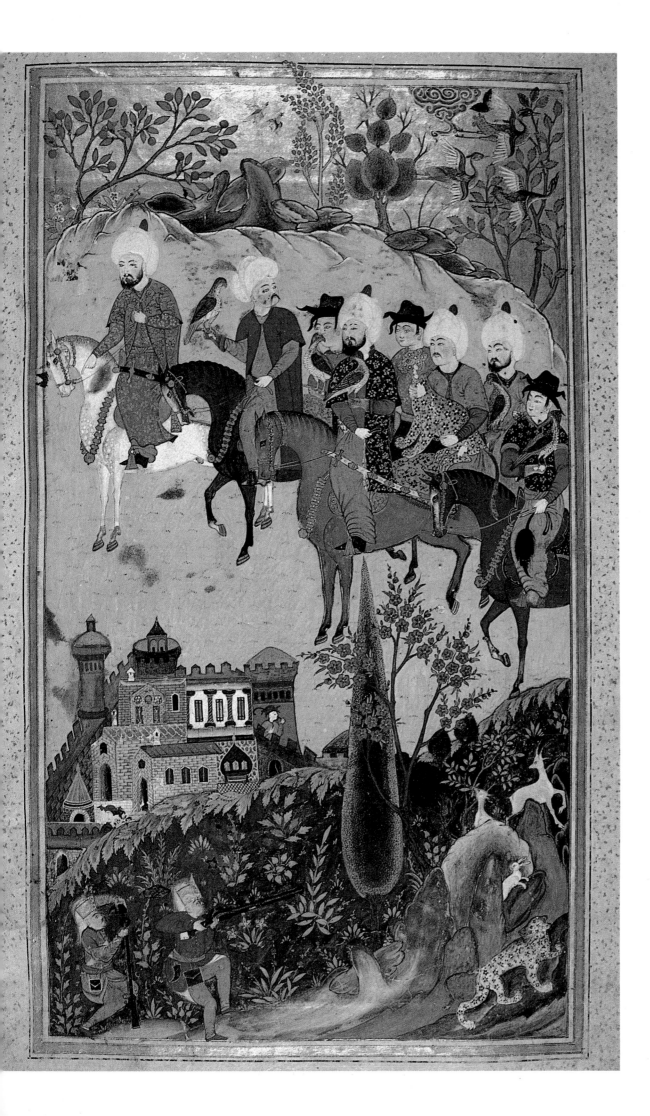

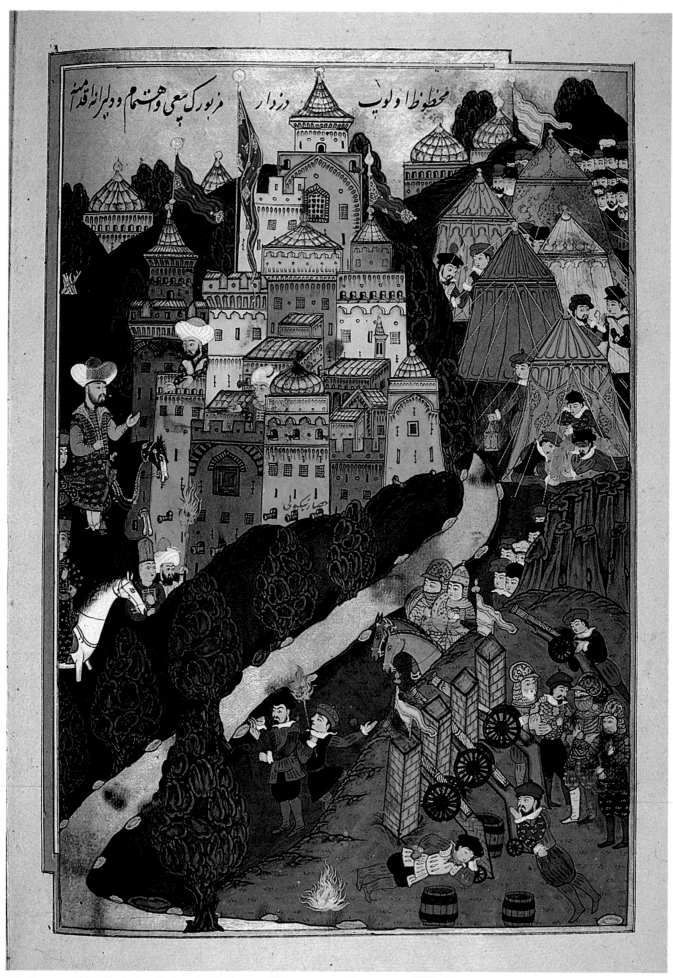

24. Rescue of Niğbolu by Beyazıd ı. Lokman, *Hünername,* volume one, 1584–85.
(İstanbul, Topkapı Sarayı Müzesi, н. 1523, fol. 108b)

In the thirteenth century the centers of manuscript production in the Islamic world were Syria and Irak, more specifically Damascus, Mosul, and Baghdad. There are extremely few works assigned to Anatolia during this period, and the surviving manuscripts appear to be isolated examples.

The oldest Anatolian manuscript is an Arabic copy of the *Kitab Suwar al-Kawakib* (Treatise on the Fixed Stars) by al-Sufi.[4] Executed in Mardin in 1134–35, the manuscript contains representations of various constellations described in the text, copied from earlier manuscripts. An original work, the *Kitab fi Marifat al-Hiyal al-Handasiya* (Book of Knowledge of Ingenious Mechanical Devices), commonly called the *Automata,* was written by al-Jazari and dedicated to Nasreddin (1201–22), the Artukid sultan of Diyarbakır. Al-Jazari's treatise, written in Arabic, is devoted to the construction of fifty mechanical devices including clocks, drinking vessels, automated pitchers and basins, fountains, and hydraulic systems. The earliest manuscript, dated 1206, was copied from the autograph of the author, who must have completed the work shortly before this date.[5] The work contains a great number of paintings that describe the general appearance of each device as well as its numerous parts. The merit of the paintings lies in the fact that they were specifically created for this text and are scientific illustrations explaining the devices.

A unique literary work, the *Varka va Gulshah,* written in verse and in Persian,[6] is attributed to Konya, since the name of the painter, Abdülmümin bin Muhammed al-Khoyi, is also found in a *vakıf* document drawn up by Celaleddin Karatay in 1253 for his *medrese* (school) in that city.[7] It is assumed that his family migrated from Khoy in Azerbayjan to Konya sometime during the second half of the twelfth century, and one of the sons, Abdülmümin, executed the paintings of the love story between Varka and Gulshah. The miniatures of the manuscript reveal the mid-thirteenth-century style of painting associated with the Mosul school of book illustration. The figural compositions with decorative motifs filling in the background reflect the impact of contemporary ceramics, particularly the luster and *minai* works executed in Anatolia (Kubadabad), Iran (Rayy and Kashan), and Syria (Rakka). The manuscript, which is undated, is assigned to the first half of the thirteenth century.[8]

plate 4 (p. 66); ills. 13, 137, 138

Another work, presented to the Seljuk sultan Giyaseddin Keyhusrev II in 1272, is the *Magical Treatise* composed by Nasreddin al-Sivasi in Kayseri.[9] The treatise, written in Persian, is devoted to astrological, occult, talismanic, and magical subjects and contains a number of representations of angels that reveal the influences of a provincial Byzantine style. Considering that the work was composed in Kayseri, the impact of local Christian art is easily understandable.

These four manuscripts—executed in Mardin, Diyarbakır, Konya, and Kayseri, spanning a period of about 150 years—are independent endeavors, using local talents and reflecting provincial styles.

The complete lack of illustrated material from the fourteenth century can be attributed to the political conditions of the land. The void in manuscript production is particularly noticeable when compared with the abundance of works executed in contemporary Iran under the Ilkhanids and the ensuing dynasties, and in Syria and Egypt under the Mamluks. This century was one of consolidation and development for the Ottoman state; its energy was directed toward territorial advance, construction of

architectural complexes, and the establishment of a phenomenal administrative system, the effect of which was felt on the artistic output of the following period.

Ottoman Manuscripts

THE FORMATIVE YEARS: 1451–1520

The first identifiable group of Ottoman paintings—consisting of three illustrated manuscripts, an album of calligraphy and drawings, and a few portraits—was executed during the reign of Mehmed II (1451–81).[10] Productivity under Beyazıd II (1481–1512) was far more extensive: close to a dozen illustrated works were made between 1490 and 1510. Only one work is assigned to the reign of Selim I (1512–20), an important period during which Iranian artists immigrated to the Ottoman court after the conquest of Tabriz in 1514.

The earliest payroll registers, dated 1526, list nine painters who entered the *nakkaşhane* during the reign of Beyazıd II, while no mention is made of those who worked for his predecessor. Among these artists were four Tabrizi masters, three of them recorded as having come with their fathers.

The stylistic features of Ottoman painting in its formative years reveal a tremendous amount of experimentation, relying on both local painters and those from the East and the West. The first production of illustrated manuscripts took place in Amasya and Edirne, important centers before the conquest of İstanbul. Amasya was a provincial capital where the Ottoman crown princes were sent to serve as governors, and its court was frequented by renowned artists and scholars. One such person was İdris Bitlisi, who dedicated to Beyazıd II his *Hasht Behist* (Eight Paradises, a history of the first eight Ottoman sultans, from Osman I to Beyazıd II) while Beyazıd was the governor of the city. Another celebrity was Şah Kuli, who came from Tabriz and lived in Amasya before joining the *nakkaşhane* in İstanbul. Illustrated manuscript production in Amasya was limited to two works, both written in Turkish by contemporary authors and illustrated by local painters.

Edirne, the capital in Thrace, was quite prolific in the production of manuscripts, its studio fully in operation during the fifteenth century. In contrast to the illustrations of contemporary Turkish texts as seen in Amasya, the artists of Edirne reproduced Persian classics, reflecting the taste of the court—a tradition to continue in İstanbul. It is the style associated with the Akkoyunlu Türkmen school of Shiraz, which dominated the output of the Edirne school. The illustrations of the manuscripts executed in İstanbul after the establishment of the *nakkaşhane* also reveal the impact of Shiraz, the late Timurid style of Herat, and the innovations of the local artists.

Before discussing the manuscripts produced during this period, the political developments of the Near East and the status of the artistic centers of Shiraz, Herat, and Tabriz should be reviewed. The schools of painting associated with these centers greatly influenced the development of Ottoman art.

During the Timurid period Shiraz had a most active studio. In the second half of the fifteenth century the city changed hands, first controlled by the Karakoyunlu (Black Sheep) Türkmens, then by the Akkoyunlu (White Sheep) Türkmens, who continued to support its painting activities. In 1503 the city was taken by Shah Ismail, a Safavid ruler. A number of the fifteenth-century manuscripts made in Shiraz were

owned by the Ottoman imperial libraries. There also must have been some Shirazi painters working in the Ottoman court, as is evident from the style of manuscripts executed in Edirne and İstanbul.

Herat, which was ruled by the Timurids, was overrun by the Uzbeks in 1507. The last Timurid sultan, Badi al-Zaman, escaped to Tabriz, the capital of the Safavids, and brought with him his treasury and court, which also included the artists and scholars of the Timurid court. In 1510 Herat was captured by Shah Ismail and became a part of the Safavid Empire.

During the fifteenth century Tabriz was the capital of the Karakoyunlus. Later, when they were defeated by the Akkoyunlus, Tabriz became the center of artistic activities under the new rulers. In 1501 the city fell to the Safavids, and the last Akkoyunlu sultan, Alvand, fled to the Ottoman court in İstanbul. In the ensuing years Tabriz was captured four times by the Ottomans. The first conquest was in 1514 by Selim I, who stayed there one week and shipped its treasury with a substantial group of artists and scholars to İstanbul. Included in this move was Badi al-Zaman, the last Timurid ruler, who was accompanied by his library and, most likely, by the members of his court. The city was taken by Süleyman I in 1534, 1538, and 1548, but by this time it was no longer the capital of the Safavids, the Iranian court having since moved to Kazvin. The conquest of Tabriz by Selim I had several beneficial effects on the *nakkaş-hane*: a large group of Iranian artists was incorporated into the imperial studio, and the rich bounty of the Tabriz libraries, including those of Herat brought by Badi al-Zaman, increased the imperial collections at the Topkapı Sarayı and provided a wealth of models for the painters.

The Age of Mehmed II

There exists only one illustrated manuscript predating the reign of Mehmed II: a copy of Ahmedi's *İskendername* (Book of Alexander the Great), executed in Amasya in 1416, a few years after the death of the author.[11] With the exception of three miniatures, its paintings were cut out from fourteenth-century Persian manuscripts and pasted into the book. The original paintings, badly damaged and extremely primitive, depict three or four riders. It is rather significant that the text was written in 1390, and an attempt was made to illustrate the work within two decades. Although qualified artists were lacking in Amasya, its library obviously had a supply of Persian manuscripts.

Another work, also executed in Amasya, is the *Cerrahiye-i İlhaniye* (Ilkhanid Surgery) of Şerafeddin, completed in 1465, during the lifetime of the author.[12] Concerned with the representation of medical cures described in the text, the images are roughly executed and repetitious. They generally show the doctor, at times accompanied by an assistant, treating a patient.

The oldest imperial manuscript dating from the reign of Mehmed II is the allegorical *Dilsizname* (Book of the Mute) of Badi al-Din al-Tabrizi, which was completed in 1455–56 in Edirne.[13] Its five paintings display a rather simplified compositional scheme and a single hand, indicating the work of a local master who was influenced by the Akkoyunlu style of Shiraz. One of the scenes represents the entertainment of a prince who ill. 64 is seated on the right, accompanied by his cupbearer, musicians, and courtiers. The figures are crammed together with a minimal indication of the setting. The blue-and-white bottle in front of the prince was obviously inspired by Chinese models, which also influenced the decoration of the tiles adorning the mosques of Edirne. plate 37 (p. 265)

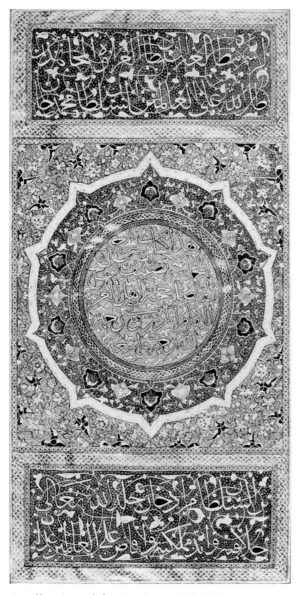

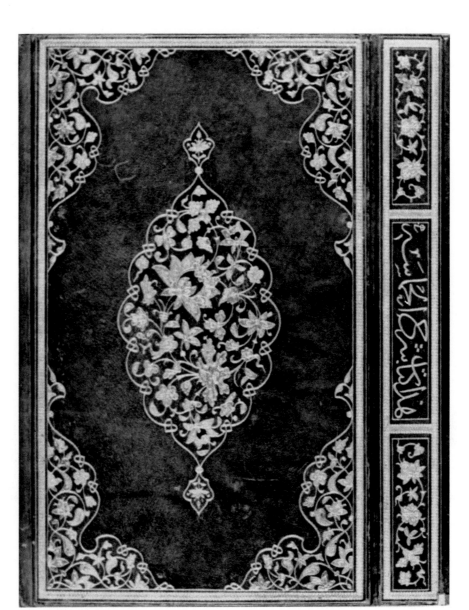

65. Illuminated frontispiece, Şerh-i Divan al-Hamasa, 1465. (İstanbul, Topkapı Sarayı Müzesi, R. 706, fol. 1a)

66. Stamped and gilded leather bookbinding. Şerh-i Divan al-Hamasa, 1465. (İstanbul, Topkapı Sarayı Müzesi, R. 706)

plate 16 (p. 141)

A fascinating work, the *Külliyat* (Complete Works) of Katibi displays similar characteristics.[14] Written in Persian, as is the *Dilsizname,* the work contains two paintings depicting enthronement scenes. One of the illustrations is spread to double folios, while the other condenses the same theme on the lower portion of a page. The latter shows the prince in the center, surrounded by a retinue of musicians, servants, and attendants. As in the previous painting, the personage sits in front of a pavilion faced with hexagonal tiles, which are turquoise-glazed with gold frames, identical to those seen in early Ottoman structures. This scene also contains blue-and-white ceramics, which were considered valuable possessions by the Ottoman sultans. The illustrations in the *Külliyat,* made by two separate painters, are the first to include the Janissaries wearing their characteristic *börks* (tall white hats). Although the work does not contain a colophon, its stylistic affinities with the *Dilsizname* suggest that it was made in Edirne, sometime between 1460 and 1480.

A number of Korans and works devoted to theological, philosophical, geographical, and literary topics were also executed during this period. The high achievement of the art of the book is seen in their exquisite illuminations, bindings, and calligraphy. The spectacular illumination of the frontispiece from an anthology copied in 1465 by Şemseddin al-Kudrisi shows a profusion of floral elements surrounding the central medallion.[15] In the panels above and below, scrolls filled with half-palmettes form the background for the script. This imperial manuscript, dedicated to Mehmed II, has a stamped and gilded bookbinding with floral motifs adorning the central medallions and corner quadrants.

ill. 65

ill. 66

Many of the motifs utilized by the artists were collected in an album containing drafts of chronograms for historical events, samples of poetry, and dedications to the sultan, which presumably were to be copied by expert calligraphers.[16] The sketches of decorative designs are of great interest since they appear on various ceramics, tiles, woodwork, stucco, and architectural paintings of the period, indicating that the *nakkaşhane* was thoroughly organized by 1481, the latest date in the album, and that its output was fully utilized by the related arts.

Although there are no surviving illustrated manuscripts executed in the new capital during the reign of Mehmed II, the court was visited by European painters whose works had a limited impact on the local artists. The influence of the Europeans on the art of İstanbul has often been exaggerated; only two artists, Costanza de Ferrara and Gentile Bellini, are actually known to have visited the capital. Ferrara made a medal of Mehmed II in 1481 and possibly a portrait in one of the albums of the Topkapı Sarayı Müzesi. Bellini was the official painter of the Republic of Venice and executed a portrait of the sultan dated November 25, 1481. However, there is doubt as to whether Bellini's work is the original or a later copy. At any rate, its date indicates that it was finished several months after the death of Mehmed II, which occurred in May 1481.

Of greater significance is the establishment of the genre of portraiture within the Ottoman world. One of the most outstanding Turkish portraits of the period is a direct copy of the work of an anonymous European artist. The portrait, held in the collections of the Freer Gallery of Art, shows a youthful artist, attired in the garments of the age, working on a painting. The model for this work, at the Gardner Museum in Boston, represents the figure with a plain pad resting on his knees.[17] Another portrait, depicting Mehmed II, in one of the İstanbul albums shows fine shading in the face and turban of the figure, reminiscent of European works.[18] However, the sultan is seated cross-legged and holds a handkerchief and a rose, true to Ottoman fashion. Establishing a prototype for Ottoman portraits, the artist has transformed the Renaissance theme into one of local tradition. This format was to be used as the model for future representations of the sultans following a revival of portraiture in the classical period, when illustrated genealogies of the rulers became popular. The impact of Westerners brought in by Mehmed II was short-lived; the future of Ottoman painting was to be along the lines of traditional Islamic manuscripts, developing its own style and iconographical features.

ill. 67

ill. 68

The Nakkaşhane under Beyazıd II

It is the literary tradition of the Edirne school that continued with the works executed under Beyazıd II. The *nakkaşhane* grew rapidly with the incorporation of Iranian artists, and great quantities of illustrated manuscripts collected in the imperial libraries were available to serve as models. One outstanding example is a copy of Assar's *Mihr u*

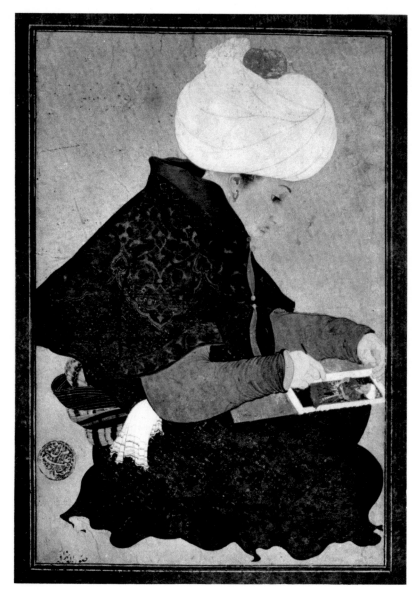

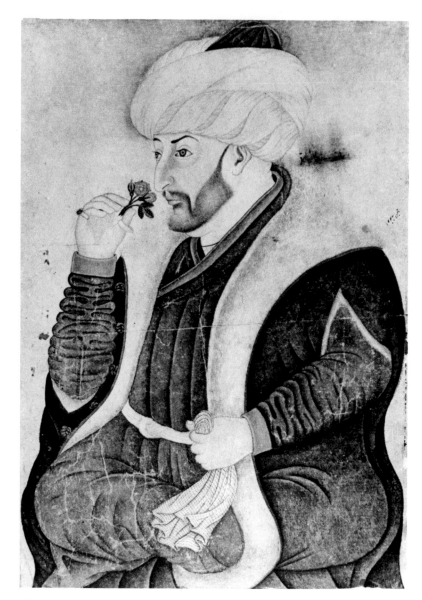

67. Portrait of a Painter, ca. 1480.
(Washington, D.C., Freer Gallery of Art, 32.28)

68. Portrait of Mehmed II, ca. 1480.
(İstanbul, Topkapı Sarayı Müzesi, H. 2153, fol. 10a)

Mushtari made for Beyazıd II in 1482 in Shiraz.[19] The manuscript, of superior quality, was likely a diplomatic gift from the Akkoyunlu sultan Yakub, who ruled both Tabriz and Shiraz at the time. The impact of both schools, either through works of art arriving in İstanbul or by the actual immigration of artists from these centers, is clearly observed in the production of the *nakkaşhane*.

The artistic milieu during the reign of Beyazıd II was highly energetic. The sultan had spent most of his life as the governor of Amasya, where he protected such scholars as İdris Bitlisi, mentioned earlier, and Şeyh Hamdullah, the celebrated calligrapher who taught his art to the sultan. Beyazıd II was not only an accomplished calligrapher and composer but also a poet, writing in Turkish and Persian under the pseudonym of Adli. When he ascended the Ottoman throne, he brought Şeyh Hamdullah to İstanbul with him. This famous calligrapher executed dozens of Korans between 1480 and 1520 and wrote the inscriptions on the mosques of Beyazıd II in İstanbul and Amasya. One of ill. 69 his Korans, dedicated to Beyazıd II in 1491, contains an illumination employing the

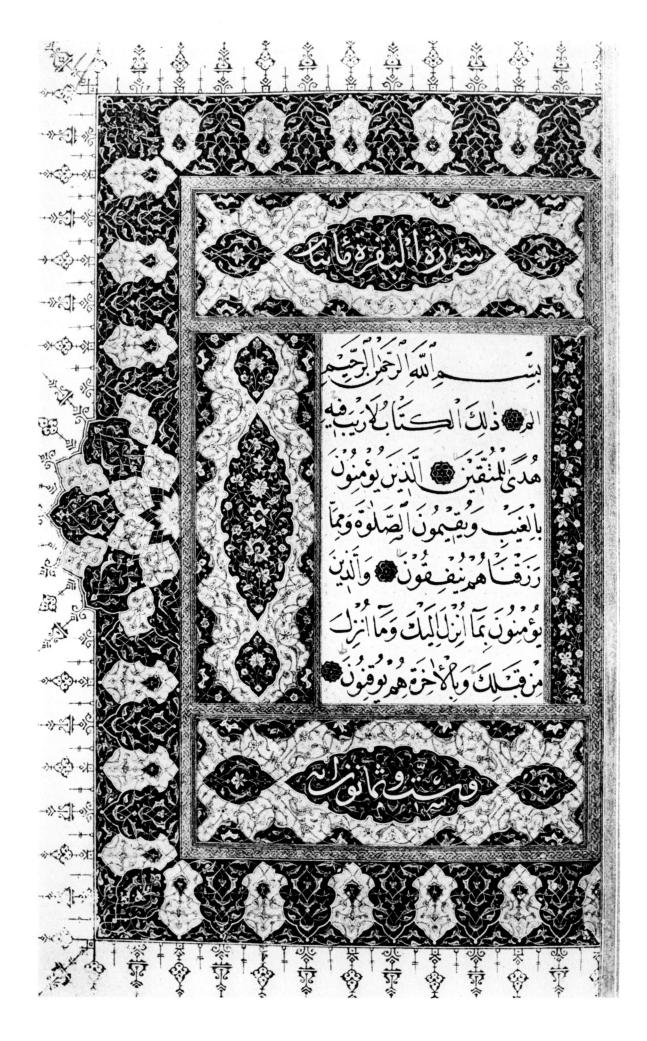

69. Illuminated frontispiece.
Koran copied by
Şeyh Hamdullah, 1491.
(İstanbul, Topkapı Sarayı
Müzesi, Y. 913, fol. 4a)

plates 39, 40 (pp. 268–69); ills. 151, 152

characteristic motifs of the age.[20] The panels surrounding the script are adorned with floral motifs that are found in the other arts, particularly in ceramics.

Şeyh Hamdullah (1429–1520), considered the most outstanding Ottoman calligrapher of all time, overshadowed the fame of another artist from Amasya, the great Yakut (died 1299), who worked for the Abbasid caliphs of Baghdad. Şeyh Hamdullah brought a new critical and aesthetic approach to the six styles of cursive script defined by his predecessor: thuluth (*sülüs*), naskhi (*nesih*), *muhakkak, reyhani, tevki*, and *rikaa*. Although the official documents were written in a uniquely Ottoman script, called *divani*, secular works were copied in *talik* (or *nastalik*) and *naskhi*. The other types of writing, including the angular kufic, were generally reserved for chapter headings or samples of calligraphy found in albums, executed to reveal the virtuosity of the artist.

Among the artists recorded in the archives dating from the reign of Beyazıd II, the most outstanding name is Hasan bin Abdülcelil, the *nakkaşbaşı*, or head of the studio (active 1505–36, *nakkaşbaşı* 1510–36), who also held that position under Selim I and Süleyman I. He is most likely the same person who illuminated a Koran dedicated to the sultan in 1503–4, also written by Şeyh Hamdullah.[21] Unfortunately the other artists recorded in the archives of this period cannot be identified with existing works, and the names of the calligraphers appearing in the colophons of the illustrated manuscripts are not listed in the existing documents.

The earliest dated manuscript from the reign of Beyazıd II is a copy of the Persian translation of Bidpai's *Kalila va Dimna*.[22] The colophon indicates that it was copied in İstanbul by Davud İnebazarlı in 1495. Its seven miniatures reveal the hands of two artists: one was rather primitive, his figures and landscape elements haphazardly placed on the folios, and the other worked in a style reminiscent of the Akkoyunlu school of Shiraz. Yet the clusters of flowers, some in full bloom and others in bud formation, that are depicted resemble the floral motifs used in the manuscript illuminations and blue-and-white pottery of the period.

The next dated manuscript, also written in Persian, is the *Khamsa* (Quintet) of Amir Khosrau Dihlavi, copied in 1498 by Mahmud Mir al-Hacı.[23] It contains twenty-six illustrations, most of which echo the late Herat style. A group of seven paintings, depicting the pavilion scenes from the Bahram Gur cycle, is highly unusual and stylistically alien to the Iranian schools. These paintings contain basilical buildings with strange buttresses, columns, and arches; structures that rise to four stories; octagonal buildings with large domes flanked by smaller ones; and arches opening into panoramic vistas with figures seen at a distance. One of the best examples represents Bahram Gur in

ill. 70

the White Pavilion. Tiny figures and trees appear through the open arches, conveying a feeling of distance and depth. The use of perspective in the structure also enhances this impression. The hand of the painter who executed these scenes resembles that of one of the artists of the *Külliyat* of Katibi, revealing a unique style and an attempt to depict rational structures, possibly based on an actual observation. The appearance of a predominant and uniquely conceived architectural background suggests the beginning of an indigenous Ottoman tradition that was to develop fully by the 1550s.

The combination of Akkoyunlu and local Ottoman styles is also seen in the seven paintings executed in 1498–99 for Hatifi's *Khosrau va Shirin*.[24] This work, written in Persian, has a particularly interesting double frontispiece that represents the enthroned ruler accompanied by characteristically Ottoman figures. On the right two *silahdar ağas* (imperial sword-bearers) stand behind Khosrau while opposite are the Janissaries, vezirs, and other members of the court represented in traditional Turkish costumes.

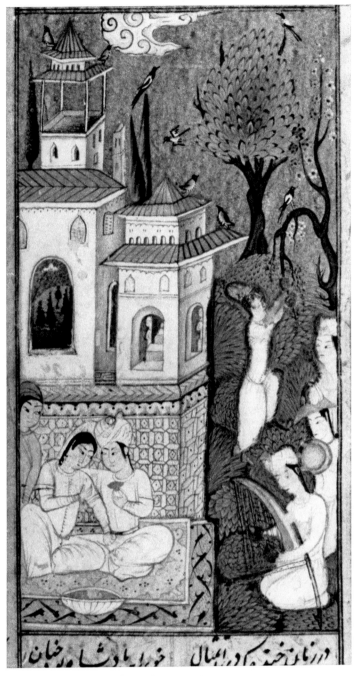

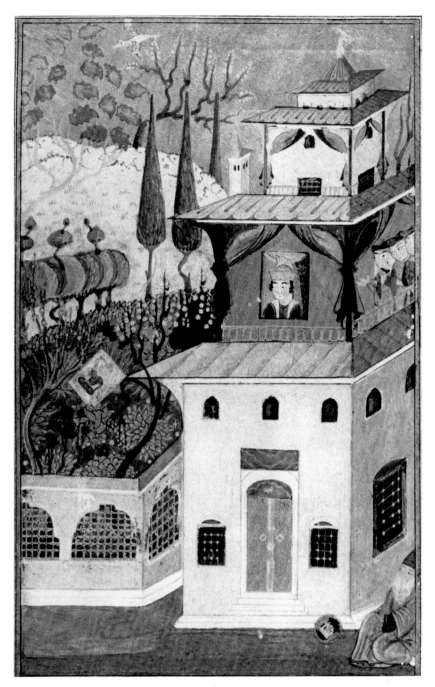

70. Bahram Gur in the White Pavilion.
Amir Khosrau Dihlavi, *Khamsa,* 1498.
(İstanbul, Topkapı Sarayı Müzesi, H. 799, fol. 196a)

71. Shirin Sees Khosrau's Portrait.
Hatifi, *Khosrau va Shirin,* 1498–99.
(New York, Metropolitan Museum of Art, 69.27, fol. 22b)

In the scene depicting Shirin seeing Khosrau's portrait the artist reveals an interest ill. 71
in architectural perspective similar to that noted in the *Khamsa* and attempts to represent
spatial values by drawing receding masses of trees and figures. Certain details of the
structure—such as the grilled windows, marble panels on the door, and broken arches
in the garden enclosure—are directly taken from contemporary architecture.

A Turkish version of the same story, called the *Husrev ve Şirin,* written by Şeyhi,
was copied in 1499 by Halil bin Abdullah Edirnevi.[25] Its fifteen paintings exhibit the
same features, depicting structures with arched openings below domical roofs. The
fascination with the representation of local architecture is also seen in an undated copy

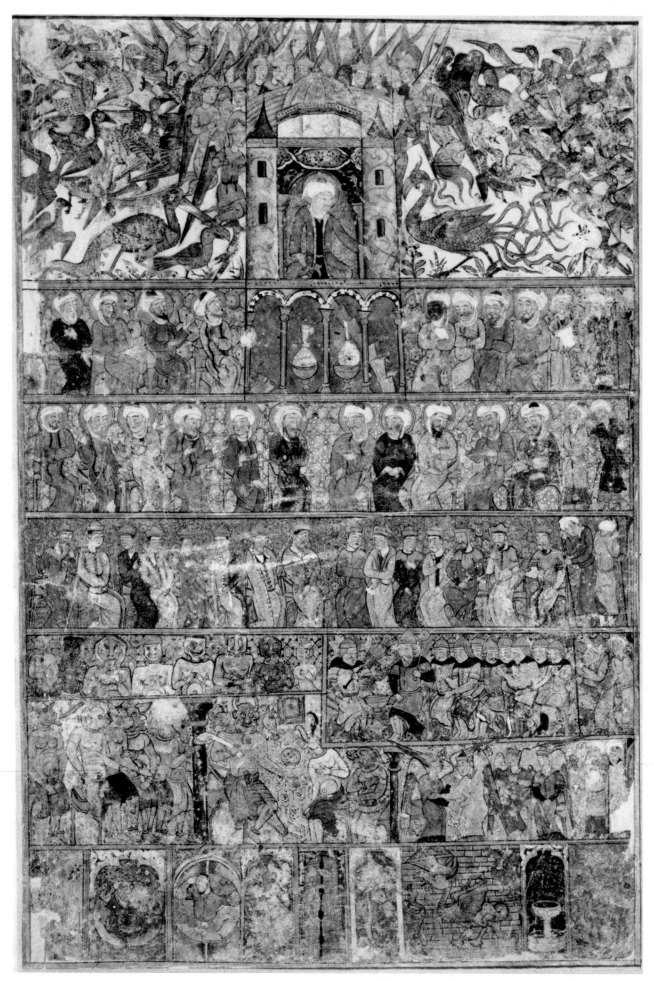

72. Solomon Enthroned. Uzun Firdevsi, *Süleymanname,* ca. 1500.
(Dublin, Chester Beatty Library, Ms. 406, fol. 1b)

of Uzun Firdevsi's Turkish work, the *Süleymanname* (Book of Solomon), which was dedicated to Beyazıd II.[26] The double frontispiece consists of five or six horizontal rows, above which are two domed pavilions with arched openings under which the personages sit. The structure on the right half, representing Solomon and his court, has two towers flanking the arched opening, which recalls the second gate of the Topkapı Sarayı, the Bab üs-Selam (Gate of Salutations) built by Mehmed II. The ruler, surrounded by angels and birds, is seated above several registers in which learned figures, kings, warriors, demons, and angels are placed. The iconography of the scene, which contains fantastic creatures and astrological symbols, has yet to be solved.

The love story of Khosrau (Husrev) and Shirin (Şirin), written either in Persian by Hatifi or in Turkish by Şeyhi, appears to have been most popular between 1490 and 1500, its pictorial cycle definitely in the repertoire of the *nakkaşhane*. Three undated works attributed to circa 1500 show a variation in quality but nevertheless exhibit the stylistic features of the decade. The best example, unfortunately badly damaged, contains five paintings of exquisite quality, while the remaining two have fairly simplified compositions.[27]

Following the imperial quality of the damaged manuscript is a small copy of Attar's *Mantik al-Tayr* (Language of the Birds) with three miniatures.[28] The work is rather remarkable in that one of the scenes—representing the king with the thorn-gatherer—depicts oversize tulips and carnations in the foreground, the very same flowers that characterize mid-sixteenth-century polychrome pottery. A similar feature, this time several tulips, makes an appearance in a single page from a Nizami manuscript, which represents Layla and Majnun.[29] Here, the popular Turkish flower is accompanied by an Ottoman structure. Once again the creative force of Ottoman design originated from the *nakkaşhane*, first appearing in manuscripts and eventually influencing the other arts.

The purest Akkoyunlu Shiraz influence appears in a work dated 1500–1501, the *İskendername* of Ahmedi.[30] The figures, landscape elements, and compositional devices are typical of contemporary Shiraz painting. No doubt an artist from that city executed the work after he joined the İstanbul studio. His work is quite rough in quality and unimaginative, particularly when compared with the paintings in a second copy of Attar's *Mantik al-Tayr* dated 1515, the only known manuscript executed during the reign of Selim I.[31] It contains sixteen paintings spread to double folios, utilizing an extensive horizontal development that became very popular during the classical period. The personage in a scene depicting the enthronement of a ruler was obviously meant to portray Selim I, showing his characteristic long and drooping mustache. The high quality of the paintings in this truly imperial manuscript indicates the hand of a master from Iran. The fact that it was executed a year after the Ottoman conquest of Tabriz strongly suggests that the paintings were by one of the artists brought back by Selim I. Floral marginal ornaments adorn each folio, and the text, placed within a white contour band on a gold ground, is written in a fine *nastalik*. The refined drawing of figures with voluminous white *kavuks* (turbans), lush landscape settings, and highly detailed architectural backgrounds characterize the style that was to dominate the *nakkaşhane* for the next forty years.

plate 17 (p. 142)

The age of Beyazıd II is important for the development of the İstanbul school of painting. Copying traditional literary works and relying on existing Iranian models, the *nakkaşhane* incorporated the stylistic features of Shiraz and Herat together with the unique attempts of the local painters. Although the predominant impact is from the East,

Beyazıd II is known to have followed the Western interests of his father. For instance, he is said to have invited Michelangelo to İstanbul, but as an engineer and not as a painter; and the Florentine scholar Francesco Berlinghieri dedicated his *Geographia* to the sultan.

Beyazıd's interest in the future of the *nakkaşhane* is evident from the fact that even as a governor in Amasya he supported painting activities, and the famous "Fatih" albums in İstanbul were originally compiled during his reign. The *nakkaşhane*, established by Mehmed II, began its most significant production under the patronage of Beyazıd II. It was in the next fifty years, between 1520 and 1570, that the imperial studios began to assimilate the Eastern and local elements and develop an indigenous Ottoman style.

Beyazıd II was also responsible for the earliest illustrated contemporary history within the Ottoman world. The *Şahname-i Melik Ümmi* (Book of Kings by Melik Ümmi), which covers the events between 1481 and 1497, was copied and illuminated by Derviş Mahmud bin Abdullah.[32] Although rather poor in quality, its seven miniatures are the first attempts to illustrate contemporary events. Dated about 1500, the paintings are thought to have been done by an artist who was trained in Shiraz, since the scenes of enthronement, battle, hunting, and entertainment follow established Akkoyunlu prototypes.

The post of the *şahnameci* (the writer of a *şahname*, or book of kings) was established by Mehmed II. However, no illustrated histories of the sultans written by official court biographers exist until the following period. The work of Melik Ümmi, an unknown historian, cannot be considered a truly Ottoman *şahname*, but merely an illustrated history of a brief period. Its significance lies in the fact that it narrates and illustrates contemporary personages and events. It also emphasizes the patronage of the sultan and his interest in documentary historical works.

Selim I, who appears to have been too busy with his eastern campaigns to concentrate on the *nakkaşhane*, nevertheless contributed immensely to the growth of the studio. It was through his conquest of Tabriz that numerous painters were added to the imperial ateliers of İstanbul. The abundance of Iranian artists coming to the *nakkaşhane* from Herat by way of Tabriz, from Tabriz proper, and from Shiraz—together with the private libraries of the last Akkoyunlu and Timurid rulers, and those of the Safavids brought in by Selim I—resulted in the tremendous burst of creative energy observed in the ensuing period.

THE TRANSITIONAL PERIOD: 1520–74

The abundance of paintings produced in this period is astonishing—more than fifty illustrated works are known to have been executed in İstanbul. Three-fourths of these works are devoted to literary subjects; the remaining manuscripts describe contemporary historic events, determining the genre of illustrated Ottoman historiography. Most of the manuscripts were produced under the patronage of Süleyman I (1520–66), the greatest figure in Ottoman history. His son, Selim II (1566–74), continued to support the activities of the *nakkaşhane*, which by 1570 had reached its golden age.

The first group of manuscripts—those depicting literary subjects—is significant in revealing the eclecticism of the *nakkaşhane*. They incorporate the works of artists who were trained in diverse traditions, including those of Timurid-Herat and Akkoyunlu-Shiraz, and at times reflect the contemporary Safavid styles of Tabriz and Shiraz. Beside the Eastern influence is the local Ottoman genre, which becomes predominant by the middle of the sixteenth century. Many manuscripts were the products of all those

artists who worked in the *nakkaşhane*, and a single volume often contains scenes made by artists from Herat, Tabriz, Shiraz, or İstanbul, as well as paintings showing the combined efforts of two or more different hands.

The earliest recorded payroll registers date from this period and confirm the heterogeneous nature of the studio. The first register, dated 1526, lists forty-one members, including twenty-nine masters and twelve apprentices. Among the masters are six artists from Tabriz and three listed as *acem*, which means from Iran. Several artists are recorded as having been sent to the Edirne studio, indicating that the former capital was still active in the production of manuscripts.

A second payroll register, dated 1545, includes fifty-nine members who are divided into two groups: twenty-four masters and twenty apprentices listed under *bölük-i rumiyan*, and eleven masters and four apprentices under *bölük-i aceman*. The distinction between the groups is rather vague and appears to have been based on the background of the artists as well as on the length of their residence in the studio. The *rumiyan* group, interpreted as meaning from the western portions of the Ottoman Empire, contains a number of painters who had been in the studio for some years. Included in the group are artists from Bosnia, Albania, Hungary, Austria, and Moldavia as well as from Georgia and Circassia. The masters in the *aceman* section are exclusively from Tabriz, although their apprentices are of mixed backgrounds. *Aceman* may refer not only to the Iranians but also to the non-Iranian natives of Iran, such as the Shiite Turks from Azerbayjan. A contemporary document lists the names of sixteen masters from Tabriz and includes a notation stating that these painters had twenty-three apprentices—also from Tabriz—who were equally talented.

The third register of the period, dated 1558, contains twenty-six members in the *rumiyan* group together with seven apprentices. Another list, drawn the same year, names twenty-six *rumiyan* and nine *aceman* painters with four apprentices. This is the last time the division into two groups occurs. The registers of the following years use only the term *nakkaşhan-ı hassa* (imperial painters) for the masters and apprentices. It appears that the *rumiyan* and *aceman* groups were consolidated in the classical period, forming a homogeneous unit that is clearly reflected in the style of the paintings executed after the 1560s. Even though scores of artists are listed in the archival documents of the age, only a handful of names appears in the manuscripts. Most of these belong to calligraphers and illuminators, the identification of the painters remaining unsolved.

The abundance of literary manuscripts executed in this period includes copies of such classic Persian works as the *Masnavi, Divan,* and *Tuhfet al-Ahrar* (Rarities of the Free) of Jami; the *Khamsa* of Nizami; the *Bustan* (Orchard) of Sadi; the *Guy u Chogan* (Ball and Mallet) of Arifi; the *Shahname* of Firdausi; and the *Divans* of Khojandi, Shahi, and Hafiz, plus several anthologies.

Among the Turkish classics are the *Husrev ve Şirin* of Şeyhi; the *Divan* and *Hamsa* of Ali Şir Nevai; the *Şeybanname;* the *Divan* of Ulvi Çelebi; the *Yusuf ve Züleyha* of Hamdi Çelebi; the *Camaspname* of Musa Abdi; translations of Firdausi's work, the *Tercüme-i Şahname;* and possibly the oldest copy of the *Hadikat üs-Süada* (Garden of the Fortunates, a history of martyrs) of Fuzuli, most likely executed during the lifetime of the great mystic. In this period we also have manuscripts devoted to the poetry of the reigning sultans, including an illustrated copy of the *Divan* of Selim I, who used the pseudonym Selimi; and the works of Süleyman I, who wrote under the name Muhibbi.

Although each literary work merits close examination and analysis to determine the artistic milieu of the period, the scope of this study means the discussions must

be limited to a few representative manuscripts. The most direct Iranian influence occurs in the manuscripts executed by artists trained in Tabriz and by the local painters who worked with them. At times it is difficult to determine whether a particular manuscript was executed in Tabriz and brought to İstanbul, or was the product of Iranian masters residing at the *nakkaşhane*. Since archival documents list dozens of artists from Tabriz, it is generally assumed that many of these works were made in İstanbul. Moreover, the Tabriz style at the turn of the century was quite diverse, showing a blend of imported late Herat style—which in turn reveals several different schools—and of local Akkoyunlu features.[33] Several manuscripts—such as the *Divans* of Nevai and Jami, the *Khamsa* of Nizami, the *Husrev ve Şirin* of Şeyhi, and the *Shahname* of Firdausi, executed between 1520 and 1540—show the purest Tabriz style.[34] The quality of execution differs slightly in each work, and the paintings reveal the influences of Timurid and Akkoyunlu styles as well as contemporary Safavid schools. For example, the enthronement

ill. 73

scene, which appears on the right portion of the double frontispiece to Jami's *Divan*, dated around 1520, cannot be distinguished from similar paintings executed in Tabriz about the same year. In another example—a painting depicting Rustam roasting meat,

plate 18 (p. 143)

from a *Shahname* of circa 1535—the figures and landscape elements are identical to those found in Safavid manuscripts. There is no doubt that both scenes were executed by the Iranian masters in the *nakkaşhane*. Although the former artist is more traditional, following Timurid and Akkoyunlu features, the latter works in the contemporary style and includes the tall red batons used on Safavid turbans.

A number of illustrated manuscripts combine local Ottoman features with those of Tabriz. One outstanding example is the *Hamsa* of Nevai, copied in 1530–31 by Pir Ahmed bin İskender.[35] The work contains sixteen paintings in a unique style, depicting local architectural types with domed and tiled pavilions. One of the paintings employs a

ill. 74

compositional scheme frequently repeated later in the classical period: a camp with its tents placed in the foreground while a fortress rises behind a series of hills in the background. The artist depicts the death of Ferhad as ordered by the Husrev in a most unconventional manner, creating an original composition while relying on Iranian models for the landscape. The receding planes and the inclusion of the fortress in the distance point to the beginning of an indigenous Ottoman school of painting. The interacting and combined efforts of native and Tabrizi artists are also found in the earliest illustrated Turkish translation of Firdausi's *Shahname*, attributed to the 1530s.[36]

ill. 75

Zahhak and Feridun are shown in an unusual structure composed of several units. The broken arches, tiled walls, and domes on hexagonal drums are closely related to local architecture.

A third group of manuscripts reveals the stylistic features of artists trained in the Akkoyunlu and Safavid schools of Shiraz, as seen in two copies of Nizami's *Khamsa* attributed to about 1540.[37] One interesting work, a *Shahname* executed in Shiraz in 1495, contains a double frontispiece, which was added in İstanbul around 1550. Another Akkoyunlu manuscript, containing both the *Shahname* and the *Khamsa* (dated 1497 and 1500, respectively), was repainted at the Ottoman court by artists who combined the features of Tabriz with those of Shiraz, further complicating the determination of the provenance of the works.[38]

The characteristic style of the literary works of the age successfully blends foreign and native elements, revealing a highly decorative concept of representation. The figures, often shown with long and drooping black mustaches, wear voluminous *kavuks* and are placed against richly detailed landscape or architectural settings. This style,

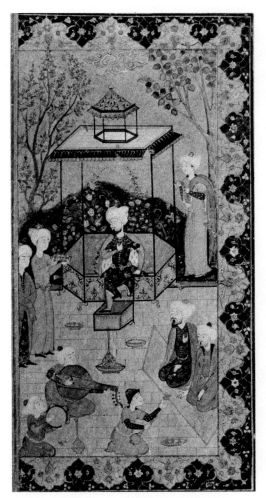

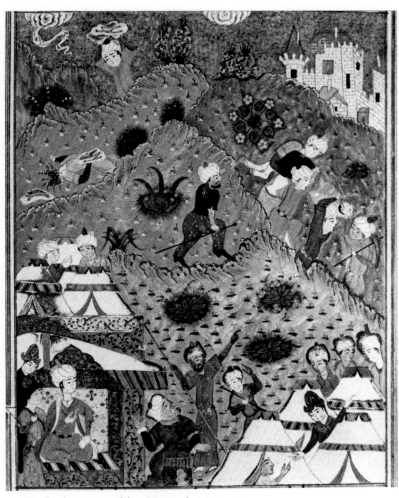

73. A Prince Enthroned. Jami, *Divan*,
ca. 1520. (İstanbul, Topkapı Sarayı
Müzesi, H. 987, fol. 1b)

74. Ferhad Captured by Husrev's Men.
Ali Şir Nevai, *Hamsa*, 1530–31.
(İstanbul, Topkapı Sarayı Müzesi, H. 802, fol. 99a)

which dominates the years between 1520 and 1560, was first seen in the *Mantik al-Tayr* of 1515. It appears in a number of manuscripts in the Topkapı Sarayı Müzesi: the *Tuhfat al-Ahrar* of Jami; the *Divans* of Shahi, Nevai, and Hafız; the *Guy u Chogan* of Arifi; and a translation of the *Shahname*.[39] Two anthologies in Dublin also reveal the same features.[40] The last group of paintings executed in this style appears in the remaining two volumes of Arifi's *Şahname-i Al-i Osman*, called the *Osmanname* and *Süleymanname*, which will be discussed later.

The best examples are found in the *Divan-ı Selimi*, a collection of Persian poems written by Selim I and copied around 1530–40 by Şahsuvari Selimi.[41] This imperial manuscript contains two pairs of paintings, placed on facing folios, depicting the sultan hunting, riding, or reading in his library. The work is of spectacular quality, each folio adorned with gold marginal drawings and minute paintings showing angels or fantastic creatures. The painting of Selim I in his library has an elaborate architectural setting plate 19 (p. 144–45) with colorful tiles and paintings adorning the walls. The tile revetment contains hexagonal and triangular units, while the wall painting depicts tulips, carnations, and roses in jugs and vases. Both features are representative of the ceramic production of the decade. The garments of the figures show the current fashion of the age, a short-sleeved coat over a kaftan. The scene on the facing page portrays the sultan riding with members of his staff. Depth is attempted by painting each of the four planes, or hills, in varying colors; the foremost is the deepest in tone and the others decrease in value

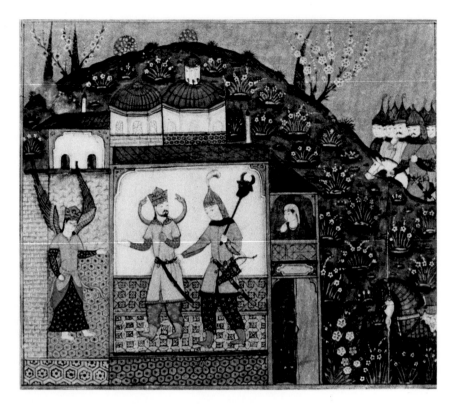

75. Zahhak and Feridun. *Tercüme-i
Şahname,* ca. 1530. (İstanbul, Topkapı
Sarayı Müzesi, H. 1116, fol. 14b)

76. A Prince Enthroned. *Tercüme-i
Şahname,* ca. 1560–70. (İstanbul, Top-
kapı Sarayı Müzesi, H. 1522, fol. 494b)

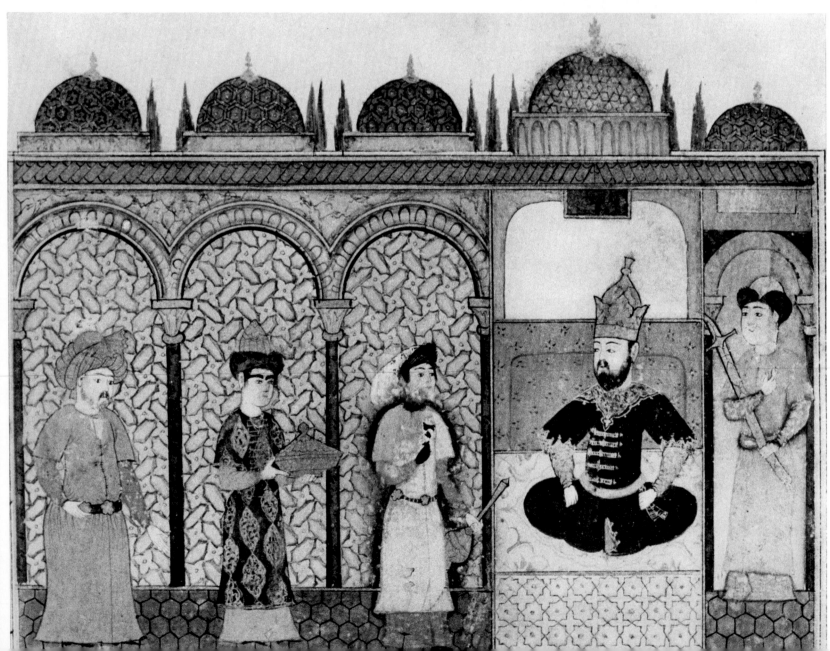

until the palest hill appears against the gold sky. A similar movement occurs in the facing folio with twisting branches laden with blossoms seen silhouetted against the gold sky through the open windows. The artist obviously had great talent, his work befitting such an imperial manuscript.

Among the literary works produced in the *nakkaşhane* were Turkish classics executed by local artists, such as Musa Abdi's *Camaspname*, the earliest illustrated copy of Fuzuli's *Hadikat üs-Süada* mentioned earlier, and Şeyhi's *Husrev ve Şirin*.[42] It is with these works, in which contemporary costumes and settings are depicted, that the classical Ottoman style begins to evolve.[43] These features are particularly noticeable in a copy of the *Ter-cüme-i Şahname*, dated about 1560–70. It contains fifty-five illustrations, the earliest paintings attributed to the celebrated master Osman, who will be discussed in the next section.[44] The scenes include structures and figures clearly identifiable as Ottoman; for instance, the personages attending an enthroned ruler are attired in the Turkish fashion, and the domed arcade in the background recalls the Bab üs-Saadet portion of the Topkapı Sarayı, in front of which took place all the accession ceremonies of the Ottoman sultans.

ill. 76

The most outstanding achievement of the transitional period is the establishment of a documentary genre devoted to Ottoman history and the development of illustrated works narrating the activities of the sultans. With the exception of the *Şahname-i Melik Ümmi*, executed for Beyazıd II, the second earliest work in this genre is Şükrü Bitlisi's *Selimname*, covering the reign of Selim I.[45] Showing Akkoyunlu and Timurid influences, the work contains scenes representing the historic events of the period, such as the meeting of the sultan with his father, the funeral of Beyazıd II, the accession of Selim I, his victories against the Safavids and the Mamluks, his reception of Badi al-Zaman, and finally his death. The personages of the Ottoman world—the vezirs, the Janissaries, and other members of the armed forces—are clearly represented. One of the scenes illustrates the celebrated battle of Çaldıran, which led to the conquest of Tabriz. It shows the Safavids on the left, wearing their characteristic turbans; opposite are the Ottoman forces with the Janissaries in the foreground.

ill. 77

The first painting in the *Selimname* depicts the author, Şükrü, together with two anonymous calligraphers, an unusual group portrait that was to recur in later historical manuscripts. This scene is the left portion of a double frontispiece; the facing folio, which is lost, most likely portrayed Selim I attended by his court. The placement of the artists of the book next to the representation of the sultan, who is not only the protagonist of the work but also its patron, is indicative of the importance given to the members of the *nakkaşhane*. Although the twenty-four paintings of the *Selimname*, dated around 1525, do not create new compositional schemes, they are significant in attempting to illustrate contemporary events involving historic personages.

One group of historical manuscripts depicts only the geographical sites of the Ottoman world and is devoid of figural representation. This topographical genre, blending architectural features with the fauna and flora of the region, is also seen in the well-known map of the New World that was copied in 1513 by Piri Reis from the lost version originally used by Christopher Columbus. It is with the 128 paintings of the *Beyan-ı Menazil-i Sefer-i Irakeyn* (Descriptions of the Halting Stations during the Irakeyn Campaign), written and illustrated by Nasuh al-Silahi al-Matraki in 1537, that the style fully develops.[46] Devoted to the 1534–35 campaigns of Sultan Süleyman in Irak and western Iran, the work describes the cities en route, giving more detailed information on those where the army halted. The accuracy of Matraki's illustrations is

remarkable, documenting many buildings and complexes that no longer exist. Obviously the artist accompanied the army, writing and sketching as he traveled from one site to another.

ill. 78 The view of İstanbul executed by Matraki is one of the oldest in existence. The Galata section, on the left, is enclosed by fortifications and depicts the famous Galata Tower. Across the Golden Horn, on the right, is the old city of İstanbul with the Topkapı Sarayı. The mosques of Aya Sofya, Beyazıd II, and Mehmed II; the Old Palace; the At Meydanı (ancient Hippodrome); the Bedesten (Covered Market); and many other structures are clearly identifiable. Many of these monuments reappear in the historical

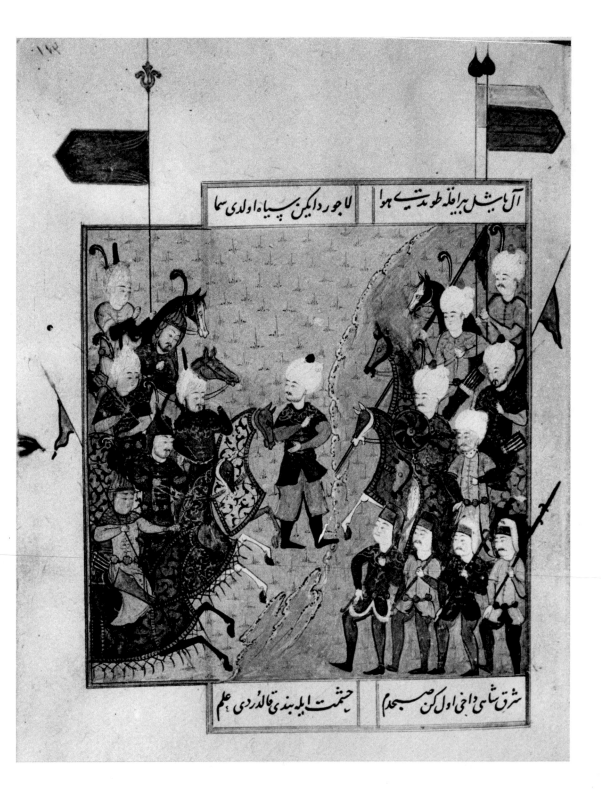

77. Battle between the Safavids and the Ottomans. Şükrü, *Selimname,* ca. 1525. (İstanbul, Topkapı Sarayı Müzesi, H. 1597–98, fol. 113a)

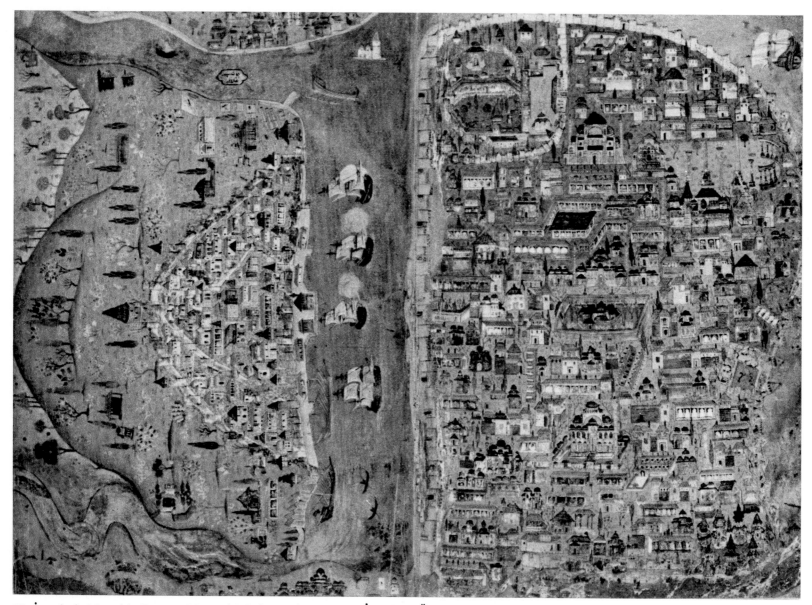

78. İstanbul. Matraki, *Beyan-ı Menazil-i Sefer-i Irakeyn*, 1537. (İstanbul, Üniversite, Kütüphanesi, T. 5964, fols. 8b–9a)

works of the classical period. There exist two related manuscripts: One is the *Tarih-i Sultan Beyazıd*, describing the events that took place between Beyazıd II and his brother Cem as well as the conquests of the age;[47] and the other is the *Süleymanname* (also called the *Tarih-i Feth-i Siklos, Estergon ve Estonibelgrad*), devoted to the 1532 campaigns of both Süleyman I in Hungary and of the Grand Admiral Barbaros Hayreddin Paşa in the Mediterranean.[48] One of the scenes in the latter work depicts Genoa, its port filled with ships, its shores lined with residential and administrative buildings. Walls surrounded the inner city and the large fortress overlooking the bay. The rhythmic flow of the sails of the fleet in the foreground forms a pleasant contrast to the static structures of the city. Both works possess a documentary value, depicting cities and ports with their buildings and ships, revealing an acute observation and a precise representation of the regions described.

ill. 79

The first monumental work illustrating the history of the Ottoman dynasty is the *Şahname-i Al-i Osman* (Book of Kings of the Family of Osman), written by Arifi (died 1561–62), the official court biographer. When the post was created by Mehmed II, the first court biographer, Şehdi, was commissioned to write the history of the

Ottoman dynasty, the *Tarih-i Al-i Osman*, but there is no proof that he fulfilled this task. His successor, Arifi, was the first *şahnameci* whose work was illustrated. He was formerly the *nişancı* (affixer of seals) of the governor of Shirvan, Elkas Mirza, who was the brother of Shah Tahmasp, the Safavid ruler of Iran. Elkas Mirza sought the protection of Süleyman after an unsuccessful rebellion against the shah and arrived in İstanbul with his court in 1547. As a result of Elkas Mirza's immigration to the Ottoman capital, several members of his retinue, such as Arifi and Eflatun, joined the imperial studios. Eflatun (died 1569) followed Arifi as the *şahnameci*, but there are no illustrated works written by him.

It is recorded that when Süleyman read the first 30,000 verses of Arifi's *Şahname-i Al-i Osman*, he was greatly impressed and set up a special group of calligraphers and painters to work on the manuscript. The personal interest and support of the sultan was not in vain since the last book, the *Süleymanname*, is a monumental work, worthy of his patronage both in quality and in originality.

It is significant that at this time the famous *Shahname* of Firdausi, an epic history of Iran written in the tenth century, was being translated and illustrated in the imperial studios. The interest in this work most likely encouraged the creation of a similar epic on the history of the Turks. The *Şahname-i Al-i Osman* was not only written in Persian, following the meter of Firdausi's work, but it also contained the same number of verses.

Arifi's *Şahname-i Al-i Osman* was originally written in five volumes; the first three, which are lost, most likely contained the genealogy of the Ottomans, beginning with Adam.[49] The fourth volume, called the *Osmanname*, copied by Mirza Hui-i Şirazi, covers the events from the reign of Osman I to Beyazıd I, up to the year 1402, when the battle of Ankara took place.[50] This incomplete work contains thirty-four illustrations executed by a single hand around 1550. The style of the paintings falls within the group discussed earlier, seen in the *Mantik al-Tayr* and the *Divans* of Shahi, Nevai, and Selimi. The fifth and last volume, the *Süleymanname*, copied by Ali bin Emir Bey Şirvani in 1558, covers the period from the accession of Süleyman I in 1520 to 1558, eight years before his death.[51] Its sixty-nine paintings reveal the hands of five separate painters. Most of the scenes, some spread to double folios, are the creation of a local master who singlehandedly determined the course of Ottoman painting; working with him was a European responsible for the representation of Western figures and settings. Twenty-three scenes were executed by the same hand as the illustrations of the *Osmanname*. And remaining paintings were made by two artists who follow the midsixteenth-century styles of Tabriz and Kazvin.

The most outstanding contribution of the master painter of the *Süleymanname* is the depiction of the actual settings of the events, including the personages and ceremonial procedures of the period. The first painting in the manuscript, spread to double folios, depicts the sultan enthroned in front of the Bab üs-Saadet (Gate of Felicity) in the second court of the Topkapı Sarayı, the precise location at which all the accession ceremonies took place. On the right, Süleyman is receiving the homage of a vezir flanked by his *iç ağas* (personal servants) and grand vezir. Three other vezirs, the *şeyhülislam* (head of state religion) and two members of his staff, the *kazaskers* (chief judicial officers) of Rumelia and Anatolia, appear on the far left. Other ministers and military officers wait in line, attended by the Janissaries, all forming a circular composition in the center of which are a pair of imperial ushers. The opposite folio represents the first court with guests arriving at the Bab-ı Hümayun (Imperial Gate) and gathering into the courtyard before entering through the Bab üs-Selam (Gate of Salutations), which leads into the

plates 17, 19 (pp. 142, 144–45)

ill. 80

ills. 32, 33

second court. Each figure in the painting is identifiable by his costume and placement; the composition illuminates the complex and hierarchic administrative system of the empire.

Another scene, representing the siege of Belgrade, shows the sultan enthroned in the imperial *otak* (tent) in front of the camp set up outside the fortress. Belgrade was conquered by the Ottomans in 1521, a year after the accession of Süleyman. The meticulous details in architectural representation as well as in the types and costumes of the Hungarians reveal the acute observation of the painter who must have joined the campaign as a member of the *nakkaşhane*, which was a part of the military system.

ill. 81

The same precision in representing the setting occurs in a painting depicting the conquest of Temeşvar by the commander Ahmed Paşa. The spectacular fortress appears in the background with a moat encircling the fortified city, its walls defended by soldiers and cannons. In the foreground a *delil* (soldier of the forward attack force), with huge wings on his head, spears an enemy. Immediately above is a vignette in which the horse of the commander Ahmed Paşa is beheaded by a direct hit from a cannon and Ahmed's aides bring him a new mount. In a superb manner the master of the *Süley-*

plate 20 (p. 146)

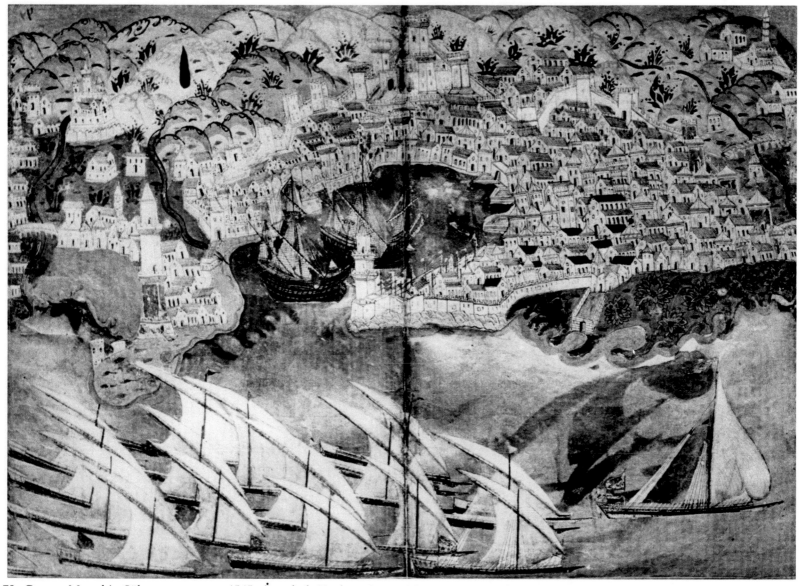

79. Genoa. Matraki, *Süleymanname,* ca. 1545. (İstanbul, Topkapı Sarayı Müzesi, H. 1608, fols. 32b–33a)

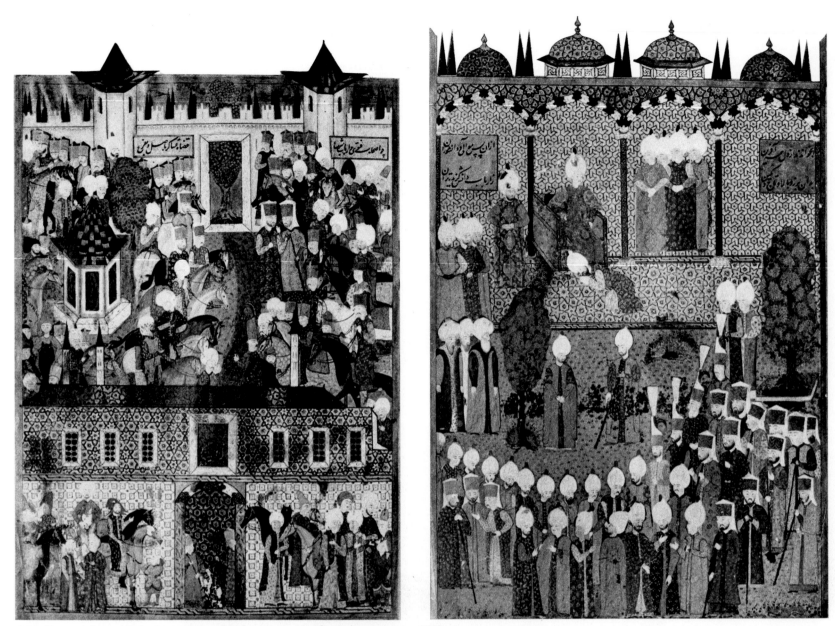

80. *Above right and left:* Accession of Süleyman ɪ. Arifi, *Süleymanname,* 1558.
(İstanbul, Topkapı Sarayı Müzesi, ʜ. 1517, fols. 17b–18a)

manname combines three different features of this battle: a general view of Temeşvar, a symbolic victory, and a specific event that occurred during the siege. The integration of a narrative episode not only enlivens the painting but also gives it historical validity.

The paintings of this work depict all the military conquests of the age as well as ceremonial and social activities, including receptions of Iranian, Austrian, and French ambassadors; historic figures, such as Devlet Giray Han, the ruler of the Crimean Tatars; Sadrazam İbrahim Paşa, the grand vezir; Barbaros Hayreddin Paşa, the grand admiral; and intimate and genre episodes showing the sultan conversing or hunting with his sons. One of the most interesting illustrations represents the collection of taxes and the registration of the *devşirme* (tribute children). On the left, an officer counts the revenue from taxes, while his assistant registers the children who appear in the foreground attired in their new red garments and carry bags holding their only possessions. The event is observed by the parents as well as by the priest whose duty was to prepare a list of the eligible children. The Western figures and architectural setting included in

ill. 82

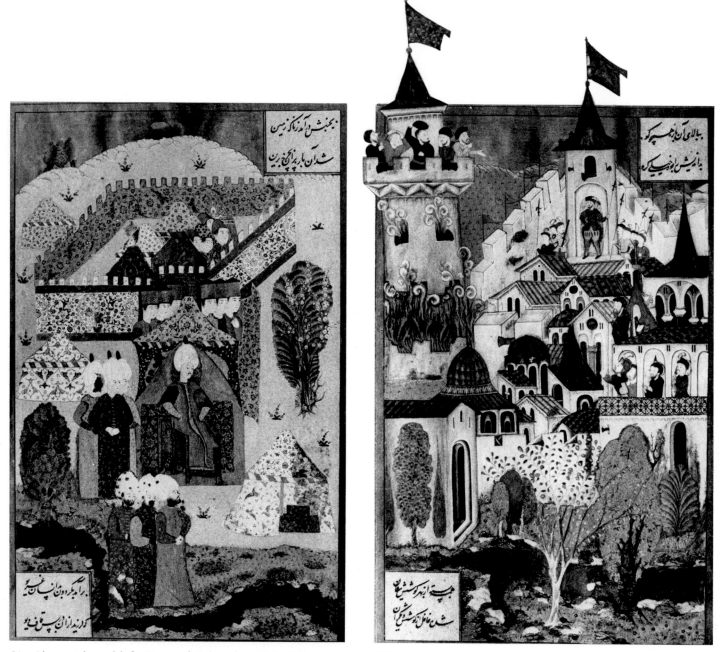

81. *Above right and left:* Siege of Belgrade. Arifi, *Süleymanname,* 1558.
(İstanbul, Topkapı Sarayı Müzesi, H. 1517, fol. 108b–109a)

this scene are attributed to a Hungarian artist called Pervane who is recorded in the archives and collaborated with the master on several paintings.

The illustration of the reception of Elkas Mirza by the sultan belongs to the hand of the conservative painter of the studio who works in the style first seen in the *Mantik al-Tayr* of 1515. The setting is highly decorative, and each unit is embellished with varying motifs, forming almost a mosaic of patterns and colors. This decorative style was soon to be replaced by the new concept of documentary realism instigated by the master of the *Süleymanname*. The representation of an episode from a circumcision festival arranged in honor of two princes, Beyazıd and Cihangir, is one of the paintings by this master. The setting is more structural although elaborately detailed. In the foreground a Janissary and a *kapıcı* (gatekeeper) guard the entrance of the complex, which has a central courtyard in which several musicians play around a fountain. Süleyman sits in a domed pavilion accompanied by his two *silahdars*. He is receiving a jeweled box presented by two youthful servants while another pair stands by. Immediately behind them are steps leading to the inner chambers of the Harem (private domain of the

ill. 83

plate 17 (p. 142)

plate 21 (p. 147)

imperial family). A *kapıcı* peers through the half-open door while several servants appear in the balcony of the Harem units in the background, giving a feeling of depth and distance to the scene.

The *Süleymanname* is significant not only because it is a befitting memorial to its patron but also because it had a long-lasting impact on the tradition of Ottoman painting, establishing the models for future scenes depicting accessions of the sultans, receptions of dignitaries, parades in the city, battles in remote lands, and foreign campaigns with the army surrounding a fortified city. Similar features appear in the seven paintings of the *Futuhat-ı Cemile* (Admirable Conquests), which narrates Süleyman's conquests in 1551 of Temeşvar, Pecs, Lipva, and Eğri (Erlau) in Hungary.[52] This work, dated 1557, appears to have been the first major manuscript of the master whose style flourishes in the *Süleymanname*.[53]

The spectacular *Nüzhet al-Ahbar der Sefer-i Sigetvar* (Chronicle of the Szigetvar Campaign), written in Turkish by Ahmed Feridun Paşa, is devoted to events that took place during the last two years of Süleyman's reign, including his death during the siege of Szigetvar and the accession of the new sultan, Selim II.[54] Completed in 1568–69, its twenty miniatures reveal that the genre of illustrated Ottoman historiography was by then fully established, and its formative and transitional years over. Glorious conquests with the Ottoman armies surrounding the fortified cities are represented in detail, further developing Matraki's topographic descriptions. The monumental enthronement scenes—showing the hierarchy of the empire, each personage attired in the garments of his rank and placed in accordance with Ottoman court protocol—reflect the impact of the *Süleymanname*.

ill. 84

The representation of Szigetvar is spread to double folios, in the center of which is the triple fortress protected by a moat. The city is completely surrounded by the Ottomans; in the foreground is the imperial *otak* while the tent for the grand vezir appears on the upper right. The attack has started with Ottoman artillery shooting at the city. The topography of the land and the physical description of the city show the journalistic concern of the artist who depicted both general and specific aspects of the event.

plate 22 (pp. 148–49)

The depiction of the accession of Selim II follows the ovoid composition established in the *Süleymanname*. Only the essential elements of the theme are given, without the complexity seen in the previous example. Selim II, accompanied by Sadrazam Sokollu Mehmed Paşa, two vezirs, and his *silahdars*, sits in front of a magnificent tent, receiving the homage of an officer. The leading members of the ulema and administrative and military bodies of the state wait their turn on the opposite folio. There is a remarkable portraitlike quality in the figure of the sultan.

The illustrations of the *Sefer-i Sigetvar*, which also describe the events and personages in their proper settings, are attributed to Osman, the most renowned painter of the classical period. His name appears in a number of archival documents dated between 1581 and 1596 as well as in several manuscripts executed in the 1570s and 1580s.[55]

ill. 76

Osman's style, which made an appearance in the *Tercüme-i Şahname* of circa 1560–70, was to dominate the second half of the sixteenth century, its vestiges to be found as late as the 1620s.

Another painter who was active during the reigns of Süleyman I and Selim II is Haydar Reis, known as Nigari (1494–1574). He executed portraits of his two patrons and of Barbaros Hayreddin Paşa which appear in albums. Nigari's portrait of Süleyman I

ill. 85

shows the sultan walking through a garden, attended by two *silahdars*. The subject is represented with stark realism, the heavy burden of years of responsibility, advanced

37

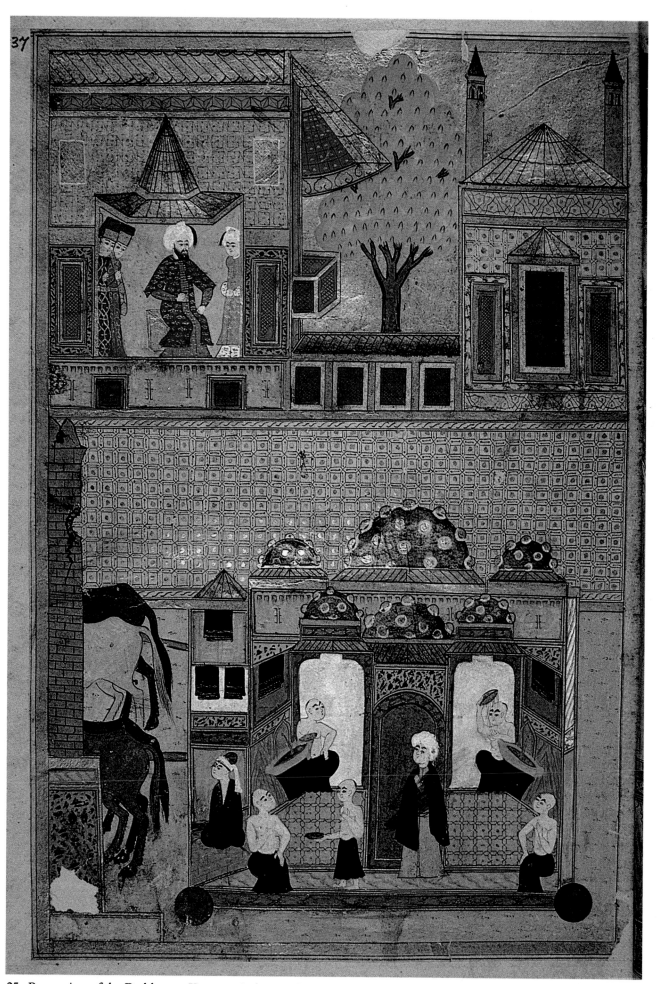

25. Procession of the Bathhouse-Keepers. Lokman, *Surname,* ca. 1582.
(İstanbul, Topkapı Sarayı Müzesi, H. 1344, fol. 337a)

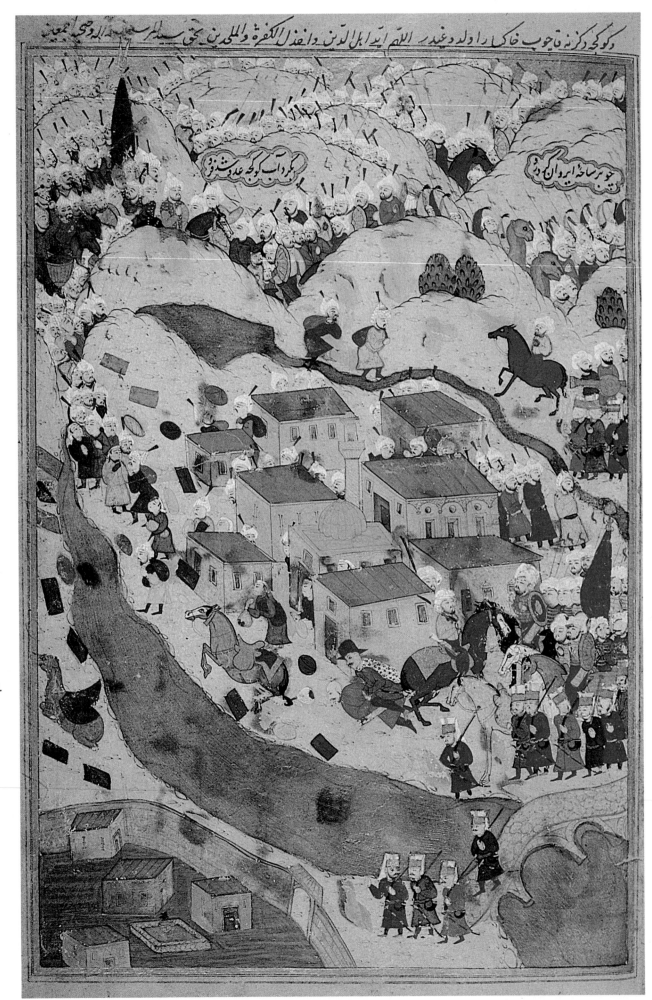

26. *Left and right:*
Conquest of Revan
by Ferhad Paşa. Lokman,
Şahınşahname, volume two, 1592.
(İstanbul, Topkapı Sarayı
Müzesi, в. 200, fols.
110b–111a)

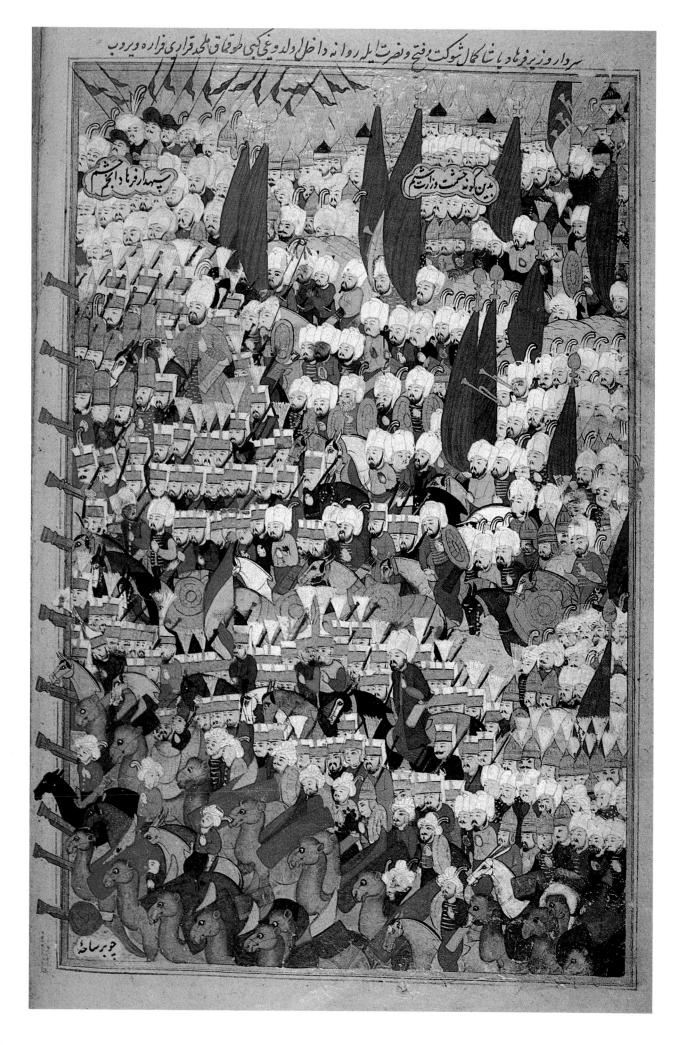

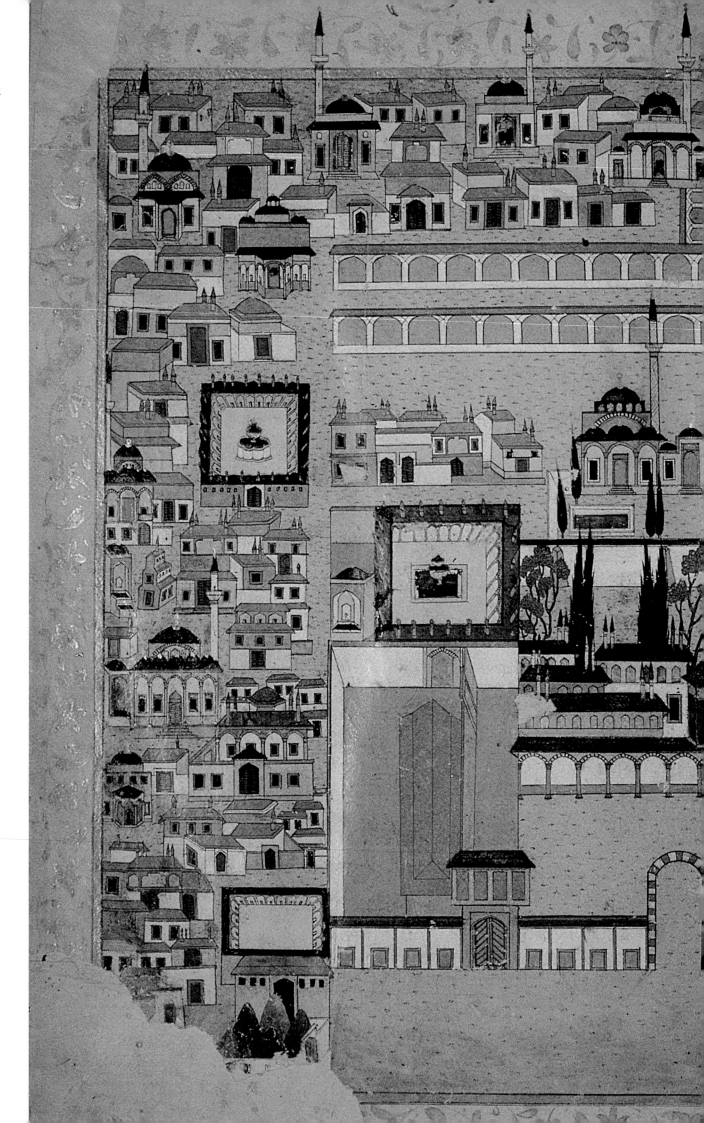

27. Manisa. Talikizade,
Şahname-i Al-i Osman,
ca. 1595. (İstanbul,
Topkapı Sarayı Müzesi,
A. 3592, fols. 10b–11a)

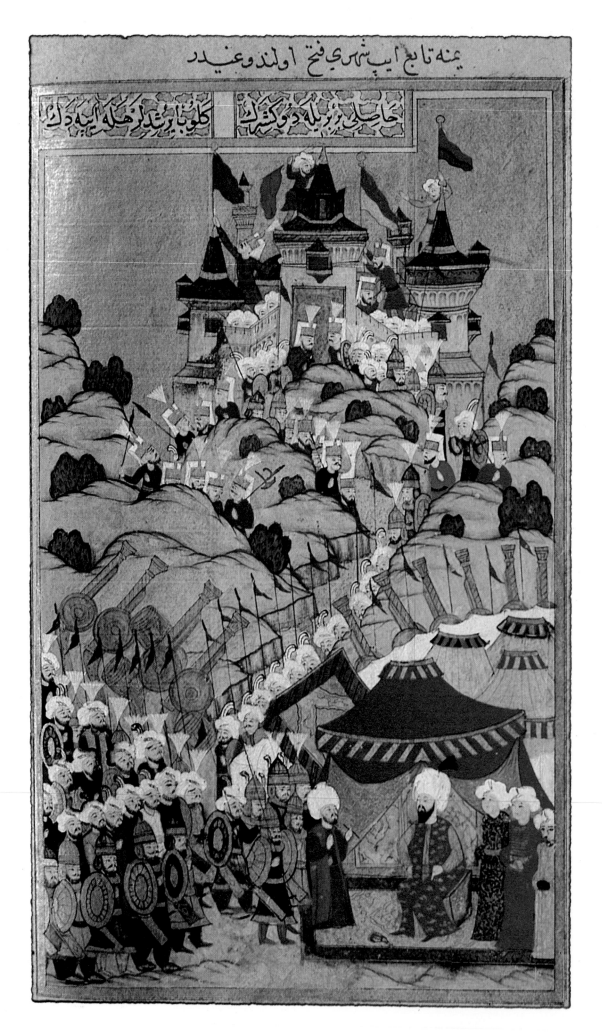

28. *Left:* Conquest of İp Fortress. Rumuzi, *Tarih-i Feth-i Yemen,* 1594. (İstanbul, Üniversite Kütüphanesi, т. 6045, fol. 140b)

29. *Right:* Meeting of Molla Şemseddin and Mevlana Celaleddin Rumi. Muhammed Tahir, *Cami as-Siyer,* volume two, ca. 1600. (İstanbul, Topkapı Sarayı Müzesi, н. 1230, fol. 112a)

وصددمبارکی شرح الدرشح لك صدركك ايلدارض الله واسعة اولمش ایدی لاجرم تشنه
دم اوردیدی وهرکون بلکه هرساعت قدرزیاده لکنك استدعاسین ایلردی مولانا شمس الدین
بوجوابدن حوشحال اولوب فریاد ایلوب بهوش دوشدی مولانا اینوب استردن شاکرلره بیور
آنی کوتروب مدرسه یه ایلتدیلرو مولانا شمس الدینك باشین زانوسی اوزرنه قومش ایدی

تاکه افاقت بولدی اندن این دوقوب منزله کوتردی اندضکره برخلوته کروب صوم ایله
ایچ آی منزوی اولدیلرکه اصلا برفرد اول خلوته کلمك قادر اولمزدی وبعضلرنقل ایلشرلر
که مولانا شمس الدین چونکیم قونیه یه کلوب مولانا جلال الدینك خدمتنه کلده موقع
صفه اوزره برحوض کنارنده جلوس ایلمشلر ایدی وبرنجه کتاب اوکده قومش ایدی شمس الدین

ولطافت ذهن ستقیم اقتضاسی ایله دلایل عقلیه دن دلایل لفظیه اظهر و معقولی

صورت محبوبه سی ابراز سهل الفهم و روشنتر اولدوغنه موفق و باخبر اولوب علاقی كبار

و مشایخ ذوی الاعتبارك منقول اولان

خبر متواتر مقبولحسبی ایله

نانی مانی بلكه مانی بنی فن نقش و تصویرك مردمیداننی معارف و كمالاتك

سخن فهم و نكته دانی نقشی یك قلمی ایله و اقعه مطابق صورت حاله موافق

30. *Left*: Osman II with Sadrazam Mehmed Paşa and Ahmed Nakşi. Taşköprülü-zade, *Şekayik-i Numaniye,* ca. 1619. (İstanbul, Topkapı Sarayı Müzesi, H. 1263, fol. 259b)

31. *Right*: Murad III Going to Friday Services. Nadiri, *Divan-ı Nadiri,* ca. 1620. (İstanbul, Topkapı Sarayı Müzesi, H. 889, fol. 4a)

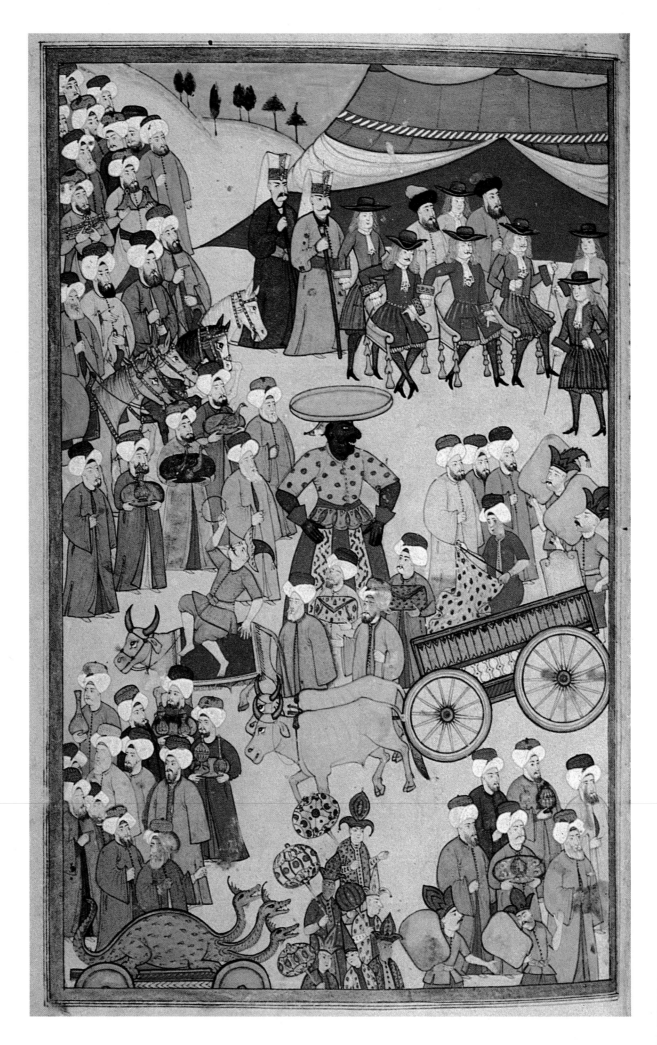

32. *Left and right:* Procession of the Silver-Threadmakers, Blacksmiths, Shipbuilders, Embroiderers, Saddlers, and Feltmakers. Vehbi, *Surname-i Vehbi,* ca. 1720. (İstanbul, Topkapı Sarayi Müzesi, A. 3593, fols. 139b–140a)

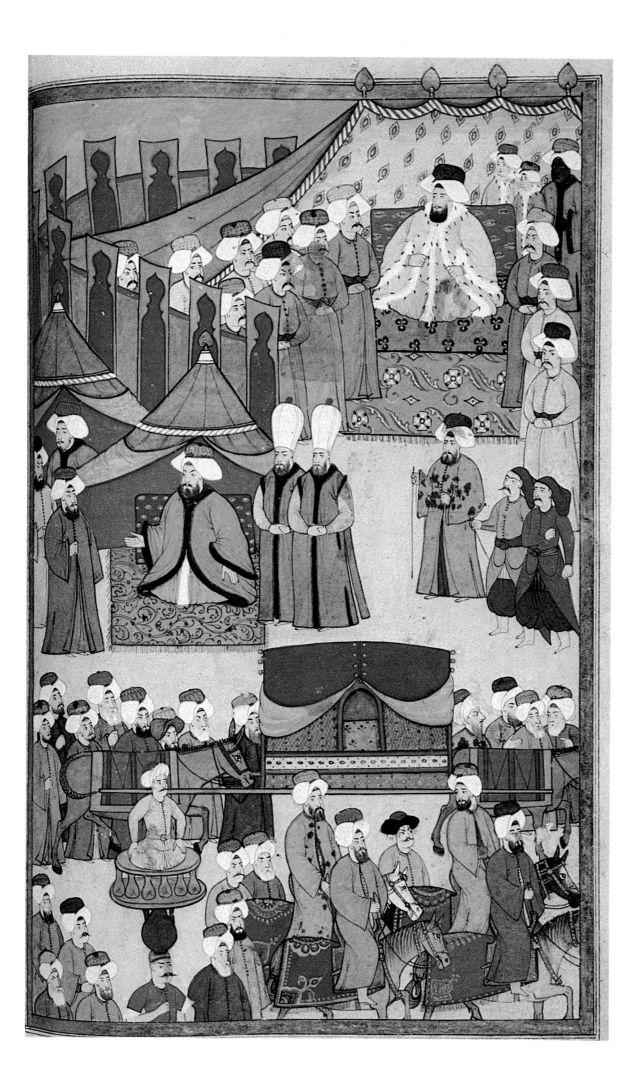

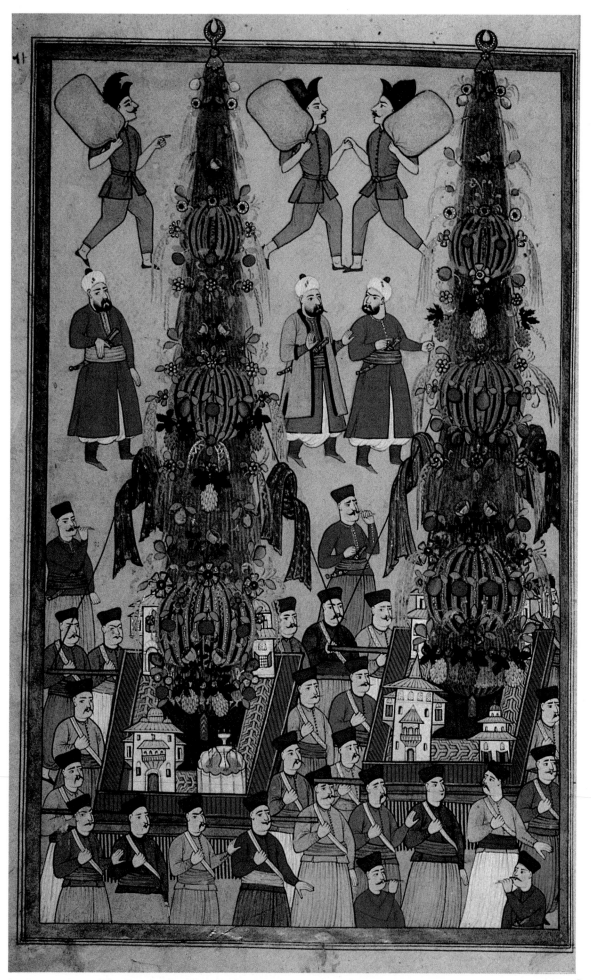

33. Procession of the Candy Gardens. Vehbi, *Surname-i Vehbi,* ca. 1720.
(İstanbul, Topkapı Sarayı Müzesi, A. 3593, fol. 161a)

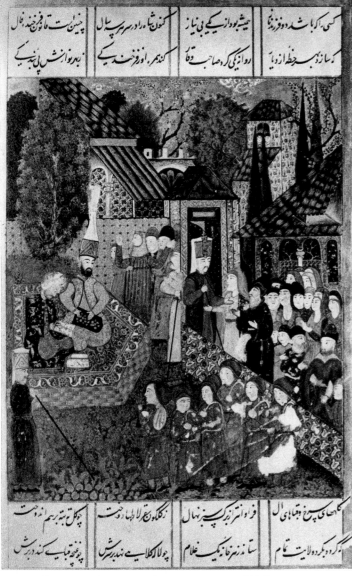

82. Collection of Taxes and Registration of Tribute Children. Arifi, *Süleymanname*, 1558. (İstanbul, Topkapı Sarayı Müzesi, H. 1517, fol. 31b)

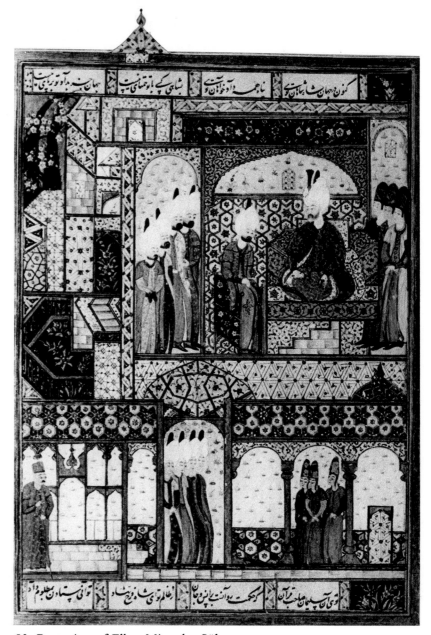

83. Reception of Elkas Mirza by Süleyman I. Arifi, *Süleymanname*, 1558. (İstanbul, Topkapı Sarayı Müzesi, H. 1517, fol. 471b)

age, and ill health visible in his face and posture. The loneliness of the sultan, silhouetted against a barren deep green background, is accentuated by his attendants whose stylized and almost wooden presence contrasts with the sensitive portrayal of the greatest figure in Ottoman history. The other two portraits do not have the same psychological impact. The elderly grand admiral is represented in a traditional manner, attired in the garments of his rank, holding a staff and a carnation. Clad in sumptuous clothes, Selim II is depicted in a more playful mood, throwing darts at a target held up by one of his officers. His renowned love for a luxurious and leisurely life is explicitly portrayed.[56]

ills. 86, 87

Dozens of *murakka*, or albums, which constitute a significant group of manuscripts were compiled by the *nakkaşhane*. Most of them are owned by the İstanbul libraries, a few are in European or American museums, while several are dismantled and dispersed among various private and public collections. Some of these albums were rebound in

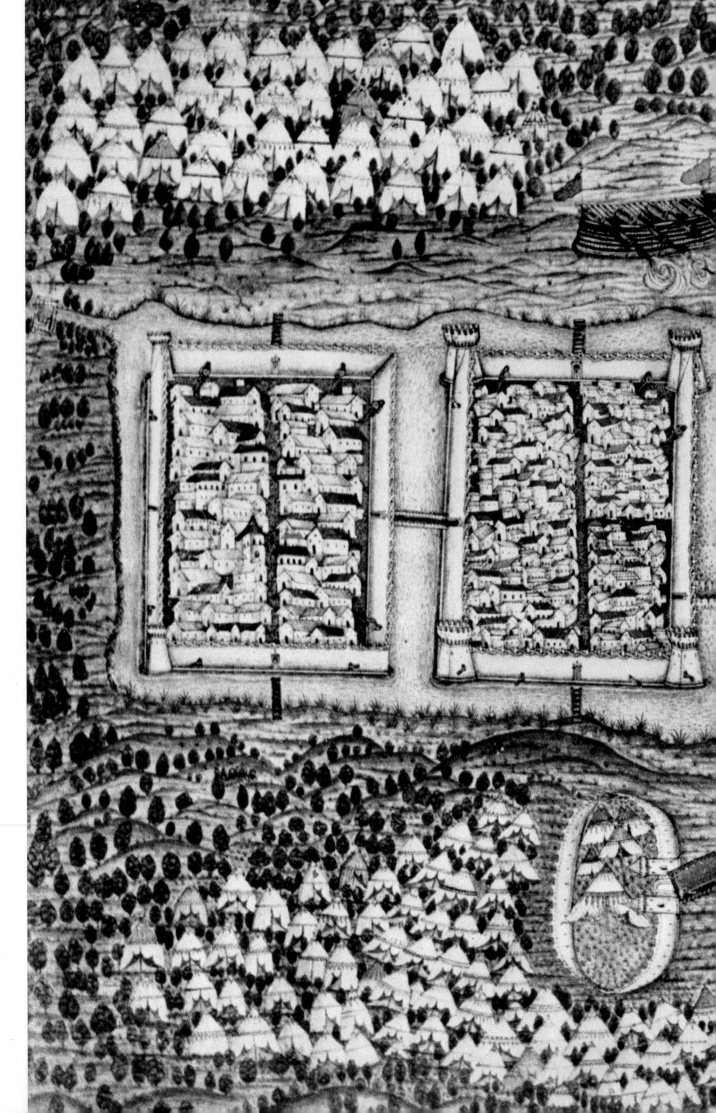

84. Siege of Szigetvar.
Ahmed Feridun Paşa,
*Nüzhet al-Ahbar der Sefer-i
Sigetvar,* 1568–69.
(İstanbul, Topkapı
Sarayı Müzesi, H. 1339,
fols. 32b–33a)

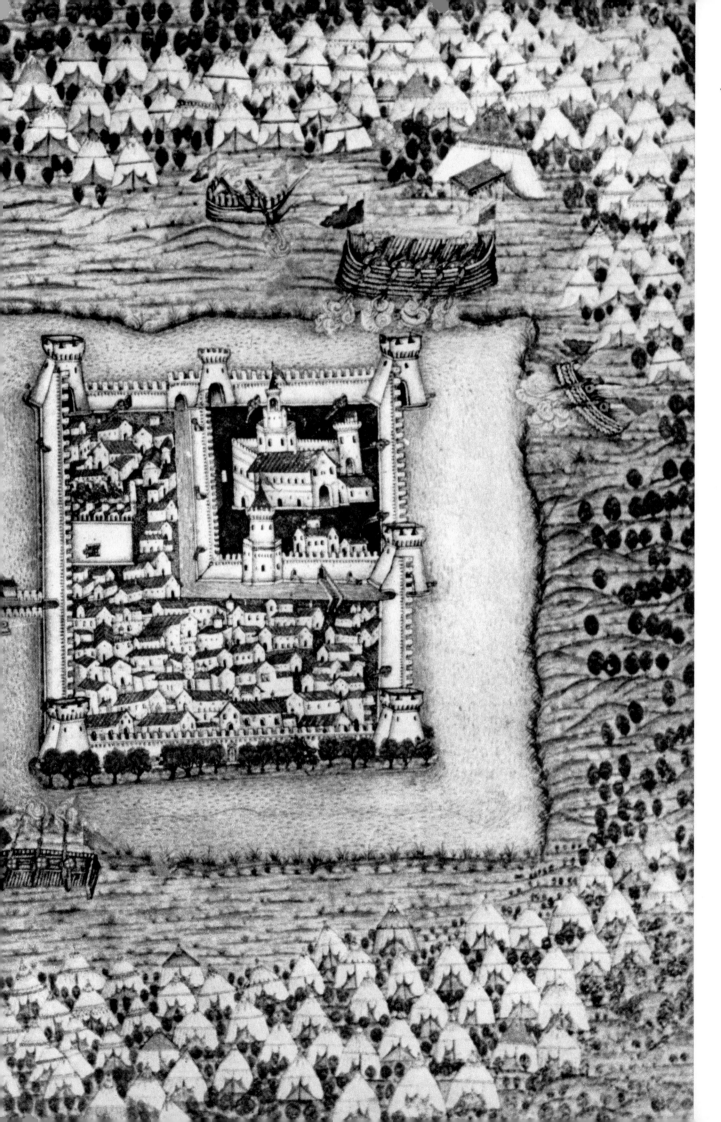

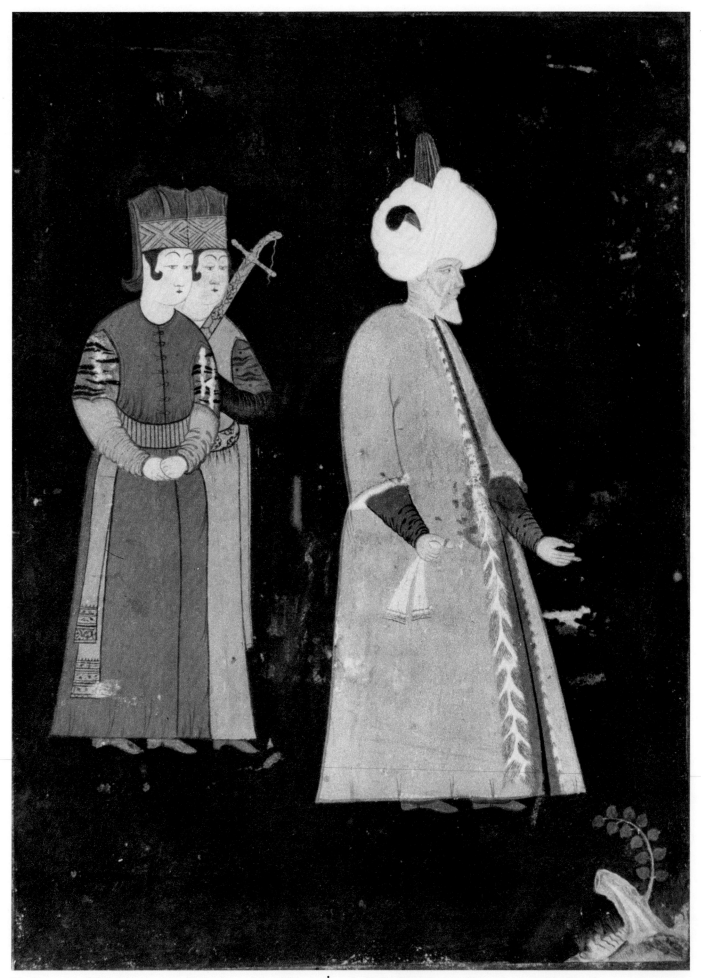

85. Portrait of Süleyman I, ca. 1560. Signed by Nigari. (İstanbul, Topkapı Sarayı Müzesi, H. 2134, fol. 8)

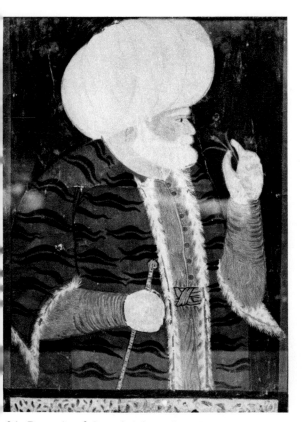

86. Portrait of Grand Admiral Barbaros
Hayreddin Paşa, ca. 1560. Signed by Nigari.
(İstanbul, Topkapı Sarayı Müzesi, H. 2134, fol. 9)

87. Portrait of Selim II, ca. 1570. Signed by Nigari.
(İstanbul, Topkapı Sarayı Müzesi, H. 2134, fol. 3)

later periods, and several folios were added. Containing a mixture of Near Eastern, Far Eastern, Central Asian, and European works, they are composed of sketches, drawings, paintings, engravings, and samples of calligraphy and illumination.

The drawings and sketches in the İstanbul albums are invaluable sources in determining the creative power of the *nakkaşhane* and its impact on the related arts. For example, the theme of a twisting leaf intersecting its own shaft, superimposed on a lotus blossom, commonly appears in the ceramics, tiles, textiles, and carpets of the age. The fantastic creatures—a phoenix swooping down on a *ch'i-lin* (a creature resembling an antelope)—are also employed not only by other craftsmen but also by the painters who added these decorative elements to their scenes.

A few drawings dating from this period are attributed to Şah Kuli, who is recorded in the palace archives as having lived in Amasya after being exiled from Tabriz and having joined the *nakkaşhane* in 1520. He is also called "Şah Kuli-i Bağdadi" (from Baghdad), possibly in reference to his city of birth. Şah Kuli's name appears in the payroll registers dated 1526 and 1545, and judging from his rank and salary, he held the highest post in the studio during these years. Another document, dated before 1545, mentions him giving a drawing of a *peri* (angel) to the sultan. This reference has led to the attribution of many such images to Şah Kuli, including the example at the Freer Gallery of Art. The flying *peri*, holding a stemmed cup and a wine bottle, is attired in exquisitely detailed garments adorned with cloud-bands and floral scrolls. The spiral motif with minute blossoms seen here also appears on the *tuğra* of Süleyman and the type of pottery called Golden Horn ware. The design on the bottle represents a phoenix attacking a

ill. 88

plates 39, 44, 45, 59 (pp. 268, 270–71, 331); ills. 160–162, 183

ill. 89

ills. 150, 154

dragon, two creatures of Central Asian and Far Eastern origin that by this date were incorporated into the vocabulary of the *nakkaşhane*.

ill. 90 The influence of Asian art is indisputable in many of the drawings. The Chinese, Japanese, and Central Asian paintings included in the albums were sources of inspiration to the artists who often combined the themes. A battle between fantastic creatures shows a contorted dragon about to devour an unsuspecting bird while a lion attacks a *ch'i-lin*. The dragon and *ch'i-lin* are taken from Asian traditions, the lion belongs to the ancient Near East, and the flowering scroll engulfing the scene is characteristically Ottoman.

 A number of album drawings are also attributed to another famous Tabrizi master, Veli Can (Vali Jan), who is known only through written documents. Last mentioned in 1596, he is listed as being one of the painters and illuminators of the first volume of the *Hünername*, which was completed in 1584–85.

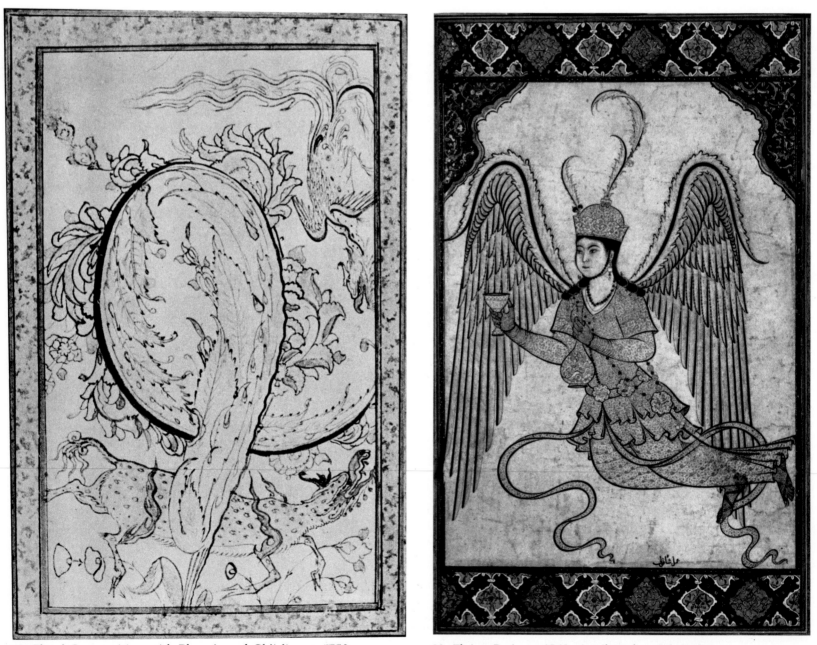

88. Floral Composition with Phoenix and Ch'i-lin, ca. 1550.
(İstanbul, Topkapı Sarayı Müzesi, H. 2147, fol. 21a)

89. Flying Peri, ca. 1560. Attributed to Şah Kuli.
(Washington, D.C., Freer Gallery of Art, 37.7)

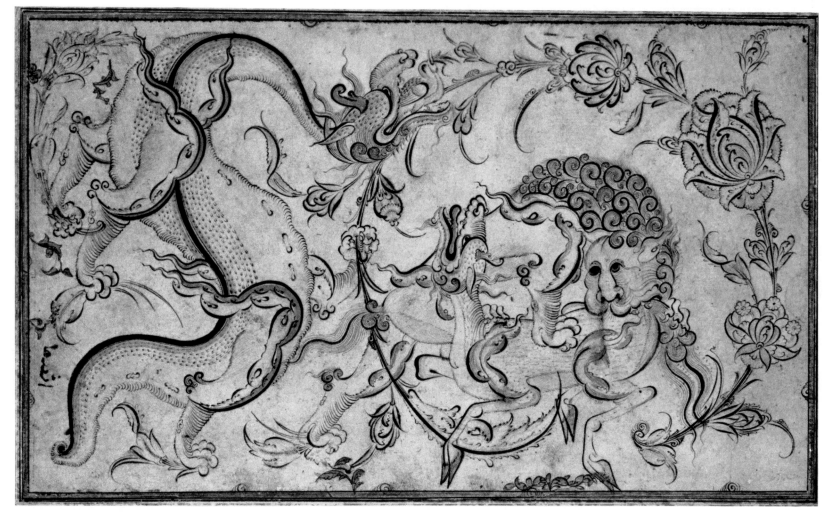

90. Battle between Dragon and Bird, Lion and Ch'i-lin, ca. 1560. (Washington, D.C., Freer Gallery of Art, 48.17)

One of the best-known artists of the age, recorded in the *tezkeres* and in the colophons of his works, is the famous calligrapher Ahmed Karahisari (1466–1556). Karahisari wrote the inscription on the Süleymaniye Mosque in İstanbul and copied many Korans dedicated to the sultan. The motifs in the illumination of one particularly outstanding Koran, showing clusters of spring flowers and cloud-bands intermingled with blossoms, also appear on contemporary pottery and tiles as well as on bookbindings. The illumination of this Koran is identical to the frontispiece of the *Süleymanname*.

 Another example of the consistency of the decorative vocabulary of the age appears on the stamped and gilded cover of the *Divan-ı Muhibbi*, the collected poems of Süleyman, who used the pseudonym Muhibbi. A fine scroll composed of blossoms and cloud-bands fills the outer border and the central field, while a bolder floral design appears in the central medallion and corner quadrants.

THE CLASSICAL AGE: 1574–1603

The historical genre initiated by Matraki's works, the *Süleymanname* and the *Sefer-i Sigetvar*, flourishes during the reigns of Murad III (1574–95) and Mehmed III (1595–1603). The outstanding *şahnameci* of the age is Lokman, who held the post between

ill. 50

ill. 91
ill. 162

ill. 92

1569 and 1595, also working during the following six years with his successor, Talikizade.

Lokman's earliest illustrated history is the *Tarih-i Sultan Süleyman*, dated 1579, covering the events from the accession of Süleyman I to his death.[57] In its introduction Lokman makes a reference to a *Şahname-i Selim Han* devoted to Selim II's reign, which is most likely the undated manuscript now in London, executed around 1575.[58] Another illustrated copy of the same work, dated 1581, is in İstanbul.[59] Lokman's most renowned works are a pair of two-volume histories: the *Hünername* (Book of Achievements), dated 1584–85 and 1587–88, which describes the period from the reign of Osman I to Süleyman I;[60] and the *Şahınşahname* (Book of the King of Kings), completed in 1581 and 1592, devoted solely to the reign of his patron, Murad III.[61]

He is also the author of a genealogy of the Ottoman sultans, the *Kıyafet al-İnsaniye fi Şemail-i Osmaniye* (General Appearances and Dispositions of the Ottomans)[62]; a general history beginning with the creation of man and concluding with the reign of Murad III, the *Zübdet üt-Tevarih* (Cream of Histories),[63] also called the *Silsilename* (Book of Genealogy); and the *Surname*, devoted to a circumcision festival that took place in 1582.[64]

In the introduction of the İstanbul copy of the *Şahname-i Selim Han* Lokman talks about his background.[65] He was brought to the post of the *şahnameci* by Ahmed Feridun Paşa, the author of the *Sefer-i Sigetvar*. Lokman's first work, the *Şahname-i Selim Han*, was first shown to Şemseddin Ahmed Karabağı, one of the leading scholars of the age, who asked that it be written in verse. Karabağı arranged a meeting with the famous calligraphers and painters of the court and showed Lokman the annals of the period. After the text had been completed, samples of calligraphy and painting were presented to Sadrazam Sokollu Mehmed Paşa for his approval, and finally to the sultan himself. It is also mentioned that the painter's sample was a scene depicting Selim II shooting an arrow from the Tower of Justice in the Harem to a target on the Kubbealtı, the pavilion where the council of ministers held their meetings. The text also states that the calligrapher was İlyas Katib. A payroll register dated 1581 identifies the painters as Osman and Ali and gives the amount of raise in salary the author and artists received. Lokman's salary was raised from 30,000 *akçes* (gold coins) to 40,000, and Osman and Ali were each given an additional two *akçes*.

ill. 93

In the introduction to the second volume of the *Hünername*, Lokman discusses his works. He mentions that the *Şahname-i Al-i Osman*, the general history of the Ottoman dynasty begun by Arifi, was continued by Eflatun; in 1577 the task of completing it was given to him by Murad III. Lokman rewrote the history in Turkish and expanded it into two volumes.

Talikizade, who held the post between 1595 and 1599, worked under Mehmed III and wrote the *Gazavat-i Osman Paşa* (Heroic Exploits of Osman Paşa) on the conquest of Revan (Erivan) in 1583 by Özdemiroğlu Osman Paşa,[66] and three *şahnames*. The *Şahname-i Al-i Osman* discusses Seljuk and Ottoman history; the *Şahname-i Talikizade* covers the events between 1593 and 1595; the *Şahname-i Sultan Mehmed III* is devoted to the conquest of Eğri in Hungary by Mehmed III in 1596.[67]

There also exist illustrated works written by diverse historians of the period other than the official *şahnamecis*, such as the *Nusretname* (Book of Victories) by Gelibolulu Mustafa Ali on the conquests of Georgia, Azerbayjan, and Shirvan by Lala Mustafa Paşa.[68] He is also the author of the unillustrated *Menakıb-ı Hünerveran* (Legends of the Talented), which lists calligraphers, illuminators, painters, and authors; and of the

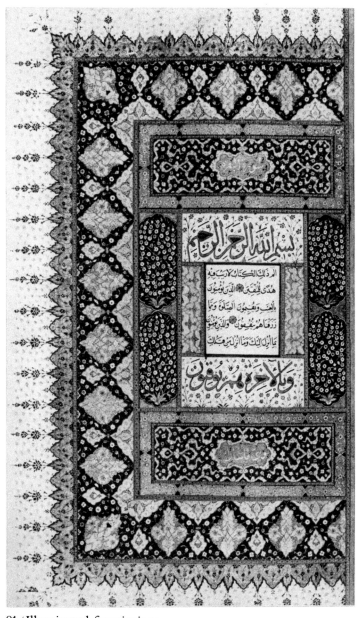

91. Illuminated frontispiece.
Koran copied by Ahmed Karahisari, 1546.
(İstanbul, Topkapı Sarayı Müzesi, Y.Y. 999, fol. 2a)

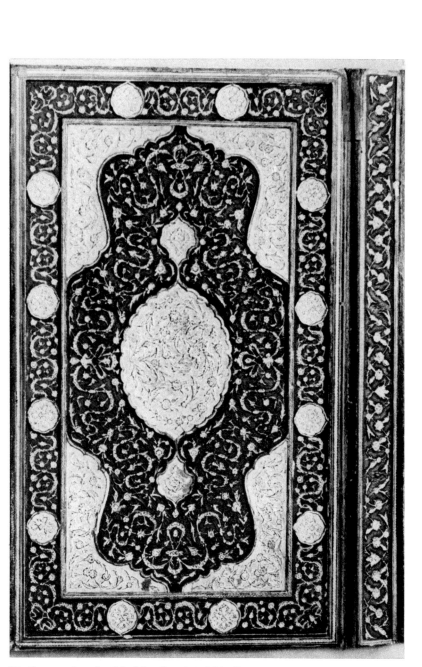

92. Stamped and gilded leather bookbinding.
Süleyman I, *Divan-ı Muhibbi,* ca. 1560.
(İstanbul, Türk ve İslam Eserleri Müzesi, 1962)

Nasihat as-Salatin (Advice of Sultans), which is devoted to ethics and adorned with three paintings.[69] Other illustrated contemporary histories by renowned writers narrate various conquests undertaken by vezirs, describe the conquered lands and cities, or are devoted to the genealogies of the Ottoman sultans—giving their physical characteristics and the outstanding achievements of their reigns.[70] One of the genealogical works, written by Yusuf, contains portraits of the sultans and their ancestors in medallions. In the sixteenth century several copies of this *Silsilename* (also called the *Zübdet üt-Tevarih,* not to be confused with Lokman's work with the same two titles) were executed in İstanbul as well as in Baghdad, whose prolific school will be discussed later.[71] The *nakkaşhane* also produced a number of historical works written by unknown authors, such as the *Tarih-i Hind-i Garbi* (History of the West Indies), a history of the

Americas, and the *Ali Paşa Vakayi*, on the events of 1601 in Egypt when Ali Paşa was the governor there.[72]

The incredible wealth of illustrated histories devoted to the genealogies of the ruling house, general histories of the empire, biographies of individual sultans, descriptions of singular campaigns, and even festive events characterize the period. Although the *nakkaşhane* executed a number of literary works and translations of Firdausi's *Shahname* and al-Kazvini's *Ajaib al-Makhlukat* (Marvels of Creation),[73] its activities were primarily concerned with illustrating the historical manuscripts that dominated the age. The preoccupation with this genre extended even beyond the Ottoman world, as observed in the most extensive work on the life of the Prophet Muhammed, the six-volume *Siyer-i Nabi* originally written by Darir.[74]

The archival documents of the period help to identify the artists of the *nakkaşhane*, the most celebrated being Osman, who is recorded as being one of the painters of the *Şahname-i Selim Han*, the *Surname*, the first volume of the *Hünername*, and the *Zübdet üt-Tevarih*.[75] He is also praised in the text of the *Kıyafet al-İnsaniye*,[76] the *Surname*, and the second volume of the *Hünername*. He appears to have been the most influential member of the imperial studio and was responsible for determining the style of the period. Aside from the manuscripts mentioned above, Osman's illustrations appear in a number of other works produced during the years between 1560 and 1600.[77] Working with him on many manuscripts were his brother-in-law, Ali, and Mehmed Bey, both of whom are also cited in the archives.

The style of a slightly later artist, Hasan (died 1622), who is stated as being the painter of the *Şahname-i Mehmed III*, dominates the period of the next sultan, Mehmed III. First recorded in 1581, Hasan was trained in the Palace School, eventually becoming the *kapıcıbaşı* (head of the imperial gatekeepers) and the *ağa* of the Janissaries; he was also a *beylerbeyi* (governor-general) and a vezir. The paintings of this distinguished statesman, who worked in the *nakkaşhane* between 1570 and 1610, appear in the *Surname, Siyer-i Nabi, Şahname-i Al-i Osman, Şahname-i Talikizade, Gazavat-ı Osman Paşa,* and *Ali Paşa Vakayi*.[78] Although the hands of Osman and Hasan are more or less identifiable, it is impossible to analyze all the paintings of the age according to the artists recorded in the archives, since many reveal the combined efforts of several *nakkaşhane* members. Two archival documents, both dated 1596, list between 124 and 129 members of which 62 to 66 are recorded as being masters. Slightly later payroll registers of the age show a decline from 93 members in 1605 to 56 in 1607–8. It is rather interesting that the *sernakkaşan* (head of the studio) in these documents is given as Lutfi Abdullah, while Osman's name appears below the categories of *kethüda, serbölük,* and *seroda* (assistants in ranking order). Obviously, the hierarchy in the studio was not only based on talent in painting but also required expertise in illumination and design layout.

The texts of the period also make references to the actual site of the *nakkaşhane*, which no longer exists. In the first volume of the *Hünername*, Lokman describes in detail the Topkapı Sarayı and mentions that the *nakkaşhane* was located on the right of the first court, which places it approximately in the area where the present Arkeoloji Müzesi (Archaeological Museum) is located. The only illustration of the *nakkaşhane* ill. 120 building appears in an early eighteenth-century manuscript, in which the sultan watches a parade from the windows of its second floor. Since the route of the parade was along the famous road that now connects the Arkeoloji Müzesi with the Topkapı Sarayı, the same location appears to have been used from the sixteenth to the eighteenth century.

The most characteristic features of the paintings executed during the classical period are well-defined types and settings, enabling us to identify the figures and the locations of the events. The members of the imperial household (including the sultan, princes, harem staff, inside and outside services with various black and white eunuchs, gate-keepers, sword-bearers, stirrup-holders, special guards, and servants in charge of the stables, imperial gates, gardens, boats, kitchens, and communications) are clearly represented, attired in their specific garments and placed upon the folios following the protocol of state. The same clarity appears in the depiction of the members of the administration (including the grand vezir, ministers, secretaries, treasurers, governors, and other officials), the religious hierarchy (headed by the *şeyhülislam* and including the *kazaskers, seyyids, şeyhs*, and other members of the ulema), the military personnel (the Janissaries and various segments of the army and navy), and even the public, with the profession of each figure clearly identifiable. The complex social structure of the Ottoman world can best be studied through these paintings, each work being a documentary filmstrip of the age.

The settings reveal the actual locations, whether in the capital or in a remote land

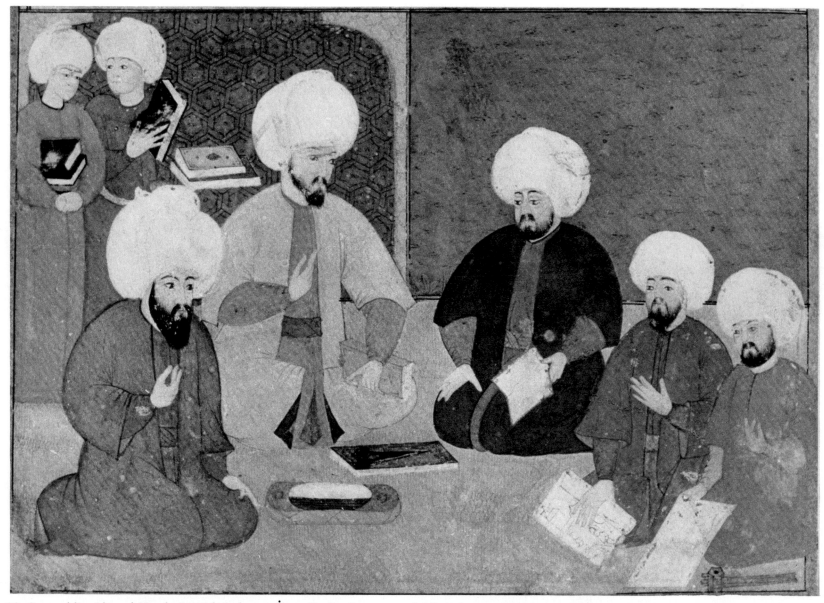

93. Şemseddin Ahmed Karabağı with Lokman, İlyas Katib, Osman, and Ali. Lokman *Şahname-i Selim Han*, 1581. (İstanbul, Topkapı Sarayı Müzesi, A. 3595, fol. 9a)

during a campaign. Architectural representations of secular and religious buildings, fortresses, and entire cities or regions contain the same documentary feature. General views of İstanbul; detailed descriptions of the Topkapı Sarayı with its courtyards, gardens, and reception chambers; representations of camps during campaigns; conquered fortresses and cities are vividly drawn.

In the classical period compositional schemes for many of the state activities became fully established. These include the accession ceremonies of the sultans; receptions of ambassadors and other dignitaries in pavilions or in tents during campaigns; processions of the armies en route to battles; actual battle scenes showing the confrontation of the armies; victorious Ottoman soldiers chasing the enemy; sieges of fortresses; funerals of sultans; hunts and various athletic competitions; and depictions of festivals, banquets, parades, entertainment, and *bayram* (religious holiday) ceremonies. Yet many of the scenes in a given manuscript had to be composed individually in order to represent a specific historical event.

ill. 93

The 1581 copy of Lokman's earliest work, the *Şahname-i Selim Han,* contains forty-four paintings in which the classical style is firmly established, most likely due to the genius of Osman.[79] The first painting pays tribute to those who worked on the manuscript, portraying the author on the left, next to the eminent scholar Şemseddin Ahmed Karabağı, while calligrapher İlyas Katib and the two painters, Osman and Ali, sit opposite. Behind Lokman are two attendants who bring in additional books for reference. The documentary representation of the scene, depicting the key personages involved with the project surrounded by the tools of the trade—such as reference books, scissors, *divit* (pen case), and samples of paintings and calligraphy—is typical of the period. A double page, showing the reception of the Iranian ambassador by the sultan at the Edirne Palace, represents Selim II enthroned on the upper right, attended by Sadrazam Sokollu Mehmed Paşa and other vezirs while Janissaries bring in the gifts sent by Shah Tahmasp. The gifts included several manuscripts; among them was the famous *Shahname,* now owned by the Metropolitan Museum of Art and Arthur A. Houghton, Jr., and other public and private collections.[80]

Other scenes in the *Şahname-i Selim Han* include the enthronement of the sultan in Belgrade; the divans (councils) of the Sadrazam Sokollu Mehmed Paşa and the six highest-ranking vezirs; receptions of various ambassadors; naval victories in Cyprus, Navarino, and Tunis; land battles in Yemen and Basra; as well as the representation of structures built by the sultan, such as the Selimiye Mosque in Edirne and a bridge in the suburbs of İstanbul, both designed by the great architect Sinan.

The first volume of the *Şahınşahname,* completed in the same year as was the *Şahname-i Selim Han,* depicts events that took place between 1574 and 1581, and contains fifty-eight paintings. The second volume, concluding with the year 1588, is illustrated with ninety-five paintings. It was finished in 1592 but was presented five years later to the next sultan, Mehmed III, after the death of his father. This truly imperial work represents the epitome of the *nakkaşhane* production. Aside from the standard enthronement, reception, and battle scenes, it includes unique subject matter such as the observatory of the great astronomer Takiyuddin in the Galata section of İstanbul. The scene

ill. 94

depicts Takiyuddin sitting on the upper right in front of his library and discussing an astrolabe held up by an associate. Several astronomers work with the scientific equipment placed on a large table while others document their findings, consult manuscripts, or locate positions on the globe. An atmosphere of fervid activity is created by showing each figure preoccupied with his particular task.

94. Takiyuddin in his Observatory at Galata.
Lokman, Şahınşahname, volume one, 1581.
(İstanbul, Üniversite Kütüphanesi, F. 1404, fol. 57a)

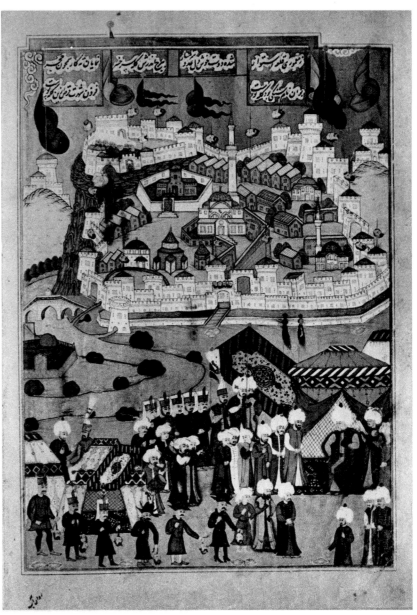

95. Kars.
Lokman, Şahınşahname, volume one, 1581.
(İstanbul, Üniversite Kütüphanesi, F. 1404, fol. 125b)

Another painting depicts a comprehensive view of Kars with its strong walls en-
closing mosques, residential buildings, and inner fortress. Following an established
scheme, the lower portion shows the commander of the campaign sitting in his tent,
surrounded by members of his staff; the fortified city rises in the background, placed
behind a series of hills and rivers. This format was first employed a half-century earlier
in the 1530–31 copy of the *Hamsa* of Nevai. The victory of the Ottomans is sym-
bolized by the severed heads of the enemy suspended on poles throughout the con-
quered city and being brought to the commander.

ill. 95

ill. 74

The *Şahınşahname* also includes several scenes describing the circumcision festival
arranged in 1582 by Murad III for the crown prince, a fifty-two-day celebration,
thoroughly represented in the 437 paintings of the *Surname*. This unique manuscript
depicts all the festive events that took place in the At Meydanı, including circus acts,

theatrical performances, athletic competitions, banquets, as well as parades and special pageants representative of the trade guilds. Among the guilds were artisans such as glass-makers, metalworkers, bookbinders, and potters. The sultan watched the entertainment from the Palace of İbrahim Paşa, which still stands at the edge of the square. One of the guilds, the bathhouse-keepers, had constructed a replica of a bath complete with units reserved for washing and dressing, which they wheeled into the arena.

plate 25 (p. 177)

The scope of Lokman's *Hünername*, containing 112 paintings, resembles the last two volumes of Arifi's *Şahname-i Al-i Osman*. The first volume, dated 1584–85, describes the events from the reign of Osman, the founder of the Ottoman Empire, to that of Selim I, while the second volume, completed in 1587–88, is devoted solely to the reign of Süleyman I. The manuscript, containing topographic views of İstanbul and of the first, second, and third courts of the Topkapı Sarayı, provides the proper setting for the story. The biography of each sultan begins with his accession, includes his major conquests and outstanding accomplishments, and gives the social and political history of his age. One of the paintings depicts Murad I resting after the conquest of a fortress. Behind him are prisoners leaving the city while the Ottoman flag is being hoisted on the towers. Members of various military corps, bodies of slain enemy, and war booty (helmets and chests) complete the scene.

ill. 96

The paintings in the *Hünername* are remarkable in quality and detail, as can be observed in the scene representing the siege of Niğbolu (Nicopolis) by the Hungarians and its rescue by Beyazıd I. The fortress, rising above the Danube River, is surrounded by enemy tents and cannons, while the sultan, who has just arrived, converses with the commander, Doğan Bey. The event takes place at night, so that the swift advance of the Ottomans is camouflaged.

plate 24 (p. 152)

Both the *Şahınşahname* and the *Hünername* stress the locations of the events and represent historic personages. The *nakkaşhane* is now handling a variety of compositions, ranging from intimate settings with the sultan hunting or conversing with his sons and ministers to elaborate receptions or crowded scenes depicting the march of armies.

One of the scenes in the second volume of the *Hünername* shows Süleyman I hunting a water buffalo, accompanied by his court, which includes his sword-bearers and falconers. On the lower right are several Janissaries shooting at wild animals in front of a superb hunting lodge. The delicate tones of the hills, contrasted by the gold sky above and the lush landscape below, reveal the technical and artistic abilities of the *nakkaşhane* artists.

plate 23 (pp. 150–51)

Armies massed together, approaching cities held by the enemy, symbolize the monumental power of the state. Ferhad Paşa's conquest of Revan (Erivan) in the second volume of the *Şahınşahname* is one of the outstanding examples. The right half of the scene, with scores of figures marching in silent dignity, leaves no doubt as to the outcome of the battle. On the left, the Janissaries have already captured the city, which is shown in detail, its surrounding hills and rivers carefully depicted. The insistence on documenting the topography of a land, as well as the protagonists of the event, appears in all the works of the age. In the *Tarih-i Feth-i Yemen*, dated 1594, the impenetrable fortress of İp, conquered by Sinan Paşa, soars above the camp of the commander. The victorious soldiers occupy the city, their siege cannons still in place. Recreating the landscape of the region, the 104 paintings in this manuscript include many scenes with fantastic castles perched on high cliffs.

plate 26 (pp. 178–79)

plate 28 (p. 182)

Not only foreign cities were documented. The *Şahname-i Al-i Osman*, executed around 1595, contains a double folio view of Manisa, a provincial capital in western

plate 27 (pp. 180–81)

Anatolia, which was the residence of the Ottoman crown princes, including Süleyman I, Selim II, Murad III, and Mehmed III. Many of Manisa's structures were built by these future sultans during their governorship. The painting represents the imperial residence in the center, surrounded by gardens and enclosed by a wall. The palace, originally built by Murad II in 1445, is composed of a number of pavilions. Outside the complex are several imperial mosques, *medreses*, baths, tombs, caravansarays, and private dwellings. The castle of Manisa, which dates from the Seljuk period, appears on the upper right.

This manuscript is the first work by Talikizade, the successor of Lokman. He mentions in the text that he was appointed the *şahnameci* by Murad III in 1595. The undated *Şahname-i Al-i Osman* is most likely his first work. Its twelve illustrations with their simpler compositions and fewer figures represent intimate scenes, such as Süleyman I giving advice to his son, Mehmed. Attired in a brocaded kaftan, the sultan sits in his library, attended by his sword-bearers and five dwarfs. The paintings in this manuscript are attributed to Hasan, who also executed the four scenes found in the *Şahname-i Mehmed III*, which is devoted to the 1596 campaign of Mehmed III in Hungary. The work contains a double folio representing an episode on the battlefield: the sultan,

ill. 97

ill. 98

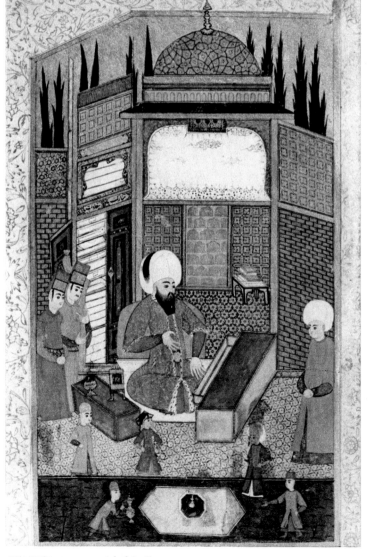

96. Murad I Relaxing after the Conquest of a Fortress. Lokman, *Hünername,* volume one, 1584–85. (İstanbul, Topkapı Sarayı Müzesi, H. 1523, fol. 88a)

97. Süleyman I with his Son. Talikizade, *Şahname-i Al-i Osman,* ca. 1595. (İstanbul, Topkapı Sarayı Müzesi, H. 3592, fol. 79a)

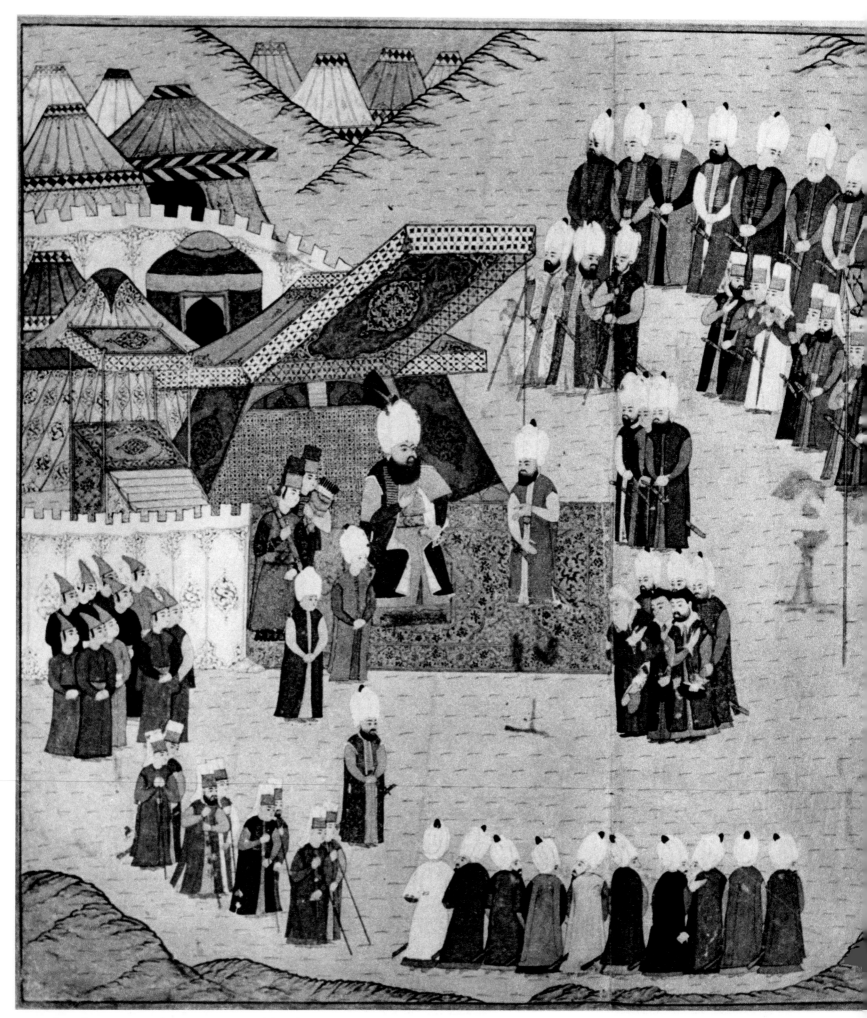

98. Mehmed III Receives the Hungarians. Talikizade, *Şahname-i Mehmed III*, ca. 1596.
(İstanbul, Topkapı Sarayı Müzesi, H. 1609, fols. 26b–27a)

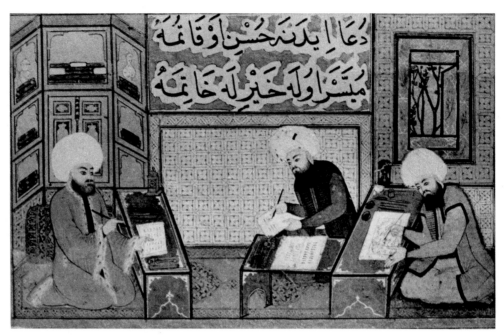

99. Talikizade with Hasan and the Calligrapher.
Talikizade, *Şahname-i Mehmed III,* ca. 1596.
(İstanbul, Topkapı Sarayı Müzesi, H. 1609, fol. 74a)

ill. 99

ill. 100

ill. 101

ill. 102

ill. 103

seated under the canopy of his tent, receives the Hungarian delegation; the figures are arranged in an oval composition, according to an established format.

The last painting in the *Şahname-i Mehmed III* portrays the artists of the work. Talikizade is seated on the left, writing the book, opposite is the calligrapher who copies the text, and on the far right the painter works on one of the illustrations. The text states that the painter of the work was Hasan, although the name of the calligrapher is not mentioned. Talikizade's portrait also appears at the end of his third work, the *Şahname-i Talikizade*, which contains four paintings assigned to Hasan.

These two manuscripts, written during the reign of Mehmed III, are the last great illustrated histories of the classical period. They contain several double-page miniatures executed on a large single sheet, folded in half, and inserted into the book with gold floral decorations filling the reverse. There is a noticeable decrease in the number of paintings included in the manuscripts, and the compositions reveal less elaborate settings, in contrast with the exuberant profusion of elements seen in the earlier works.

Hasan, who was responsible for the paintings in these late sixteenth-century works, also participated with Osman and other artists of the *nakkaşhane* in the illustrations of the *Siyer-i Nabi*. The work, originally commissioned by Murad III but completed during the last years of the reign of Mehmed III in 1594–95, is a voluminous study devoted to the life of the Prophet Muhammed and the early history of Islam. Written by Darir of Erzurum in 1388, it includes the genealogy of the Prophet and covers the events from his birth to his death, from 571 to 632. With the exception of the fifth volume, which is lost, the number of paintings in the remaining five books totals 614; the genealogy was originally meant to have close to 750 scenes. This ambitious undertaking, reflecting the overwhelming interest in historiography, is the only illustrated and comprehensive biography of the Prophet.

The compositions in the *Siyer-i Nabi* are simpler than the monumental and extensive schemes seen in earlier imperial histories. Although the interest in placing the events within their proper settings is still evident, the panoramic views and massive crowds are omitted. The scene portraying the birth of the Prophet shows the infant enveloped by a celestial light, accompanied by his mother and three angels. The interior of the chamber is covered with tiles, following the Ottoman style. The inclusion of contemporary architectural elements and even figures appears in another illustration depicting Ali, the fourth caliph and the son-in-law of the Prophet, meeting his enemy, Miskal. In the background is a fortress with European figures attired in sixteenth-century garments, looking down from the parapets.

A copy of the *Tercüme-i Acaib al-Mahlukat* (Translation of the Marvels of Creation), completed about the same date, also represents contemporary types and settings. The confrontation between Muslim and Christian holy men takes place in front of a basilical church and a classical Ottoman mosque.

Restrained compositions appear in the three illustrated copies of the *Zübdet üt-Tevarih,* which were executed in the 1580s and contain forty to forty-five paintings. The text is divided into two sections: the first part describes the events from the creation of man to the rise of Islam and includes extraordinarily advanced maps of the earth; the second is devoted to Ottoman genealogy and contains portraits of the sultans, identical to those in the *Kıyafet al-İnsaniye.* These portraits show the figures, attired in the garments of the period, sitting in a niche, often in the same pose. There is an effort to individualize the personages with each sultan identifiable by his physical characteristics. The representation of Mehmed II in the 1588 copy of the *Zübdet üt-Tevarih* recalls the

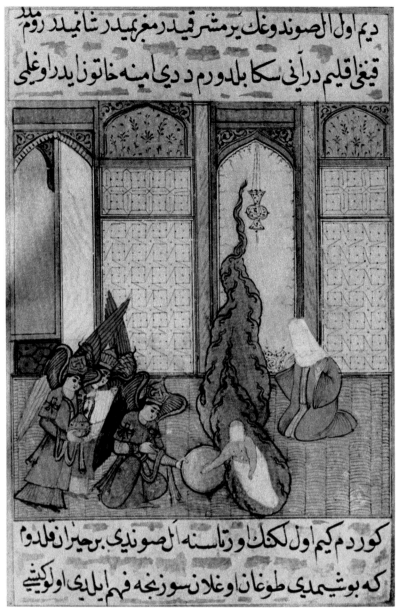

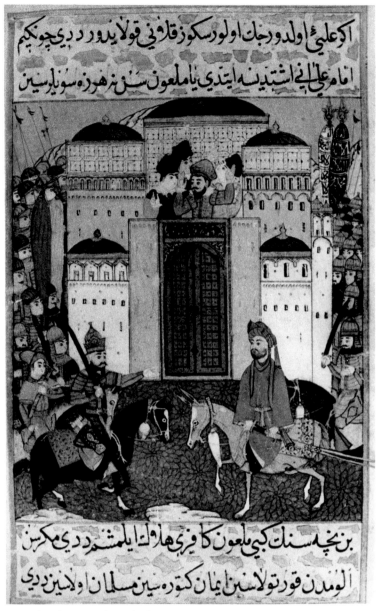

100. Birth of the Prophet.
Darir, *Siyer-i Nabi,* volume one, 1594–95.
(İstanbul, Topkapı Sarayı Müzesi, H. 1221, fol. 223b)

101. Ali, the Fourth Caliph, Meets Miskal, his Enemy.
Darir, *Siyer-i Nabi,* volume six, 1594–95.
(İstanbul, Topkapı Sarayı Müzesi, H. 1223, fol. 100b)

portrait of the same subject executed a hundred years earlier during the formative years ill. 68
of the *nakkaşhane.*

The tremendous output of the age was not limited to the imperial studio in the capital.
A group of manuscripts reflecting a less polished but nevertheless most dynamic style
is attributed to provincial centers, more specifically to Baghdad. The school of Baghdad,
having a long history in painting, appears to have been revitalized under a brilliant pa-
tron, Hasan Paşa, the son of Grand Vezir Sokollu Mehmed Paşa. The Baghdad paint-
ings reveal an interest in depicting lively figures, at times rendered in caricature. The
subjects include Shiite texts, lives of the prophets, and holy martrys as well as classical
literature and historical works.[81] Fuzuli's *Hadikat üs-Süada* and Yusuf's *Silsilename*
appear to have been most popular, as there exist many illustrated copies of these works.

Spanning the years from 1580 to 1610, this prolific school produced close to thirty

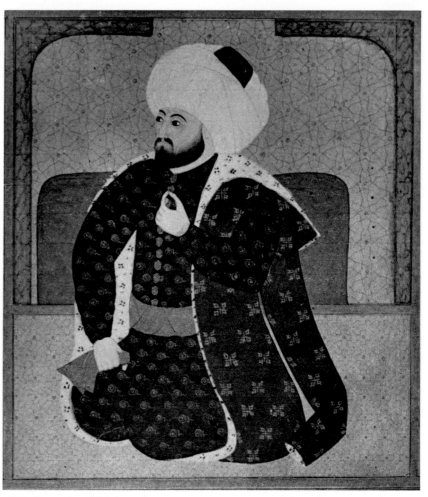

102. Conversation between Muslims and Christians.
Tercüme-i Acaib al-Mahlukat, ca. 1595.
(İstanbul, Topkapı Sarayı Müzesi, H. 3632, fol. 119b)

103. Portrait of Mehmed II.
Lokman, *Zübdet üt-Tevarih,* 1588.
(İstanbul, Topkapı Sarayı Müzesi, H. 1321, fol. 76a)

known manuscripts plus scores of single pages from volumes now dispersed in various collections. Four of the *Silsilenames* and a copy of the *Hadikat üs-Süada* indicate that they were copied in Baghdad.[82] Since the style of the paintings in these manuscripts is identical to that in the others, Baghdad is the most likely center of production of the entire group. The best illustrations are in a copy of Hüseyin Kashifi's work on morals, the *Ahlak-i Muhsini* (Ethics of Muhsin); Mirhond's history, called the *Ravzat al-Safa* (Garden of Delights); and the two-volume study on the prophets and caliphs of Muhammed Tahir, the *Cami as-Siyer* (Compendium of Biographies).[83] Although influences of Shiraz and Kazvin appear in some of the paintings, the style is of local origin. Janissaries, dervishes, and other native figures are represented. This school flourished for a short period, terminating soon after the death of Hasan Paşa in 1602—a fact demonstrating the tremendous importance of patronage in the art of book production.

The *Ahlak-i Muhsini* contains only two paintings. The Persian text was originally written for Abu'l-Muhsin, the son of Sultan Hüseyin Mirza of Herat. One of the paintings depicts a camp scene with a banquet taking place in front of the tents. Although the figures are attired in the Ottoman fashion, several vignettes—such as the woman on the top left, the horse and groom opposite, the figure peering in from the side of the tent

ill. 104

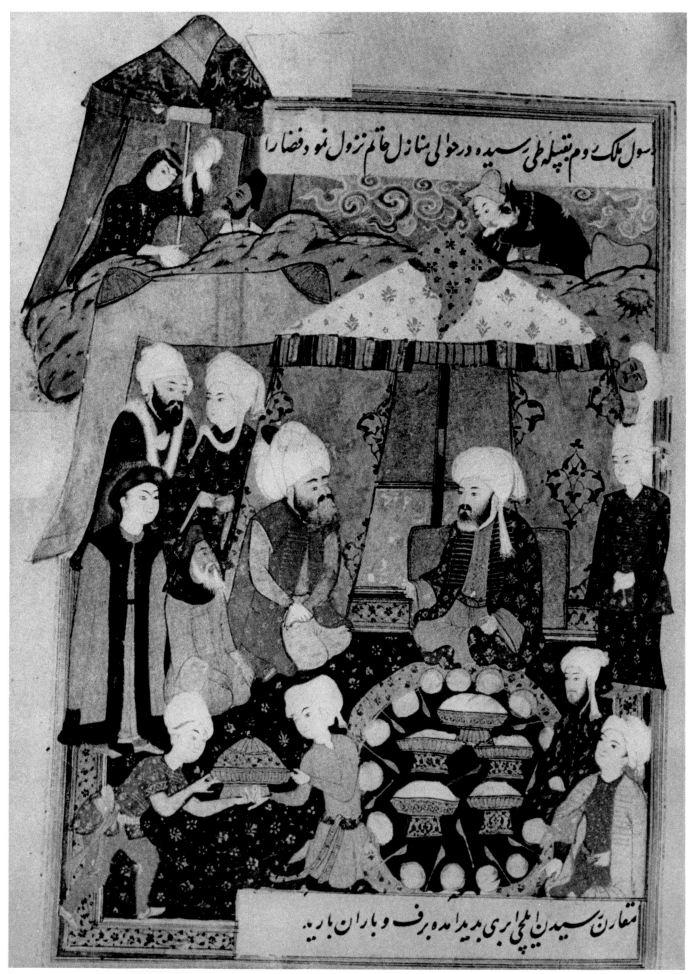

104. Banquet Scene. Hüseyin Kashifi, *Ahlak-i Muhsini,* ca. 1595–1600.
(İstanbul, Topkapı Sarayı Müzesi, R. 392, fol. 61a)

105. Stamped and gilded leather bookbinding. Lokman,
Hünername, volume one, 1584–85. Made by Abdi.
(İstanbul, Topkapı Sarayı Müzesi, H. 1523)

106. Embroidered satin bookbinding.
Mustafa Ali, *Nusretname,* 1584.
(İstanbul, Topkapı Sarayı Müzesi, H. 1365)

on the far right—reflect contemporary Safavid themes and indicate that several traditions and styles are blended together in this school.

The first volume of the *Cami as-Siyer* is incomplete and contains six unfinished paintings. The second volume has nine illustrations, one of which represents the meeting of Molla Şemseddin and Mevlana Celaleddin Rumi. As seen in the other works of the Baghdad school of painting, dervishes, Janissaries, and learned figures clutching books mix with the townsfolk. Şemseddin, depicted as a dervish, converses with Celaleddin, who is mounted on a donkey and attired in an Ottoman kaftan and *kavuk.* Although the school of Baghdad created remarkable works during such a short period of time, the center of artistic production was İstanbul, its unrivaled *nakkaşhane* having an inexhaustible supply of talented calligraphers, painters, illuminators, and bookbinders.

plate 29 (p. 183)

The outstanding quality of the İstanbul *nakkaşhane* can also be seen in bookbindings ill. 105 and illuminations. The stamped and gilded cover of the first volume of the *Hünername* is a characteristic example. Made by an artist named Abdi, the exterior of the

bookbinding is in black leather and contains a central ogival medallion enclosed by corner quadrants and a wide border adorned with blossoms and cloud-bands. The red leather interior follows the same decorative layout; in addition to stamped and gilded medallions and corner quadrants the field is decorated with motifs painted in gold.

Some of the bindings of the period are embroidered, such as that of the 1584 copy of *Nusretname*. The design is executed in metallic gold and multicolored silk threads on a deep red satin ground. This technique, called *zerduzi* (embroidered), also appears on textiles. The combination of wavy lines and triple balls on the spine is directly taken from the embroidered or woven fabrics, while the motifs on the covers follow the traditional themes employed in bookbindings.

A different technique is observed on the cover of the poems of Sultan Murad III, the *Divan-ı Muradi*, dated 1588. Here the bookbinding is of solid gold; its central me-

ill. 106

plate 53 (p. 327); ill. 205

ill. 107

107. Hammered gold bookbinding encrusted with gems. Murad III, *Divan-ı Muradi*, 1588. Made by the imperial jeweler Mehmed. (İstanbul, Topkapı Sarayı Müzesi, Hazine 2/2107)

108. Illuminated heading. Lokman, *Hünername*, volume one, 1584–85. (İstanbul, Topkapı Sarayı Müzesi, H. 1523, fol. 5b)

dallion, corner quadrants, and outer border are encrusted with emeralds, rubies, and diamonds. The field around the central medallion is filigreed, placed against a blue ground; a poem, written in black enamel, surrounds the main panel. Made by Mehmed, the chief jeweler of the court, this example belongs to a group of bookbindings executed in expensive metals and embellished with precious gems. There also exist ivory and lacquer covers, revealing the same rich and dazzling quality.

ill. 108

Decorative features commonly found on textiles, ceramics, and other arts are also employed in illuminations. The opening verses of the first volume of the *Hünername* appear below an illuminated heading, enclosed by gold contour bands enhanced with floral decorations. Executed in gold and pink, the marginal ornaments utilize the motifs seen on ceramics and textiles, with large blossoms and overlapping leaves. The text, written in a fine *nastalik*, was copied by Bosnalı Sinan.

THE LATE CLASSICAL PERIOD: 1603–1700

In contrast to the spectacular achievements of the classical age and the tremendous output of both the imperial *nakkaşhane* and the provincial school of Baghdad, the seventeenth century shows a decline in the quality and quantity of illustrated manuscripts, paralleling the political developments of the time. A lack of strong imperial support (that is, patronage by powerful sultans, which was essential for the growth and development of the *nakkaşhane* during its formative, transitional, and classical periods) is particularly visible after 1650.

The first half of the seventeenth century is still productive, with a number of albums and an oversize work on fortune-telling, the *Falname*,[84] executed during the reign of Ahmed I (1603–17). The *Falname* includes thirty-five paintings combining folk themes and religious figures, which were used to predict the future and the fate of the reader.

ill. 109

One of the paintings represents Adam and Eve in the Garden of Eden, complete with the serpent. A peacock and an angel appear in the doorway of the heavenly structure, which is depicted in the traditional Ottoman style with arcades and tiled walls.

There also exist several anthologies and two copies of a genealogy with portraits of the sultans accompanied by their sword-bearers and a few dignitaries, expanding the *Kıyafet al-İnsaniye* scenes discussed earlier.[85] One of the most original works of the period is on the art of horsemanship. Entitled *Umdet al-Mülük*, it was translated into Turkish from Arabic and contains 164 paintings describing various trappings and breeds of horses and their functions in war, hunting, and athletic competitions.[86]

There occurs a burst of energy under the patronage of Osman II (1618–22). The official court biographer of his reign was Nadiri, who wrote the *Şahname-i Nadiri* narrating the 1621 Hotin campaign.[87] This work is the last illustrated historical manuscript written by a *şahnameci*. Although the post was not officially abolished until 1663, there are no surviving illustrated histories of the sultans following Nadiri's work. The twenty paintings of the *Şahname-i Nadiri* reveal the hands of two painters, one of them identified as Ahmed Nakşi. The style of Nakşi, a highly eclectic and eccentric artist, dominates the studio's output during these years. Although he is not recorded in the archives, several *tezkeres* mention him as being from the Ahırkapı section of İstanbul. Nakşi was a poet and a painter of great merit as well as a renowned astrologer and the official timekeeper of the Süleymaniye Mosque in İstanbul.

The most outstanding feature of Nakşi's style is the portrayal of figures whose physical characteristics are stressed. Another distinction is the suggestion of a great

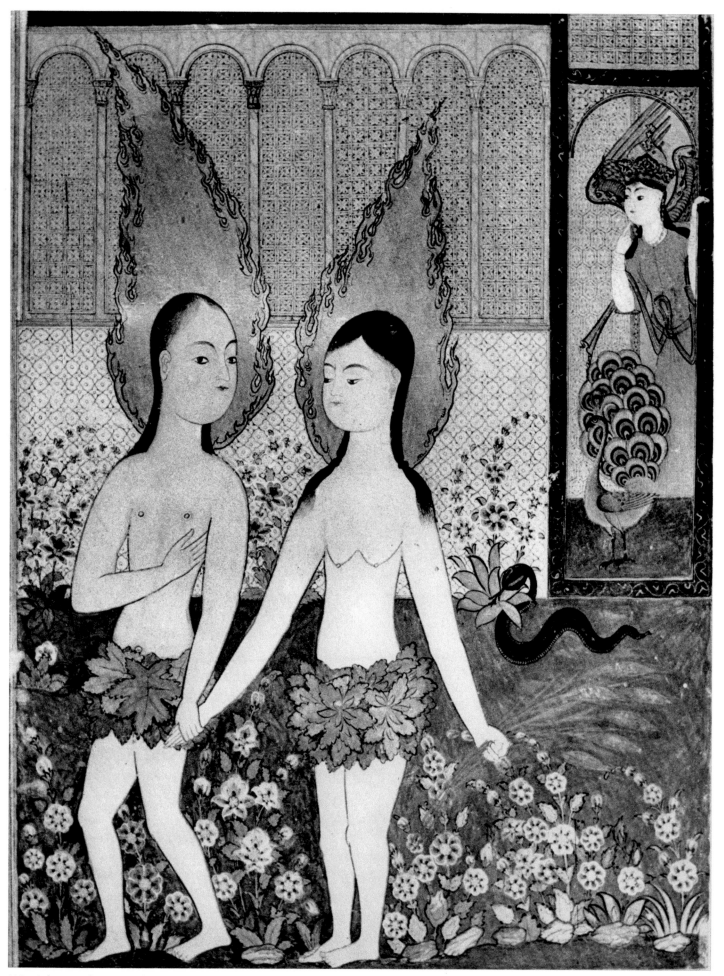

109. Adam and Eve in the Garden of Eden. Kalender Paşa, *Falname*, ca. 1610.
(İstanbul, Topkapı Sarayı Müzesi, H. 1703, fol. 7b)

110. House of Şeyhülislam Mustafa Efendi at Kasımpaşa.
Nadiri, *Divan-ı Nadiri*, ca. 1620.
(İstanbul, Topkapı Sarayı Müzesi, H. 889, fol. 18b)

111. Destruction of Tabriz.
Nadiri, *Şahname-i Nadiri,* ca. 1622.
(İstanbul, Topkapı Sarayı Müzesi, H. 1124, fol. 14a)

expansion of space in the background, accentuated by tiny figures and buildings appearing through open arches and windows. Often minute architectural complexes, approached by winding steps, are placed in the distance. Nakşi's interest in perspective is particulary noticeable in the multiple recessed arches of doors and windows and the panoramic vistas seen through openings. In many ways his paintings recall the early works of the Turkish artists, particularly the scenes in the 1498 copy of the *Khamsa*.

ill. 70

This highly personal style first makes its appearance in the forty-nine paintings of the *Şekayik-i Numaniye* (Red Peony), biographies of famous ulema and *şeyhs* who lived during the reign of the first ten Ottoman sultans, up to Süleyman I.[88] Originally written in Arabic by Taşköprülüzade in 1558, it was translated into Turkish by Mehmed Belgradi, who presented the work to Osman II. The *Şekayik-i Numaniye* contains portraits of the scholars discussed in the text. The scholars are shown meditating, working, or participating in discussions with sultans, colleagues, and students. The work terminates

with a group portrait: Osman II and Sadrazam Mehmed Paşa, who commissioned the plate 30 (p. 184) work, discuss the contents of the manuscript; the figure standing in the arched doorway is the painter Ahmed Nakşi, who is mentioned in the text immediately below the scene. Although the work is undated, it must have been completed in 1619 during the grand vezirate of Mehmed Paşa, who held the post for only one year.

Nakşi also executed the nine paintings of the undated *Divan-ı Nadiri*, an anthology of the poems of the *şahnameci*.[89] In this work he utilizes larger compositions with a greater number of figures and reveals a keen interest in perspective. Even though the figures are massed together, each personage possesses a distinct physiognomy. There is a genre quality in the paintings, with the figures moving about, conversing, and gesturing. A characteristic image is the depiction of Murad III going to Friday services, plate 31 (p. 185) leaving the Bab-ı Hümayun, the outer gate of the Topkapı Sarayı, with his retinue and approaching Aya Sofya, the imperial mosque. The placement of figures so that they are seen from the back in the foreground and the use of perspective in architecture give a sense of depth to the scene. Nakşi's representation of the house of Şeyhülislam Mustafa Efendi characterizes his style. The structure is in two stories, with Mustafa Efendi ill. 110 working in his study on the upper right. Below, an assistant gathers petitions from the men gathered in the courtyard. Various members of the household appear through the windows of the second floor. Windows also open into the alley behind the house; the one in the courtyard shows a pair of inquisitive horses peering in with shadowlike figures in the background; seen through the windows above are two conversing figures. By showing the figures in varying sizes, the painter attempts to convey a feeling of depth and distance, which unfortunately is not very successful.

The two scenes attributed to Nakşi in the *Şahname-i Nadiri* mentioned earlier follow the classical schemes: the first represents the Ottoman forces, led by Osman II, leaving İstanbul en route to Hotin in Poland, and the other shows a meeting in one of the pavilions of the palace with the sultan enthroned. The second artist of the work was responsible for the remaining eighteen paintings, which depict processions, battles, and Ottoman soldiers chasing the enemy and which adhere to the compositions and themes established earlier. A typical example represents the destruction of Tabriz by ill. 111 the Iranians with the Ottoman soldiers running to prevent the flames from spreading to the mosque.

Nakşi also collaborated with other artists in two copies of the *Tercüme-i Şahname*, one of which, translated by Mehdi for Osman II, consists of two volumes owned by separate collections.[90] The second manuscript, dated 1620, is based on Şerifi's translation made for the Mamluk sultan Kansu al-Ghuri in the early part of the sixteenth century.[91] Its 123 paintings combine the hands of several painters. Some, revealing the traditionalism of the *nakkaşhane*, follow the classical style created by Osman and his studio around 1560. Others reveal the early seventeenth-century style as exemplified by the painting representing Bizhan imprisoned in the cave, mourned by his lover. The ill. 112 enormous demon in the background, presumably guarding the captive, is an innovation of the artist and does not appear in the text nor in the other paintings of this story. The twenty-six paintings executed by Nakşi in this manuscript fully expose his eclecticism. Nakşi, with his unique and individual style, borrowed freely from contemporary Safavid paintings and late sixteenth-century European engravings. There are also a few nineteenth-century paintings that were added to the work when the manuscript was restored in 1873. The followers of Nakşi and other early seventeenth-century artists appear to have worked mainly on albums. They created single paintings, depicting

either solitary figures or groups placed within a landscape, the backgrounds of which generally fade in the distance.

Two manuscripts executed before 1650 are worth mentioning. One of them is İbrahim Efendi's *Paşaname*, narrating the military and naval activities of Kenan Paşa, the grand admiral of Murad IV (1623–40). Dated 1630, its six miniatures are the last examples of the historical genre.[92] They depict enthronement and reception scenes with relatively few figures or crowded compositions showing the march of the armies and naval battles. The artist, generally following the style of Nakşi and his associates, shows the figures in the foremost plane turning into the scenes and tiny architectural

ill. 113

complexes far in the distance. One of the paintings depicts the reception of Kenan Paşa, who rides amidst his victorious forces after squelching a rebellion in Macedonia. The army moves up on the folio, disappearing behind the hills.

The second work, a copy of Assar's *Mihr u Mushtari*, is written in Persian. Completed in 1647–48, it contains three exquisite paintings.[93] One of them, bearing the date 1638

ill. 114

and the signature of an unknown artist named Riza, was obviously done before the manuscript was completed. It depicts the young prince consulting a hermit who resides in a cave. The lyric quality of the scene, with softly painted rocks and flora surrounding the figures, indicates that the artist was a highly accomplished master. As the same hand appears on the remaining two paintings, all the illustrations in this work are attributed to the artist called Riza. This style is also observed in some of the album paintings, which show similar execution of figures and architectural and landscape settings.

The production of illustrated manuscripts in the second half of the seventeenth century is extremely limited. There are no biographies of the sultans or even historical works. Paintings appear in a few literary works or in albums with figures attired in the costumes of their ranks and identified as such (probably made for foreign markets).[94]

An interesting but most traditional work is a copy of Mehmed bin Ramazan's *Sub-hat al-Ahbar* (Rosary of Chronicles), which contains circular portraits of the sultans and their ancestors, similar to the earlier *Silsilename* manuscripts.[95] The painter's name is given as Hasan al-Musavvir al-İstanbuli. The fact that he is identified as being from İstanbul suggests that he worked elsewhere, possibly in Edirne.

There seems to be at the time a revival of interest in the *Tercüme-i Acaib al-Mahlukat,* several copies of which exist with crude and derivative illustrations.[96] A couple of other works, executed around the turn of the century, also have similar rough paintings and deal with strange creatures and magical or cosmological subjects.[97]

Two interesting manuscripts, dated in the last decade of the seventeenth century, reveal a strong impact of Western art. One of them is a work on cosmology, the *Ter-cüme-i İkd al-Cuman*, originally written in Arabic by Ayni and translated into Turkish by Mehmed Emin al-Üsküdari. The other is the *Hamsa* of Atai, which is devoted to erotic themes. As the paintings in these two works were added at a later date and belong to the second quarter of the eighteenth century, they will be discussed in the following section.

The *nakkaşhane* shows a noticeable decline in the last quarter of the seventeenth century. Approximately forty to sixty artists are listed in the documents drawn between 1610 and 1670; however, the number drops to seven to ten after this date. The enrollment in the *nakkaşhane* is reflected in the production of illustrated manuscripts, which shows the same decline.

With the exception of Ahmed Nakşi, the artists of this period rely on the models established during the classical period. The paintings, bookbindings, and illuminations

112. Bizhan and Manizha.
Tercüme-i Şahname, 1620.
(New York Public
Library, Spencer Coll.,
Turkish Ms. 1, fol. 277a)

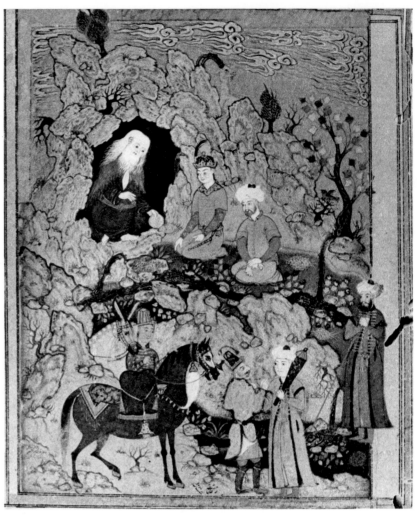

113. Kenan Paşa in Macedonia.
İbrahim Efendi, *Paşaname*, 1630.
(London, British Library, Sloane 3584, fol. 20a)

114. Prince Visiting a Hermit, 1638.
Assar, *Mihr u Mushtari*, 1647–48. Signed and dated by Riza.
(İstanbul, Topkapı Sarayı Müzesi, R. 1027, fol. 8b)

ill. 115

lack originality although they reveal a high degree of technical competence. The stamped and gilded cover of the *Şahname-i Nadiri* is a typical example, superbly executed and highly traditional.

ill. 116

Although there are no outstanding painters and illustrated works dating from the second half of the seventeenth century, the works of the renowned calligrapher Hafız Osman (1642–98) were executed during this period. He copied more than twenty-five Korans and wrote a great number of chapter headings and poetry samples for albums. Hafız Osman was the teacher of both Mustafa II and Ahmed III and excelled in the six styles of writing, particularly in the *naskhi* script. After his Korans were printed in facsimile in İstanbul in the nineteenth century and circulated throughout the Islamic world, Hafız Osman became the most widely esteemed Turkish calligrapher.

THE SECOND CLASSICISM: 1700–1750

The decline of illustrated manuscripts, which was most noticeable after 1650, was halted by the appearance of a remarkable artist, Levni (died 1732). He revived the *nakkaşhane*, stimulating the second classical age, which extended to the middle of the eighteenth century.

Levni was originally from Edirne, the second capital and the preferred residence of the sultans during the late seventeenth and early eighteenth centuries. Since the Edirne palace and its libraries were destroyed in later years, it is not possible to determine the scope of the painting activities that took place there. The technical mastery seen in the works of Levni and his studio strongly suggests that the Edirne school was exceedingly active and creative. The lack of high-quality manuscripts belonging to previous years may be due to the destruction of the Edirne collections.

Mustafa II (1695–1703), who resided in Edirne, was most likely Levni's first patron. His brother, Ahmed III (1703–30), also supported the painter and took him along when he moved the court to İstanbul in 1718. Levni's signatures appear on the portrait of Mustafa II in the *Silsilename* of Seyyid Muhammed, on almost all of the images in the *Murakka*, an album of figures, and on two of the scenes in the *Surname-i Vehbi*, a festival book written by Vehbi to commemorate the circumcision of the sons of Ahmed III in 1720.[98]

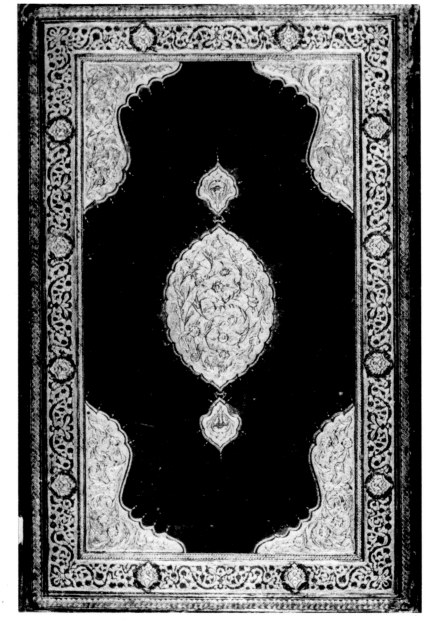

115. Stamped and gilded leather bookbinding. Nadiri, *Şahname-i Nadiri*, ca. 1622. (İstanbul, Topkapı Sarayı Müzesi, H. 1124)

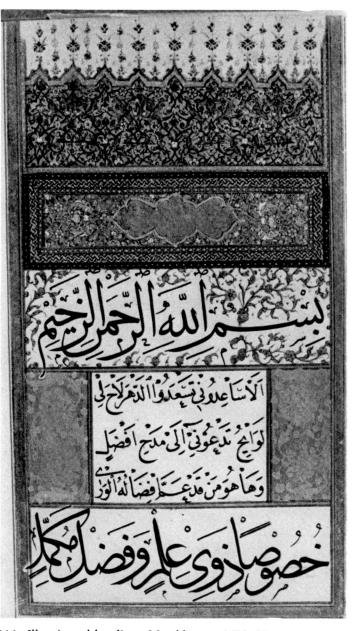

116. Illuminated heading. *Murakka*, ca. 1670–90. Calligrapher: Hafız Osman. (İstanbul, Topkapı Sarayı Müzesi, E.H. 2215, fol. 1b)

The style of Levni dominated the age called the Tulip Period, which began with the arrival of the court in İstanbul. This enchanting era ended in 1730 when a Janissary uprising resulted in the abdication of Ahmed III and the death of his grand vezir, Nev-şehirli İbrahim Paşa, who was one of the chief personages of the second classical age. Levni's influence survived up to the middle of the eighteenth century, when Western art started to infiltrate the style of the *nakkaşhane*. Levni was trained in the traditional manner, and his works bring nothing new to Ottoman painting. Yet his superb technique, dramatic and directional movement in composition, and clarity of representation make his paintings outstanding.

The compositional schemes for the portraits of the sultans in the *Silsilename* and the diverse types of men and women within the Ottoman world (including Iranians and Europeans) seen in the *Murakka* are highly conservative. The *Silsilename* contains twenty-nine paintings, the first twenty-two executed by Levni and the remaining added during the second half of the eighteenth century. With the exception of the last portrait, that of Ahmed III, the figures are seated on cushions and carpets, following

ill. 117

the scheme of the classical period. As seen in the representation of Mustafa II, the subjects are attired in the garments of the age and drawn with extreme finesse. The portrait of Ahmed III depicts the sultan enthroned and accompanied by his son. The same high technical quality appears in the forty-three paintings of the *Murakka*. Many

ill. 118

of the figures are identified, such as the *peyk* (a member of the imperial guard), who, according to the inscription, is named, "Halil bin Uveys Ağa."

It is with the *Surname-i Vehbi*, executed around 1720, that Levni's style shows full maturity. With one exception, the remaining 136 paintings in this work are spread onto double folios and utilize both repetitive and unique compositions. The repetitive ones, resembling the paintings of the 1582 *Surname*, show the sultan and his retinue seated either in their tents at the festival grounds or in pavilions along the shores of the Golden Horn. This formula is the static setting for a variety of festive events—theatrical shows, athletic competitions, processions of the guilds, and firework displays—which parade in front, continually changing and enlivening the folios. Included in this group are banquets in tents, with the personages seated around large round tables, and imperial processions spread to dozens of consecutive folios, conceived as a long, continuous frieze. The unique scenes depict singular episodes that took place during the festival, such as the preparation of the festival grounds prior to the event, the visit of the court to the Old Palace, receptions given by the grand vezir and the sultan, the special banquet for the Janissaries, a religious service in the great imperial tent, and the final ceremonies in the third and fourth courts of the Topkapı Sarayı.

ill. 119

One of the unique scenes depicts the imperial reception. The right portion of the double folio portrays Ahmed III seated on a high throne, accompanied by his three sons, his grand vezir, Nevşehirli İbrahim Paşa, a pair of sword-bearers, and the leading black and white eunuchs of the palace. He is receiving the Nakıb ül-Eşref, a direct descendant of the Prophet, who wears the green turban of his class. The facing folio represents all the religious and administrative officials of the empire who are lined in accordance with their ranks. Levni's signature appears on the footstool placed below the feet of the sultan.

The parade of the guilds is of great sociological importance, with each guild displaying its art or craft and putting on special pageants representative of its profession.

plate 32 (pp. 186–87)

Several groups are combined in one scene, such as the guilds of the silver-threadmakers, blacksmiths, shipbuilders, embroiderers, saddlers, and feltmakers who display their

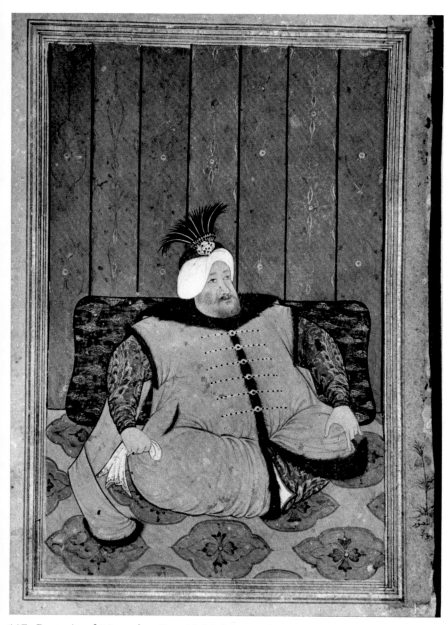

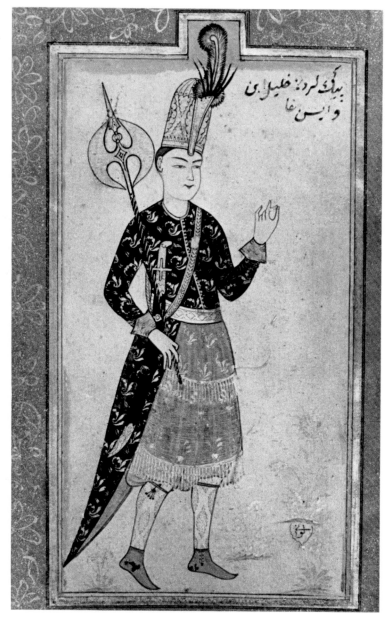

117. Portrait of Mustafa II Seyyid Muhammed,
Silsilename, ca. 1700–1710. Signed by Levni.
(İstanbul, Topkapı Sarayı Müzesi, A. 3109, fol. 22a)

118. Peyk. *Murakka,* ca. 1710–20. Signed by Levni.
(İstanbul, Topkapı Sarayı Müzesi, H. 2164, fol. 3a)

products and carry gifts for the sultan. They parade with their masters, apprentices, armed units, and entertainment corps in front of the tents set up for the sultan and his grand vezir, which appear on the right half of the double folios. To make the maximum use of space, Levni depicts on the opposite page the guilds in an s-shaped, at times a double-s-shaped, formation. This particular scene includes the French and Russian ambassadors who were invited on that day as special guests of the sultan.

The circumcision procession, in which the princes are escorted from the festival grounds outside the city to the Topkapı Sarayı, where the actual operation took place, is spread to sixteen consecutive double pages. It represents each segment of the state with its leaders and special corps in their proper place and ceremonial attire. The sultan is shown watching the procession from the *nakkaşhane,* which is depicted as a two-storied

plate 33 (p. 188)

ill. 120

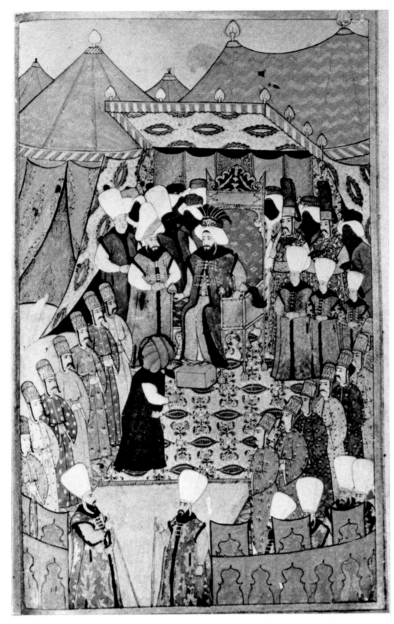

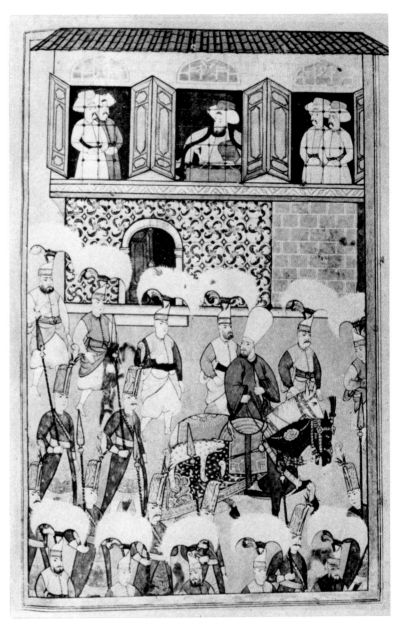

119. Ahmed III Receiving the Nakıb ül-Eşref.
Vehbi, *Surname-i Vehbi*, ca. 1720. Signed by Levni.
(İstanbul, Topkapı Sarayı Müzesi, A. 3593, fol. 17b)

120. Ahmed III Watching the Circumcision Parade from the
Nakkaşhane. Vehbi, *Surname-i Vehbi*, ca. 1720.
(İstanbul, Topkapı Sarayı Müzesi, A. 3593, fol. 168b)

building with shuttered windows on its second floor and a tiled revetment on the lower portion. This structure is no longer in existence, and Levni's painting is the only documentation we have of its appearance.

The *Surname-i Vehbi* includes the representation of the library built by Ahmed III in 1718 in the third court of the Topkapı Sarayı. It appears in the scene depicting the princes being taken from the Harem to the Circumcision Pavilion. The marble structure originally housed Levni's manuscripts, which were later moved to the Mosque of the Ağas (seen on the upper right, next to the entrance of the Harem) when the palace became a museum and the mosque was converted into the new library. Levni's depiction of the *nakkaşhane*, where he worked, and the library, where his manuscripts were kept, is indicative of the importance he gave to the structures he knew so well.

ill. 121

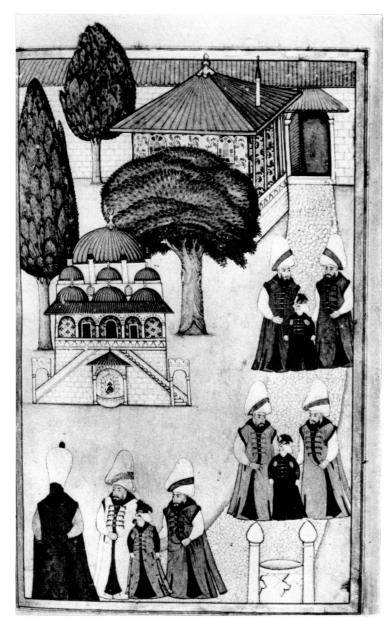

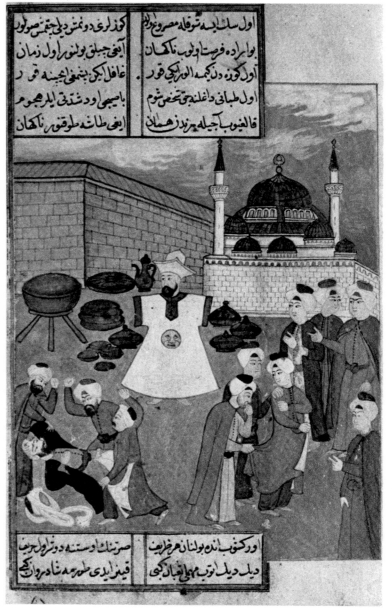

121. Princes Walking in the Third Court of the
Topkapı Sarayı. Vehbi, *Surname-i Vehbi*, ca. 1720.
(İstanbul, Topkapı Sarayı Müzesi, A. 3593, fol. 173)

122. Street Scene.
Atai, *Hamsa*, 1728.
(İstanbul, Topkapı Sarayı Müzesi, R. 816, fol. 109b)

The influence of Levni continues into the middle of the eighteenth century. A second
copy of the *Surname-i Vehbi* was made by the members of his studio several years
later. The paintings follow the exact compositional schemes, figure groupings, and
movements created by Levni, although they display a coarser manner of execution.[99]
Another work in the same style is the *Hamsa* of Atai, dated 1728, which contains forty-
three paintings.[100] One of the scenes in the *Hamsa* takes place on a street in front of a ill. 122
mosque where an itinerant magician works with a number of pots and pans. His act
is ignored by the crowd, which concentrates instead on a group of figures beating an
older man for having made improper advances to a youth.

The Tulip Period was truly a second classical age in Ottoman art. Sultan Ahmed III's
patronage resulted in the revival of the *nakkaşhane* and in the creation of remark-

ill. 123

able works. Among the numerous albums executed for the sultan is an exquisite manuscript with a lacquer cover dated 1723 and signed by Ali Üsküdari.[101] The delicately executed cloud-bands adorning the central medallion, corner quadrants, and border form a most pleasing contrast to the dense floral composition filling the field. Its immaculate technique indicates that the artists were capable of producing quality works upon demand. This album also contains a *besmele* written by the sultan himself, who was trained by Hafiz Osman, the celebrated calligrapher.

ill. 124

Another *Murakka-ı Has* (Imperial Album) contains the *tuğra* of Ahmed III executed by Ahmed bin Mehmed. In contrast to the traditional motifs employed in the former volume, the design here reflects the beginning of a rococo Ottoman style, which was to become more pronounced in the future. This album also has an outstanding lacquer binding, made in 1727 by Ahmed Hazine.[102]

ill. 125

Working about a decade after Levni is another artist, Abdullah Buhari, whose works appear only in albums.[103] He has signed and dated many of his paintings, which were executed between 1735 and 1744. Abdullah Buhari's portraits of Ottoman court types, including sultans and female violinists, show the impact of Western art. Attempting to produce three-dimensionality in his figures, he uses heavy shading in the faces and elaborate drapery in the garments.

This new style can also be seen in two copies of the *Tercüme-i İkd al-Cuman* (Translation of the Pearl Necklace). Although the colophon of the first manuscript gives the date 1692–93, the dozen folios that are illustrated appear to have been inserted at a later period.[104] One of the paintings, depicting the personification of the planet Venus, bears the date 1725. Since the execution of the remaining paintings is identical to that of Venus, this section must have been incorporated around that time. The second manuscript, dated 1747–48, is an exact copy by a lesser hand, and the illustrations of the planets, zodiac, and constellations are taken from the earlier work.[105]

ill. 126

A group of nine paintings revealing a related style appears in another version of Atai's *Hamsa*, its colophon bearing the date 1690.[106] These illustrations employ perspective in architectural renderings, illusionistic landscape settings, and shading in figures that indicate they were executed around 1740. One of the least erotic scenes represents a brothel with ladies waiting inside while a group of men hold a discussion in the street. The paintings in the *Hamsa* are inserted into the text with floral compositions of roses, tulips, hyacinths, and carnations filling the reverse. These flowers are similar to those found in several anthologies made in the second quarter of the eighteenth century, such as the *Gazels* and the *Sümbülname*, the latter devoted to the cult of hyacinths.[107] The representations of flowers also appear in albums, several signed by Abdullah Buhari or Ahmed Ataullah. These flowers are painted with botanical realism.

ill. 127

The influence of Western art was partially the result of the political and social environment of the age. During the reign of Ahmed III, Ottoman ambassadors were sent to Paris and Vienna, and the Ottoman world, now opened to the West, displayed first a curiosity about and later an admiration for European culture. Ottomans started building pavilions in the style of Fontainebleau and Versailles, and incorporating baroque and rococo elements into their decorative arts. The Western delegates and artists residing in İstanbul were influential in promoting European art. Its counterpart in Europe led to the Turquerie genre, enjoyed in the courts of the Bourbons and Hapsburgs.

THE FINAL PHASE: 1750–1900

The illustrations in manuscripts produced during the second half of the eighteenth and

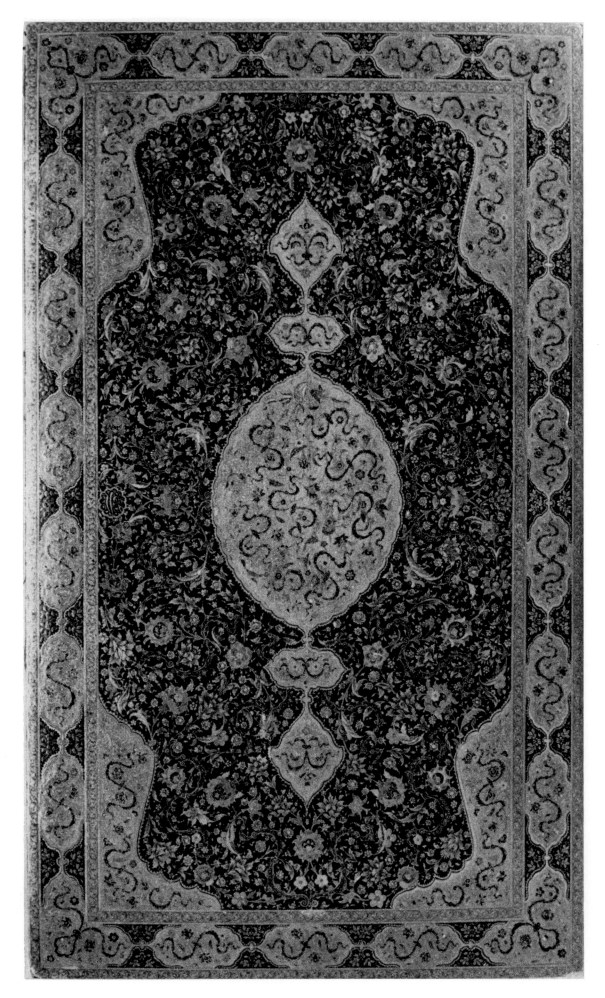

123. Lacquered bookbinding.
Murakka-ı Has, 1723.
Signed by Ali Üsküdari.
(İstanbul, Topkapı Sarayı Müzesi,
A. 3652)

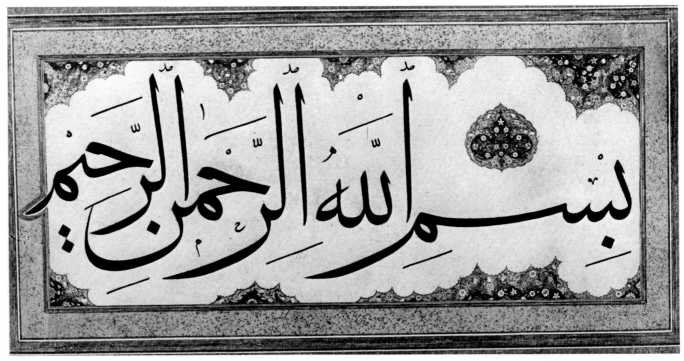

124. Besmele. *Murakka-ı Has*, 1723. Calligrapher: Ahmed III.
(İstanbul, Topkapı Sarayı Müzesi, A. 3652, fol. 1a)

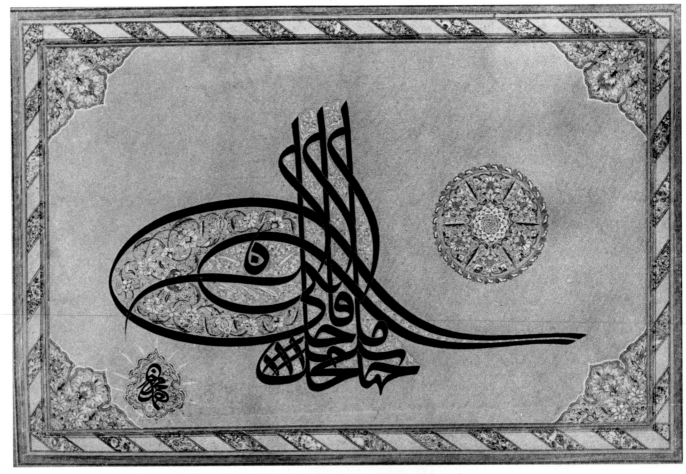

125. Tuğra of Ahmed III. *Murakka-ı Has*, 1727. Signed by Ahmed bin Mehmed.
(İstanbul, Topkapı Sarayı Müzesi, A. 3653, fol. 5a)

127. Ladies in a Brothel, ca. 1740. Atai, *Hamsa*, 1690.
(İstanbul, Türk ve İslam Eserleri Müzesi, 1969, fol. 90a)

126. Planets Venus and Mars, dated 1725. *Tercüme-i İkd al-Cuman,*
1692–93. (İstanbul, Üniversite Kütüphanesi, T. 5953, fol. 25b)

throughout the nineteenth century show a mixture of traditional themes and foreign elements. The art of the book is generally limited to poor copies of classical works or albums devoted to portraits of the sultans.

This period reveals a greater interest in wall paintings, with panoramic views adorning both religious and secular buildings. These large paintings generally depict real or fantastic landscapes with pavilions lining the shores. Devoid of figural representations, they recall Matraki's works of the 1530s and 1540s, yet their vocabulary is contemporary, mixing local elements with the European concepts of painting.

Although some early eighteenth-century structures had been decorated with wall paintings—such as the breakfast room of Ahmed III in the Topkapı Sarayı and the Köprülü House on the Bosporus—the motifs used there were limited to bunches of flowers and bowls of fruits, reflecting the taste of the Tulip Period. The later wall paintings reveal a more extensive and realistic representation in architectural and naturalistic settings. These wall paintings appear in the pavilions of the Topkapı Sarayı (such as the Valide Sultan Suites), waterside villas and city mansions of İstanbul, and in Anatolian mosques.[108] It is remarkable that in the provinces scenic views of cities like İstanbul and Mecca as well as panoramic landscapes adorn the mosques, whereas in the capital they are found only in residential buildings.

Aside from the contemporary fashion of wall paintings, the popularity of *levhas* (large sheets of calligraphy quoting Koranic verses or poetry) is indicative of the final phase in the tradition of illustrated manuscripts. The *nakkaşhane* barely survived, with an average of seven members recorded between 1750 and 1800. Among its works are several copies of the *Tercüme-i Acaib al-Mahlukat* and the interesting three-volume *Tercüme-i Şahname*.[109] The latter work reuses paintings from fifteenth-century Iranian and late sixteenth- and early seventeenth-century Turkish manuscripts and adds a number of contemporary images. Many of the scenes are composed of several paintings from diverse periods, revealing an excellent use of the art of assemblage, although failing in originality.

The influence of Western art is particularly noticeable in portraits of the sultans in such works as the *Tevarih-i Al-i Osman* by Ahmed Taib.[110] The representation of Mustafa III shows the sultan, attired in traditional garments, seated on a throne. The modeling of the face and the elaborate volutes of the throne, adorned with large blossoms and leaves, characterize the baroque Ottoman style of the age. Similar motifs appear on the illuminations and lacquer bookbindings, often showing a bouquet of roses surrounded by twisting and turning leaves.

ill. 128

One of the characteristic illuminations appears in the most fascinating work of this period, the *Hubanname ve Zenanname* (Book of Beauties and Women), which combines the representation of single figures found in albums with the panoramic views seen in architectural decoration.[111] The text, written by Fazıl Hüseyin, describes the world's men and women. The manuscript was executed in 1793 at the court of Selim III (1789–1807). The first part, the *Hubanname*, is devoted to men and contains forty-four paintings illustrating different types of figures from all continents and including some "manly" activities. Each type, identified through his costume, physical characteristics, and regional differentiation is placed against a setting descriptive of his land. The paintings related to the activities of men are of greater interest for the study of the period. Among them is a scene in a local tavern. A man, seated at a round table laden with food and drink, is listening to a song performed by a youth accompanied by two musicians. The setting is highly accurate: in the background are tables and stools, a "bar," and

ill. 129

ill. 131

128. Portrait of Mustafa III.
Ahmed Taib, *Tevarih-i Al-i Osman*, 1786–87.
(İstanbul, Topkapı Sarayı Müzesi, E.H. 1435, fol. 57a)

129. Illuminated heading.
Fazıl Hüseyin, *Hubanname ve Zenanname*, 1793.
(İstanbul, Üniversite Kütüphanesi, T. 5502, fol. 73b)

several large barrels stored under an arcade adorned with ceramic plates; the walls of the upper storey are decorated with paintings of figures framed by garlands. The use of perspective and modeling in figures, to suggest volume, appears in all the paintings.

The second part, the *Zenanname*, contains thirty-nine paintings describing the women of various regions and showing their characteristic activities, such as bathing in a local *hamam* (bath), working in a brothel, giving birth, and participating in an outing. One of the scenes, painted sideways on the folio, represents ladies at play with a panoramic ill. 130 background showing pavilions and gazebos along a pool adorned with fountains, including the *çeşme* (square fountain) of the age. The setting is characteristic of the parks, picnic, and promenade grounds so popular with the residents of İstanbul. The illustration has the feeling of a large panel or a mural, developed horizontally with a great spaciousness in the background, similar to the paintings employed in contemporary interior decoration.

The *Hubanname ve Zenanname* is among the last illustrated books produced in the traditional manner and including original paintings. The final attempt occurred in 1873 with the fifteen paintings added to the Spencer *Tercüme-i Şahname*.[112] These are executed in the style of the age, showing extensive modeling in the figures and employing illusionistic landscapes and interior settings with proper perspective. The Western traditions of painting are most alien to manuscript illustrations, and the aesthetic results leave much to be desired when they rely on styles and techniques better suited for panels and murals.

The remaining nineteenth-century manuscripts are devoted only to the portraits of the sultans or, at times, ambassadors and ministers.[113] These portraits, and those added to the classical *Silsilenames*, are executed either in the current westernized style or are poor imitations of the earlier works. The importance given to portraiture in the nineteenth century is also indicated by a special medal of honor, the *tasvir-i hümayun* (imperial representation) established by Mahmud II (1808–39). This honor, which was in effect until the reign of the last Ottoman, Mehmed VI (1918–22), was presented by the sultans to high government officials in recognition of their service to the state. The medal consisted of a miniature painting, generally on ivory, encased in a jeweled frame.

Mahmud II, who completely westernized the administrative and educational systems as well as court attire, had his portraits hung in various state offices. During his reign, the traditional manuscripts were replaced by printed books illustrated with engravings or woodcuts. The arts of the calligrapher, illuminator, and miniaturist became quaint vestiges of the past, as paintings were being executed on large canvases or wood panels adorning the walls.

In the early part of the nineteenth century, painting in the European sense, that is, easel painting, was incorporated into the academic curricula of the Mühendishane-i Hümayun, the imperial academy for the training of engineers, architects, and military officers. Many of its graduates, such as Ferik Tevfik, Osman Hamdi, Hüseyin Zeki, and Ahmed Ali (called Şeker Ahmed due to his sweet disposition), were sent to Vienna, London, Paris, Rome, and Berlin to further their studies, working with such masters as Boulanger, Gérôme, and Cabanel. These artists executed portraits, still lifes, landscapes, genre scenes, and military subjects in the prevailing traditions of the West. The leading figure was Osman Hamdi, who was responsible for the establishment of the Academy of Fine Arts in 1877 in İstanbul, which trained students in painting, design, and architecture.[114] The academy was under the supervision of the Ministry of Education, which also controlled the newly established public museums. In 1882 the Çinili Köşk, built by Mehmed II, who had founded the *nakkaşhane* 400 years before, became the Museum of Ancient Arts with a fine arts school attached to it.

The museums displayed works that had been purchased in Europe together with those executed by the Turks in the same styles, making Western art accessible to the people.[115] The teaching of applied arts and art history in public schools and universities further helped to transplant the "international" schools of painting. The elite *nakkaşhane*, which had produced thousands of illustrated works for the private libraries of the sultans and for the enjoyment of a select few, ceased to exist. The arts, particularly painting, became a part of the entire society. After the establishment of the Republic, scores of public museums were opened, and applied arts, art history, and archaeology were taught and practiced in educational institutions throughout Turkey.

The development of Ottoman manuscripts, like that of the empire, was directly related to the ambitions and power of the sultans. Beginning with humble works executed in the secondary capitals of Amasya and Edirne, the *nakkaşhane* started to take shape around 1500 in İstanbul, showing at first an eclectic style incorporating both native and Iranian elements. The burst of productivity seen in the ensuing fifty years resulted not only from the increase of the number of artists employed in the studio but also from the tremendous creative energy of the period, which affected all the arts. The culminating point of this phenomenal energy was the establishment of a unique Turkish genre, illustrated historiography, with native artists evolving as the masters of the *nakkaşhane*, creating compositional schemes based on actual observation and portraying contemporary figures and settings.

Reaching its climax in the last quarter of the sixteenth century, Ottoman painting reflected the spectacular political and social achievements of the state. Employing hundreds of artists in the creation of monumental works, the golden age of the *nakkaşhane* left a legacy yet to be equaled in the history of the Turkish empires. The historical significance of the paintings often tends to overshadow their aesthetic merits, the observer being taken by the documentary filmstrip quality of representation in which each personage, location, and event can be identified. The dramatic compositional schemes, superb use of color and form, movement and arrest, general and specific, harmoniously employed within one scene prove that the painters were capable of creat-

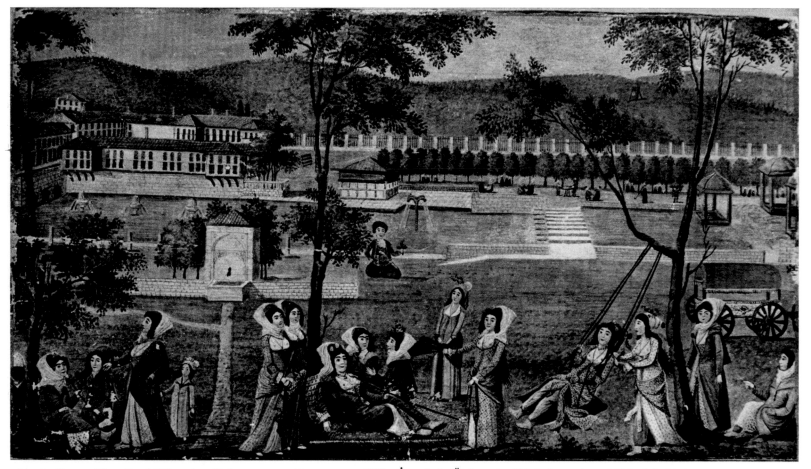

130. Ladies at Play. Fazıl Hüseyin, *Hubanname ve Zenanname*, 1793. (İstanbul, Üniversite Kütüphanesi, T. 5502, fol. 78a)

ing unique works of art while illustrating a given historic theme. The dignity and monumentality present in most scenes—often with an overall static quietude—symbolize the magnitude of the state, its rigid protocol, and absolute power. The recreation of an event and its participants within a given time-space capsule without the sacrifice of inherent force and potentiality is the greatest achievement of the *nakkaşhane*.

The slow decline witnessed after the middle of the seventeenth century was halted by the appearance of a master from Edirne. This brief renaissance, like the period itself, soon disintegrated, and traditional themes and styles gradually disappeared with the surfacing of a different style and way of life. By the end of the nineteenth century, classical works ceased to exist, and the empire and its arts reflected a turn to the West.

The two major forces of great significance in the life cycle of Ottoman manuscripts came from opposite directions and had contrasting effects. One, from the East, was easily absorbed given the nature of the state, which was a part of the Islamic world, and led to the birth of an Ottoman style. The other, coming from the West, was fatal since it was alien to that tradition. However, the latter was absorbed and in due time integrated, leading to the creation of new and different modes of expression—representative of a society that had become a part of the Western world.

When the absolute power of the Ottoman sultans became restricted by the Tanzimat and was eventually replaced by the Republic, there occurred inevitable changes in social and political institutions and, above all, in the tastes and demands of the patrons. Of all the Ottoman arts, it was the tradition of illustrated manuscripts that suffered the most, no longer answering the needs of the new society. The manuscripts produced by the *nakkaşhane* were created for personal use, and their existence depended on the support of an extremely elite and limited patronage. In contrast, the other arts—such as architecture, ceramics, and textiles—were able to survive the change from empire to republic, since they were made for public consumption and had a wide range of markets, both domestic and foreign. As a result of its private nature, the tradition of illustrated manuscripts died out when the demanding and omnipotent patron, the sultan, was no longer present.

Notes

Since the imperial manuscripts were zealously guarded in the palace libraries during the Ottoman period, relatively few works of outstanding quality are present in other collections. Most illustrations in this chapter were chosen from the vast amount of unpublished material in the İstanbul museums, with special consideration given to representative examples of calligraphy, illumination, and bookbinding, which were as essential as the paintings in the creation of a book.

The following abbreviations are used for the collections frequently cited:

BL British Library, London
BN Bibliothèque Nationale, Paris
CB Chester Beatty Library, Dublin
IU İstanbul Üniversite Kütüphanesi, İstanbul
TIEM Türk ve İslam Eserleri Müzesi, İstanbul
TKS Topkapı Sarayı Müzesi, İstanbul

1. All references to archival documents mentioned are from Rıfkı Melil Meriç, *Türk Nakış Sa'natı Tarihi Araştırmaları, 1: Vesikalar* (Ankara, 1953).

2. Of particular importance is the *Menakıb-ı Hünerveran* (Legends of the Talented) by Gelibolulu Mustafa Ali. This work, dedicated to Murad III, was completed in 1587. TKS EH 1231, H 1291, and R 1504. It was printed in 1926 in İstanbul, edited by Mahmud Kemal İnal. For other works by Mustafa Ali (1541–1600) see p. 197.

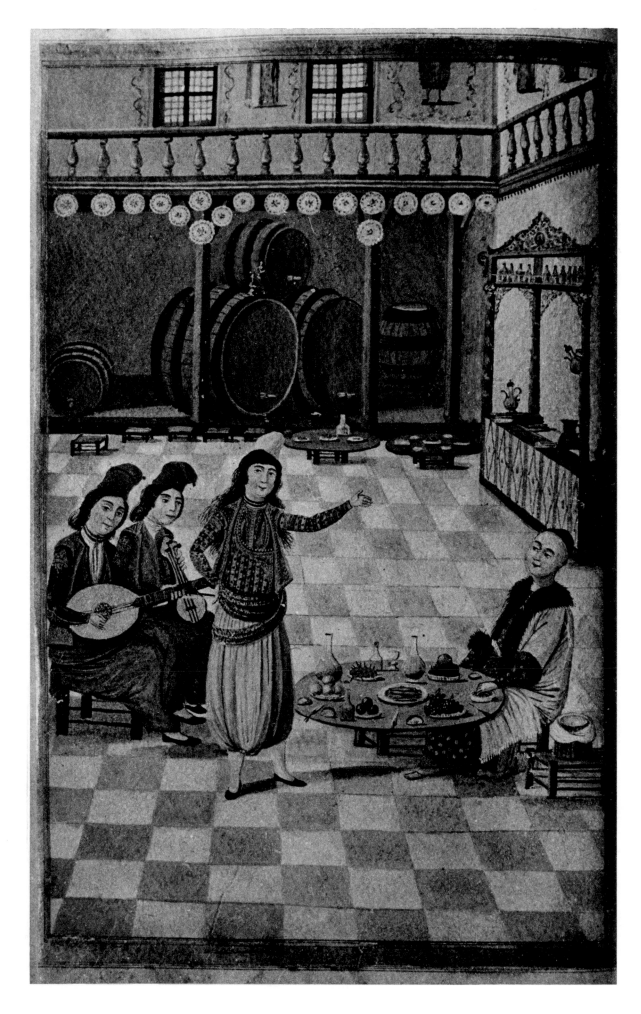

131. Entertainment in a Tavern.
Fazıl Hüseyin, *Hubanname
ve Zenanname*, 1793.
(İstanbul, Üniversite Kütü-
phanesi, т. 5502, fol. 41a)

3. The life cycle of the *nakkaşhane* was directly related to the strength of the Ottoman Empire; both were dependent on the power of the patron and ruler, the sultan. The number of artists enrolled in the *nakkaşhane* appears to reflect the growth and decline of illustrated manuscripts as well as the power of the state.

Date of Register	Number of Artists
1526	41
1545	59
1557	34
1558	39
1596	124–29
1605	93
1606	57
1607	55–56
1617	61
1623	48
1637	39
1649	37
1650	39–40
1655	41
1670	45–49
1687	9
1689	10
1690	8
1691	8
1698	7
1699	7
1700–1790	average 7

4. İstanbul, Fatih Library, no. 3422.

5. TKS A 3472. The English translation of this work was published by Donald Hill, *The Book of Knowledge of Ingenious Mechanical Devices* (Dordrecht and Boston, 1974).

6. TKS H 841. Full translation of the text and reproductions of the paintings are published in Assadullah Souren Melikian-Chirvani, "Le Roman de Varqe et Golšâh," *Arts Asiatiques* 22 (1970).

7. M. Kemal Özergin, "Selçuklu Sanatçısı Nakkaş Abdülmü'min el-Hoyi Hakkında," *Belleten* 34, no. 134 (April 1970): 119–230.

8. A second manuscript that can be assigned to Konya is a Persian version of the *Kalila va Dimna*, TKS H 363. The 124 illustrations of this work, executed in the Seljuk Mesopotamian style, are dated circa 1300 (M. Ş. İpşiroğlu, *İslâmda Resim* [İstanbul, 1971], pls. 7–14).

9. BN pers. 899. The manuscript contains two treatises, one composed in 1271 at Aksaray and the other in 1272 at Kayseri (E. Blochet, *Les Enluminures des manuscrits orientaux turcs, arabes, persans de la Bibliothèque Nationale* [Paris, 1926], pp. 70–72, pls. 18–19; idem., *Musulman Painting* [London, 1927], pl. 34).

10. For a study of this period and full bibliography see Esin Atıl, "Ottoman Miniature Painting under Sultan Mehmed II," *Ars Orientalis* 9 (1973): 103–20.

11. Ahmedi died around 1412. The manuscript is in BN suppl. turc 309.

12. BN suppl. turc 693.

13. Oxford, Bodleian Library, Ms. Ouseley 133.

14. TKS R 989.

15. TKS R 706.

16. IU F 1423.

17. See Atıl, "Ottoman Miniature," fig. 22.

18. Ibid., figs. 9, 12.

19. TKS A 3563. I. Stchoukine, "Un Manuscrit illustré de la Bibliothèque de Bayazıd II," *Arts Asiatiques* 24 (1971): 9–22.

20. TKS Y 913.

21. TKS A 5.

22. Bombay, Prince of Wales Museum, no. 51.34 (Glynn M. Meredith-Owens, "A Persian Manuscript of the Reign of Bāyezīd II with Ottoman Miniatures," *Bulletin of the Prince of Wales Museum of Western India* 10 [1967]: 27–31).

23. TKS H 799.

24. New York, Metropolitan Museum of Art, no. 69. 27.

25. Şeyhi, who lived during the reign of Murad II, wrote the work circa 1420. The manuscript is in Uppsala (Sweden) University Library, Vet. 80 (Carl J. Lamm, "Miniatures from the Reign of Bāyezīd II in a Manuscript Belonging to the Uppsala University Library," *Orientalia Suecana* 1 [1952]: 95–114).

26. Uzun Firdevsi was born in Bursa in 1453. This manuscript is in CB 406.

27. The damaged work is in Cambridge, Mass., Fogg Art Museum, no. 1958–155. The second manuscript has three miniatures and is in TKS H 686. Only seven paintings of the third work are known; they are dispersed among Cairo, University Library; London, Edmund de Unger Collection; and Geneva, Musée d'Art et d'Histoire (Gaston Wiet, *Miniatures persanes, turques et indiennes: collection de Son Excellence Chérif Sabry Pacha* [Cairo, 1943], nos. 82–86; Basil W. Robinson, "Catalogues des peintures et des calligraphies Islamiques légées par Jean Pozzi au Musée d'Art et d'Histoire," *Geneva* 21 [1973]: nos. 243–44; Basil W. Robinson, ed., *The Keir Collection: Islamic Painting and the Arts of the Book* [London, 1976], nos. IV. 1–4).

28. Edwin Binney, 3rd, *Turkish Treasures from the Collection of Edwin Binney 3rd* (Portland, 1979), pp. 5–6.

29. Ernst J. Grube, *Islamic Paintings from the Eleventh to the Eighteenth Century in the Collection of Hans P. Kraus* (New York, n.d.), no. 178.

30. TKS H 679.

31. TKS EH 1512.

32. TKS H 1123.

33. The impact of Herat on both early Ottoman and Safavid schools of painting is discussed by Filiz Çağman, "The Miniatures of the *Divan-i Hüseyni* and the Influence of Their Style," in *Fifth International Congress of Turkish Art*, ed. G. Fehér (Budapest, 1978), pp. 231–59.

34. Nevai: TKS H 983 and Cairo, University Library, Ms. 3; Jami: TKS H 987; Nizami: TKS H 757 and B 145; Şeyhi: BL Or. 2708; Firdausi: TKS H 1499.

35. TKS H 802.

36. TKS H 1116. This work, which is not dated and its translator unknown, contains six paintings.

37. TKS H 753 and H 764.

38. TKS R 1542 and H 1510.

39. Jami: R 914; Shahi: B 140; Nevai: R 806 and R 804; Hafiz: YY 846; Arifi: H 845; Firdausi: H 1520.

40. CB 166 and 424.

41. IU F 1330.

42. BL Add. 24962, dated 1527; Binney Collection, circa 1550 (see Binney, *Turkish Treasures*, pp. 16–17); TIEM 1960, circa 1558.

43. Also belonging to this group is Sadi's *Bustan* in Washington, D.C., Freer Gallery of Art, no. 49.6 (Esin Atıl, *Turkish Art of the Ottoman Period* [Washington, D.C., 1973], no. 7).

44. TKS H 1522. For the works of Osman see pp. 176 and 198.

45. TKS H 1597–98.

46. IU T 5964. Published in facsimile with Turkish and English commentaries in Hüseyin G. Yurdaydın, *Nasuhü's-Silahi (Matrakçı), Beyan-ı Menazil-i Sefer-i Irakeyn-i Sultan Süleyman Han* (Ankara, 1976); for the

representation of İstanbul see Walter B. Denny, "A Sixteenth-Century Architectural Plan of Istanbul," *Ars Orientalis* 8 (1970): 49–64.

47. TKS R 1272, circa 1540.

48. TKS H 1608, circa 1545.

49. An illustrated manuscript that was recently sold in London is more likely the first volume of the series. This manuscript, devoted to the history of the ancient prophets beginning with Adam and terminating with the Deluge, is written in Persian and contains ten paintings. The work was commissioned by Sultan Süleyman and completed in 1558 (Christie's, *Islamic and Indian Manuscripts and Miniatures*, Wednesday, November 17, 1976, pp. 12–13). A painting depicting Muhammed with his disciples, owned by the Los Angeles County Museum of Art, might have originally belonged to the second volume (no. M.73.5.446. Pratapaditya Pal, ed., *Islamic Art* [Los Angeles, n.d.], pp. 144–45).

50. Grube, nos. 185–218.

51. TKS H 1517. For a discussion of one of the painters see Nurhan Atasoy, "1558 Tarihli *Süleymanname* ve Macar Nakkaş Pervane," *Sanat Tarihi Yıllığı* 3 (1970): 167–96.

52. TKS H 1592.

53. The style of this master also appears in the works cited above in fn. 49 as well as in Arifi's *Razvat al-Ushak* (Garden of Lovers), written in Persian and illustrated with three paintings around 1560 (Binney, *Turkish Treasures*, pp. 25–27).

54. TKS H 1339.

55. They occur in the *Kıyafet al-Osmaniye fi Şemail-i İnsaniye* (TKS H 1563 and IU T 6087, both dated 1579), *Surname* (TKS H 1344, ca. 1582) and in the second volume of the *Hünername* (TKS H 1524, dated 1587–88).

56. Nigari's name appears on another representation of Selim II, as well as on the portraits of Francis I, king of France, and Charles V, emperor of the Holy Roman Empire, copied from European prints (Binney, *Turkish Treasures,* pp. 22–25).

57. CB 413.

58. BL Or. 7043. Glynn M. Meredith-Owens, "Turkish Miniatures in the Selīm-nāme," *The British Museum Quarterly* 26, nos. 1–2 (September 1962): 33–35.

59. TKS A 3595. For a detailed study of this manuscript see Filiz Çağman, "Şahname-i Selim Han ve Minyatürleri," *Sanat Tarihi Yıllığı* 5 (1973): 411–42.

60. TKS H 1523 and H 1524. Nigar Anafarta, *Hünername: Minyatürleri ve Sanatçıları* (İstanbul, 1969).

61. Vol. 1 in IU F 1404; vol. 2 in TKS B 200.

62. There exist several copies of this work: IU T 6087, dated 1579; TKS H 1563, circa 1579–80; IU T 6088, circa 1580; TKS R 1264, dated 1587; BL Add. 7880, dated 1589; and TKS R 1265, dated 1597. Some of these volumes contain only the portraits of the twelve sultans up to Murad III while the others have additional paintings of the later rulers, which were incorporated in the following years.

63. Three copies of this work are known: TIEM 1973 and CB 414, both dated 1583; and TKS H 1321, dated 1586. Günsel Renda, "Topkapı Sarayı Müzesi'ndeki H. 1321 No.lu *Silsilename*'nin Minyatürleri," *Sanat Tarihi Yıllığı* 5 (1973): 443–80; English summary on pp. 481–95.

64. TKS H 1344.

65. TKS A 3595, fol. 11a.

66. TKS R 1300, circa 1595.

67. TKS A 3592 and TIEM 1965, both circa 1595; and TKS H 1609, circa 1596.

68. BL Add. 22011, dated 1582–83; and TKS H 1365, dated 1584.

69. TKS R 406, dated 1581.

70. These include Rumuzi's *Tarih-i Feth-i Yemen* on Sinan Paşa's conquest of Yemen in 1570 and that of Tunisia in 1574 (IU T 6045, dated 1594); Asafi's *Şecaatname* on the eastern campaigns of Özdemiroğlu Osman Paşa between 1578 and 1586 (IU T 6043, dated 1586); İbrahim Çavuş's *Kitab-ı Gencine-i Feth-i Gence* on the conquest of Gence by Ferhad Paşa in 1588 (TKS R 1296, dated 1589–90); Faramarz's *Kıssa-ı Şehr-i*

Şatran on the city of Şatran (IU T 9303, dated 1589–90); and Hoca Saddeddin's *Tac al-Tevarih* describing the sultans (TKS R 1112, ca. 1590). A related work by Hoca Saddeddin is the *Zübdet al-Asar*, narrating the festival of Murad III in 1582 (TKS R 824, ca. 1582).

71. The author's full name is Yusuf bin Hasan bin Abdülhadi. The İstanbul manuscripts are in TKS A 3110 and H 1624. For those made in Baghdad see fn. 82.

72. The history of the Americas describes the discoveries of Columbus and Cortez and the geography of the continent and contains illustrations of the animals, plants, and natives of the New World (TKS R 1488, ca. 1582; İstanbul, Beyazıt Library, no. 4969, dated 1583). It was among the first books printed in Turkey by İbrahim Müteferrika in 1730 and is the earliest to contain woodcut illustrations. Ali Paşa's activities are recorded in İstanbul, Süleymaniye Library, Halet Efendi 612, circa 1602.

73. Among the literary texts are Baki's *Divan* (BL Or. 7084, ca. 1595); Fuzuli's *Divan* (TKS Y 897, dated 1574–75); Hamdullah Çeiebi's *Yusuf ve Züleyha* (New York, Kraus Collection, ca. 1582–87 [Grube, *Islamic Paintings*, nos. 219–23] and CB 428, ca. 1585–90); Faramarz's *Romance of Faruhruz* (BL Or. 3298, ca. 1595); Yahya Bey's *Kitab-ı Şah ve Geda* (Binney Collection, ca. 1600 [Binney, *Turkish Treasures*, pp. 40–42]); Şerif's *Destan-ı Faruk ve Huma* (IU T 1975, dated 1601); and Cennabi's *Cevahir al-Garaib* (Binney Collection, dated 1582 [Binney, *Turkish Treasures*, pp. 33–39]). Firdausi: TKS H 1518, circa 1575; Binney Collection, circa 1580 (Binney, *Turkish Treasures*, pp. 48–50); and BL Or. 7204, circa 1590. Al-Kazvini: BL Add. 7894 and TKS A 3632, both circa 1597. There are other works that resemble al-Kazvini's treatise, the *Matali al-Saadet* (BN suppl. turc 242, dated 1582) and the *Marvels of Creation* (BL Harleain 5500, ca. 1595), both of which are devoted to astrological and cosmological subjects. A related work is the *Tercüme-i Miftah Cifr al-Cami,* based on obtaining esoteric knowledge through the use of words (IU T 6624, dated 1597–98; and TKS B 373, ca. 1600).

74. Vol. 1 in TKS H 1221; vol. 2 TKS H 1222; vol. 3 New York Public Library, Spencer Collection, Turkish Ms. 3; vol. 4 CB 419; vol. 5 lost; vol. 6 TKS H 1223.

75. This the TIEM 1973 copy.

76. TKS H 1563 and IU T 6087.

77. Examples include a copy of the *Tercüme-i Şahname, Sefer-i Sigetvar, Matali as-Saadet, Yusuf ve Züleyha* (Dublin copy), *Siyer-i Nabi,* and *Tarih-i Feth-i Yemen.*

78. Hasan's paintings also appear in the *Divans* of Baki and Fuzuli, *Destan-i Faruk ve Huma, Tercüme-i Acaib al-Mahlukat, Marvels of Creation, Kıssa-ı Şehr-i Şatran,* and *Tercüme-i Şahname* (London copy).

79. Two paintings from this work, which is incomplete, are now in the Museum of Fine Arts, Boston, nos. 14.693 and 14.694.

80. Stuart C. Welch, *A King's Book of Kings* (New York, 1972).

81. Included in this provincial group are Lamii Çelebi's *Maktel-i İmam Hüseyin* (Martyrdom of Imam Hüseyin) and *Maktel-i Al-i Resul* (Martyrdom of the Prophet's Family), Jami's *Nafahat al-Uns* (Biographies of the Sufi Saints), Celaleddin Rumi's *Mesnevi,* Firdausi's *Shahname,* and Baki's *Divan.* There are also copies of Ali Çelebi's translation of the *Kalila va Dimna,* called the *Hümayunname;* and Mahmud Dede's translation of the biography of the Mevlana, the *Menakıb-ı Sevakıb* (Stars of the Legends).

82. *Silsilenames:* TKS H 1324 and H 1592, both dated 1597; CB 423, dated 1598; and BN suppl. turc 126, dated 1604. Fuzuli: New York, Brooklyn Museum, no. 70.143, dated 1602.

83. Kashifi: TKS R 392 and Berlin, Staatsbibliothek, Ms. Diez A. fol. 5, both circa 1595–1600; Mirhond: BL Or. 5736, dated 1599–1600 (Glynn M. Meredith-Owens, "A Copy of the *Razwat al-Safa* with Turkish Miniatures," in *Paintings from Islamic Lands,* ed. R. Pinder-Wilson [Oxford, 1969], pp. 110–23); Muhammed Tahir: TKS H 1369 and H 1230, circa 1600.

84. TKS H 1703. The dimensions of the manuscript are 68.3 x 47.5 cm. (26 7/8 x 18 3/4 in.).

85. The genealogy is the *Tac at-Tevarih* of Hoca Saddeddin: IU T 5970 and Paris, Jacquemart-André Museum, both dated 1616.

86. TKS H 415, circa 1610.

87. TKS H 1124, circa 1622.

88. TKS H 1263, circa 1619. For an analysis of Nakşi's work see Esin Atıl, "Ahmed Nakşi: An Eclectic Painter of the Early Seventeenth Century," in *Fifth International Congress on Turkish Art,* pp. 103–21.

89. TKS H 889, circa 1620.

90. Vol. 1: Uppsala (Sweden) University Library, Celsing 1, dated 1620; vol. 2: BN suppl. turc 326, circa 1622.

91. New York Public Library, Spencer Collection, Turkish Ms. 1.

92. BL Sloane 3584. Glynn M. Meredith-Owens, "Ken'ān Pasha's Expedition against the Cossacks," *The British Museum Quarterly* 24, nos. 3–4 (December 1961): 76–81.

93. TKS R 1027.

94. Examples include a copy of Fuzuli's *Leyla ve Mecnun* (BL Or. 405, dated 1664) and a damaged version of Hamdi Çelebi's *Yusuf ve Züleyha* (BL Or. 7111, ca. 1650).

95. Vienna, Nationalbibliothek, A. F. 50, circa 1685. *Subhatu'l-Ahbar*, facsimile edition (İstanbul, 1968).

96. Cairo, National Library, Hist. Turq. 125, dated 1684–85; BN suppl. turc 1063, dated 1685; TKS R 1662, dated 1696–97; and TKS H 400, dated 1699–1700, executed in Baghdad.

97. Examples include the *Davetname* of Uzun Firdevsi, who also wrote the *Süleymanname*, circa 1500, now in Dublin. His *Davetname* is in IU T 208, dated 1702–3. A related work is the *Mirat-i Acaib al-Mahlukat* in Berlin, Staatsbibliothek, Ms. or. fol. 2562, dated 1703.

98. All three manuscripts are in TKS. *Silsilename*: A 3109, circa 1700–10; *Murakka*: H 2164, circa 1710–20; *Surname-i Vehbi*: A 3593, circa 1720. The latter work is discussed in detail in Esin Atıl, *The Surname-i Vehbi: An Eighteenth-Century Ottoman Book of Festivals*, Ph. D. diss. (Ann Arbor, Mich.: University Microfilms, 1969).

99. TKS A 3594, circa 1730.

100. TKS R 816. Another work that reveals the conservatism of Levni and his studio is the Turkish translation of the *Al-Durr al-Munazzam* of al-Bistami, which is devoted to cryptic science (CB 444, dated 1742).

101. TKS A 3652.

102. TKS A 3652. The cover is published in Kemal Çığ, *Türk Kitap Kapları* (İstanbul, 1971), pl. 36.

103. Most of his paintings are collected in an album in IU T 9364.

104. IU T 5953, fols. 21–33.

105. TKS B 274.

106. TIEM 1969.

107. *Gazels*: IU T 5650, dated 1726; *Sümbülname*: TKS H 413, circa 1726–36.

108. These provincial mosques are in Soma, Yozgat, Milas, Birgi, Acıpayam, Urfa, Merzifon, Amasya, Datça, and Yenişehir (Rüçhan Arık, *Batılılaşma Dönemi Anadolu Tasvir Sanatı* [Ankara, 1976]; Günsel Renda, *Batılılaşma Döneminde Türk Resim Sanatı, 1700–1850* [Ankara, 1977]).

109. TKS H 409, dated 1784; IU T 6131–33, dated 1773–74.

110. TKS EH 1435.

111. IU T 5502. An earlier copy of the *Zenanname*, dated 1776, is in BL Or. 7094. A copy of the *Hubanname*, dated 1800, and three paintings from a late eighteenth-century version of the *Hubanname ve Zenanname* are in the Binney Collection (Binney, *Turkish Treasures*, pp. 117–27).

112. See p. 215 and fn. 91.

113. These include Hoca Saddeddin's *Tac al-Tevarih* (Berlin, Staatsbibliothek, Ms. or. quart 1163, ca. 1890); Ahmed Taib's *Tevarih-i Al-i Osman* (Berlin, Staatsbibliothek, Ms. or. fol. 4113, ca. 1830, and Ms. or. fol. 3064, dated 1844) and *Hadikat al-Mülük* (BL Or. 9505, ca. 1850); Şefik's *Tasvir-i Selatin-i Osmaniye* (TIEM 1976, ca. 1865) and Mehmed Hamdani's work of the same title (İstanbul, Süleymaniye Library, Hafız Paşa 1183, ca. 1870).

114. Mustafa Cezar, *Sanatta Batı'ya Açılış ve Osman Hamdi* (İstanbul, 1971).

115. The state also commissioned copies of outstanding and representative examples of European schools of painting since the originals were not accessible in Turkish museums. The choice of periods and artists was quite varied and included works by Velázquez, Jan van Eyck, Bruegel the Elder, Teniers, Rubens, van der Weyden, Snyders, Rembrandt, Hals, David, Claude Lorraine, Watteau, Chardin, Coypel, Dürer, and Holbein.

Right: Mosque lamp, from the Dome of the Rock, Jerusalem.

Ceramics

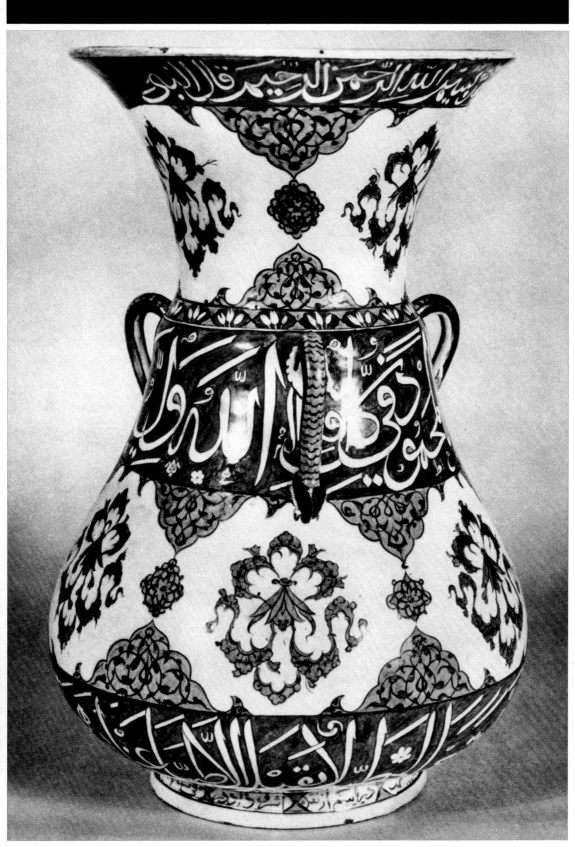

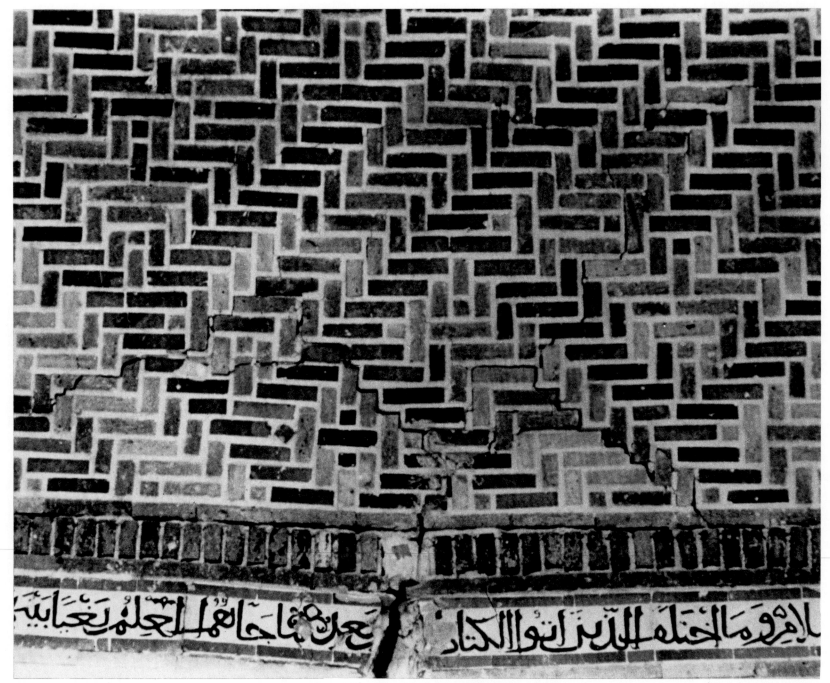

132. Malatya, Ulu Cami: glazed brick decoration in the interior of the dome; ca. 1224.

THE HISTORY OF Turkish ceramics in Anatolia is inextricably interwoven with that of architectural decoration and of the art of the book. Because of their relationships to other arts, their inherent durability, as well as their often quite literal attachment to datable buildings, the ceramic works of the Turkish tradition frequently emerge as a major means of dating an entire decorative and pictorial style, encompassing rugs, textiles, book decoration, and numerous other genres of Turkish artistic production.

The definition of "Turkish" assumed here is not ethnic but cultural in scope. Geographically, it encompasses the Anatolia and Rumelia of modern Turkey, and the larger cultural sphere of the Ottoman Empire as well; temporally, it extends from the beginnings of Seljuk and later Ottoman political and cultural hegemony into our own century. And while on occasion some of the artisans and artists involved with the production of Turkish ceramics may have been Greek, Armenian, or Iranian by birth, the tradition within which they worked, by virtue of its development within a Turkish-Islamic cultural context over the centuries, is for our purposes defined as the Turkish ceramic tradition.

Anatolian Ceramics under the Seljuks

Traditions of ceramic building decoration in the Near East, developing out of both pottery-making and brick-making techniques, have an ancient lineage. It was well established over a millennium before the emergence of Islam from the Arabian peninsula in the seventh century of our era and the subsequent entry of wave after wave of Turkic peoples into an Islamic world that was profoundly affected by its contacts with Persian civilization. In its origins, ceramic building decoration was primarily associated with brick edifices. The stone buildings of the Hellenistic tradition of the Mediterranean littoral relied for ornament on sculptural decoration carved in the basic building material and on the application of polychrome pigments directly to the stone. In the dry climate of parts of Iran, Irak, and greater Syria, stucco and plaster, painted and unpainted, proved to be yet another means of decorating buildings. These materials were not only relatively cheap in terms of material and labor but also adaptable to the decorative needs of both the pre-Islamic and Islamic cultures that utilized them. The use of mosaic decoration composed of tiny square tesserae, which entered the early Islamic decorative vocabulary through contact with the Byzantine world, appears to have waned in the Near East after the first century of Islamic rule.

In northern and eastern Iran and in Central Asia, stone of a suitable quality for building was in relatively short supply, and in the time of the Great Seljuk Empire in

the eleventh and twelfth centuries the technology and skills needed to quarry, dress, and decorate the stone were also limited. Indigenous traditions of brick architecture, which the Seljuks found exemplified in a number of magnificent early monuments in Central Asia and Iran, drew on an abundance of suitable clay, together with wood adequate both for the firing of bricks and for building the centering and scaffolding necessary to erect brick structures of substantial size. Brick buildings from earlier dynasties provided models for the exploitation of the modular building material—baked or unbaked brick—in a variety of decorative schemes, which in the strong light and shadow of the environment provided an important element of architectural surface texture and accented the important parts of buildings. This led to remarkable Seljuk brick buildings in Iran in the eleventh and twelfth centuries. One decorative dimension—that of color—was lacking in these buildings. As they were composed of the very earth that stretched for miles in every direction, the early Iranian Seljuk buildings tended to form an integral aspect of the landscape surrounding them. This fundamental characteristic of Turkish architectural decoration—a relationship with the natural environment—remained unchanged for seven centuries but adapted itself to changing surroundings as the Turks moved to the west.

By the thirteenth century the Seljuks in both Iran and Anatolia had evolved more sophisticated and complex forms of building decoration. In Anatolia earlier Iranian Seljuk traditions of decorative brick and carved stucco were adapted to the excellent building stone found in abundance near almost every major Turkish building site. Around the same time, both in Iran and in Anatolia, the established traditions of glazed pottery began to find new applications in building decoration. The first ceramic decorations utilized basic modular brick glazed on one or more surfaces; to the brick were applied coats of glassy, colored material, either brown, turquoise, dark purple, or blue. Patterns were created by contrasting the glazed brick designs against unglazed brick or stone on building surfaces. The four-square nature of the brick decoration adapted admirably to an austere and rectilinear form of the kufic script long used in monumental inscriptions in Islamic decoration. Glazed brick decoration, once established, remained a genre in the repertory of architectural decoration for many centuries in both Iran and Anatolia. The limited palette of blue, warm brown, and turquoise reflected the sky, the earth, and the vegetation of the environment.

A further development of ceramic decoration came with the emergence of a new technique, that of tile-mosaic. Monochrome tiles baked and glazed in the kiln were then laboriously cut to fit together, according to a planned design, into elaborate decorations no longer limited by the fixed modular dimensions of glazed bricks. These tile compositions appear to have been made to measure on or near the building site and were then carefully cemented into place on the appropriate parts of buildings. Tile-mosaic was an adaptable technique, highly labor-intensive but fashioned with relatively inexpensive materials. It could be cemented easily to both brick and stone structures and allowed the use of cursive calligraphic and floral-vegetal designs, which could originate in designs made with pen upon paper. Together with carved stone, a similarly labor-intensive technique, tile-mosaic formed one of the two major genres of architectural decoration in the Seljuk monuments of Anatolia.

Three further factors—one technical, one environmental, and one aesthetic—influenced and broadened the use of tile-mosaic in thirteenth-century Anatolia. Tile-mosaic as such is a two-dimensional technique, which cannot draw upon the effects of light and shadow utilized in decorative brickwork and carved stone. But the addi-

tion to the flat tile-mosaic of glazed tile elements molded in relief occurs fairly rapidly after the introduction of tile-mosaic itself, adding greatly to the complexity and visual effectiveness of ceramic decoration.

A second factor inherent in the Anatolian environment influenced the use of such decoration on buildings. The generally harsh climate dictated the progressive assimilation of the open courtyards of the four-*eyvan* (vaulted chamber open at the front) Iranian tradition into larger and larger vaulted, domed, and enclosed spaces in Anatolian architecture. It also caused tile-mosaic, a medium vulnerable to the effects of freezing water trapped in the cracks between colors, to "come in from the cold." Thus, there was a tendency in Anatolia for ceramic decoration to concentrate more and more in the interiors of buildings, while the exterior decoration continued to use the more durable carved stone.

A third factor that emerges during the thirteenth century in Anatolian ceramic decoration might be termed the "blurring" of the relationship between technique and style. As we have noted, tile-mosaic incorporating molded elements could imitate the texture of relief decorations in glazed brick and carved stone. But the development of tile-mosaic did not mean the abandonment of the four-square designs of earlier glazed brick decoration; even when the technical rationale for such a form had ceased to be relevant, such designs continued to be used in tile-mosaic decoration as part of its ever-expanding repertory. At the same time glazed brick and stucco continued to be used side by side with the newer techniques, as prominent parts of Anatolian architectural decoration, throughout the thirteenth century and beyond.

Before considering specific examples of the first Turkish ceramics in Anatolia, we might look briefly at the materials, tools, and techniques employed by ceramic artisans. In this respect the Seljuks of Anatolia were able to rely to some extent on developments achieved by their cousins to the east in Iran. In the twelfth and thirteenth centuries potters in Rayy and Kashan developed an incredibly wide range of techniques in the making of both wares and tiles. The simplest form of ceramic decoration, glazed brick, involved coating the surface of a baked clay brick with a glaze, which was composed of glassy material, color, and lead or alkaline compounds that enabled the mixture to melt evenly when fired at great heat. When baked in a kiln, generally a simple brick structure partly or totally buried in the ground, and fired with wood or charcoal, the glaze melted and fused, covering the surface with a thin coat of glassy colored material that adhered to the porous brick. In the case of tile-mosaic a finer potter's clay was used to make rectangular tiles, generally little more than a centimeter thick, or to make molded elements that would stand up in relief. These were similarly coated with glazes of different colors, and upon cooling after firing, the tiles were broken and chipped with iron tools to conform to the shapes necessary to form complex mosaic designs. The cut edges were then smoothed with abrasives.

The entire technique of tile-mosaic evolved in part as a response to technical problems that made it rather difficult to make a design of several colors upon a single tile. Apparently different glazes fused or "cooked" at different temperatures, so that by the time one color had properly fused, another may not have begun to melt, or may have burned off the tile or spoiled its hue by being subjected to too high a temperature. Another problem was that in the heat of firing colored glazes became liquid and tended to run into one another, spoiling the design. Some early attempts to deal with this problem included molding a raised design on the tile before firing in order to separate colors. This raised portion remained off-white, the color of the clay. Such techniques

appeared in Anatolia under the Artukids in Diyarbakır in the twelfth century but did not seem to find widespread acceptance under Seljuk rule.

The technique of sgraffito ("scratched" designs) and that of unglazed pottery, both relatively simple, are used in much local production of pottery vessels all over both Islamic and Byzantine Anatolia in the thirteenth century. In the former technique designs were scratched with iron tools through the colored glaze and into the clay of the vessel, giving a decoration of dull brown lines on the pottery surface. Unglazed pottery, frequently burnished to improve its capability for holding water, was used for storing both dry provisions and drinking water.

The technique of underglaze-painting, already in use in Iran in the thirteenth century, did not find widespread use under the Anatolian Seljuks in either architectural decoration or wares. In this technique various designs were painted on the fired tile or vessel in a variety of colors. The design was then covered with a clear or colored transparent glaze that would allow the designs to show through. The few architectural decorations utilizing this technique in Anatolia appear to have been secular in nature, such as the revetments of the palace at Kubadabad near Konya and the tile decorations of secular buildings found at Aspendos.

In the technique of luster-painting, a very few examples of which have been excavated in Anatolia, the tile or vessel of hard white material was first baked and then painted with pigments containing metallic copper elements. Upon subsequent firing at a low temperature, the design emerged as a golden brown lustrous metallic coating on the tile or vessel.

One last technical characteristic of early Anatolian Turkish ceramics is noteworthy. Rather than being made from coarse brick clay, or even from the finer potter's clay found in many parts of Anatolia, the finest ceramics use an artificially constituted mixture of ingredients containing a very high percentage of silica or glassy material. This results in a ceramic body that is frequently off-white. It was strong and could be shaped into thin tiles and light-bodied wares and was easily shaped into complex forms, either on a potter's wheel or in wooden or ceramic molds. The availability of this white siliceous material in Anatolia, and the establishment of its use during the thirteenth century, were of utmost importance for the subsequent history of Turkish ceramics under the Ottomans.

BUILDING DECORATION

ill. 132

ill. 133

The Ulu Cami (Great Mosque) of Malatya, the main part of which was completed around 1224, shows the remains of a handsome decoration in both glazed brick and tile-mosaic from the first half of the thirteenth century. The interior courtyard and the dome chamber and *eyvan* before the mihrab still show both types of decorations in turquoise blue and an almost purplish black in tile-mosaic. The designs exhibit the full range of thirteenth-century Seljuk decoration, incorporating calligraphic inscriptions in cursive thuluth script against a curling vine background, combined with vegetal and floral designs that swirl and interlace among borders and geometric elements of complex interlacing straps and stars. Architecturally, the Ulu Cami of Malatya is closely linked to the earlier Seljuk traditions in Iran, which may account for the extensive use of glazed brick in turquoise and warm brown decorating the vaults and the interior of the dome before the mihrab. Unusual in Anatolia for its extensive use of brick as a facing material, the Ulu Cami of Malatya provides an important link between the emerging Anatolian ceramic decoration and the older traditions from Turkish rule in Iran.

plate 2 (pp. 62–63); ills. 8, 9

133. *Right*: Malatya, Ulu Cami: molded tile-mosaic decoration of the courtyard; ca. 1224.

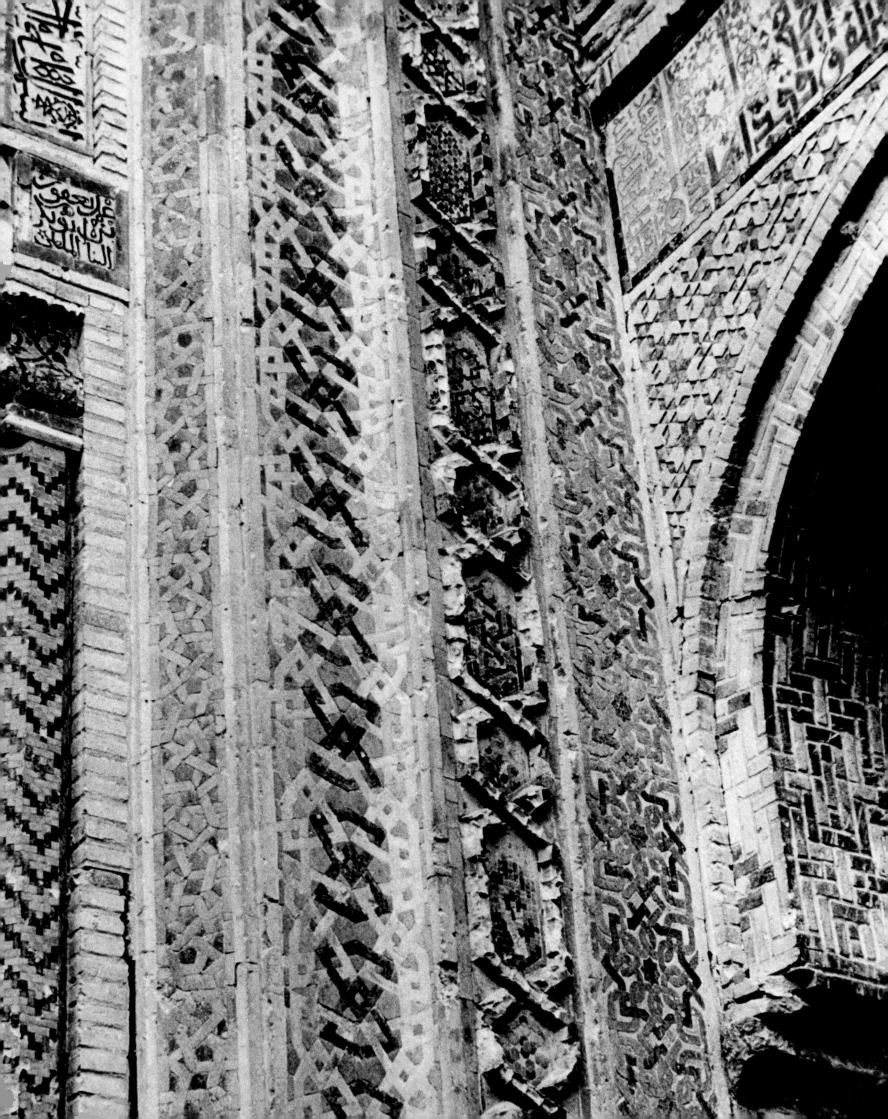

ill. 134

plate 34 (p. 261)

ill. 135

ill. 136

ill. 137

ill. 13

In smaller buildings from Seljuk times and in foundations of local rather than kingly patronage, ceramic decoration may be confined largely to a single focal point in the building. Such is the case in the Güllük Cami in Kayseri, founded in 1210 by a local notable. Here we see an elaborate mihrab constructed in tile-mosaic forming the central decorative element in a massively constructed ensemble. Although the lower portion has disappeared over time, the remains of this handsome decoration incorporate both tile-mosaic and molded elements, in which turquoise and purple-black cut tiles are set into white plaster, which adds lightness to the design. The inscriptions appear in both a *naskhi* cursive script, set against the traditional background of spiraling vines and the curious lobed split-leaf forms known as *rumi* decoration in Turkey, and, above the niche itself, an imposing composition in elaborately plaited kufic script. The borders exhibit a geometric interlace forming star after star, each polygonal segment of which contains *rumi* forms in purple-black.

There are many such ceramic mihrab decorations in thirteenth-century Anatolian architecture. Among the best-known examples are the mihrab of the Mosque of Alaeddin in Konya dated 1227, replaced by an Ottoman mihrab in later times; in the complex of Sahip Ata in Konya, dated 1258, a simple structure decorated entirely in geometric tile-mosaic and hexagonal tiles; in the Sırçalı Medrese (school) in Konya of 1242, only a portion of which remains; in the Mosque of Bey Hakim in Konya, now heavily restored in East Berlin, utilizing a light-green turquoise and warm brown; and in the Aslanhane Cami in Ankara dating from the last decade of the thirteenth century.[1] This last mihrab is one of the most complex achievements of Anatolian Seljuk ceramic art, with a significant component of white stucco in the design and numbers of molded stucco and ceramic elements. The outer vegetal and calligraphic borders are white stucco in high relief, as are the tiny columns to either side of the niche and the great round boss directly above. The use of such decorated bosses either singly or in pairs, protruding from flat tile-mosaic surfaces, becomes an established tradition in western Turkish architectural decoration; it varies from simple hemispherical forms like ceramic bowls, as found in the Sahip Ata complex in Konya, to complex carved wood, stone, or stucco elements, such as the one in Ankara. The form also appears frequently in wooden mosque furnishings, such as the celebrated wooden mihrab from Damsaköy now in the Etnoğrafya Müzesi in Ankara.

The design of the Aslanhane mihrab not only best demonstrates the complexity of Anatolian ceramic decoration used in conjunction with stucco but also, when compared to stone and wood decoration, illustrates what we have termed the blurring of distinctions between technique and style.

Beyond any doubt the most splendid of all thirteenth-century Anatolian ceramic decorations are to be found at the Karatay Medrese built by a Seljuk vezir in Konya in the year 1251–52. Architecturally the building represents the ultimate stage in the enclosing of the central *medrese* courtyard under a vast dome, set not upon squinches but upon a pendentivelike arrangement of flat triangles that make the transition from the square room to the round dome. The building was originally covered with tile-mosaic to a height of almost four meters on the interior walls, and the Turkish triangles of the dome itself still show their elaborate decoration. The decorations use turquoise, dark blue, purple-black, and white plaster in the mosaic compositions. The walls also incorporate panels of hexagonal turquoise tiles, which by their slight variations in color and the even slighter variations in their angle of reflection create a subtle, changing monochrome surface of great richness. The triangles and the interior of the dome are covered

with an array of geometric and calligraphic designs, from the four-square kufic of the triangles, echoing on a small scale earlier glazed brick decoration, to the extraordinarily complex plaited kufic frieze of the dome, surmounted by a star-filled geometric interlace that fills the entire hemisphere. This ceramic decoration is confined to the interior of the building, while the exterior exhibits elaborate cut stone decorations in the warm colored building stone of Konya, counterpointed by multicolored marble decorations of geometric stars closely akin to the tile-mosaic decorations of the dome interior. The Karatay Medrese points out two important characteristics of Anatolian Seljuk decoration: first, different types of decoration are separated from one another in separately defined panels or areas; second, the tile-mosaic decoration proceeds from the same sense of propriety, the same stylistic vocabulary, and quite possibly from the same designers using wood, stone, brick, and stucco decoration of the same period. The same general principles of design apply therefore to a wooden mihrab, such as that from Damsaköy, and a ceramic mihrab of the same period from Ankara; to the stone decoration of a *medrese* in Konya and the ceramic decoration of a mosque in Kayseri. All mediums reflect the same basic genres of design, while technical developments in one medium, leading to stylistic change in that medium, are subsequently reflected by adaptations in other mediums.

ill. 138

plate 4 (p. 66)

The period of dominance of the Seljuk rulers in Konya begins to wane by the end of the thirteenth century in Konya, and by the fourteenth century the political fragmentation into small emirates, or principalities, together with the dominance of Mongol vassal states, begins to show some effects on ceramic architectural decoration. The first splendid Mongol architectural foundations continue the Seljuk tradition virtually without a break; their lofty minarets of glazed brick and tile-mosaic especially show continuity with earlier works. But the gradual diminishing of the human and economic resources that any individual ruler could apply to a building program brought about a gradual change in architectural decoration, not primarily of style but rather of scale. Not only the money and skills, but also the wood necessary for centering and kiln fuel, appear to have diminished in supply over the fourteenth century, and as a result the number and scale of ceramic decorations diminishes.

POTTERY WARES

When we turn to the question of pottery wares produced under early Turkish rule in Anatolia, we must rely on relatively scanty evidence to date revealed mainly in archaeological excavations, primarily in the cities of Diyarbakır and Konya and in the palace of the Seljuk sultans in Kubadabad near Konya.[2] It is clear that there was a variety of local wares produced continually in Anatolia, both in glazed and unglazed ceramics, in order to serve the needs of people of all social strata for storage vessels and tableware. A number of fragments unearthed in Anatolia show the presence of techniques and genres more closely associated with the pottery of Rayy and Kashan under the Great Seljuks in Iran. Fragments of underglaze-painted vessels and tiles with designs of animals and inscriptions executed in black or cobalt blue under a clear or turquoise glaze have been found in Kubadabad and Aspendos, while fragments utilizing luster painting and *minai* (polychrome overglaze) technique have likewise appeared in small numbers. Sites of royal palaces have yielded types of tiles not found in the still-standing and primarily religious buildings in Anatolia and fragments of wares not unearthed elsewhere. Such evidence gives rise to the speculation that such ceramics were imported from Seljuk Iran. Perhaps the Anatolian Seljuk rulers made a conscious effort to evoke

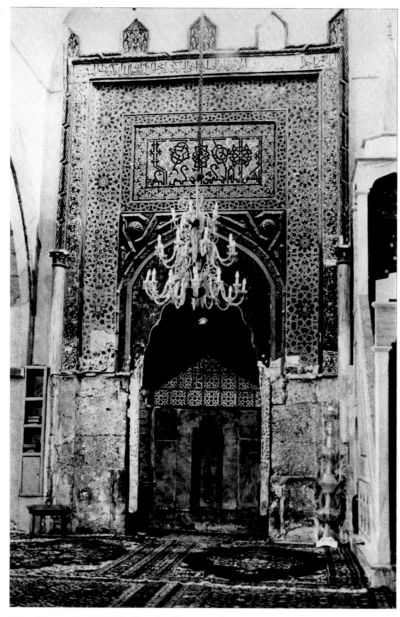

134. Kayseri, Güllük Cami: tile-mosaic
and stucco mihrab; after 1210.

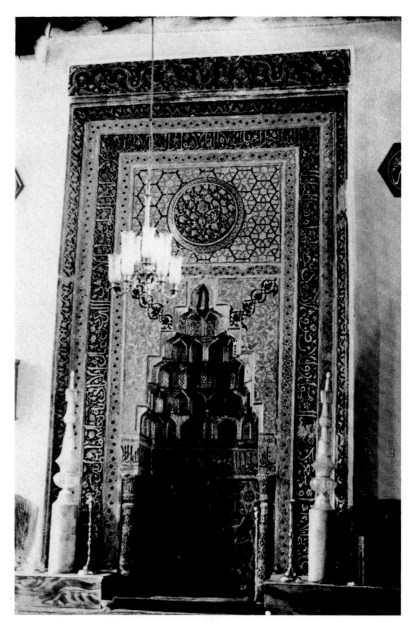

135. Ankara, Aslanhane Cami: tile-mosaic
and molded mihrab; ca. 1290.

the splendor of the courts of their Iranian relatives and to emphasize the continuity of the tradition of Turkish rulership from Iran into Anatolia. However, two things are apparent on the basis of the archaeological discoveries to date. First, the emphasis of courtly patronage of ceramics in Anatolia appears to have concentrated on building decorations, and primarily religious building decoration, rather than on the production of sophisticated pottery wares. Second, while it is possible that artisans and perhaps even materials were imported from Iran under Anatolian Seljuk patronage to provide some of the wares and decorations for palaces, it may be that metal wares made from the abundant Anatolian supplies of copper were used extensively in the court, while common people continued to use either wooden tablewares or the largely anonymous glazed sgraffito or unglazed pottery that every site in Anatolia yields up in abundance. The final resolution of this question, however, awaits the results of future excavations in Anatolia.

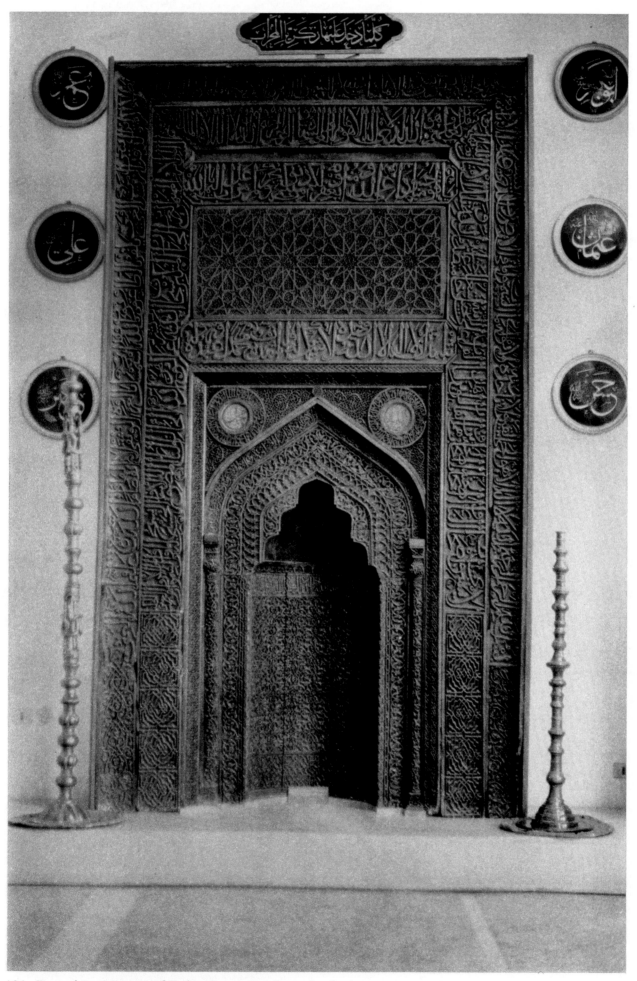

136. Damsaköy, Mosque of Taşkın Paşa: carved wood mihrab; ca. 1325. (Ankara, Etnoğrafya Müzesi)

Ottoman Ceramic Tradition

The dramatic emergence of the Ottoman polity from a tiny and impoverished warrior state on the borders of the Byzantine Empire in northwest Anatolia is paralleled in the history of Turkish ceramic art by a similar dramatic story. It now appears that with the conquest of İznik in the year 1330 the second ruler of the Ottoman line, Orhan, inherited a small local ceramic industry with a rich supply of both ceramic materials and fuel. It was to expand from a purely local tradition to a substantial source of commercial revenue for the nascent Ottoman Empire during the fourteenth and fifteenth centuries and beginning in the sixteenth century was to develop styles and techniques that made it famous throughout the Mediterranean world and beyond. İznik ceramic production under the early Ottomans consisted largely of rather simple pottery and was distinguished mainly by its great volume of production and the wide diffusion of that production in western Anatolia. The gradual growth of imperial and court patronage, together with new technical developments pioneered at İznik, brought about in the sixteenth century new styles of ceramic decoration. In that development the history of ceramics and that of the *nakkaşhane* (imperial painting studio) of İstanbul came together. It is this complex history that has led to the great interest of scholarship in Ottoman ceramics and also has resulted in complex problems of attribution, dating, and terminology. Curiously, at the beginning of the present century virtually all the Ottoman ceramics now recognized as having been made in İznik were variously assigned to Iran, to Miletus (Balat) in western Anatolia, to the Armenian communities of Kütahya, to the Arab production of Damascus, and to Greek potters on the island of Rhodes.[3]

EARLY OTTOMAN BUILDING DECORATION

In ceramic building decoration, it is possible to see the first major developments under the Ottomans as proceeding directly from the Seljuk tradition. An early Ottoman mosque, the famous Yeşil Cami (Green Mosque) of İznik completed in the year 1391, was constructed of stone, but with a brick minaret that, despite a rather overenthusiastic restoration in recent years, shows a decoration of glazed brick and tile immediately recalling the decorated minarets of Sivas and Konya from the thirteenth century. This early Ottoman building reflects the austerity of the emerging empire in its small size and in the economical placement of decoration in maximally effective locations on the building. Even when viewed from some distance, the minaret, with its gay colors, gives an impression of richness, its shaft decoration of glazed bricks with projecting molded elements contained within two bands of tile-mosaic, and surmounted by a balcony with molded ceramic *mukarnas* (stalactite vaulting).

ills. 20, 21

The greatest example of early Ottoman ceramic decoration is to be found in the Mosque of Mehmed I in Bursa, the Bithynian town that became the Ottoman capital in the fourteenth century. The building was completed in 1419, only a few years after the crushing defeat of Beyazıd I by Timur at Ankara, and after a period of civil war within the remains of Beyazıd's empire. Mehmed's mosque, with its two main domed chambers, side rooms, and royal gallery, is unique in the entire Ottoman tradition in the richness of its decoration. The building appears to have served as an affirmation of the unity and confidence of an Ottoman Empire newly reconstituted in even greater strength after disastrous defeat and fratricidal civil war.

ills. 24–27

Two new technical advances are apparent in the decoration of this mosque, also popularly called the Green Mosque. The first is the introduction of new colored glazes,

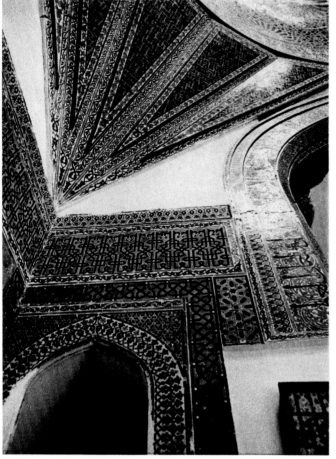

137. Konya, Medrese of Celaleddin Karatay:
interior view; 1251–52.

138. Konya, Medrese of Celaleddin Karatay: tile-mosaic decoration
of the Turkish triangles imitating glazed brick decoration; 1251–52.

including a sapphire blue and a golden yellow, the latter according to tradition a favorite
Turkish color since pre-Islamic times. The second was the invention of a technique
enabling a number of colors to be fired as part of the design on a singular modular tile,
thus eliminating the lengthy process of cutting and fitting fragments of tile together in
tile-mosaic. The technique, known as "dry cord" or *cuerda seca* (a Spanish term stem- ill. 139
ming from the technique's utilization in Spain), involved placing a line of greasy ma-
terial on the tile between areas of different colored glaze preparatory to firing. In the
firing, this material separated the glazes on the tile and burned off, leaving a dark dry
line between colored areas. The new technique meant that, in effect, "prefabricated
tile-mosaic" was now possible, the designs being painted before firing in glaze across
fields of identical modular flat or molded tiles. The technique appears to have come to
Bursa from Iran; an inscription in the tilework of the Mosque of Mehmed I reads,
"the work of the masters of Tabriz." The technique appears in the late fourteenth cen-
tury as far east as the Timurid capital of Samarkand, from whence it undoubtedly
spread westward. But, paradoxically, there are no monuments of any significance in
the new style in Tabriz until the second half of the fifteenth century.

The decorations of the Green Mosque of Bursa exhibit an international decorative
style found from Central Asia to the Aegean Sea throughout the fifteenth century.
It drew upon the repertoire of Seljuk decoration with its floral-vegetal, calligraphic, and
geometric designs, which during the period of Mongol domination was enriched by
Chinese elements including convoluted cloud-bands and stylized lotus flowers with
their butterflylike petals. The complex designs of this international or "Turanian" style

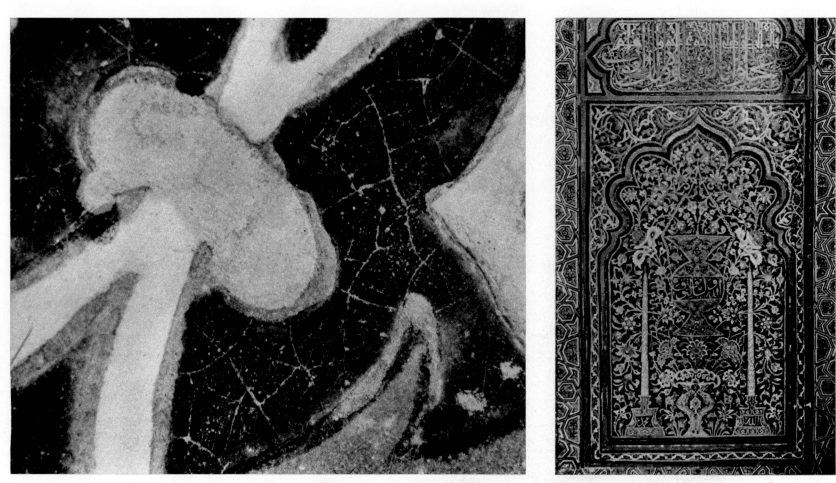

139. Bursa, Yeşil Türbe: *cuerda seca* tile decoration; ca. 1421.

140. Bursa, Yeşil Türbe: interior panel of the *cuerda seca* mihrab; ca. 1421.

were beautifully adapted to the wider range of colors and the intricate designs possible with the new *cuerda seca* polychrome ceramic technique.

Mehmed's mosque is decorated with carved stone and a limited amount of monochrome tile on the exterior, showing the characteristic Ottoman restraint and balance of decorated and undecorated areas. By contrast, the interior is lavishly decorated with stucco, carved stone, painted decoration, and above all by monochrome and polychrome ceramic tiles. The latter are found on the lower walls of the southern or upper chamber of the mosque and form on the *kıble* wall an elaborate mihrab with lofty proportions, which extends virtually up to the transitional zone. Other tiles form tympana, with calligraphic inscriptions over windows, and accent arches and doorjambs. The most elaborate decorations apart from those of the mihrab are found in three *eyvan*-like niches on the back wall, two at floor level and one forming a balcony on the second floor where the sultan himself could pray privately. Like the mihrab, these niches are decorated with extremely complicated molded polychrome tiles, decorated with *rumi* forms, complex cursive and kufic inscriptions, and geometric interlaces already familiar from Seljuk times. Tiled *mukarnas* corbels, tiled arch soffits, and in the sultan's balcony a tiled ceiling of great richness—all incorporating golden yellow together with the cooler turquoise and blue—create a surface rich in color and texture, endlessly responsive to light, and glistening mysteriously in the dark interior.

ill. 141

The component parts of the mihrab, with its many borders, show the implicit rules of propriety, which in Turkish art separate one type of decoration from another. The

spandrels of the niche are filled with a *rumi* split-leaf design on a background of complex vegetal whorls. The main borders of the mihrab, starting from the outside, utilize first a calligraphic decoration in cursive script, with a smaller gloss in kufic hidden behind it; then a lavish border of *mukarnas*, which in Ottoman times was more frequently employed as a molding than in zones of architectural transition; then a marquetrylike molded geometric border; then a molded torus half-round border with raised vegetal arabesque above an unglazed ground; finally, a very delicate interior border in which five-petaled lotus flowers are repeated inside lacy cartouches formed by *rumi* leaves interspersed with other stylized flowers. The first, third, and fourth borders represent continuations of earlier Seljuk decorative themes, while the second and fifth anticipate new directions. The palette is extensive: dark blue, turquoise, yellow white, dark green, and yellow, as well as touches of purple-black. In parts of the mosque small panels of tile-mosaic still appear; the use of tiles on the underside of arches and as ceiling decoration demonstrates that the virtuoso decorators of the Mosque of Mehmed I regarded any type of architectural surface as suitable for their ceramic decorations.

plate 35 (pp. 262–63)

The total effect of the interior is again one of a counterpoint of undecorated surfaces, where the texture of lightly veined marble is the only ornament, against small but extremely intensely decorated focal points in the program. And despite the complexity and richness of the decoration it enhances rather than detracts from the atmosphere of cool quiet pervading the entire interior.

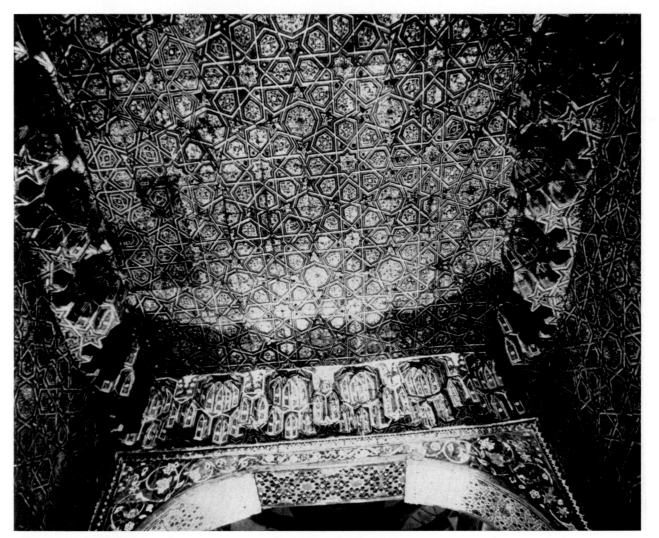

141. Bursa, Yeşil Cami: ceiling decoration of the sultan's balcony; 1412–19.

The sense of appropriateness to the visual environment that for so long formed an essential part of Ottoman architecture is nowhere better seen than in the Tomb of Mehmed I, the Yeşil Türbe (Green Tomb) directly adjacent to that sovereign's mosque in Bursa. The exterior of the tomb is covered with blue-green tiles, which echo the verdure of the mountainside site and which have given the popular name not only to the tomb but to all other buildings in the *külliye* (complex) of Mehmed I. The main gateway of the tomb, with its ribbed niche in *cuerda seca* polychrome tiles, looks like a miniature half-mold used to cast a Timurid ribbed dome in Samarkand, affirming once again the international nature of what we have called the Turanian style. The interior of the octagonal tomb contains a magnificent tiled *sanduka* (symbolic sarcophagus) directly above the subterranean burial chamber, while the *kıble* wall exhibits one of the loveliest of all Islamic mihrabs in ceramic, depicting in its central panel a lamp hanging above a field of Turanian flowers. The walls are covered with monochrome hexagonal turquoise tiles, punctuated with large medallions showing *rumi* designs on a cobalt blue ground. The Yeşil Türbe is the only Ottoman monument with a substantial amount of exterior ceramic decoration, although its exterior tiles have suffered much damage due to weather and restoration over the centuries. In the proportions of its mihrab, in its simple octagonal shape crowned by a low lead-covered dome, and in the impression of restraint that emerges through the rich decoration, it presents a prototype for Ottoman royal tombs built in great numbers during the following centuries. Its deserved fame stems not so much from its unique quantities of ceramic decoration as from the quality of its decorations and its place at the head of a noble tradition. But paradoxically, the *cuerda seca* ceramics of the entire complex of Mehmed I in Bursa represent not only the first major application of the technique in the history of Ottoman decoration but its zenith as well, even though the technique continued to be used for the next 130 years.

plate 36 (p. 264); ill. 140

The impact of the style and technique of ceramic decoration, as exemplified in the Mehmed I complex in Bursa, is difficult to assess. The same group of workmen was employed in the year 1435 in the creation of a complex ceramic mihrab in the Mosque of Murad II in Edirne, but after this time, *cuerda seca* decoration was confined largely to panels of modular square tiles, while complex molded revetments were no longer seen. It may be that the "masters of Tabriz" did not train their apprentices in the production of molded tiles. More likely is it that the relatively simple *cuerda seca* revetments of the second half of the fifteenth century and the first half of the sixteenth reflect a period of decreased patronage. Only three major revetment schemes in the technique appear before its demise in the mid-sixteenth century and its eventual replacement by underglaze-painted tiles. Further, it is difficult to localize the place of production of these *cuerda seca* tiles. Although containing up to eighty-five percent silica, the body is decidedly reddish in color, unlike the fifteenth-century ceramic production of İznik, and is moreover quite coarse.

ills. 36–38

It appears that the tradition founded by the Tabriz masters under Mehmed I in Bursa found no permanent home. It may have moved to İstanbul after the conquest in 1453; there, aside from a few minor decorations in smaller mosques, the Turanian style is seen in the decorations of the palace pavilion known as the Çinili Köşk (Tiled Kiosk), built by Mehmed II around 1473. The last appearance of the Turanian style in *cuerda seca* ceramics in İstanbul is in the splendid decorations of the Tomb of Şehzade (Crown Prince) Mehmed, son of Süleyman I, completed around 1548, where designs already made popular in underglaze-painted ceramics began to show up in the older technique. Evidently the *cuerda seca* artisans were sent off to Jerusalem in the mid-sixteenth century

to participate in the Ottoman project of redecorating the Dome of the Rock. From that time on their work was no longer seen in the capital and was supplanted completely by the underglaze-painted tile production of İznik.

Early Ottoman Underglaze-painted Ceramics

The second half of the fifteenth century presents a problem in the history of Ottoman ceramics. As we have noted, ceramic building decoration appears to have suffered from a lack of court patronage, probably explained by the great Ottoman military efforts of the time and the preoccupation with conquest in Rumelia and Anatolia. During this period, many experiments were undertaken, but no major projects resulted, with one exception. In the production of ceramic wares, however, recent archaeological evidence indicates that the İznik ateliers flourished during the later part of the century.

142. Provincial bowl with lotus decoration; ca. 1425–50. (İstanbul, Topkapı Sarayı Müzesi, 41/1557)

In the past seventy years excavations all over western Anatolia have uncovered large quantities of glazed pottery with rather unsophisticated blue-and-white decorations painted on a slip (a thin coating of white material) under a thin transparent glaze, the slip providing a white ground on the reddish clay of the pottery. This pottery was first discovered in quantity in excavations at the Turkish village of Balat on the site of classical Miletus. It was classified at that time as fifteenth-century pottery and dubbed "Miletus ware." The excavations in İznik during the 1960s by the Turkish scholar Oktay Aslanapa showed conclusively that "Miletus ware" was produced in Ottoman İznik, where numerous shards of this pottery had been found for decades.[4] The number of shards unearthed around Anatolia, appearing today in the antiques shops of numerous provincial towns, leaves no doubt that the "Miletus ware" was rather widely used and hence probably cheap and easily obtained. The decorations range from simple fantasies, executed with splashes of blue on a white slip, to more sophisticated designs, showing Chinese elements such as lotus flowers and other motifs borrowed from Chinese porcelain. The blue-and-white coloration of cobalt pigments painted on the slip coating the reddish colored body of these wares reflects the influence of Chinese blue-and-white wares, which from the late fourteenth century onward were much in evidence in the Islamic world of west Asia. One especially interesting tendency in this provincial Ottoman pottery is the practice of showing the petals of flowers in dark blue, with a strip of reserve white contained within a blue line separating them from other petals. The almost stencillike effect obtained by this stylistic device characterizes many of the best examples of fifteenth-century İznik ware and appears more frequently toward the end of the century in a group we will call for convenience "transitional" objects, leading to a much more sophisticated production in the following century.

143. Provincial plate with elaborate floral decoration; ca. 1450–75. (İstanbul, Topkapı Sarayı Müzesi, 41/460)

One of the loveliest of these is a small fragmentary bowl in the British Museum, in which the relatively undisciplined forms found in the bulk of these transitional wares have begun to tighten up. The floral scroll covering the outside of the bowl is carefully thought out and meticulously drawn; in the interior the reserve-white "stencil" effect continues, and the floral forms have become small and compacted, with the lower petals of each flower folding in like the thumbs of mittens. Such objects as this small bowl, purportedly found at Efes (Ephesus) in western Anatolia, represent the highest development of the provincial İznik wares, before a dramatic change in style and patronage took place at the very end of the fifteenth century.

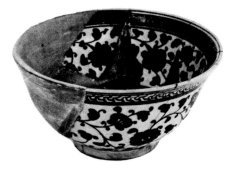

144. Transitional blue-and-white bowl; ca. 1480–1500. (London, British Museum, OA 936)

It was during the fifteenth century that parallels between wall tiles and pottery wares finally began to emerge in Anatolia. At the beginning the blue-and-white provincial wares of the İznik potters may indeed have been more heavily influenced by

plate 37 (p. 265)

plate 38 (pp. 266–67)

tile-making than by direct exposure to Chinese porcelains. In the Mosque of Murad II in Edirne the "masters from Tabriz" completed in about 1434 an important *cuerda seca* molded tile mihrab. It incorporated in the *mukarnas* of the niche specially made underglaze blue-and-white designs of "stenciled" palmettes, in which the reserve white separating the petals strongly recalls the "dry cord" separating colors on the *cuerda seca* tiles. On the side walls of the prayer chamber of the same mosque appear fields of hexagonal blue-and-white underglaze tiles set in triangles of monochrome turquoise tile. The designs are widely diverse but include many variants on the theme of lotus flowers as well as six-pointed stars. Many, though by no means all, of the Edirne tiles show designs with close relationships to the provincial pottery wares of İznik, including the now familiar dark blue petals surrounded with reserve white.[5] An even more striking parallel is seen in the tiled tympana in the courtyard of the Üç Şerefeli Cami in Edirne, built by Murad II around 1447. The border of one in particular presents us with our familiar lotus forms and the white outlining of petals.

These experiments in Edirne had parallels in Bursa itself, where during the fifteenth century a number of small buildings continued the tradition of monochrome and *cuerda seca* color-glaze ceramics, occasionally accented by the conspicuous inclusion of a hexagonal blue-and-white tile with a six-pointed star in the decoration. It is clear that the underglaze-painting technique, where a design painted on a white slip was covered with a thin transparent glaze, had advantages in ware production over *cuerda seca* ceramics, which would leak water through the dry lines into the porous body. It is equally clear that underglaze-painting as a technique began increasingly to intrude into color-glaze wall decoration, which, from glazed brick, through tile-mosaic, to *cuerda seca* tiles, had dominated Anatolian building revetments for two centuries. By the end of the fifteenth century further technical developments in İznik and the arrival of a new type of patronage and organization of work were to result in far-reaching consequences for the provincial Ottoman town.

DEVELOPMENT OF THE COURT TRADITION IN İZNİK

Sometime in the latter part of the fifteenth century, probably during the middle years of the reign of Beyazıd II, developments occurred in İznik and possibly also in the minor center of Kütahya that were dramatically to affect the course of Turkish ceramic art. The production of wares in İznik changed from that of a local, provincial tradition to that of a metropolitan, court tradition of underglaze-painted vessels and tiles of extraordinarily high artistic and technical quality, which even began to appear in the inventories of the sultan's palace in İstanbul. The new patronage of the court resulted in the emergence of new types of designs closely linked to those of manuscript illumination and bookbinding, beginning with a continuation of the international "Turanian" style and quickly developing distinctively "Ottoman" characteristics.

The new pottery wares employed an almost pure white body, incorporating kaolin, quartz, and a frit (prepared glassy material), which resulted in the production of pottery wares of a size, scale, and lightness not seen in the provincial production of the fifteenth century. The small bowls and occasional flat plates of the provincial style were replaced by a new variety of shapes; some of these owed their origins to metalwork and others were verbatim copies of those of Yüan and Ming porcelains from the sultan's collection. Much greater care was taken in the preparation of the wares for painting, and the slip, which provided the sparkling white ground, was applied evenly

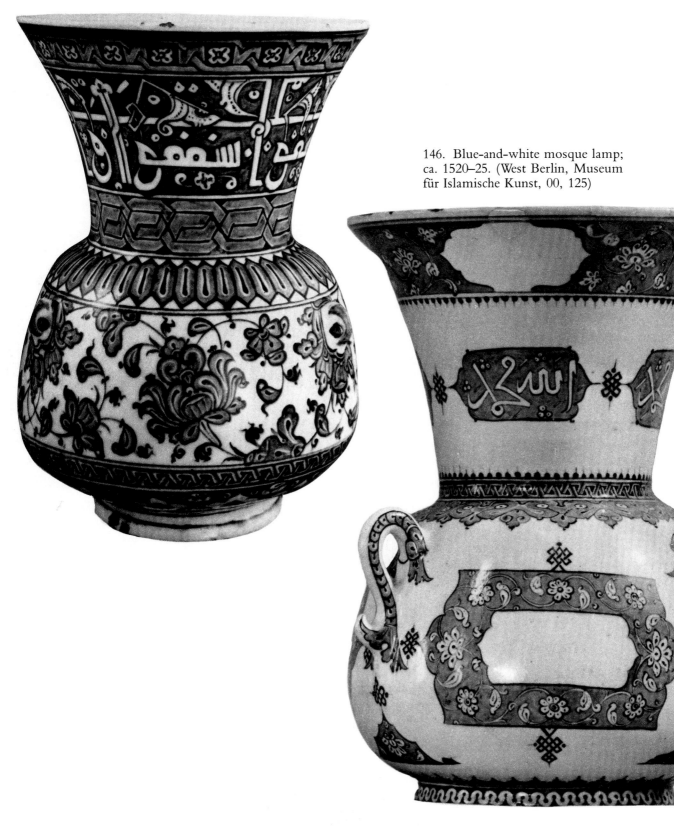

145. Blue-and-white mosque lamp,
said to come from the Tomb of Beyazıd II;
ca. 1510. (London, British Museum,
78 12–30 500)

146. Blue-and-white mosque lamp;
ca. 1520–25. (West Berlin, Museum
für Islamische Kunst, 00, 125)

over interior and exterior surfaces of vessels with the exception of the foot ring. The designs themselves, painted in blue and turquoise under a clear and shiny glaze, show none of the slapdash quality of most of the provincial İznik wares but instead embody the careful planning of forms and the fine calligraphic line and attention to texture characteristic of the work of the professional penman or *nakkaş* (painter-designer). The cobalt blue pigments, which at the beginning of the sixteenth century tended to be quite intense in saturation, could be applied in varying values on the white slip. Thinly applied, they were translucent, allowing the slip to show through, creating a light blue; thickly applied, they were an opaque dark blue.

ill. 144

plate 40 (p. 269)

The new designs fall into a number of categories. Most were designs incorporating vegetal arabesques of *rumi* split-leaf motifs and small flowers and leaves showing the characteristic mittenlike petals of the transitional British Museum bowl and as seen on a plate in the Freer Gallery. The outlining is very strong, in darker values of blue, and frequently forms small scroll-like spirals giving an inward "curl" to the edges of leaves and tendrils. The centers of leaves are accented by teardroplike applications of dark blue. The earlier pieces in this new variant of the Turanian style stress more heavily the outlining, while in later, more sophisticated pieces, minuscule hatching in blue frequently adds a sense of texture. As the style develops, it is found on larger and larger

ill. 147

vessels, including large footed bowls approaching a diameter of fifty centimeters. The large number of mosque lamps produced in this Turanian style attests to the strong religious patronage of the time. Three of the lamps incorporating this decoration appear to have been commissioned around 1510 for the tomb of Sultan Beyazıd him-

ill. 145

self. One of these, in the British Museum, illustrates the new style in its first emergence. The main frieze on the body of the lamp incorporates large palmettes, complex stylized variants of lotus flowers with curled-in petals, each with a dark teardrop accent on reserve white in the center; the outlining is thick and strong. The kufic inscription on the flare of the lamp, in reserve white on blue, is decorated with similar tiny trilobed flowers and *rumi* split-leaves. Another lamp, dating from about 1520–25 and now in the

ill. 146

Museum für Islamische Kunst in West Berlin, is much larger, and both slip and glaze are more brilliant. The design, this time partially in reserve white on light blue, again incorporates *rumi* leaves with curling elements and the now familiar "mitten" flowers with teardrop accents. Four cursive inscriptions are found on the flare; between the three handles of the body are white unornamented lozenges, which originally bore decorations over the glaze. This later lamp shows an evolutionary development into more sophisticated designs, accompanied by a higher level of technical attainment.

ill. 148

The new stylistic characteristics are readily apparent even in what at first sight appears to be a direct imitation of Ming porcelain, produced in İznik around 1510. Texture is added to the leaves in the usual way, and the leaves show a tendency to become *rumi* forms despite the lack of such forms in the prototype. As an appreciation of Ming ware, the İznik example is sincere, but its Turkish origins and its basically Turkish character remain all the same. The powerful impact of Chinese porcelains on the development of court wares at İznik cannot be underestimated, but the propensity of artists in the Turkish tradition to borrow selectively, while preserving the essential characteristics of their own style, again illustrates one of the most basic tendencies of Ottoman culture as a whole: the ability to assimilate from a wide variety of sources into a synthesis whose character is above all its own.

A smaller number of wares from the same period, at one time attributed to a seventeenth-century İstanbul factory on the Golden Horn, exhibits another design type

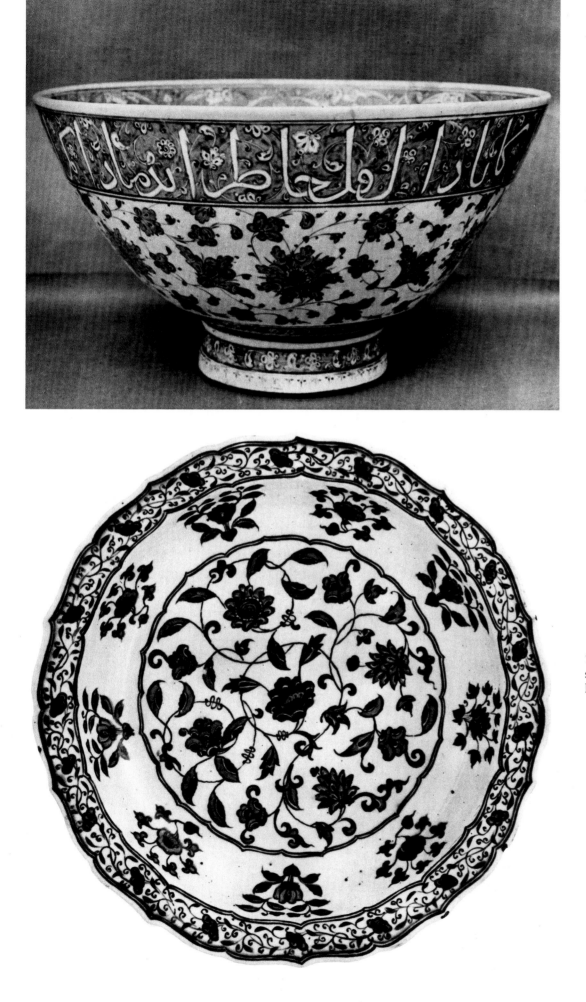

147. Blue-and-white bowl; ca. 1530.
(London, British Museum,
1897 6–18 1)

148. Blue-and-white plate in Chinese
style; ca. 1510. (Boston, Museum of
Fine Arts, 19.1196)

consisting of small-scale dark blue spirals of vines with tiny leaves and flowers. Several very early pieces incorporate both the Turanian style and the spiral designs, with one on the exterior and the other on the interior. This "spiral style" of decoration proves quite persistent in ceramic decoration, and examples continue to appear into the middle of the sixteenth century and beyond, although the blue spirals are later replaced by spirals in a black line.

It now appears that the new types of designs emerged about the same time in two separate centers of production, İznik and nearby Kütahya. The relatively meager production of the latter center, with its large Armenian population, is posited largely on the evidence provided by two inscribed and dated pieces in the Godman collection in Horsham, England. One, a ewer of unique shape, dated in an Armenian inscription to the year 1510, bears the following legend:

149. Blue-and-white ewer with an Armenian inscription on the foot; dated 1510. (Horsham, England, Godman Collection)

> This mass-cruet commemorates the servant of God, Abraham of Kütahya.
> In the Armenian year 959.

The other, a cut-down bottle with spiral decorations, also bears an inscription in Armenian, with a date corresponding to 1529:

> Ten Martyros sent word from Ankara: may this water-bottle be an object of Kotays [Kütahya] for the monastery of the Holy Mother of God.

The ambiguity in these inscriptions has caused two interpretations: one, that the objects were made in Kütahya itself; and two, that these are İznik objects commissioned by Armenians from the city of Kütahya but not produced in that locality. The British scholar John Carswell has argued for the possibility that both pieces may have been made in Kütahya itself.[6] The ewer, with its complex shape derived from metalwork, does have the *rumi* split-leaves and mittenlike flowers of the Turanian style and is clearly within the orbit of that style despite its unique shape. The cut-down bottle, on the other hand, while again showing many similarities to objects ascribed to İznik, includes a band of floral rinceaux rarely seen in the more accomplished works in the spiral style and has a peculiar very dark blue coloration in its decorations, which does not correspond with production ascribed to İznik around 1530.

150. Blue-and-white bottle with Armenian inscriptions; dated 1529. (Horsham, England, Godman Collection)

The "Kütahya Question" has been the cause of a good deal of scholarly speculation. The weight of the evidence now suggests, without proof positive, that there may have been a parallel production in İznik and Kütahya during the sixteenth century, but that İznik, with its royal patronage, its accessibility to the capital, and its well-developed complex of kilns and workshops remained the main center of innovation and production throughout the sixteenth century and is responsible for most of the production in the Turanian style in blue-and-white. By the early seventeenth century Kütahya did emerge as a secondary center of Turkish ceramic production, but the precise identification of its sixteenth-century output is a complex task yet to be undertaken.

The well-established predominance of color-glaze *cuerda seca* tiles in architectural decoration persisted, as we have noted, until the mid-sixteenth century, finishing in a blaze of glory in the Tomb of Prince Mehmed in 1548 and in the restoration of the Dome of the Rock in Jerusalem. As in the fifteenth century, when blue-and-white revetment tiles appear in buildings of the period 1490–1550, they appear sparingly; however, they are of great beauty and refinement. The first underglaze blue-and-white revetments produced in the court style proved to be such a success, however, that they eventually led to an enormous increase in the number and wealth of the İznik ateliers

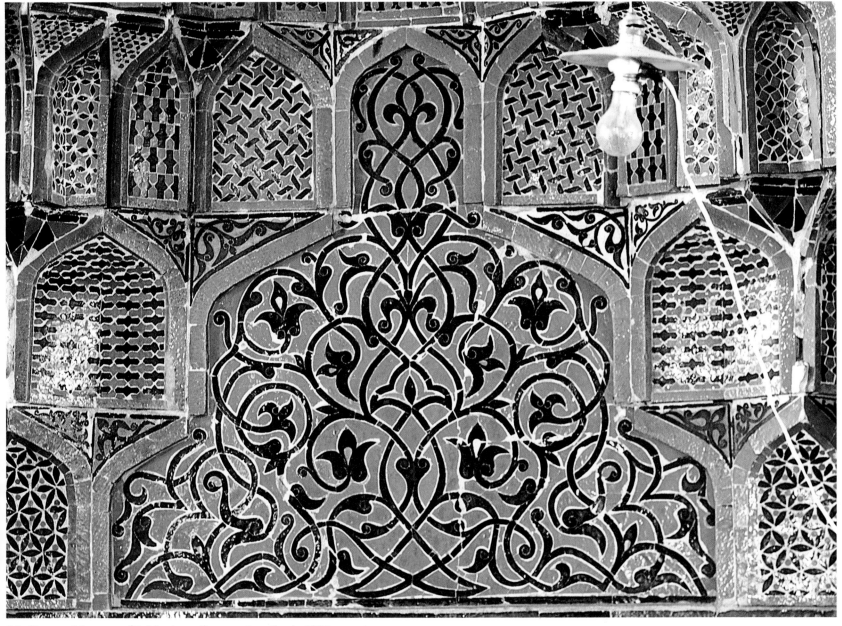

34. Konya, Mosque of Sahip Ata: tile-mosaic mihrab; 1258.

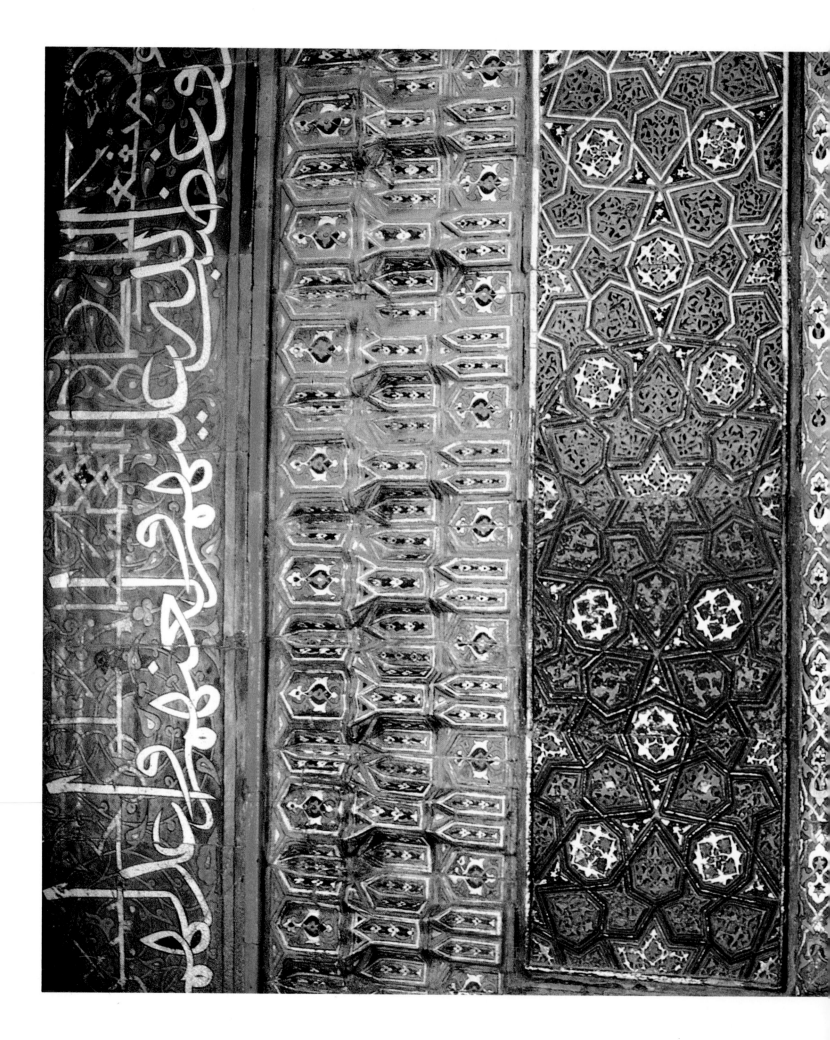

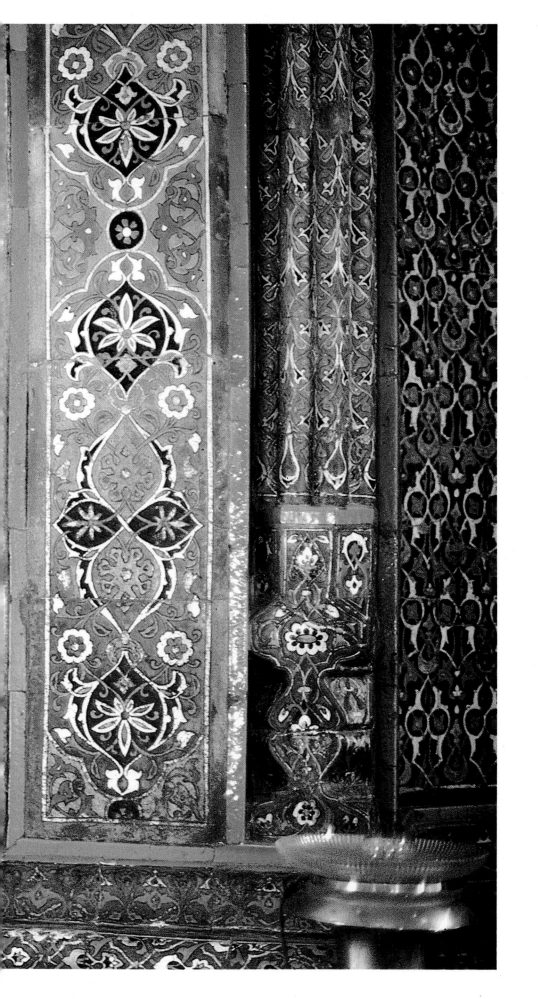

35. Bursa, Yeşil Cami: *cuerda seca* borders of the mihrab; 1412–19.

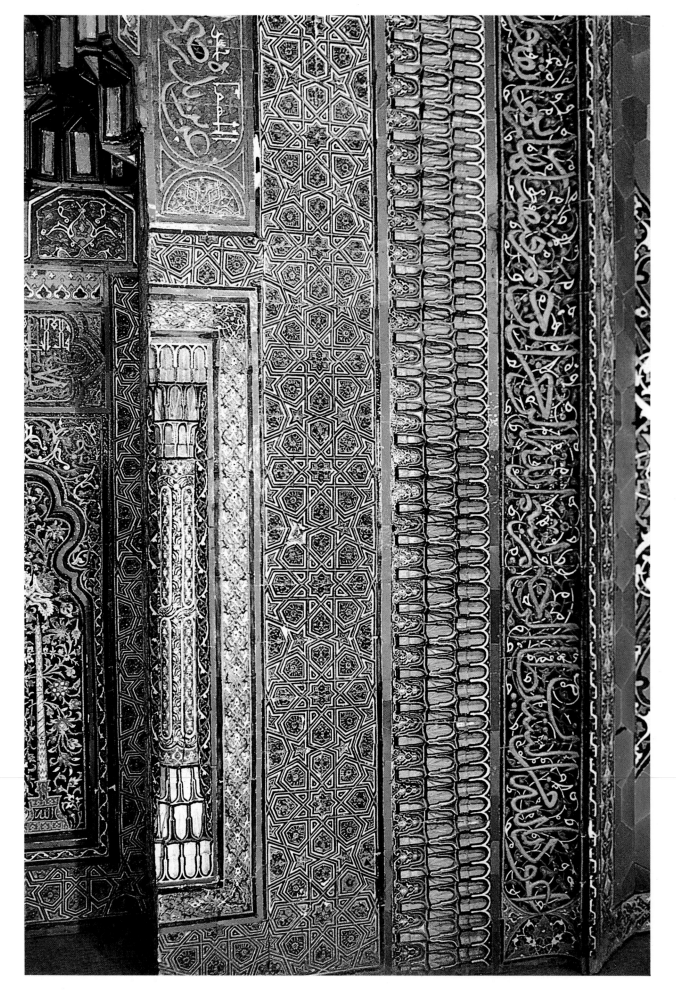

36. Bursa, Yeşil Türbe: *cuerda seca* mihrab; ca. 1421.

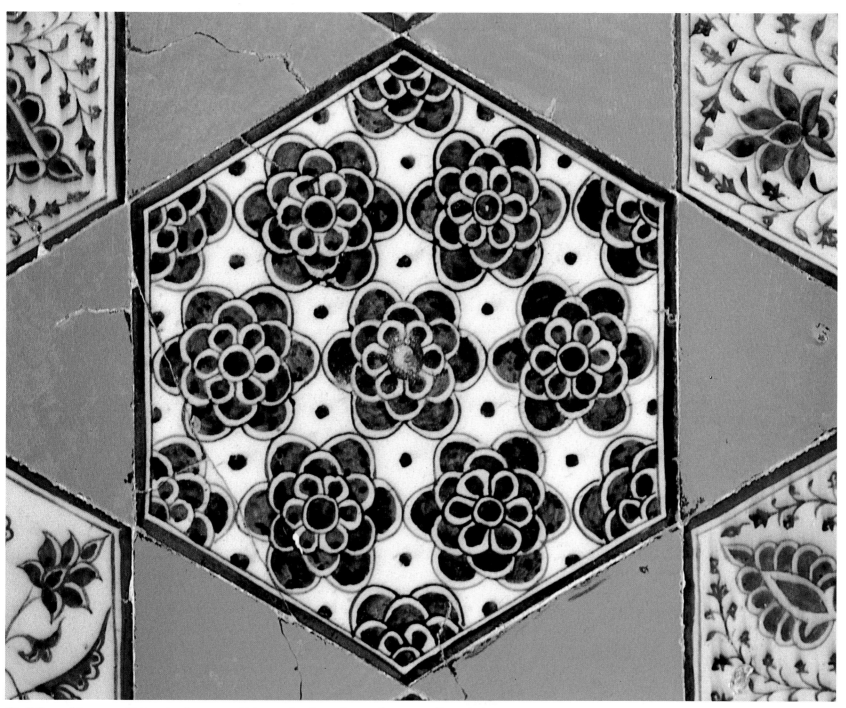

37. Edirne, Mosque of Murad II: hexagonal blue-and-white tiles on the east wall; ca. 1434.

38. Edirne, Üç Şerefeli Cami: blue-and-
white tympanum in the courtyard;
ca. 1447.

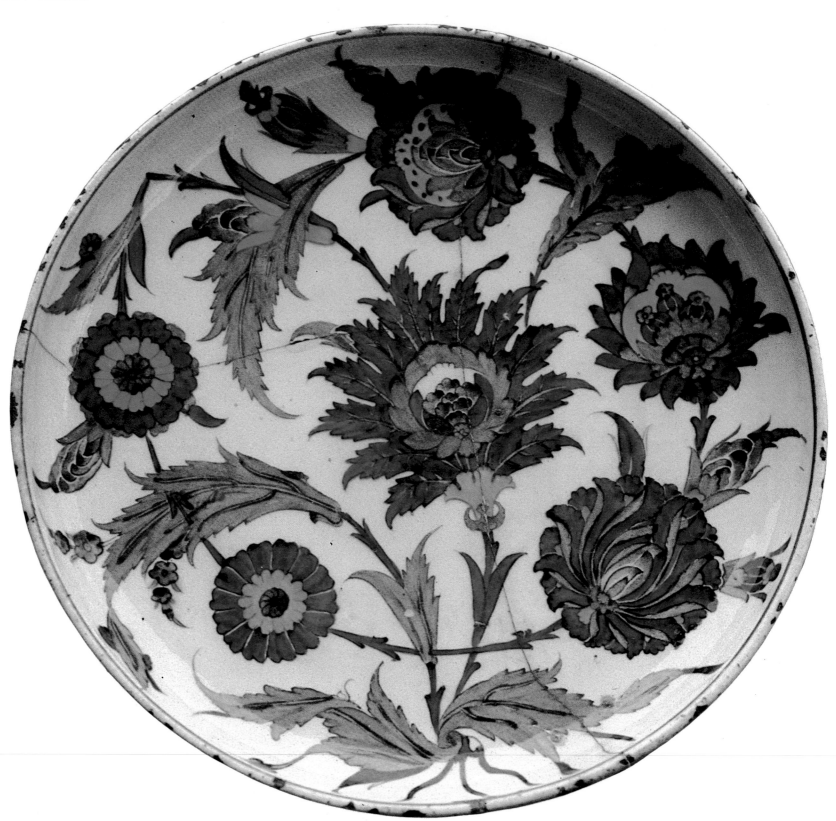

39. Polychrome plate with *hatayi* decoration; ca. 1555–65. (Private collection)

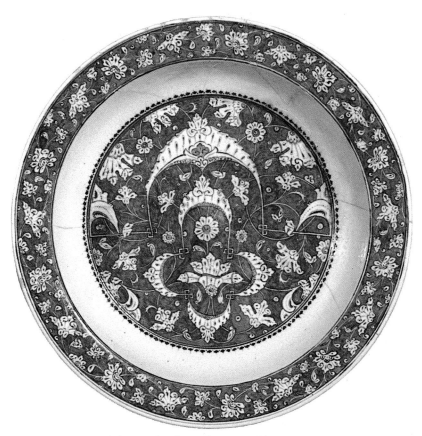

40. Blue-and-white plate; ca. 1525.
(Washington, D.C., Freer Gallery of Art, 54.3)

41. Blue, turquoise, and white rimless plate; ca. 1545.
(New York, Metropolitan Museum of Art, 14.40.727)

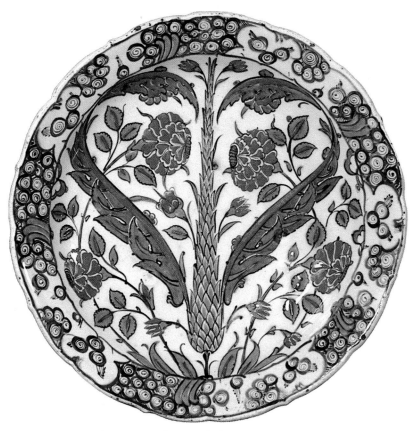

42. Polychrome plate with floral decoration; ca. 1575.
(Washington, D.C., Freer Gallery of Art, 66.25)

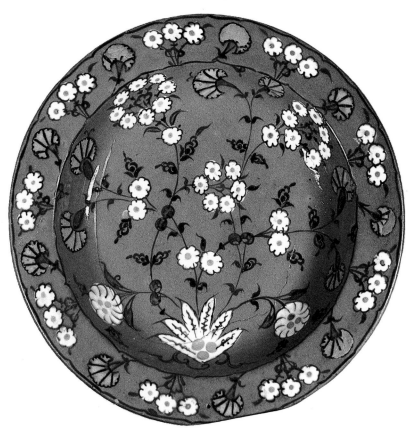

43. Experimental blue-ground plate with polychrome decoration;
mid-sixteenth century. (Paris, Louvre, 7880–90)

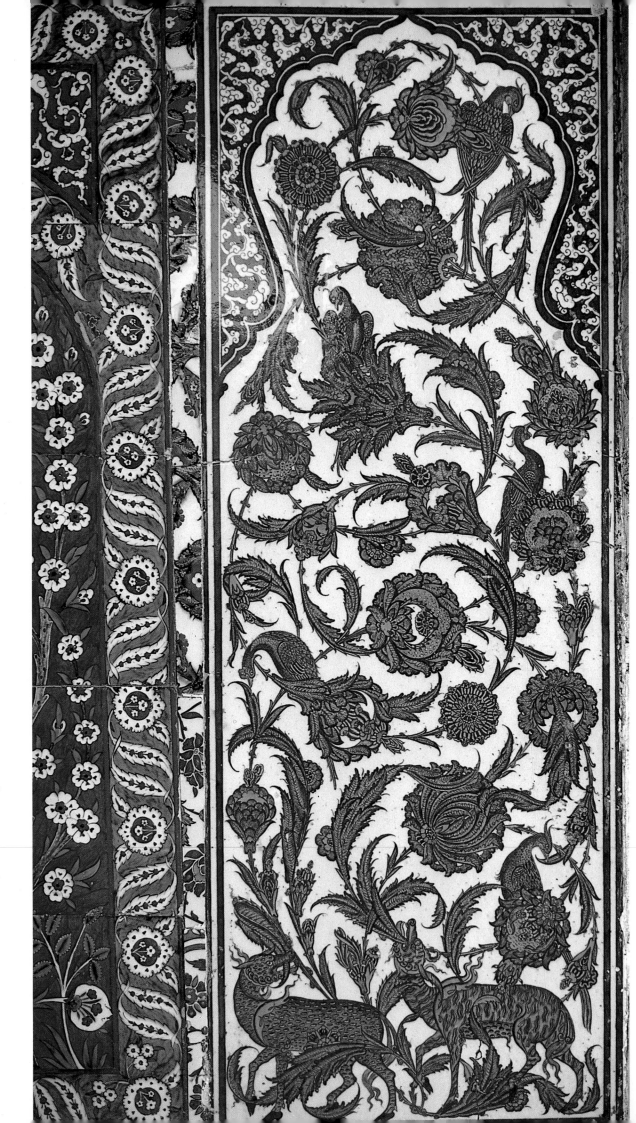

44. İstanbul, Topkapı Sarayı,
Sünnet Odası: large blue, tur-
quoise, and white tile with
hatayi decoration; ca. 1555–65.

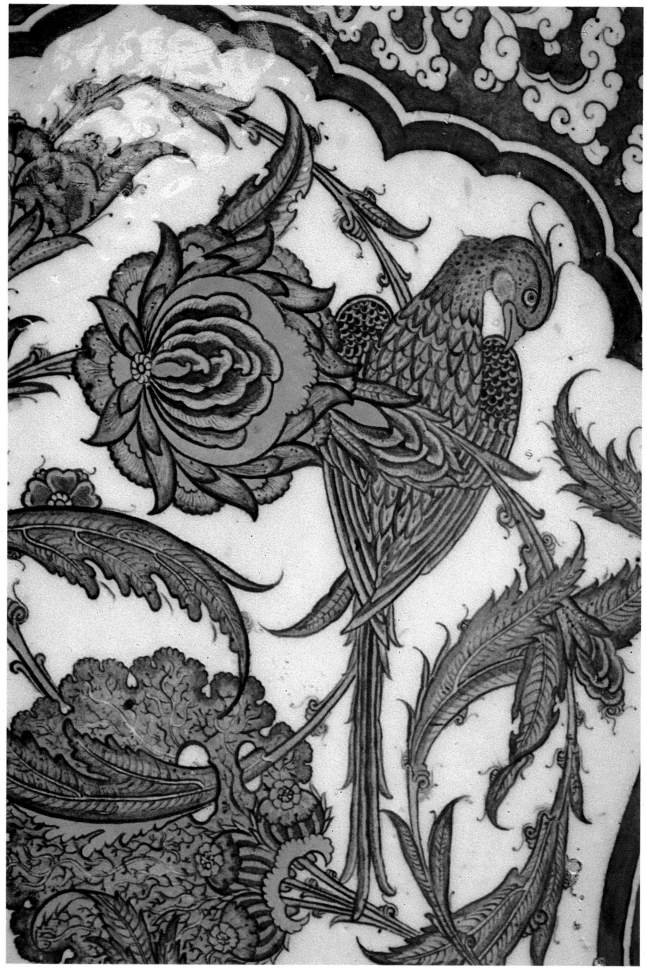

45. Detail of Plate 44.

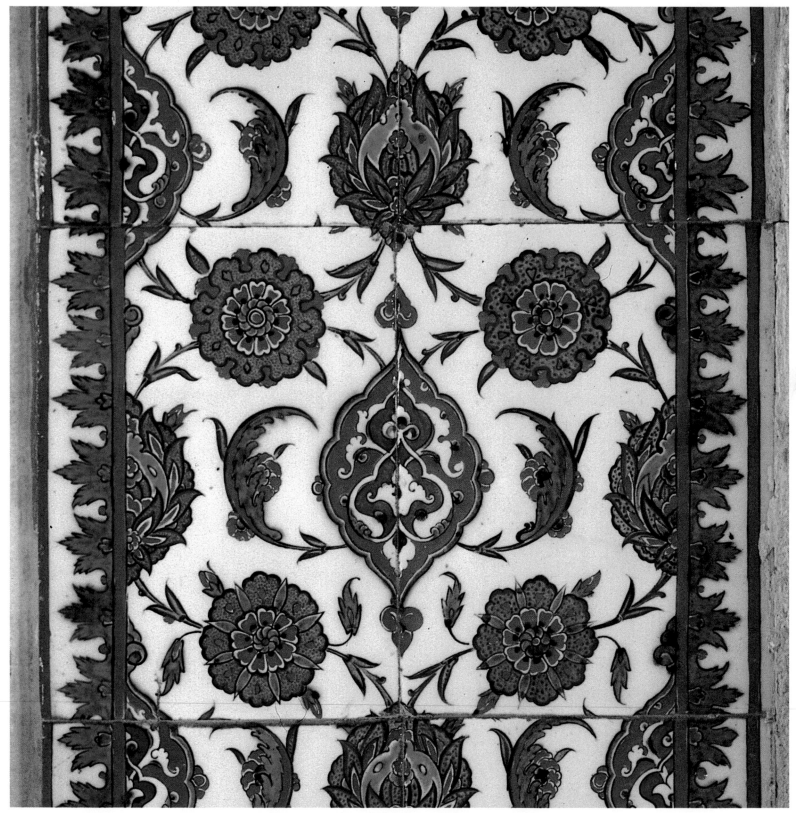

46. Edirne, Selimiye Cami: polychrome tile panel on the *kible* wall (detail); ca. 1575.

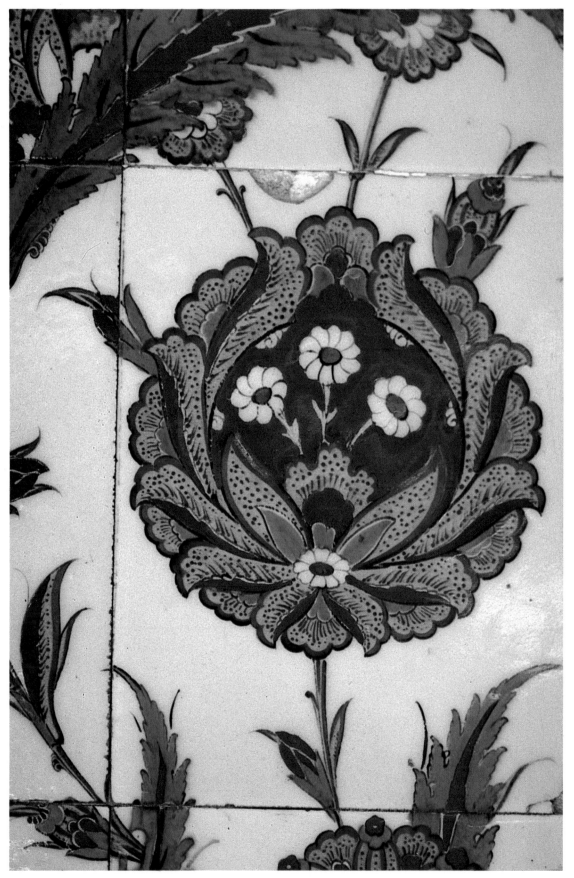

47. Edirne, Selimiye Cami: Lotus palmette (detail of tile panel); ca. 1575.

48. *Overleaf:* İstanbul, Mosque of Hekimoğlu Ali Paşa:
representation of Mecca on Tekfur Sarayı tiles; ca. 1733.

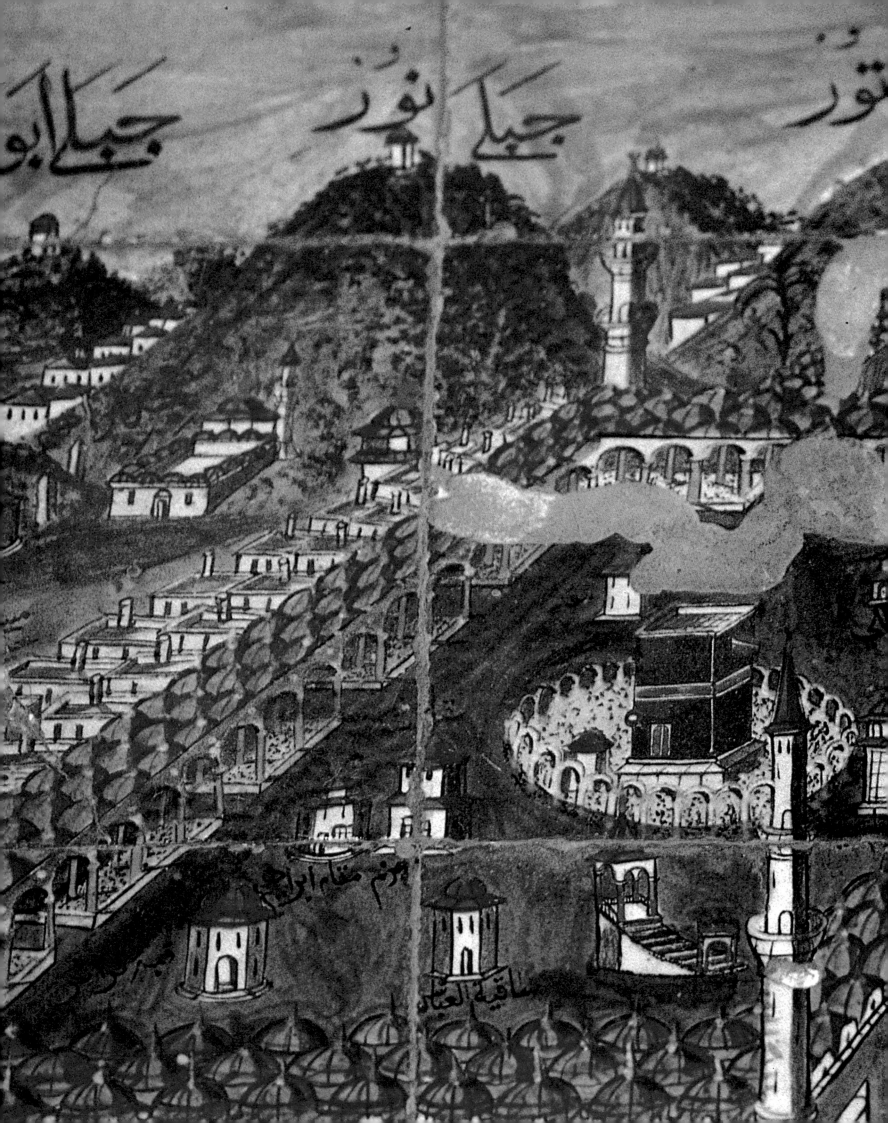

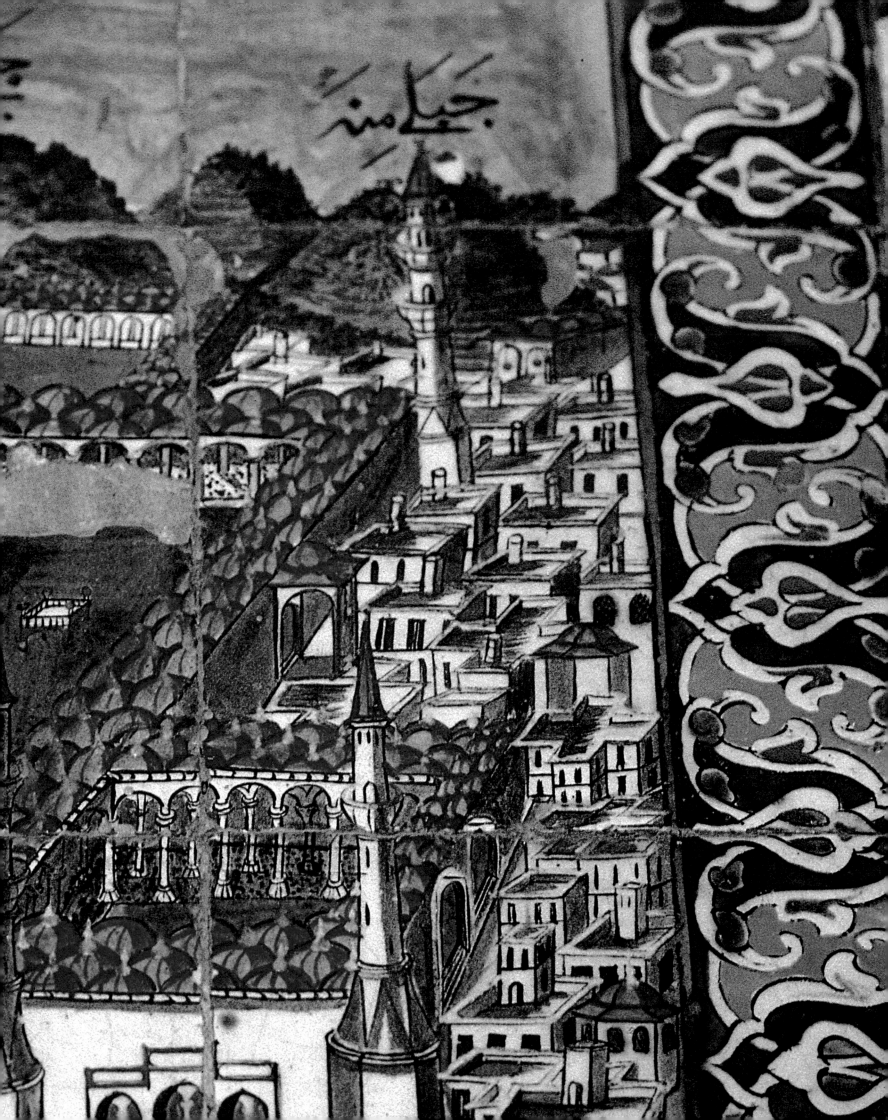

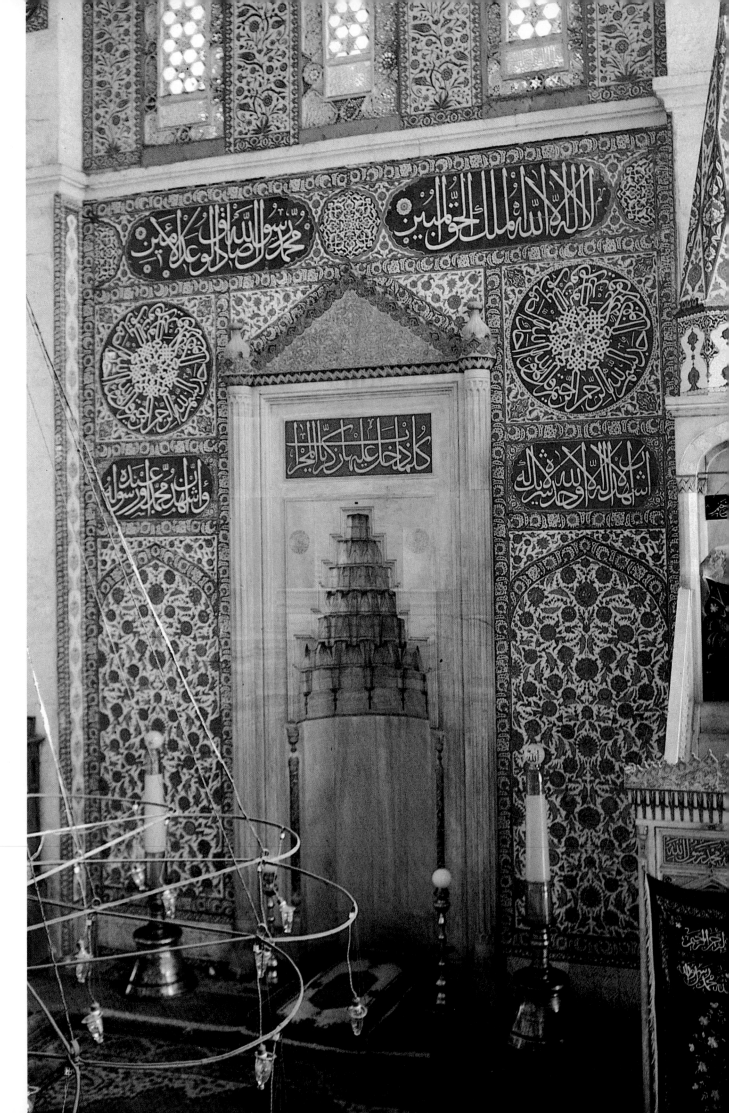

49. İstanbul,
Mosque of Sokollu
Mehmed Paşa: tile
panels flanking the
mihrab; ca. 1572.

due to commissions for tiles in the second half of the century. Such tiles appear in two tombs in Bursa: these are the tombs of Mustafa, son of Mehmed II (and half-brother of Beyazıd II), who died in 1474; and Mahmud, son of Beyazıd II, who was executed by his half-brother Selim I around 1506. The tile decorations of both tombs, which are contemporary and which postdate stylistically the lamps made for the Tomb of Beyazıd II around 1504, probably date to around 1520, when passage of time had diminished the historical enmities caused by rivalries for the Ottoman throne. Both decorations show the well-developed Turanian style of blue-and-white decoration in a sophisticated and well-developed form.

The blue-and-white tiles are confined in their present arrangement to borders in both tombs, which serve to accent the green, turquoise, and blue hexagonal color-glaze tiles, sometimes with gold-leaf ornament, which form the bulk of the wall decoration. The designs of the Tomb of Prince Mustafa are in blue on white, incorporating knotted vines framing delicately textured blossoms with the edges turned in, and accented by *rumi* leaves. A close examination reveals the delicacy and texture created by the skillful manipulation of the lighter value of blue, imparting a detailed and almost fragile, soft quality to the designs. The tiles from the Tomb of Prince Mahmud, with their design of reserve white on blue, together with the inclusion of blank white cartouches, which seem formerly to have borne designs applied in some manner over the glaze, more strongly recall the West Berlin mosque lamp. Both tile decorations are identical in quality and technique with the finest blue-and-white wares of the period and were undoubtedly created by the same individuals who decorated the finest wares. Few in number (in part because of the departure of many of these tiles to France during late nineteenth-century "restorations" in Bursa), the Bursa tiles represent, with the blue-and-white court wares also produced in İznik, the first evidence in the Ottoman ceramic tradition of a parallel production of building revetments and fine pottery wares, a production with further parallels in manuscript illumination and in other arts.

The artisans of İznik and their patrons in the capital never lost their fascination with blue-and-white ceramic decoration throughout the entire sixteenth century and through the first three-quarters of the seventeenth as well, even though subsequent technical developments in İznik after 1535 made possible a much greater range of colors and eventually led to the abandonment of the Turanian style and the adoption of many new and different types of designs.

EXPANSION AND TECHNICAL INNOVATION

By the 1530s a number of changes began at İznik that were eventually to affect dramatically both the artistic output and the internal organization of the ceramic ateliers. Around this date, a new color was added to the blue-and-white palette of the İznik artisans, a warm and translucent turquoise. While it tended to run or bleed into the glaze if carelessly fired, the new color was used together with both values of cobalt blue in the revetments of the Tomb of Çoban Mustafa Paşa at Gebze and in a number of hexagonal tiles and vessels as well. A decade later a black color based on chrome was developed, which, although it tended to fire as a dirty green if spread over large areas, could be effectively used as a line on the white slip and apparently could be applied not only from a fine brush but from an adapted reed pen.

The significance of this black line is two-fold: it brought closer together the tasks of the *nakkaş*, working with pen on paper, and the pottery-decorator, who undertook

151. Bursa, Tomb of Prince Mustafa: blue-and-white tile border; ca. 1525.

152. Bursa, Tomb of Prince Mahmud: blue-and-white tile border; ca. 1525.

a similar process on white ceramic; further, it made possible a division of labor that eventually resulted in the mass production of ceramics at İznik. This latter development resulted from the specialization of a master within a tile-making atelier who sketched out the basic design on slip-covered tiles and the apprentices who filled in the black lines with colors. Uniformity was maintained through the use of a pounced drawing, a template with thousands of tiny pinpricks perforating the paper along the lines of the design, through which finely powdered charcoal was sifted onto the ceramic surface. Using this rudimentary "carbon paper," the master traced the outlines of the design in chrome black on the tile.

Around the same time two new colors were added to the palette of the İznik artisans: a rather grayish or sage green and a very thin purple based on manganese. Both colors were translucent and hence very light in value; much like the purple and green of the Ottoman court carpets and textiles of the period, they were essentially subdued and soft. As an accent and a confining element in designs, the black line formed an integral element of the new polychrome decoration, which appears on a fairly large number of wares but oddly enough almost never on tile revetments from İznik. Perhaps the new colors were used only in workshops specializing in wares; perhaps, as Arthur Lane has suggested, the green and purple were not considered strong enough colors in their visual impact to be suitable for wall tiles. A much later production of wall tiles using this coloration, beginning near the end of the sixteenth century and centered in Damascus, at one time led scholars to assign to the provenance of Damascus all İznik wares bearing this soft and elegant coloration of blue, turquoise, purple, and sage green with the black line.

Together with the new colors and the black line, the ceramic artisans of İznik began to utilize more daring shapes and larger sizes of vessels, requiring greater and greater skill on the part of the potter. The most famous example of the new decoration used on a large scale is a mosque lamp in the British Museum in London, said to have come from the Dome of the Rock in Jerusalem. More than fifty centimeters in height, this splendid lamp (or rather, lamplike object, for being opaque it could cast no light) was designed as a decoration for the Jerusalem shrine as part of the mid-century restorations undertaken by Süleyman I. The British Museum lamp may be a second attempt; the first, having lost its flare, is in the Godman collection in Horsham. The British Museum lamp presents us with a decoration of three reserve-white cursive inscription bands on dark blue ground, one on the bottom, one on the neck, and one on the rim of the flare. The body and flare of the lamp, the latter turned separately on the potter's wheel and then joined to the body, bear elaborate compositions of Chinese cloud-bands in pale blue, alternating with half-medallions of *rumi* designs in greenish black filled with a pale green coloring. The bevel between the two major parts of the lamp shows a succession of miniature cartouches, each filled with three reserve-white tulip buds. A close examination of the major inscription bands shows under the blue the "first-draft" sketching of the inscription by the artist, which does not correspond exactly to the final design. Around the foot of the lamp is a partially effaced inscription that bears the distinction of being the only inscription on a ceramic object from İznik mentioning that town by name:

ill. 153

> Oh, holy man who art at İznik, Eşrefzade! In the year 956 in the first month of Jumadha. The painter, the poor, the humble Mus . . .

The painter Mustafa evokes Eşrefzade, the patron saint of İznik, using a conventional

formula of humility, which may belie the artisan's status as a *nakkaş* and calligrapher high on the social scale of Ottoman artists. The date corresponds to 1549.

Another example of ceramic decoration from the 1540s that shows both the new ill. 154 type of decoration and an attempt to stretch the limits of scale is a large bowl in the Victoria and Albert Museum decorated with the familiar pattern of spirals, this time in greenish black line interspersed with ornaments in blue and turquoise. Unlike the mosque lamp, which is a highly individualized object, the shape of the bowl is somewhat prosaic. The decoration has no focal point and was rarely employed in İznik ceramics after the middle of the century. Under the decoration the bowl is pure white, and the decoration has been planned carefully in great detail. Its size, more than forty-five centimeters in diameter, shows the ability of the İznik artisans to produce wheel-turned pottery in almost any practical dimension.

One of the most successful experiments in mid-century İznik production resulted in another unique object, this one a rimless plate in the Metropolitan Museum. With its plate 41 (p. 269) coloration of turquoise, blue, and white, and the luxuriant soft foliage of lotus palmettes and tiny leaves in a quinquefoliate vine around the rim, there is little at first sight to remind us of pottery previously seen, except for the technique and coloration. The border and the unique grid pattern in the center have been shown to be a free adaptation of a fourteenth-century Chinese dull green celadon porcelain design, again pointing out the recurrent influence of Chinese ceramics on Ottoman traditions. The type of design, distinguished by lotus flowers with their distinctive butterflylike petal arrangement, is termed in Turkish *hatayi* (from Cathay), although its immediate sources in Turkish art appear to stem from western Iranian miniature painting in the late fifteenth century.

153. Mosque lamp, from the Dome of the Rock, Jerusalem, dated 1549. (London, British Museum, 875–6 1)

154. Large bowl with black-line spiral decoration; ca. 1540–50. (London, Victoria and Albert Museum, 243–1876)

A dish from the Metropolitan in the same coloration and probably from about the
same time shows a much more literal adaptation of a fifteenth-century blue-and-white
porcelain Chinese original. Bunches of grapes in a central field are surrounded on the
cavetto of the dish by a frieze of floral bouquets. The flat rim utilizes a design that in
the Chinese original represented waves of the ocean with the interspersion of crests of
white foam. Out of deference to the porcelain model the outer rim of this pottery plate
from İznik has the characteristic cusping, and there is no black line.[7]

The mosque lamp, bowl, and plate with *hatayi* border that we have examined repre-
sent experimental and hence virtually unique products of the 1540s and 1550s. There
does exist a large class of pottery wares more typical of production at that time. By
mid-century two new elements of design were entering the Ottoman decorative vo-
cabulary and were to dominate it for the next century. The first was a complex and
calligraphic type of design, consisting of various kinds of complicated *hatayi* floral
palmettes and rosettes, together with highly serrated, sinuous, and contorted leaves,
which in their twisting gyrations often took on a quasi-animate character. The leafy
decoration, known in Turkish as *saz*, with its elaborate and imaginative conceits, its
virtuosity of calligraphic line, and its careful manipulation of colors to create a texture
of softness, is the Ottoman linear style par excellence. The *nakkaş* artists who practiced
this style formed one part of the court atelier, beginning in the late 1550s and reaching
their zenith toward the last quarter of the century. They were concerned largely with
black-line drawings for albums, of a fantastic and imaginative nature, which influenced
not only ceramics, but carpets, textiles, stone-carving, metalwork, and bookbinding.

The second major design type that emerges in mid-century is a vocabulary of rela-
tively simple forms, consisting largely of stylized flowers. The tulips, roses, carnations,
hyacinths, and peonies of these designs, which might be viewed as a reaction against
the implicit rules and discipline of the Turanian style, call upon the imagination of the
colorist rather than that of the draftsman and find their ideal application in ceramics.

The impact of both the "leaf style" and the "flower style" on mid-century poly-
chrome ceramics of İznik can be seen on a lovely plate in the Louvre. Within a border
of the "wave-and-foam" variety, which is now stylized and considerably simplified, a
variety of floral and leaf forms springs from a single source at the bottom of the design.
The center of the plate is dominated by two large and complex palmettes, each with a
cluster of buds in the center, from which spring cockadelike leaves. Various smaller
palmettes and rosettes fill the top of the composition, including two round scale-covered
forms that appear to represent peony buds. The whole composition—asymmetrical,
energetic, and free—is punctuated at irregular intervals by tiny curled Chinese cloud-
bands. It is perhaps because so many of these forms originated in Chinese prototypes
that such leaf-and-palmette designs became characterized as the "Cathay" style. But,
as represented by the Louvre plate, the synthesis is one of powerful originality and
is distinctly Turkish.

Another example, in the Victoria and Albert Museum, displays a rim with groups
of reserve-white tulip buds strikingly similar to those on the British Museum mosque
lamp. The central field again consists of a number of stems, all originating from a single
point at the base of the composition. If we look back to the blue-and-white Boston dish
from the early part of the century imitating Ming ware, we can see how its topological
arrangement—providing for an even and balanced, if asymmetrical arrangement of
flowers on a white field—is all that remains in the later example, in which the character
of the ornament has so dramatically changed.

ill. 155

ills. 88, 90

plate 59 (p. 331); ills. 92, 182

ill. 156

ill. 157

ill. 148

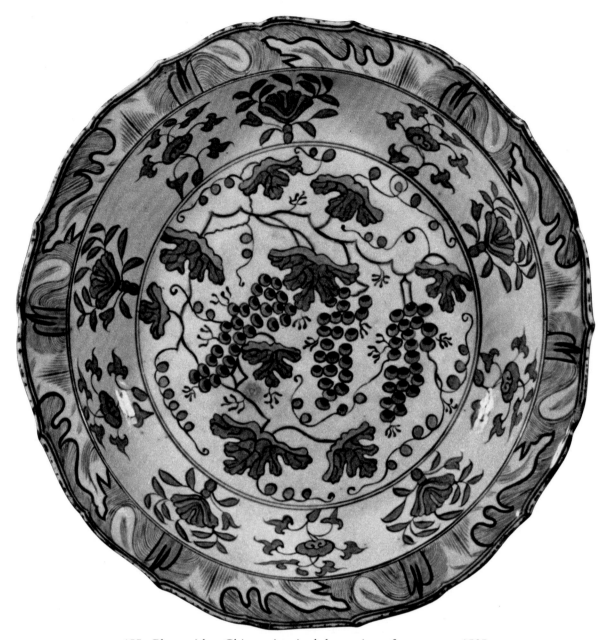

155. Plate with a Chinese-inspired decoration of grapes; ca. 1535.
(New York, Metropolitan Museum of Art, 66.4.10)

Among the many mid-century polychrome wares utilizing turquoise, blue, sage green, pale purple, and black, there are both artistic successes and artistic failures. The green and purple tended to be weak colors, rather sparingly used and not well adapted to the simple forms of stylized flowers. They do, however, form part of some of the great masterpieces created around the middle of the century and later, in which we can see the direct participation of court artists in painting of designs on ceramics.

From this limited group one rather small plate in an American collection is certainly among the finest. The artist has disregarded the natural division between the flat bottom and the curved cavetto of the rimless plate, so consequently there is no border except for a miniaturist's compass line around the periphery. Two blue vines spring from a cluster of two serrated leaves writhing and curling in dragonlike fashion, forming a small vortex where they join. One blue vine almost immediately terminates in another great curling sage green veined leaf; the other springs to the upper left, breaks, and

plate 39 (p. 268)

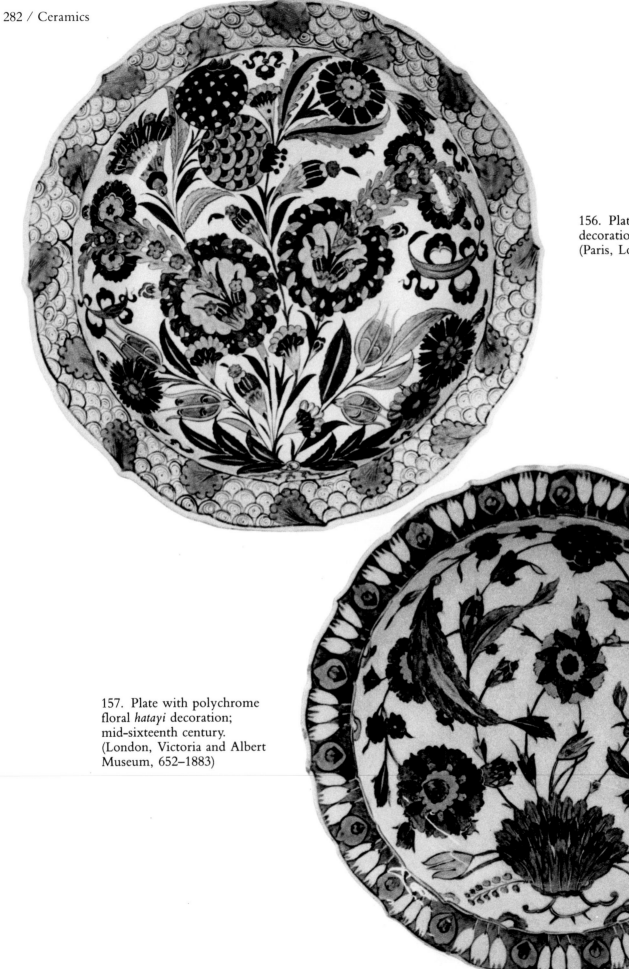

156. Plate with polychrome *hatayi* decoration; mid-sixteenth century. (Paris, Louvre, AO 7590)

157. Plate with polychrome floral *hatayi* decoration; mid-sixteenth century. (London, Victoria and Albert Museum, 652–1883)

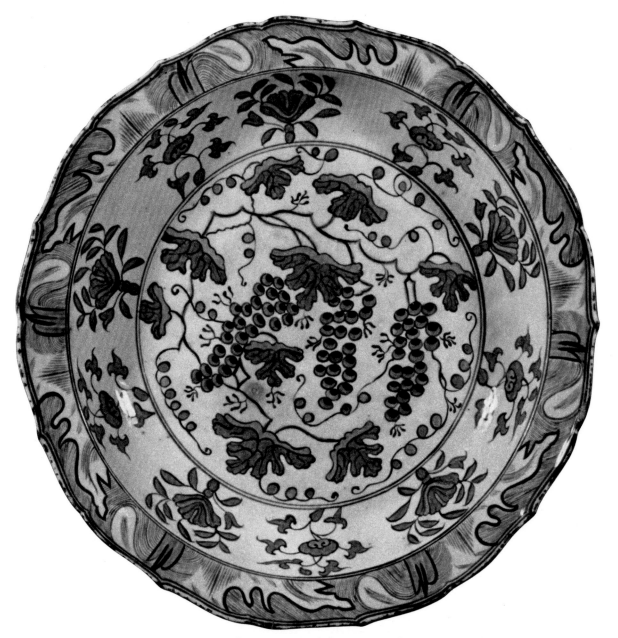

155. Plate with a Chinese-inspired decoration of grapes; ca. 1535.
(New York, Metropolitan Museum of Art, 66.4.10)

Among the many mid-century polychrome wares utilizing turquoise, blue, sage green, pale purple, and black, there are both artistic successes and artistic failures. The green and purple tended to be weak colors, rather sparingly used and not well adapted to the simple forms of stylized flowers. They do, however, form part of some of the great masterpieces created around the middle of the century and later, in which we can see the direct participation of court artists in painting of designs on ceramics.

From this limited group one rather small plate in an American collection is certainly among the finest. The artist has disregarded the natural division between the flat bottom and the curved cavetto of the rimless plate, so consequently there is no border except for a miniaturist's compass line around the periphery. Two blue vines spring from a cluster of two serrated leaves writhing and curling in dragonlike fashion, forming a small vortex where they join. One blue vine almost immediately terminates in another great curling sage green veined leaf; the other springs to the upper left, breaks, and

plate 39 (p. 268)

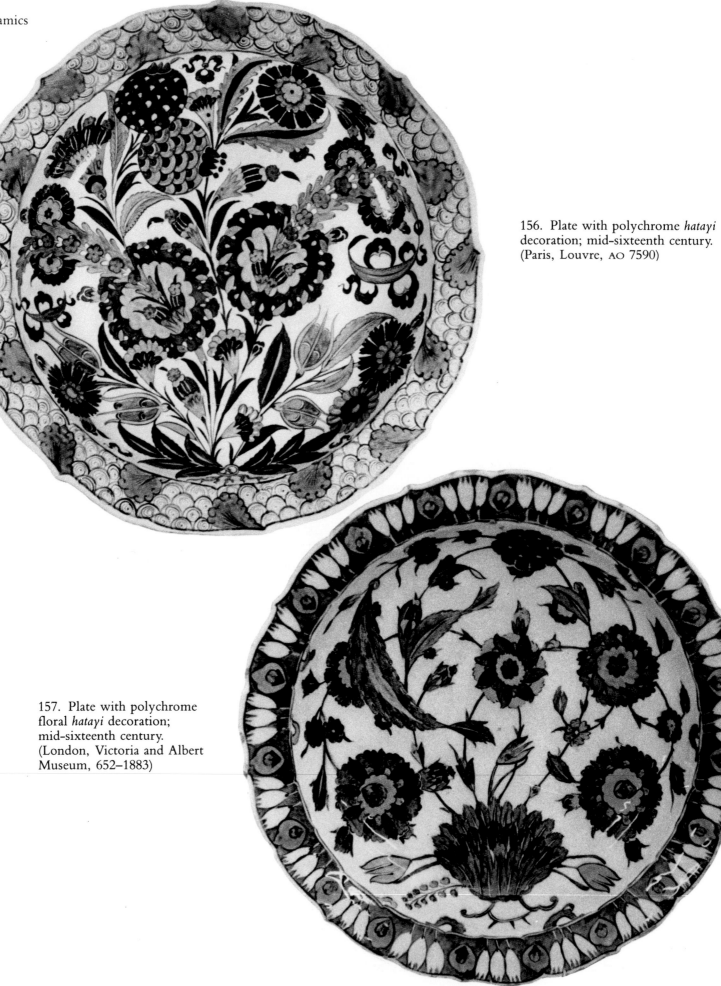

156. Plate with polychrome *hatayi* decoration; mid–sixteenth century. (Paris, Louvre, AO 7590)

157. Plate with polychrome floral *hatayi* decoration; mid–sixteenth century. (London, Victoria and Albert Museum, 652–1883)

sweeps down and then up to the right, bearing two rosettes and four complex palmettes, some adorned by cockadelike buds. The entire design is delicately textured by skillful use of the natural translucency of the pigments, especially the green, purple, and turquoise. The balance of white slip and darker floral forms is at once spontaneous and carefully planned. This masterpiece of the *hatayi* style reflects the great court drawings, many incorporating dragons, which appear in Ottoman album pages created from the 1560s through the 1580s. The style emerges as a sixteenth-century Ottoman response to the examples of black-line drawings of earlier periods contained in four great fifteenth-century albums that served the *nakkaşhane* as pattern books, teaching examples, and challenge alike.

The closest rapport between the *hatayi* style as practiced in black-line album painting and the same style in ceramics is not seen in polychrome painting on wares, but rather within the restricted range of blue and turquoise coloration painted on a series of wall tiles. These are the five great tiles, four of them made from the same pounced paper cartoon, that today decorate the south exterior wall of the Sünnet Odası (Circumcision Pavilion) in the Topkapı Sarayı.[8] Like so many Ottoman buildings, the seventeenth-century Sünnet Odası was redecorated in the late nineteenth or early twentieth century with a wide assortment of tiles from earlier buildings, which are arranged in a somewhat arbitrary and even haphazard manner and which upon close examination serve as a virtual textbook of the development of Ottoman ceramic production from around the year 1500 up to the late seventeenth century. The large tiles in question appear to have been created in the 1550s or 1560s as decorations for the Arz Odası (Throne Room) of Sultan Süleyman and, through the vicissitudes of time, found their way to their present location. As mentioned, four of the tiles, measuring about 48 centimeters in width by 127 centimeters in height, were designed from the same pounced cartoon reversed twice, so that two tiles are mirror images of the other two. The artist created masterpieces much more appropriately within the rubric of album painting than within that of ceramic decoration. At the bottom of the composition two *ch'i-lins* (Chinese antelopelike creatures) stand among the luxurious foliage of curved leaves, palmettes, rosettes, and vines, which rise in sinuous but carefully spaced asymmetry to the top of the tile, under a nichelike arch whose spandrels are filled with reserve-white cloud-bands on dark blue. Among the decorated leaves and floral forms are delicate birds, some of which may originally have had precious stones set in their eyes. The veining of the leaves and flowers, in darker blue against pale translucent blue, and the complex texturing of the palmettes, some of them pierced by swordlike leaves, are a miracle of subtlety and softness, of texture and technical proficiency, to which no reproduction can do justice. Occupying a place of great prominence in the palace complex since their creation, these great paintings on tile understandably had a tremendous influence on other ceramic production in ensuing years. So great was their appeal that in the 1630s artisans under Murad IV were commissioned to re-create these panels for the decoration of one of the sultan's kiosks, although their attempt was without notable success. With the placing of these large tiles in the walls of the sultan's palace, the *hatayi* style, incorporating the *saz* serrated leaves, was established firmly in the Ottoman artistic tradition.

The preeminence of such great paintings on tile as the Sünnet Odası panels undoubtedly did much to further court patronage of İznik ceramics and to involve court artists directly in the ceramic industry but did not keep the İznik artisans from further experimentation. Because the sage green and pale purple were hard to spread evenly

plates 44, 45 (pp. 270–71)

on the tile and were always translucent, hence light in value, they were not entirely satisfactory colors for a stylistic vocabulary that included tulips, carnations, and hyacinths. Pale purple tulips had no personality; sage green carnations were an affront to nature. The İznik artisans needed two colors, a true red and a true green, which would adapt not only to the floral style but also to the new methods of mass production made possible by the invention of the black line and by increased royal patronage for decorative tiles. The simple floral designs were admirably suited to mass production; what was lacking was the appropriate range of colors. By the late 1550s a red color was developed, utilizing iron-red pigments mixed with siliceous material. It appeared in early experiments as a thin, blotted, and semitransparent brownish red. But by the early 1560s it was discovered that, when applied thickly in heavy opaque blobs, it reacted with the covering transparent glaze during firing to form a color ranging from true scarlet to a near orange. Always a difficult color to mix and fire properly, the new "Turkish red" came to characterize the production of İznik from 1560 to 1670 and has deservedly contributed greatly to the fame of İznik ceramics. By varying ingredients in the copper-based turquoise pigments used for decades, artisans were finally able to develop in the later part of the 1560s a grass green color, which like the turquoise tended to run and bleed but which when properly applied gave a dark and lustrous green.

plate 42 (p. 269) The new colors, especially the red, influenced the stylistic character of both wares and tiles, increasing the use of stylized flowers in decorations. And while blue-and-white and even sage green and purple color schemes were still occasionally employed during the rest of the sixteenth century, it was the polychrome style of turquoise, blue in two values, green and red, used with the black line, that came to dominate the vast bulk of İznik ceramic production in ensuing decades.

One last important experimental undertaking of the İznik kilns in the 1560s was the invention of what might be called a colored slip, which replaced the white slip in a small number of wares but which, unlike the red and green colors, had surprisingly little impact on subsequent production. These rare objects, which seem to have been produced in a plate 43 (p. 269) single workshop, utilize a milky red or blue ground, on which designs could then be painted in other colors, including white slip. Given the great attractiveness of these wares today, it seems a puzzling quirk of sixteenth-century Ottoman taste that kept this technique from being used for tiles and for all but a very few pottery wares.

POLYCHROME CERAMICS AND MASS PRODUCTION IN İZNİK

plates 10, 11 (pp. 109–11); ills. 49–52 The first important imperial project of building decoration using underglaze tiles on a large scale occurred during the zenith of Ottoman political, economic, and cultural development: the building of the Mosque of Süleyman in İstanbul by the architect Sinan, which was completed in 1557. The ateliers in İznik specializing in underglaze tile production were still fairly small at this time, and the architect planned for only the central portion of the *kıble* wall surrounding the mihrab to be decorated with tiles, along with panels of calligraphy bearing Koranic inscriptions over the windows of the inner court. The decoration consists of two types of tiles: mass-produced modular tiles of identical repeating pattern, often with a diagonal axis of symmetry and repeated in groups of four; and large compositions of calligraphic and floral designs upon a field consisting of many individual square tiles. The inscriptions are the work of Ahmed ills. 50, 91 Karahisari, the preeminent calligrapher of his day, and were probably executed on cartoons at the İznik workshops and transferred to the large fields of tiles. Peculiar no-

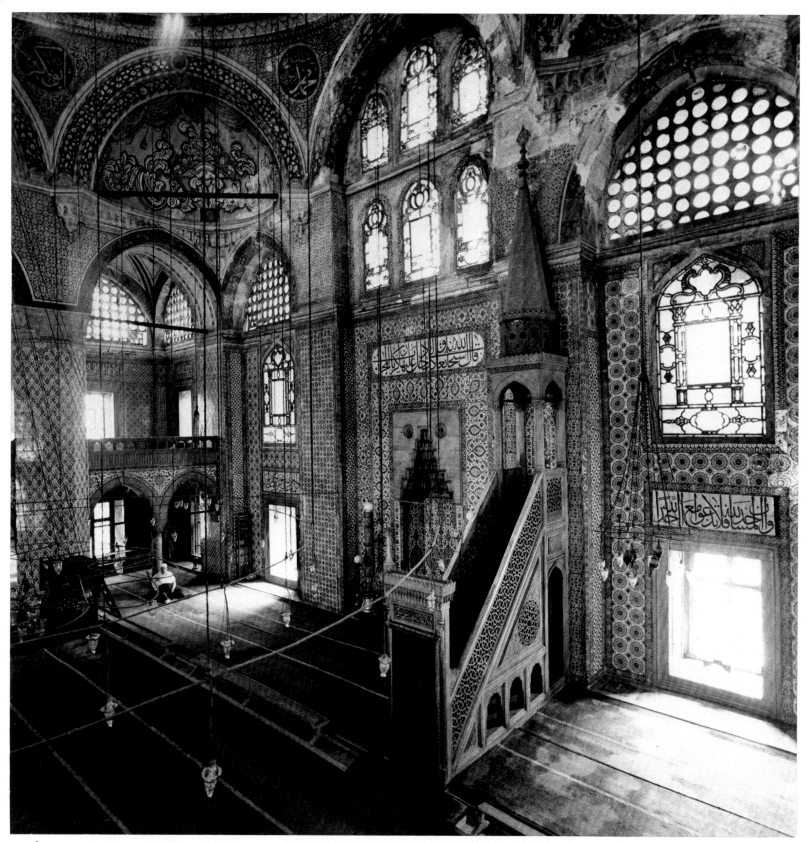

158. İstanbul, Mosque of Rüstem Paşa: general interior view showing the *kıble* wall; ca. 1561.

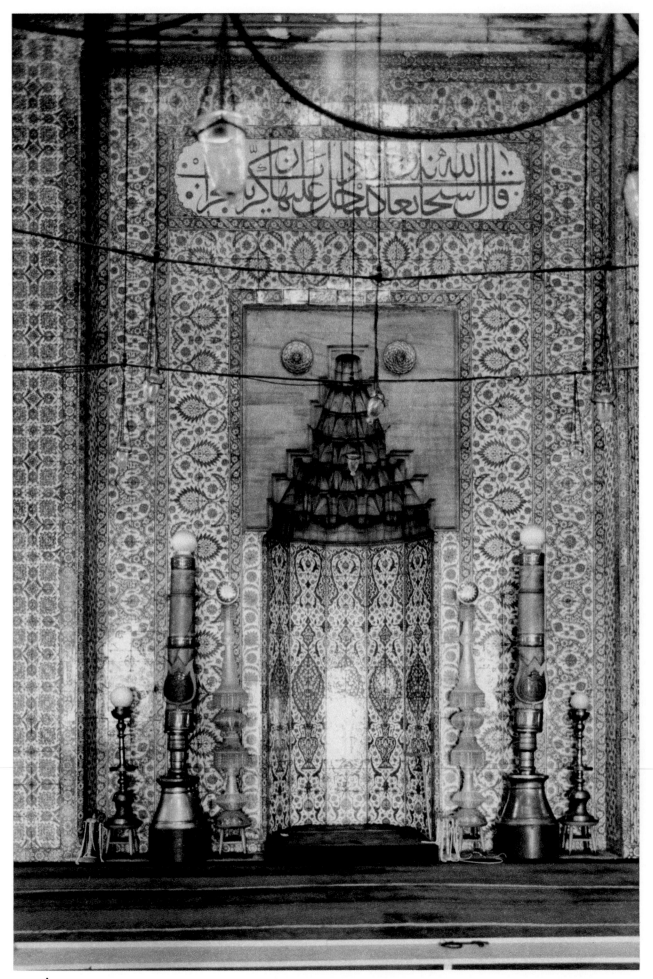

159. İstanbul, Mosque of Rüstem Pşa: mihrab with polychrome tiles; ca. 1561.

tations appearing in the *İnşaat Defterleri* (account books for the construction of the mosque) mention that İznik tiles were used in the mosque, and İstanbul tiles in the Tomb of Süleyman behind the mosque.[9] The latter tiles, dating from mid-1560s, consist mostly of large *hatayi* compositions on fields of tiles. It is possible that the notations in the account books refer to the difference between the modular tiles, which were easily made by mass production in the town of İznik and could be trimmed if necessary to fit wall surfaces in the mosque, and the large *hatayi* compositions on fields of tiles in the tomb, which were actually designed in the *nakkaşhane* in İstanbul. A further possibility is that many "İznik" tiles made to order for the Süleymaniye Mosque and for other buildings erected over the second half of the century may have been made in situ near the construction site, with artisans from İznik traveling to the site for the purpose.

If the tile decorations of the Süleymaniye Mosque are almost lost in the vast interior of the great imperial monument, the mosque constructed by Rüstem Paşa, Süleyman's grand vezir, in the early 1560s, provides a smaller and more intimate setting for display of the fortunate collaboration of İznik potters and court designers. Almost every corner of the mosque is tiled with an incredible variety of ceramics in the *rumi*, *hatayi*, and floral forms of decoration, all showing the red coloration and a few incorporating the newly developed green. The decorations include both large compositions painted over fields of tiles, specifically designed to fit parts of the architectural surface, and panels of mass-produced modular tiles showing many different designs, in which the tiles on two edges of the composition were cut if necessary to fit within the architectural surface and surrounded by a distinctive border used everywhere in the mosque. The Rüstem Paşa tiles may safely be called the starting point for the lavish ceramic decorations so frequently encountered in Ottoman buildings built during the following 130 years. At first the mixture of designs appears almost chaotic; a close examination shows that the tiled mihrab, the focal point of the decoration, was designed by an older and more experienced *nakkaş*, probably the calligrapher Hasan, the greatest pupil of Karahisari. In its dry and symmetrical arrangements with subdued coloration the decoration of the mihrab betrays its origins in the world of calligraphic illumination and bookbinding, associated at this time with conservative elements in the court atelier. The mihrab decorations use the red color sparingly, where accents of gold leaf would have been used by an illuminator. It is possible to distinguish in the rest of the mosque a variety of hands and aesthetic preferences. Some younger artists readily adopted the new vocabulary of stylized flowers, especially the tulips and carnations already used in pottery wares; others, of a more conservative bent, relied more heavily on calligraphic designs in which the black line predominated and color was at a minimum. The supervisor of the decoration, despite his own conservatism, seems to have given best placement in the mosque to some of the most advanced and coloristic designs, which were to have a signal impact on future building revetments. The less successful designs, on the other hand, were placed in out-of-the-way corners and in the backs of the galleries.

The Rüstem Paşa ceramics range from the relatively conservative mihrab and tiles with designs copied from color-glaze ceramics in the Turanian style, through exciting fields of *saz* leaves that appear to be whipped by an unseen wind, to large panels showing flowering trees, originally placed on either side of the main doorway of the mosque. These panels exhibit a wide variety of flowers and flowering plants on a blue ground, itself clearly showing feathery textured brushstrokes echoing the main elements of the design. *Namaz* (the obligatory Muslim prayer) is an essential act of the believer who wishes to enter paradise, and the flowering tree panels clearly evoke the Koranic de-

<div style="text-align: right">ill. 158</div>

<div style="text-align: right">ill. 159</div>

<div style="text-align: right">ills. 160, 161</div>

scription of life after death, likening heaven to a garden in which the righteous will enjoy repose:

> Among lote trees without thorns
> Among acacia trees with abundant flowers
> In the spreading shade
> By the flowing waters
> With abundance of fruit. . . .
>
> [LVI: 28–32]

Although only one of the two blue-ground flowering tree panels remains today, they inspired as prototypes a number of coloristic wall paintings on large tile fields completed throughout the last third of the century. The Rüstem Paşa panels—utilizing blue, red, turquoise, and purple in addition to the black line and incorporating, in violation of traditional standards of propriety, *rumi, hatayi, saz,* and stylized flower elements—are in their unabashed originality a revolutionary statement of the new trends in decoration. It is a great loss to Turkish art that one of the two panels, that on the right of the entrance, has virtually disappeared; only a few remaining tiles now can be found in the left gallery of the mosque, while none has yet come to light in museum collections.

Technically, in their great profusion the Rüstem Paşa tiles suggest that a number of different İznik ateliers contributed to the project. Some workshops handled the red rather badly, while others began to master the technique of applying the pigment in thick layers on the slip, giving an almost scarlet color in high relief under the glaze. The variety of designs suggests that the mosque involved a great experiment, or even competition, with many designers, each eager to surpass the others in the brilliance and originality of composition and execution. Some clearly were trained in the *cuerda seca* tradition, or used the traditional Turanian designs as appropriate to wall tiles, while others were clearly under the spell of the new and fanciful *hatayi* style exemplified in album painting and the great blue-and-white tiles in the sultan's palace. The great predominance of mass-produced modular designs provided the İznik kilns with their first experiments in such production. Some of the panels designed to fit specific architectural surfaces do not fit very well and were cut down as a result. Aside from the single border used throughout the building, and the symmetrical placement of identical panels on either side of the building at ground level, there is little overall unity in the decoration when compared to some of the more tightly knit decorative programs of the 1570s and 1580s. But the decorations of the Rüstem Paşa Mosque do represent the most ambitiously scaled use of underglaze revetments in any Ottoman mosque, and they provide a virtual pattern book of design types that influenced subsequent decorations, as many of the younger *nakkaş* went on to other tasks of decorating later in the century.

Two tombs of the mid-1560s helped to establish firmly another basic type of tile decoration, that of white-ground *hatayi* compositions contained within an arch, symmetrically arranged over large fields of tiles. The tomb of Rüstem Paşa himself, completed after his death around 1564, and that of Sultan Süleyman, completed a few years later, show the first use of these compositions, which are found in many monuments in the following decades. They owe their basic inspiration to the blue-and-white tiles of the Sünnet Odası in the Topkapı Sarayı and also bear close relationships to bookbinding designs and especially to Ottoman prayer rugs of the latter part of the century. These large compositions employ in the field under the arch the full vocabulary of the *hatayi* decoration, with its curved leaves, elaborately composed lotus palmettes, and rosettes.

160. İstanbul, Mosque of Rüstem Paşa: tiles with *saz* leaf design; ca. 1561.

Also, in a characteristic Ottoman separation of types of decoration, they use intricate interlaces of *rumi* leaves and complex compositions of cloud-bands in small medallions and in the spandrels of the arch, while employing floral decoration in their borders. From the relatively simple shapes of the 1560s the white-ground arched compositions evolve by the end of the century into complex decorated arch shapes, and the middle of the field commonly contains a richly adorned medallion. Characteristic examples of the fullest development of the genre are seen on the *revak* (porch) of the Tomb of Murad III in İstanbul, completed around 1596.

ill. 162

During the reigns of Selim II and his son, Murad III, the evolution of the polychrome ceramic decorations continued, relying more and more on brilliance of color. Decorations of secular buildings of the time, such as the tile panels of the famous Golden Way of the Imperial Harem, used ever-increasing amounts of red color, some even employing a red ground with reserve-white designs. The elegant *hatayi* white-ground arched panels of the *kıble* wall of the Selimiye Mosque in Edirne, finished about 1575, are among the loveliest and most technically accomplished examples of a style at once delicate and calligraphic, yet forceful enough in its color to form a prominent part of the interior decoration of the powerful and overwhelmingly engineered interior spaces of the great architect Sinan. The red stands up under the glaze, and in place of the soft

plates 46, 47 (pp. 272–73)

ills. 53–55

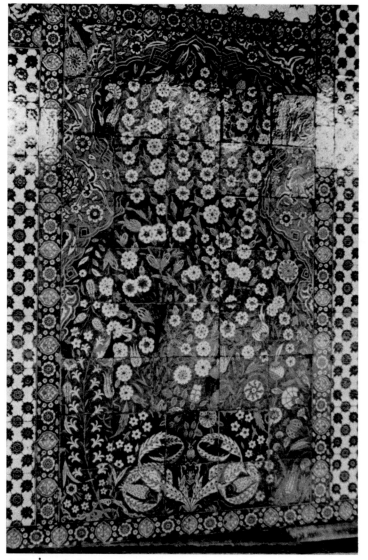

161. İstanbul, Mosque of Rüstem Paşa: tile panel on the portico; ca. 1561.

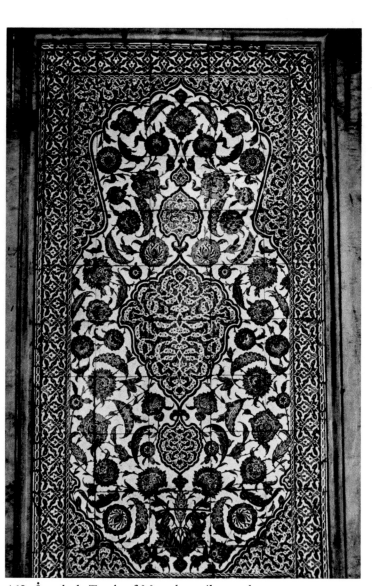

162. İstanbul, Tomb of Murad III: tile panel on the portico; ca. 1596.

and delicate texturing of the Sünnet Odası leaves and flowers, the İznik artisans developed a "shorthand" method of texturing, involving the use of stippled dots of dark blue upon lighter blue.

The apogee of polychrome revetment decoration in the sixteenth century is perhaps achieved again in a grand vezir's mosque, the one completed around 1572 for Sadrazam Sokollu Mehmed Paşa, who served Süleyman I, Selim II, and Murad III. Located in the Kadırga quarter of İstanbul, the mosque is approximately the same size as Rüstem Paşa's, but its tile decorations are more limited and its program of decoration is more carefully and elegantly planned. Throughout the mosque, there are decorative panels crowning the windows, and a lovely calligraphic inscription moves from window to window across the facade. The judicious use of ceramics, counterpointed by bare, warm colored building stone and decorations in paint and polychromed wood, lends to each medium of decoration a special and distinctive role in the overall program. To either side of the mihrab, above dadoes of tile with bizarre imitation marble designs, are two identical arched white-ground *hatayi* panels, composed of elaborate palmettes of complex design, equally complex rosettes, and brilliant green curving leaves each decorated with a tight-

plate 49 (p. 276)

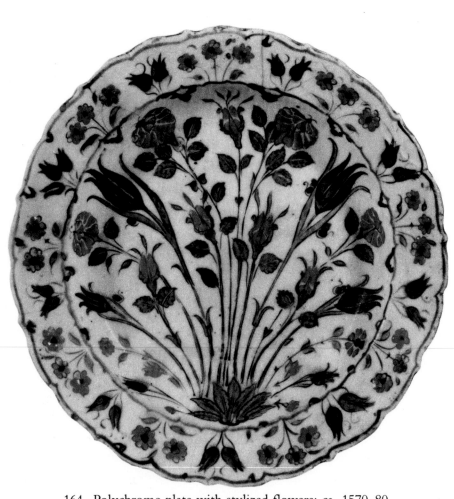

163. Polychrome bottle with animal decoration; ca. 1580–90. (Sèvres, Musée National de Céramique, 1842)

164. Polychrome plate with stylized flowers; ca. 1570–80. (Washington, D.C., Freer Gallery of Art, 69.26)

ly curled cloud-band. The genre remains completely pure—no *rumi* elements, no stylized flowers, no geometric elements intrude into the disciplined and yet animated designs. Unlike the Sünnet Odası panels, and unlike the *hatayi* designs painted on plates, the overall design, except at the top of the arch, makes no effort to accommodate itself to the confines of the blue ground border; rather, the design abruptly terminates when cut by the thick red guard stripe of the surrounding borders, which are themselves painted upon the same field of modular tiles. In the perfection of color, fluency of draftsmanship, and above all in the technical skill involved in firing such large fields of tiles so as to insure uniform coloration throughout, the panels of the Mosque of Sokollu Mehmed Paşa demonstrate most fully the artistic integrity, high technical standards, and efficient organization of work characterizing İznik production at its very best.

The last three decades of the century saw many ambitious tile decoration projects, in which a variety of designers and ceramic workshops participated. Tile decorations were also commissioned for wooden buildings long since destroyed and were evidently incorporated into the *kayıks* (royal longboats), which carried the sultan and his courtiers on the waters of the Bosporus and Golden Horn. Throughout the Ottoman Empire secular and sacred buildings alike show examples of the ceramics with the brilliant red and the lively designs that made the name of İznik famous throughout the world.

From the 1560s onward the İznik kilns also produced great numbers of beautiful pottery wares in the new coloration. *Tabak* (plates), *şişe* (bottles), *ibrik* (pitchers), *hanap* (mugs or tankards), *güze* (jars), and *liğen* (bowls) most frequently decorated with bouquets of the charming stylized flowers so easily adaptable to small-scale compositions were used throughout the Ottoman Empire. In addition, these also were made to order for European clients, even adopting European shapes and family coats-of-arms. The İznik wares were exported as far as Germany and England, and Italian majolica artisans were influenced by Turkish pottery reaching them through the port of Venice, in much the same way as Ottoman textiles influenced European and especially Venetian production. The range of designs is incredibly wide, and yet the notion of a "set" of matching plates or bowls appears to be completely lacking. Among the literally thousands of İznik wares spread among museums and private collections the world over, although it is possible to identify the distinctive products of certain individual workshops from İznik, one almost never encounters two works of identical design. Indeed, it is one of the great paradoxes of İznik production that the mass production of modular tiles for wall decoration through the use of pounced drawings was a common practice, but the same method was rarely, if ever, applied to pottery wares. Only one design feature became virtually universal over the last third of the sixteenth century and later: the heavily stylized wave-and-foam border of tight black-line spirals separated at intervals by a host of arbitrary shapes in blue outline.

The distinction between the magical sixteenth century and the decadent seventeenth has become almost a cliché in dealing with the history of Ottoman art. It is now recognized that throughout the seventeenth century and into the eighteenth the Ottoman classical style established under Süleyman I and his successors lived on, as evidenced by works of high quality and great originality in architecture, miniature painting, carpets, textiles, and ceramics. However, beginning around the year 1610, there is a perceptible decline in both the artistic and technical quality of Ottoman revetment tiles, paralleled by a similar decline in pottery wares. The most ambitious revetment project of the seventeenth century, the tiling of the Mosque of Ahmed I in İstanbul around the year 1616, relied heavily on the reuse of revetment panels created during the last third of the

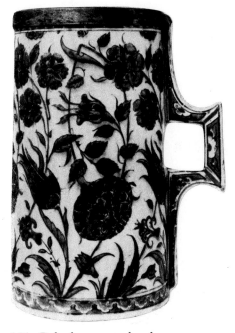

165. Polychrome jug with stylized cloud decoration; ca. 1575. (Sèvres, Musée National de Céramique, 16341)

166. Polychrome tankard; ca. 1580–90. (Paris, Louvre, 6323)

plate 12 (pp. 112–13); ills. 56–58

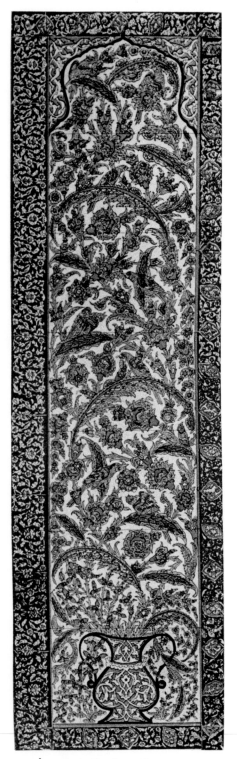

167. İstanbul, Topkapı Sarayı,
Bağdad Köşkü: blue, turquoise,
and white panels with *hatayi*
designs; ca. 1637.

preceding century. The inability of the İznik ateliers to fill the huge orders for modular mass-produced tiles for the vast building forced a reliance on the less experienced potters of Kütahya, who produced tiles virtually identical in design to those of İznik, but of an inferior technical quality. As a result, the decorations of this impressive monument are uneven in quality, ranging from the greatest brilliance to flawed and dull tiles with hackneyed designs, carelessly executed with inferior materials and carelessly fired. The practice of reusing earlier tile panels, already established in the preceding century, results in the Mosque of Ahmed I in a disunity strikingly similar to that of the Mosque of Rüstem Paşa; as in the earlier building, the varying decorations are unified in part by a characteristic border used throughout the building.

In the fourth decade of the seventeenth century Murad IV, fresh from new military triumphs in the east and south, sought to revive the glories of the classical *hatayi* style exemplified in the Sünnet Odası tiles. He commissioned blue-and-white tile decorations for the pavilion in the Topkapı Sarayı, which he built in 1637 to commemorate his conquest of Baghdad. While patently an attempt to copy the Sünnet Odası tiles, these later compositions follow the established practice of using numbers of standard square tiles to form a field rather than the single great slabs of tile used eighty years before. The result, while an ambitious attempt, is disappointing. The gross quality of the drawing, with its peremptory treatment of texture, is further flawed by unevenness in firing and a pronounced running of the colors into the glaze. The tiles of the Bağdad Köşkü demonstrate the continuing influence of the classical Ottoman style, but they lack the creative force and the *nakkaş*'s pride of meticulous detail. They represent the work of humble artisans laboring to create a royal commission for which they were ill qualified.

The reasons for this decline in the quality of İznik production are many and complex, in part paralleling a general breakdown of institutions in the Ottoman Empire due to political causes. One important reason for the İznik decline was certainly economic in nature. A massive inflation in prices, which swept over Europe in the sixteenth century, began to affect the Ottoman Empire by the end of the century. It undermined the system of fixed prices for artistic products, among them tiles, established by royal decree many decades before. The palace in İstanbul was paying the same price per tile for the decorations of the Mosque of Sultan Ahmed in the year 1616 that it had paid for those of the Mosque of Süleyman in 1559, although the costs of production had risen. The artisans of İznik preferred to produce wares that they could export or sell on the free market at higher prices. It appears that every court commission for tiles set at the old prices forced the İznik kilns closer and closer to bankruptcy and definitely prompted a decline in the quality of the ceramics produced. Royal *fermans* (edicts) issued in the latter part of the sixteenth century and into the seventeenth attest to the great difficulty encountered by the sultans in getting the İznik artisans to abandon their profitable work for the free market in order to produce tiles on royal commissions at prices pegged to an artificially low standard.

One other possible cause of the decline may have been some disaster at İznik, whether a catastrophic fire, always possible within the complex of kilns and the stored masses of fuel, or the long-term but equally grave effect upon the health of craftsmen working with poisonous lead oxides and other potentially dangerous ceramic materials over many years. At any rate, when the Ottoman traveler Evliya Çelebi visited İznik in 1648, he recorded that only a handful of ceramic workshops remained out of the several hundred that had flourished there at the beginning of the century.[10]

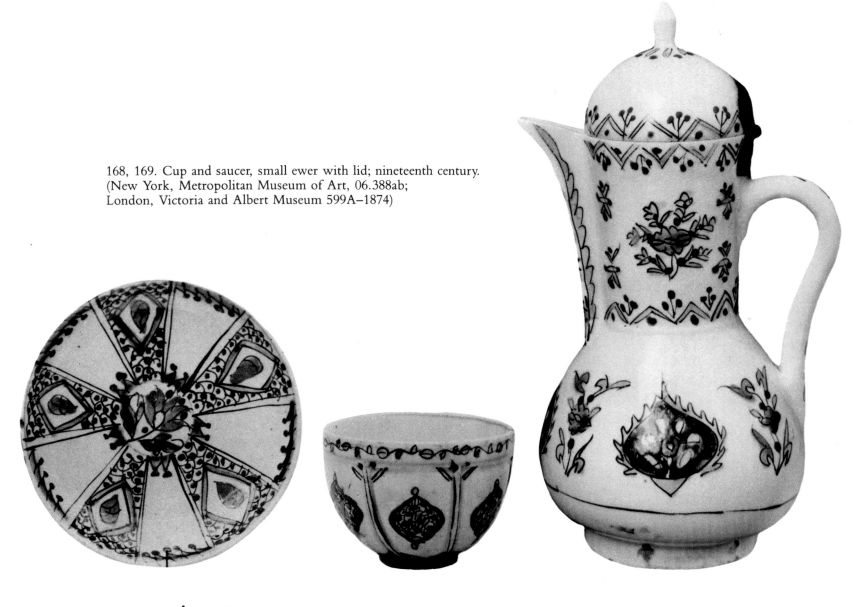

168, 169. Cup and saucer, small ewer with lid; nineteenth century.
(New York, Metropolitan Museum of Art, 06.388ab;
London, Victoria and Albert Museum 599A–1874)

INHERITORS OF THE İZNİK TRADITION

The decline of the İznik ateliers, resulting from declining patronage, a cost-price squeeze, and possibly from other reasons as well, did not mean the end of the great İznik tradition. Provincial centers using the İznik techniques existed in Syria in the sixteenth and seventeenth centuries. And in Anatolia the İznik traditions in part were taken over in the eighteenth and nineteenth centuries by the Armenian potters of Kütahya. These artisans continued to produce a charming variety of small underglaze-painted wares in simple designs often reflecting to a limited extent their İznik forebears and even developed a small production of revetment tiles. These tiles were largely made on commissions from Armenian churches in the Ottoman Empire, most notably the Cathedral of Saint James in Jerusalem, which today is a virtual museum of Kütahya production spanning two centuries. Their largely figural decoration and Christian iconography are, however, far removed stylistically from the İznik legacy. Certain technical developments resulted from Kütahya production, among them an underglaze yellow of great attractiveness, which was used effectively in conjunction with the red color inherited from İznik. The Kütahya pottery was also exported to Europe, and, unlike the İznik production, matching sets of wares were occasionally produced, undoubtedly reflecting European taste.

The potters of Kütahya were ceramic artisans only, lacking the important collaboration with the *nakkaş* which often raised İznik ceramics from the status of decorative

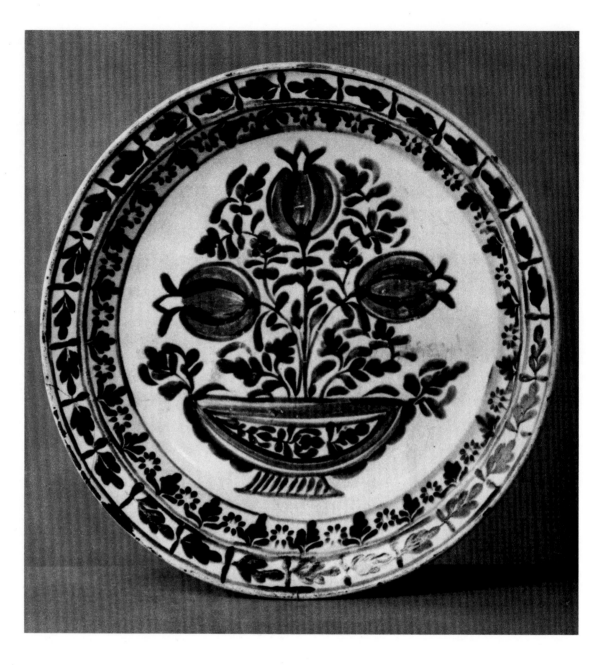

170. Plate with slip-painted decoration of flowers; nineteenth century. (London, Victoria and Albert Museum, 879–1884)

objects to that of great paintings on ceramic. Without a court patronage, the Kütahya tradition produced in the main what might be called "middle-class" pottery, charming and often original in its decoration, but falling in the realm of everyday utility.

In the early eighteenth century the Ottoman court under Ahmed III and his ambitious son-in-law and grand vezir, Nevşehirli İbrahim Paşa, attempted to revive the production of İznik by moving the few remaining artisans to a site near the Byzantine palace of Tekfur Sarayı on the walls of İstanbul above the Golden Horn. The Tekfur Sarayı production, while never of the volume or the technical quality of İznik production in its heyday, resulted in some attractive ceramic revetments in yet another revival of the classical style of the second half of the sixteenth century. The revival extended through all of the arts. The neoclassical Mosque of Hekimoğlu Ali Paşa, completed by an Ottoman notable in İstanbul in 1733, is perhaps the best representative of the revival. It is lavishly tiled with panels recalling the great days of the later sixteenth century. In the remarkable depiction of Mecca painted in underglaze colors including a bright yellow, and found near the mihrab of the mosque, the influence of European perspective is

plate 48 (pp. 274–75)

seen in an accurate aerial view of the Kaaba and its enclosure. Another great achievement of the Tekfur Sarayı artisans is the large *ocak* (tiled fireplace) dated 1731, in the Victoria and Albert Museum. The Tekfur Sarayı revival, however, remained precisely that—a backward-looking movement reflecting an earlier time, an attempt to bring back the past cultural glories of the empire in a period when they could not endure in the face of both political and economic realities and the growing influence of European traditions on Ottoman art and architecture.

The influence of İznik continued, however, in traditions outside the Ottoman cultural sphere, beginning in Italy with the impact of the Turkish wares on majolica production and finding appreciation in the northwest Iranian pottery of the seventeenth century known as "Kubatchi ware." This ware, now thought to have been produced under Safavid patronage near the city of Tabriz, incorporated the underglaze techniques of İznik, including the red color and the black line, into a variety of interesting, if technically rather mediocre, vessels and wares often reflecting traditions of miniature painting then current in the Safavid capital of Isfahan. Also in the Balkans, itinerant potters from İznik evidently produced local imitations of İznik tile decoration for a castle in Transylvania.[11]

The decline of the İznik workshops undoubtedly diffused the style and technique over large parts of the Ottoman Empire, even leading in the later seventeenth century to a small and rather poor-quality production on the island of Rhodes. The designs made famous by the İznik potters, especially the tulips, carnations, and other flowers, not only continued to be an important part of the tradition of Turkish textiles and rug weaving, but made an enduring impression on the folk art of Turkish villages, where even today humble village rugs and embroideries and simple painted decorations on village houses and mosques still show, albeit sometimes in barely recognizable form, the designs and motifs of the great age of the sixteenth century.

The İznik tradition and its inheritors powerfully influenced both metropolitan and provincial traditions for centuries after the Ottoman Empire had entered a long political decline. Yet certain village traditions persisted in the production of simple pottery using neither the expensive materials and techniques nor the court-inspired designs. In the nineteenth century one of these village traditions, centering on the town of Çanakkale on the Dardanelles, gained for a brief period enough attention from both Turkish and Western markets to sustain a fairly high level of production. These ceramics are painted in a limited range of slip colors under a yellowish glaze, and the designs are generally composed of extremely simplified floral forms.

ill. 170

The last inheritors of the İznik tradition are a diffuse group. In the late nineteenth century the French ceramic tradition was affected by exposure to the İznik tiles and wares, which by that time were found in large numbers in museums and in private collections. The French ambassadors to Turkey were among the first avid collectors of İznik ceramics and were even able to remove revetments from important Ottoman mosques and tombs, which subsequently ended up in a variety of European and American collections. In Sèvres, the center of ceramic studies in France, Théodore Deck was able to duplicate technically the İznik wares and published a book in which he outlined his formulas. Inevitably, the European fascination with İznik pottery and the rediscovery of old techniques led to the production of not only imitations but forgeries as well. In the former group belong the works of the distinguished English studio potter William de Morgan, the French ceramist Edmond Lachenal, and the Hungarian Vilmos Zsolnay, and the exquisite Viennese glass in İznik style by Lobmeyr. Most of the latter are

today easily detectable, although a not inconsiderable number have found their way as respectable originals into great museum collections and many are still found in the limbo of the art market. Occasionally forthright imitations, such as those produced by Cantagalli in Florence in the nineteenth century, have had their marks destroyed in order to be made to appear as authentic İznik objects.

In the political turmoil of the early twentieth century, many Armenians from the city of Kütahya fled to Syria and Palestine as refugees, carrying with them traditions of pottery making, which even today continue in Jerusalem. With the advent of the Young Turks and their political control of the Ottoman Empire in 1908, the then-prevailing intellectual doctrines of pan-Turkism and a determined effort to revive once again the styles of bygone ages resulted in a modest revival of the Turanian style in architectural revetments. Underglaze tiles attempted to recreate the *cuerda seca* designs of the fifteenth century. The restoration of early monuments was begun in Bursa in the late nineteenth century by the Frenchman Léon Parvillée, a disciple of Viollet-le-Duc, and resulted in some overenthusiastic reinterpretations of past traditions common to the period. Some restoration was undertaken with the use of imitation tiles made to order in France, but more frequently tile panels in old monuments were repaired by the "patchwork" method of filling in blank spaces with whatever sort of tile was available, regardless of period, design, or origin. This very naïve and unfortunate "restoration," frequently carried on without adequate documentary or photographic records, has created numerous problems for historians of art, in some cases casting considerable doubt on the relationships between the date of a building and the date of its tile revetments.

In Turkey today the Kütahya production continues, incorporating a variety of Ottoman, Moorish, and calligraphic decorations into products ranging widely in quality and attractiveness. The unselective application of motifs in pastiches of earlier designs, which is encountered in the bulk of contemporary Kütahya production, does little credit to the older tradition. But in recent years some of the Kütahya manufactories have revealed a greater consciousness of the rules of propriety implicit in the sixteenth-century production, instead of a reliance on the more ephemeral demands of touristic taste. And in İstanbul the research carried on by a few talented potters has begun to result in a very small number of excellent contemporary reproductions of sixteenth-century wares, of which those signed by Faik are the best.

Conclusion

To sum up the achievements of the Turkish ceramic tradition is a difficult task. They were complex and diverse and must be viewed in a multitude of contexts. It seems appropriate to characterize the Turkish tradition—and especially that of İznik—as one of the great periods in the history of ceramic production, both from the size and scale of the output and from the technical and aesthetic qualities embodied in the bulk of this output. Always sought by collectors throughout the world, and even in our time exerting a powerful influence on decorative arts in many cultures, Turkish ceramics represent an almost perfect marriage of the capabilities of artist and artisan, mutually reinforcing each other. Moreover, Turkish ceramic art reached great heights in congruence with the maximum political and economic strength and cultural development of

an enlightened patron class. The end results, observable in museums all over the world and above all in the monuments and museums of İstanbul, are an enduring testament to the magnitude and appeal of this major artistic tradition.

Notes

1. Expanded lists of tiled Seljuk monuments in Anatolia are to be found in Tahsin Öz, *Turkish Ceramics* (Ankara, n.d.), pp. 5–6; and in Oktay Aslanapa, *Türkische Fliesen und Keramik in Anatolien* (İstanbul, 1965), pp. 11–27.

2. Katharina Otto-Dorn, *Türkische Keramik* (Ankara, 1957), pp. 45–58. Professor Otto-Dorn discusses the very limited finds of pottery wares in Anatolia as well as the limited numbers of decorative tiles in polychrome techniques excavated at Kubadabad, Aspendos, and Alanya on the sites of Seljuk secular buildings.

3. The development of scholarship on Turkish ceramics of the Ottoman period is discussed by Arthur Lane in "The Ottoman Pottery of Isnik," *Ars Orientalis* 2 (1957): 247–81; Oktay Aslanapa's excavations at İznik brought the so-called Miletus ceramics into the İznik orbit (Aslanapa, *Türkische Fliesen*, pp. 29–32).

4. See Aslanapa, *Türkische Fliesen*, for a report on the İznik excavations and a catalogue of the ceramics found.

5. The complex problems surrounding the early blue-and-white Ottoman underglaze revetments are discussed by John Carswell in "Six Tiles," in *Islamic Art in the Metropolitan Museum of Art*, ed. Richard Ettinghausen (New York, 1972), pp. 99–124.

6. Carswell's theory is expounded in *Kütahya Tiles and Pottery from the Armenian Cathedral of St. James, Jerusalem* (Oxford, 1972), vol. 2.

7. Both plates and their Chinese prototypes are discussed in John A. Pope, "Chinese Influences on İznik Pottery: A Re-examination of an Old Problem," in *Islamic Art in the Metropolitan Museum of Art*, pp. 125–39.

8. For a discussion of this controversial monument see Walter B. Denny, *The Ceramics of the Mosque of Rüstem Pasha and the Environment of Change* (New York, 1977), pp. 114–22 and 219–22.

9. The documents have been published by the Turkish economic historian Ömer Lütfi Barkan in *Süleymaniye Cami ve İmareti İnşaatı* (Ankara, 1972), p. 18, and are paraphrased in translation by Öz, *Turkish Ceramics*, p. 29.

10. See the important translations (into German) of this and other documents by R. Anhegger in Katharina Otto-Dorn, *Das Islamische İznik* (Berlin, 1941), pp. 165–95.

11. See Veronica Gervers-Molnár, "A Sárospataki Bokályos Ház," *Folia Archaeologica* 22 (1971): 183–217, including an English résumé, "The Tiled House at Sárospatak" (Hungarian National Museum, Budapest).

Rugs and Textiles

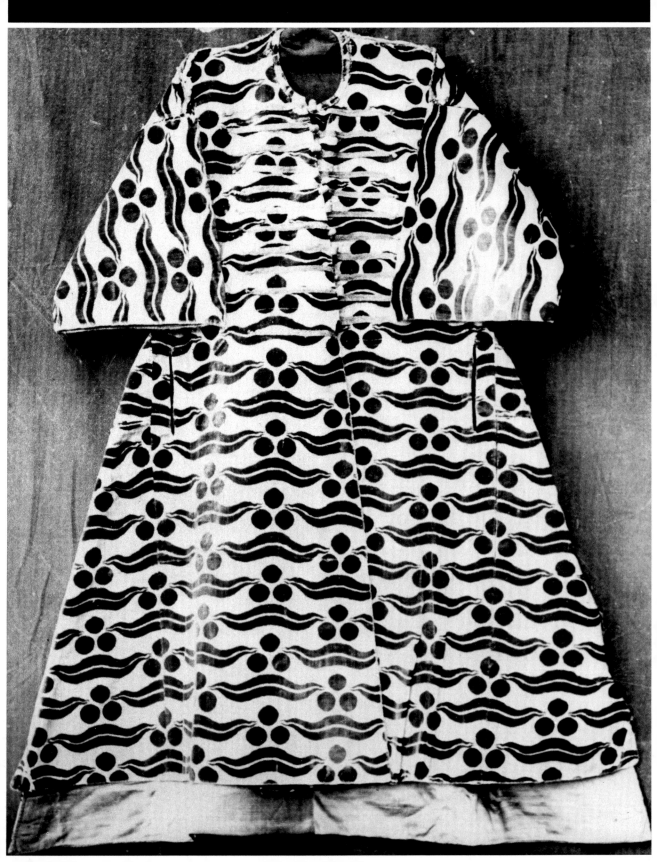

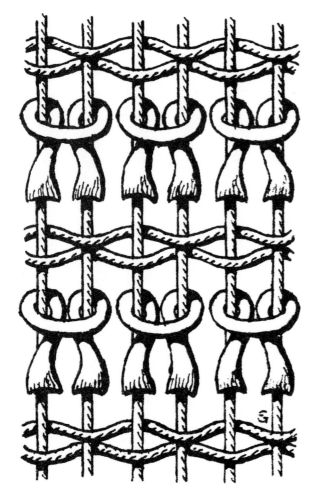 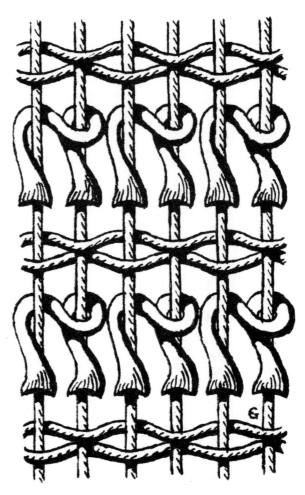

171. *Left:* Symmetrical rug knot (Gördes or Turkish).
Right: Asymmetrical rug knot (Senneh or Persian).

HOW CAN ANY fabric survive for hundreds of years? Neither the individual fiber nor the woven textile has innate properties to protect it. Woven fabrics do not have qualities comparable to stone and brick that can endure harsh weather for centuries; nor can they receive treatment comparable to the application of a glaze over a painted ceramic plate to protect the colorful design and pottery body.

Perhaps a fabric's only inherent protection is a proper correlation of the fiber content and woven structure with its intended function. A completed fabric serves as a cover, either as clothing or furnishing, to provide protection from the harsh elements during cold winters and hot summers.

A very successful example of this vital balance is the knotted-pile rug made with wool. It was developed at least 2,500 years ago and used primarily as a ground or floor cover. The woolen pile is soft underfoot and has physical properties and resiliency to endure years of abrasion before wearing out. The knotted pile also offers the visual advantage of being able to display a variety of colors in fashionable patterns. The oldest known sizable example, excavated at Pazyryk in Siberia and attributed to the fifth century B.C.,[1] has the same woven structure and symmetrical knot (often called Gördes, ill. 171 Ghiordes, or Turkish knot) that has been used in Turkey during the last 700 years.

A comparable balance of fiber, structure, and function is evident in the use of silk-velvet fabrics for cushion covers that would be leaned against and sat upon on divans. ill. 207 The velvet pile could withstand more abrasion than other types of patterned silk fabrics. Most of the Turkish fabrics known today have survived in their country of origin, the silk kaftans through careful planning, the rugs through fortuitous circumstances. Most of the examples in Western collections were exported shortly after they were woven, and a few of these were treasured enough to have survived several hundred years.

Most of the rugs and silks come from two different traditions, a folk-art tradition and a court tradition, yet both display bold designs and rich colors. The two traditions can be clearly identified by the style of drawing—the angular style of the folk art and the curvilinear style of the Ottoman court—and by the use of specific shades of color. These two traditions, however, had different long-range effects on the woven fabrics. Those influenced by the court, the silks and only a few rugs, reflect the height of the Ottoman court's artistic production as well as the ensuing years of decline, whereas those influenced by the continuous folk-art traditions, the rugs, were able to retain their quality and visual strength for a considerably longer period of time.

Rugs

The present knowledge about Turkish rugs is primarily dependent on the proportionately few examples that have survived several hundred years, usually in mosques in

Turkey or in collections in Europe where they were greatly admired. While they have long delighted the eyes of beholders, the rugs themselves shed little light on their age or place of manufacture. Numerous questions arise in studying rugs woven over a span of 700 years in an area where weaving the same pattern for several generations was a time-honored tradition. Only slowly are some of the problems being resolved.

Most Turkish rugs are characterized by bold drawing and bright colors that form a pattern whose infinite nature is contained only by the presence of a framing border. The repetition of the pattern unit is an integral part of weaving, and one that the Turkish rug designers understood and used to full advantage. The pattern units flow one into another to become infinite. The pattern repeats do not suffer from awkward spacing or from minor motifs ending in primary locations. The angular style of drawing that dominates most Turkish rugs complements the woven structure of the rug, which is, after all, composed of vertical and horizontal elements. The weavers throughout Anatolia used the same woven structure with remarkable consistency over many centuries.[2] Their woolen rugs are well woven and typically have between fifty and ninety symmetrical knots per square inch. The weavers used the knot count appropriate to achieve the desired visual effect. Had they wished to produce rugs with delicate patterns, which require at least twice as many knots, they could most likely have done so. For example, many of the rugs woven in Gördes have more than 200 symmetrical

ill. 195

knots per square inch forming very detailed patterns.

Since the style of drawing, regardless of the source of the pattern, in probably ninety-nine percent of all classical Turkish rugs was part of a folk-art tradition, there are no comparative artistic sources to assist with dating them. In contrast, the Ottoman rugs, which account for probably no more than one percent of all rugs woven in Turkey, are the only rugs with curvilinear patterns and a style of drawing closely related to the art of the Ottoman court, and they are therefore the only rugs that can be compared stylistically with Ottoman art for purposes of dating. All the other rugs, which means almost all Turkish rugs, must depend on other sources for dating and provenance attributions.

ill. 177

The most valuable documents currently available for dating Turkish rugs are European paintings. The earliest representation of a rug confirms that the pattern shown was being woven by that date. As early as the fourteenth century, "Turkey Carpets" were exported to Europe, where they were held in such high regard that they were frequently depicted in paintings under the throne of the Madonna and Child. With the advent of genre painting during the fifteenth century the various uses of "Turkey Carpets" by Europeans become increasingly apparent, as floor covers as well as fashionable table covers. They are even shown being aired out over balconies.

Some Turkish rugs were copied in Europe, either as rugs or as embroideries, and those that can be securely dated, usually by means of identifiable coats of arms, provide additional documentation. A third European source still needing extensive research consists of inventories that list quantities of "Turkey Carpets." The available information sheds little light on the imported patterns, sizes, costs, places of manufacture, or trade conditions. Although most of the rugs imported to Europe were woven in Turkey, the term "Turkey Carpet" was also used as a catchall for other rugs woven in the Near and Middle East.

It is unfortunate that Turkish sources currently contribute little information to the study of classical rugs. Even the Ottoman court paintings, which have been shown to depict faithfully specific buildings and historical events, only rarely document actual

rugs. Most rug patterns portrayed are merely cursory sketches of large medallion patterns.

ills. 70, 96, 98

It remains unknown whether the Turkish archives contain valuable information, yet to be gleaned, about rug-weaving centers, specific patterns, and trade conditions as well as wool, dyeing, and weaving guilds. As will be discussed later, the archives have yielded significant details about the silk industry owing to its vital role in the Ottoman economy. Wool, on the other hand, was probably little more than a local concern for the rug weavers (and garment weavers) and therefore was mentioned less frequently.

The paucity of documentation about the locations in which rugs have been woven since the thirteenth century has caused scholars to base some attributions, such as Bergama, on somewhat similar patterns woven in that area during the twentieth century. While these observations are valuable, they should not be relied upon for the precise provenance of rugs woven many centuries earlier. As a result of this lack of information, it is not known where many of the classical rugs were woven.

ill. 186

Despite the importance of the representation of Turkish rugs in European paintings, comparatively few rug patterns were actually recorded. Some of the patterns depicted have not survived as rugs, and conversely some of the rugs that have been treasured in Europe for several centuries have patterns not represented in European paintings. Certainly only a small fraction of the many thousands of exported "Turkey Carpets" survive today. But even the exported rugs are believed to represent only a small percentage of the total rug-weaving production in Turkey. Export trade has certain prerequisites. Not only must the weaving center be located in an area accessible to the trade routes, but it must also be of sufficient size to supply the needs of the local inhabitants as well as the export trade. These basic requirements would automatically eliminate the many rugs woven by nomadic tribes and by villagers in remote regions, especially in eastern Anatolia, whose historic rug-weaving tradition remains little known. The many types of rugs that were woven in Turkey but were not exported to Europe are virtually unknown outside Turkey. An astonishing range of patterns can be seen among the rugs in two museums in İstanbul that contain by far the largest and most comprehensive collections of Turkish rugs in the world.

As early as 1914 the Evkaf Müzesi in İstanbul, today called the Türk ve İslam Eserleri Müzesi (Turkish and Islamic Arts Museum), gathered old rugs from mosques throughout Turkey where circumstances occasionally made their survival possible—although often in a somewhat ragged and worn condition—as "padding" under more recently acquired rugs. The original collection of about 700 rugs has doubled in number over the decades. In addition to this great collection the recently established Vakıflar Müzesi (Museum of Pious Foundations) in İstanbul is also dedicated to continuing the search for old rugs in order to preserve, study, and display them. Within these two museums are rugs containing many of the little-known clues to the variety of patterns and the development of stylistic variations in rugs woven in Turkey since the thirteenth century.

THIRTEENTH AND FOURTEENTH CENTURIES: KONYA RUGS

In the history of rugs, the so-called Konya rugs are of special importance; they are the oldest surviving Islamic knotted rugs. The Konya rugs, sometimes inaccurately called Seljuk rugs, are composed of two finds comprising three very large rugs and eight fragments.[3] In 1905 F. R. Martin recognized the importance of several rugs in a dark corner in the principal mosque of the Seljuks, the Alaeddin Mosque in Konya. They consist

plate 50 (p. 325); ill. 172

ill. 6

of three very large, though damaged, rugs and five fragments, now in the Türk ve İslam Eserleri Müzesi.

The second lot of three fragments and several later rugs was discovered in the Eşref-oğlu Mosque in Beyşehir located about fifty miles southwest of Konya. They are in the Mevlana Müzesi in Konya, except for a fragment in the Keir Collection in London. When the mosque was built in 1298, was it appointed with all new rugs that would provide a *terminus ante quem*?

Several distinctive features characterize the Konya rugs. Although some of them are extremely large, the field patterns are composed of one small, usually angular motif repeated in staggered rows. The small motif is isolated in five of the rugs, which is a highly unusual feature in the long history of Turkish rugs. Latticework or linear extensions connect the motifs on the other four rugs, one of which survives in two different color renditions.

The small motifs in the field pattern are in marked contrast to the monumental scale of the main border patterns, which display either very large pseudo-kufic or huge stars. The only visual correlation between the field and border patterns appears to be the use of the same limited color range: two shades of red (medium and dark), two shades of blue (medium and dark), yellow, brown, and ivory.

The subtle and specific use of two tones of the same color is an especially noteworthy feature of the Konya rugs, which does not occur in later Turkish rugs. Frequently one tone forms the pattern and the other the ground, such as pale red on deep red or vice versa, or medium blue on deep blue. Often a second color outlines the motif or forms a minor interior design. Occasionally a third color is present.

The marked juxtaposition of small- and large-scale patterns, which is an enigmatic feature of these rugs, also appears in the one other medium of sufficient size for its development, architecture. The quality of the patterns, however, is much finer than in the rugs. The concept of small-scale patterning in the field surrounded by a strikingly monumental border pattern such as pseudo-kufic appears in the tympanum of the Hospital at Divriği, built in 1228–29. Relatively small patterning and immense interlacing knots dominate the entrance facade of the İnce Minareli Medrese (literally, theological school with a slender minaret) in Konya, dating from the third quarter of the thirteenth century.

Although inexplicably small, the field patterns with connected motifs in the Konya rugs can be associated with Turkish patterning. The drawing of most of the patterns with isolated motifs, however, appears foreign. Indeed, the asymmetrical motif in one of the rugs was derived from a cloud in a Chinese silk damask woven during the Yüan dynasty (1279–1368),[4] fragments of which have been excavated in Egypt. The curvilinear Chinese cloud form in the Yüan silk damask has been appropriately stylized to complement the coarser weaving in the rug. Even in its simplification, the motif in the rug shows the same movement of the "tail" of the cloud, with the identical number of "steps" up and down. In addition, the size of the motif, staggered placement, and successive rows facing in opposite directions all contribute to an unquestionable stylistic dependence upon a Yüan silk damask.

The Yüan damask fragments with this cloud pattern excavated in Upper Egypt together with silks bearing the name of the Mamluk sultan, Muhammed al-Nasir ibn Kalaun (1309–41), confirm the presence of the damasks in the Near East. Their fashion in Egypt during the first half of the fourteenth century is also indicated by Egyptian versions of the Yüan damasks. The Konya rug shows that the vogue also extended into

ill. 172

plate 50 (p. 325)

plate 3 (pp. 64–65); ill. 3

ill. 172
ill. 173

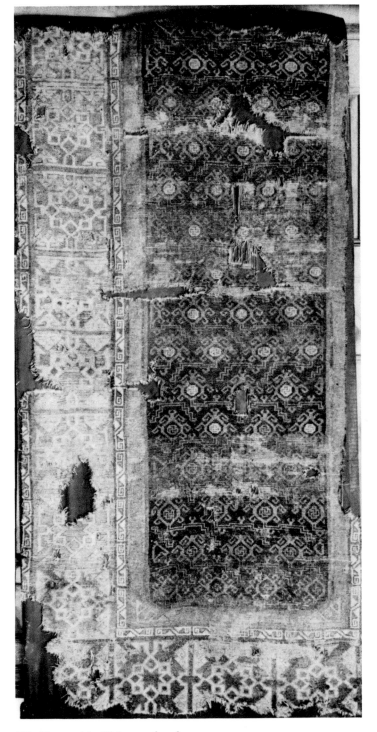

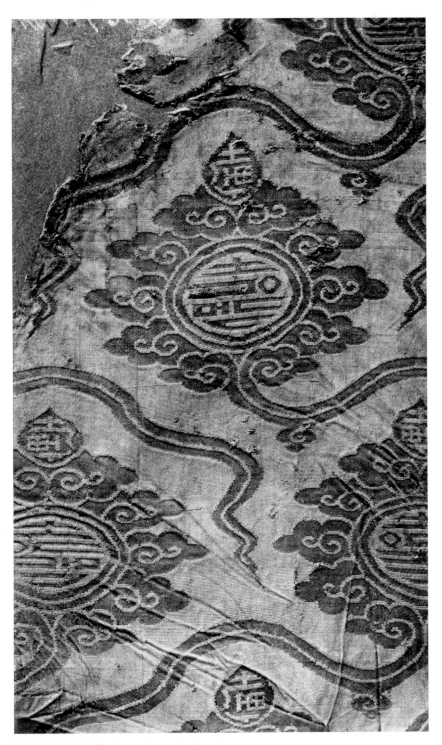

172. Rug with Chinese cloud pattern,
found in the Alaeddin Cami, Konya;
late thirteenth century or early fourteenth century.
(İstanbul, Türk ve İslam Eserleri Müzesi, 688)

173. Chinese silk damask with cloud pattern;
Yüan dynasty (1279–1368). (New York,
Metropolitan Museum of Art, 46.156.20)

Turkey, and a comparable date can be proposed for the rug. The isolated motifs in three other Konya rugs can also be compared in general terms with this and other Yüan damasks. The Yüan damasks have also been identified as being the models for the use of two tones of one color in the Konya rugs.[5] Although most damasks are woven with only one color, the pattern appears either lighter or darker than the ground owing to the sheen produced by the different directions of the pattern and ground fibers. These Yüan silk damasks are usually either red or blue, the very colors that dominate in the Konya rugs.

Unfortunately neither the circumstances under which the rugs were woven nor where or when are known. A few travelers' descriptions are the only available documents that refer to rugs in Turkey during the thirteenth century. Ibn Said (died 1274) was quoted by Abu'l-Fida as mentioning beautiful rugs woven in Aksara (Aksaray) and stating that rugs were made in Asia Minor that were "exported to all countries."[6] No evidence has been found, however, in the archives or in European paintings to suggest that these rugs were exported to Europe.[7] Konya rugs were, however, exported to Egypt, where small fragments have been reported to have been excavated at Fustat, which served as the refuse area for Cairo by the thirteenth century. The fragments have patterns, colors, and technique closely related to the Konya rugs.[8]

On his return from China by way of Iran, Marco Polo traveled across Asia Minor in 1271–72 and recorded that "they weave the finest and handsomest carpets in the world."[9] Was he referring to the style and quality of the Konya rugs or to considerably finer rugs that have not survived? Disagreement prevails. Had Marco Polo seen rugs in China and Iran before arriving in Anatolia? In China he visited Karakorum, where a workshop is said to have been established in 1262 to manufacture rugs for the Chinese imperial court in Peking. Nothing survives. Unfortunately knowledge about thirteenth-century Iranian rugs is lacking. If the Konya rugs are the quality of rug Marco Polo was praising, perhaps the Seljuk court did not have a manufactory for rugs. Would not the best rugs have been used in the principal Seljuk mosque, the Alaeddin Mosque, where most of the Konya rugs were discovered?

The simple angular drawing of the patterns in the Konya rugs lacks the sophistication of the refined curvilinear style that characterizes most of the art produced by or for the Seljuk court. Simple patterns are presented directly without secondary motifs or additional levels of design. The color palette is limited. The rugs are relatively coarse, with only thirty-six to fifty symmetrical knots per square inch. The large size of several of the rugs, the largest being 2.58 meters wide by 5.50 meters long, suggests that they were woven in an organized manufactory, probably on upright looms, located possibly in Konya. Several features of the rugs—the patterns, colors, and knot count—cause them to be viewed as a group that remains apart from the mainstream of Turkish rugs. As such, they are usually dated together. The one rug whose pattern was copied from a Yüan damask can be quite securely attributed to the first half of the fourteenth century, if not slightly earlier, as can three other rugs with related motifs. These four rugs probably provide the firmest ground on which to attribute the Konya rugs to the late thirteenth and first half of the fourteenth centuries.

Although the rugs do not have any features to associate them with the Seljuk court, the dependence of the patterns in several of the rugs on Yüan silk damasks from China may be of special significance. Clearly, the silks were sufficiently admired to be imitated. Whether Yüan damasks were in the Konya area cannot be confirmed. However, certainly the exact patterns and the specific use of color tones were available for the

weavers to copy. Although these rugs with Chinese motifs do not display the sophistication of the court art, they may well have contributed to the standards of the court through the age-old prestige associated with things foreign.

FOURTEENTH AND FIFTEENTH CENTURIES: ANIMAL RUGS

The colorful patterns of the newly imported "Turkey Carpets" as well as their useful function as warm and soft floor covers caused them to be highly desired by Europeans. As has been mentioned, European painters during the fourteenth and fifteenth centuries included them in their most sacred paintings—the Annunciation and the Madonna and Child—which today provide the primary source for reconstructing the rug production of this period.[10]

The rugs depicted in the paintings frequently display single or confronted animals, usually within rows of octagons that are sometimes framed by squares. Many of these rugs, however, have stylistic features not readily associated with the character of Turkish rugs. Since only three contemporary fragments of ample size have survived, the provenance of the rugs depicted in the paintings, some of which may not even be knotted-pile rugs, cannot be resolved easily.

In the earliest of these animal fragments, attributed to about 1400, two stylized red birds on an ivory ground flank a central tree whose foliage is reflected in mirror image at the bottom, replacing the roots. The octagonal frame has a reciprocal pattern of "latch hooks" and is contained within a square. Stylized leaves form the border stripes. Although this fragment is the full width of the rug (both selvages are present), it has been cut across the center and therefore could have been a long runner, a shape that is exceptionally rare among classical rugs. This rug is known as the Marby rug, named after the church in Sweden where it was found.

ill. 174

The second related fragment, also with only two panels, displays an animal combat.[11] On a deep yellow ground, a stylized blue phoenix attacks a blue dragon. Although the two animals are motifs that were adopted from the Far East, their symbolism was altered in the Islamic West to represent a combatant world in which the phoenix symbolizes the overworld fighting the dragon of the underworld. The closest representation of a similar rug was painted by Domenico di Bartolo in *The Wedding of the Foundlings*, dated 1440–44. The German art historian Ernst Kühnel mentioned cautiously that artistic license had been taken in the drawing of the border and the corner brackets;[12] however, a close parallel for the brackets exists in a tiny fragment with the same animal combat and layout, excavated at Fustat.[13] Possibly a model for the border will also be found.

ill. 175

A third and different type of animal pattern displaying rows of stylized birds alternating with rows of small diamonds was painted by the Spanish artist Jaume Huguet in *Madonna Enthroned* in 1455–56.[14] The only known Turkish rug with a similar pattern has been attributed to a later date owing to its stylistic variations.

The representation of rugs with large animal patterns in paintings is limited to the brief period of the fourteenth and early fifteenth centuries. Just as several of the patterns in the Konya rugs were derived from those in silk fabrics, the animal patterns in these rugs were probably stylized versions of animals within roundels in other mediums, again possibly silks. Were the silks Turkish? Unfortunately only one extant silk with animals can be positively associated with the Turks. Silks with animal patterns had been fashionable for centuries in the Islamic Near East and Byzantium, and, eventually, also in

ill. 198

Europe. Rugs with animal patterns might therefore have enjoyed a similar vogue.

The scope of the animal rug production must be considered in the light of the representation of an animal rug in an Iranian miniature, "Zahhak Enthroned" from a *Shahname* painted about 1330.[15] The rug depicted shows single quadrupeds within octagons. Since no Iranian rugs exist from the fourteenth century and the details in the rug are similar to those in Turkish animal rugs, it must be asked whether a Turkish rug was the model for the rug in the Iranian painting. It is more likely, however, that animal rugs were woven in both Turkey and Iran and that the style developed from a common source, as is also suspected with the geometric patterns soon to be discussed.

Although evidence is lacking, it is believed that most of the rugs woven in Turkey during the fourteenth and early fifteenth centuries had nonfigural patterns. There are a few rugs in İstanbul whose interlacing patterns, colors, and physical appearance suggest that they may have been woven during this time,[16] but no documents exist to

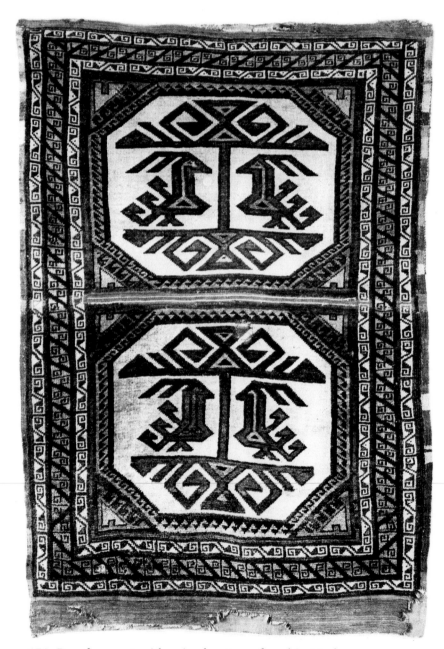

174. Rug fragment with animal pattern, found in Marby church, Jämtland, Sweden; late fourteenth century or early fifteenth century. (Stockholm, Statens Historiska Museum, 4445/63)

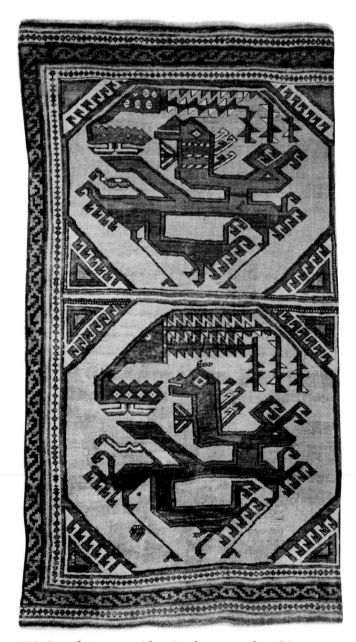

175. Rug fragment with animal pattern, found in a church in central Italy; late fourteenth century or early fifteenth century. (East Berlin, Staatliche Museen zu Berlin, Islamisches Museum, I.4)

confirm the suspicion. Undue emphasis appears to have been given to the animal rugs in light of their frequent representation in European paintings. Their popularity in the West can be understood through Westerners' traditional preference for animated patterns, whereas in Turkey, the subtle qualities of geometric and foliate patterns have long been favored and dominated the artistic production from the thirteenth century through the present day.

FIFTEENTH AND SIXTEENTH CENTURIES: GEOMETRIC PATTERNS

There is considerable European evidence to indicate that large quantities of "Turkey Carpets" were exported to Europe from the fifteenth century on. This suggests not only a prolific rug production in Turkey but also favorable export conditions and trade routes. The rugs were transported to the seaports of Anatolia, from where they were sent by ship to European ports.

The patterns of several Turkish rugs were copied in Europe, especially in Alcaraz, Spain, by the Mudejars (Muslims living in areas ruled by Christians) and in as yet unidentified areas in northern and southern Europe. The primary source for dating the Turkish rug patterns is still the depiction of rugs by European painters; the length of time certain patterns were portrayed tentatively suggests the duration of manufacture and export of those specific patterns.

The fifteenth-century geometric rug patterns are considerably more complex than the patterns in the earlier rugs, and they often have several more colors. The patterns no longer exist on one plane but have interlacing outlines, swirling stars, and overlapping design motifs that result in the introduction of a second plane, and, in some cases, a second level of design.

For reasons unknown the names of Hans Holbein the Younger (ca. 1497–1543) and Lorenzo Lotto (ca. 1480–1556) are traditionally associated with specific rug patterns, although neither was the first nor the most prolific painter of the respective pattern. Several early fifteenth-century paintings depict presumably Turkish rugs with geometric patterns for which no convincingly early rugs are known. The earliest representation of a geometric pattern for which actual rugs survive is the small-pattern "Holbein," painted in the middle of the fifteenth century. Closely related to the age-old Islamic star-and-cross layout, the small-pattern "Holbein" is composed of rows of octagons with an interlacing outline alternating with rows of crosses formed by an arabesque with split-palmette leaves. Very small octagons bearing stars serve as the interstitial motifs.

plate 51 (p. 326); ill. 176

ill. 180

ill. 176

Several dozen rugs are known with this pattern, and they have more color variations than are generally associated with classical Turkish rugs. The ground may be one color—blue, red, or green—and the octagons either one or two colors. An almost equal number of rugs have two ground colors—red and green or red and blue.[17]

The borders of the small-pattern "Holbein" rugs display variations in their patterns and in the width of the guard stripes (the narrow stripes flanking the main border stripe). Pseudo-kufic may be the most common main border pattern and, judging from depictions by European painters, it became increasingly simplified with time. The most sophisticated rendition of the pseudo-kufic has knotted shafts with foliate finials and appears only in the three earliest depictions of the rug pattern between 1451 and 1460, the earliest of which was painted by Piero della Francesca in the Church of San Francesco in Arezzo.[18] Only two Turkish fragments with this elegant border are known, and only they may be securely attributed to the first half of the fifteenth century.[19] Simplified

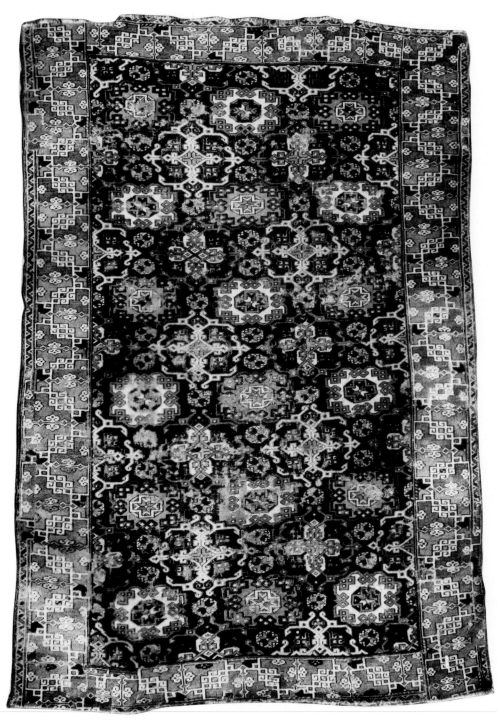

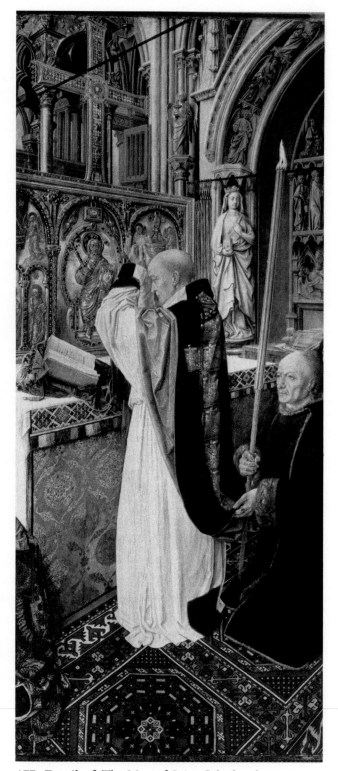

176. Small-pattern "Holbein" rug; first half of sixteenth century. (Washington, D.C., Textile Museum, R34.17.1)

177. Detail of *The Mass of Saint Giles* by the Flemish Master of Saint Giles (ca. 1500) showing a large-pattern "Holbein" rug. (London, National Gallery, 4681)

pseudo-kufic with continuous shafts occurs more frequently in the extant rugs and in the paintings, one of the latest representations being *Somerset House Conference* painted in 1604 by the artist Juan Pantoja de la Cruz.[20]

The widespread popularity of this pattern in Europe is also attested to by copies in rugs and embroideries. Two large rugs survive. One with bright colors and the earliest style pseudo-kufic border pattern was woven by the Mudejars in Alcaraz, Spain, during the mid-fifteenth century.[21] The other was woven in northern Europe and has dark colors, a simplified pseudo-kufic pattern, and the date 1603.[22] Among the several embroideries, five woolen examples have dates ranging between 1533 and 1609.[23]

Rugs with remarkably similar interlacing motifs, layouts, and even color changes were represented in late fourteenth- and fifteenth-century Iranian paintings.[24] Although those rugs were probably woven in Iran and not imported from Turkey, no Iranian rugs survive from that period. If they were indeed Iranian rugs, their similarities with surviving Turkish rugs suggest that the patterns of both Turkish and Iranian rugs came from a common source, probably brought by the Turks from Central Asia. In that area, rugs with closely related layouts, motifs, and even color changes were still being woven by the Türkmen (Turkoman) tribes in the nineteenth century.[25] Their nomadic life-style precluded the survival of their weavings; as a result the oldest Türkmen rugs date only from the early nineteenth or possibly late eighteenth century.

The numerous representations of small-pattern "Holbeins" over a period of about 150 years and the extant rugs themselves, both large and small, confirm that the scale of the pattern and the actual drawing, with only slight spatial variations, remained remarkably constant. This adherence to original patterns over many generations of weavers expresses the honored continuity of designs, a feature characteristic of Turkish rugs that complicates dating attributions. The provenance of these rugs is generally ascribed to Uşak or to central Anatolia.

Another pattern of approximately the same period with strong, rich colors is the large-pattern "Holbein." Several versions are visible in European paintings, but the rarity of actual rugs makes it difficult to confirm their Turkish manufacture.

plate 51 (p. 326)

The primary unit of the large-pattern "Holbein" is a star-octagon-square: a whirling star surrounded by a row of volutes and a row of connected stars and bars all within an octagon that is framed by a square or rectangle. Two different layouts are associated with this pattern. One has a field composed of a vertical arrangement of star-octagon-square units; the other has a field with one star-octagon-square unit alternating usually with two smaller octagons in a 2:1:2 layout.

The simpler version with the 1:1:1 layout probably evolved from the only slightly earlier animal rugs. The pattern was painted as early as 1486 by Carlo Crivelli (1430?–1494?) in *The Annunciation*.[26] An especially beautiful representation, in both its drawing and vivid colors, appears in *The Mass of Saint Giles* painted by the Flemish Master of Saint Giles in about 1500. Classical rugs in this pattern with brilliant colors are exceptionally rare;[27] most are considerably later in date. This pattern was also copied by the Mudejar rug weavers in Alcaraz during the fifteenth century.[28]

ill. 177

The smaller octagons in the second version with the 2:1:2 or 2:1:2:1:2 layout, which probably developed slightly later than the 1:1:1 layout, have either abbreviated renditions of the drawing in the main star-octagon unit, or other patterns such as octagons with an interlacing outline similar to that in the small-pattern "Holbeins." Based on strong stylistic affinities with rugs woven more recently in Bergama, the large-pattern "Holbeins" have been tentatively attributed to that town.

ill. 186

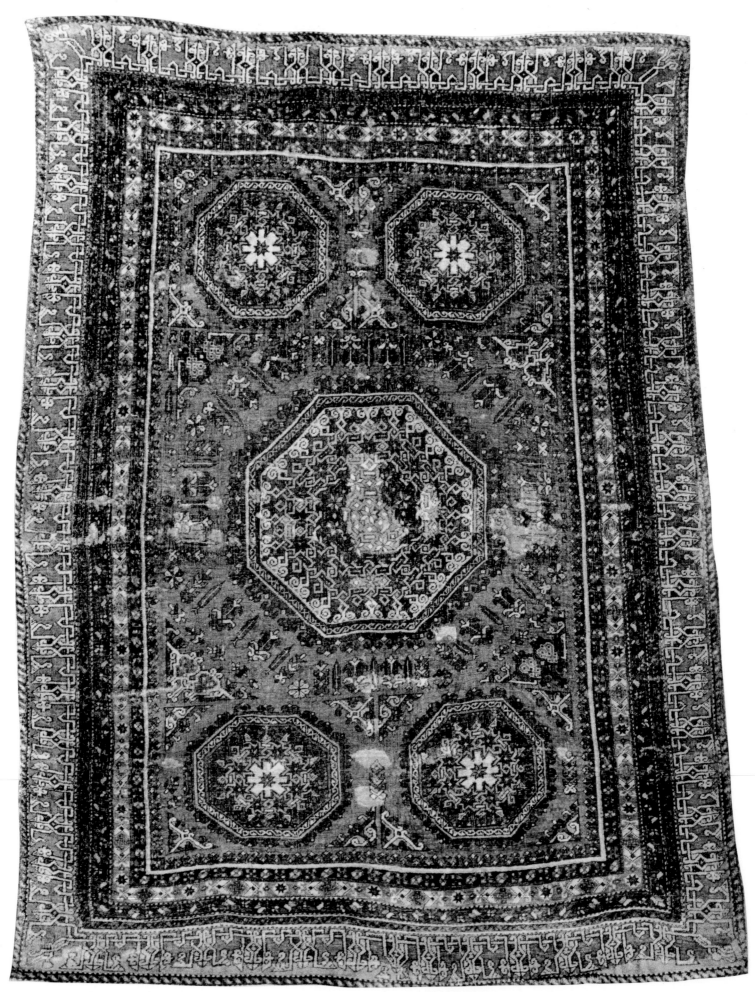

178. Rug with 2:1:2 layout; sixteenth century. (Philadelphia Museum of Art, 55–65–2)

Roughly contemporary with these rugs is a small but unusual group of rugs with a 2:1:2 layout and a similar use of some of the motifs in the star-octagon unit.[29] Their exceptional features include the presence of isolated motifs, probably influenced by late fifteenth-century Mamluk rugs from Cairo, a well-turned corner solution of the pseudo-kufic border pattern, and the use of the asymmetrical knot (also known as the Senneh or Persian knot), which is otherwise unknown in traditional Anatolian rugs. The wool, colors, and use of pseudo-kufic are all Turkish features. This group of rugs was primarily represented in sixteenth-century Italian paintings, such as *The Protho-notary Apostolic Giovanni Giuliano* by Lorenzo Lotto.[30]

Another contemporary rug pattern, the so-called Lotto pattern, previously called a third "Holbein" pattern, has been the most enigmatic. Although these rugs had been in the literature since the end of the last century, the pattern was deciphered only more recently: highly stylized yellow arabesques are arranged in the same octagon and cross layout as in the small-pattern "Holbein."[31]

ills. 179, 180

Despite drawing variations, the use of color remains surprisingly consistent: yellow arabesques with bright blue highlights pattern a red ground. Among the many main border patterns are pseudo-kufic, cloud-bands, flowers and vines, and cartouches, which in some examples display well-turned corner solutions, an unusual feature in Turkish rugs.[32] Although the surviving rugs vary in overall length from 1.5 meters to over 6 meters, the scale of the pattern is not altered, even though sometimes less than half the pattern fits into the allotted space.

Three specific styles of drawing, affecting the appearance of the pattern but not its layout, have been identified by Ellis.[33] Arabesques with delicate spikes characterize the "Anatolian" style illustrated here. Extraneous forms are added to the spiky arabesques in the "ornamented" style. The pattern acquires a heavy regimented appearance in the "kilim" style where the arabesques have evenly stepped protrusions, reminiscent of patterns in tapestry-woven rugs known as kilims. Although all three styles must have developed from a common source, it is unlikely that they were all woven in Anatolia. The Anatolian style has been attributed by Ellis to Konya and possibly also to Uşak, depending on the main border pattern, and the ornamented and kilim styles to more distant production in the Balkans or in Transylvania.[34]

179. Diagram of "Lotto" rug pattern.

The origin of the design is puzzling. The drawing of the Anatolian style warrants comparison with the angular leaf treatment in the Konya rug in the Keir collection whose layout and pattern suggest a silk fabric model.[35] Possibly the style in this Konya rug was later adapted to the octagon and cross layout. No convincing prototype or comparison in any medium is known.

"Lotto" rugs were exported by the sixteenth century and portrayed as early as 1516 in *Cardinal Bandinello Sauli, his Secretary and Two Geographers,* a painting by Sebastiano del Piombo, and thereafter by Italian and Dutch artists during the sixteenth and seventeenth centuries. Lorenzo Lotto painted the pattern only twice. Rugs with the "Lotto" pattern were also woven in Europe, either in Flanders or in England,[36] and survive in considerable quantity from seventeenth-century Spanish production.[37]

SIXTEENTH CENTURY: UŞAK RUGS

During the first decades of the sixteenth century a new concept of scale, design, drawing, and use of color appeared in rugs woven in Turkey that are attributed to Uşak in western Anatolia. Large units, usually stars or medallions, dominate and are repeated

plates 52, 54 (pp. 326–27)

in the field in a manner characteristic of woven fabrics. Multiple levels of design are introduced to pattern the large units while the ground area between them displays comparatively small flowering vines. Many of the vines, leaves, and blossoms have curved outlines while the stars and medallions have gracefully serrated profiles. Unpredictable color changes occur, even within a single leaf or blossom, enriching and vitalizing the pattern.

These Uşak rugs have patterns noticeably different from the smaller controlled designs and angular drawing that characterize almost all Anatolian rugs, those woven both earlier and later. The drawing indicates that it developed independently of the folk-art tradition that influenced most Turkish rugs. These patterns were probably influenced by a style in Ottoman court art dominated by Iranian artists. When their patterns were woven in the Anatolian tradition with fewer than 100 symmetrical knots per square inch, a remarkable degree of curvilinear drawing was retained.

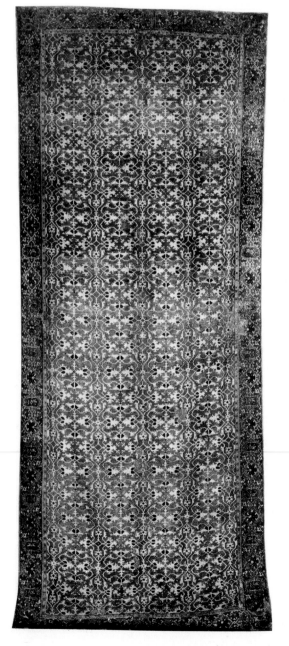

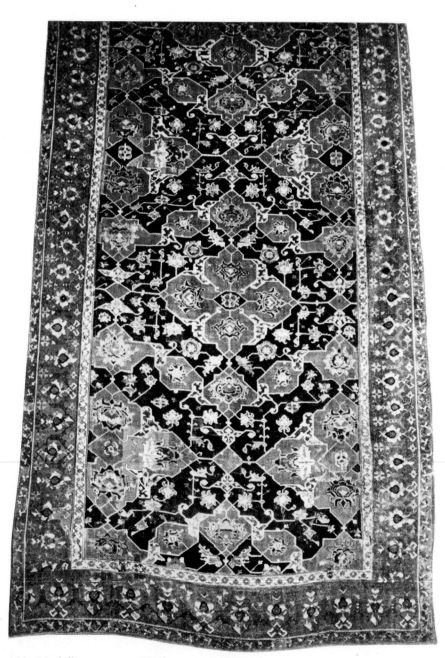

180. "Lotto"-pattern rug; sixteenth century. (Washington, D.C., Textile Museum, R34.18.1)

181. Medallion-pattern Uşak rug; seventeenth century. (Paris, Musée des Arts Décoratifs, 10570)

The star Uşak pattern was recorded in a painting as early as about 1533, the medallion Uşak as early as about 1565–70. Ottoman rugs with delicate curvilinear patterns closely related to Ottoman court art have often been credited with influencing these Uşak rugs. The Ottoman rugs, however, have patterns that do not appear in Ottoman art until about 1550. Whether they were woven then or not until later in the century will be discussed later. In any case, they were made too late to have influenced the pattern of the star Uşak, and they have no stylistic features that indicate they might have affected the pattern of the medallion Uşak.

What is definite is the place of production, Uşak, the one center in Anatolia where rug weaving is cited in customs documents as early as 1490–1512.[38] Rugs from Uşak are listed in an inventory, dated 1674, of the Yeni Valide Mosque in İstanbul.[39] In 1726 an imperial edict was sent from İstanbul to the manufactory in Uşak requesting rugs for the room in the Topkapı Sarayı where the relics of the Prophet Muhammed were

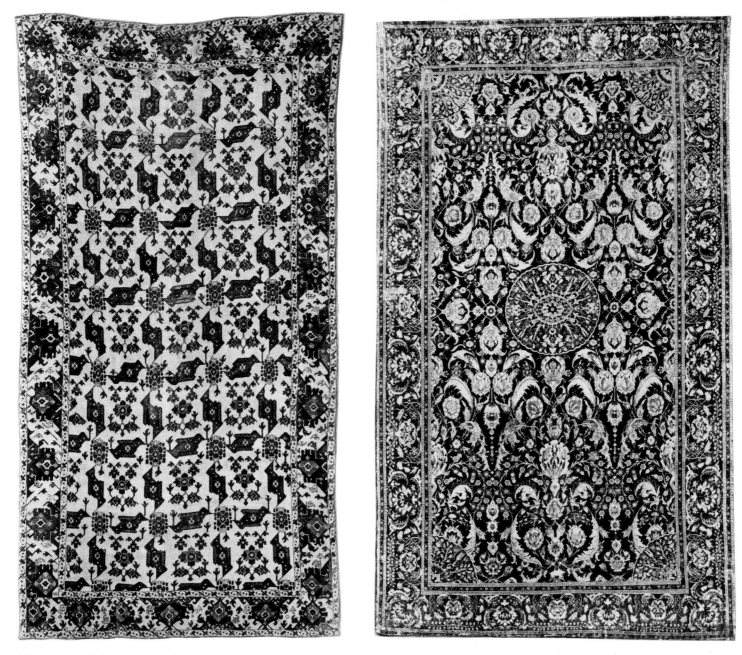

182. Rug with leaf pattern; late sixteenth century or early seventeenth century.
(New York, Metropolitan Museum of Art, 63.207)

183. Rug with Ottoman pattern, from the İstanbul area or Bursa; late sixteenth century.
(Paris, Musée des Arts Décoratifs, 7861)

housed.[40] Since it seems that only the finest rugs would have been ordered for use in this holy room, this edict suggests that during the early eighteenth century the finest Turkish rugs were being woven in Uşak. Another eighteenth-century imperial edict, dated 1763, was sent to Uşak and its environs ordering rugs for the Laleli Mosque, with the specifications that they be of superior quality and that the patterns should not have mihrabs but have the furnished design.[41] This may well be the only reference known in which the Ottoman court is recorded as providing the actual design for a rug. Unfortunately the furnished design cannot be identified.

plate 52 (p. 326)

In star Uşaks large eight-pointed blue stars alternate with smaller indented blue diamonds to form the central axis on a rich red ground. Only parts of these units appear along the sides of the field before being interrupted by the border. The units are connected to each other only on the horizontal axis. Complex yellow arabesques with varying accent colors pattern the interiors of the stars and diamonds. The floral vine that covers the interstitial areas in the field is sometimes rendered in somber moss greens or, in the finest examples, in brilliant shades of yellow, blue, and green in ever-changing positions. Regardless of the size of the rug, the size of the units remains relatively constant—a feature, as has been observed, characteristic of Anatolian weaving until the nineteenth century. Many of the later rugs, however, are smaller, with the result that the star fills the width of the field, and the drawing of all the motifs becomes simplified and increasingly angular.

The illustrated star Uşak has one of the most frequent border patterns: a continuous split-palmette arabesque that partially frames lotus blossoms. The border pattern is usually on the same red ground as appears in the field, a relatively unusual feature in rugs but one that occurs in other rugs woven in Uşak.

ill. 181

The earliest representation of a star Uşak appears to have been painted by Paris Bordone in about 1533, in *The Fisherman Presents the Ring to the Doge*.[42] These rugs continued to be depicted in European paintings well into the seventeenth century. There are also three fine European copies of this pattern, woven in either England or Belgium, with the coat of arms of the English family Montagu, two of which have inwoven dates of 1584 and 1585.[43]

There are several variations of this pattern that have stars in different shapes and in varying layouts.[44] Based on their very similar details and coloring, they were also probably woven in Uşak during the sixteenth and seventeenth centuries.

The second major pattern woven in Uşak is the medallion Uşak. The pattern has two different types of large medallions arranged in a staggered layout on either a red or a dark blue ground. On the more common red ground dyed with madder, a large dark blue serrated medallion with small pendants dominates and fills the center of the field. In staggered placement both below and above are stellar half-medallions in either blue-green or dark brown. In the finest early examples the central medallion has two levels of design, large split-palmette leaves and a small vine bearing lotus blossoms and small flowers. The red ground between the medallions displays a continuous blue peony vine, the drawing of which is very delicate and graceful in the early rugs and more simplified and angular in the later ones.

plate 54 (p. 327)

The drawing in the less common, dark blue ground medallion Uşaks tends to be even finer than in those with a red ground. In one very large carpet, two red main medallions alternate with medium blue severed medallions on a dark blue field that displays a fine pale yellow peony vine. This distinctive carpet, with superb drawing

and radiant colors, confirms the infinite, rather than centralized, nature of the pattern; the red main medallions are repeated on the horizontal axis.

Several patterns were used in the main border. A few of the finer rugs have pseudo-kufic or small and rather naturalistically rendered lotus blossoms on vines with vibrant color changes as in the illustrated rug. Cloud-band borders appear occasionally, but most of the borders have large angular blossoms on a vine. Narrow vines often appear in the inner and outer guard stripes.

The great popularity of medallion Uşaks is indicated by their numerous representations in European paintings, the earliest known example dating from about 1565–70 in *Allegory of the Peaceful Reign of Queen Elizabeth* attributed to Hans Eworth.[45] These rugs, which are often very large, survive in surprisingly large quantities, partially as a result of having been woven as late as the nineteenth century. Usually the central medallion in the later rugs loses its oval shape and acquires straight sides that suggest or form a hexagon. The drawing in some of these very large rugs is compressed and angular. In the smaller rugs, it is simplified.[46] A number of rugs that may have been woven in villages in a wide area around Uşak also exist with variations in the drawing and coloring.[47]

Several prayer rug patterns are also attributed to Uşak based on their drawing, colors, and border patterns.[48] Whether they were woven as early as the sixteenth century or not until the seventeenth century is difficult to confirm.

SIXTEENTH CENTURY: WHITE-GROUND RUGS

In addition to the predominance of red-and blue-ground rugs, there appears to have been a tradition of weaving rugs with white grounds, as can be seen in a Konya rug[49] and in the Marby animal rug. Two Turkish patterns in particular are associated with white grounds, the so-called bird pattern and the three balls and paired wavy lines pattern. Both have small motifs forming the field pattern.

ill. 174

ill. 182; plate 53 (p. 327)

Several European inventories list white-ground Turkish rugs during the sixteenth century. "Weisse türkische Teppiche" appears in an account dated 1503 of Kronstadt in Transylvania (today Brasov, Romania).[50] Others are dated 1571–72, 1578, and 1585–93,[51] and the English Hardwick Hall inventory dated 1601 lists white-ground Turkish rugs "to lay about the bed."[52]

The misnomer "bird" pattern continues to be associated with an inanimate pattern whose foliate nature has long been identified. On a white ground, a grid layout is formed by angular paired leaves that are attached to rosettes. Because the area between the paired leaves has a colored instead of a white ground, thereby suggesting a bird with two heads, the misnomer has been applied. The flowering motif in the center of each square unit causes the pattern to have a bottom and top, a very unusual feature in Turkish rugs. The red and blue-green that dominate the pattern in the field are also prominent in the white ground of the main border, whose patterns include cloud-bands and reciprocally placed triangles with stylized foliation.

One of the earliest representations in European paintings appears in about 1557 in *Portrait of Count Ladislaus von Hag* by Hans Mielich,[53] and it continued to be depicted during the seventeenth century. The popularity of the pattern is further attested to by a copy woven in Europe bearing the arms of a Latin archbishop of Lemberg (1614–33).[54] These rare rugs of comparable size are tentatively attributed to the Konya area. A number of often smaller rugs with more somber colors have been preserved in Transyl-

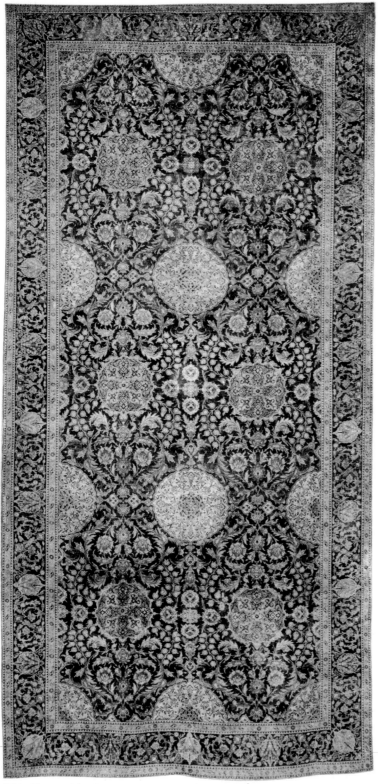

184. Rug with Ottoman pattern, from the İstanbul
area or Bursa; late sixteenth century.
(New York, Metropolitan Museum of Art, 41.190.257)

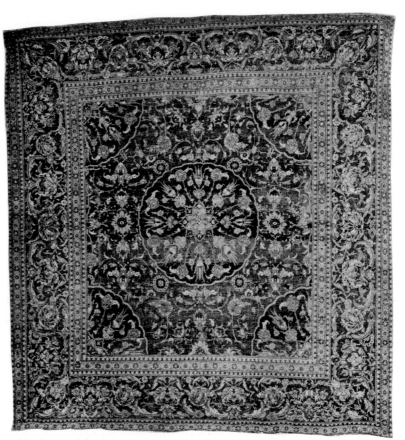

185. Rug with Ottoman pattern, from Cairo;
second half of sixteenth century.
(Washington, D.C., Textile Museum, R16.4.1)

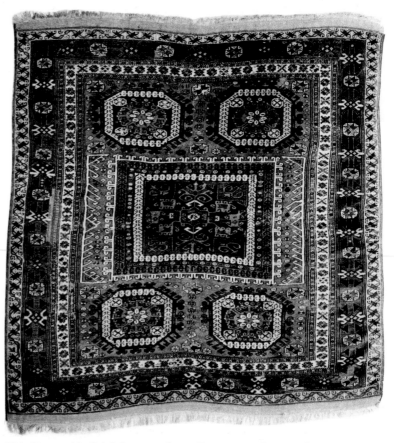

186. Rug with 2:1:2 layout, from Bergama; nineteenth century.
(Washington, D.C., Textile Museum, R34.2.2)

vanian churches in Romania. Their physical characteristics and other considerations cause some leading scholars to attribute them to Balkan production of the seventeenth and eighteenth centuries.[55]

Of all the patterns in Anatolian rugs none appears more frequently in Ottoman court art than the second major pattern associated with white-ground rugs. It is composed of a pair of wavy lines and a triangular arrangement of three balls in evenly spaced, staggered rows.[56] The motifs may have evolved from animal skins—tiger stripes and leopard spots—worn by rulers to suggest their temporal power and strength. However, the true significance and source of this ancient pattern, which appears in Central Asian painting and is associated with the ruler Timur, still await satisfactory explanation.

plate 53 (p. 327)

This pattern was fashionable in Ottoman art from the fifteenth century on, which undoubtedly inspired the Anatolian rug weavers to use it. A comparison between identical layouts of the pattern in an Anatolian rug and in an Ottoman silk emphasizes the varying predilections of the two different groups of artisans and the intrinsic characteristics of each medium. The rendering in silk, and also in ceramics, flows with a graceful rhythm, whereas in the rug the drawing is more angular. Anatolian rug weavers, however, used their medium to maximum advantage and incorporated unpredictable color changes into the pattern, which greatly enliven and enrich its otherwise repetitive nature.

ill. 205

The border patterns are similar to those used in the "bird" rugs, including a main border pattern with cloud-bands alternating with rosettes on a vine. This border pattern was depicted as early as about 1532 by Jacob Claesz van Utrecht in *The Annunciation*.[57] The motifs and drawing of the pattern indicate that they were adapted from the court art in İstanbul, which in this case reflects Iranian influence.[58]

Although these spot-and-stripe patterned rugs were not represented in European paintings, they are usually attributed to the second half of the sixteenth and to the seventeenth centuries in the Konya area, because of their border patterns, use of colors, and similarities with the "bird" rugs. European paintings and datable circumstances have confirmed the existence of all three border patterns in the spot-and-stripe rug by 1560, thereby making possible the attribution of this exceptionally rare rug to the end of the sixteenth century.[59] Special caution is warranted in dating rugs with this pattern since their numbers were increased early in this century, as revealed by Erdmann in "A Carpet Unmasked."[60]

SIXTEENTH CENTURY: OTTOMAN RUGS

What rugs did the Ottomans select to cover the cold marble floors of their newly built palace, the Topkapı Sarayı, and what rugs were placed on the floors of their mosques? After the conquest of İstanbul in 1453, Ottoman decorative arts and manuscripts were in existence for about a century before any rugs with Ottoman patterns were even woven. Ottoman rugs comprise the one group of rugs woven in Turkey whose designs closely reflect the Ottoman court arts. Stylistic comparisons with Ottoman art indicate that their patterns were not woven before 1550. Several factors suggest that they may not even have been woven in the İstanbul area until 1585.

plate 55 (p. 328); ills. 183, 184, 192

The curvilinear patterns in the Ottoman rugs are composed of extremely graceful leaves and blossoms whose sweeping movement tends to conceal the infinite nature of the layout. This is skillfully achieved usually with only one level of design, which is characteristic of most Ottoman court art. Groups of overlapping flora are included within the one design level. Curving lancet leaves and palmette blossoms dominate the pat-

plates 44, 45 (pp. 270–71); ills. 88, 90, 160–162

terns. The fashionable Ottoman tulips, carnations, hyacinths, and pomegranates are also present, mainly contained within small medallions in the field and in the border patterns. A wide range of colors was used to create a rich effect, but the shades themselves are delicate, and some have faded. Crimson, for example, is used instead of bright red for the ground color in both the field and border in most of the rugs.

ills. 183, 185

A small central medallion and four quarter-medallions in the corners of the field appear in both large and small Ottoman rugs. Although the sixteenth-century northwest Iranian medallion rugs have often been cited as influencing the medallion Ottomans, the differences in scale and concept of patterning cause it to be highly unlikely. If a foreign prototype existed, it probably came from Cairo.

There are at least two distinct qualities of Ottoman rugs woven in two very distant areas. Technical and stylistic features confirm that some were woven in Cairo, already a rug-weaving city when conquered by the Ottomans in 1517, and some in the İstanbul area or in Bursa.

Although only one document, dated 1474, mentions rug weaving in Mamluk Cairo, Mamluk rugs are securely attributed to Cairene production during the last third of the fifteenth and early sixteenth centuries on stylistic and technical grounds.[61] The admirable complexity of their geometric patterns and their luminous colors—including a highly desirable green—suggest that they were products of a well-organized center. Whether it was under the auspices of the Mamluk court is unknown. Nor is it known how long it took the industry to stop weaving the geometric Mamluk patterns and to adopt the new curvilinear Ottoman style. That the change may not have occurred until about 1550 is indicated by a few "transitional" rugs that combine both Mamluk and mid-sixteenth-century Ottoman patterns.[62]

What prompted the change in style after the Ottoman conquest in 1517? No documents support the traditional view that the Ottoman court artists in İstanbul supplied the patterns for the rugs woven in Cairo. Indeed, Ottoman patterns would have been available soon enough in Cairo for the weavers to copy on their own.[63] The answer is probably closely linked with economic viability. The taste of the new rulers for sweeping foliate patterns might well have prompted the rug industry to produce patterns that they could sell best, including to the Ottoman court, thereby supporting their enterprise. As will be discussed with regard to sixteenth-century silk fabrics, the Ottoman court purchased silks for its own use from shops in Bursa, and there is no evidence that the court owned manufactories or supplied designs to the silk weavers in that city.

ill. 185

A number of inventories from the sixteenth to the eighteenth centuries confirm the continuing production of rugs in Cairo, including "Turkish rugs from Cairo."[64] The traveler Thèvenot recorded seeing in 1663 the active rug-weaving industry in Cairo where the rugs were called "Turkish rugs" and were exported to Europe and to İstanbul.[65]

Several documents also list rugs from Cairo in mosques in İstanbul. In 1573 Dufresne recorded seeing "Cairene" rugs in the mosques of Mehmed II and Beyazıd II, and in about 1650 the famous Turkish writer Evliya Çelebi mentioned seeing "Persian and Egyptian rugs" in the Yeni Valide Mosque.[66] An inventory of that mosque dated 1674 lists rugs from Iran, Turkey, and Egypt and specifies the sizes of some Egyptian rugs. It includes large multiple-niche prayer rugs (saff in Arabic) from Egypt, the largest of which had no fewer than 132 mihrabs while the smallest had only 10.[67] It seems incredible that only a few Ottoman rugs have survived in İstanbul; most are in European or American collections.

When the Cairene rug weavers began weaving the new Ottoman patterns in the middle of the sixteenth century, they continued to use the same technique and materials they had used in the Mamluk rugs. Craft habits rarely change. The Ottoman Cairenes are all-wool and are woven with the asymmetrical knot. The wool has an s-twist. The same colors are present and a few more are added.

In order to weave a clear curvilinear pattern with precise details in a rug, a knot count of at least 200 knots per square inch is needed. The fineness of the design is directly related to the number of knots—the more knots, the finer the pattern. The patterns in the Ottoman rugs do not in themselves indicate where they were woven; however, when grouped together on technical grounds, certain designs emerge as characteristic of a specific group. It remains, nevertheless, especially difficult to determine where some of the all-wool Ottoman rugs were woven.

ill. 184

The all-wool Ottomans that continue to have approximately the same knot count as the Mamluks, between 95 and 150 per square inch, are generally attributed to Cairo. Their drawing appears slightly fuzzy. One distinctive feature often occurs in the center of the main border pattern: a motif is awkwardly repeated in mirror image, thereby altering the continuity of the pattern. In addition, certain border patterns and the contours of the quarter-medallions are associated with these Ottoman Cairenes. There are, however, some all-wool Ottomans with as many as 220 knots per square inch that have fine, sophisticated drawing.[68] Were they also woven in Cairo or were they woven in the İstanbul area together with the first-quality Ottoman rugs? Until additional research is completed, they can only very tentatively be attributed, on the basis of their fine quality, to the İstanbul area.

ill. 185

The first-quality Ottoman rugs are grouped on technical grounds and are believed to have been woven in the İstanbul area or in Bursa, the nearby silk-weaving center in Turkey. They are woven with wool, silk, and cotton. The warps and wefts are silk, the pile is cotton (white and sometimes light blue) and wool (all other colors). The asymmetrical knot is used with a knot count varying between 165 and 380 knots per square inch. Both this first-quality and the all-wool Ottomans have two distinctive and very significant features in common: the asymmetrical knot and wool with an s-twist. Turkish wool, in contrast, has a z-twist and almost all Turkish rugs are woven with the symmetrical knot.

plate 55 (p. 328); ills. 183, 192

The explanation for these otherwise puzzling, shared technical features has been preserved. A very important but enigmatic document records that in 1585 Murad III ordered eleven master rug weavers, cited by name, from Cairo to İstanbul along with almost 4,000 pounds of their wool.[69] This confirms that the rugs woven by the Cairenes were admired by the court, and, as mentioned earlier, Dufresne saw "Cairene" rugs in mosques in İstanbul in 1573. But why were the Cairene weavers sent for and where did they work upon arrival in İstanbul?

The request for nearly 4,000 pounds of Cairene wool seems to provide a clue. The specific shades of color of this wool—crimson, blue, and green—are extremely similar to the favorite colors in the beautiful silk kaftans worn by the sultans during the sixteenth century. These shades are noticeably different from those seen in Anatolian rugs. In ordering the eleven master rug weavers from Cairo to İstanbul, the Ottomans imported the skill of weavers already accustomed to weaving curvilinear patterns and the desirable colors of their wool to insure the production of fine rugs.

In attributing the first-quality rugs to the Cairene weavers summoned to İstanbul in 1585, this date must be considered. Since the foliate nature of the patterns can be

compared with the Ottoman art that blossomed around 1550, it is highly probable that Cairene weavers had been ordered to İstanbul ever since the middle of the century. The fortuitous survival of the 1585 document confirms what would be suspected on technical grounds.

Unfortunately it is not known where the eleven master rug weavers from Cairo worked. One record mentioning rug weaving in İstanbul is the register of the year 1515, which classifies tradesmen into groups including fifteen "rug makers," six masters, and nine apprentices.[70] It is particularly unfortunate that the large *Surname* manuscript of about 1582, which illustrates dozens of guilds in İstanbul participating in the circumcision festival of the son of Murad III, is no longer complete. Rug weaving is neither mentioned nor illustrated in the surviving pages, although many other types of weaving are recorded. Rug weavers are also not included in the list of 735 different guilds and professions recorded by Evliya Çelebi in about 1635. He did state, however, that there were 111 rug dealers with forty shops.[71] While it seems unlikely that rugs were not woven in İstanbul and that court manufactories for weaving rugs did not exist there, no evidence has yet come to light to confirm the suspicion.

The former Ottoman capital and highly renowned silk-weaving city of Bursa has frequently been suggested as a possible manufacturing center for the first-quality Ottoman rugs. In 1474 the traveler Barbaro mentioned Bursa as a rug-weaving center, and a city register dated 1525 lists "six rug makers and nine workmen."[72] Extensive research, however, that has been undertaken recently in the sixteenth- and seventeenth-century archives in Bursa has surprisingly yielded no reference to rug production.[73]

Ottoman rugs are usually referred to as "Ottoman court rugs," which, based on their similarities with Ottoman court patterns, is correct. However, since there is no evidence to confirm they were woven in an Ottoman court manufactory, the inclusion of the word "court" is misleading. The rugs should probably be called "Ottoman rugs," which is clear and accurate.

It is evident that this relatively small group of Ottoman rugs—no more than one percent of all Turkish rugs—poses many problems that require additional research. Yet the importance of Ottoman rugs in the 700-year-old history of Turkish rugs cannot be overestimated. Although they were woven only during the second half of the sixteenth and during the seventeenth centuries, the patterns in many of the rugs exerted a long-lasting influence on the Anatolian weavers who adapted the curvilinear patterns to conform to their own preference for angular drawing. These include individual motifs such as curving lancet leaves, palmette blossoms, tulips, and carnations, as well as specific border patterns and, in addition, the complete layout and patterns for regular rugs and prayer rugs, as will be discussed later. In some instances, the patterns in nineteenth- and twentieth-century Anatolian rugs can easily be traced back to Ottoman rug prototypes; and in other cases, angular motifs can only be understood after recognizing their Ottoman ancestry.

SEVENTEENTH TO TWENTIETH CENTURIES

Many of the rug patterns woven in Anatolia before the Ottoman rugs were made continued to be produced during the seventeenth century. The star and medallion Uşaks retained their popularity, and simplified versions of the medallion pattern were woven during the nineteenth century. The 2:1:2 layout seen in the large-pattern "Holbein" rugs also continued to be woven in Bergama in slightly altered versions even into the twentieth century.

plate 25 (p. 177)

ills. 187, 189

ill. 186

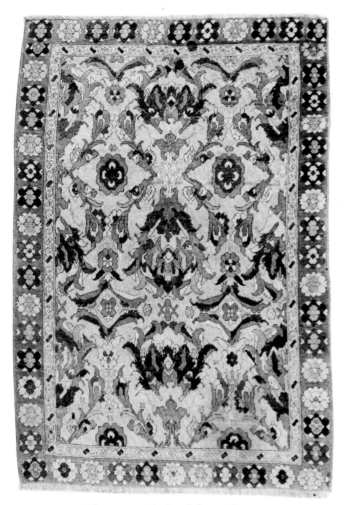

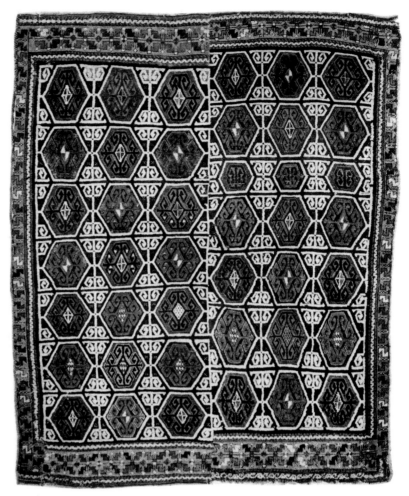

187. Rug with pattern derived from Ottoman rugs, from İzmir; late eighteenth century or nineteenth century. (St. Louis Art Museum, 114:1929)

188. Rug with hexagons, from central Anatolia; eighteenth century. (Washington, D.C., Textile Museum, R34.12.5)

In comparison with the different types of patterns in large rugs that had been exported earlier to Europe in great quantities, relatively few distinct groups with new patterns can be firmly identified with the seventeenth and eighteenth centuries. Only occasional isolated examples were recorded by European painters or preserved in European collections. One group is composed of the so-called Smyrna (İzmir) rugs,[74] named after their town of export from Turkey during the eighteenth and nineteenth centuries. Their field patterns, dominated by large palmette blossoms, were derived from the much finer late sixteenth-century Ottoman rugs. Smyrna rugs were sufficiently admired abroad during the eighteenth century to be copied in England and possibly even exported to the United States with other Turkish rugs.[75]

ill. 187

In addition, there are handsome rugs with strong patterns and colors attributed to the seventeenth and eighteenth centuries, housed primarily in the vast collections of the museums in İstanbul. A few have been published by Yetkin,[76] while others are scattered throughout the literature.[77]

ill. 188

As would be expected, considerably more rugs survived from the nineteenth century, but unfortunately they are only beginning to receive the attention and appreciation that their striking designs and colors deserve. Often for want of specific information, scholars pass over these intermediary centuries in search of more modern rugs that can be documented.

ill. 189

Recent fieldwork by Beattie in the Konya area led to the neighboring town of Karapınar, where patterns long associated with the Konya region are still being woven, although little has been documented.[78] The simple drawing of the medallion and corner designs has been traced back to older and previously ungrouped rugs,[79] and a closely related pattern is now recognized as being represented in a painting of about 1620–30 by an unknown artist.[80] Beattie cautions against attributing the older examples of the group to Karapınar, a former caravan stop with a Mosque of Sultan Selim attributed to the royal architect Sinan, and states that some could have been made in other rug-weaving villages in the Konya area, although related patterns have not been observed in those villages.[81]

The importance of this fieldwork deserves emphasis, for this type of research will be possible only so long as the age-old traditions of weaving are in existence—in other words, until industrialization entices the weavers to the big cities. Thus far, Turkey has

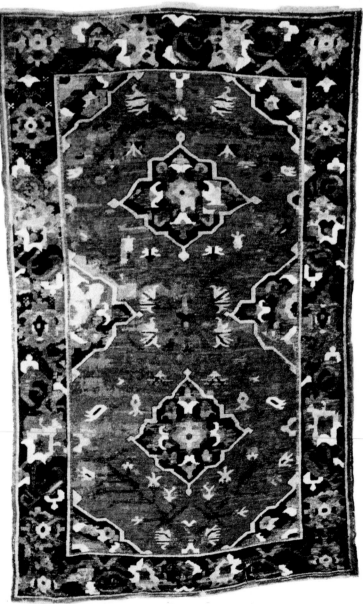

189. Rug with medallions, from Karapınar; eighteenth century or early nineteenth century. (Washington, D.C., Textile Museum, R34.00.1)

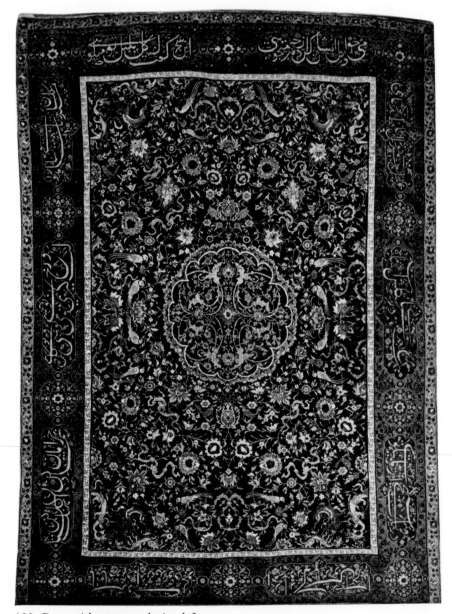

190. Rug with pattern derived from sixteenth-century Iranian rugs, from Hereke; 1860–80. (London, Victoria and Albert Museum, T.402–1910)

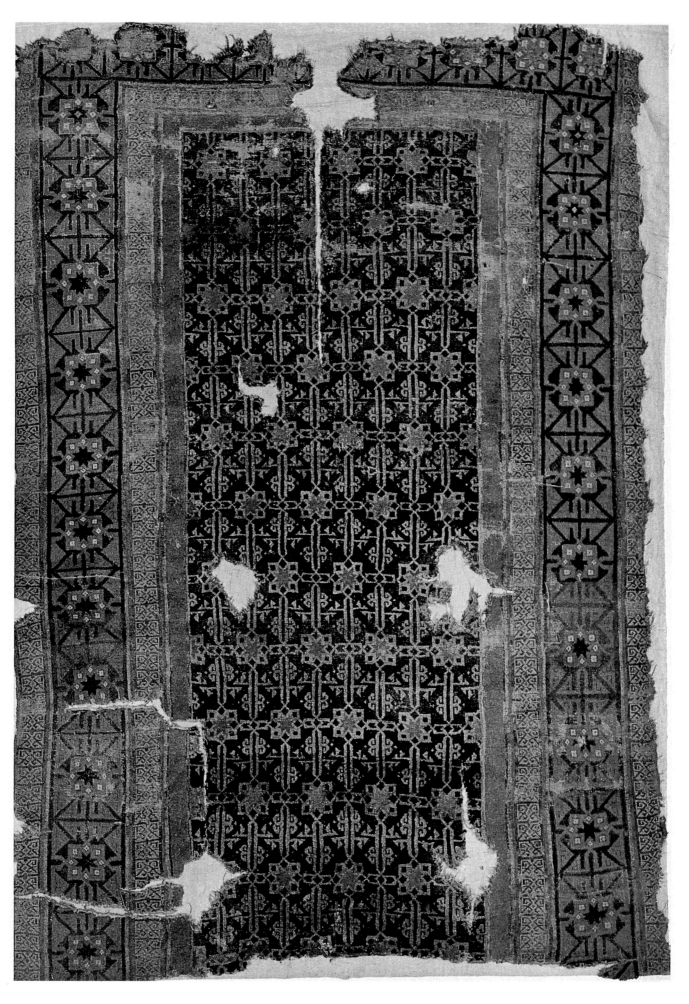

50. Rug with connected
pattern, found in the
Alaeddin Cami, Konya;
late thirteenth century
or early fourteenth century.
(İstanbul, Türk ve İslam
Eserleri Müzesi, 685)

51. Large-pattern "Holbein" rug; sixteenth century.
(İstanbul, Türk ve İslam Eserleri Müzesi, 468)

52. Star-pattern Uşak rug; second half of sixteenth century.
(New York, Metropolitan Museum of Art, 58.63)

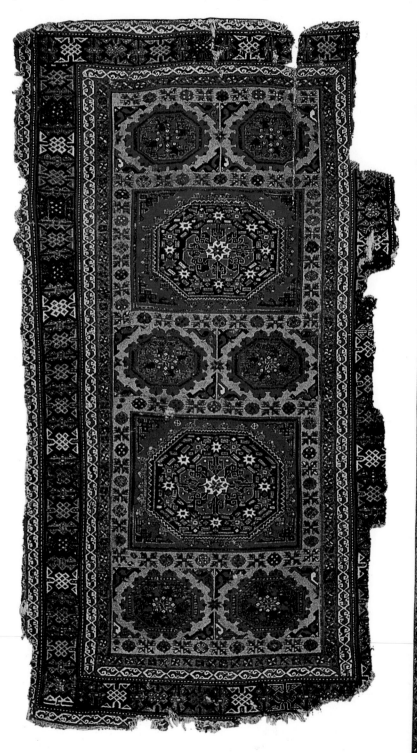

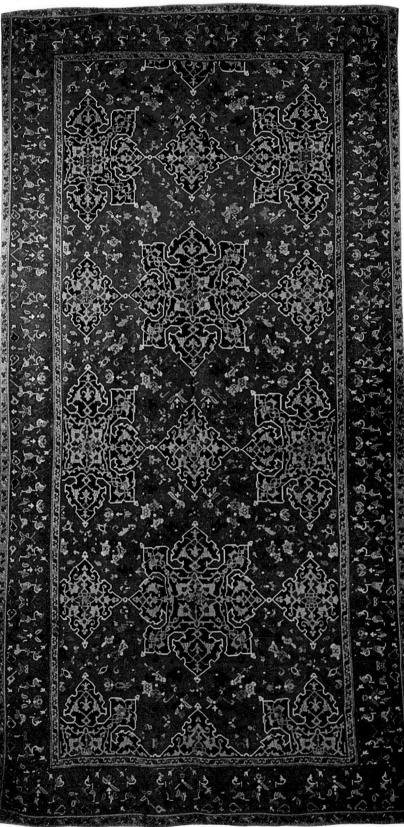

53. Rug with spot-and-stripe pattern; late sixteenth century or early seventeenth century. (Washington, D.C., Textile Museum, 1976.10.1)

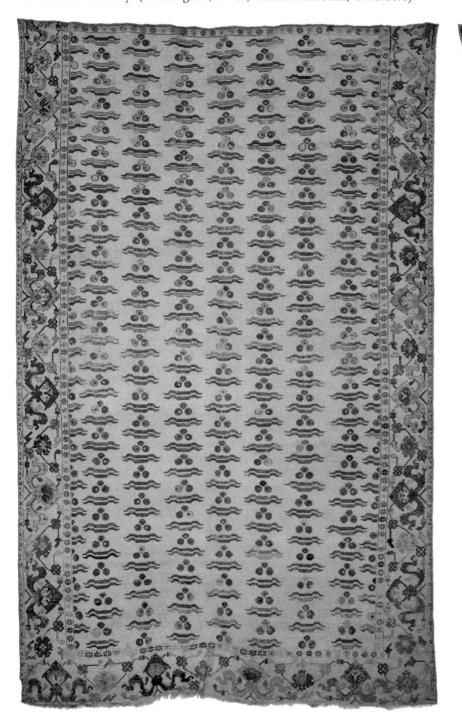

54. Medallion-pattern Uşak rug; second half of sixteenth century. (Switzerland, The Wher Collection)

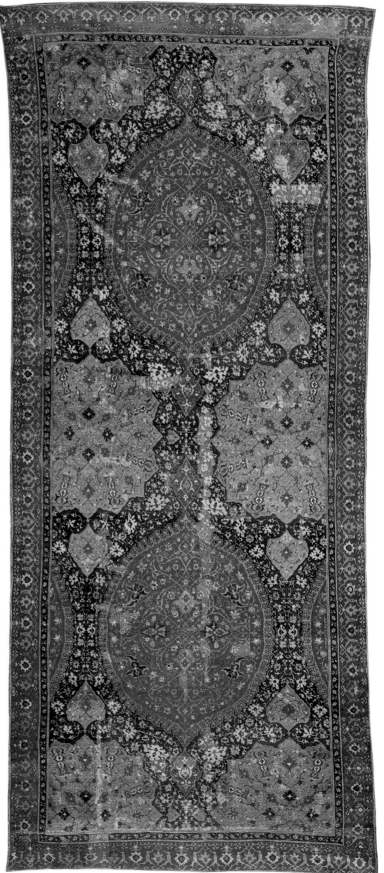

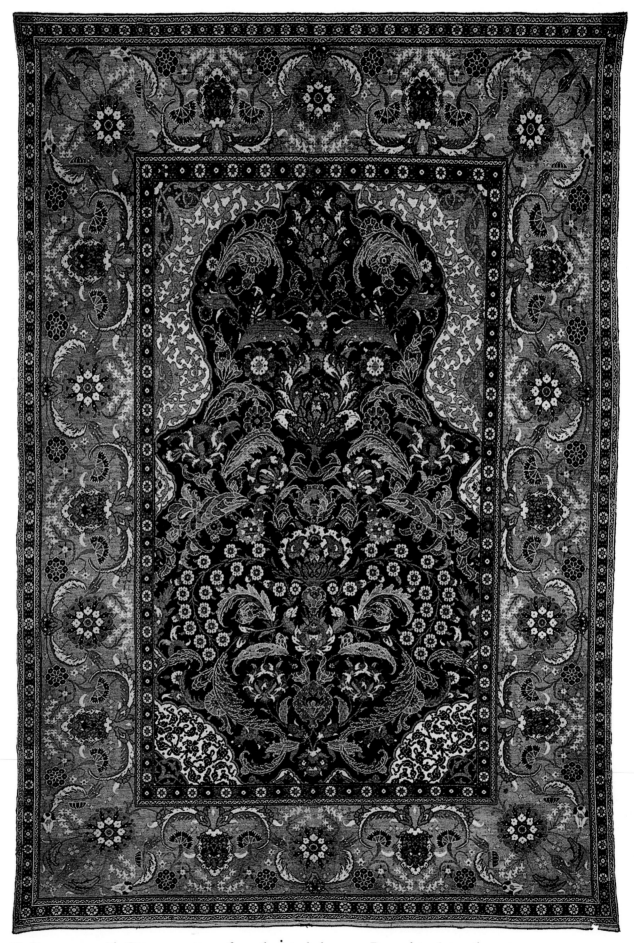

55. Prayer rug with Ottoman pattern, from the İstanbul area or Bursa; late sixteenth century.
(Vienna, Österreichisches Museum für Angewandte Kunst, T 8327)

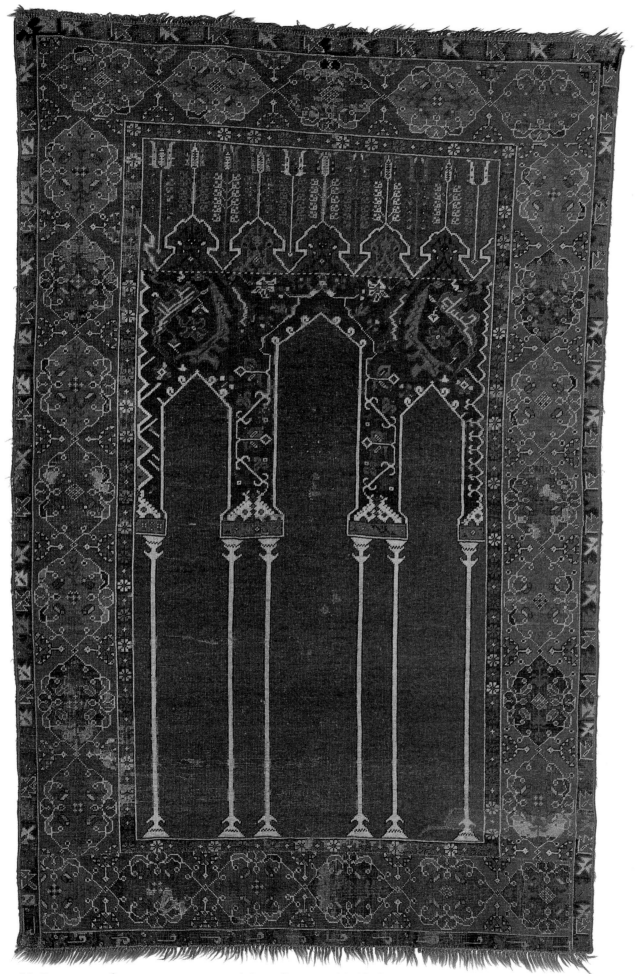

56. Prayer rug, from western or central Anatolia, second half of seventeenth century.
(Washington, D.C., Textile Museum, R34.22.1)

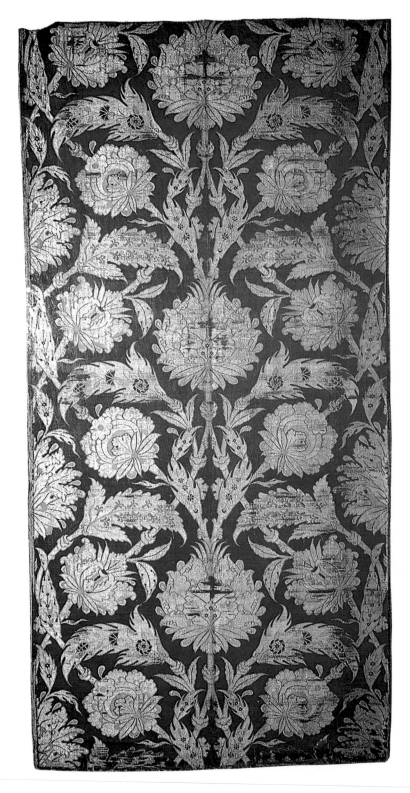

57. Brocaded silk length with two overlapping ogival patterns, from İstanbul or Bursa; third quarter of sixteenth century. (Athens, Benaki Museum, 3897)

58. Kilim with Ottoman pattern (detail); seventeenth century. (Divriği, Ulu Cami)

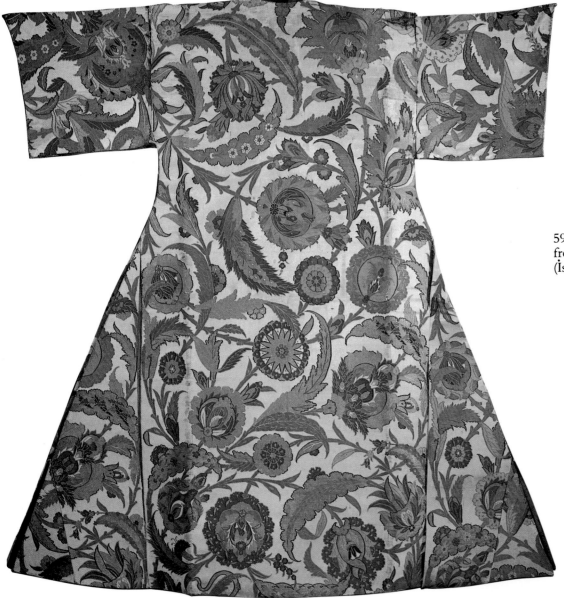

59. Brocaded silk kaftan in seven colors,
from İstanbul or Bursa; mid–sixteenth century.
(İstanbul, Topkapı Sarayı Müzesi, 13/529)

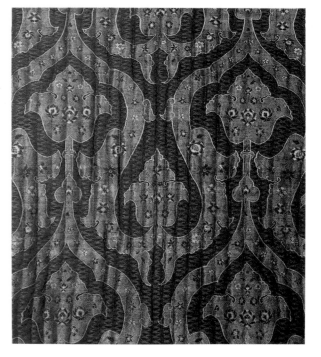

60. Brocaded and quilted silk kaftan with arabesques
(detail), from İstanbul or Bursa; mid–sixteenth
century. (İstanbul, Topkapı Sarayı Müzesi, 13/46)

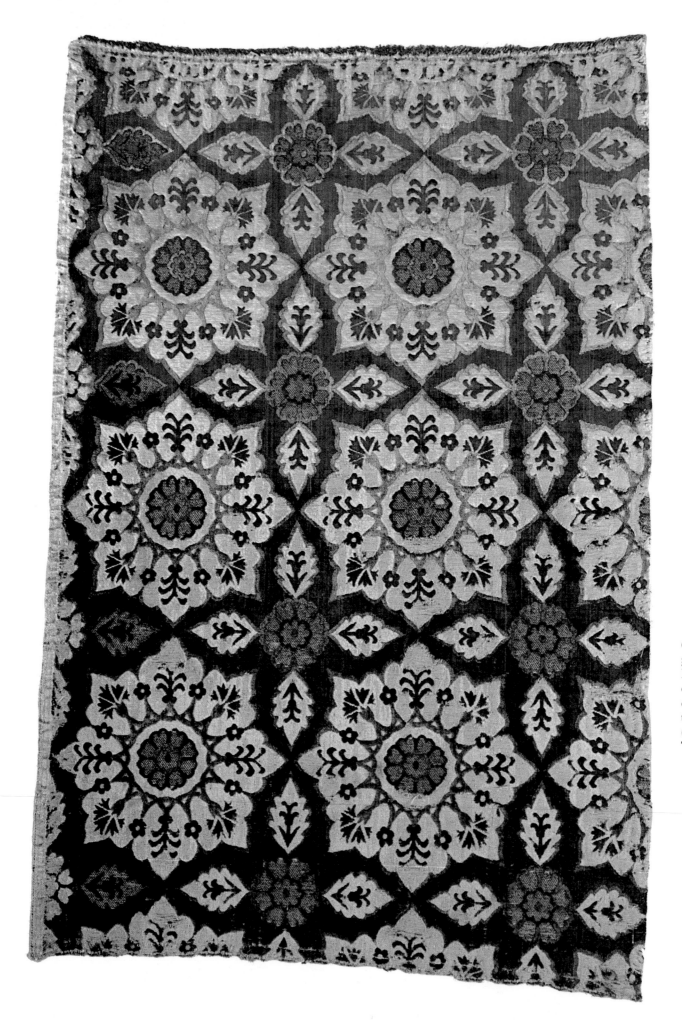

61. Velvet length with stars and crosses, from Istanbul or Bursa; second half of sixteenth century or early seventeenth century. (Washington, D.C., Textile Museum, 1.53)

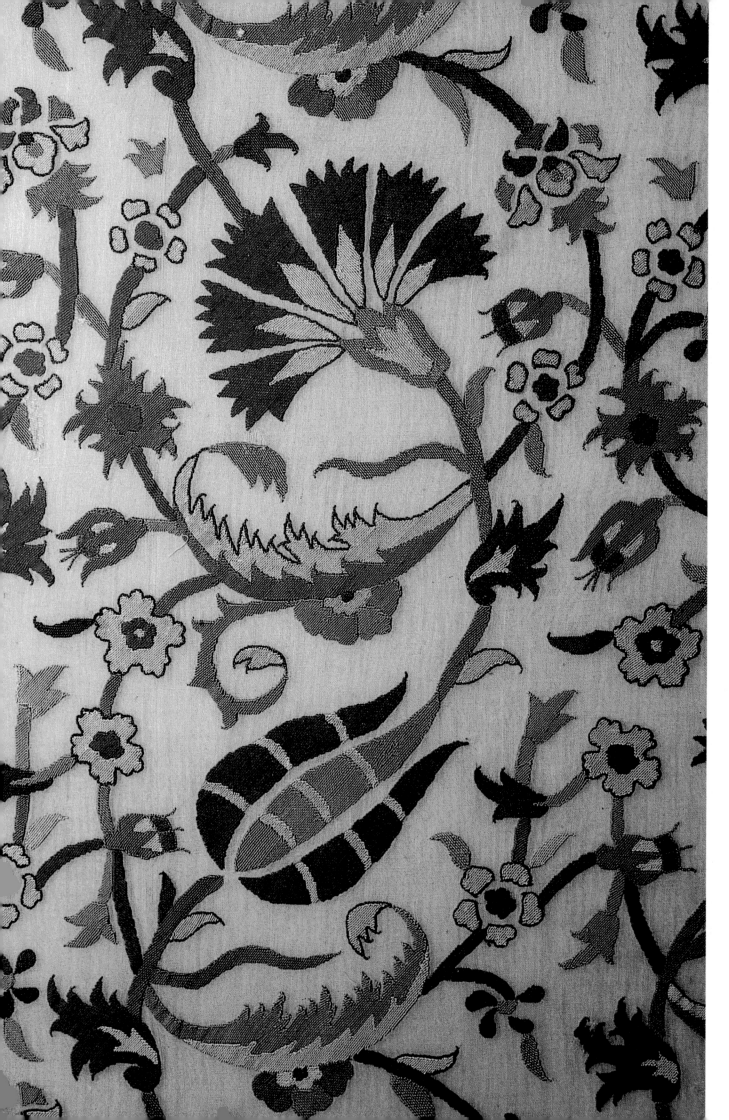

62. Embroidered
cover with vertical
stem pattern (detail),
from Istanbul (?);
beginning of eighteenth
century. (Washington,
D.C., Textile
Museum, 1.22)

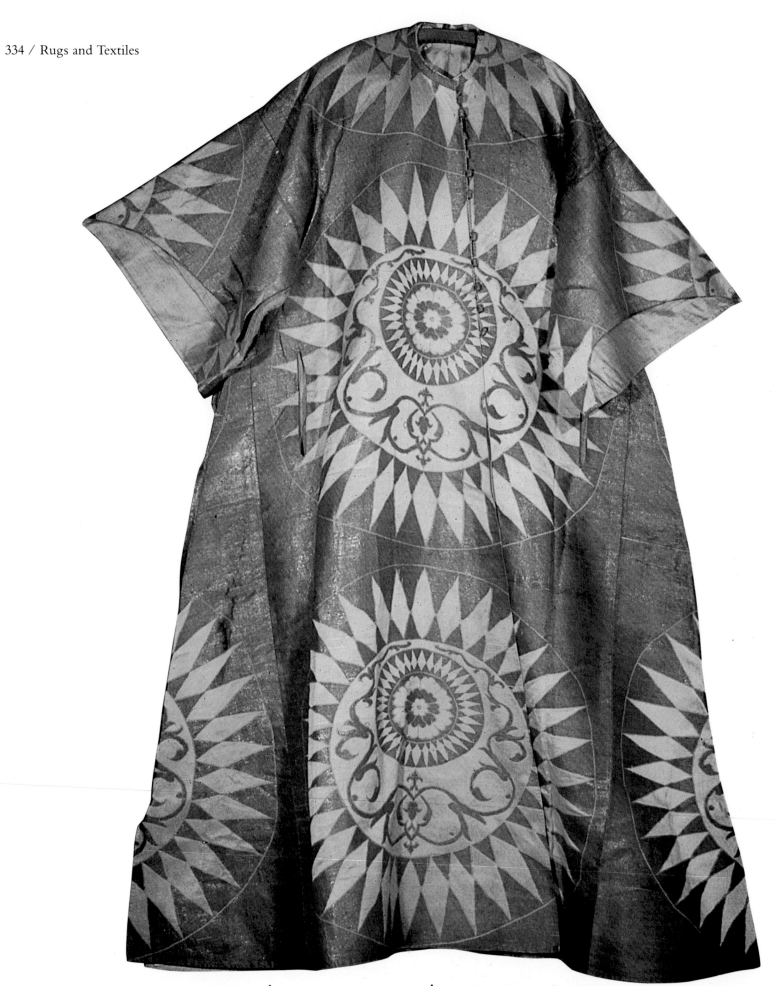

63. Seraser kaftan, from İstanbul; sixteenth century. (İstanbul, Topkapı Sarayı Müzesi, 13/177)

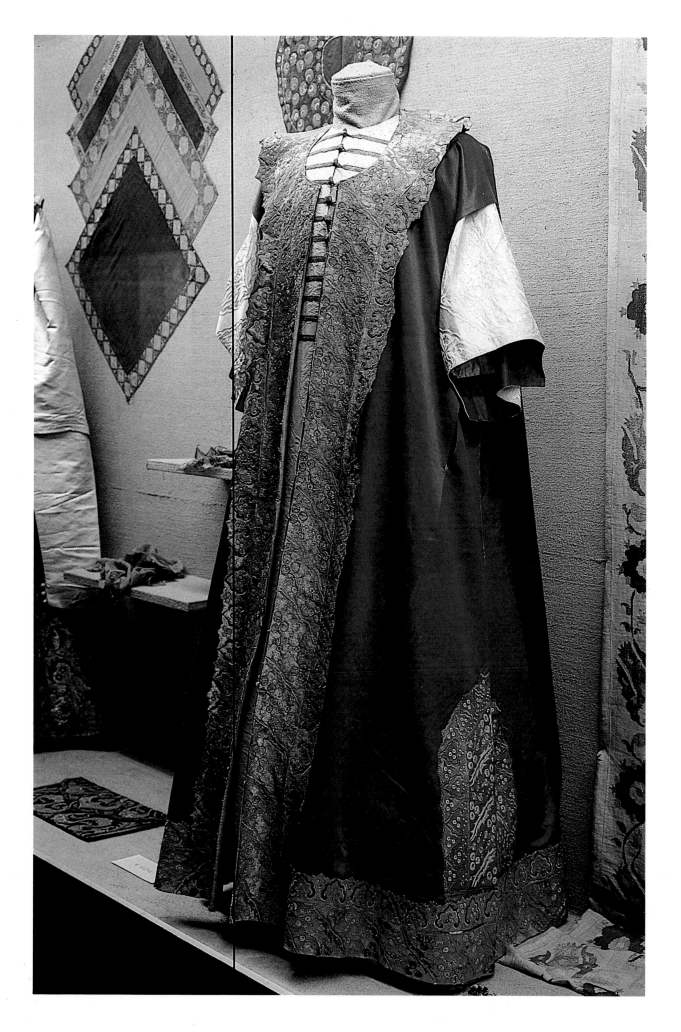

64. Embroidered over-robe, from İstanbul (?); second half of sixteenth century or seventeenth century. (İstanbul, Topkapı Sarayı Müzesi)

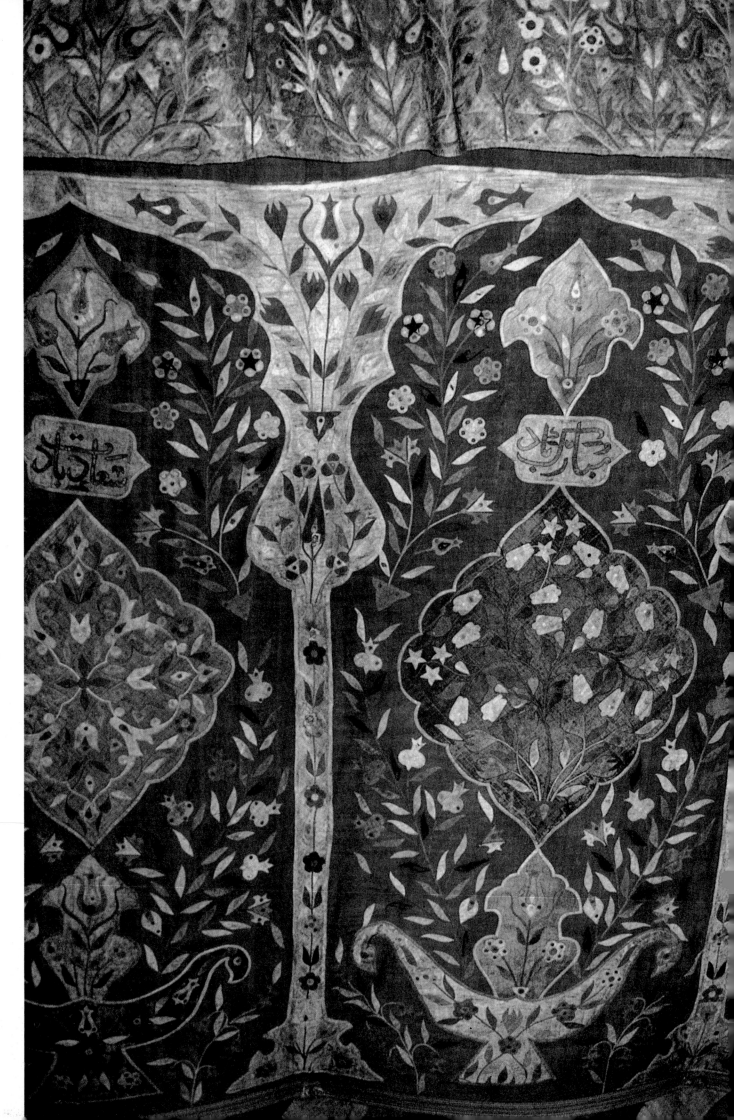

65. Cotton tent
with pattern appli-
quéd in cotton, silk,
and leather (detail);
seventeenth century.
(Krakow, Poland,
Wawel Castle, 896)

been exceptionally fortunate in having maintained its rug-weaving traditions for centuries without suffering political or economic upheavals that have caused the temporary if not permanent cessation of the production of rugs in all the other rug-weaving countries. This continuity has unquestionably contributed to the quality and character of Turkish rugs. In order to contribute to a broader understanding of the great rug-weaving traditions of Turkey, it is now the responsibility of modern scholars to record and document what remains of this tradition while it is still possible.

In contrast with the patterns in all known Turkish rugs, a very different style was begun shortly after 1850 in a new factory in Hereke, located not far from İstanbul on the Marmara Sea. Many of the Hereke rugs have curvilinear patterns reminiscent of sixteenth-century Iranian designs.[82] The rugs are made of wool, often with metal threads, and are finely woven with a relatively high knot count. Their quality suggests that they were primarily intended for use by the Ottoman court. A number of these rugs have been acquired by collectors and museums as cherished sixteenth-century Iranian rugs. Details of the design, the slightly garish or surprisingly somber colors, and the technique have only more recently caused the rugs to begin to be identified as nineteenth-century rugs from Hereke. These rugs, bearing the pseudonym "Salting" after the generous donor of the illustrated rug, are slowly and sometimes painfully being unmasked.

ill. 190

PRAYER RUGS

The continuity of designs over many centuries is particularly apparent in prayer rugs from Anatolia, where the greatest quantity and also the largest variety of prayer rugs have been woven in the Islamic world. Although the act of praying may be performed on any "sacred place," small knotted-pile rugs associated with prayer have been represented in manuscript illustrations since the fourteenth century, and some prayer rugs survive from the sixteenth century. Over the centuries descriptive texts indicate that prayer rugs have bestowed social status upon their owners and at times have allegedly yielded magical properties.[83]

plates 55, 56 (pp. 328–29); ills. 191–195

Within the borders of a prayer rug there is an arch, sometimes supported by columns, representing the mosque's mihrab, the prayer niche indicating the direction of Mecca, the Holy City of Islam, which the faithful face during prayer. The profile of the arch varies noticeably from one rug-weaving area to another; it can be rounded, stepped, pointed, polylobed, or even irregularly shaped. Flowers suggesting the gardens of paradise[84] are often present in various locations under or above the arch. In some of the sixteenth- and seventeenth-century rugs, mosque lamps are suspended from the arch to remind the faithful of a verse in the Koran, "God is the light of the heavens and the earth; a likeness of His light is as a niche in which there is a lamp" (XXIV: 35). In later rugs from the eighteenth and nineteenth centuries the drawing of the mosque lamp apparently became misunderstood and was sometimes replaced by a floral bouquet. Occasionally an ewer, associated with the prescribed ablutions performed before prayer, is represented. One of the most infrequent depictions in prayer rugs is the Kaaba,[85] the holy shrine in Mecca, although it is represented on ceramic tiles of the seventeenth and eighteenth centuries and in a seventeenth-century mihrab in the Topkapı Sarayı.

ills. 192, 140

ill. 195

ill. 194: plate 48 (pp. 274–75)

Several stylistic features in the oldest extant prayer rug, woven in Mamluk Cairo about 1500,[86] appear in a group of Anatolian prayer rugs that were depicted in Italian paintings between 1469 and 1562.[87] Features in the Mamluk prayer rug also appear in the late sixteenth-century Ottoman prayer rugs woven in Cairo and in the İstanbul

ill. 191

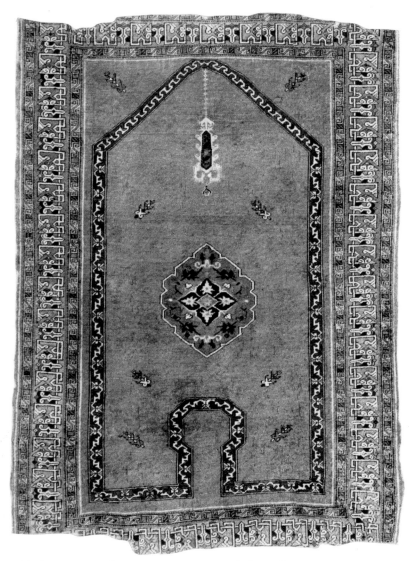

191. Prayer rug, from western or central Anatolia;
late fifteenth or early sixteenth century.
(West Berlin, Museum für Islamische Kunst, 87,1368)

192. Prayer rug with Ottoman pattern, from the
İstanbul area or Bursa; late sixteenth century.
(New York, Metropolitan Museum of Art, 22.100.51)

ill. 192 area. This suggests that probably the Anatolian and Ottoman—and Mamluk—prayer rugs developed from an earlier, now missing, model.

Ottoman prayer rugs typically have a lobed arch beneath which the ground is either undecorated, displays a central floral medallion, or has a field covered with typical Ottoman leaves and blossoms. An outstanding example is the first-quality prayer rug plate 55 (p. 328) in the Österreichisches Museum für Angewandte Kunst in Vienna. It has a superb balance between the dense field pattern on an intense maroon ground and the spacious border pattern on ethereal blue. The sophisticated drawing of swaying leaves and blossoming branches skillfully contrasts delicacy and strength. This rug is a woven masterpiece of design and color. Certainly the most celebrated artists must have been involved with drawing the pattern and weaving the rug. This suggests Ottoman court plates 44, 45 (pp. 270–71); ills, 88, 90, 160 affiliation, an attribution as yet unprovable.

The floral grounds of these rugs influenced the only classical curvilinear prayer rug design known from Anatolia. It was woven in Uşak in several color and design variations, primarily in *saffs*.[88] Two of the documents cited above mentioning Uşak refer to prayer rugs: the 1674 inventory lists two *saffs*, and the 1763 edict orders rugs without mihrabs.

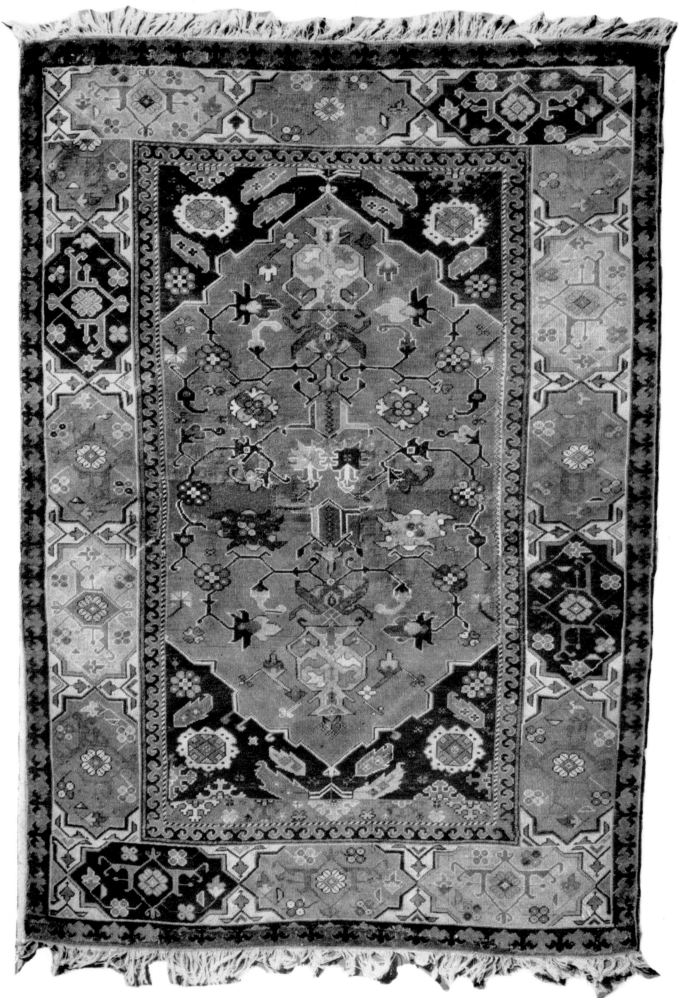

193. Transylvanian
double-ended prayer
rug, from western or
central Anatolia; eigh-
teenth century. (Wash-
ington, D.C., Textile
Museum, R34.21.1)

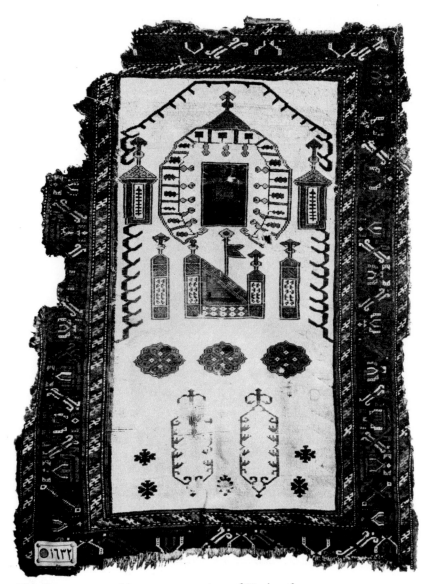

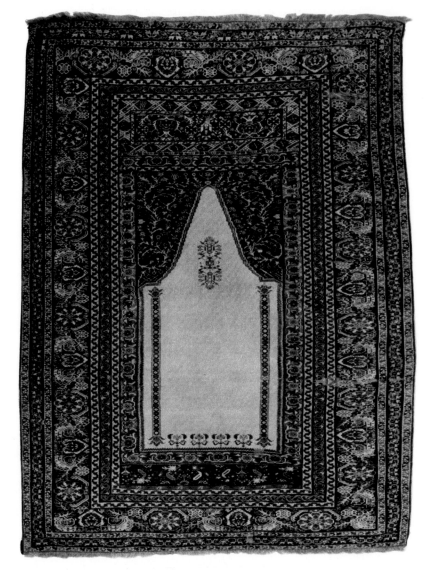

194. Prayer rug with a representation of Kaaba, from western or central Anatolia; eighteenth century. (İstanbul, Türk ve İslam Eserleri Müzesi, 1632)

195. Prayer rug, from Gördes; late eighteenth century or early nineteenth century. (St. Louis Art Museum, 79:1929)

ill. 192

The beautiful first-quality Ottoman triple-arch prayer rug, woven in the İstanbul area during the late sixteenth century, displays several features that were adopted by Anatolian weavers and used for centuries. A mosque lamp is suspended from the higher central arch, whose patterned columns are supported by sturdy bases flanked by a chimerical display of the favorite Turkish blossoms. Above the split-palmette-patterned spandrels is a horizontal register with curved crenellations alternating with cypresses and blossoms, and four pavilions appear in the center. The treatment of the columns, spandrels, horizontal register, and borders is seen in stylized renditions in triple-arch

plate 56 (p. 329)

prayer rugs woven in central Anatolia. Some rugs can be attributed to the mid-seventeenth century based on their depiction in Netherlandish painting as early as 1664, while others continue the tradition well into the nineteenth century in an increasingly simplified but still often attractive style.[89]

Some triple-arch rugs with extremely similar patterns, but somewhat heavier construction, have been preserved in churches in Transylvania,[90] together with several versions of the so-called double-ended prayer rugs. These rugs have a second niche seen

in mirror image at the opposite end of the field. Those with a cartouche border pattern are referred to as Transylvanian prayer rugs.[91] Some scholars attribute them to Balkan rather than Anatolian production, although little has been published about them to date.[92]

ill. 193

Most of the surviving prayer rugs were woven during the second half of the eighteenth and during the nineteenth and twentieth centuries. The well-known Gördes prayer rugs woven in northwest Anatolia typically display a compressed version of the sixteenth-century Ottoman main-border pattern, derivative blossoming vines in the spandrels, floating columns, and a suspended floral bouquet instead of a mosque lamp. Prayer rugs woven in Kula[93] may include "columns" supported by carnations drawn in profile, while those from Mucur[94] sometimes display two ewers. The popular Ladik prayer rugs[95] continue the tradition of a horizontal panel with large tulips emanating from the crenellations, which may appear either above or below the mihrab. Although considerable changes occur in the concept of the design, such as the introduction of numerous border stripes framing a shrunken mihrab and an increased number of colors, the continuity of patterns unquestionably contributes to the quality of the designs and workmanship that has been admirably maintained over the centuries.

ill. 195

FLAT-WOVEN RUGS

The general term "flat-woven rugs" refers to rugs woven without pile. Tapestry-woven rugs, usually called kilims, form one large category, while a second includes rugs constructed by a number of wrapping techniques such as *sumak, cicim,* and *zili.*[96] The types of patterns vary considerably and are usually influenced by their woven structure. For

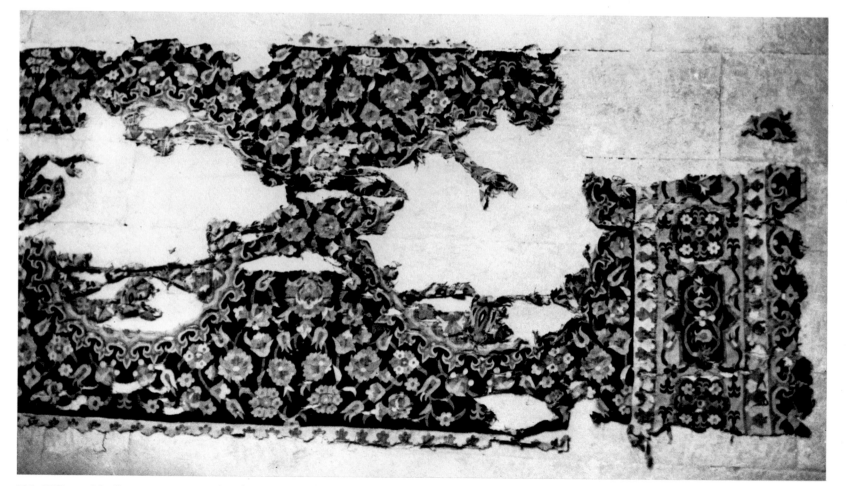

196. Kilim with Ottoman pattern (detail); seventeenth century. (Divriği, Ulu Cami)

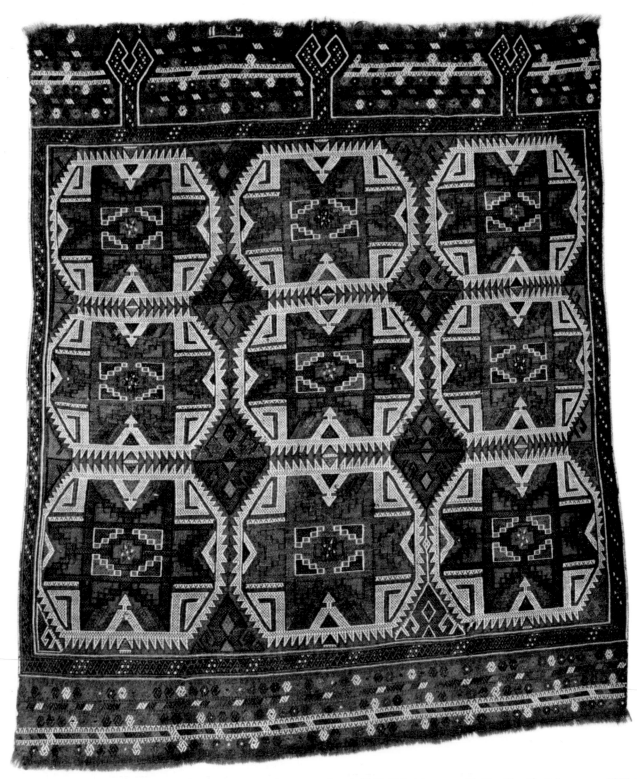

197. Brocaded flat-weave from the Bergama-Ezine area; dated 1763 (Washington, D.C., Textile Museum, 1971.9.1)

centuries flat-weaves have been made by villagers and nomads for their own constant use as covers and bags. As such, they received hard wear. Since flat-weaves are considerably less sturdy than knotted-pile rugs, those made before the nineteenth century have rarely survived.

The exception to this occurs in a few kilim fragments with delicate floral patterns similar to those in the brocaded silks worn by the Ottoman sultans during the sixteenth century.[97] They display the fashionable ogival layout with the favorite Ottoman flowers skillfully rendered in brilliant colors. Certainly their style was inspired by the art of the Ottoman court, where kilims of this quality may well have been used. As such, these rare fragments dating probably from the early seventeenth century form a little-known counterpart to the traditional Anatolian village kilims.

plate 58 (p. 330); ill. 196

Anatolian flat-weaves from the nineteenth and twentieth centuries typically have strong patterns and distinctive, rich colors. Although considerably less well known than the knotted-pile rug tradition, the striking appearance and fine workmanship of many of the flat-weaves deserve equal admiration and attention. Fieldwork and documentation are likewise essential before industrialization irrevocably alters the age-old tradition.[98]

ill. 197

All of these rugs, both flat-woven and knotted-pile, were made with natural dyes until the development of the first synthetic dye in 1856. Shortly thereafter, additional artificial dyes were synthesized and exported to Turkey. They afforded the dyers a quicker and cheaper means to attain brighter colors, a feature that is sometimes more desirable in the eyes of the weaver than in the eyes of the collector.

Textiles

It is not surprising that of all the fabrics used as wearing apparel and furnishings, only those woven with the finest materials or owned by the sultans would have been treasured enough to have survived. The common daily fabrics were items of necessity that received hard wear in protecting the inhabitants from the cold of the long Anatolian winters and the heat of the summers.

Neither the climate nor the political conditions was conducive to preserving textiles in Turkey until after the conquest of İstanbul, when it became the policy of the Ottomans to save the wardrobes of the sultans. Their clothing was stored in the Topkapı Sarayı, which as a result contains by far the greatest collection of Turkish silks and embroideries.

Even though the Chinese secret of the cultivation of silk was smuggled to the West in the sixth century during the reign of Justinian, silk was not cultivated in Turkey until a thousand years later. Therefore, the fibers for weaving silk cloth in Turkey had to be imported. During both the Seljuk and the Ottoman periods most of the imported silk fibers were transported along the silk route from the Iranian city of Astarabad, located south of the Caspian Sea, which produced a highly desirable fine silk. The silk route went through Sultaniye to the Turkish cities of Erzurum, Erzincan, and Sivas to Konya, with two minor routes branching off at Sivas for İstanbul. There was an alternate sea route along the Black Sea from Trabzon to İstanbul. During the fourteenth century the shorter and more popular route went through Erzurum, Erzincan, Tokat, and Amasya to Bursa, the city that became the major silk trading center in Turkey.[99]

While Iranian silk merchants traveled with the several silk caravans that went to Bursa each year, they also resided in Bursa, where they could make safe and direct contact with merchants from Europe, the destination of most of the unwoven silk.[100]

In contrast to the dependence of modern scholars upon European sources for dating Turkish rugs, the primary sources for dating silk fabrics are Turkish. They include descriptions by contemporary authors, archival documents from Bursa and İstanbul, representation of fabrics in Ottoman miniature paintings, and stylistic comparisons with contemporary art in other mediums.

Thirteenth Century

Nothing is known about the weaving industry per se during the Seljuk period. A few contemporary authors list Seljuk fabrics as imperial gifts or items of praise. *Kemha*, a brocaded silk fabric with metallic thread from Antalya, was listed among the tribute sent by the Seljuks to the Ilkhanid ruler in Iran in 1258, and 2,000 rolls of brocaded silk from Erzincan and 4,000 rolls from other Anatolian cities were recorded as sent to the important Ilkhanid vezir Rashid al-Din.[101] Although the quantities are undoubtedly exaggerated, they confirm that brocaded silks of a quality suitable for royal gifts were woven in Anatolia.

On his return from China, Marco Polo stated that he had seen in Anatolia, in addition to fine rugs, "a great quantity of fine and rich silks of cramoisy [crimson] and other colors, and plenty of other stuffs." He also mentioned that "spicery and cloths of silk and gold, and the other valuable wares" were transported from the interior of Anatolia to Aya (Laias), located on the southern coast, where Venetian, Genoese, and other foreign merchants met to sell their goods and buy Turkish products.[102]

Despite these references to silks and the belief that the Seljuk court was clothed in silk, unfortunately only one silk fabric can be firmly associated with the Turks during the thirteenth century. It is a brocaded silk that probably survived because it was later made into a cope. Part of an inscription at one end indicates that it was made for Alaeddin Keykubad, son of Keyhusrev, which probably refers to the first ruler by that name, who ruled from 1220 to 1237. On a crimson ground, the color Marco Polo mentioned, gold threads form the well-balanced pattern of large roundels framing a pair of addorsed lions. The predilection for foliation is visible in the drawing of the lions—arabesques grow from their mouths while their tails skillfully terminate in an arabesque with a a dragon's head. Rosettes fill the border of the roundels, which are connected on the diagonal axis by arabesques that pattern the interstitial area. The specific rendering of the pair of lions, especially their dragon-head tails, is characteristic of contemporary Seljuk art in Anatolia. Although the drawing in a few other silks may suggest their Seljuk manufacture, it remains impossible to confirm the hypothesis. It should be mentioned that since this silk is the only extant example datable to the thirteenth century, it cannot be confirmed that it was actually woven by Turks and was not a foreign order or a gift from a foreign dignitary.

The tradition of patterning with animals within roundels, as seen on this silk, was derived from Sasanian art in pre-Islamic Iran. The layout was highly favored by the Muslims and was widely used throughout their lands until the fourteenth century in what might be loosely called an international Islamic style. The style was also adopted in Christian areas, both in Byzantium and in Europe, and undoubtedly influenced the few surviving fifteenth-century animal rugs and the numerous representations in Italian paintings, as previously mentioned.

ill. 198

ills. 174, 175

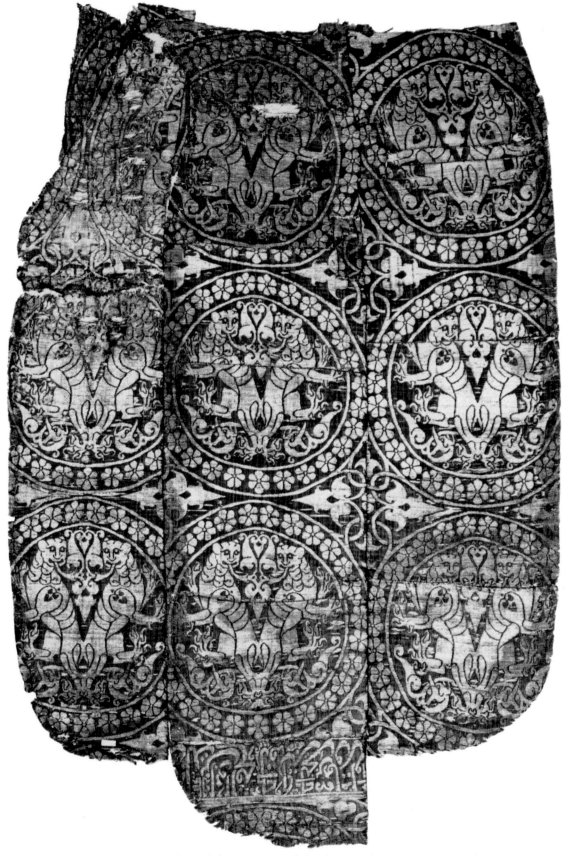

199. Striped silk (detail); late fourteenth
century. Inscription includes the name of
Sultan Beyazıd Han (probably Beyazıd I).
(Yugoslavia, Monastery of Studenica, 12)

198. Silk with lions in roundels; thirteenth century.
Inscription includes the name of Alaeddin Keykubad.
(Lyon, Musée Historique des Tissus, 23.475)

FOURTEENTH CENTURY

Equally little is known about fourteenth-century Turkish fabrics. Umari (1301–48) reported that "inestimable quantities" of woven silk, "quite equal to Byzantine brocade and cloth of Constantinople," were exported from the kingdom of Akira, south of the Black Sea, to Christian countries.[103] And the geographer Ibn Battuta described an unparalleled and extremely durable cotton cloth with borders of gold, which was named after Ladik, its town of manufacture.[104]

ill. 199

Again, nothing survives, except one striped silk, which is believed to have served as a funerary pall. Two inscriptions appear in thuluth characters: "the wise and just sultan" and "the sultan, Beyazıd Han, may his victory be glorious." Ettinghausen convincingly suggests that the inscription refers to Beyazıd I (1389–1402), during whose time striped silks were fashionable both in China and the Near East.[105] The stripes in this silk are subdivided into different sized rectangles that are alternately patterned with geometric, interlacing, and floral motifs, as well as calligraphy. Several of the motifs are very dependent upon Chinese drawing. None of them can firmly be associated with Turkish art owing to the lack of stylistic comparisons in this or any other medium. Several Chinese striped silks with a layout, motifs, and Arabic script similar to those in the Beyazıd silk have survived in European churches.[106] The patterning of some of these is formed by gilded leather strips, often called strap gold, a technical feature associated primarily with Chinese weaving. In order to assist in determining whether the Beyazıd silk was woven in Turkey or in China, the specific nature of the gilt thread needs identification.

The concept of patterning by means of subdivided bands, which occurs in medieval Islamic metalwork, influenced Chinese designs beginning with the Mongol rule in the Near East and in China. During the Yüan dynasty (1279–1368), the Chinese adopted the Islamic concept of banding, which is more restrained and confined than traditional Chinese patterning, and applied it to ceramic vessels, sometimes with Arabic inscriptions, for export to the Near East.[107] It is very possible that the Chinese striped silks are another example of the Islamic banding concept adapted, in this case, to the "flat" surface of woven silks and made for export to the Near East. And it is most likely that these Chinese silks, many with Arabic inscriptions, initiated the ensuing striped silk fashion in the Near East and in Europe.[108]

If this silk was woven in Turkey, it may be another instance in which Turks admired and copied a Chinese silk fabric. If, on the other hand, it was woven in China especially for Beyazıd I, presumably as a gift and not as a special order from the Ottoman sultan, the silk would acquire additional political significance. Wherever the place of manufacture, the Turkish taste for Chinese silks is evident, and one that was to continue to influence Turkish silks, although to a lesser degree, during the height of Ottoman artistic production in the sixteenth century.

FIFTEENTH TO EIGHTEENTH CENTURIES: THE SILK INDUSTRY

A number of illuminating archival documents have been published that provide a basis for a partial reconstruction and understanding of the extremely important silk industry in Turkey during the fifteenth through eighteenth centuries. Most of the information pertains to Bursa, the silk capital of the country. Bursa was the major trading center for the unwoven silk imported from Iran, most of which was weighed, taxed, and exported to Europe. The main merchants during the fifteenth century were the Genoese, Venetians, Florentines, and the Jews.[109] Only a small percentage of the material remained in

Turkey to be woven into silk fabrics and most of it was woven in Bursa. Considerably less is known about silk weaving in İstanbul and the extent to which the court influenced and controlled the silk manufactories in that city.

The vital importance of the trade of unwoven silk fibers cannot be overestimated. It was a dominant element in the economies of both Turkey and Iran during the sixteenth century, and one that was adversely affected by recurring wars between the two countries. Blockades were set up by Selim I (1512–20) and continued briefly by Süleyman I in a relatively unsuccessful attempt to reduce the shah's revenues from the sale of silk. The silk trade between Iran and Turkey was active during the middle of the century until a long period of wars, beginning in 1578 and lasting sixty years, reestablished silk as a political weapon. The effect of the resultant shortage of silk can be seen in Bursa, where three-fourths of the looms were shut down in 1586.[110] The tax revenues from the export of the unwoven silk would also have been lost.

Relatively early in the sixteenth century the government encouraged the cultivation of silk within the empire so that it might eventually become less dependent upon purchasing silk from Iran. Rumelia and Albania are recorded in the Bursa archives as the first producers, and considerably later, in 1588, Bursa is listed. By the middle of the seventeenth century the plains around Bursa were covered with mulberry orchards for the cultivation of silkworms. Bursa remained the silk center throughout the eighteenth century, but it was not until this time that the quantity and the quality of her silk production enabled Turkey to compete with Iran for the export of unwoven silk to Europe.[111]

Through the establishment of trade guilds in Bursa, strong attempts were made to maintain control over the quality of silk fabrics as well as to protect the rights of the weavers both as individuals and as a group. The entrepreneurs involved with silk were organized into two main categories: the dealers of unwoven silk and the weavers of silk fabrics. The weavers were divided according to the specific type of cloth they wove and were headed by master craftsmen. Both men and women served as apprentices and masters. Each step in the preparation of the silk for weaving was carefully regulated: the quality of the silk, the dyeing, the diameter of the warp and weft threads, and the number of threads used in weaving each type of fabric. The shops in the market in which a weaver could sell his products were also regulated. It was apparently difficult, however, for the guilds to prevent untrained weavers from weaving and selling their goods, which affected the quality of cloths available on the market.[112]

Although most of the weaving appears to have been done on looms in private houses in Bursa, occasional inventories indicate the ownership of many looms. Several men in Bursa are recorded in about 1587 as owning from twenty to sixty looms apiece.[113]

In spite of the intentions of the guilds to establish and maintain acceptable standards, the quality of the fabrics appears to have slackened, as indicated by the special laws and imperial edicts that were issued repeatedly throughout the sixteenth century in the attempt to reattain the desired quality. One of the financial laws of Bursa issued in 1502 lists specific types of cloth and instructs the weavers to return to weaving the quality of twenty-five years earlier. It is unfortunately no longer possible to identify firmly those earlier fine fabrics. This 1502 law specified the width of the fabric, the number and ply of the weft, and the quantity of gold and silver to be used. It also stated that 1,000 weavers in Bursa were doing defective work at that time and that 600 artisans had been summoned to testify as expert witnesses.[114] These figures indicate the large size of the silk weaving industry in Bursa.

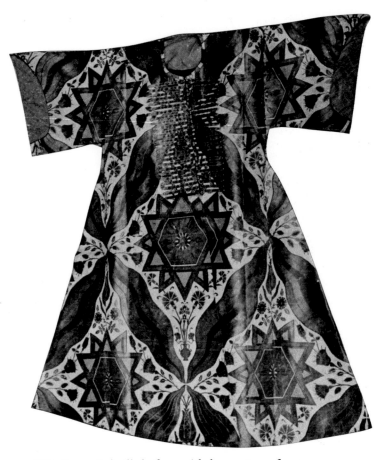

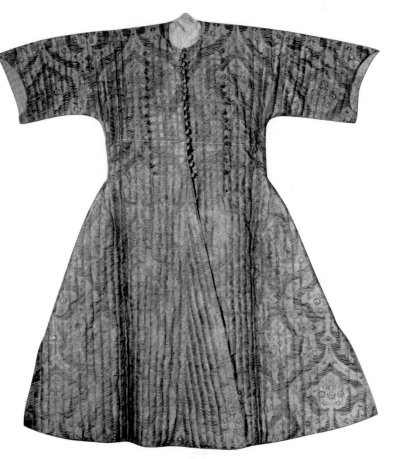

200. Brocaded silk kaftan with large stars, from İstanbul or Bursa; mid-sixteenth century. (İstanbul, Topkapı Sarayı Müzesi, 13/21)

201. Brocaded and quilted silk kaftan with arabesques, from İstanbul or Bursa; mid-sixteenth century. (İstanbul, Topkapı Sarayı Müzesi, 13/46)

plate 63 (p. 334); ill. 210

The Topkapı Sarayı purchased its Turkish silk fabrics from Bursa during the fifteenth century and continued buying there even after about 1525, when some silk fabrics could be acquired in İstanbul. An inventory of the Palace Treasury, dated 1504, itemizes fabrics used for kaftans, skirts, cushions, and nightcaps with Bursa in their name. Thirty kaftans are listed, "9 of Bursa Çatma, 9 of dotted silk of Bursa, 8 of velvet wrought with golden thread, 4 of gold and silk Kemha of Bursa."[115]

In 1518 Selim I ordered a supply of six specific types of Bursa fabric for the Palace Treasury from the *kadı* (judicial officer) of Bursa. The largest request was for 500 complete lengths of *seraser*, one of the most opulent Turkish fabrics, whose surface is primarily covered with gilt-and silver-metallic threads. Monochrome taffetas in red, yellow, and green were also ordered. Payment for the fabrics and their shipment was to be taken from the royal purse.[116]

It is particularly noteworthy that this very precise order does not specify any patterns. Which *seraser* pattern was desired? Were all 500 lengths identical? There is no indication in any of the known records that the court supplied weavers in Bursa with the patterns to be woven. Instead, it seems that patterns were designed especially for silk fabrics in the fashionable contemporary style of the court in order to compete favorably with all the other merchants selling fabrics. The court appears to have purchased silks from the same merchants as would anyone of sufficient means.

It is particularly difficult to try to reconstruct the development of the silk-weaving

industry in İstanbul, which eventually also supplied some of the needs of the palace. Although no Turkish records are known referring to silk weaving in İstanbul before the sixteenth century, silk fabrics were woven there during the Byzantine period, and weaving appears to have continued after the Turkish conquest. In 1480 Louis XI summoned Greek weavers from İstanbul to France.[117]

Among the published documents are several registers of craftsmen working in İstanbul, including weavers of specific cloths: 27 weavers in 1525, 105 in 1545, and 156 in 1557. The register for 1557 also lists sixteen designers for *kemha* (brocaded silk with metallic threads). Öz reports that between forty and fifty designers made colored models, which were carefully adapted for the brocaded silks and velvets.[118] Were any of these weavers or designers working in imperial workshops?

One of the earliest suggestions of the existence of imperial weaving manufactories in İstanbul occurs in 1530, when palace personnel were sent to Bursa to learn the art of weaving various fabrics from master craftsmen.[119] By 1577 there were 268 looms in the capital, 88 of which were "attached to the Palace."[120]

It appears that the imperial manufactories did not specialize in weaving only one type of cloth for the palace. About a half-dozen different types of fabrics including velvets, brocaded silks, the opulent *seraser*, and monochrome silk fabrics formed the 103 lengths of fabric that was one month's production by an imperial manufactory for the palace in 1568. A note at the end of the document states that additional fabrics had to be acquired to supply the needs of the palace.[121]

Edicts were also issued in İstanbul in an attempt to maintain the desired quality of the silk fabrics. An imperial edict issued by Süleyman I in 1564 states that in İstanbul the number of looms weaving four specific types of fabric had increased to 310 and that as a result of the "falsification" of silk and gold threads, requirements were being established to assure quality. Only one hundred honest owners of looms, not tenants, could continue weaving, and they must be registered. All fabrics with gold must receive a government stamp, and only such stamped fabrics could be sold. Price-fixing was also introduced. A length of the opulent metallic *seraser* fabric could not be sold for less than thirty-five Turkish gold liras.[122] Based on this edict, which was reissued by later sultans, stamping and price-fixing were maintained until the nineteenth century. However, other than noting that fabrics with gold were stamped after 1564, research by Öz into stamping and taxes sheds little light on the dating of the textiles.

An especially important imperial edict was issued in 1574 that, assuming it was enforced, greatly assists in the provenance attributions of most surviving sixteenth-century Turkish silks. It was addressed to the *kadı* of Bursa and stated that only the imperial manufactories in İstanbul were to be permitted to weave with gold in the future. Because extravagant amounts of gold had been used in weaving silks in Bursa, thereby exerting a strain on the country's gold supply, all weavers in Bursa were forbidden to use gold in their fabrics ever again.[123] This implies that the late sixteenth-century silks with gold, which have traditionally been ascribed to Bursa, were probably woven in İstanbul in the imperial workshops.

KAFTANS

There are today more than 1,000 kaftans in the Topkapı Sarayı Müzesi. Very few exist in other museums. It is extremely fortunate that it became the custom of the imperial palace to preserve the kaftans of the sultans, which were carefully wrapped and stored in the Palace Treasury. Inventories were written and rewritten. Through the process

plates 59, 60, 63, 64 (pp. 331, 334–35);
ills. 200, 201, 205, 210, 212, 213

of preserving and rewrapping the kaftans some identification labels have inadvertently been placed with the wrong kaftans,[124] and consequently the dating of the contents can no longer be relied upon. The unfortunate nature of this can hardly be overestimated. Instead of a corpus of kaftans whose contents are securely datable we have one whose dates must be questioned constantly. As a result, the dating of Turkish fabrics remains imprecise and must be based primarily on stylistic comparisons with other mediums, which provide tentative guidelines at best.

Most of the more than 1,000 kaftans in the Topkapı Sarayı are made of monochrome fabrics of silk, wool, or felt. No more than ten percent have patterns, almost all of which are silk fabrics. Of these, perhaps only one half are Turkish silks. The remaining patterned silks are imported.

ill. 68

The kaftans were worn as overrobes and were loosely tailored with flaring skirts, sometimes with protruding hips, and pockets. They are usually collarless. The full-or floor-length kaftans have three typical sleeve lengths: to the elbow, to the wrist, or tapered to the hem. The last usually has an opening at the elbow for the arm to emerge, while the rest of the sleeve hangs gracefully at the side. Many of these kaftans could also be worn "over the shoulder," an arrangement cleverly provided for by an opening slit in front of the shoulder for the arms. Many of the knee-length kaftans also have this same functional shoulder-opening slit, usually with elbow-length sleeves, as do those of jacket length.

The kaftans can be closed in the front by varying numbers of buttons or "frogs." The evidence provided by miniature paintings indicates that this type of closure was not associated with rank, nor does it seem to have been significant which side of the buttoned kaftan was folded over on top. Often when a kaftan was closed, a sash was worn as a belt, whereas when it was open, no sash was used.

Since the kaftans served as outer robes, relatively sturdy, tightly woven fabrics were desired to best display their wide, flaring shapes. Additionally the style of the kaftan allowed the large uninterrupted surfaces of the fabric to show the pattern to maximum advantage, especially the large-scale designs that characterize the sixteenth-century patterned silks.

ill. 201

Almost all the kaftans, whether fashioned of silk, wool, or felt, were lined, often with a monochrome plain-weave cotton fabric. For additional warmth during the winter, many were lined with fur, a few of which have star or ogival patterns formed by assembling different types of fur or by dyeing pieces of fur. The fur rarely showed on the exterior of the kaftan. However, three sheepskin coats survive that are decoratively pieced with many small brocaded fragments. In addition to fur linings many of the silk kaftans, both patterned and unpatterned, were padded and quilted for increased warmth.

Two kaftans confirm that the sultans wore "suits of armor"; a chain-mail vest was sewn inside a cotton lining, which in turn was hidden inside a typical monochrome satin-weave kaftan. Only its weight reveals its function.

BROCADED SILKS

plates 57, 59, 60 (pp. 330–31); ills. 200–204, 206

Turkish brocaded silks show considerable variety in their patterning, which is generally characterized by large designs and brilliant colors. A number of the designs woven in silk are stylistically comparable to those in other mediums, especially in manuscripts and ceramic revetments of buildings. The brocaded silks, however, have a vitality that can hardly be equaled. Vibrant colors are juxtaposed in areas both large and small, and they are further enhanced by the appearance of the fibers themselves—lustrous silk

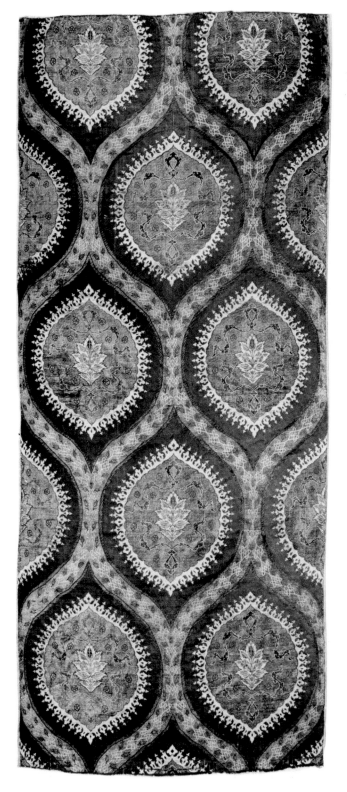

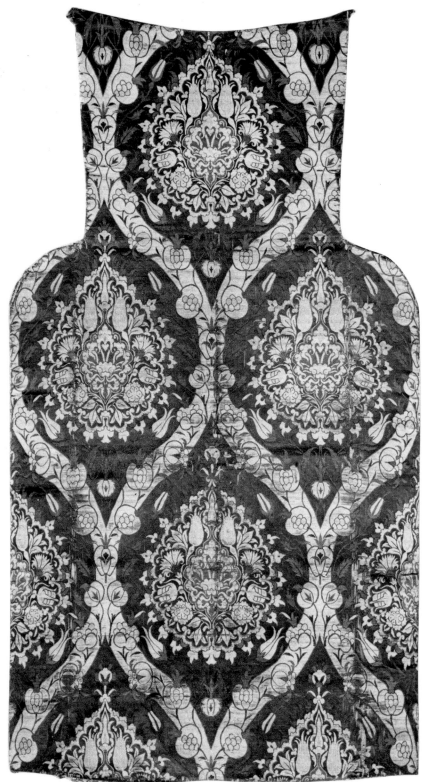

202. Brocaded silk length with ogival pattern, from İstanbul or Bursa; third quarter of sixteenth century. (Washington, D.C., Textile Museum, 1.70)

203. Brocaded silk length with ogival pattern, from Bursa; first half of seventeenth century. (Washington, D.C., Textile Museum, 1.57)

and brilliant metallic threads. The sophistication of the patterns indicates that the designers were not only familiar with the art of the court, but were also thoroughly knowledgeable about the weaving process and the means of achieving exquisitely detailed patterns. The patterns glorify flora in their imaginative use of designs in which small flowers are often silhouetted on larger leaves and blossoms. Foliate motifs intertwine and overlap each other. The real and the fanciful are combined to form brilliant imaginary gardens. This is achieved usually with only four or five vividly juxtaposed colors, which have admirably retained their original intensity over the centuries. Crimson, chartreuse, medium blue, white, and gilt-metallic threads are the most prevalent; less common are purple, dark brown, dark green, peach, and silver-metallic threads.

As previously mentioned, the dating of the elaborately patterned kaftans must be based on stylistic comparisons with other mediums. Although several of the documents cited refer to the excellent quality of the silks woven during the fifteenth and first quarter of the sixteenth centuries, it remains difficult on stylistic grounds to attribute the surviving brocaded silks to those early years with the one possible exception of the fashionable Ottoman pattern with three balls and paired wavy lines.[125] Most of the brocaded kaftans have patterns or display a handling of motifs comparable to the art of the third and fourth quarters of the sixteenth century.

plate 59 (p. 331)

Two arbitrary groups of brocaded silks are distinguishable: the very fine silk kaftans in the Topkapı Sarayı Müzesi and the lengths of fabric of indeterminate function in Western collections. Considerably more of the latter survive, generally with related patterns that rarely attain the quality found in the comparatively few extant brocaded silk kaftans.

The most creative and lavish textile pattern survives in two different color renditions, which is exceptional in itself. One fabric has an ivory ground, the other a dark brown ground.[126] In an infinite display, the real and imaginary palmette leaves and flora intertwine and are superimposed one upon another. Palmette leaves appear to sway in a breeze with the reverse side of a leaf rendered in a markedly contrasting color. The movement of the flora is further enhanced by the use of seven colors, including gilt-metallic thread, which is an exceptionally high number in Turkish brocaded silks. Contrary to almost all Turkish patterns, the layout of this exquisite design can hardly be identified, and the motifs do not repeat themselves on the entire length of either kaftan, both feats of superior design ability. The refinement of the design, sophistication of the continuous foliate pattern, and vivid placement of the colors confirm the consummate skill of the designer who, it would seem, must have been affiliated with the

ills. 88, 90

court. The sturdy quality of the fabric itself attests to the expertise of the weaver. Although none of the other decorative arts truly compares with the luxurious display of color, the closest stylistic parallel may be the Ottoman prayer rug in the Österreichisches

plates 55, 44, 45 (pp. 328, 270–71)

Museum für Angewandte Kunst in Vienna, and the exceptionally fine blue-and-white tiles made for the throne room in the Topkapı Sarayı in the 1550s and 1560s, now on the exterior of the Sünnet Odası.

ills. 200–204, 206

The patterns of almost all the other Turkish brocaded silks are organized into modular units that are immediately recognizable and become primary elements in the overall design. In accentuating rather than disguising the modular repeat of the pattern the intrinsic qualities of the woven medium are expressed. The individual design motifs are also directly represented, limiting the use of multiple levels of design primarily to small motifs silhouetted on larger flora. The almost immediate perception of the pattern

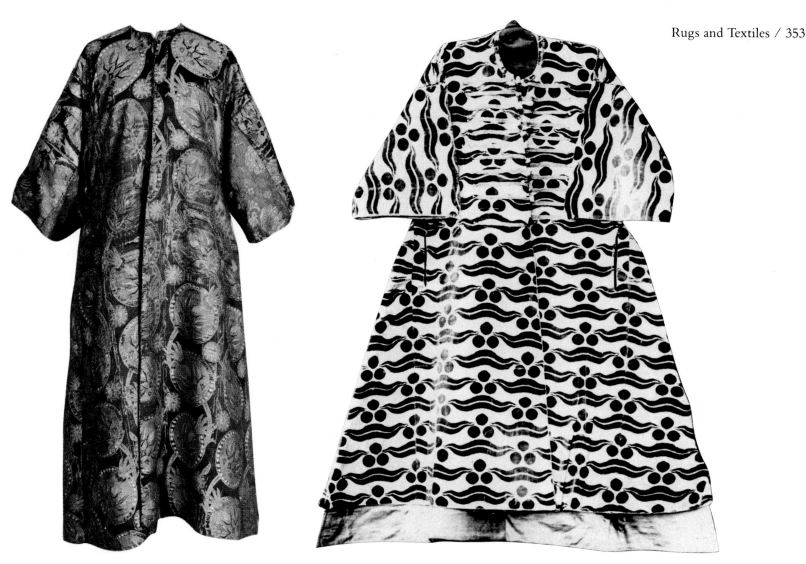

204. Brocaded silk kaftan with pomegranates, from İstanbul or Bursa, mid-sixteenth century. (Athens, Benaki Museum, 3900)

205. Velvet kaftan with spot-and-stripe pattern, from İstanbul or Bursa; sixteenth century. (İstanbul, Topkapı Sarayı Müzesi, 13/6)

with its subtle refinements reflects Turkish taste. Although Iranian artists were working in the Ottoman court studios during the sixteenth century, the concept of design and space in the sixteenth-century brocaded silks is a Turkish contribution, and an outstanding one in the history of patterned silks.

The particularly striking pattern of one kaftan consists of very large twelve-pointed stars framed by "diamonds" that are formed by paired wavy lines. The latter are similarly placed on the diagonal in large tile panels, ceramic plates, bookbindings, and rugs dating from the second half of the sixteenth century.[127] The Turkish predilection for chimerical flora was as fashionable in brocaded silks as in other mediums, as can be seen in the polychrome blossom in the center of the star from which hyacinths and tulips grow. Outside the star, carnations, roses, tulips, and spiraling blossoms appear on the ivory ground and give the pattern an upward direction.

ill. 200

Another beautiful pattern in a short-sleeved, padded, and quilted kaftan is formed by a bold gilt-metallic arabesque bearing delicate rosettes and palmette blossoms on a crimson diaper ground. The crimson diaper pattern produces a shimmering and enigmatic effect that is achieved by the contrasting ninety-degree angles of the warps and wefts.

plate 60 (p. 331); ill. 201

ills. 202–204, 206

plate 58 (p. 330)

ills. 203, 204

plate 57 (p. 330)

ill. 202

ill. 203

ill. 87

This textile is another example in which the designer and weaver utilized their expertise in weaving silk to maximum advantage.

Only very few extant kaftans are patterned by the two types of layout that characterize most of the fabric lengths in Western collections: ogival and vertical stem layouts. The large scale of these modular units requires ample space in which to develop fully and repeat the pattern, with the result that most of the stylistic comparisons are on the tile revetments of buildings. Occasionally a rare example appears in a later knotted-pile or tapestry-woven rug.[128]

The ogival layout, formed by a curved diamond lattice, typically displays a row with two ogival medallions alternating with a row with one complete medallion flanked by two half-medallions across the loom width of the silk, about sixty-five centimeters. In using this layout the designers varied the details of the drawing and the juxtaposition of relatively few colors with considerable skill. The favored motifs include the many popular Turkish flowers, leaves, interlacings, and cloud-bands. Only rarely were animals or birds included.[129]

In the finest silks, which are usually very tightly woven, the outlines of the large units, the medallion and framing ogival lattice, are rendered to create visual interaction between the adjacent areas by means of scalloped, serrated, or reciprocal contours. This refinement adds a subtle vitality to the large repetitive pattern.

An exceptionally beautiful and sophisticated version of the ogival patterning appears in a silk in the Benaki Museum in Athens. Exquisite palmette blossoms and leaves are arranged in a layout less common in Turkish art: the pattern is formed by two overlapping ogival units.

The drawing in these silks suggests at least two identifiable periods of style. The earlier is a classical, restrained style, which can date from as early as about 1550, in which all the motifs are carefully contained within the outlined areas. From this evolved a freer and looser style in which the motifs move from one spatial area to another, creating a flamboyant effect. These can be attributed to the very late sixteenth and early seventeenth centuries.[130] In addition, the scale of the pattern is reduced in some of the later seventeenth-century fabrics, producing three or more ogees across the loom width. These fabrics usually have a flimsy, rather than sturdy, well-woven appearance and handle. However, the fabrics cannot be attributed to the seventeenth century solely because of their woven quality. The numerous imperial edicts issued during the sixteenth century confirm the uncontrollable fluctuations in the woven quality of silks. Some flimsy silks are undoubtedly sixteenth-century productions. The nature and quality of the design, therefore, remain important guidelines in dating these silks.

As a result of the extensive trade with Italy, which will be discussed later, a few Italian motifs, especially the crown and pomegranate, were adopted by the Turkish silk designers and incorporated into their patterns.[131] In Italy the designers also copied Turkish motifs and in some instances made brocaded silks remarkably similar to the patterns and colors in Turkish silks.

In contrast with the extremely few surviving kaftans with ogival layouts, sixteenth-century Turkish manuscript illustrations depict kaftans with ogival patterns probably more often than any other type. The illustrations also record two important uses for lengths of patterned silks in which ogival patterning is prominent. On ceremonial occasions when the sultan appeared on horseback, lengths of a specially named silk were laid on the ground as a royal "carpet" for his horse to tread on. Also in these scenes and during festivals attendants hold lengths of silk to form barricades to contain the crowds.

The use of ogival patterning for tile revetments is frequently found by the 1560s, as can be seen in the Rüstem Paşa Mosque in İstanbul, and it appears to have retained its popularity well into the seventeenth century. These dates would indicate a similar time span for the silks displaying comparable stylistic features.

The source of the very popular ogival layout in sixteenth-century Turkish art is uncertain. A few earlier examples are scattered throughout the Near East, usually in silk fabrics, including medieval Iranian and Byzantine silks. It appears to have gained its greatest popularity in Mamluk Egypt, with examples occurring in thirteenth-century metalwork and fourteenth- and fifteenth-century silk fabrics.[132] Ogival patterning was also widely used in fifteenth-century Italian silks. Although either Egypt or Italy could have supplied the ogival layout prototypes for the Ottomans, the survival of Italian fabrics, including the fifteenth-century examples in the Topkapı Sarayı Müzesi, suggests that Italy may have provided the inspiration.

The second type of layout—vertical stem patterning—occurs considerably less frequently than the ogival patterning in both the brocaded silks and the tile revetments. Kaftans of this type are also extremely rare. The pattern is based on the repetition of an undulating vertical stem from which grow large leaves and sometimes flowers. Often smaller flora are silhouetted on the larger leaves.

The drawing styles can again be identified as the simple and the elaborate. The earlier examples display their elegant foliate patterning with admirable clarity and restrained grace. The drawing in the slightly later fabrics is more lavish and exuberant with fanciful, swaying palmette leaves bearing superimposed swirling blossoms.[133] Some of the latest renditions, dating from the mid-seventeenth and possibly even eighteenth century, have a compressed layout that denies the vitality of the mid-sixteenth-century examples. The appearance and workmanship of these fabrics also tend to be inferior.[134]

An exceptionally graceful and uncluttered vertical stem pattern is found in Bursa on the tile revetments of the Mausoleum of Şehzade Mustafa, who died in 1552.[135] This type of patterning appears to have become especially fashionable from the early 1560s until at least the seventeenth century.

It is highly probable that this layout developed from the innovative fourteenth-century Chinese brocaded silks with undulating vertical stem patterns, which are believed to have greatly influenced Italian silks. Whether the Chinese silks inspired the Turkish designers directly, or the Italian silks served as the intermediary, remains unknown.

VELVETS

There are very few extant velvet kaftans that were unquestionably made with Turkish velvets. There are, however, a number of fine velvet fragments, some of which are exceptionally well woven, and a surprisingly large quantity of cushion covers in Western collections. Records confirm that velvet was woven in Bursa during the fifteenth century; however, very few fabrics can be dated so early owing to their patterns.[136] Although only three or four colors were used in the velvets—maroon, ivory, chartreuse, or pale blue and gilt- or silver-metallic thread—the nature of the pile weave provides the appearance of additional color tones. The perception of color in velvet changes depending on the relation between the angle of light striking the velvet pile and the position of the viewer. The same fabric may appear to have shimmering delicate tones or lush rich tones.

The fashionable Ottoman pattern of paired wavy lines and three balls appears in one

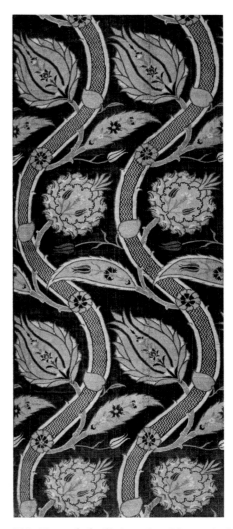

206. Brocaded silk length with vertical stem pattern, from İstanbul or Bursa; third quarter of sixteenth century. (New York, Metropolitan Museum of Art, 52.20.21)

ill. 205

ill. 207

ill. 205

plate 53 (p. 327)

velvet kaftan in maroon on an ivory ground. This is probably the closest example to the previously mentioned, similarly patterned white-ground Anatolian rug. A comparison of the differing effects in the two woven mediums is particularly striking and revealing. The drawing in each reflects the intrinsic characteristics of that specific medium. This same pattern in maroon and metallic threads also appears in fine fragments in Western collections, as do a variety of large carnation patterns.

ills. 99, 207

Based on their depiction in Turkish miniatures, cushion covers can be readily identified by the presence of a row of lappets across each end of the fabric, which is usually about 110 centimeters long. They were used to cover cushions placed on divans. Although the patterns of some of the covers face one direction, most are symmetrical and self-contained, with a large central medallion displaying flora flanked by large leaves or blossoms bearing superimposed motifs. The strong, bold patterns that characterize these cushion covers were usually achieved with a palette of three colors: maroon, ivory, and metallic threads. Sometimes chartreuse or blue was included. Most of these silk-velvet covers were woven with cotton foundation weft. The use of cotton in velvets is known from an inventory, dated 1486, that lists "cotton velvet of Bursa."[137] The quality of the pattern and woven fabric in most of the many surviving covers suggests that they are seventeenth- and eighteenth-century pieces. Cushion covers were also woven in Üsküdar (Scutari), located across the Bosporus from İstanbul, during the nineteenth century.

plate 61 (p. 332)

ill. 209

There is a small group of velvets with exceptionally large ogival patterning that combines both Turkish and Italian designs. Often the fashionable Italian motif of a crown is present.[138] These velvets may have been woven throughout the sixteenth century and survive today as lengths in Western collections.

ill. 208

Velvet fabrics were not limited to clothing and furnishings; they were also used to make handsome book covers and gorgeous horse covers. Gilt and silver threads form the fashionable flowers that are skillfully arranged on a lush maroon velvet ground in this horse cover. Two shaped fabrics, each loom-width, were sewn down the center to form the cover, which apparently was never used.

It is especially difficult to compare the patterns in velvet with those in other mediums, and therefore their dating remains tenuous. The patterns do, however, display the general features discussed in relation to the ogival and vertical stem layouts. Only a few velvets have delicate patterns; most have exuberant designs and date from the seventeenth and eighteenth centuries.

In comparison with the velvets that were being woven in Iran and Europe during the sixteenth century, Turkish velvets prove their excellent technical quality in being able to withstand considerable abrasion. They do not, however, utilize as many colors as the Iranians were ingeniously able to weave into one fabric, nor do they display the contrast of texture possible through varying the heights of pile or using uncut pile (loops) as did the Italians. The weaving of Turkish velvets does not appear to have developed to the same degree of excellence as the contemporary international manufacture of velvets or to the extraordinary heights achieved by the designers and weavers of the Turkish brocaded silks.

SERASER FABRICS

The most opulent Turkish fabric, *seraser*, does not appear in the records in either Bursa or İstanbul until the sixteenth century. This fabric is covered with gilt- and silver-

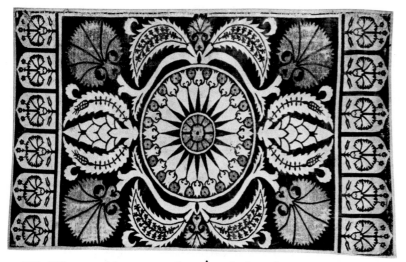

207. Velvet cushion cover, from İstanbul; early seventeenth century. (Washington, D.C., Textile Museum, 1.54)

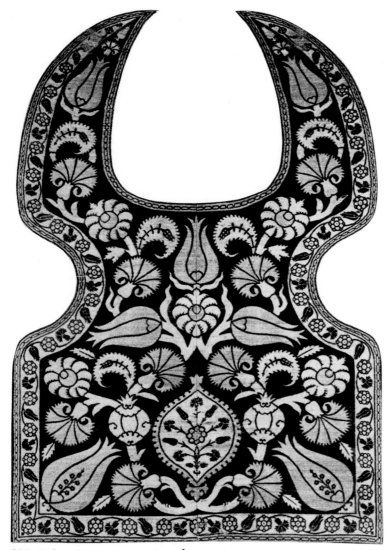

208. Velvet horse cover, from İstanbul; late sixteenth century or early seventeenth century. (Athens, Benaki Museum, 3784)

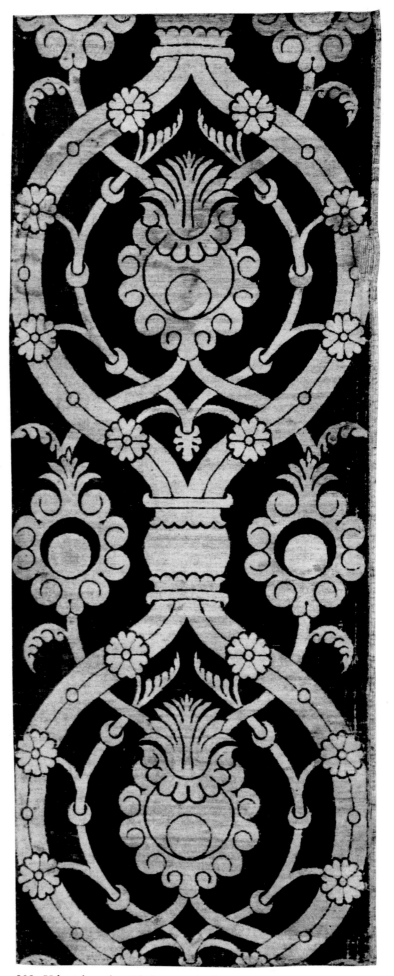

209. Velvet length with large ogival pattern, from İstanbul; seventeenth century. (Lisbon, Calouste Gulbenkian Foundation, 190)

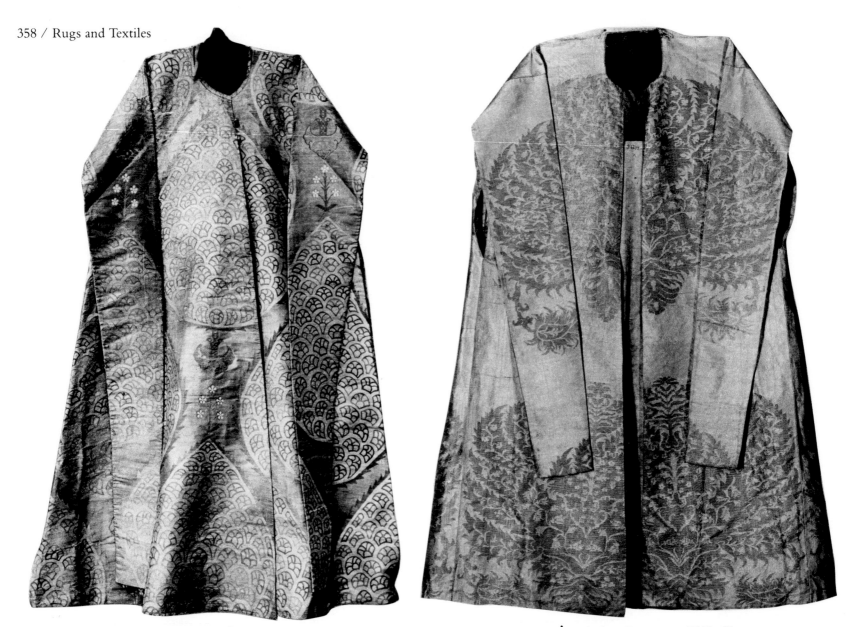

210. Seraser kaftan, from İstanbul; second half of sixteenth century.
(İstanbul, Topkapı Sarayı Müzesi, 13/9)

211. Silk kaftan, from İstanbul or Bursa; ca. 1760. Given to an envoy of Frederick the Great of Prussia to the Ottoman court in 1762.
(East Berlin, Staatliche Museen zu Berlin, Islamisches Museum, 1.6894)

plate 63 (p. 334); ill. 210

metallic threads, with only a little chartreuse or rose silk used to outline the pattern. Perhaps in order to show off large areas of shiny metallic threads, the patterns are atypically large and sparse, with only one motif filling the loom width of the fabric. Stylistic parallels are lacking even on a smaller scale in other mediums. One record indicates that five different qualities of *seraser* were woven,[139] all of which remain to be identified.

The lack of comparative material makes it difficult to date the few known examples. Those that are extremely well woven with a clearly rendered pattern are attributed to the sixteenth century, when documents confirm the manufacture of the cloth. The luxurious gilt- and silver-metallic surfaces caused this fabric to be one of the most expensive ever woven anywhere, and one that probably could have been made only while the court was at its height.

Among the few surviving examples are a pair of wide loose trousers (*şalvar*) with a huge crescent,[140] kaftans with large "artichokes" or with triple peacock tails, and

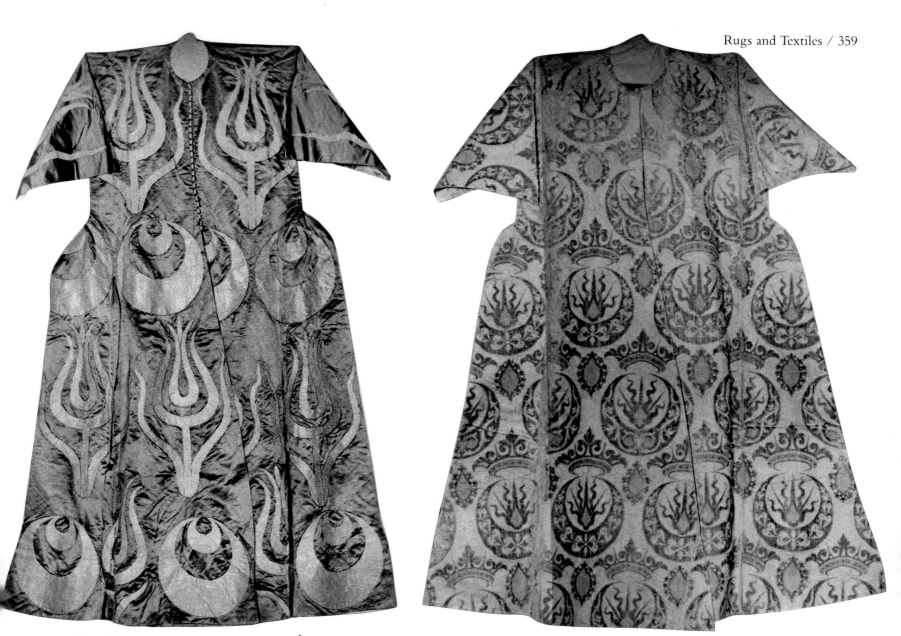

212. Silk kaftan with metallic appliqué, from İstanbul or Bursa; seventeenth century. (İstanbul, Topkapı Sarayı Müzesi, 13/514)

213. Italian (Venetian [?]) velvet kaftan with Turkish and Italian motifs; sixteenth century. (İstanbul, Topkapı Sarayı Müzesi, 13/279).

an occasional cushion cover. Such covers, embroidered with pearls, were used in the throne room of the Topkapı Sarayı.[141]

The only large designs related to those on the *seraser* appear in very flimsy, lightweight, unlined kaftans. Yellow or brown silk patterns a white ground. Two kaftans of this quality have been referred to as fourteenth century.[142] A remarkably similar kaftan is securely dated to 1762, when it was given as an honorary robe to a special envoy of Frederick the Great of Prussia to the Turkish court.[143] The colors, monumental drawing, and mediocre weaving remain relatively consistent in all the examples, which suggests that they all were probably made during the eighteenth century.

ill. 211

OTHER TECHNIQUES

A variety of techniques was employed in the production of textiles.[144] Pressing weighted stamps onto already woven fabrics was widely practiced to form subtle

patterns. Many of the monochrome satin kaftans were "patterned" by closely set lines, sometimes skillfully arranged as chevrons. Occasionally floral motifs or crescents were stamped, and, when done on velvet, an especially lush textural effect was produced.[145] Another type of stamping involved the application of gold or silver paste to a monochrome ground,[146] a technique illustrated in the *Surname* of Murad III.[147]

ill. 212

A few kaftans are patterned by appliquéing large motifs, such as tulips and crescents made with metallic threads, on a crimson satin-weave fabric. Occasionally damask fabrics survive, including one with a pattern of large circles containing three balls.

IMPORTED FABRICS

Since antiquity silk as well as woolen fabrics were highly regarded and therefore were often cherished possessions. Rulers frequently presented them as gifts. The transportation of fabrics from one remote area to another has often been recorded by geographers and historians. Their light weight and easily transportable nature also helped them become major and highly desirable items of trade. The patterns of imported fabrics often influenced local designers. As previously mentioned, the patterns in some Chinese silks inspired late thirteenth- or early fourteenth-century Konya rugs, fourteenth-century striped silks, and sixteenth-century silks with vertical stem patterning. Although many Chinese silks must have been transported across Anatolia on the silk route, none is known to have survived there. One imperial edict even records that Chinese silks of specified quality were imported in 1452.[148]

ills. 172, 173
ills. 199, 204

The existence of documents and actual fabrics confirms the transportation of woven silk fabrics between Turkey and Iran during the sixteenth century. Iranian silk fabrics are recorded in the previously mentioned Topkapı Sarayı inventory of 1504, and a few lengths of Iranian velvet of a later date survive in the Topkapı Sarayı Müzesi. None of the kaftans observed, however, appear to have been made of Iranian fabrics, nor do any of them display stylistic influence from Iran. Among the items listed when the Safavid capital of Tabriz was temporarily captured by Selim I in 1514 were ninety-one garments of Bursa fabric.[149] That Turkish fabrics were highly regarded in Iran is confirmed by an order from Shah Tahmasp in 1575 for cloth from Bursa.[150]

As for the West, both Turkish and Italian archives confirm the importance of the trade of woven silks between the two countries. Italian merchants, especially the Venetians, Genoese, and Florentines, lived in Bursa and in Galata, located across the Golden Horn from İstanbul, where they were actively involved in trade. According to the evidence provided by customs registers, Bursa fabrics were highly prized in Italy by the end of the fifteenth century, and they were also exported to northern Europe. Three different types of Bursa velvet are recorded in 1483 as gifts to Bendirye, the ambassador of Venice.[151]

Italian textiles were also imported to Turkey, as suggested by the entry citing "Western" textiles in the 1504 palace inventory. Velvets from Venice, Genoa, and Florence were sold in three specific shops in Galata according to the İstanbul 1533 register.[152]

As previously mentioned, approximately one-half of the kaftans with patterns are made with Turkish fabrics; the other half, with Italian silks. It is especially noteworthy that so many of the kaftans are made with foreign fabrics and that almost all of these imported fabrics are Italian. This apparent choice of the sultans reflects the contemporary political atmosphere and the desire to substitute for the previous admiration of Iranian culture the new, envied European, and especially Italian, artistic traditions. This became

particularly apparent in the brief "Italian" painting style of the portraits of the sultans initiated by Mehmed II.

Among the Italian silks used in the kaftans are two general categories: those with purely Italian designs and those with some, or occasionally all, Turkish motifs. Most of the kaftans with Italian fabrics are velvets, some of which have a strip-metal ground,[153] as in the illustrated example. Orange cut velvet and uncut velvet (loops) form an international pattern of Italian crowns and Turkish crescents. Other favorite motifs include tulips and paired wavy lines. Some of these Italian velvets display such an abundance of Turkish features to the exclusion of Italian motifs that their provenance can be determined only on technical grounds. The individual motifs, layout, scale, and colors may appear Turkish but the presence of a strip-metal ground or of two levels of velvet pile indicates an Italian origin.[154]

ill. 213

A few of the Italian velvets with typical Italian patterns form a distinctive group of kaftans that have large pointed collars in the Italian fashion instead of having no collar in the Turkish style. The linings of the kaftans, however, indicate that they were made in Turkey. These kaftans with their large pointed collars were not the sole prerogative of the sultans, but were also worn by high-ranking government officials, according to their representations in sixteenth-century paintings. It is quite possible that these kaftans made with Italian velvet in an Italian fashion were among the most highly admired in the court.

ill. 67

Banners and Tomb Covers

Two specific types of fabrics—banners and tomb covers—have long been associated with Muslim religious practices according to early reports. Ottoman manuscript illustrations record the use of banners during religious and ceremonial processions, during battle when they symbolically invoke the blessings of God on the soldiers, and during the pilgrimage to Mecca. Most of the surviving banners are very large, in the shape of a shield; many bear pious inscriptions that may include the Muslim Profession of Faith, "There is no God but Allah and Muhammed is His Prophet," verses from the Koran, framed geometric and foliate patterns, and occasionally the two-bladed sword. Green and crimson are the dominant ground colors. None of the banners can be firmly dated earlier than the beginning of the seventeenth century.[155]

ills. 214, 215

Also represented in Ottoman painting and found on the symbolic sarcophagi in Ottoman mausoleums are silks decorated with calligraphy. Within a large chevron layout is the Profession of Faith, phrases praising God, and Koranic texts. These silk fabrics are frequently crimson or green with white calligraphy and may occasionally have metallic threads.[156] Their dating is particularly difficult since they appear to have been woven for several hundred years without significant variation. Because many of the extant fabrics are wider than the sixteenth- and seventeenth-century silks and in excellent condition, it must be questioned whether they are actually that early. They do, in any case, represent the continuation of a tradition, whose holiest expression was the *kiswa*, the cover of the Kaaba in Mecca.

Embroidery

Fine embroidery was a cherished item during the sixteenth century. It was, for example, awarded as the winner's prize in archery contests, according to the Hapsburg ambassador, Ogier Ghiselin de Busbecq.[157] The value of embroideries was manifold since

plates 62, 64, 65 (pp. 333, 335–36); ills. 216–221

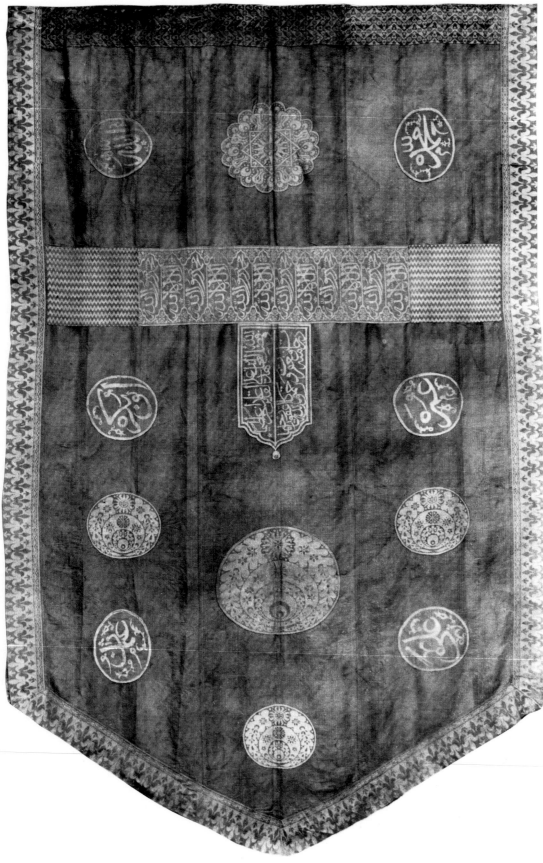

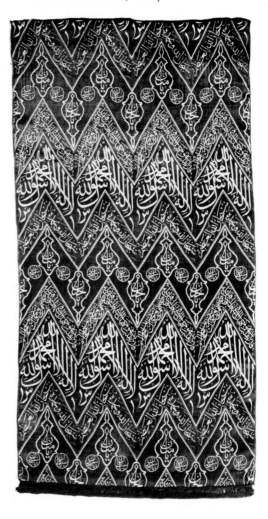

215. Silk tomb cover with verses from the Koran and pious invocations; eighteenth century or nineteenth century. (Washington, D.C., Textile Museum, 1.84)

214. Silk banner; early seventeenth century. (Cambridge, Mass., Fogg Art Museum, 1960.97)

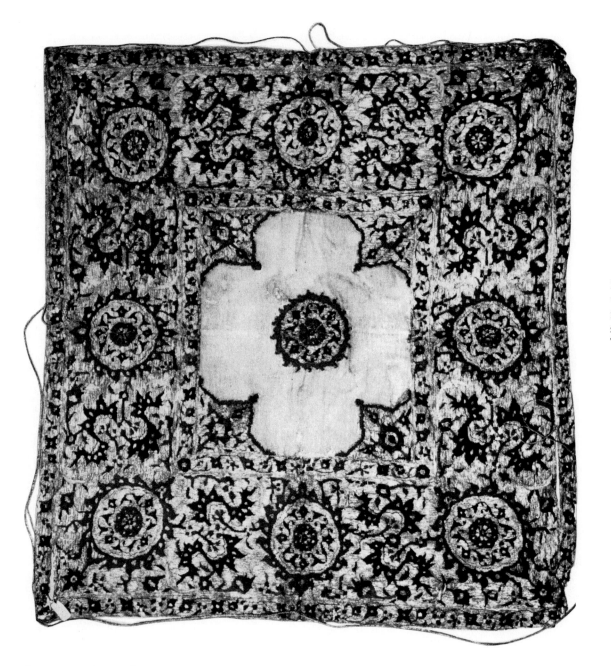

216. Handkerchief embroidered with silk and metallic threads, from İstanbul (?); second half of sixteenth century. (İstanbul, Topkapı Sarayı Müzesi)

they served a wide variety of important and specific functions, such as curtains, covers, towels, and many types of wearing apparel.

The craft was worked by women in the seclusion of their quarters. As young girls, they learned the embroidery stitches from their elders while following the tradition of preparing embroideries for their dowries. The finished product required little financial expenditure. Silk was used for the stitches embroidered on linen, and later cotton, cloth that was often woven at home. Time was the greatest prerequisite.

In Turkey as in many other areas of the world, women, regardless of their station in life, often chose to embroider the most fashionable designs available, which would have been those worn by the sultan and members of his court. Embroideries became homemade versions of elegant silk fabrics, especially brocaded silks. Most of the early extant embroideries survive in museum collections, especially in the Topkapı Sarayı Müzesi, which houses some truly exceptional examples. Perhaps they were made by the sultans' harem. Since embroideries are not the products of any type of organized manufacture, it is unlikely that informative records exist to illuminate the dilemma of dating them.

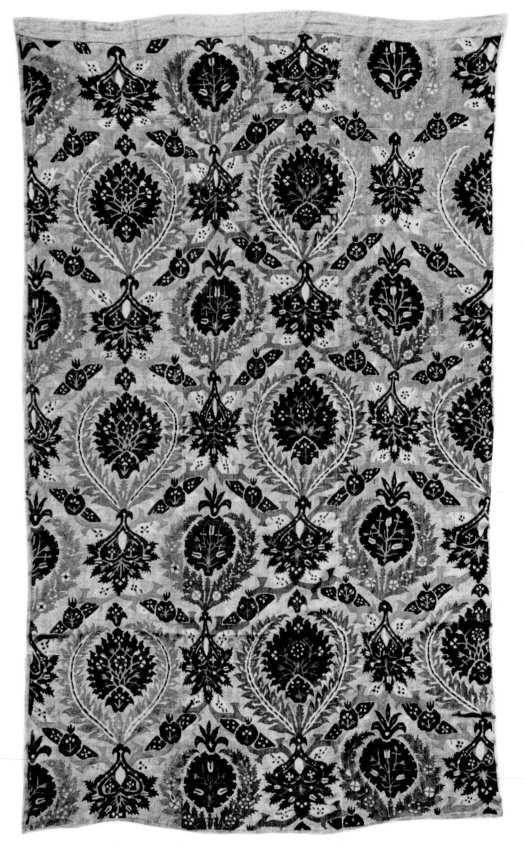

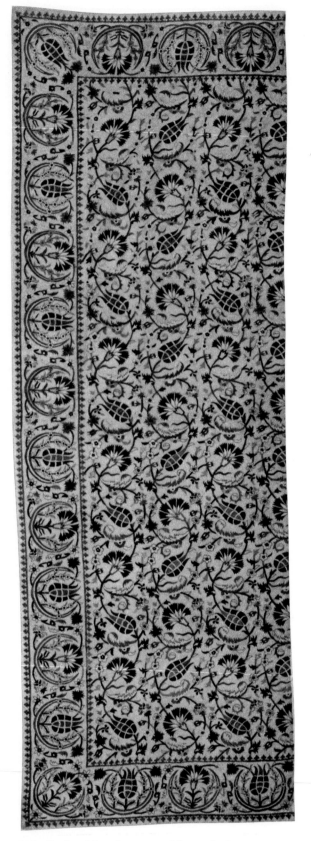

217. Embroidered curtain (?) with two ogival patterns; seventeenth century. (Washington, D.C., Textile Museum, 1.42)

218. Embroidered cover with vertical stem pattern, from İstanbul (?), beginning of eighteenth century. (Washington, D.C., Textile Museum, 1.22)

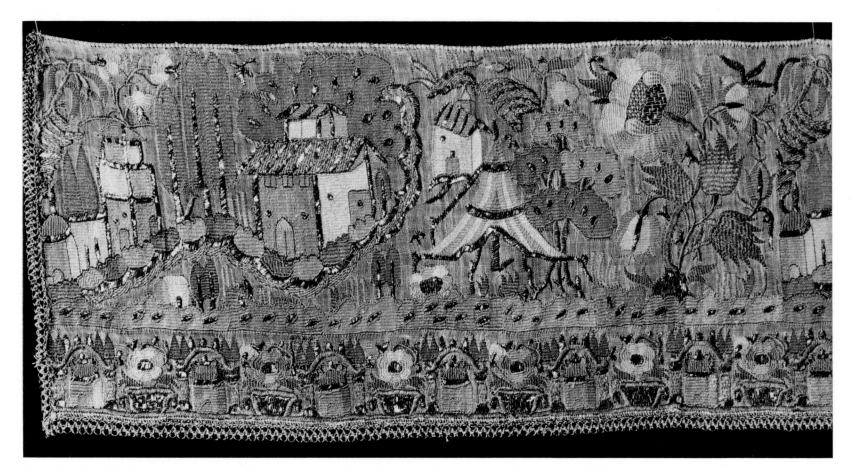

219. Towel end (embroidered pattern of houses, tent, and trees beside a river); nineteenth century. (Chicago, Art Institute of Chicago)

Among the treasures of the Topkapı Sarayı Müzesi are two large full-length coats with exquisite embroidery to be worn over a monochrome kaftan. Both coats are made with an undecorated crimson satin-weave fabric and have a very wide embroidered border outlining the neck, front, hem, and side slits. On the vibrant gilt-metallic ground of this border are either finely worked arabesques and cloud-bands or diagonally placed motifs of the "spot-and-stripe" pattern together with delicate blossoms. Both the fine workmanship of the embroidery and the luxurious appearance of the design and colors are outstanding. Although embroideries are more difficult to date than woven silks, the patterning in the embroidered bands is in the style of the finest mid-sixteenth century Ottoman art and may possibly date from that century. plate 64 (p. 335)

Ceremonial handkerchiefs (*mendil*), undoubtedly used by the sultans, form another exceptional group of embroideries in the Topkapı Sarayı Müzesi.[158] Since early Islam, Turkish rulers have traditionally been represented holding in their left hand a handkerchief, a symbol of rank. One of these rare examples has a gilt-metallic ground patterned with silver medallions outlined in red, separated by blue cloud-bands and a delicate green arabesque. Both the drawing and colors suggest that it was made in the second half of the sixteenth century. ills. 216, 68

The earliest surviving embroideries from the sixteenth and seventeenth centuries are characterized by simple and direct patterns worked with the same four colors that typify the woven silks: crimson, medium blue, green, and ivory. Metallic threads are rare. Reflecting the stylistic development of the brocaded silks from the refined to the exuberant, embroidered patterns of the seventeenth and following centuries ill. 217

220. Warrior's shield with pattern formed by silk threads wrapped around wicker; second half of sixteenth century or seventeenth century. (İstanbul, Topkapı Sarayı Müzesi, 1/2571)

plate 62 (p. 333); ills. 217, 218

221. *Right:* Two-poled, oval, cotton tent with pattern appliquéd in cotton, silk, and leather (detail); seventeenth century. (Krakow, Poland, Wawel Castle, 896)

become increasingly complex and elaborate. The shading of floral motifs was introduced, enhanced by the use of about a dozen colors, which has resulted in some especially fine embroideries from the eighteenth and nineteenth centuries.[159] The use of metallic threads was also very fashionable.

Various embroidery stitches used over the centuries have been carefully identified and published.[160] The stitches, however, do not shed light on a chronological development or on dating the embroideries.

Wearing apparel with fancy embroidery includes head scarves, *şalvar*, shaving robes (which were also worn at meals), sashes, shoes, slippers, and leather boots. Covers (*bohça*) embroidered with the favorite Turkish flowers were made to protect clothing, bedding, and tables. Some were also used as wrappings and for carrying supplies. Specific sizes, often with a special design layout, were used for certain types of covers.[161] A turban, for example, was covered by a square cloth embroidered with a floral medallion in the center and floral bouquets facing inward from the corners. During the eighteenth and nineteenth centuries, fabrics were also lavishly embroidered with mihrabs,

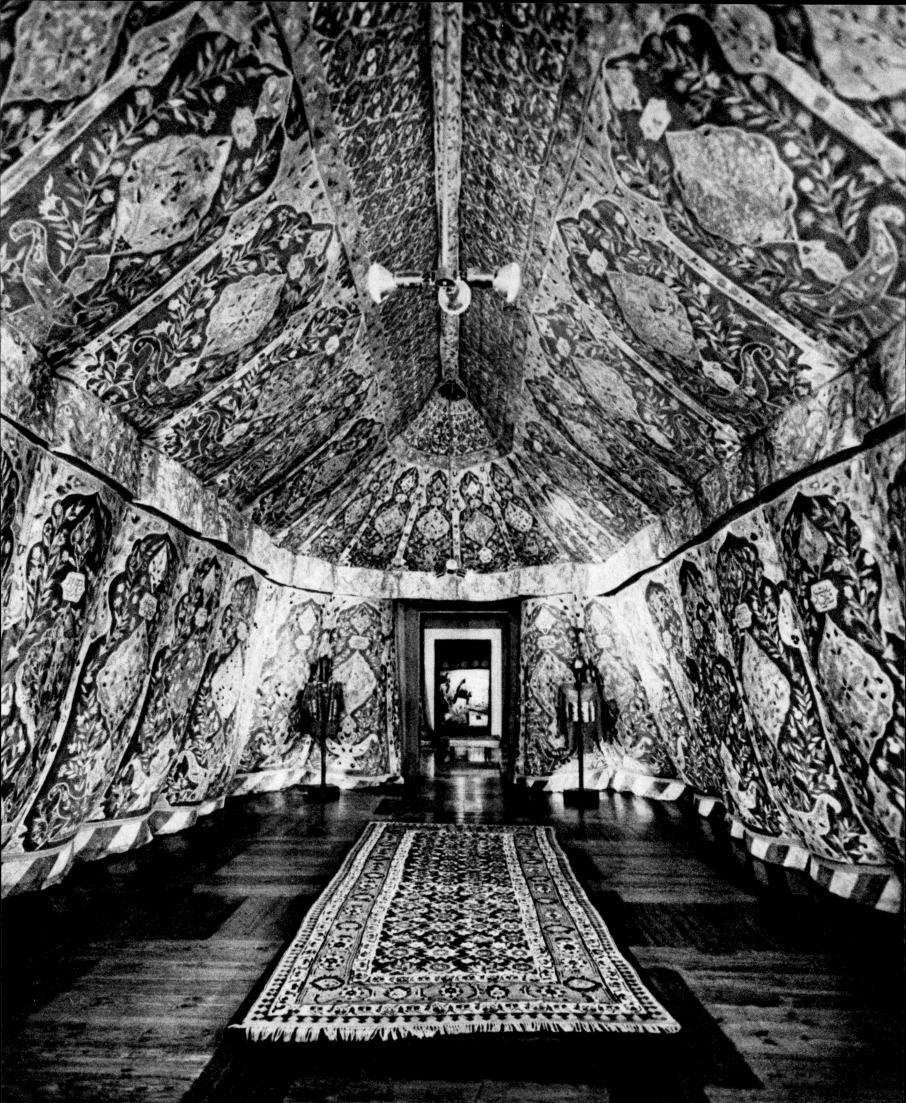

probably to be used in secluded quarters as prayer "rugs." Among the larger embroideries are curtains and a velvet "rug."

ill. 219

Possibly the best-known Turkish embroideries are the towels.[162] Some large Turkish towels have pile loops; many, however, have no pile and are similar to the Western guest towel. They are fancifully embroidered at each end of the long cloth with a variety of brightly colored patterns such as buildings, trees, landscapes, figures, sailboats, fruit, flora, and *tuǧras*. These towels show the skill and imagination of the embroiderer.

ill. 220

Although embroidery is not readily associated with armament, several finely embroidered quivers in the Topkapı Sarayı Müzesi were probably made during the seventeenth century[163] as were round warrior shields. Silk was wrapped around wicker to form decorative floral patterns.[164] These would have been used while on campaigns

plate 65 (p. 336); ill. 221

during the night the sultan and his retinue would rest within lavishly appliquéd and embroidered tents.[165] Fabrics were an essential ingredient in the daily lives of the Turks and one which, when associated with the Ottoman court, acquired a degree of elegance and refinement still highly admired several centuries later.

Conclusion

This discussion of some of the rugs and textiles woven in Turkey provides only a brief overview of an immense production. Extensive research is still needed in the Turkish and European archives to increase our understanding of the socioeconomic conditions under which the fabrics were woven, as well as their artistic sources. Further study of the fabrics themselves will undoubtedly reveal a host of unasked questions and provide clues to some of the existing queries.

Perhaps the most pressing concern is the need for immediate fieldwork in villages in Turkey where rugs and textiles are still being woven. Information should be recorded about the types of weaving, the patterns, and all aspects of their production and marketing. With industrialization beckoning the weavers away from the villages, the ancient traditions may disappear before our eyes during the final decades of the twentieth century. Therefore, the importance of this documentation cannot be overestimated. Not only are they significant as a record of contemporary production, but modern examples of certain types of textiles and rugs can also shed invaluable light on older pieces and customs. Assembled together, this information contributes to a broader understanding of an old tradition that has produced some of the most outstanding woven fabrics in existence. Many of the Turkish rugs and textiles display a superb sense of design and marvelous use of color in harmony with the woven structure. Both in the folk-art style and in the court-art style they have made outstanding contributions to the history of woven fabrics.

Notes

1. Sergei I. Rudenko, *Frozen Tombs of Siberia* (Berkeley and Los Angeles, 1970), pp. 298–304 and figs. 174–75 (color). Slight structural difference: the Pazyryk rug has three wefts between each row of knots, Turkish rugs have two.

2. All-wool; ivory (sometimes brown) warp, two z-spun s-plied; red weft, z-spun yarns, two shots; pile, two z-spun yarns, symmetrical knot, slant to left, knot count ranges generally between fifty and ninety

per square inch. Distinctive features may include end and side finishes, diagonal lines (formed by successive rows of discontinuous wefts), and colors.

3. Kurt Erdmann, *Seven Hundred Years of Oriental Carpets*, ed. Hanna Erdmann, trans. M. H. Beattie and H. Herzog (Berkeley and Los Angeles, 1970), pp. 41–46, figs. 23–30.

4. Agnes Geijer, "Some Thoughts on the Problems of Early Oriental Carpets," *Ars Orientalis* 5 (1963): 83 and figs. 1–2.

5. Ibid., p. 83.

6. R. B. Serjeant, "Material for a History of Islamic Textiles up to the Mongol Conquest," *Ars Islamica* 15–16 (1951): 57.

7. Ernst Kühnel suggests that Turkish rugs were exported to Europe before 1304, basing this supposition on what he incorrectly called a "fully analogous" rug painted by Giotto in the Arena Chapel in Padua. The rug, or possibly textile, does not appear Turkish and may be European (Wilhelm von Bode and Ernst Kühnel, *Antique Rugs from the Near East*, 4th ed., trans. C. G. Ellis [Braunschweig, 1958], p. 24).

8. C. J. Lamm, "The Marby Rug and Some Fragments of Carpets Found in Egypt," in *Svenska Orientsällskapets* (Arsbok, 1937), pp. 55 ff.

9. Serjeant, "Material for a History of Islamic Textiles," p. 57.

10. Bode and Kühnel, *Antique Rugs*, pp. 26–27; Erdmann, *Seven Hundred Years*, pp. 17–20.

11. Bode and Kühnel, *Antique Rugs*, p. 25, fig. 4, Islamisches Museum, East Berlin.

12. Four triangles formed by placing an octagon inside a square (ibid., p. 26, fig. 5).

13. Şerare Yetkin, *Türk Halı Sanatı* (İstanbul, 1974), p. 37, fig. 9.

14. Richard Ettinghausen, "New Light on Early Animal Carpets," in *Aus der Welt der Islamischen Kunst*, ed. R. Ettinghausen (Berlin, 1959), pp. 108–14 and figs. 12–14.

15. Ibid., pp. 98–108 and figs. 4–7.

16. Erdmann, *Seven Hundred Years*, fig. 44.

17. Ibid., p. 53.

18. Ibid., p. 52.

19. Ibid., fig. 184, Islamisches Museum, East Berlin; Keir Collection, London, no. 72/5/90.

20. John Mills, *Carpets in Pictures* [in the National Gallery, London] (London, 1975), pl. 15; also Bode and Kühnel, *Antique Rugs*, fig. 11.

21. Erdmann, *Seven Hundred Years*, fig. 271.

22. A. F. Kendrick, *Victoria and Albert Museum, Guide to the Collection of Carpets* (London, 1920), pl. 44.

23. Bode and Kühnel, *Antique Rugs*, p. 34; Yetkin, *Türk Halı Sanatı*, fig. 28.

24. Amy Briggs, "Timurid Carpets: Geometric Carpets," *Ars Islamica* 7 (1940): 20–54.

25. Ulrich Schürmann, *Central-Asian Rugs* (Frankfurt, 1969), pp. 13–15, pls. 1–3, 10, 18, 57, 59.

26. Mills, *Carpets in Pictures*, pl. 12.

27. Maurice S. Dimand and Jean Mailey, *Oriental Rugs in the Metropolitan Museum of Art* (New York, 1973), pp. 178–79, fig. 151.

28. Erdmann, *Seven Hundred Years*, fig. 269.

29. Charles Grant Ellis, "A Soumak-Woven Rug in a Fifteenth-Century International Style," *Textile Museum Journal* 1, no. 2 (December 1963): 5–7, figs. 2–3; also Dimand and Mailey, *Oriental Rugs in the Metropolitan*, fig. 155.

30. Dimand and Mailey, *Oriental Rugs in the Metropolitan*, fig. 156, collection of National Gallery, London.

31. Erdmann, *Seven Hundred Years*, p. 57, fig. 53, pattern diagram; p. 58 cites old descriptions.

32. The pattern in the border continues around the four corners of the rug without any interruption in the design. Two large "Lotto" rugs with coats of arms in the field and border pattern with isolated diagonal leaves are considered to be of twentieth-century production. See May H. Beattie, "Book Review of

Dimand and Mailey, *Oriental Rugs in the Metropolitan Museum of Art*," *Oriental Art*, n.s. 20, no. 4 (Winter 1974): 451; Charles Grant Ellis, "The 'Lotto' Pattern as a Fashion in Carpets," in *Festschrift für Peter Wilhelm Meister*, ed. A. Ohm and H. Reber (Hamburg, 1975), p. 26 and fig. 8, classical model.

33. Ellis, "The 'Lotto' Pattern," pp. 19–31.

34. Ibid., pp. 24–27.

35. Erdmann, *Seven Hundred Years*, fig. 29.

36. Ellis, "The 'Lotto' Pattern," p. 28 and fig. 14; May H. Beattie, "Britain and the Oriental Carpet," *Leeds Art Calendar* 55 (1964): 8–11.

37. Ernst Kühnel and Louisa Bellinger, *Catalogue of Spanish Rugs* (Washington, D.C., 1953), pl. 38.

38. Halil İnalcık, *The Ottoman Empire: The Classical Age, 1300–1600* (London, 1973), p. 130.

39. Arménag Bey Sakisian, "L'Inventaire des tapis de la mosquée Yèni-Djami de Stamboul," *Syria* (1931): 368–69.

40. Ibid., p. 370.

41. Ibid.

42. Yetkin, *Türk Halı Sanatı*, fig. 48, Accademia, Venice.

43. May H. Beattie, "A Legacy of Carpets," *Connoisseur* 191, no. 770 (April 1976): 255 and fig. 1.

44. Kurt Erdmann, "Wenige Bekannte Uschak Muster," *Kunst des Orients* 4 (May 1963): 78–97, includes diagrams.

45. May H. Beattie, *The Thyssen-Bornemisza Collection of Oriental Rugs* (Ticino, Switzerland, 1972), p. 99, private collection. The author wishes to thank Charles Grant Ellis and Sarah B. Sherrill for bringing this painting to her attention.

46. Mildred B. Lanier, *English and Oriental Carpets at Williamsburg* (Williamsburg, Va., 1975), pls. 28–32.

47. *Turkish Rugs*, ed. Ralph S. Yohe and H. McCoy Jones (Washington, D.C., 1968), fig. 5.

48. Louise W. Mackie, *The Splendor of Turkish Weaving* (Washington, D.C., 1973), fig. 36.

49. Erdmann, *Seven Hundred Years*, fig. 23.

50. May H. Beattie, "Antique Rugs at Hardwick Hall," *Oriental Art*, n.s. 5, no. 2 (Summer 1959): 53.

51. Kurt Erdmann, *Der Türkische Teppich des 15. Jahrhunderts* (İstanbul, n.d.), p. 38.

52. Beattie, "Hardwick Hall," p. 53.

53. Dimand and Mailey, *Oriental Rugs in the Metropolitan*, fig. 174.

54. Erdmann, *Seven Hundred Years*, fig. 263. Charles Grant Ellis has kindly discussed this rug with me and believes that it was woven in Europe and not in Turkey.

55. Lanier, *English and Oriental Carpets*, pl. 34.

56. Louise W. Mackie, "A Turkish Carpet with Spots and Stripes," *Textile Museum Journal* 4, no. 2 (1976): 4–20. The term *chintamani* is discussed on p. 9 and at fn. 8.

57. Volkmar Enderlein, "Zwei ägyptische Gebetsteppiche im Islamischen Museum," Staatliche Museen zu Berlin, *Forschungen und Berichte* 13 (1971): 11; also Mackie, "A Turkish Carpet," fig. 13.

58. Mackie, "A Turkish Carpet," pp. 14–16.

59. Ibid, pp. 13–17.

60. Erdmann, *Seven Hundred Years*, pp. 81–85 and p. 224, no. 92 with reference to pl. 12; results of analysis of dyes in rug in pl. 12. Friedrich Spuhler, "Review of Kurt Erdmann, *Siebenhundert Jahre Orientteppich*," *Kunst des Orients* 8 (1974): 137.

61. Beattie, "Book Review of Dimand and Mailey," p. 450.

62. Ernst Kühnel and Louisa Bellinger, *Cairene Rugs and Others Technically Related, Fifteenth–Seventeenth Century* (Washington, D.C., 1957), pl. 22.

63. Beattie, "Book Review of Dimand and Mailey," p. 451.

64. Kühnel and Bellinger, *Cairene*, p. 41.

65. Ibid.

66. Ibid., fn. 3.

67. Sakisian, "L'Inventaire des tapis de la mosquée Yèni-Djami," pp. 368–71.

68. Dimand and Mailey, *Oriental Rugs in the Metropolitan*, p. 157, fig. 184 and color pl.

69. Kühnel and Bellinger, *Cairene*, p. 57.

70. Tahsin Öz, *Turkish Textiles and Velvets, XIV-XVI Centuries* (Ankara, 1950), p. 52. Topkapı Sarayı Müzesi, Archives, D. 9706/5804.

71. Kühnel and Bellinger, *Cairene*, p. 57.

72. Ibid.

73. Haim Gerber, Ph.D. candidate at Hebrew University, Jerusalem, who was completing his dissertation research in the Bursa archives in 1974, kindly discussed this with me.

74. Dimand and Mailey, *Oriental Rugs in the Metropolitan*, fig. 168.

75. Sarah B. Sherrill, "Oriental Carpets in Seventeenth- and Eighteenth-Century America," *Magazine Antiques* 109, no. 1 (January 1976): 155–60 and pls. 9–11.

76. Yetkin, *Türk Halı Sanatı*.

77. Erdmann, *Seven Hundred Years*, figs. 115–29; Yohe and Jones, eds., *Turkish Rugs*; Joseph V. McMullan, *Islamic Carpets* (New York, 1965); J. Iten-Maritz, *Der Anatolische Teppich* (Munich, 1975).

78. May H. Beattie, "Some Rugs of the Konya Region," *Oriental Art* 22, no. 1 (Spring 1976): 60–76.

79. Ibid., figs 6–16, 20–22.

80. Ibid., pp. 64, 75 and fig. 17.

81. Ibid., pp. 70–71.

82. Erdmann, *Seven Hundred Years*, pp. 76–80.

83. Richard Ettinghausen, "The Early History, Use, and Iconography of the Prayer Rug," in *Prayer Rugs*, by Maurice S. Dimand, Louise W. Mackie, and Charles Grant Ellis (Washington, D.C., 1974), pp. 11–18.

84. Schuyler V. R. Cammann, "Symbolic Meanings in Oriental Rug Patterns: Part I," *Textile Museum Journal* 3, no. 3 (December 1972): 17–22.

85. Ettinghausen, "Prayer Rug," fig. 9.

86. Volkmar Enderlein, "Zwei ägyptische Gebetsteppiche im Islamischen Museum," p. 9; also Charles Grant Ellis, "The Ottoman Prayer Rugs," *Textile Museum Journal* 2, no. 4 (December 1969): 5–7 and fig. 5.

87. Johanna Zick, "Eine Gruppe von Gebetsteppichen und ihre Datierung," *Berliner Museen, Berichte aus den ehemals Preussische Kunstsammlung*, N.F. Jg. 11, pp. 11 ff.; also Ettinghausen, "Prayer Rug," pls. 8–9 and fig. 19.

88. Erdmann, *Seven Hundred Years*, figs. 127–28.

89. May H. Beattie, "Coupled-Column Prayer Rugs," *Oriental Art* 14, no. 4 (1968): fig. 24; Ettinghausen, "Prayer Rug," pl. 19.

90. Beattie, "Prayer Rugs," figs. 7–9; Emil Schmutzler, *Altorientalische Teppiche in Siebenbürgen* (Leipzig, 1933); J. de Vegh and Ch. Layer, *Tapis Turcs: Provenant des Eglises et Collections de Transylvanie* (Paris, 1926).

91. Lanier, *English and Oriental Carpets*, pls. 57–59.

92. Charles Grant Ellis, "Mixed Thoughts on Oriental Carpets," in *The Delaware Antiques Show* (Wilmington, 1969), pp. 51, 53.

93. Ettinghausen, "Prayer Rug," pl. 17.

94. Ibid., pl. 18.

95. Ibid., pl. 16.

96. Belkis Acar, *Kilim ve Düz Dokuma Yaygılar* (İstanbul, 1975); Ralph S. Yohe, "Book Review: *Kilim ve Düz Dokuma Yaygılar*," *Textile Museum Journal* 4, no. 2 (1976): 75–78.

97. May H. Beattie, "Some Weft-Float Brocaded Rugs of the Bergama-Ezine Region," *Textile Museum*

Journal 3, no. 2 (December 1971): 20–27; Anthony N. Landreau, "Kurdish Kilim Weaving in the Van-Hakkari District of Eastern Turkey," *Textile Museum Journal* 3, no. 4 (December 1973): 27–42.

98. Şerare Yetkin, "Zwei Türkische Kilims," in *Beiträge zur Kunstgeschichte Asiens, In Memoriam Ernst Diez*, ed. Oktay Aslanapa (İstanbul, 1963), pp. 182–92; also Yetkin, "The Kilims in Ottoman Court Style Discovered in Divriği Ulu Mosque," in *Fifth International Congress of Turkish Art*, ed. G. Fehér (Budapest, 1978), pp. 907–20.

99. Halil İnalcık, "Harīr [Silk]: The Ottoman Empire," *Encyclopaedia of Islam*, new ed., vol. 3 (Leiden and London, 1971), p. 212.

100. Ibid., p. 213.

101. Ibid., p. 215.

102. Serjeant, "Material for a History of Islamic Textiles," p. 57.

103. Ibid., pp. 57, 59.

104. Ibid., p. 57.

105. Richard Ettinghausen, "An Early Ottoman Textile," in *First International Congress of Turkish Arts* (Ankara, 1961), pp. 134–40 and pls. 89–94.

106. Otto von Falke, *Decorative Silks*, 3d ed. (New York, 1936), figs. 288–94.

107. Margaret Medley, "Chinese Ceramics and Islamic Design," in *The Westward Influence of the Chinese Arts from the Fourteenth to the Eighteenth Century*, Colloquies on Art and Archaeology in Asia, no. 3 (London, 1972), pp. 1–10.

108. Falke, *Decorative Silks*, figs. 309–10, 327; İnalcık, "Harīr," pl. 6c. Museum of Islamic Art, Cairo.

109. İnalcık, "Harīr," p. 213.

110. Ibid., p. 214.

111. Ibid., p. 215.

112. Ibid., pp. 217–18.

113. Ibid., p. 217.

114. Öz, *Turkish Textiles and Velvets*, pp. 48–51.

115. Ibid., pp. 26, 37, Topkapı Sarayı Müzesi, Archives, D. 4.

116. Ibid., pp. 56, 59.

117. O. M. Dalton, *Byzantine Art and Architecture* (1911), p. 586.

118. Öz, *Turkish Textiles and Velvets*, p. 53.

119. İnalcık, "Harīr," p. 216.

120. Öz, *Turkish Textiles and Velvets*, p. 56.

121. Ibid., pp. 53–54.

122. Ibid., pp. 55–56.

123. Ibid., p. 59.

124. Ibid., pp. 16–17 and especially 18. Because of this fact, it has been decided not to repeat the attributions of the kaftans to specific sultans, as Öz had done in his important publication, but to consider their dating on stylistic grounds.

125. Richard Ettinghausen, *Treasures of Turkey: The Islamic Period*, p. 206.

126. Ibid., p. 207 (color).

127. Yetkin, *Türk Halı Sanatı*, figs. 70 (bookbinding, Topkapı Sarayı Müzesi), 69 (rug, also in Erdmann, *Seven Hundred Years*, fig. 166).

128. Walter B. Denny, "Ottoman Turkish Textiles," *Textile Museum Journal* 3, no. 3 (December 1972): fig. 19 (probably nineteenth century, Uşak); Yetkin, "Zwei Türkische Kilims," fig. 1.

129. Tahsin Öz, *Türk Kumaş ve Kadifeleri*, vol. 2 (İstanbul, 1951), pls. 76, 78.

130. Mackie, *The Splendor of Turkish Weaving*, fig. 20.

131. The Arts Council of Great Britain, *The Arts of Islam* [exhibition catalogue] (London: Hayward Gallery, 1976), fig. 644 (Benaki Museum).

132. Ibid., fig. 20; Falke, *Decorative Silks,* figs. 314, 324.

133. Denny, "Ottoman Turkish Textiles," figs. 12–14.

134. Mackie, *The Splendor of Turkish Weaving,* fig. 22.

135. Kurt Erdmann, "Neue Arbeiten zur Türkischen Keramik," *Ars Orientalis* 5 (1963): 214, pl. 17, and fig. 56.

136. Mackie, *The Splendor of Turkish Weaving,* fig. 2.

137. Öz, *Turkish Textiles and Velvets,* p. 26.

138. Falke, *Decorative Silks,* figs. 532–33.

139. Ibid., p. 73; for technical analysis of *seraser* and other fabrics, see Mackie, *The Splendor of Turkish Weaving,* p. 25, nos. 11–12.

140. Öz, *Turkish Textiles and Velvets,* pl. 26.

141. Ibid., pp. 72–73.

142. Ibid., p. 23 and pls. 1–2.

143. Ernst Kühnel, "Erinnerungen an eine Episode in der Türkenpolitik Friedrichs d. Gr.," *Oriens* 5, no. 1 (1952): 72–81 (Islamisches Museum, East Berlin).

144. The variety of terms for fabrics in the archives indicates that many different types were woven. Only rarely, however, can the terms be identified; therefore, they have been omitted from this text. In some instances, the terms may refer to patterns rather than woven structures.

145. Öz, *Türk Kumaş ve Kadifeleri,* pl. 50.

146. Öz, *Turkish Textiles and Velvets,* pl. 16.

147. Ibid., pl. 15.

148. Ibid., p. 25.

149. Ibid., p. 51.

150. İnalcık, "Harīr," p. 214.

151. Öz, *Turkish Textiles and Velvets,* p. 26.

152. Ibid., p. 73.

153. Ibid., pl. 32.

154. Ibid., pls. 6–7 (this is the same layout as the illustrated Turkish brocaded kaftan, fig. 22), 32–33.

155. Walter B. Denny, "A Group of Silk Islamic Banners," *Textile Museum Journal* 4, no. 1 (December 1974): 67–81.

156. Denny, "Ottoman Turkish Textiles," fig. 24.

157. Ogier Ghiselin de Busbecq, *The Turkish Letters of Ogier Ghiselin de Busbecq* (Oxford, 1968), p. 134.

158. Nurhayat Berker, "Saray Mendilleri," in *Fifth International Congress of Turkish Art* (with English summary), pp. 173–81.

159. Mackie, *The Splendor of Turkish Weaving,* pl. 2 (color), cat. no. 10.

160. Macide Gönül, "Some Turkish Embroideries in the Collection of the Topkapı Sarayı Museum in İstanbul," *Kunst des Orients* 6, no. 1 (1969): 42–76, includes discussion of the functions of embroideries.

161. Ibid., pp. 72–76.

162. Ibid., fig. 29.

163. Ibid., fig. 4.

164. Richard Ettinghausen, "The Islamic Period," in *Art Treasures of Turkey* (Washington, D.C., 1966), color cover of catalogue.

165. Agnes Geijer, *Oriental Textiles in Sweden* (Copenhagen, 1951), pl. 11.

Turkish Dynasties

Pre-Ottoman

Great Seljuks (Irak and Iran) 1038–1194
Seljuks of Syria 1078–1117
Seljuks of Kirman 1041–1186
Seljuks of Rum (Anatolia) 1077–1307

Akkoyunlu (southeastern Anatolia and Azerbayjan) 1378–1508
Artukid (southeastern Anatolia) 1098–1232
Aydınlı (southwestern Anatolia) circa 1300–1426
Danişmend (central and eastern Anatolia) circa 1071–circa 1177
Karakoyunlu (eastern Anatolia and Azerbayjan) 1360–1468
Karaman (central Anatolia) circa 1256–1483
Mengücük (eastern Anatolia) circa 1071–circa 1250
Saltuk (eastern Anatolia) circa 1071–1243

Ottoman

1299(?)–1324(?)	Osman I	1640–1648	İbrahim
1324(?)–1362(?)	Orhan	1648–1687	Mehmed IV
1362(?)–1389	Murad I	1687–1691	Süleyman II
1389–1402	Beyazıd I	1691–1695	Ahmed II
1402–1413	interregnum	1695–1703	Mustafa II
1413–1421	Mehmed I	1703–1730	Ahmed III
1421–1451	Murad II	1730–1754	Mahmud I
1451–1481	Mehmed II*	1754–1757	Osman III
1481–1512	Beyazıd II	1757–1774	Mustafa III
1512–1520	Selim I	1774–1789	Abdülhamid I
1520–1566	Süleyman I	1789–1807	Selim III
1566–1574	Selim II	1807–1808	Mustafa IV
1574–1595	Murad III	1808–1839	Mahmud II
1595–1603	Mehmed III	1839–1861	Abdülmecid I
1603–1617	Ahmed I	1861–1876	Abdülaziz
1617–1618	Mustafa I (first reign)	1876	Murad V
1618–1622	Osman II	1876–1909	Abdülhamid II
1622–1623	Mustafa I (second reign)	1909–1918	Mehmed V
1623–1640	Murad IV	1918–1922	Mehmed VI
		1922–1924	Abdülmecid II (caliph only)

* Mehmed II also reigned from 1444 until 1446, during which time Murad II abdicated in his favor.

Selected Bibliography

History

Berkes, Niyazi. *The Development of Secularism in Turkey*. Montreal, 1964.

Birge, John Kingsley. *The Bektashi Order of Dervishes*. London, 1937.

Braudel, Fernand. *The Mediterranean and the Mediterranean World in the Age of Philip II*. 2 vols. New York, 1972–73.

Cahen, Claude. *Pre-Ottoman Turkey*. London, 1968.

Cook, Michael, ed. *A History of the Ottoman Empire to 1730*. Cambridge, 1976.

Davison, Roderic H. *Turkey*. Englewood Cliffs, N. J., 1968.

İnalcık, Halil. *The Ottoman Empire: The Classical Age, 1300–1600*. London, 1963.

Itzkowitz, Norman. *Ottoman Empire and Islamic Tradition*. New York, 1972.

Lewis, Bernard. *The Emergence of Modern Turkey*. London, 1968.

———. *Istanbul and the Civilization of the Ottoman Empire*. Norman, Okla., 1963.

Lewis, Geoffrey. *Modern Turkey*. New York, 1974.

Lewis, Raphaela. *Everyday Life in Ottoman Turkey*. London, 1971.

Mantran, Robert. *Istanbul dans la seconde moitié du XVIIᵉ siècle*. Paris, 1962.

Naff, Thomas, and Roger Owen, eds. *Studies in Eighteenth-Century Islamic History*. Carbondale, Ill., 1977.

Shaw, Stanford J., with Ezel Kural Shaw. *History of the Ottoman Empire and Modern Turkey*. 2 vols. New York, 1976–77.

Vaughan, Dorothy. *Europe and the Turk: A Pattern of Alliances, 1350–1700*. Liverpool, 1954.

Vryonis, Speros, Jr. *The Decline of Medieval Hellenism in Asia Minor and the Process of Islamization from the XIth through the XVth Century*. Berkeley, 1971.

Wittek, Paul. *The Rise of the Ottoman Empire*. London, 1967.

Architecture

Anhegger, Robert. *Beiträge zur Frühosmanischen Baugeschichte*. İstanbul, 1953.

Aslanapa, Oktay. *Turkish Art and Architecture*. London, 1971.

Davis, Fanny. *The Palace of Topkapi*. New York, 1970.

Erdmann, Kurt. *Das Anatolische Karavansaray des 13. Jahrhunderts*. 2 vols. Berlin, 1962.

———. "Serailbauten des 13. und 14. Jahrhunderts in Anatolien." *Ars Orientalis* 3 (1959): 77–94.

Eyice, Semavi. "Un Type de mosquée de style turc-ottomane ancien." *Proceedings of the First International Congress of Turkish Art*. Ankara, 1962, pp. 141–43.

Gabriel, Albert. *Une Capitale turque, Brousse [Bursa]*. Paris, 1958.

———. *Les Monuments turcs d'Anatolie*. Paris, 1931–34.

———. "Les Mosquées de Constantinople." Offprint from *Syria*. Paris, 1926.

———. *Voyages archéologiques dans la Turquie orientale*. Paris, 1940.

Gebhard, David. "The Problem of Space in Ottoman Architecture." *Art Bulletin* 45, no. 3 (1963): 271–75.

Goodwin, Godfrey. *A History of Ottoman Architecture*. London, 1971.

Gurlitt, Cornelius. *Die Baukunst Konstantinopels*. 4 portfolios. Berlin, 1912.

Kuban, Doğan. *Anadolu-Türk Mimarisinin Kaynak ve Sorunları*. İstanbul, 1965.

———. "The Mosque-Hospital at Divriği and the Origins of Anatolian Turkish Architecture." *Anatolica* 2 (1968): 122–30.

———. "Sinan and the Classical Age of Turkish Architecture." *Mimarlık* 2 (1967): 13–44.

Kuran, Aptullah. *Anadolu Medreseleri*. Vol. 1. Ankara, 1969.

———. *The Mosque in Early Ottoman Architecture*. Chicago, 1968.

Öz, Tahsin. *İstanbul Camileri*. 2 vols. İstanbul, 1962.

Riefstahl, Rudolf M. *Turkish Architecture in Southeastern Anatolia*. Cambridge, 1931.

Rogers, J. Michael. "The Çifte Minare Medrese at Erzurum and the Gök Medrese at Sivas." *Anatolian Studies* 15 (1965): 63–85.

Ünal, Rahmi Hüseyin. *Les Monuments islamiques anciens de la ville d'Erzurum et de sa région.* Paris, 1968.

Ünsal, Behçet. *Turkish Islamic Architecture in Seljuq and Ottoman Times.* London, 1959.

Vogt-Göknil, Ulya. *Living Architecture: Ottoman.* London, 1966.

Yetkin, Suut Kemal. *Turkish Architecture.* Translated by B. Uysal. Ankara, 1965.

Manuscripts

Atasoy, Nurhan, and Filiz Çağman. *Turkish Miniature Painting.* İstanbul, 1974.

Atıl, Esin. *Imperial Turkish Painting: Illustrated Historical Manuscripts from the Classical Period.* New York, forthcoming.

Çığ, Kemal. *Türk Kitap Kapları.* İstanbul, 1971.

Stchoukine, Ivan. *La Peinture turque d'après des manuscrits illustrés.* Part 1: Paris, 1966. Part 2: Paris, 1971.

CATALOGUES OF COLLECTIONS

Berlin, Staatsbibliothek: I. Stchoukine, B. Flemming, P. Luft, and H. Sohrwiede. *Illuminierte islamische Handschriften.* Wiesbaden, 1971.

Dublin, Chester Beatty Library: A. J. Arberry, M. Minovi, and E. Blochet. *The Chester Beatty Library: A Catalogue of the Persian Manuscripts and Miniatures.* 3 vols. Dublin, 1959–62.

Dublin, Chester Beatty Library: V. Minorsky. *The Chester Beatty Library: A Catalogue of the Turkish Manuscripts and Miniatures.* Dublin, 1958.

İstanbul, İstanbul Üniversite Kütüphanesi: F. Edhem and I. Stchoukine. *Les Manuscrits illustrés de la Bibliothèque de l'Université de Stamboul.* Paris, 1933.

İstanbul, Topkapı Sarayı Müzesi: F. E. Karatay. *Topkapı Sarayı Müzesi Kütüphanesi Türkçe Yazmalar Kataloğu.* 2 vols. İstanbul, 1961.

_____. *Topkapı Sarayı Müzesi Kütüphanesi Farsca Yazmalar Kataloğu.* İstanbul, 1961.

İstanbul, Türk ve İslam Eserleri Müzesi: Kemal Çığ. "Türk ve İslâm Eserleri Müzesi'ndeki Minyatürlü Kitapların Kataloğu." *Şarkiyat Mecmuası* 3 (1959): 51–90.

London, British Museum: C. Rieu. *Catalogue of the Persian Manuscripts in the British Museum.* 3 vols. London, 1879–83.

_____. *Catalogue of the Turkish Manuscripts in the British Museum.* London, 1888.

London, British Museum: G. M. Meredith-Owens. *Turkish Miniatures.* London, 1963.

Paris, Bibliothèque Nationale: E. Blochet. *Catalogue des manuscrits turcs de la Bibliothèque Nationale.* 2 vols. Paris, 1932–33.

_____. *Peintures des manuscrits orientaux de la Bibliothèque Nationale.* 2 vols. Paris, 1914–20.

San Diego, Calif., Binney Collection: Edwin Binney, 3rd. *Turkish Treasures from the Collection of Edwin Binney, 3rd.* Portland, 1979.

Vienna, Nationalbibliothek: G. L. Flügel. *Die Arabischen, Persischen und Türkischen Handschriften der K. K. Hofbibliothek zu Wien.* 3 vols. Vienna, 1865–67.

Washington, D. C., Freer Gallery of Art: Esin Atıl. *Turkish Art of the Ottoman Period.* Washington, D.C., 1973.

Ceramics

Aslanapa, Oktay. *Türkische Fliesen und Keramik in Anatolien.* İstanbul, 1965.

Carswell, John. *Kütahya Tiles and Pottery from the Armenian Cathedral of St. James, Jerusalem.* 2 vols. Oxford, 1972.

Denny, Walter B. *The Ceramics of the Mosque of Rüstem Pasha and the Environment of Change.* New York, 1977.

Erdmann, Kurt. "Neue Arbeiten zur Türkischen Keramik." *Ars Orientalis* 1 (1963): 192–219.

Kiefer, Charles. "Les Céramiques siliceuses d'Anatolie et du Moyen-Orient." *Bulletin de la Société Française de la Céramique* 30 (1956): 5–34.

Lane, Arthur. *Later Islamic Pottery.* 2d ed. London, 1971.

_____. "The Ottoman Pottery of Isnik." *Ars Orientalis* 2 (1957): 247–81.

Otto-Dorn, Katharina. *Türkische Keramik.* Ankara, 1957.

Öz, Tahsin. *Turkish Ceramics.* Ankara, n.d.

Rugs and Textiles

Beattie, May H. "Coupled-Column Prayer Rugs." *Oriental Art* 14 (1968): 243–58.

_____. "Some Rugs of the Konya Region." *Oriental Art* 22, no. 1 (Spring 1976): 60–76.

Bode, Wilhelm von, and Ernst Kühnel. *Antique Rugs from the Near East.* 4th ed. Translated by C. G. Ellis. Braunschweig, 1958.

Denny, Walter. "Ottoman Turkish Textiles." *Textile Museum Journal* 3, no. 2 (1972): 55–66.

Ellis, Charles Grant. "The Ottoman Prayer Rugs." *Textile Museum Journal* 2, no. 4 (1969): 5–22.

Erdmann, Kurt. *Oriental Carpets.* 2d ed. Translated by C. G. Ellis. New York, 1960.

_____. *Seven Hundred Years of Oriental Carpets.* Edited by Hanna Erdmann, translated by M. H. Beattie and H. Herzog. Berkeley and Los Angeles, 1970.

Ettinghausen, Richard, Maurice S. Dimand, Louise W. Mackie, and Charles Grant Ellis. *Prayer Rugs.* Washington, D.C., 1974.

İnalcık, Halil. "Harīr [Silk]: The Ottoman Empire." *Encyclopaedia of Islam.* New ed. Vol. 3, pp. 211–18. Leiden and London, 1971.

Mackie, Louise W. *The Splendor of Turkish Weaving.* Washington, D.C., 1973.

Öz, Tahsin. *Turkish Textiles and Velvets, XIV–XVI Centuries.* Vol. 1. Ankara, 1950.

_____. *Türk Kumaş ve Kadifeleri.* Vol. 2. İstanbul, 1951.

Yetkin, Şerare. *Türk Halı Sanatı.* İstanbul, 1974.

Acknowledgments

The editor, authors, and publishers would like to express their sincere thanks to the following persons and institutions for granting permission to reproduce photographic material in this volume.

Oktay Aslanapa: ills. 1, 3, 6, 8, 12, 16, 18, 49, 53, 63
Aptullah Kuran: ills. 10, 11, 13
Private collection: pl. 39

Ankara, Etnoğrafya Müzesi: ill. 136
Athens, Benaki Museum: ills. 204, 208; pl. 57
Berlin (East), Staatliche Museen zu Berlin, Islamisches Museum: ills. 175, 211
Berlin (West), Museum für Islamische Kunst: ills. 146, 191
Boston, Museum of Fine Arts: ill. 148
Cambridge, Mass., Fogg Art Museum: ill. 214
Chicago, Art Institute of Chicago: ill. 219
Chicago, University of Chicago Press (Aptullah Kuran, *The Mosque in Early Ottoman Architecture*, © 1968): ills. 20, 22, 24–26, 30, 40, 44
Divriği, Ulu Cami: ill. 196; pl. 58
Dublin, Chester Beatty Library: ill. 72
Fribourg, Switzerland, Office du Livre (Ulya Vogt-Göknil, *Living Architecture: Ottoman*, © 1966): ills. 48, 52, 55
Horham, England, Godman Collection: ills. 149, 150
İstanbul, Topkapı Sarayı Müzesi: ills. 65, 66, 68–70, 73–77, 79–88, 91, 93, 96–111, 114–125, 128, 142, 143, 200, 201, 205, 210, 212, 213, 216, 220; pls. 16–18, 20–27, 29–33, 59, 60, 63, 64
İstanbul, Türk ve İslam Eserleri Müzesi: ills. 92, 127, 172, 194; pls. 50, 51
İstanbul, Üniversite Kütüphanesi: ills. 78, 94, 95, 126, 129–131; pls. 19, 28
Konya, Konya Müzesi: ill. 7
Krakow, Wawel Castle: ill. 221; pl. 65
Lisbon, Calouste Gulbenkian Foundation: ill. 209
London, British Library (Courtesy of the British Library Board): ill. 113
London, British Museum: ills. 144, 145, 147, 153
London, National Gallery: ill. 177
London, Thames and Hudson, Ltd. (Godfrey Goodwin, *A History of Ottoman Architecture*, © 1971): ills. 29, 31, 32, 34, 36, 37, 39, 42, 46, 58–60, 62
London, Victoria and Albert Museum: ills. 154, 157, 169, 170, 190
Lyon, Musée Historique des Tissus: ill. 198
New York, Metropolitan Museum of Art: ills. 71, 155, 168, 173, 182, 184, 192, 206; pls. 30, 40, 41, 52
New York, New York Public Library, Spencer Collection (Astor, Lenox and Tilden Foundations): ill. 112
Oxford, Bodleian Library: ill. 64
Paris, Louvre: ills. 156, 166; pl. 43
Paris, Musée des Arts Décoratifs: ills. 181, 183
Philadelphia, Philadelphia Museum of Art: ill. 178
St. Louis, St. Louis Art Museum: ills. 187, 195
Sèvres, Musée National de Céramique: ills. 163, 165
Stockholm, Statens Historiska Museum: ill. 174
Switzerland, The Wher Collection: pl. 54
Vienna, Österreichisches Museum für Angewandte Kunst: pl. 55
Washington, D.C., Freer Gallery of Art: ills. 67, 89, 90, 164; pls. 40, 42
Washington, D.C., The Textile Museum: ills. 176, 180, 185, 186, 188, 189, 193, 197, 202, 203, 207, 215, 217, 218; pls. 53, 56, 61, 62
Yugoslavia, Monastery of Studenica: ill. 199

Index